THE NOUR FOUNDATION

THE NASSER D. KHALILI COLLECTION OF ISLAMIC ART

VOLUME IV

Part One

General Editor Julian Raby

The Nour Foundation
in association with
Azimuth Editions and Oxford University Press

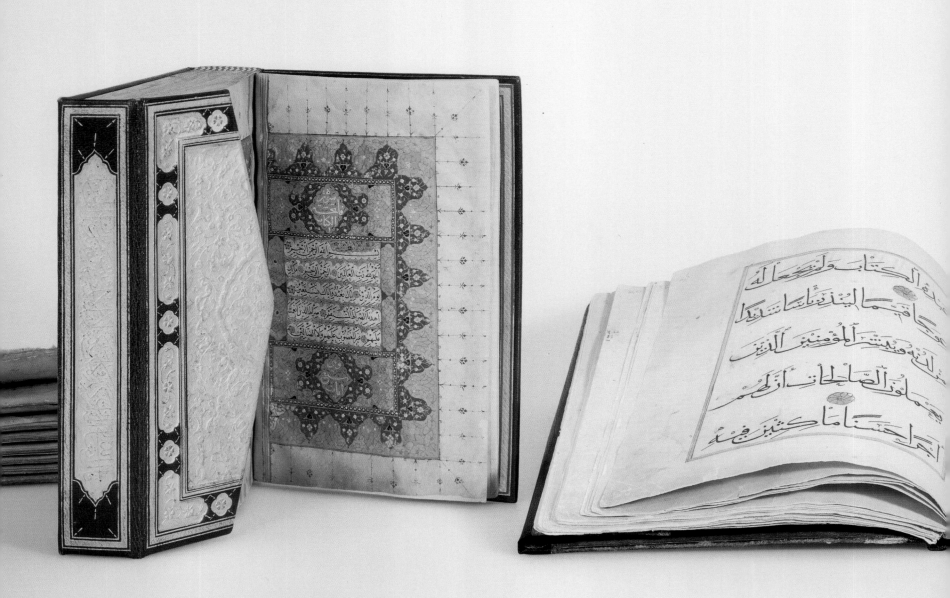

THE DECORATED WORD

Qur'ans of the 17th to 19th centuries

by Manijeh Bayani, Anna Contadini
and Tim Stanley

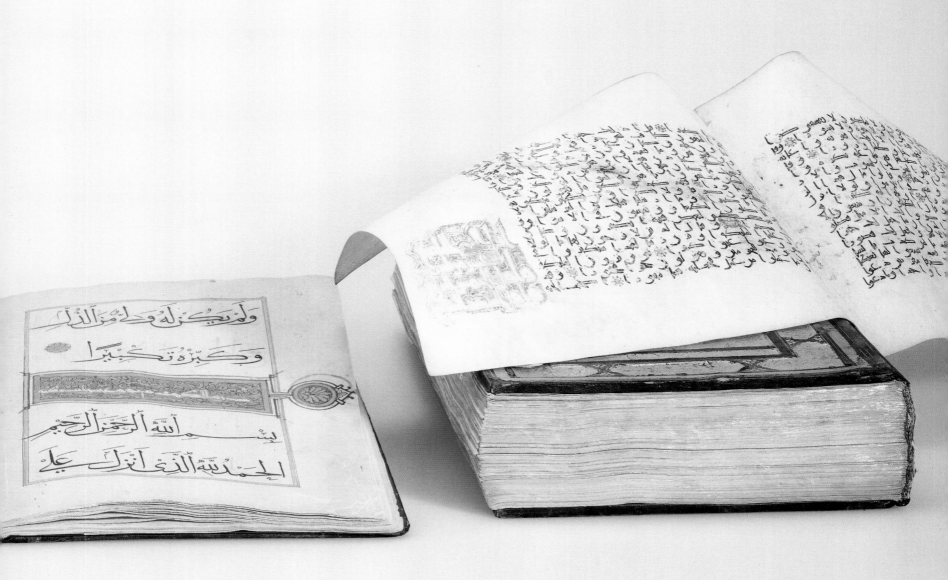

Published in the United Kingdom
by The Nour Foundation
in association with Azimuth Editions
and Oxford University Press

The Nour Foundation is part of The Khalili Family Trust

The Nour Foundation
PO BOX 2827, LONDON W IX 5NL
WEBSITE:www.khalili.org EMAIL:nourhouse@aol.com

Azimuth Editions
Unit 1, Roslin Road, London W 3 8BH, England
Edited by Julian Raby and Alison Effeny
Design by Anikst Associates

Oxford University Press, Walton Street, Oxford OX2 6DP

Oxford New York
Athens Auckland Bangkok
Bombay Calcutta Cape Town Dar es Salaam Delhi
Florence Hong Kong Istanbul Karachi Kuala Lumpur
Madras Madrid Melbourne Mexico City
Nairobi Paris Singapore Taipei Tokyo Toronto
and associated companies in
Berlin Ibadan

Oxford is a trade mark of Oxford University Press

Published in the United States
by The Nour Foundation
in association with Azimuth Editions
and Oxford University Press Inc., New York

British Library Cataloguing in Publication Data
 Bayani, Manijeh
 The decorated word: Qur'ans of the 17th to 19th centuries – (The Nasser
 D. Khalili Collection of Islamic Art; v. 4, pt. 1)
 1. Koran – Manuscripts 2. Illumination of books and manuscripts, Islamic
 I. Title II. Contadini, Anna III. Stanley, Tim IV. Nour Foundation
 745.6'74'927
 ISBN 0−19−727603−2

Library of Congress Cataloging in Publication Data
 (data applied for)
 ISBN 0−19−727603−2

Photography by Christopher Phillips

Typeset by Azimuth Editions
Printed by PJ Reproductions, London

Contents

Foreword

Islamic manuscripts form one of the great intellectual and artistic patrimonies of mankind. Their importance has long been recognized in the non-Muslim West, where private individuals and public institutions have been collecting them for at least four centuries, but most are still to be found in the lands where they were made. Despite the efforts of several Muslim governments in the Near East and beyond and of institutions such as the Manuscripts Commission of the League of Arab States, neither the total number of these works nor a full list of their locations can be given. This is so even in the case of Arabic manuscripts, the most extensively studied group. Nevertheless, it is clear that the numbers involved are considerable. A substantial proportion of these contain the text of the Holy Qur'an, for no other work can have been copied out by hand so often in the course of the last 1400 years. The majority of surviving Qur'ans are simply written and sparsely illuminated, but many are magnificent examples of the arts of the calligrapher and illuminator.

The largest and finest collection of Qur'ans is undoubtedly that of the Topkapı Palace Library in Istanbul, which contains the major part of the former imperial library of the Ottoman sultans. There are also important collections in the library attached to the Astan-i Quds-i Razavi, the shrine of the Imam Riza in Mashhad; in the Museum of Ancient Iran in Tehran; in the National Library in Cairo; and in various libraries and museums in India. While circumstances have made the huge Topkapı collection well-nigh comprehensive, the others are not only smaller but have a more regional bias.

Collecting activity in Europe and North America has led to the accumulation of large numbers of Islamic manuscripts, and as a matter of course these have included copies of the Qur'an. The main collections of Qur'ans outside the Muslim world are to be found in the British Library in London, the Bibliothèque Nationale in Paris, the Vatican Library in Rome, and the Chester Beatty Library in Dublin. However, with the exception of the Chester Beatty Library, the acquisition of this material was never pursued as systematically as in the case of literary, historical and scientific manuscripts. Even though the text of the Qur'an is invariable, palaeographic, aesthetic or historical criteria could have been used to determine what entered these collections, but, with the one exception, no attempt was made to apply such criteria.

It was with an awareness of the need for a consistent approach of this kind that I began to form a collection of Qur'anic manuscripts some 30 years ago under the auspices of the Khalili Family Trust. During this time attempts have been made to secure examples from every period and every part of the Islamic world. As a result the body of material acquired is notable for the wide range it covers. This material can now be used to illustrate the entire spectrum of Qur'anic manuscript development, and, as there are often several examples from the same period, comparisons can be made both within the period and between contemporary manuscripts from different areas. The items in the Collection are of great historical and aesthetic importance. They have been conserved and, where appropriate, restored, and in some cases this has led to interesting discoveries.

With this volume the Qur'anic manuscripts that I have brought together will have been published as the first four volumes of the general catalogue of the Collection. My hope was that, when the publication of these four volumes was complete, they would constitute the most comprehensive survey of Qur'anic calligraphy and illumination yet undertaken, and I am glad to say that this aspiration is well on the way to being fulfilled. The first three volumes, which cover the period before 1600, appeared in 1992, and they set a new standard in the subject, earning the respect of specialists and the admiration of those with a more general interest in Islamic art. It subsequently became clear that the Collection's holdings of later Qur'an manuscripts are so substantial that they could not be contained in the fourth volume in the series, which has therefore been divided into two parts. This first part deals with two categories of material. One consists of Qur'ans produced in the Islamic empires that controlled the

Mediterranean world, Iran and India; it includes all the examples produced in North Africa and India after 1600 and the Iranian and Ottoman Qur'ans of the 17th and 18th centuries. These large sections are prefaced by a smaller group of manuscripts representing Qur'an production 'beyond the Islamic empires', which contains material from China, from the coastlands of the Indian Ocean, and from sub-Saharan Africa. The second part will publish the Iranian and Ottoman Qur'ans of the 19th century, which form part of the world's last great flowering of manuscript production.

This catalogue has had a long and complex gestation, and it has benefited from the contributions made by several people. Some of the original identifications were made by David James, who was responsible for the catalogues of the Qur'anic material from the 11th to 16th centuries, while he was on secondment from the Chester Beatty Library. Dr James also made extensive notes on some items, which were later used as the starting-point for two of the essays published below, and these have been credited in the footnotes. Subsequently, Anna Contadini prepared drafts of the entries that form the substance of the first half of the book, but ceased working on our project when she moved to a teaching post at Trinity College, Dublin. I am pleased to say that she has since been appointed to the faculty of my own *alma mater*, the School of Oriental and African Studies in London. At the same time, Manijeh Bayani, who has been an important contributor to the study of the Collection as a whole, took responsibility for drafting the Iranian and Indian sections. More recently Tim Stanley, the deputy curator of the Collection, undertook the task of combining the material these authors had provided and supplementing it with his own contributions. Manijeh Bayani had drawn on a wealth of comparative material and Persian literary sources in evaluating the Iranian and Indian items, and Tim Stanley was able to balance this by extracting significant information from Turkish and other sources, and he provided other important data by paying close attention to distinctive codicological features. These two authors have also been able to supply no less than ten essays on different manuscripts and groups of manuscripts in the Collection, all of which provide new interpretations, and several of which are the first in their particular field. As a result, and despite the very varied nature of the Qur'an manuscripts concerned, through their combined efforts the contributors have been able to maintain the standard set by François Déroche and David James for the first three volumes in the series, and I am grateful to them for their fine work.

Dr Julian Raby, the general editor of the series, played an important role in bringing this volume to completion, and he deserves my thanks. These are also due to Helen Loveday, for her technical analysis of the papers employed; to Diane Dixson-O'Carroll, who provided the drawing on p.13; to Christopher Phillips, for his photography; to Anikst Associates, who created the design; to Alison Effeny, who was text editor at Azimuth Editions; and to Lorna Raby, who supervised the production process. Wendy Keelan and Sally Chancellor provided invaluable administrative help.

The time and resources needed to bring together the manuscripts recorded in this catalogue and to arrange for their publication has been considerable, and I cannot conclude without acknowledging the tolerance and affection shown to me by my wife, Marion, and my sons, Daniel, Benjamin and Raphael. They have my gratitude.

Nasser D. Khalili
London, 1999

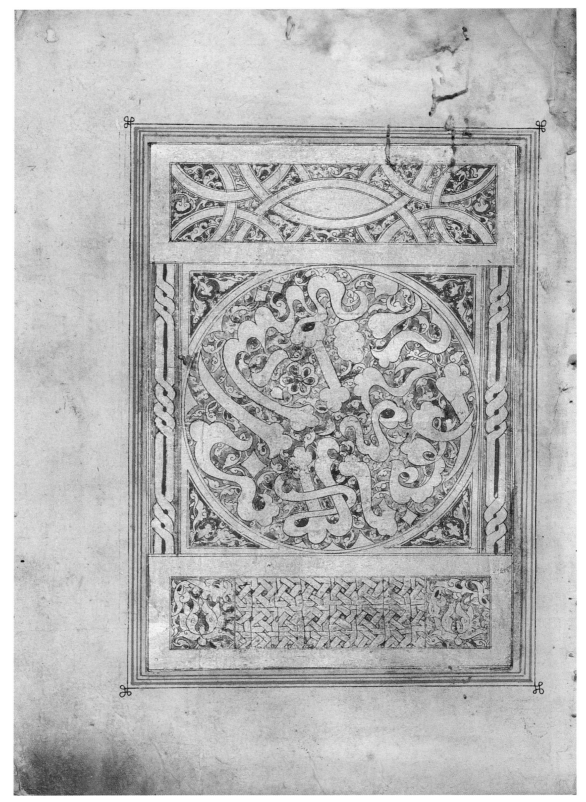

1 folio 2a

Noble exceptions. Qur'an production beyond the Islamic empires

Most of the Qur'ans in the Khalili Collection are from what are generally considered to be the main centres of Islamic civilization, in the Mediterranean coastlands, in the Middle East, and in India. The Qur'ans presented in this section, however, were produced in other parts of the world, in areas that are not normally studied by specialists in Islamic art. The 'marginal' zone from which they come is, like the core territory of the Islamic world, of enormous dimensions – it stretches from China (cat.1–3), through South-east Asia (cat.4) and East Africa (cat.5) to the Sahel region of West Africa (cat.6, 7). The period under discussion is also longer than that considered in the rest of this volume, for it covers the 500 years from the 15th century to the 19th. The physical character of the manuscripts is as varied as one would expect in pieces produced in regions so far apart and at such different periods. The two 19th-century examples from the Sahel (cat.6, 7) are not even bound in the same manner as the other items, as they are loose-leaf books, and their bindings resemble portfolios with open ends, top and bottom. At the same time, the illumination of cat.7 is reminiscent of contemporary West African textile designs, while one of the two 15th-century Qur'an sections from China (cat.2) is decorated with motifs that are of a distinctively local character.

Despite their diversity, the traditions of Qur'an production considered here were all affected by certain common factors associated with their location on the periphery of the Islamic world. In the regions where these traditions grew up Islam was not introduced as the direct result of the Arab conquests of the 7th and 8th centuries AD, as it was in the Mediterranean world, the Middle East, western Central Asia and north-west India. It was brought there through peaceful contact, which was primarily commercial in character. Muslims first settled in China during the Tang period (618–907), both as merchants and as colonists. Some came overland from the west, while others arrived by sea from the south and made their homes in ports such as Hangzhou and Guangzhou (Canton), where the celebrated Tang-period minaret of the Huaisheng mosque still stands. As we shall see, however, the most important factor in the growth of this community was the Mongol invasions of the 13th century. Thereafter Muslims formed a majority in eastern Central Asia, annexed by the Qing dynasty in the 18th century, but in China proper Muslims remained a minority living under pagan rule. On the surface the development of Islam in the coastlands of the Indian Ocean and in the Sahel seems very different, as penetration by Muslim merchants and by missionaries following trade routes led eventually to the establishment of Muslim states. Yet these never achieved the wealth and power of the great empires of the Islamic heartlands, which had such a profound influence on artistic production from the Abbasid period onwards.

In other words, the regions of the marginal zone shared a type of history different from that of the central Islamic lands, and this led in turn to differences in the nature of Qur'an production. Specialists in Islamic art tend to define that art in terms of dynastic styles, but this cannot have the same significance for regions governed by non-Muslim dynasties, as in China, or where the resources available to local rulers were too meagre to allow great acts of royal patronage, as in sub-Saharan Africa. In both cases the result was a degree of stability in Qur'an production over long periods, with changes occurring piecemeal rather than as the result of the concerted reformulations of taste that characterized successful dynastic states.

China. Qur'ans of the Ming period

by Tim Stanley

The establishment of the Mongol empire by Chinggis Khan (*reg.*1206–1227) had an immense effect on the history of Islam. In many ways, of course, this effect was detrimental. Countless Muslims lost their lives; many of the great cities of the medieval period were left as heaps of ruins, with their agricultural infrastructure destroyed; and a large part of the Muslim world fell under pagan rule for the first time since the Islamic conquests. The formation of the Mongol empire was also accompanied by great movements of population, as the invaders amalgamated many non-Mongol elements into their forces and swept them into the lands settled by Muslims. When Chinggis Khan and his descendants undertook conquests in China, however, the process was reversed. The armies they assembled incorporated large numbers of their Muslim subjects from the western regions of the empire, and this led to a great increase in the Muslim population of China – the total at the end of Mongol (Yuan) rule in 1368 has been estimated at four million.[1] In this respect, then, the Mongol expansion contributed to the geographical spread of Islam, of Persian, the language the newcomers used in their daily life, and of Arabic, the language of their religion. As we shall see, in later periods manuscripts in these languages were produced all over China – material in the Khalili Collection was copied in provinces as far apart as Gansu in the north-west (MSS993), Hebei in the north-east (cat.1), and Yunnan in the south-west (cat.2).[2]

Many Muslims who entered China under the Mongols participated in the government of the country at the highest levels, and the whole Muslim community was given a privileged status second only to that of the conquerors themselves.[3] A celebrated member of this Muslim elite was Shams al-Din 'Umar of Bukhara, known as Sayyid-i Ajall (1211–1279). He first entered Mongol service under Chinggis Khan, and he was commander-in-chief of one of the three war zones under Qubilay Khan (*reg.*1260–1294), the first emperor of the Yuan dynasty. From 1273 until his death six years later Sayyid-i Ajall was governor of Yunnan, the province created after the conquest of the kingdom of Nan Zhao in 1253. Yunnan, which had a predominately Buddhist, Tibeto-Burmese population, became a focus of Muslim settlement, and Muslim primacy there was maintained for some time by the succession of Sayyid-i Ajall's sons as governors after his death.

In 1368 the Yuan dynasty was overthrown by the first emperor of the Ming dynasty, resulting in a restoration of Chinese supremacy within the empire. The Ming regime excluded Muslims from government service and sought to integrate them with the indigenous population. The eventual effect of this policy was that, through intermarriage and the adoption of the externals of Chinese culture, such as dress and language, the Muslims of China became Chinese Muslims (*huihui*). The use of Persian and Arabic declined, and by the late 16th century a Muslim apologetic literature written in Chinese had emerged. Nevertheless, this sinification had very little effect on the Qur'ans and other Islamic religious books produced in the Ming period.

The Khalili Collection includes four such manuscripts. Two of these, cat.1 and 2 below, are single parts of two 15th-century Qur'ans prepared in 30 parts; the third, MSS993, is a collection of devotional texts in Persian and Arabic copied by a female scribe in 1548; and the fourth, cat.3, is a complete Qur'an in 30 parts produced in 1605. Examples of ornament in a Chinese style can be found in these manuscripts,[4] and they have one or two other features that mark them off from books of Middle Eastern origin, such as the character of the paper employed, and the use of small stamps to decorate the binding. In most other respects, however, all four are typical examples of the Islamic codex as it had developed in the eastern half of the Iranian world in the pre-Mongol period. The text was copied in ink on paper with a reed pen, the use of which is betrayed in the deliberately uneven endings of some downward strokes; the manuscripts have extensive illumination in colours and gold, which served as decoration and to express the structure of the text; and the text on each page is surrounded by a frame of two red rules. In cat.1, cat.2 and the Khalili Collection's devotional manuscript of 1548 the original structure of the manuscript has been preserved to a large extent; and this shows that the gatherings are quinternions, that is, groups of five bifolia, which were sewn at four stations. The bindings, which have an envelope flap attached to the lower cover, are of leather over pasteboard, worked in gold and in blind with tools (and the stamps mentioned above), and lined with textiles. Perhaps most importantly, the

style of script employed is a form of the *muḥaqqaq* hand that has some notable peculiarities (see the discussion under cat.1) but was very probably derived from a type of *muḥaqqaq* current in Iran before the Mongol invasions.[5] For this 13th-century Western Asian tradition to have survived into the Ming period, there must have been Qur'an production in China during the Yuan period, but no surviving examples have yet been identified.[6]

The four Khalili manuscripts show considerable technical and stylistic uniformity, even though, as noted above, they were produced at different times over a period of 200 years and in cities separated by vast distances. In the case of the Qur'anic material this standardization extends to the page dimensions, the presentation of the text in a five-line format, and the type of surah headings, verse markers and illumination employed. A further feature shared by the Khalili pieces, and indeed by the majority of the published material from China, is that they come from Qur'ans in 30 sections.[7] This suggests that the uniformity they displayed was underpinned by a strong tradition of Qur'an recitation, either as a part of the life of the Muslim community as a whole, in more private contexts such as mausolea, or within a widespread Sufi fraternity.

The earliest Chinese Qur'an section in the Khalili Collection is cat.1, which was completed in what is now Beijing in 1401. The illumination includes a setting for the first lines of text on folios 2b and 3a, and the layout used here is found on the opening pages of almost all other published Qur'an sections from China:[8] the plain text area is surrounded by a broad illuminated frame composed of four sections, two horizontal panels top and bottom, and a narrow vertical panel on either side. In cat.1 the panels were painted gold, and the motifs were reserved in brown and blue grounds painted over the gold. The overall effect is generally typical of Qur'anic illumination of the later Middle Ages;[9] but the central text area is

1 binding

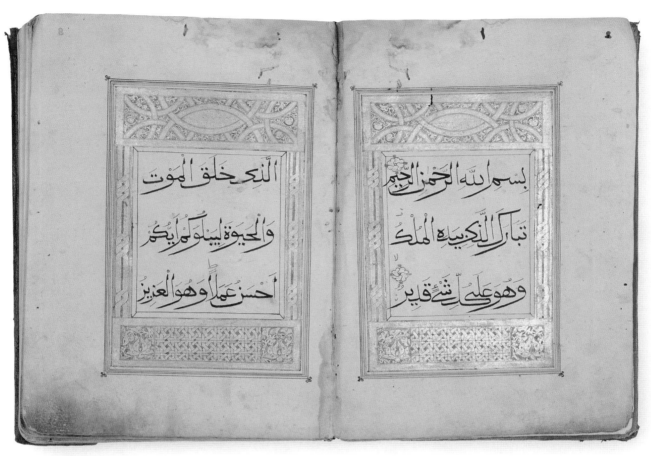

1 folios 2b–3a

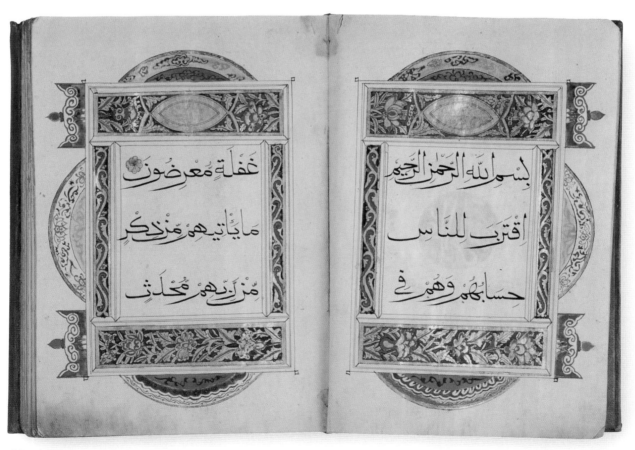

2 folios 2b–3a

surrounded by a narrow frame formed by single black rules, and this has 'mitred' corners, suggesting depth. In other words, we are tempted to see the text as through a window, for which the illumination forms a grandiose frame. The same effect can be seen in the panels in the same position in cat.3, but here the 'mitred' frame occurs not around the central text area but within the four illuminated panels that frame it. This Qur'an was produced more than 200 years after cat.1, but the illuminator remained true to the same model in almost every other respect: only the motifs in the lower horizontal band are different. In an almost contemporary non-Qur'anic manuscript, however, the plain 'mitred' frames seen around the text areas in cat.1 have been developed much further. The work in question is a book of Qadiri devotions produced in 1614,[10] and in the illumination of the opening pages individual 'mitred' frames of this type surround each of the four illuminated panels on each page. The frames fit together, with the result that the illuminated panels look as though they have been fitted into a relatively complex piece of three-dimensional joinery, which has been left undecorated. Needless to say, such an illusion is completely alien to the Islamic tradition. The same feature occurs on the opening pages of cat.2, which was completed in Kunming, the capital of Yunnan province, in 1471. It has been suggested, though, that the illumination in this Qur'an was executed in two stages, one contemporary with the manuscript, the other attributed to the late 17th century or the early 18th.[11] In fact the illumination is all of a piece (see below, p.18), and the similarity of the design with the Qadiri manuscript of 1614 suggests that all the decoration in cat.2 was added more than 100 years after the text was completed – although the Qadiri manuscript may, of course, be a facsimile of an earlier original.

These (relatively minor) developments in illumination, and parallel innovations in bindings, appear to be the only substantial changes in the Chinese Muslim tradition of book production in the Ming period. The Chinese tradition clearly remained undisturbed by developments in Qur'an production that occurred in the Iranian world after the Mongol invasions,[12] and as a result it became increasingly archaic as compared with Middle Eastern products, reflecting the isolation of Chinese centres of production from their counterparts in the Islamic empires. Amendments were introduced gradually, reflecting the assimilation of the Muslims to Chinese culture. It is difficult to be categorical, as so little material has been published, and so little of that is securely dated; but it does seem that the more dramatic stylistic changes, exemplified by the decidedly Chinese marginal illumination in cat.2, occurred after the fall of the Ming and the advent of the Qing dynasty (1644–1911).

1. Israeli 1977.
2. For architectural evidence of the Muslim presence in China, see Luo 1994; Tanaka 1996, and the sources cited there. For a recent general treatment of Chinese Muslim material culture, see Copenhagen 1996, pp.312–23.
3. For what may be a portrait of a Persian administrator in China in the Yuan period, see Soudavar 1992, no.1.
4. This work in the Chinese style should not be confused with the *chinoiserie* employed in the Islamic art of the Middle East.
5. See, for example, Bahrami & Bayani 1328, no.38; Paris 1987, no.30.

6. A Qur'an of AD1269 in the Khalili Collection (James 1992a, no.17) was attributed by David James to Eastern Iran or India, but the same arguments could be used to attribute it to China.
7. See, for example, Arberry 1967, nos 243, 244; James 1980, no.87; Sotheby's, 28 April 1993, lot no.100; 27 April 1994, lot no.23; 19 October 1994, lot no.43; 18 October 1995, lot nos 12, 13; 16 October 1996, lot no.12; 29 April 1998, lot nos 32, 33; Christie's, 18 October 1994, lot no.69; 27 April 1995, lot no.49; 17 October 1995, lot nos 26, 37, 38; 23 April 1996, lot no.31; 15 October 1996, lot no.62; 25 April 1997, lot

no.24; 14 October 1997, lot no.64; and similar material sold in Paris, including Claude Boisgirard, Hôtel Drouot, Paris, 25 September 1997, lot nos 184–90.
8. The only exception appears to be Chester Beatty Library, Dublin, MS.1588; see Arberry 1967, no.244; James 1980, no.87.
9. *Cf.* such important examples as James 1992a, no.12.
10. Christie's, London, 17 October 1995, lot no.52.
11. Sotheby's, London, 22 October 1993, lot no.36.
12. See the chapters on Ilkhanid Iran in James 1988, for example.

1

Part 29 of a Qur'an in 30 parts

Great Mosque of Khanbaliq, 30 Muharram 804 (9 October 1401)

56 folios, 24.5 × 17.5 cm, with 5 lines
to the page
Material A smooth, cream laid
paper, lightly burnished; there are
approximately nine laid lines to the
centimetre, and no apparent chain
lines or rib shadows. Each sheet is
made up of three layers
Text area 15.8 × 10.8 cm
Script The main text in *muḥaqqaq*,
written in black, with reading marks
in red; the text on folio 2a in a deco-
rative script, in gold; surah headings
in red, in a more cursive script, prob-
ably a form of *riqā'*; inscriptions in
marginal devices in the same script,
in white
Illumination Extensive decoration
on folios 2a–3a, 56b; text frame
of two red rules; verses marked by
gold rosettes set off with red and
blue dots; marginal devices marking
divisions of the text
Scribe and illuminator Hajji Rashad
ibn 'Ali al-Sini
Documentation A colophon
Binding Perhaps 16th century
Accession no. QUR974

1. See Luo 1994, pp.222–3.
2. *Cf.* the bindings of cat.2 and of
Sotheby's, London, 28 April 1993,
lot no.100, which are probably later.

This Qur'an section (*juz'*) is of considerable importance, because of its early date, and
the precise character of the information given in the colophon. From this we know the
manuscript was completed by Hajji Rashad ibn 'Ali al-Sini on the last day of Muharram
in the year 804 in 'the Great Mosque of the city of Khanbaliq, one of the cities of China'.
Khanbaliq was the former seat of the Mongol emperors, renamed Beijing when it became
the Ming 'Northern Capital' in 1421; and the Great Mosque is presumably to be identified
with the present Niu Jie Si ('mosque on Ox Street'), although this received its present
form only in 1427.[1]

The script used by Hajji Rashad is the distinctive form of *muḥaqqaq* used in Chinese
Qur'ans in 30 parts, of which this is the oldest published example. The scribe wrote
painstakingly, although the effect is not as elegant as in 13th-century Qur'ans from the
Middle East, which probably served as the model for manuscripts of this type. This is
due in part to the manner of execution. The vertical strokes are overly thin, for example,
because of the way the scribe turned the pen; and the *tarwīsah*, or serif, on some letters
alif, *lām* and *ṭā'* was not produced as part of the same stroke as the ascenders to which
they are attached. There is also a problem with the relative size of the letters, as *wāw*, *rā'*,
zā' and *mīm* are too large. This is not to say, however, that the script lacks its own clarity
and grandeur. The collation of the text was carried out in an unusual manner, as mistakes
were pasted over with pieces of paper and rewritten. Some errors remain, though: on
folios 42b–43a, for example, we find *wa-'annaka* written as *wa-lam naku*, and on folio
50b we find *'āliyahum* for *'alayhim*.

Hajji Rashad was also the illuminator of cat.1. The manuscript opens with a roundel
bearing the words *a'ū[dhu] bi-llāh min al-shayṭān al-rajīm*, 'I seek refuge in God from
Satan the accursed' (illustrated on p.10). The inscription is in an ornamental script in
which the letters appear to be dissolving into cloud-like forms, and it is arranged in a
rotating design, with the circumference of the circle acting as a notional base line. The
roundel is surrounded by a frame consisting of narrow side panels filled with a cable
motif and broad upper and lower panels. This frame recurs on folios 2b and 3a, where
it surrounds the three lines of text, and on folio 56b, where it surrounds the roundel
containing the colophon. In all these cases the upper panel is divided into compartments
by interlaced arcs, while the lower panel is filled with a tight pattern of interlace flanked
by a pair of stylized lotus blossoms. As the surah headings were left plain, the remaining
illuminated elements are the verse markers and the marginal devices, medallions and a
cartouche, marking the division of the text into four quarters.

The brown leather binding (illustrated on p.13) does not appear to be contemporary
with the manuscript, as the shadow of a flap seen on the first page of the original text
block is of a different shape from the present flap. Nevertheless, it appears to be of some
antiquity and may have been added as early as the 16th century.[2] The main feature is a
large central roundel very similar to that on folio 2a but containing the *basmalah*, which
was reserved in a ground tooled in gilt. The binding has been relined with turquoise
cotton, but the evidence of the other Ming-period Qur'ans in the Khalili Collection
indicates that the original doublures would also have been of cloth.

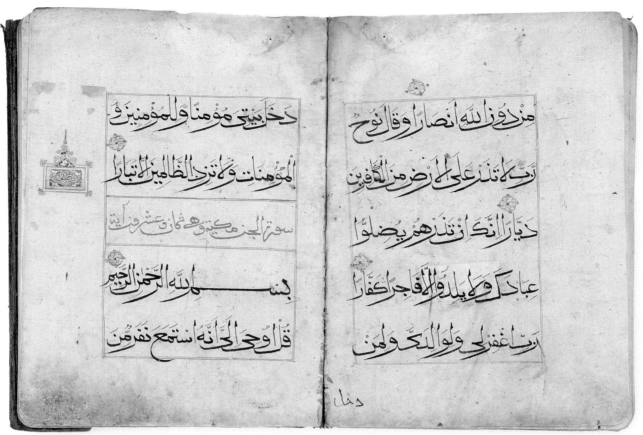

1 folios 29b–30a

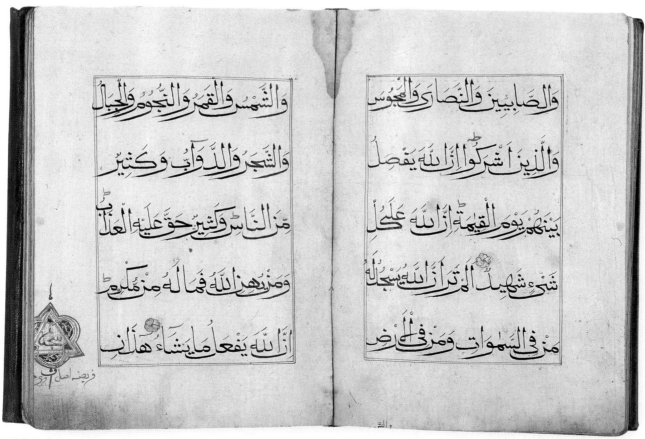

2 folios 31b–32a

2
Part 17 of a Qur'an in 30 parts

Yunnanfu, 1 Ramadan 875 (21 February 1471)

50 folios, 25 × 17.5 cm, with 5 lines
to the page
Material A smooth, cream laid paper,
burnished; there are approximately
nine laid lines to the centimetre, and
no apparent chain lines or rib
shadows. Each sheet is made up of
at least two layers
Text area 17 × 11.5 cm
Script The main text in *muḥaqqaq*,
written in black, with reading marks
in red; the text on folio 2a in a deco-
rative script, in gold; surah headings
and marginalia in red *riqā'*
Scribe Shams al-Din ibn Taj al-Din
Illumination Medallion on folio 2a;
extensive decoration on folios
2b–3a; text frame of two red rules;
verses marked by gold rosettes;
marginal devices marking a division
of the text and a *sajdah*
Documentation A colophon
Binding Perhaps 19th century
Accession no. QUR960
Published Sotheby's, London,
22 October 1993, lot no.36

1. *Cf.* cat.3, in which the last pages
of most volumes have reduced text
areas surrounded by blank panels
defined by red rules.
2. In the Sotheby's catalogue entry.
3. *Cf.* Sotheby's, London, 28 April
1993, lot no.100, which has been
attributed to the 18th century.

This fine Qur'an section was written by Shams al-Din ibn Taj al-Din in the Dar al-Hadith
madrasah 'in Madinat Yunnan, one of the great cities of China' on 1 Ramadan 875. 'Madinat
Yunnan' is probably a translation of the Chinese name Yunnanfu, which was applied to the
city of Kunming as capital of the province of Yunnan. The text is written in the distinctive
muḥaqqaq style also seen in cat.1. In other respects, too, this manuscript is very close to
the earlier Qur'an section in terms of its size, the number of lines to the page, the red rules
used to frame the text area, the presentation of the surah headings, and other features.

It appears that the manuscript was left unilluminated when it was produced in the
15th century,[1] as the decoration is in a mixed style that can be attributed to the 17th
century or later (see p.15 above). The first page bears a roundel containing the words
kalām Allāh, 'the word of God', in an ornamental script, which may be a very fluid form
of *riqā'*. The inscription is in gold on a green ground, and the roundel is edged with a
blue band outlined in gold, which is decorated with a Chinese scroll motif in gold. The
roundel is surrounded by cloud motifs in a variety of colours. Illumination in the same
style is found on the following two pages, where it was used for the decorative elements
of Chinese origin that extend into the margins from the ornamental frame around the
text. The frame itself is in a second style, which is very close to that found in cat.1 and
consists of Middle Eastern motifs executed in colours on a solid gold ground. A sinicizing
note is provided by the borders that surround each panel. These were executed in ink
on a plain ground and suggest a three-dimensional wooden or other frame. It has been
suggested that the two styles show that the manuscript was decorated at two different
periods,[2] but they are more likely to be contemporary. They were both executed in the
same type of paint in the same range of colours, and the apparent difference is due to the
use of a plain ground for the first style, and a ground covered with gold for the second.

A roundel in the margin of folio 26a indicates the middle of the Qur'anic text and bears
the word, *nisf*, 'half'. On folio 32a there is a geometric motif marking a point for ritual
prostration (*sajdah*). The *nisf* marker is in the first style, whereas the *sajdah* marker is in
the second style.

The first word of part 17 was written on folio 1a, and the first word of the following
part appears on the final folio. These are in the same hand as the main text, but they were
obscured when three-quarters of both pages were covered with blue, self-patterned silk,
cut in a lobed pattern along its outer edge. This silk probably formed the lining of an
earlier binding, but the boards themselves now have plain leather doublures. The binding,
made of brown leather and worked with two stamps and one tool, is very similar to
that of cat.1 in design (the covers have a central medallion bearing the *basmalah* in the
same ornamental script) and technique (one stamp and the tool are of the same pattern
as those used on cat.1). The quality, though, is not as high, and these covers appear to
be of much more recent date, perhaps as late as the 19th century.[3] As such they are a
witness to a long, stable tradition of binding.

3
Qur'an in 30 parts
China, Ramadan 1013 (January–February 1605)

Between 54 and 65 folios, 24 × 18 cm, with 5 lines to the page
Material A stiff, light-brown laid paper, lightly burnished; there are approximately ten laid lines to the centimetre, and no apparent chain lines or rib shadows. The bifolia were cut from composite sheets of paper
Text area 16 × 11.5 cm
Script The main text in *muḥaqqaq*, written in black, with reading marks in red; surah headings and marginalia in red *riqāʿ*
Scribe ʿAbd al-Latif ibn Shams al-Din al-Sini
Illumination Extensive decoration on folios 2a–3a; text frame of one red rule; verses marked by devices in red
Documentation A colophon
Binding Perhaps contemporary
Accession no. QUR992

This Qur'an represents a very conservative rendition of the type of 30-part copy seen in cat.1, which was produced two centuries earlier. As was noted above, the similarities extend to the motifs chosen for the illumination on the opening pages. The one difference is that the two lotus elements do not occur in the lower panels, which are filled with an interlace pattern.

The illumination is confined to the opening pages of text, except in the thirtieth part, which has similar decoration on the last pages of text (folios 52b–53a). In the other sections the last pages of text are laid out to receive illumination, but this has not been executed. On these pages the panels to be decorated were ruled in red ink, which was also used for the rules framing the text area, the verse markers, the reading marks, and the few marginal inscriptions. These last include a letter ʿayn for each *rukūʿ*; the words *rubʿ*, *niṣf* and *thalāthat arbāʿ* indicating the end of each quarter of the text; and occasional reading and other instructions, often in Persian, such as *agar nah istād* [sic] *kufr ast*, 'if not [recited] standing, it is blasphemy' (part 7, folio 384a).

The bindings are of brown leather and are decorated with various combinations of ruled devices, rows of stamps and single stamps. On the covers of part 1, for example, there is a design of four panels surrounding a central field, an arrangement clearly derived from the illumination of the opening pages in Chinese Qur'an sections, including this copy. The panels are each filled with a row of stamps, while the central field contains a ruled lozenge, which surrounds a central lobed figure. The spaces in and around these devices are decorated with single stamps. Other features of the bindings were destroyed during restoration, but traces of cloth on the first and last pages of each section show that the covers originally had cloth doublures, which were also pasted over the end leaves. The lack of comparative material means that these bindings are difficult to date.

3, part 30, binding

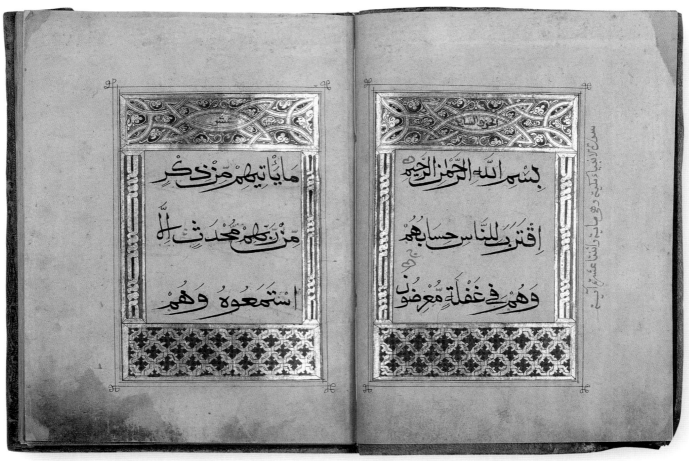

3, part 17, folios 2b–3a

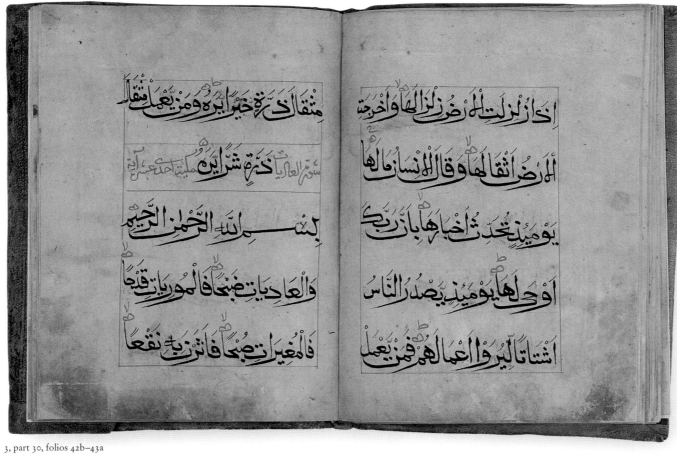

3, part 30, folios 42b–43a

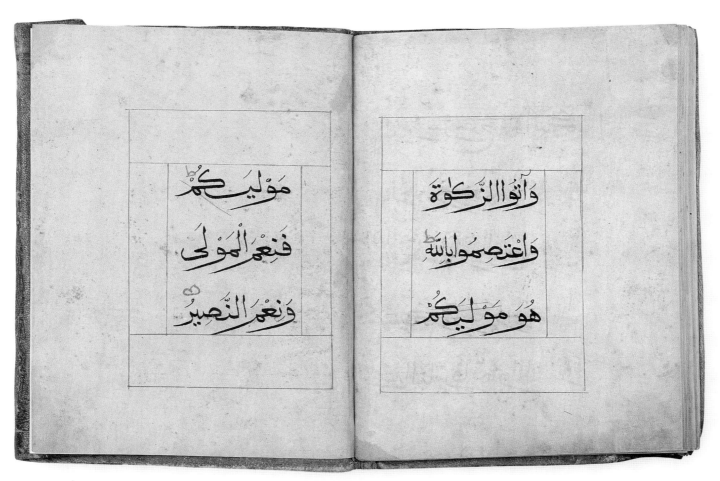

3, part 17, 52b–53a

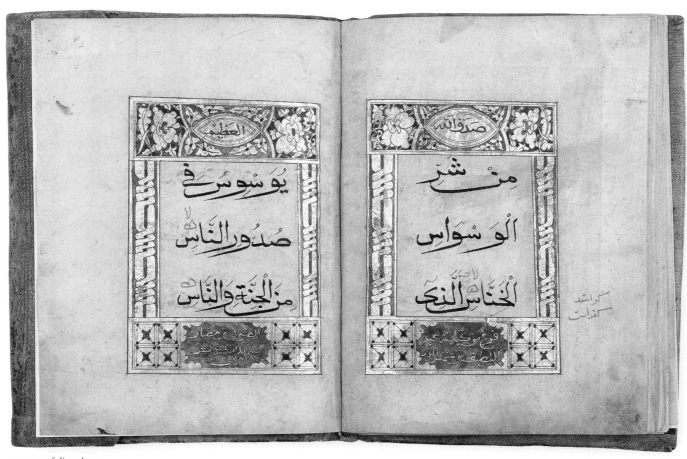

3, part 30 folio 52b–53a

أهل قرية استطعما
أهلها فأبوا أن يضيّفو
هما فوجدا فيها جدار
يريد أن ينقض فأقامه
قال لو شئت لاتخذت
عليه أجرًا ۝ قال هذا

قَالَ اَلَمْ اَقُلْ لَّكَ اِنَّكَ لَنْ
تَسْتَطِيعَ مَعِيَ صَبْرًا قَالَ
اِنْ سَاَلْتُكَ عَنْ شَيْءٍ
بَعْدَهَا فَلَا تُصَاحِبْنِيْ
قَدْ بَلَغْتَ مِنْ لَّدُنِّيْ عُذْرًا
فَانْطَلَقَا حَتَّىٓ اِذَآ اَتَيَا

لقد جيت شيا امرا ۞ قال الم اقل انك لن
تستطيع معي صبرا ۞ قال لا تؤاخذني بما
نسيت ولا ترهقني من امري عسرا ۞ فانطلقا
حتي اذا لقيا غلاما فقتله قال اقتلت نفسا
ربكية بغير نفس لقد
جيت شيا
نكرا

لا اله الا الله محمد رسول الله

4
Single-volume Qur'an
Indonesia, 18th or 19th century

425 folios, 31.5 × 21.5 cm,
with 14 lines to the page
Material A crisp, cream, European
laid paper, barely burnished; there
are nine laid lines to the centimetre,
and chain lines arranged at intervals
of 2.7 cm
Text area 21 × 11 cm
Script The main text in a 'Jawi' script
close to *naskh*, written in black, with
reading marks, and the line of text
coinciding with the beginning of a
juz' in red; surah headings and the
juz' headings in the margins in red,
in a hand close to *naskh*; other
inscriptions in a decorative script,
in white
Illumination Extensive decoration
on folios 1b–2a, 208a, 208b–209a,
416b–417a; text frames of four rules,
alternating black and red; verses
marked by yellow or red discs; mar-
ginal devices marking text divisions
and prostrations
Binding Modern
Accession no. QUR133
Published Vernoit 1997, no.31

1. The end of the Qur'anic text on
folio 415b is followed immediately
by a prayer, which continues to the
foot of folio 416a.
2. *Cf.* Berg 1965.
3. See, for example, Gallup & Arps
1991, nos 1–41.

The littoral of the Indian Ocean includes Arabia, the original home of Islam; and from
an early date Arab armies carried their religion to other regions along its shores, so that
by the 8th century AD it was established from the Gulf of Aden as far east as Sind. In sub-
sequent centuries Islam spread to the whole of the vast African and Asian coastline of
the Ocean, a process that eventually led to the formation of Muslim states. In most cases,
though, Islam was first introduced not by military conquest but by traders and by mis-
sionaries following trade routes. This was the origin of Islam in Indonesia, where cat. 4
was copied in the 18th or 19th century, and of the Muslim Swahili culture of East Africa,
of which cat. 5 is an expression.

The fine illumination in cat. 4 is mainly concentrated on three double-page spreads that
mark the beginning of the text (folios 1b–2a), the half-way point (folios 208b–209a), and
the end of the text (folios 416b–417a).[1] The end of the first half of the text is also illuminated
(folio 208a), and marginal ornaments mark each eighth of a *juz'*. This decoration was
executed in red, yellow and a very dark green, with the motifs or decorative script in white.
The composition on folios 416b–417a is similar to that on folios 1b–2a, but the central
fields are blank.

The main text is in a large hand of great poise and regularity. This is of the regional type
described as 'Jawi', a term that referred to the island of Java and in a more general sense
to the whole of South-east Asia (*Bilād al-Jāwah*).[2] Jawi is, then, used for any form of the
Arabic script written by Muslims of this region, from the plainest *naskh* to the most
elaborate decorative hand.[3] It is therefore of limited value. The hand of cat. 4 may be better
defined as a fine Indonesian copyhand distinguished from the classical *naskh* of the Middle
East by a limited number of mannerisms, such as the slight slant to the left.

The surah headings are in red and are mostly set in a panel framed top and bottom by
double red rules. This panel is otherwise plain except for brief inscriptions recording the
number of verses, words, letters, etc. in the surah in question.

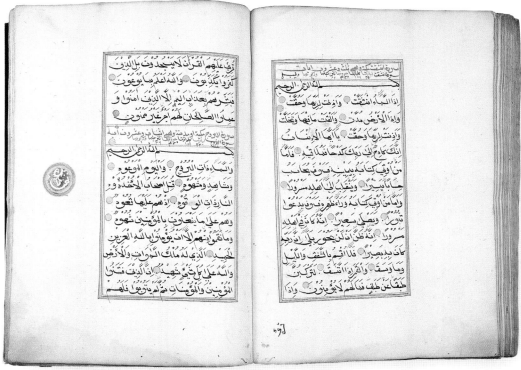

4 folios 405b–406a

A Qur'an once in Zanzibar. Connections between India, Arabia and the Swahili coast

by Tim Stanley

The trade routes that ran from the Arabian Sea southwards along the East African coast were frequented from Antiquity by merchants in search of African raw materials such as gold, ivory and rock crystal and of slaves. In the Islamic period this commerce expanded and gave rise to permanent settlements, some on the coast itself, and many on offshore islands. The main towns developed into rival city-states, but they shared a population of mixed African and Middle Eastern origin, which was united by a common religion, Islam, and by the use of the Swahili language. The Swahili states achieved great prosperity during the later Middle Ages, but their independence was brought to an end by the Portuguese, who arrived in the region at the very end of the 15th century. Their control over the ports lasted until the end of the 17th century. In 1698 they were ejected from Mombasa with the aid of the ruler of Oman, and by the end of the 1720s they had been excluded from the coast north of Mozambique. The Swahili ports then fell under Omani suzerainty, although they enjoyed a great deal of autonomy until the reign of Sayyid Sa'id ibn Sultan (1806–1856). Sa'id moved his capital to Zanzibar in 1840, and a separate sultanate was established there on his death.

The period of Portuguese rule did not affect the strength of Islam in the Swahili settlements, and even after the coming of the Omanis, a majority of whom were members of the 'Ibadi sect, most Swahilis remained loyal to the Shafi'i school, which had been well-established by the 15th century.[1] The maintenance of this religious tradition required the use of Qur'ans and other books, many of which survive.[2] Nevertheless, only one locally produced Arabic manuscript has been published in full.[3] This is the second volume of a Qur'an bound in two volumes, preserved in the library of the Royal Asiatic Society in London. Another Qur'an with East African connections is cat. 5 below, which was copied in AH 1162 (AD 1749). According to an accompanying document, the Qur'an in the Royal Asiatic Society was 'got at Witu and belonged to the Sultan of Witu who was deposed', which probably means that it was taken as plunder in 1893, when the British sacked this small state on the East African mainland.[4] The manuscript is undated, but it seems that it was already old when the sack of Witu occurred. Simon Digby, who published the manuscript, noted that its endpapers bore late 18th-century watermarks, and he concluded that the endpapers were added when the manuscript was rebound in two volumes, in 1800 or thereabouts. He therefore dated the production of the original, single-volume Qur'an to the early to mid-18th century.[5] This is supported by the *nisbah*, al-Siyawi, borne by the scribe responsible for the manuscript. The name associates him with the small settlement of Siyu on the island of Pate, which was a great centre of Islamic learning and manuscript production in the 18th and 19th centuries.[6] It seems very likely that the Qur'an was produced in Siyu and was removed from Pate in the early 1860s, when the island's rulers, the Nabhani dynasty, were expelled by Sayyid Majid ibn Sa'id of Zanzibar and took up residence in Witu.

Whereas the Witu Qur'an is not dated but can be associated securely with Pate, the Khalili Qur'an, cat. 5, is securely dated, but its place of production is far from clear. The scribe's name, 'Hajj Sa'd, son of the late ?Adish 'Umar Din', suggests that he was not from an Arabic- or Persian-speaking area; and a note on folio 7a shows that by Safar 1255 (April–May 1839), almost a century after it was written, the manuscript was in Zanzibar, having been acquired at that date by 'Abd al-Qadir ibn al-Shaykh al-Salah 'Umar, a native of Oman who had settled on the island. It is possible, then, that cat. 5 was copied in Zanzibar, which in 1749 had not yet gained the prominence it acquired under its Omani rulers. It is also possible that, as Omani domination established itself on the island in the first half of the 19th century, the Qur'an was brought there from another centre of learning.[7]

The Witu Qur'an and cat. 5 are very different in stylistic terms. The Witu Qur'an was copied in an excellent large hand, with elements both of the *thulth* style and the *muhaqqaq*.[8] The limited decoration consists of patterns and inscriptions in the natural colour of the paper reserved in red and black grounds.[9] The script of cat. 5, however, shows some similarities to the scribal idiom of the so-called Bihari Qur'ans produced in India from the late 14th century.[10] The Bihari style is characterized by the angularity of some letter forms as compared with equivalent Middle Eastern styles; by a tendency to exaggerate the contrast between thick and thin caused by changes in the angle of the nib; and by the way

the line was composed as a row of separate words, with spaces between them, rather than as continuous sequences of letters and groups of letters, as they appear in almost all other forms of Arabic script.[11] The hand of cat.5 shares the tendency to angularity, and some letter forms, such as those of *wāw* and *qāf*, are very similar in both. The two other features are lacking, however, as the ductus is relatively even, and there are no spaces between the words. On this basis alone it would be difficult to link cat.5 and the Indian Qur'ans, but they also share other features. One is an unusual type of vocalization. In most Qur'anic hands the vowels *fatḥah* and *kasrah* were regularly written at an angle of 45 degrees, while in cat.5 and in Bihari Qur'ans, these vowels were written as horizontal strokes. At the same time some Bihari Qur'ans were written in two sizes of script, as is the case in cat.5. In one published Bihari fragment, for example, there are 17 lines to the page, and the first, ninth and seventeenth line are in a larger hand than the remainder,[12] while in cat.5 there are 15 lines to the page, with the first and fifteenth line in the larger hand. Unlike Middle Eastern Qur'ans in two sizes of script, where different styles were employed in different registers,[13] the larger hand in the Bihari examples and in the Khalili Qur'an is essentially an expanded version of the smaller script, or *vice versa*.

These similarities may be coincidences, or the result of reliance on the same model, but there are sound reasons for proposing that the earlier style of script played a role in the formation of the hand of cat.5, either directly or through an intermediary. This seems all the more the likely in view of the provenance of the 17-line Bihari fragment referred to above, which was recovered from the ruined great mosque of Dawran in Yemen. Jan Just Witkam, who published it, noted three Yemeni Qur'ans which he felt showed signs of affiliation to the Bihari mode of Qur'an production.[14] Thus the patterns of trade, missionary activity and pilgrimage that have linked the coasts of East Africa, Arabia and southern Iran to western India for centuries have inevitably had an effect on the material culture of these regions. And if, as seems likely, cat.5 is of East African origin, a model for its relationship to Indian prototypes is offered by Ronald Lewcock, who explained features of East African mosques, tombs and residential buildings by reference to the Islamic architecture of Western India from much the same period as the Bihari Qur'ans (13th–15th centuries).[15] With regard to architectural decoration, for example, he concluded that, 'In the 13th century the East African coast seems to have begun to receive a strong injection from the culture of Western India, from which emerged the architectural style which became fixed as most characteristic for the decoration of buildings for many centuries. After a brief and somewhat transient period of Portuguese influence on the culture of the coast, the hegemony of Oman and Muscat reintroduced the links between the African coast and the Arabian Gulf; but by this time the coastal towns were either in decline or firmly fixed in patterns which the later Islamic styles could barely effect.'[16]

1. Sālim 1978, p.886.
2. Allen 1979, p.20; 1981.
3. Digby 1975. See also Allen 1979, pp.20–21; 1981, pp.17–18; Christie's, 27 April 1993, lot no.44.
4. Digby 1975, pp.49–50.
5. Digby 1975, p.54. The Qur'an was probably rebound as two volumes so that it could be placed in niches on either side of a doorway; see Allen 1979, p.20, n.52 (on p.33); 1981, p.18.
6. More precisely, *circa* 1725 to *circa* 1865; see Allen 1979, pp.20–25; 1981; Brown 1988, pp.110–12.
7. It has been suggested that cat.5 was produced in Siyu (Vernoit 1997, no.28), but the stylistic disparities between it and the Witu Qur'an described below remain to be explained.
8. Digby (1975, p.51 and fig.2) thought the hand was 'related to *thulth*', but it displays features of *muḥaqqaq*, such as the 'dry' endings of some letters.
9. For another Qur'an written and decorated in the same manner, see Allen 1981, where it was attributed to Siyu in the late 18th century.
10. See James 1992b, p.102.
11. See James 1992b, nos 27, 28, for example.
12. Witkam 1989, p.162, fig.8. For another example, see Qaddumi 1987, p.36.
13. See James 1992b, nos 7, 8, 14, for example.
14. Witkam 1989, pp.157–8.
15. Lewcock 1976.
16. Lewcock 1976, p.22. The starting-point for this essay was notes prepared by David James, although the conclusions are my own. I am grateful for David's generosity in allowing me to use his work, and I must also acknowledge the assistance he received from Michael Pollock and Mark Lawton.

5

Single-volume Qur'an

East Africa, Shawwal 1162 (September – October 1749)

290 folios, 32.5 × 22.5 cm, with 15 lines to the page
Material A cream, European laid paper, lightly burnished; there are approximately seven laid lines to the centimetre, and chain lines arranged at intervals of 3 cm
Text area 24.5 × 13.5 cm
Script The main text is in two sizes of a regional hand, written in black, with reading marks in red and letters in green indicating authorities for particular readings; the surah headings are in red *naskh*, with key words in green (black on folios 7b–8a); alternative readings in the margins in another *naskh* hand, in red and black; divisions of the text marked in the margins in large hands, in red or white; front and end matter in a variety of good *naskh* hands
Scribe Hajj Sa'd ibn ?Adish 'Umar Din
Illumination Extensive illumination on folios 7b–8a; text frames of one black and two red rules; verses punctuated by devices of two types; text divisions and some prostrations marked by devices in the margin
Documentation A colophon and ownership inscriptions
Binding Modern
Accession no. QUR706
Published Vernoit 1997, no.28

This Qur'an, one of the earliest known from the East African coast, was copied in AH 1162 (AD 1749) by Hajj Sa'd, 'son of the late ?Adish 'Umar Din'. We do not know where Hajj Sa'd worked, but by Safar 1255 (April–May 1839) the manuscript was in Zanzibar, for a note on folio 7a records that it was acquired at that date by 'Abd al-Qadir ibn al-Shaykh al-Salah 'Umar, a native of Oman who had settled on the island. Other notes record that in AH 1229 (AD 1813–14) a man called Ahmad, 'a slave of His Excellency' ('*abd sarkār*), purchased the Qur'an for 100 reals from another man, called Muhammad ibn Ibrahim Shaykh (folio 8a); and that in Ramadan 1289 (November 1872) it became the property of Sa'd ibn 'Umar ibn Shaykh Mahmud al-Zanjibari (folio 290a).

The text is copied in two sizes of script. The larger was used for the first and last line, the smaller for the remainder. Comparison with the smaller, *naskh* hands used for the surah titles, for writing out alternative readings in the margins, and for other supplementary texts suggests that this script is an expanded form of *naskh*. But in some respects, such as the angular letter forms, the horizontal vowel signs and the combination of large and small scripts, it resembles the script of the so-called Bihari Qur'ans produced in India in the late 14th to early 17th centuries (see pp.26–7 above). The opening pages of the Qur'anic text (folios 7b–8a) are illuminated in red, a muddy yellow, black and olive-green. The text is set within roundels, which are flanked by bands filled with a white cable motif. Other bands above and below the roundels contain quotations from the surahs *al-Ḥijr* (XV, verse 87) and *al-Wāqi'ah* (LVI, verses 77–80), in black. Traditions on the importance of these two surahs and their efficacy as charms are inscribed in the panels above the text and are continued in the margins. All the alternative names for *al-Fātiḥah* are also given.

The undecorated surah headings in the remainder of the manuscript contain more details than is normal, including the number of words and the number of letters in each surah, as well as the number of verses according to the count of Kufa. Differences in the numbers of verses between the counts of Kufa, Mecca and Medina are also noted. The verses are punctuated by markers of two types. One has the shape, circular with a point at the top, of the independent form of the letter *hā'*, which was often used to mark groups of five verses in other traditions. These devices were executed alternately in red and yellow. The second, and less common, type consists of an inverted triangle in yellow, surrounded by three small red circles, one to each side. Bold circular ornaments painted in red, yellow and white were placed in the outer margin to mark some divisions of the text and *sajdah*s, with the word *juz'*, *ḥizb* or *sajdah* written in white in the centre, on a red ground. Other sub-divisions, down to a quarter-*ḥizb*, are noted in the margins in red. Variant readings are given as marginal glosses in red and black *naskh*, with their authority mentioned at the beginning of each. Letters in green in the body of the text relate to the authority on which a reading or verse division was based.

The Qur'anic text occupies folios 7b–283b of the manuscript and is preceded and followed by a number of short complementary texts. Folios 1–5, for example, contain a compendium of Qur'anic lore. This consists of a collection of Hadiths on the virtues of reading the Qur'an (1b–2b) and a work in 12 sections explaining technical details of Qur'an recitation, such as assimilation (*iddighām*) and the lengthening of vowels (*madd*), and their relationship to the reading marks placed over the Qur'anic text; the information given in the surah headings (*awā'il al-sūrah*); the punctuation of verses; the orthography employed, which is that of Basra; and the marginal inscriptions, including alternative readings and excerpts from al-Baghawi. There are other texts on Qur'an recitation (folio 6) and the canonical readings (folio 284a) and two sequences of prayers (folios 7a, 284b–289b).

الله يضلله ومن يشا يجعله على صراط مستقيم

قل ارايتكم ان اتاكم عذاب الله او اتتكم الساعة اغير الله تدعون

ان كنتم صادقين بل اياه تدعون فيكشف ما تدعون اليه ان شا

وتنسون ما تشركون ولقد ارسلنا الى امم من قبلك فاخذناهم

بالباساء والضراء لعلهم يتضرعون فلولا اذ جاهم باسنا تضرع

وا ولكن قست قلوبهم وزين لهم الشيطن ما كانوا يعملون

فلما نسوا ما ذكروا به فتحنا عليهم ابواب كل شي حتى اذا فرحوا

بما اوتوا اخذناهم بغتة فاذا هم مبلسون فقطع دابر

القوم الذين ظلموا والحمد لله رب العلمين قل ارايتم ان اخذ الله

سمعكم وابصاركم وختم على قلوبكم من اله غير الله ياتيكم به

انظر كيف نصرف الايت ثم هم يصدفون قل ارايتكم ان اتكم

عذاب الله بغتة او جهرة هل يهلك الا القوم الظلمون

وما نرسل المرسلين الا مبشرين ومنذرين فمن امن واصلح

فلا خوف عليهم ولا هم يحزنون والذين كذبوا باياتنا يمس

هم العذاب بما كانوا يفسقون قل لا اقول لكم

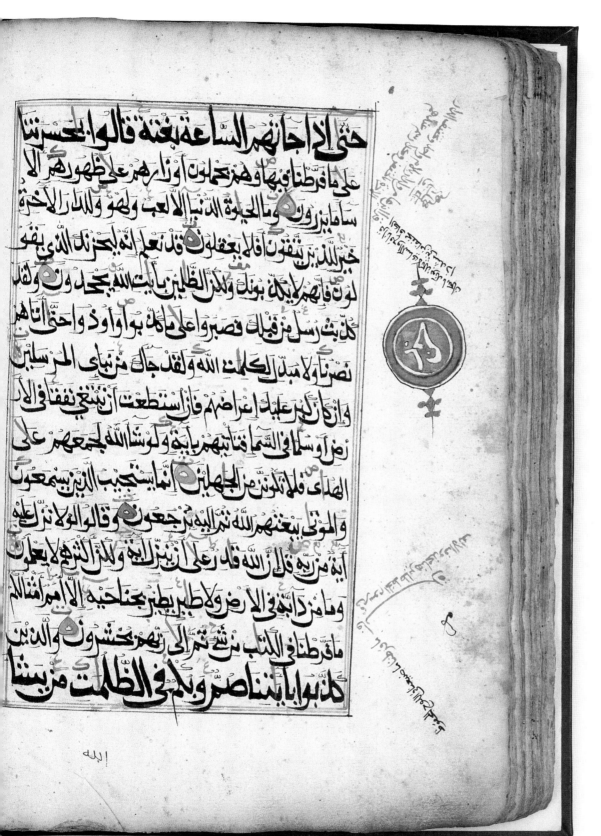

حتّى إذا جاءتهم الساعة بغتة قالوا يا حسرتنا

على ما فرّطنا فيها وهم يحملون أوزارهم على ظهورهم ألا

ساء ما يزرون ۝ وما الحيوة الدنيا إلّا لعب

ولهو وللدار الآخرة

خير للّذين يتّقون أفلا يعقلون ۝ قد نعلم إنّه ليحزنك الذي يقو

لون فإنّهم لا يكذّبونك ولكنّ الظالمين بآيات اللّه يجحدون ۝ ولقد

كذّبت رسل من قبلك فصبروا على ما كذّبوا وأوذوا حتّى أتاهم

نصرنا ولا مبدّل لكلمات اللّه ولقد جاءك من نبإ المرسلين

وإن كان كبر عليك إعراضهم فإن استطعت أن تبتغي نفقًا في الأر

ض أو سلّمًا في السماء فتأتيهم بآية ولو شاء اللّه لجمعهم على

الهدى فلا تكوننّ من الجاهلين ۝ إنّما يستجيب الذين يسمعون

والموتى يبعثهم اللّه ثمّ إليه يرجعون ۝ وقالوا لولا نزّل عليه

آية من ربّه قل إنّ اللّه قادر على أن ينزّل آية ولكنّ أكثرهم لا يعل

ومن دابّة في الأرض ولا طائر يطير بجناحيه إلّا أمم أمثالكم

ما فرّطنا في الكتاب من شيء ثمّ إلى ربّهم يحشرون ۝ والّذين

كذّبوا بآياتنا صمّ وبكم في الظلمات من يشا

اللّه

The Qur'anic script of Western Sudan.
Maghribi or Ifriqi?

by Tim Stanley

The Khalili Collection contains two loose-leaf Qur'ans, cat.6 and 7 below, that are products of a recognizably West African tradition. The two were produced in Western Sudan in the 19th century, and, like other examples of their type,[1] they were written in a characteristic Maghribi hand and have painted decoration in vivid earth colours. The earliest physical evidence for Qur'an production in the region is provided by a specimen examined by A.D.H. Bivar in Maiduguri in Bornu in 1959.[2] It had interlinear glosses in an archaic form of Kanembu, while the margins contain a commentary in Arabic, the *Jāmi' li-aḥkām al-Qur'ān* of al-Qurtubi, which was completed on Sunday, 1 Jumada'l-Ukhra 1080 (27 October 1669). Bivar was able to show that the family of the scribe who added the commentary had been resident in Bornu as early as the last quarter of the 15th century.[3] He therefore concluded that this Qur'an, and three other copies with Kanembu glosses he saw in Northern Nigeria,[4] were produced in Birni N'gazargamu, the former capital of the Bornu empire, which was destroyed during a revolt of the local Fulanis in 1808. In the same year the Fulanis also sacked Alkalawa, the capital of the sultanate of Gobir, and another Qur'an published by Bivar was supposedly looted from Yunfa, sultan of Gobir, at this time. As Yunfa came to the throne in 1799, Bivar dated the Qur'an *circa* 1800.[5] A more precisely dated example was formerly in the Newberry Library in Chicago.[6] It was written by a scribe called Sayrallah for Malam al-Qadi ibn al-Husayn of Bornu and was completed on 8 Rabi' al-Awwal 1250 (15 July 1834). A curious note follows the colophon, 'But the scribe is in Tunis, in Bab Suwayqah.[7] He wrote it in the settlement [*balad*] of W.z.к.' The author of the note hesitated over the spelling of this last toponym, adding, 'in the settlement of W.z.Q'.[8] It may be, therefore, that the scribe copied the manuscript on a journey from his home in Western Sudan to Tunis.[9]

The hazardous trade routes that took the scribe Sayrallah across the Sahara to the North African coast were the means by which Islam had established itself in the Western Sudan many centuries before. The first stages in this process went largely unchronicled because they were initiated by commercial contact rather than military conquest,[10] but movement between Muslim North Africa and the trading cities of the Sahel, the southern 'shore' of the Sahara, was already under way in the 9th century AD.[11] It is clear that the 'Sudani' style of calligraphy seen in Qur'ans from the Sahel came to the region by the same routes, for, as noted above, it is a type of Maghribi hand. It has the Maghribi system of diacritics, distinguished by the single dot above the letter *qāf* and the single dot below the letter *fā'*; and the letter form *ṣād/ḍād* lacks a final 'tooth', following the Maghribi rather than the Middle Eastern model.[12] Less certain is the Sudani style's identification with the Ifriqi script, asserted by Bivar and others.[13]

Ifriqi, a general term for the style of Arabic script current in Ifriqiyyah (modern Tunisia and eastern Algeria) in the early Middle Ages, was used by the historian Ibn Khaldun, writing *circa* 1375. He related how the Spanish Muslim refugees who had settled in the cities of Ifriqiyyah 'attached themselves to the ruling dynasty (in Northwest Africa). In this way their script replaced the Ifrîqî script and wiped it out. The scripts of al-Qayrawân and al-Mahdîyah were forgotten, once the custom and crafts of (these two cities) were forgotten. All the various scripts of the inhabitants of Ifrîqîyah were assimilated to the Spanish script used in Tunis and adjacent regions, because there were so many Spaniards there after the exodus from eastern Spain. The (old script) has been preserved in the Jarîd, where the people had no contact with those who wrote Spanish script.'[14]

The 'Spanish script' in question can only be what are now called the Maghribi hands, which have been current in Tunisia from Ibn Khaldun's time until today (see p.42 below); while the character of the Ifriqi script to which the historian referred can be judged from a Malikite legal text in the Khalili Collection (MSS 303, illustrated opposite).[15] The manuscript contains two sections of the *Mukhtaliṭah* of Sahnun and was copied in AH 406 (AD 1015), almost certainly in al-Qayrawan, for it was made *ḥubus* (that is, *waqf*) in that city for the followers of the Maliki school of law.[16] The script is a good copyhand related to the script François Déroche classified as 'New Style III' (NS.III),[17] which we know was in use in parts of the Maghrib (al-Qayrawan, Córdoba, Palermo) in the 10th century AD.[18] Nevertheless, it has some features of contemporary Middle Eastern *naskh*, such as the medial form of the letter *hā'*. The text has almost no diacritics, and it is therefore impossible to tell whether the Maghribi or the Middle Eastern system was

used; but the *ṣād/ḍād* letter form ends with a pronounced 'tooth', which sets this hand apart from the Maghribi group as a whole, including its Sudani subset. The same may be said of a manuscript cited by Adrian Brockett.[19] Brockett accepted Bivar's description of the Sahelian hand as Ifriqi and proposed a derivation from the neo-Kufic (Déroche NS.1) hand seen in the Qur'an written in AD 1020 for the nursemaid of the Zirid ruler Ibn Badis. The published pages from this manuscript show that a direct relationship is impossible,[20] not least because here too the *ṣād/ḍād* letter form follows the Middle Eastern pattern.

Bivar argued that the Ifriqi style of script was introduced into the Sahel by the Almoravids during their invasion of the Upper Niger region from what is now Mauritania. This occurred in the later 11th century, when the Almoravids' main force was making its way north into Morocco, where Marrakech was founded as their capital in 1062, and then, in 1086, over to Spain. Other forces remained in the south under the leadership of Abu Bakr ibn 'Umar (d.1087?), who is often credited with the extension of Islam southwards and westwards into Ghana, the gold-rich state that encompassed the headwaters of the Senegal and the Niger. The Almoravid conquest of Ghana is no longer accepted as a historical reality, however, and it is thought that the empire's conversion to Islam was a peaceful process that occurred in the early 12th century.[21] There was, then, no Almoravid conquest by which the Ifriqi script could have been transmitted to the Western Sudan. What is more, the Almoravid empire did not control Ifriqiyyah, the home of the Ifriqi script and the region from which the Almoravids would presumably have caused it to be diffused.[22]

We may conclude from this that the style of script first seen in the Bornu Qur'ans of the 17th century is definitely not a relic of the ancient Ifriqi hand in use before the triumph of the Maghribi mode described by Ibn Khaldun. We can say this because Ifriqi was not a member of the Maghribi group of scripts, whereas the Sudanese hand is. Ifriqiyyah may well have been the source of the Sudani style, as that region and Bornu lay at either end of active trade routes and shared an attachment to the Malikite school of law. If this was the case, however, the transmission of the style can only have taken place after Ifriqiyyah had adopted the Maghribi mode. The Sudani style of script was not, though, confined to Bornu; it was used throughout Western Sudan. It is therefore equally possible that it came to the Sahel from another part of the Maghrib.[23]

1. Published examples include Abbott 1938, pl.1; Arberry 1967, nos 239–42, and pl.69; Safadi 1978, p.24; James 1980, nos 94, 115; Uppsala 1982, pp.13, 15, no.13; Bravmann 1983, p.21, pl.5; Brockett 1987, figs 1–6, 10–22; Stuttgart 1993, p.294, fig.501; Paris 1994, no.67; Copenhagen 1996, no.236; Stanley 1996, no.21.
2. Bivar 1960, pp.200–204.
3. Bivar 1960, p.199. See also Bivar 1968, p.7, and pl.1.
4. Bivar 1960, p.204.
5. Bivar 1968, pp.7–8 and pl.2.
6. Stanley 1996, no.21.
7. A suburb named after a gate in the north wall of the *madīnah* of Tunis; see, for example, Lézine 1971, p.150.
8. I have not been able to identify W.z.Q./W.z.K., which may have been a settlement or a district, as *balad* means both.
9. Although none of the other published Qur'anic material from the 19th century is explicitly associated with Bornu, official correspondence reproduced by Bivar (1959, pls I, II)

shows that the Sudani version of the Maghribi script was still in use there under Shaykh Muhammad Amin al-Kanemi (*reg.*1812–1835) and his descendants.
10. Trimingham 1959, p.28.
11. This is clear from the history of Abu Yazid al-Nukkari, who was born in the Western Sudan, the son of a Kharijite merchant from southern Tunisia, and who led a major revolt against the Fatimids in Ifriqiyyah in AD 943–7; see Stern 1960; Bivar 1968, p.5.
12. Bivar 1968, p.7. See also Houdas 1886; Van den Boogert 1989. Houdas made 'Sudani' one of the four regional types of calligraphy in the Maghribi style, while Van den Boogert gave it a cognate relationship with the Maghribi group as a whole.
13. Bivar 1968, pp.8–10; Brockett 1987, pp.45–6. But see Stanley 1996, pp.25–6.
14. Ibn Khaldun, trans. Rosenthal, II, p.386. See also Bivar 1960, pp.204–5; 1968, p.9. Bivar silently contradicted Houdas 1886, pp.94–5, 99.

15. De Blois & Stanley, forthcoming.
16. *Cf.* Chabbouh 1956, pl.7.
17. Déroche 1992, pp.132–7, and nos 75–77, 79, 81, 91.
18. Houdas 1886, pl.1, fig.1.Granada & New York 1992, p.177, fig.3; Déroche 1992, no.81.
19. Brockett 1987, pp.45–6.
20. Chabbouh 1956, pl.1; Lings & Safadi 1976, nos 25, 26; Paris 1982, nos 356, 357; Tunis 1986, no.IV.9; Derman 1992, no.16; Paris 1995, p.9.
21. See Norris 1993 for a resumé of current views.
22. After the fall of the Almoravid empire, two members of the dynasty, 'Ali ibn Ghaniyah of Majorca (d.1188) and his brother Yahya (d.1237), made the Jarid a base for their harrying of the Almohads; see Marçais 1965.
23. As in the case of the previous essay, the starting-point here was notes prepared by David James, although the conclusions are my own. I am grateful for David's generosity in allowing me to use his work.

6
Single-volume Qur'an
Western Sudan, 19th century

488 folios, 22.5 × 17 cm, with 14 lines
to the page
Material A smooth, cream,
European laid paper, unburnished;
there are approximately 12 laid lines
to the centimetre and chain lines at
intervals of 2.5 cm
Text area 14 × 8.5 cm
Script The main text in the Sudani
variant of the Maghribi script,
written in dark-brown ink, with
vowels, *sukūn*s and *shaddah*s in red,
and *hamzah* marked by a yellow
dot; surah headings and marginalia
also in Sudani, in red and dark-brown
respectively; the surah headings
have diacritics, vowels, *sukūn*s and
*shaddah*s in dark-brown, and
hamzah marked by a yellow dot
Illumination Full-page illumination
on folios 1b–2a, 115b–116a,
238b–239a, 358b–359a; decorative
panel before surah II on folio 2b;
verse markers; marginal devices
marking each eighth of a *ḥizb*, each
sub', and each prostration
Binding Contemporary
Accession no. QUR110
Published Vernoit 1997, no.27

1. Bivar 1968, pl.1.
2. Bivar 1960.
3. The same feature appears, for
example, in Arberry 1967, pl.69;
James 1980, no.94; and Stanley 1996,
no.21, which was written in 1834.
4. For the function of these boards,
see Brockett 1987, p.48.
5. The exceptions are folios 347 and
387, which are of an inferior type of
European laid paper.
6. Brockett 1987, pp.48–50.
7. *Cf.* Brockett 1987, pl.1.

This loose-leaf Qur'an and the very similar cat.7 are of a type that was being produced in Western Sudan by 1800,[1] and which was preceded by a very similar type being produced in Bornu by the 17th century at the latest (see above, p.32).[2] The hand of this manuscript is that characteristic of Qur'ans written in Western Sudan. It may, however, be distinguished from some other examples by such details as the medial form of the letter *ḥā'*. Here *ḥā'* has the form of two loops of the same size resting on the horizontal base line,[3] which appears to be an autonomous development from the standard Maghribi form seen in 17th-century examples.

In other respects, too, the manuscript is typical of Western Sudanese production. These include the illumination, the loose-leaf structure and the wallet-like binding. The illumination is notable for its vivid colours and variety of patterns. Double-page compositions, which consist of a pair of panels containing contrasting designs, each with round 'hasps' projecting into the three outer margins, mark the beginning of each quarter of the text, and there is a smaller decorative panel between surahs I and II. The text is further divided into sixty *ḥizb*s, indicated by marginal devices that are all of the same size and shape but vary greatly in the colours and patterns used to fill them. Multiple versions of the same device are used to mark each seventh (*sub'*) of the Qur'anic text and each point for ritual prostration (*sajdah*), while rectilinear devices mark each eighth of a *ḥizb*.

Surah headings were written in red and are always followed immediately by the *basmalah*, which completes the line. The verse markers have three forms. Single verses are punctuated by a group of three yellow dots outlined in red; every fifth verse by what appears to be a red letter *ḥā'* outlined in dark-brown ink; and every tenth verse by a roundel, with a yellow centre and four red dots in the border.

The Qur'an consists of 486 loose folios, made up of 222 bifolia and 38 single folios. As in other manuscripts of this type, they were not gathered in quires but were merely assembled in a pile. Two folios discarded during the copying process because they bear defective text were used as 'end papers', and at either end of the text block, and of roughly the same dimensions, there is a piece of flexible pasteboard edged with leather.[4] Most of the manuscript was made from the same type of European paper,[5] which bears a watermark of the *tre lune* type. It indicates that the paper was produced by the Galvani mills of Pordenone in the Veneto, which dominated the Western Sudanese paper market in the 19th century.[6]

The binding, like book covers from other parts of the Islamic world, consists of an upper and lower cover, a spine, and a two-part flap. It was used in a different manner, however. It is not attached to the loose-leaf text block but wrapped around it, and the flap was closed *over* the upper cover so that the leather thong attached to its point could be wrapped around the binding to keep it secure.[7] The binding is of light-brown leather over pasteboards, which are exposed on the interior. The covers and flap are decorated with horizontal registers tooled with repeats of a single small stamp and separated by triple rules. The spine and 'hinge' for the flap bear a diaper pattern formed by double rules, with the same stamp at the crossings.

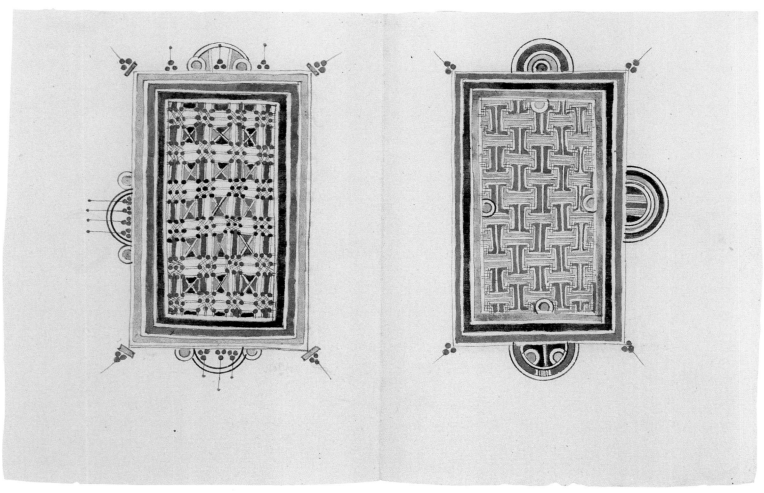

6 folios 115b–116a

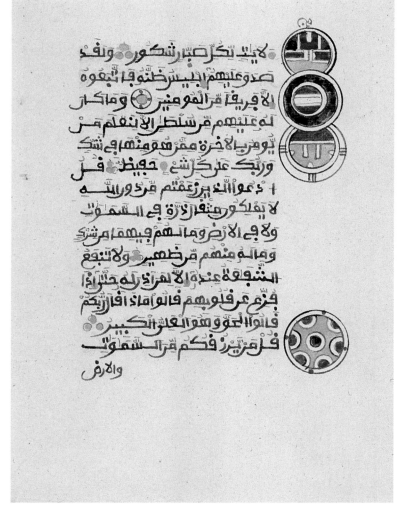

6 folio 340b

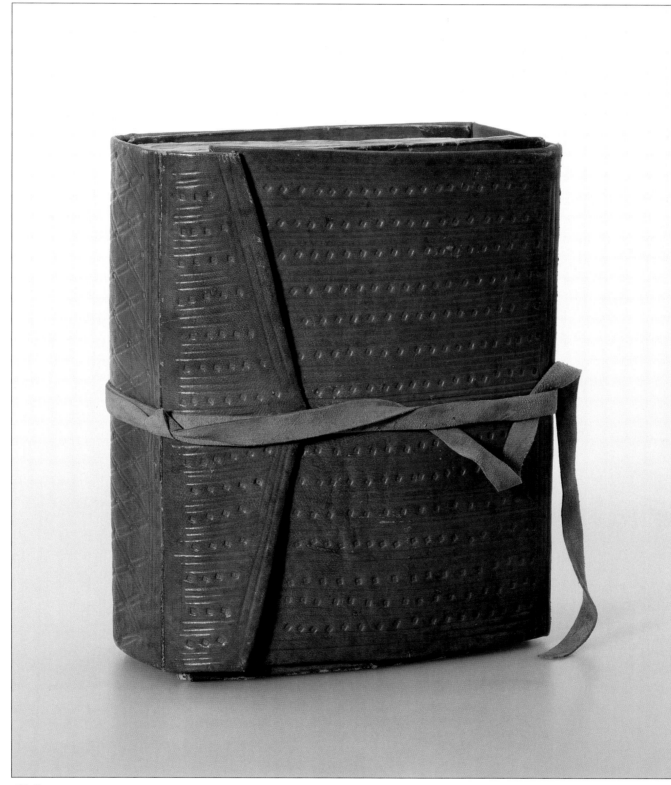

6 binding

7
Single-volume Qur'an
Western Sudan, late 19th century

528 folios, 22.8 × 16.2 cm, with
15 lines to the page
Material A smooth, cream,
European machine-made paper,
unburnished
Text area 17 × 8.5 cm
Script The main text in the Sudani
variant of the Maghribi script,
written in dark-brown ink, with
vowels, *sukūn*s and *shaddah*s in red,
and *hamzah* marked by a yellow dot;
surah headings and some marginalia
in Sudani, in red, with diacritics,
vowels, *sukūn*s and *shaddah*s in
dark-brown, and *hamzah* marked
by a yellow dot; other marginalia in
Sudani in dark-brown ink
Illumination Full-page decoration
on folios 1b–2a; extensive decor-
ation on folios 2b–3a; ornamental
panels on folios 140a, 274a, 396b;
verse markers; marginal devices
marking each eighth of a *hizb*,
each *sub'*, and each prostration
Binding Modern
Accession no. QUR109
Published Vernoit 1997, no.26

This Qur'an is very similar to cat.6. The most striking difference is the wove, machine-made paper on which it was written. In addition, all 528 folios are single leaves, and there are no end boards. Instead, folios 1 and 528 had another sheet of paper stuck to them as reinforcement.

There is also a good number of marginal inscriptions in the same red script as the surah headings. Some give alternate readings and instructions on recitation technique, while

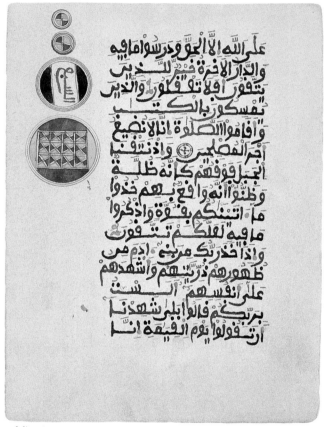

7 folio 161a

others give information supplementary to the headings, namely, the numbers of verses, words and letters in each surah.

The illumination, which was executed in dark-brown ink, an earthy red and yellow, is less lavish than in cat.6 but is of outstanding quality and inventiveness. Each quarter of the Qur'anic text is marked not by double-page compositions but by single panels (the largest 7 × 7.5 cm) between the end of surahs VI, XVIII and XXXVII and the beginning of surahs VII, XIX and XXXVIII. On folio 2b the whole of surah I and the title of surah II are written within a patterned frame, and there are five roundels of different design in the outer margins of this page and that opposite.

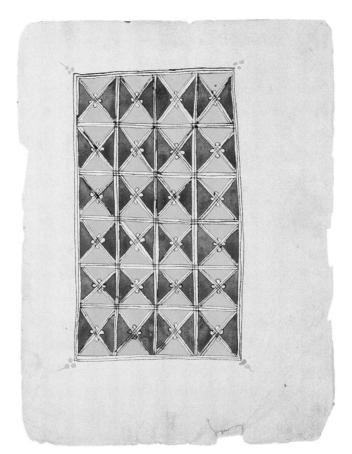

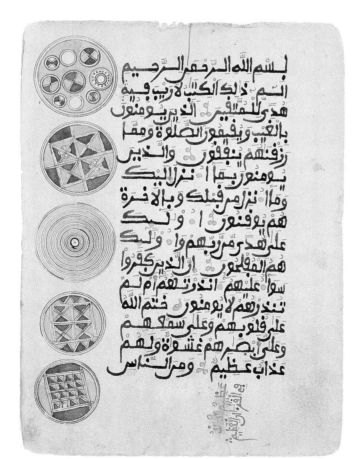

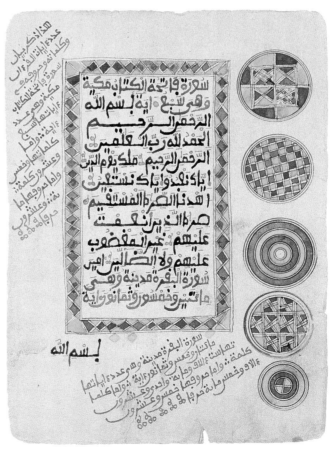

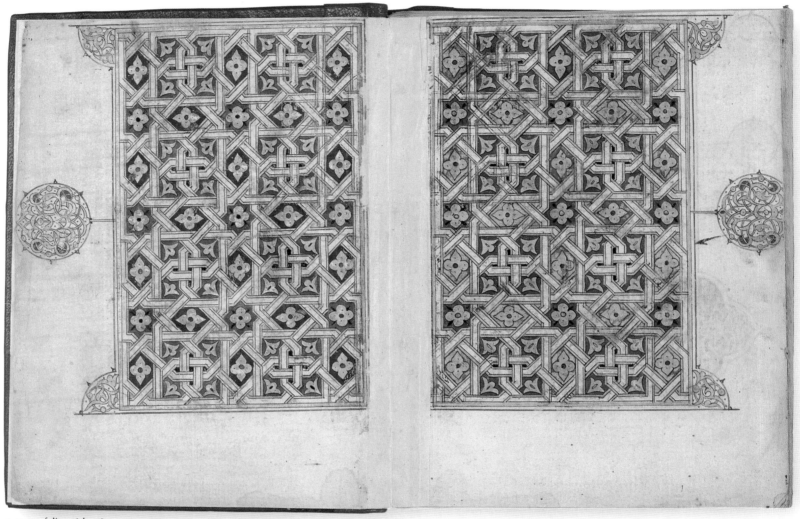

9, part 2, folios 163b–164a

The Mediterranean world after 1600

Unlike the regions discussed above, the Muslim lands bordering the Mediterranean Sea had formed part of the Islamic heartlands from the beginning of the Muslim era, in the 7th and 8th centuries AD, and many of the greatest centres of Islamic power had been situated there. North Africa was the home of several great Muslim empires, including the Fatimid caliphate, which was founded in Ifriqiyyah in AD 909, and the Almoravid and Almohad states, which had capitals in Morocco from the 11th century. In the later 15th and the 16th centuries, however, their successors found themselves increasingly threatened by the Spanish monarchy to the north and the Ottoman empire to the east. The contest between these two powers meant that by the beginning of the 17th century Morocco was the only independent state in North Africa, a situation that endured until the 19th century. Despite this retrenchment, local Qur'an production maintained its identity, and, as we shall see, copies made in Morocco show only limited and very gradual change. Indeed, while there were moments of cultural accommodation with the Middle East, it seems that in general the 17th to 19th centuries were a period of resistance to foreign, that is, Ottoman, models. To some extent this was also true of the Ottoman provinces of Tripoli, Tunis and Algiers, where the Maghribi script – but not the Maghribi style of illumination – remained in use for Qur'ans (see cat.12 below). This script was also employed for a variety of other purposes, including legal documents, and its survival was no doubt ensured by its association with the Maliki school of law, to which the population of these provinces, like those of Morocco and Western Sudan, adhered.

In the eastern Mediterranean the 16th century was a period of Muslim expansion, but in the process one Islamic power gained ground to the exclusion of all others. The Ottomans absorbed their great rival, the Mamluk sultanate of Egypt and Syria, in 1516–17, and they subsequently consolidated their hold on south-eastern Europe. The minor states and Italian colonies of the Aegean coasts and islands were eliminated, and the conquest of Cyprus in 1571 left Crete as the only major non-Ottoman territory in the region. The integration of these territories, which had previously been subject to a variety of political systems, was a long process that was not intended to impose complete uniformity and never did so. This evolving political complexity was reflected in Qur'an production. In the 17th century a remarkably uniform type of Qur'an manuscript found favour in the Ottoman capital (see pp.60–75 below), but it was not dominant in the Arab provinces, where pre-Ottoman types were still being produced, as cat.13 and 14 show. The second of these, which was probably copied in Syria, continues a Mamluk tradition, while the first, which was written in Cairo, appears to have been based on an Iranian prototype.

In the 18th century, however, Istanbul seems to have established an artistic hegemony over the whole Levant. There was a considerable movement of scribes out from Istanbul to the provinces, and they took with them the capital's noble tradition of *naskh* and *thulth* calligraphy, associated with Şeyh Hamdullah. Some returned home, as in the case of 'Ali ibn 'Abdallah, the scribe of cat.21, but others remained in the provinces and established sub-schools of their own. Muhammad Nuri founded such a tradition in Egypt, and cat.32 is a product of it, having been written by an important pupil of his called Isma'il Wahbi. Even though it was copied in Cairo, its character was clearly determined in Istanbul.

North Africa. The maintenance of a tradition

by Tim Stanley

We know almost nothing certain about Qur'an production in the western Islamic world until the period after the Almohad conquest of Spain in 1145, when Valencia was evidently an important centre.[1] The collapse of Almohad power in the Iberian peninsula after 1212 and the loss of most of the major Muslim cities there to the kingdom of Castile led to the disruption of Qur'an production, with many Spanish scribes moving to North Africa. Indeed, as we have seen in connection with the fate of the Ifriqi script (p.32 above), they moved there in such numbers and were so highly regarded that they more or less extinguished the local writing styles. The Spanish scribal tradition, which employed the Maghribi form of Arabic script, was continued during the Nasrid period in Granada (1232–1492),[2] the Marinid period in Morocco (1269–1549),[3] and the Hafsid period in Ifriqiyyah (1237–1574).[4] The Castilian-Aragonese conquest of Granada in 1492 and the third and final Ottoman annexation of Tunis in 1574 left Morocco as the only independent Muslim state in the region, but, as noted above, this did not necessarily restrict manuscript production in the Maghribi style to that country. In the Ottoman provinces of Tripoli, Tunis and Algiers imperial chancery styles and the Istanbul tradition of *naskh* and *thulth* calligraphy were employed in some contexts, but the Maghribi script continued to be employed for other purposes, as cat.12 shows.[5]

In Morocco the two dynasties that succeeded the Marinids – the Saʿdis (*reg.*1511–1659) and the ʿAlawis (*reg.* from 1631) – have both included manuscript patrons of importance. In AH 975 (AD 1568), for example, the Saʿdi ruler Mawlay ʿAbdallah commissioned a Qur'an that is now in the British Library in London.[6] Another copy was completed in Marrakesh in AH 1008 (AD 1599), under ʿAbdallah's most celebrated successor, Ahmad al-Mansur (*reg.*1578–1603). It later came into the possession of one of Ahmad's sons, Mawlay Zaydan (*reg.*1603–28), and it was among the thousands of books and household effects belonging to the sultan that were captured by Spanish pirates off the Moroccan coast about 1611.[7] The books were presented to King Philip III of Spain, and the Qur'an is now in the Escorial library,[8] having survived the fire there in 1671, which destroyed half the sultan's manuscripts.

Mawlay ʿAbdallah's Qur'an is similar in several respects to the fragment that forms cat.8 below, which can therefore be attributed to the Saʿdi period.[9] The illumination is of the same type, and both manuscripts were written in a medium-sized Maghribi hand, with no frame around the text area. The Escorial Qur'an, on the other hand, was written in a smaller, finer hand, and the text area is surrounded by a frame of gold, black, red and blue rules. Text frames were a feature of Middle Eastern manuscripts, and their appearance in Morocco may well have been a minor result of Ahmad al-Mansur's policy of emulating the Ottomans in order to strengthen his state in its conflicts with Spain and Portugal.[10] The use of text frames in Qur'ans did not immediately become the norm, to judge by a copy dated AH 1028 (AD 1618),[11] but they do occur in a Qur'an written in AH 1113 (AD 1701–2),[12] and in a spectacular example in Cairo that dates from AH 1142 (AD 1729–30).[13] In short, the frames had become a standard feature of fine Qur'an manuscripts by the ʿAlawi period (compare cat.9–11 below). In non-Qur'anic manuscripts of the 17th and 18th centuries, too, text frames are seen in the finer examples, such as an elegant copy of the *Dalā'il al-khayrāt* that has been dated to the mid-17th century.[14]

The Qur'ans of 1618 and 1701–2 have surah headings in a mannered form of Kufic, written in gold in spaces left between the surahs. In both cases, too, the colophon was written in an illuminated panel, in the decidedly fluid variant of *thulth* used in the Maghrib. In the Qur'an of 1729–30, as in the *Dalā'il* manuscript of the mid-17th century, the headings were written in Kufic within illuminated panels. In other fine non-Qur'anic manuscripts of the mid- and late 18th century, however, the style of script used for illuminated headings was the regional variant of *thulth*. This is the case in the head-piece of volume I of an elegant copy of the *Mafātīḥ al-ghayb* of Fakhr al-Din al-Razi made in AH 1169 (AD 1755–6), for example;[15] and it occurs, too, in a series of copies of a work on the Hadith by the ʿAlawi sultan Muhammad III (*reg.*1757–1790). Three of these, all preserved in the Royal Library in Rabat, are dated AH 1198 (AD 1783–4).[16] All these types of heading are found in cat.9, a two-volume Qur'an that probably dates from the second half of the 18th century. Most headings are in gold Kufic and are set in the spaces between surahs; but the illuminated headings of surahs I, II, VII and XIX, which coincide with the

beginning of the first, second and third quarters of the text, were written in *thulth*, while that for surah XXXVIII, which marks the beginning of the fourth quarter, is in Kufic. The two colophons are set in similar panels and were written in *thulth*. The variety seen in cat. 9 may be seen as transitional, for in the 19th century the *thulth* style became standard for surah headings, as cat. 10 and 11 show.

Although the use of text frames and of headings in *thulth* may be seen as developments away from the Maghribi tradition towards the Middle Eastern mode of Qur'an production, another change shows a return to an earlier, specifically Maghribi practice. This is the restoration of the square format. The Qur'ans of the Saʿdi period discussed above, including cat. 8, are much longer than they are wide, in the manner of Middle Eastern Qur'ans, whereas medieval Maghribi Qur'ans tended to be square.[17] Cat. 9 was cut down when it was rebound, and so it is impossible to know what its original format may have been; but cat. 10 and 11 are still enclosed in their original bindings, and they are perfectly square.[18] This revivalist format was also used for some of the fine copies of the *Dalā'il al-khayrāt* produced in considerable

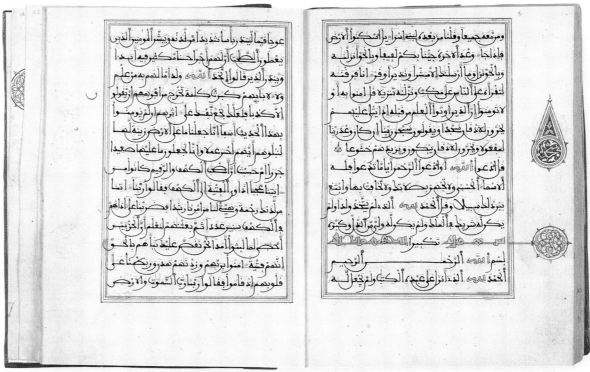

9, part 1, folios 157b–158a

numbers in the 19th century,[19] while other fine books have the normal, vertical format.[20] Written with great care, often in a range of coloured inks, and decorated with splendid illumination, these manuscripts provide a brilliant coda to a great tradition of book production that had lasted since the first square Qur'ans were copied in the Maghribi script, in the 12th century or earlier.

The question arises as to whether the bindings of cat. 10 and 11 are also revivalist in character. They are so similar that they are surely the product of the same workshop. The outer covers bear an all-over pattern of geometric interlace, based around a small central star and composed of bands tooled in gilt with a cable pattern; the bands appear in relief, as the compartments between them are sunken. Each compartment contains a single stylized, plant-based motif, tooled in blind, with the surrounding field painted gold; and the whole composition is surrounded by a frame tooled in gold with a single large stamp that creates a guilloche pattern in which stepped bands frame a quatrefoil motif.[21] The model for this work ought to be the strikingly similar, and celebrated, binding of a Qur'an manuscript in the

Royal Library in Rabat (MS.12,609), which has been attributed to the 12th century as the Qur'an to which it is attached was copied in AH 573 (AD 1177–8).[22] It has to be admitted, however, that the binding in question is so similar to the covers of cat.10 and 11 that it is more likely to be the product of the same 19th-century Moroccan workshop. The central panels of interlace on the Rabat binding are approximately the same size as those on the Khalili examples, and the all-over pattern, the cabling in gilt along the bands of interlace, and the motifs inserted within the sunken compartments are all identical. As the Rabat Qur'an is larger (16.5 × 16.5 cm), the difference has been made up by creating three gilt borders in place of one; and the stamps employed for these borders are of the same general types as those used in

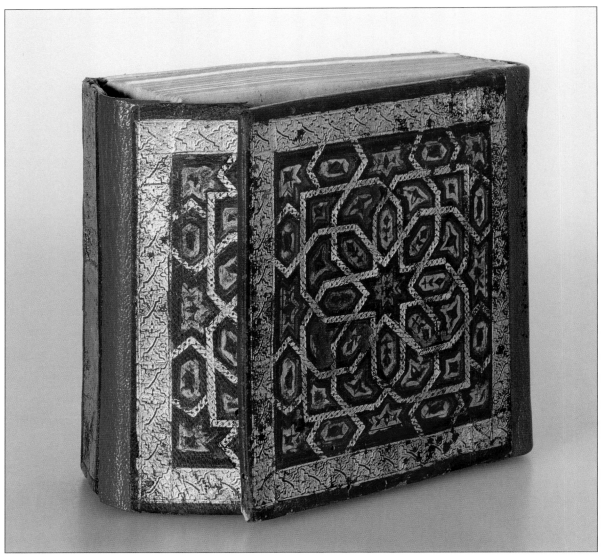

10 binding

making the Khalili Qur'an bindings. The similarity between the Rabat binding and the 19th-century specimens in the Khalili Collection is balanced by the dissimilarity between the Rabat binding and the contemporary covers of a celebrated 13th-century Qur'an from the hand of the Almohad caliph ʿUmar al-Murtada,[23] which are close in character to a Mamluk type of binding with an all-over pattern of strapwork filled with texturing tooled in gold.[24] This is further compelling evidence that the present binding of the Rabat manuscript was attached to it in the 19th century, perhaps when it entered the royal collections. The style of binding produced at this time may well have represented a revival of medieval Maghribi types, but the evidence to prove this has yet to be found.

1. James 1992a, pp.89–91; see also Granada & New York 1992, pp.115–25; Stanley 1996, pp.20–24. The Qur'ans listed at James 1992a, p.89, as nos 1, 4, 5, 15 and 16 have now been published as Granada & New York 1992, nos 74, 75, 76, 79 and 80; while James's nos 8, 10 are Derman 1992, nos 18, 21. Other dated examples are Sotheby's, London, 30 April 1992, lot no.336, copied in Valencia in AH 556 (AD 1160); a Valencian Qur'an of AH 559 (AD 1163–4) in the library of the Great Mosque, Tetuán, reported by al-Mannuni (1969, p.6, no.1) and in Granada & New York 1992 (p.116, n.2, on p.125); a copy produced in AH 573 (AD 1177–8), now in the Royal Library, Rabat (MS.12,609; see note 22 below); and one produced in AH 598 (AD 1202) and preserved in the Public Library, Rabat (MS.G.934; al-Mannuni 1969, p.7, no.3).

2. See James 1992a, pp.212–13; Granada & New York 1992, nos 83–6 (all speculative attributions).

3. Examples of Marinid Qur'ans are the first and last volumes of an eight-part copy made for Abu Ya'qub Yusuf in 1306 (Staatsbibliothek, Munich, Cod.arab.2, 3; Munich 1982, nos 58, 59); and the seventh volume of an eight-part copy made *waqf* by Abu 'Inan Faris between 1348 and 1359 (Bibliothèque Nationale, Paris, MS. arabe 423; Déroche 1985, no.297; Paris 1987, no.12; Paris 1990, no.508).

4. Examples of Hafsid Qur'ans are the last volume of a four-part copy made at Tunis in 1306 (British Library, London, Add.MS.11,638; Lings & Safadi 1976, no.49); volumes I, II, III and V of a five-part copy made *waqf* by Abu Faris 'Abd al-Aziz in 1415 (Bibliothèque Nationale, Paris, MSS arabes 389–92; Déroche 1985, nos 305–8; Paris 1987, no.14; Paris 1995, p.49; but *cf.* Paris 1990, no.514); and perhaps three volumes (I, II, VI of eight) taken by the Emperor Charles V during the sack of Tunis in 1535 (Bibliothèque Nationale, Paris, MSS arabes 438–40; Déroche 1985, nos 309–11; Paris 1987, no.15; Paris 1995, p.54).

5. For copious Tunisian examples, see Chabbouh 1989; Paris 1995.

6. British Library, Or.MS.1405; Lings & Safadi 1976, no.50, and pl.VII; Lings 1976, pls 108–10; Safadi 1978, figs.79, 80.

7. Jones 1987, p.103. It is not clear why the sultan's property was loaded on to a ship in the first place.

8. Biblioteca Real, San Lorenzo del Escorial, MS.1340; Lings 1976, pls 106–7.

9. A Qur'an section in the Chester Beatty Library (MS.1560) has been attributed to the same period; see James 1980, no.92.

10. *Cf.* Stanley 1996, no.20. The information given there about al-Mansur's manuscripts, which was also the starting point of the present essay, was kindly provided by Dr Nadia Erzini. For a full exposition of the subject, see Erzini, forthcoming.

11. Sotheby's, London, 12 October 1990, lot no.220.

12. British Library, London, Add.MS.13,382; Lings 1976, pl.III.

13. National Library, Cairo, MS.25; Lings & Safadi 1976, no.53; Lings 1976, pls 112–14.

14. Royal Library, Rabat, MS.88; Sijelmassi 1987, p.53, lower illustration; Paris 1990, no.521, illustrated on p.76.

15. Royal Library, Rabat, MS.2640; Paris 1990, no.538.

16. Royal Library, Rabat, MS.1778 (Sijelmassi 1987, pp.94, 185; Paris 1990, no.540); MS.11,140 (Sijelmassi 1987, p.169); MS.1398 (Sijelmassi 1987, p.98; Paris 1990, no.539).

17. James 1992a, nos 19, 20, for example.

18. Not all 19th-century Moroccan Qur'ans were square, however. An alternative tradition is represented by the copy in 12 volumes produced by Muhammad al-Qandusi in AH 1266 (AD 1849–50); see Paris 1990, no.553.

19. See, for instance, three copies in the Khalili Collection, MSS172, MSS270, MSS524 (De Blois & Stanley, forthcoming). Other examples include MS.1640 in the library of the Qarawiyyin mosque in Fez (Paris 1990, no.564), which was produced in that city in AH 1311 (AD 1893–4); and MS.G.356 in the Public Library, Rabat (Paris 1990, no.569).

20. An example is MSS556 in the Khalili Collection, which was copied for the future 'Alawi sultan Hasan I in 1868; see Maddison & Savage-Smith 1997, cat.20.

21. The same tool was employed on the brilliantly coloured binding of MSS 556 in the Khalili Collection; see note 20 above.

22. Ricard 1934; al-Mannuni 1969, p.6, no.2; Sijelmassi 1987, p.47; Paris 1990, no.496; Granada & New York 1992, no.78.

23. Ricard 1933, pp.111–17; see Lings & Safadi 1976, no.158; Granada & New York 1992, p.123, fig.10.

24. For a Mamluk example, see Tanındı 1990, fig.13, for example; also Raby & Tanındı 1993, pp.8–9.

8
Fragment of a Qur'an

Morocco, *circa* 1550–1650

6 folios, 22 × 14.5 cm, with 12 lines
to the page
Material A thick, light-brown, laid
paper, barely burnished; there are
approximately seven laid lines to the
centimetre; individual chain lines are
found only sporadically, and no rib
shadows are apparent. Due to the
density of the pulp, individual sheets
are semi-opaque
Text area 16.5 × 9.5 cm
Script The main text in Maghribi, in
black, with vowels and *shaddah*s in
red, and *hamzah* marked by a yellow
dot; marginal inscriptions in red
thulth; those in the marginal devices
in white Kufic
Illumination Marginal devices
Binding Kashmiri, 19th century
Accession no. QUR104

The manuscript consists of six folios written in a bold Maghribi hand with a thick-knibbed
pen. The text on folios 1–2 is from the surah *al-Baqarah* (II, verses 101–110); that on folio 3
is from the surah *Āl ʿImrān* (III, verses 33–9); while those on folios 4–6 are also from
al-Baqarah (II, verses 120–26, 126–31 and 114–20 respectively). The illumination, which
is of good quality, is restricted to the elaborate medallions in the margins, which were
painted in gold, red and blue.

The manuscript has no documentation, but, as noted on p. 42, it is similar in some
respects to a Qur'an in the British Library, London, which was copied in AH 975 (AD 1568)
for the Saʿdi ruler of Morocco, Mawlay ʿAbdallah al-Ghalib bi-llah (*reg.* 1557–1574). It
may therefore be attributed to the period from the unification of Morocco under Saʿdian
rule, in 1549, to the fall of the dynasty in 1659.

The pages are currently bound in Kashmiri lacquer covers. These have a white ground
decorated with an overall floral pattern in gold, with details in red and blue, and there is a
triple border.

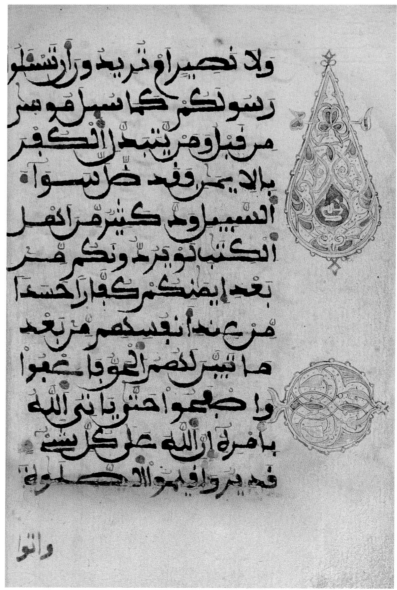

8 folio 2b

9
Qur'an in two volumes
Morocco, 18th century

Both parts have 163 folios,
21.2 × 16.3 cm, with 14 lines to
the page
Material A thick, cream European
laid paper, burnished; there are eight
laid lines to the centimetre, and chain
lines arranged at intervals of approx-
imately 2.7 cm
Text area 15.8 × 10.3 cm
Script The main text in Maghribi,
written in black, with the words
Allāh (and *wa-llāh*, *bi-llāh* etc.)
and *Muḥammad* in gold outlined in
black; the vowels in red, *hamzah*
as yellow and green dots, and *sukūn*,
shaddah etc. in blue; the headings
of surahs I, II, VII and XIX and the
inscriptions on folio 163a of both
parts in gold *thulth*; other surah
headings and all marginalia in gold
Kufic
Illumination Full-page decoration
on folios 1b–2a, 163b of part 1 and
folios 1a, 163b–164a of part 2; exten-
sive decoration on folios 2b–3a of
part 1; text frames of gold, black,
red and blue rules; markers in text
for each quarter-*ḥizb*; headings
of surahs VII, XIX, XXXVIII and con-
cluding inscriptions in both parts
set in illuminated panels; marginal
ornaments marking other surah
headings, *ḥizb* divisions and *sajdah*s
Binding Modern
Accession no. QUR149

1. National Library, Tunis,
MS. al-Ahmadiyyah 679/11,570;
Chabbouh 1989, no.13.
2. Rabat, Royal Library, MS.1778;
Sijelmassi 1987, p.95.
3. Royal Library, MSS 11,140 and
11,172; Sijelmassi 1987, pp.169, 189.
Six other manuscripts containing
works by this sultan are listed; see
Sijelmassi 1987, pp.42–6.

This copy of the Qur'an was prepared in two volumes, and each half began and ended with a double-page illumination. Six of the original eight pages survive. They each bear an overall strapwork design formed from white bands edged in gold, and the compartments formed by the bands are filled with stylized floral motifs in gold on blue, red, black or green grounds. Each pair of pages displayed a different design. Those at the beginning of each volume are formed around a central star-polygon. They can be compared with the single published page from the frontispiece of a four-volume copy of the *Jāmi' al-Ṣaḥīḥ* of al-Bukhari produced by a Tunisian scribe in AH 1133 (AD 1720–21) and decorated in the Moroccan style.[1] Those at the end are paratactic compositions with two vertical rows of small star-polygons (part 1) or knots (part 2). This last design is close to that of a frontispiece executed for the 'Alawi sultan Muhammad III (*reg.*1757–1794).[2] In fact, there is a general resemblance between the illumination of cat.9 and that of a series of manuscripts in the Royal Library in Rabat. These all contain works written by Muhammad III, and two are dated 1784 and 1787.[3]

The illumination on the opening and closing pages of cat.9 is completed by motifs that extend into the outer margins. There is a lobed device at each corner, and a roundel on a long 'stalk' half-way down the page. They are all filled with gold arabesques on a natural ground set off with red dots. On the first pages of text (part 1, folios 2b–3a) this arrange-ment was reversed: there is a lobed device in the centre, with a roundel above and below. In this case the arabesques, executed in gold and blue, are on a red ground. The first two surah headings are grouped at the top and bottom of folio 2b. Written in the Maghribi version of *thulth*, they are set in elegant illuminated panels. Similar panels occur at the beginning of the second, third and fourth quarters of the text, where they contain the headings of surahs VII, XIX and XXXVIII, and at the end of each volume, where they contain a short prayer.

Roundels containing gold arabesques on a natural ground accompany the other surah headings, which are in gold Kufic. The other marginalia consist of the words *rub'* ('quarter') and *niṣf* ('half') in gold Kufic, marking fractions of each *ḥizb*, and roundels containing the word *ḥizb* in gold Kufic on a red ground. These last are accompanied in the body of the text by a triple-dot motif in gold set off with red and blue dots, but there are no verse markers.

The text was written in an elegant Maghribi script, with the words *Allāh* and *Muḥammad* in gold throughout. It is made even brighter by the colour coding of the vowel and other signs, and by the introduction of a frame of coloured rules around the text area.

9, part 1, folios 2a–3b

9, part 2, folios 162b–163a

10
Single-volume Qur'an
Morocco, probably Fez, 19th century

305 folios, 11.3 × 11 cm, with 13 lines
to the page
Material A smooth, off-white
machine-made paper, burnished
Text area 7.7 × 6.8 cm
Script The main text in a reduced
Maghribi hand; surah I written in
gold, the rest in black, with the word
Allāh (and *wa-llāh*, *bi-llāh* etc.) in
red or blue; the vowels in red,
hamzah as yellow and green dots,
and *sukūn*, *shaddah* etc. in blue;
surah headings and marginalia in
Maghribi *thulth*, in gold; concluding
prayer on folio 305a in white *thulth*
Illumination Extensive decoration
on folios 1b–2a; text frames of gold,
black and blue rules; markers in text
for each eighth of a *hizb*; headings
of surahs VII, XIX, XXXVIII and con-
cluding prayer on folio 305a set in
illuminated panels; marginal orna-
ments marking surah headings, *hizb*
divisions and *sajdah*s
Binding Contemporary
Accession no. QUR434

1. Sijelmassi 1987; see, for example,
p.67 (MS.1192).
2. Chester Beatty Library, MS.5459;
James 1981, nos 42, 53.
3. Cairo National Library, MS.
Tasawwuf 1606; Moritz 1905, pl.49.
4. For a signed specimen of the work
of this family, see, for example,
National Library, Tunis, MS.
al-Ahmadiyyah 621/10,783, which is
dated AH 1213 (AD1798); Chabbouh
1989, no.10. *Cf.* also Chabbouh
1989, nos 14–16. Other members of
the family appear to have worked in
Tunis; see Chabbouh 1989, no.8.

This Qur'an bears witness to the remarkable florescence of manuscript production in
Morocco in the 18th and 19th century, under the patronage of the 'Alawi sultans. Many of
the examples in the Royal Library, Rabat, were published by Sijelmassi,[1] while other, par-
ticularly fine specimens are a copy of the *Dalā'il al-khayrāt* in Dublin, which has no less
than 60 illuminated pages,[2] and another in the National Library, Cairo, dated 1871.[3] This
style of manuscript production is associated with the Awlad al-Hilu who worked at Fez in
the 18th and 19th centuries.[4]

The opening pages (folios 1b–2a) have an illuminated panel of the same size and shape as
the text area in the rest of the manuscript, with complex extensions into the outer margins.
The two panels each have a central roundel from which the rest of the composition radi-
ates. In addition to gold, the colours used were yellow, blue, red, orange, black and white.
The roundel on the right contains the text of surah I, with the title and *basmalah* worked
into the orange and blue cells above. The roundel on the left contains the heading of surah
II. The headings of surahs VII, XIX and XXXVIII are set in panels of illumination of the same
quality, which mark the beginning of each fourth part of the Qur'anic text. Other surah
headings are written in gold *thulth* on a natural ground, with a small device in gold pro-
truding into the margin. There are also elegant marginal devices marking each *hizb*.

The manuscript was copied in a good Maghribi hand reduced to fit the format. The
text is enlivened by the use of red and blue for the word *Allāh* and by the red, blue, yellow
and green for the vocalization and other diacritics. There are no verse markers, but small
devices in red mark each eighth of a *hizb*, being replaced by a gold device at the beginning
of a *hizb*.

The binding bears a close resemblance to the celebrated 'Almohad' example in the
Royal Library in Rabat (see p.44 above). The doublures survive only on the two sections
of the flap. They are of green leather tooled in gold with an all-over scale pattern, each
scale being filled with a cruciform motif.

10 folios 1b–2a

10 folios 78b–79a

10 folios 304b–305a

10 folios 316b–317a

11
Single-volume Qur'an
Morocco, 19th century

349 folios, 11.2 × 10.7 cm, with 13 lines to the page
Material A smooth, cream European machine-made paper, unburnished
Text area 8.5 × 6.5 cm
Script The main text in a reduced form of Maghribi, in black, with the vowels in red, *hamzah* as red and green dots, and *sukūn*, *shaddah* etc. in blue; surah headings and concluding prayer on folio 348a in Maghribi *thulth*; marginalia in a minute script, in blue
Illumination Illuminated panels containing the titles of surahs I, VII, XIX, XXXVIII; text frames of red and blue rules; simple markers in text for each eighth of a *ḥizb* and each *sajdah*
Binding Contemporary
Accession no. QUR175

Cat. 11, which was written in a small, neat hand, is very similar to cat. 10, although it is not as sumptuous. The manuscript begins with a one-line prayer, which is followed by the heading of surah 1. This is set in an illuminated panel, with a roundel in the margin beside it. The same composition occurs at the beginning of each quarter of the text.

The binding, too, is very similar to that of cat. 10, although the doublures are mostly plain, except for small floral motifs in the corners and a single rope border, all worked in gold.

12
Single-volume Qur'an
Ottoman North Africa, 19th century

469 folios, 23.6 × 16.7 cm, with 11 lines to the page
Material A smooth, cream to grey European machine-made paper, barely burnished; laid lines are cross-hatched, and chain lines are arranged at intervals of 2.6 cm
Text area 17 × 11 cm
Script The main text in Maghribi, written in black, with the vowels, *shaddah* and *sukūn* in red, *hamzah* as yellow and green dots, and reading marks in blue; surah headings and marginalia in a script resembling Maghribi *thulth*, in red
Illumination Extensive decoration on folios 1b–2a; decorative frames around the text and the headings of surahs VII, XIX on folios 114a, 236b; text frames of two red rules; markers in text for each quarter-*ḥizb*; surah headings; marginal ornaments marking text divisions and *sajdah*s
Binding Contemporary
Accession no. QUR265

The text of this Qur'an is presented in the same way as in the Moroccan examples published above, except for the layout of folios 1b–2a, where both surah headings are arranged at the top of each page, within illuminated head-pieces. This composition seems to have been borrowed from 18th- and 19th-century Ottoman Qur'an production. The illumination, executed in a sketchy but attractive style in red, yellow, blue and green, seems to have been painted directly onto the paper, without any prelimary drawing. The surah headings are accompanied by decoration in the same style and colours, but this stops after surah XXXVI.

The binding is in red morocco with blind-tooled decoration, of which a central medallion with pendants is the main feature. On the fore-edge section of the flap there is a cartouche containing verse 79 from the surah *al-Wāqiʾah* (LVI), written in *thulth*. A quotation from the same verse is included in the head-pieces on folios 1b–2a.

11 folios 158b–159a

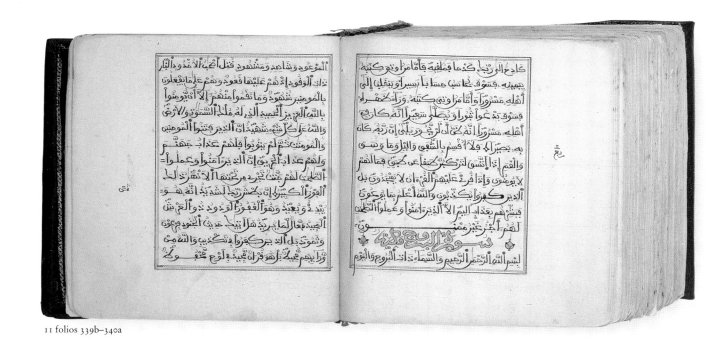

11 folios 339b–340a

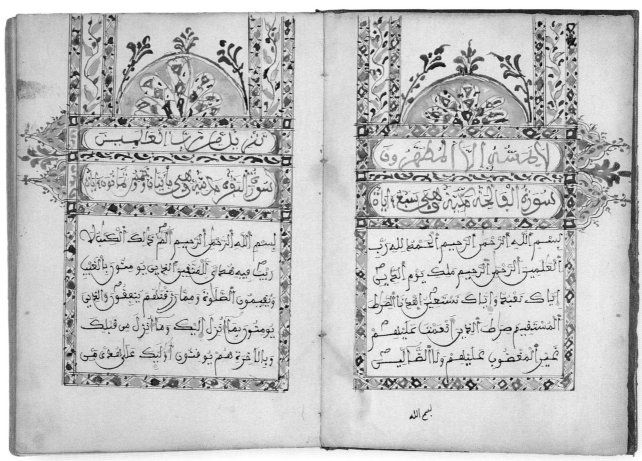

12 folios 1b–2a

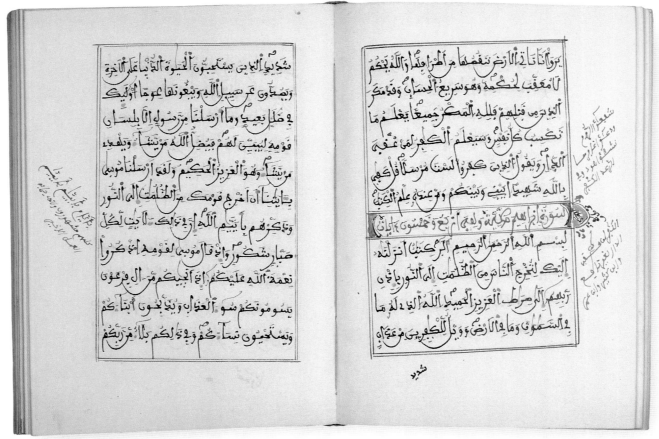

12 folios 195b–196a

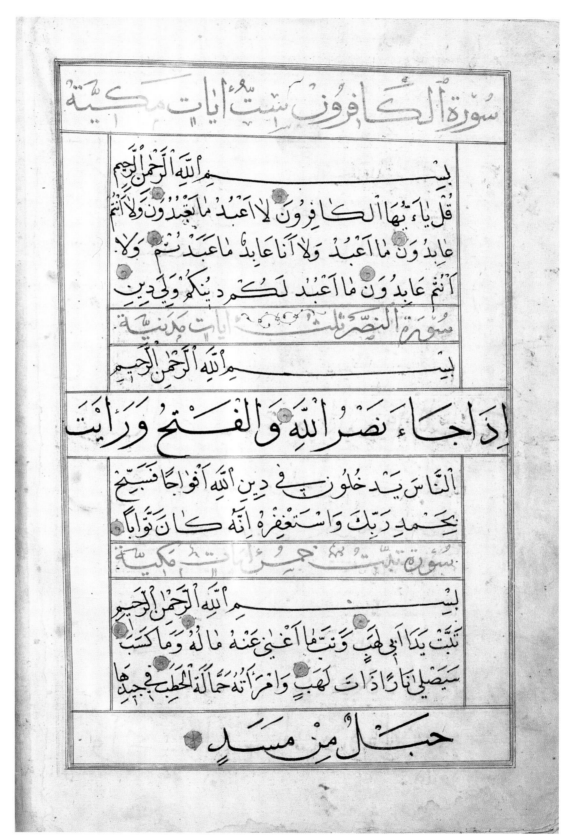

سُورَةُ الْكَافِرُونَ سِتُّ آيَاتٍ مَكِّيَّةٌ

بِسْمِ اللَّهِ الرَّحْمَنِ الرَّحِيمِ

قُلْ يَا أَيُّهَا الْكَافِرُونَ لَا أَعْبُدُ مَا تَعْبُدُونَ وَلَا أَنْتُمْ

عَابِدُونَ مَا أَعْبُدُ وَلَا أَنَا عَابِدٌ مَا عَبَدْتُّمْ وَلَا

أَنْتُمْ عَابِدُونَ مَا أَعْبُدُ لَكُمْ دِينُكُمْ وَلِيَ دِينِ

سُورَةُ النَّصْرِ ثَلَاثُ آيَاتٍ مَدَنِيَّةٌ

بِسْمِ اللَّهِ الرَّحْمَنِ الرَّحِيمِ

إِذَا جَاءَ نَصْرُ اللَّهِ وَالْفَتْحُ وَرَأَيْتَ

النَّاسَ يَدْخُلُونَ فِي دِينِ اللَّهِ أَفْوَاجًا فَسَبِّحْ

بِحَمْدِ رَبِّكَ وَاسْتَغْفِرْهُ إِنَّهُ كَانَ تَوَّابًا

سُورَةُ تَبَّتْ سِتُّ آيَاتٍ مَكِّيَّةٌ

بِسْمِ اللَّهِ الرَّحْمَنِ الرَّحِيمِ

تَبَّتْ يَدَا أَبِي لَهَبٍ وَتَبَّ مَا أَغْنَى عَنْهُ مَالُهُ وَمَا كَسَبَ

سَيَصْلَى نَارًا ذَاتَ لَهَبٍ وَامْرَأَتُهُ حَمَّالَةَ الْحَطَبِ فِي جِيدِهَا

حَبْلٌ مِنْ مَسَدٍ

13
Single-volume Qur'an

Egypt, probably Cairo, 26 Dhu'l-Qa'dah 1026 (25 November 1617)

321 folios, 34.5 × 23.5 cm, with 15 lines to the page
Material A stiff, off-white, European laid paper, lightly burnished; there are approximately ten laid lines to the centimetre, and chain lines arranged at intervals of 3 cm
Text area 29 × 18 cm
Script The main text in a combination of *muḥaqqaq* (lines 1, 8, 15) and *naskh* (lines 2–7, 9–14), both in black; surah headings in gold *riqā'*; each *ḥizb*, *juz'* and *sajdah* marked by a marginal inscription in red *riqā'*; colophon in black *riqā'*; *waqf* inscriptions in black *naskh*
Scribe Muhammad ibn Khidr
Illumination Extensive decoration on folios 1b–2a; text frames ruled in gold and black; text area divided into nine compartments by single gold rules; verses marked by gold whorls or rosettes with six petals, many with red, blue or red-and-blue dots; surah headings in plain compartments defined by single gold rules
Documentation A colophon, endowment notices, seal impressions
Binding Modern
Accession no. QUR146
Published Geneva 1995, no.25

1. See, for example, James 1992b, no.59; Geneva 1995, no.24.
2. James 1992b, nos 30–38, for example.
3. See, for example, James 1992a, nos 14, 16; 1992b, nos 7, 35, 36, 40, 43, 44, 46, 48, 49.
4. See, for example, Arberry 1967, no.106, and pl.4.
5. See, for example, Atıl 1987, nos 9a–b.
6. Potential evidence against this is the existence of a Qur'an in the Topkapı Palace Library also copied by a person called Muhammad ibn Khidr, although this manuscript was produced almost half a century later, in AH 1074 (AD 1664); see Karatay 1962, no.1010.

Cat.13 was copied in Egypt in 1617, exactly a century after the Ottoman conquest. For much of that period manuscripts continued to be produced in the Mamluk style,[1] although their decoration became increasingly hybrid, due to the the adoption of many elements derived from 15th-century Iranian styles. The illumination of cat.12, however, does not derive from these precedents but must have been based on a 16th-century Iranian model from a centre other than Shiraz, such as Tabriz, Qazvin, Herat or even Baghdad.[2]

The illumination of cat.13 is concentrated almost entirely on the opening pages of text and consists principally of panels with blue, gold and black grounds overlaid with polychrome floral motifs arranged in chains or on spiralling scrolls. The use of grounds of three colours sets this example apart from Ottoman work of the period, in which blue and gold only were used, as does the lack of a border around the composition. The text on the opening pages is arranged in seven lines and written in a combination of *naskh* (lines 1–3, 5–7) and *muḥaqqaq* (line 4). The combination of lines in a larger *muḥaqqaq* and a smaller *naskh* hand and the presentation of the text within a series of ruled compartments are features of the manuscript as a whole and were probably based on the same 16th-century model as the illumination.

This type of layout was particularly popular in 15th- and 16th-century Iran,[3] and the fashion is found in Mamluk Qur'ans from the early 16th century,[4] and in some spectacular 16th-century Ottoman examples.[5] By the 17th century, however, it had fallen out of favour in major centres of Qur'an production such as Istanbul and Isfahan and survived only in secondary centres in India (see cat.61 and 62) and, it seems, in Cairo.

The copyist of cat.12 was Muhammad ibn Khidr, who described himself, in sub-standard Ottoman Turkish, as *muqāṭi'a-i rizaq bi-diyār-i Miṣr*. This appears to mean, '[who is charged with] the tax farm on foodstuffs in the lands of Egypt', and Muhammad ibn Khidr must have been either a tax farmer or an official who supervised the farm on behalf of the state. Muhammad ibn Khidr was clearly a competent scribe, but his work in *muḥaqqaq* in this manuscript was done with a nib that was too narrow to allow him to reproduce the full majesty of the original. We may therefore presume that he was unused to work on this scale. All in all, the manuscript has the air of a one-off produced by a man who was not a professional Qur'anic calligrapher and who was attempting to imitate a magnificent product of another land and another century.[6]

The material placed after the Qur'anic text, which ends on folio 320a, also suggests that the scribe based his work on a Safavid model, for, after a short prayer and the colophon on folio 320b, there is a *fālnāmah*, a work explaining how to use the Qur'an for divination, on folio 321a–b. Such an appendix is a common feature of Iranian Qur'ans but is unusual in Ottoman examples.

An early owner of cat.12 was a man called Muhammad Suhrab, whose oval seal is dated AH 1033 (AD 1623–4). Much later, on 9 Rabi' al-Thani 1243 (30 October 1827), the manuscript was made *waqf* by al-Shaykh Hamid Efendi ibn al-Shaykh Ahmad Efendi ibn al-Shaykh 'Ubayd al-'Attar. According to the inscriptions on folios 1b, 2a and 5a, Shaykh Hamid carried out this pious act for the soul of his unmarried daughter Fatimah, who had died in the plague of AH 1242 (AD 1826–7).

14
Single-volume Qur'an

Probably Syria, AH 1068 (AD 1657–8)

210 folios, 28.2 × 19.6 cm, with 17 lines to the page
Material A thick, cream, European laid paper, lightly burnished; there are approximately eight laid lines to the centimetre and chain lines arranged at intervals of 3 cm
Text area 22 × 13 cm
Script The main text in *naskh*, written in black, with reading marks in red; the headings of surahs I and II in *muḥaqqaq*, in gold and (discoloured) white; other surah headings in red *naskh*, with diacritical dots and vocalization in black; marginalia in red *naskh* or red *riqāʿ*, with diacritic dots, vocalization and other notations in black
Scribe Zayn al-Din ibn al-Sawwaf
Illumination Decoration in a Mamluk style on folios 1b–2a
Documentation A colophon, an endowment notice, and seal impressions
Binding Fabricated from older elements
Accession no. QUR103

1. *Cf.* James 1992a, nos 36–47; 1992b, nos 12, 14, for example. Text frames occur only intermittently in Mamluk manuscripts (e.g. James 1992b, no. 10), while they became increasingly common in Iranian and Turkish production during the 14th century, and they were often added to earlier, unruled examples (see Stanley 1996, no. 28).
2. These observations are based on an as yet unpublished catalogue of a private collection that contains numerous 18th- and 19th-century Syrian Qur'ans.
3. James 1992a, no. 43.

This manuscript, which was written in a clear *naskh* hand by a scribe who is otherwise unknown, illustrates the survival into the 17th century of a pre-Ottoman tradition of book production, for it has many of the features of a Mamluk manuscript, such as the lack of a ruled frame around the text.[1] A Syrian, rather than an Egyptian, provenance seems likely, as the manuscript shares a number of features with 18th- and 19th-century Qur'ans from Syria, including the use of red for the surah headings, which lack a surrounding panel; the transformation of the final *tāʾ marbūṭah* in those headings into a knot; and the use of an arrangement of three red 'inverted commas' to punctuate verses.[2]

The text commences with two pages (folios 1b–2a) illuminated in a rather debased revival of a Mamluk style of the 14th century; it may be compared, for example, with the decoration of a Qur'an in the Khalili Collection produced in Damascus *circa* 1330–40.[3]

The margins of the manuscript contain a full set of alternative readings, noted in red *naskh*, and each is accompanied by a letter or series of letters in black that indicate which of the seven authorities accepted by Ibn Mujahid of Baghdad (d. AD 936) reported the reading in question. In explanation of these notations another hand has added an appendix after the Qur'anic text, on folios 207b–209a, which ends with a key presented in tabular form.

The manuscript bears a number of impressions of a poorly engraved late Ottoman seal, and on folio 1a the words *Hamdaʾnın vakfı* ('*waqf* of Hamdah') have been inscribed in Turkish.

رَبِّكِ رَاضِيَةً مَرْضِيَّةً فَادْخُلِي فِي عِبَادِي وَادْخُلِي جَنَّتِي

سُورَةُ الْبَلَدِ مَكِّيَّةً وَأَيُهَا عِشْرُونَ آيَةٌ

بِسْمِ اللَّهِ الرَّحْمَنِ الرَّحِيمِ

لَا أُقْسِمُ بِهَذَا الْبَلَدِ وَأَنْتَ حِلٌّ بِهَذَا الْبَلَدِ وَوَالِدٍ وَمَا وَلَدَ
لَقَدْ خَلَقْنَا الْإِنْسَانَ فِي كَبَدٍ أَيَحْسَبُ أَنْ لَنْ يَقْدِرَ عَلَيْهِ أَحَدٌ
يَقُولُ أَهْلَكْتُ مَالًا لُبَدًا أَيَحْسَبُ أَنْ لَمْ يَرَهُ أَحَدٌ أَلَمْ نَجْعَلْ
لَهُ عَيْنَيْنِ وَلِسَانًا وَشَفَتَيْنِ وَهَدَيْنَاهُ النَّجْدَيْنِ فَلَا اقْتَحَمَ
الْعَقَبَةَ وَمَا أَدْرَاكَ مَا الْعَقَبَةُ فَكُّ رَقَبَةٍ أَوْ إِطْعَامٌ فِي يَوْمٍ
ذِي مَسْغَبَةٍ يَتِيمًا ذَا مَقْرَبَةٍ أَوْ مِسْكِينًا ذَا مَتْرَبَةٍ ثُمَّ كَانَ مِنَ الَّذِينَ
آمَنُوا وَتَوَاصَوْا بِالصَّبْرِ وَتَوَاصَوْا بِالْمَرْحَمَةِ أُولَئِكَ أَصْحَابُ الْمَيْمَنَةِ
وَالَّذِينَ كَفَرُوا بِآيَاتِنَا أُولَئِكَ أَصْحَابُ الْمَشْأَمَةِ عَلَيْهِمْ نَارٌ مُؤْصَدَةٌ

سُورَةُ الشَّمْسِ مَكِّيَّةً وَأَيُهَا سِتَّ عَشْرَةَ آيَةً

بِسْمِ اللَّهِ الرَّحْمَنِ الرَّحِيمِ

وَالشَّمْسِ وَضُحَاهَا وَالْقَمَرِ إِذَا تَلَاهَا وَالنَّهَارِ إِذَا جَلَّاهَا وَاللَّيْلِ إِذَا يَغْشَاهَا
وَالسَّمَاءِ وَمَا بَنَاهَا وَالْأَرْضِ وَمَا طَحَاهَا وَنَفْسٍ وَمَا سَوَّاهَا فَأَلْهَمَهَا
فُجُورَهَا وَتَقْوَاهَا قَدْ أَفْلَحَ مَنْ زَكَّاهَا وَقَدْ خَابَ مَنْ دَسَّاهَا كَذَّبَتْ
ثَمُودُ بِطَغْوَاهَا إِذِ انْبَعَثَ أَشْقَاهَا فَقَالَ لَهُمْ رَسُولُ اللَّهِ نَاقَةَ اللَّهِ

كَيْفَ رُفِعَتْ وَإِلَى الْجِبَالِ كَيْفَ نُصِبَتْ وَإِلَى الْأَرْضِ كَيْفَ سُطِحَتْ
فَذَكِّرْ إِنَّمَا أَنْتَ مُذَكِّرٌ لَسْتَ عَلَيْهِمْ بِمُسَيْطِرٍ إِلَّا مَنْ تَوَلَّى وَكَفَرَ
فَيُعَذِّبُهُ اللَّهُ الْعَذَابَ الْأَكْبَرَ إِنَّ إِلَيْنَا إِيَابَهُمْ ثُمَّ إِنَّ عَلَيْنَا حِسَابَهُمْ

سُورَةُ الْفَجْرِ مَكِّيَّةٌ وَأَيُهَا ثَلَاثُونَ آيَةٌ

بِسْمِ اللَّهِ الرَّحْمَنِ الرَّحِيمِ

وَالْفَجْرِ وَلَيَالٍ عَشْرٍ وَالشَّفْعِ وَالْوَتْرِ وَاللَّيْلِ إِذَا يَسْرِ هَلْ فِي ذَلِكَ
قَسَمٌ لِذِي حِجْرٍ أَلَمْ تَرَ كَيْفَ فَعَلَ رَبُّكَ بِعَادٍ إِرَمَ ذَاتِ الْعِمَادِ الَّتِي
لَمْ يُخْلَقْ مِثْلُهَا فِي الْبِلَادِ وَثَمُودَ الَّذِينَ جَابُوا الصَّخْرَ بِالْوَادِ وَفِرْعَوْنَ
ذِي الْأَوْتَادِ الَّذِينَ طَغَوْا فِي الْبِلَادِ فَأَكْثَرُوا فِيهَا الْفَسَادَ فَصَبَّ عَلَيْهِمْ
رَبُّكَ سَوْطَ عَذَابٍ إِنَّ رَبَّكَ لَبِالْمِرْصَادِ فَأَمَّا الْإِنْسَانُ إِذَا مَا ابْتَلَاهُ
رَبُّهُ فَأَكْرَمَهُ وَنَعَّمَهُ فَيَقُولُ رَبِّي أَكْرَمَنِ وَأَمَّا إِذَا مَا ابْتَلَاهُ فَقَدَرَ
عَلَيْهِ رِزْقَهُ فَيَقُولُ رَبِّي أَهَانَنِ كَلَّا بَلْ لَا تُكْرِمُونَ الْيَتِيمَ وَلَا
تَحَاضُّونَ عَلَى طَعَامِ الْمِسْكِينِ وَتَأْكُلُونَ التُّرَاثَ أَكْلًا لَمًّا وَتُحِبُّونَ
الْمَالَ حُبًّا جَمًّا كَلَّا إِذَا دُكَّتِ الْأَرْضُ دَكًّا دَكًّا وَجَاءَ رَبُّكَ وَالْمَلَكُ
صَفًّا صَفًّا وَجِيءَ يَوْمَئِذٍ بِجَهَنَّمَ يَوْمَئِذٍ يَتَذَكَّرُ الْإِنْسَانُ وَأَنَّى لَهُ
الذِّكْرَى يَقُولُ يَا لَيْتَنِي قَدَّمْتُ لِحَيَاتِي فَيَوْمَئِذٍ لَا يُعَذِّبُ عَذَابَهُ
أَحَدٌ وَلَا يُوثِقُ وَثَاقَهُ أَحَدٌ يَا أَيَّتُهَا النَّفْسُ الْمُطْمَئِنَّةُ ارْجِعِي إِلَى

رَبِّكِ

Istanbul and its scribal diaspora.
The calligraphers of Müstakim-zade

by Tim Stanley

Ottoman history after 1600 was long regarded as a period of decline, a long descent from the glories of the 16th century to the empire's collapse during the First World War. This generalization can be regarded with scepticism, not least because the 'decline' took so long. The Ottoman empire was one of the longest-lived of Islamic states, and its very longevity indicates that its rulers were able to adapt themselves successfully to the enormous changes that occurred over the empire's 600-year history. Nevertheless, the conditions that prevailed after 1600 were very different to those current in the previous century, and this was reflected in artistic production, including that of fine Qur'an manuscripts. The type of Qur'an copied in Istanbul and elsewhere in the 17th and 18th centuries can be judged from the examples in the Khalili Collection; and through them we can observe the revival of production after a period of crisis in the early 17th century. This transition – from crisis to revival – can also be traced in the literary sources of the period devoted to calligraphy. The most important of these was the *Tuḥfah-i khaṭṭāṭīn* ('The pick of calligraphers') of Müstakim-zade Süleyman Saʿdeddin Efendi (d.1788). In this book Müstakim-zade provided biographies of all the most important calligraphers known to him through other works and through his own experience. He did not confine his researches to the Ottoman Turkish tradition, and his work is also a summation of writing on calligraphy in the Arab lands and Iran. But the *Tuḥfah* is especially valuable for the history of Ottoman calligraphy between 1600 and AH 1202 (AD 1787–8), when the work was completed. The succession of Sultan Selim III one year later, in AH 1203 (AD 1789) ushered in a new age, expressed in the abandonment of classical models in Qur'an illumination and the belated flowering of the 'Baroque' style.

Decline or change?

The notion of decline was first formulated by the Ottomans themselves in the later 16th century. According to the celebrated man of letters Mustafa Âlî (d.1600), for example, the decline had come about because the government had strayed from the standards set earlier in the century.[1] But Âlî and other Ottoman sources for the decline theory are works of polemic disguised as traditional advice-literature. They were designed to advertise the superiority of one set of policies over another, and they should not be judged as dispassionate observations on contemporary events. It should be borne in mind, too, that the authors of these tracts were not critical of the system as a whole, since they wished to control it, not destroy it. They were therefore confined to accusing their political enemies of unwarranted changes to the imperial system. This essentially conservative discourse about who was and who was not true to the Ottoman tradition became typical of Ottoman culture in the 17th century, and, as we shall see, it is reflected in metropolitan Qur'an production of the period, which remained unquestioningly loyal to certain 16th-century models.

 In the late 16th century the Ottoman imperial system was in fact reaching the climax of a series of changes that were the inevitable result of its expansion in the first half of the 16th century. The wealth acquired during these conquests funded patronage of the arts on a spectacular scale, as in the architectural projects undertaken by Sultan Süleyman the Magnificent and his immediate successors, and in the magnificent Qur'an manuscripts prepared for them by Ahmed Karahisari (d.1556) and his adopted son, Hasan Çelebi (d. after 1596). Towards the end of the 16th century, however, the imperial system entered a period of crisis, marked, for example, by the collapse in the value of the silver *akçe*, the Ottoman unit of account, and the so-called Celali revolts in Anatolia. The end of the boom shook the system of government severely, and, although the empire did eventually recover from this crisis, when it did so the nature of that system, and consequently the pattern of patronage, had changed for good. The sultan was now enclosed by an immense household in which other figures, such as the sultan's mother, known as the Valide Sultan, and the chief eunuch of the harem, who was entitled the Agha of the Abode of Felicity, often played a more important role than the sultan himself.[2] Even those sultans who were able to re-establish their personal authority had much less freedom of action than their predecessors, as they had to manipulate various factional interests in order to stay in power. As a consequence they were no longer in a position to direct the resources available to the state towards major

projects of their own. Harking after the great days of the 16th century remained a common preoccupation, and it had its effect on the arts, but it could not alter the underlying factors that determined the character of the empire.

Patronage restrained

The tradition of the sultan's personal patronage on the grand scale survived into the 17th century, as the mosque complex of Sultan Ahmed I (*reg.*1603–1617) in Istanbul and the illustrated manuscripts of Ahmed's son Osman II (*reg.*1618–1622) testify. As early as the reign of Sultan Murad III (1578–1595), however, Mustafa Âlî had been critical of the vast sums spent on the imperial household, and his examples included the production of an illustrated copy of one of his own works, the *Nuṣrat-nāmah*, or 'Book of Victory'.[3] The trappings of sultanic power, which included the commissioning of illustrated manuscripts, were consuming vast resources; while the essence of that power was passing into other hands, which Mustafa Âlî considered unworthy. The successors of Osman II clearly had, or were allowed, much less money to spend on architecture and books. In celebration of his military victories Osman II's brother Murad IV erected palace buildings, and a limited number of illustrated manuscripts were produced for patrons in his circle, but this sultan established no great religious foundation.

One example of Murad's patronage of books is known from an anecdote related by Müstakim-zade.[4] When the sultan resolved to conquer Baghdad, he sought to please 'certain pious souls' by summoning the calligrapher İmam Mehmed Efendi (see cat.17 below) and commanding him to write a copy of the Qur'an. But the calligrapher refused to accept the commission until the sultan had agreed his fee: '"Set the price so that, God willing, the task may be completed with both the prayers and the ardour worthy of the honour you have bestowed upon me." The Sultan of the Age was astonished. "How much do you want?", he asked. "I cannot write it for less than a thousand piastres", came the firm reply.' When the sultan offered to pay him a thousand gold ducats 'below the line' (*i.e.* in addition to any account he might submit), the calligrapher was, of course, extremely pleased and began work. On Murad's return from the conquest of Baghdad (he landed in Istanbul on 10 June 1639), İmam Mehmed Efendi brought the Qur'an to court, and the sultan examined it with care, noting that the calligraphy was better at the end than at the beginning. When quizzed on this, İmam Mehmed declared that, 'the beginning was written while I was worried about the conquest of Baghdad, and the end was written while I was picturing the joy occasioned by the conquest and the rejoicing that would accompany your arrival.' For this nimble reply he received another thousand ducats as a gift from the sultan,[5] which prompted Müstakim-zade to quote the hemistich, 'A quip can be worth a thousand dinars.'[6] The story throws an unflattering light on the quality of the work prepared for Murad, and İmam Mehmed's attitude to the sultan seems to have been far from obliging.[7] It may also reflect the political situation at the time. In 1632, soon after he had assumed personal rule of the empire, Murad was nearly toppled by a prolonged army mutiny, and he turned for support to a number of factions within the population of the capital. These included a group of puritan clerics known as the Kadızadelis, the followers of Mehmed Birgevi and his pupil Kadızade Mehmed Efendi, and the Kadızadelis may well have been the 'pious souls' whom Murad sought to please in commissioning the Qur'an from İmam Mehmed.

The patronage of Murad's successors followed much the same model: they were modest patrons of the private arts associated with the role of sultan, but their public works were characterized more by restoration and repair than by novel undertakings. This was partly the result of the decrease in the personal power of the sultan, but it also reflected a wider change in the circumstances of the empire. By the beginning of the 17th century the Ottoman state had reached the limits of its potential as an aggressive power and had therefore ceased to expand significantly – and to generate plunder, which had largely funded the major artistic enterprises of the 16th century. The empire was therefore thrown back on its own resources, which were necessarily devoted more to the sustenance of existing institutions than to the creation of new ones. In earlier periods royal patronage had had a determining effect on the character of Ottoman art, so that changes in taste generated within the court were eventually reflected

in production for a wider market, at least in Istanbul and the Ottoman heartlands. The limitations now placed on that patronage had a notable effect on production. Change for its own sake stopped, and any change that did occur was evolutionary. These circumstances could never allow the creation of work of the outstanding quality that had been seen in the 16th century, and so the period after 1600 may indeed be seen as a period of artistic decline. Yet the artistic output of the 17th century does have an identity of its own. It may be called traditionalist in that it perpetuated forms developed in an earlier age, but this does not necessarily tell the whole story, as an examination of the 17th-century Ottoman Qur'ans in the Khalili Collection shows.

Qur'an production in the 17th century

The character of 17th-century Ottoman Qur'ans was marked as much by selection as traditionalism. In the 16th century there had been considerable variety in Qur'an production, both in terms of the style of calligraphy, illumination and binding and of the presentation of the text and the programme of decoration. In the following century, however, this variety became greatly restricted. Consequently, most fine copies from this period are of the same general type, while other possible models were set aside. Such selectivity can be seen in Ottoman art in previous periods, but the loss of some types had been compensated for by the creation of others, usually by means of imperial patronage. As a result variety had never been lost. Now that imperial patronage had receded, a variety of themes was replaced by variations on a single theme – at least in Qur'ans produced by scribes resident in Istanbul or trained there (for provincial work, see cat. 13, 14 above). This formula is exemplified by seven 17th-century Ottoman Qur'ans in the Khalili Collection (cat. 17–21, 23, 24 below). These manuscripts are medium-sized single-volume Qur'ans, suitable for personal use, while other pieces of the same period in the Collection are one volume from a medium-format Qur'an in 30 parts copied by Hafız Osman in 1687–8 (cat. 22), and, if the date in the colophon is correct, a large-format single-volume copy produced by an illuminator called Seyyid Abdullah in 1694 (cat. 25).

In all seven medium-format, single-volume examples the main text was written in the *naskh* script, in the style attributed to the calligrapher Şeyh Hamdullah, a contemporary of Sultan Bayezid II (*reg.* 1481–1512), while surah headings and other supplementary inscriptions were marked as such by being written in the *riqā'* script, usually in a contrasting colour. The main text was always presented in a simple, straightforward manner, and never in the more complex layouts employing different sizes and styles of script, seen, for example, in the superb Qur'an written by Ahmed Karahisari in AH 953 (AD 1546–7) in a combination of the *naskh* and *muḥaqqaq* styles,[8] and in cat. 13 above. All seven 17th-century examples under consideration have extensive illumination, and this decoration follows a more or less consistent programme, which is similar to that found in fine 16th-century Qur'ans by Şeyh Hamdullah and his school. The 17th-century programme does not, however, include the purely decorative double-page frontispieces that occur in the best examples of 16th-century work.

On every page the text is set within a frame, which generally consists of a wider gold rule outlined with thin single or double black rules, often accompanied by an outer rule in red or blue; and it is punctuated with illuminated verse markers, either in the form of whorls, or discs divided into six segments. The surah headings were set in plain gold panels (cat. 18), in plain gold panels with a coloured border (cat. 24), or in more elaborate arrangements of a central cartouche and small areas of fragmentary floral scrollwork (cat. 17, 19–21, 23). In all but two copies (cat. 17, 19) the margins are set with ornamental devices. A few of these show the points in the text where the reader has to make a *sajdah*, or prostration, while most mark the division of the Qur'anic text into 30, 60 and 120 parts, allowing a believer to read an equal amount of text at regular intervals. The absence of these marginal devices from cat. 17 and 19, which date from 1640–41 and 1656 respectively, shows that they were not a standard element of Ottoman Qur'ans in the mid-17th century, although it is clear that they became standard at a later date. What is more, the devices in cat. 18, which dates from 1643–4, are in a decorative style unrelated to the plain gold settings for the surah headings, and this raises the possibility that these devices are later additions.

In the absence of double-page frontispieces, the most extensive decoration was the illuminated setting for the first two pages of text (usually folios 1b and 2a). On these pages the text areas were reduced in order to accommodate the first surah on the right-hand page, and they form the central compartments in a symmetrical decorative composition. There is a broad horizontal panel above and below each central compartment, and a narrow vertical panel on either side, and the whole arrangement is usually surrounded by a continuous broad frame with a lobed outline. In cat.17, however, it has a straight outline, and in cat.18 the frame was replaced by a pair of 'crests' of the type also found on the first page of text in cat.22 and in other 30-part Qur'ans. The stylistic idiom of this ornament, which was dominated by gold or blue-and-gold parti-coloured grounds overlaid with diminutive, spiralling floral scrolls, also dates from the reign of Bayezid II, when it was imported from the scriptoria of western Iran by illuminators who had previously worked for Qaraqoyunlu and Aqqoyunlu patrons.[9] The type of binding employed was derived from the same source in the same reign (see cat.15). It has areas of plain leather contrasting with recessed areas that have ornament

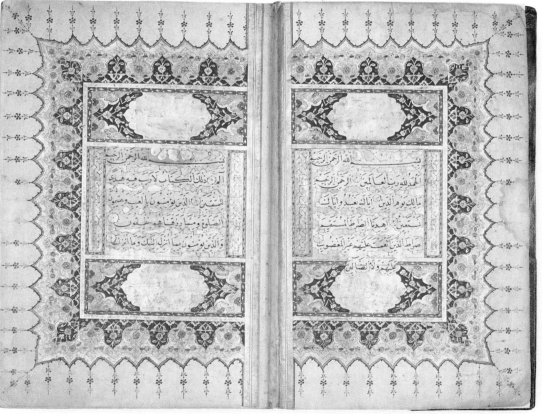

19 folios 1b–2a

worked in relief and gilded.[10] This style of Qur'an flourished during the 16th century, and on occasion examples of great refinement were produced.[11] In the 17th century, as we have seen, it provided the single theme on which the variations in Qur'an production were based, and this situation continued in the 18th century. There is no more eloquent evidence of its exclusivity in the period after 1600 than cat.25 below, which is notable principally for its unusually large format. In the past, Qur'ans of this size, which were, of course, much more expensive to produce, had been prepared by artists capable of generating layouts and designs that fitted the dimensions of a particular manuscript, and of executing work of commensurate quality. In this example, however, the illuminator responsible for its production merely increased the size of the various elements of a standard medium-format Qur'an of the period, so that it resembles a blown-up photograph of a copy of normal size. The quality of execution, too, is no better than a standard production.

15
Single-volume Qur'an
Probably Istanbul, *circa* 1500 and later

302 folios, 17 × 11 cm, with 15 lines
to the page
Material A thin, cream laid paper,
burnished; there are approximately
ten laid lines to the centimetre,
and no apparent rib shadows or
chain lines
Text area 10 × 5 cm
Script The main text in *naskh*, in
black, with reading marks in red;
surah headings and inscriptions in
marginal ornaments in white *riqā'*;
other marginalia in red *riqā'* or
red *naskh*
Illumination Extensive decoration
on folios 1b–2a, 302a; text frames
ruled in two tones of gold, black
and red; verses marked by gold
whorls or gold six-petal rosettes,
all set off with red and blue dots;
surah headings; marginal ornaments
marking text divisions and *sajdah*s
Binding 15th century
Accession no. QUR46

1. Topkapı Palace, Istanbul,
MS.E.H.71; Karatay 1962, no.799;
Istanbul 1983, no.E.14; Raby &
Tanındı 1993, no.41.

This Qur'an is a composite manuscript. The exquisite binding and the fine illumination on folios 1a–2b are work of the late 15th or the early 16th century, while the remainder of the text block, written in a small *naskh* hand, must date from the 18th century at the earliest, judging by the 15-line format and the way that each page ends with a complete verse. At this point, too, the central panels in the illumination on folios 1b–2a were overpainted with silver and inscribed in the same hand as the rest of the Qur'an, but in a smaller size.

The illumination of the opening pages is in the style found in manuscripts produced for Bayezid II (*reg.* 1481–1512), such as a Qur'an copied by Şeyh Hamdullah in 1499 and still kept in the Topkapı Palace.[1] This style, developed from that current in Iran under the Turcoman dynasties of the 15th century and marked in particular by the use of diminutive floral scrolls over gold or blue-and-gold grounds, was the almost exclusive model for Ottoman Qur'an illumination until the emergence of a Europeanizing trend in the 18th century. A late version of the traditional style is seen in the surah headings and marginal ornaments of cat.15, while the new, Europeanizing style is represented by the decoration on folio 302a, which consists of a bunch of flowers tied by a cord, set on a plain ground within a frame of rules.

The Bayezid II binding of this manuscript is in something close to its original condition, despite at least one renovation. The covers are of brown morocco and are decorated with a centre-and-corner composition; the recessed elements were pressure-moulded with a design of rotating floral scrollwork and then gilded. The doublures have a field of red morocco, with the centre-pieces cut out, gilded and filled with an arabesque design in leather filigree painted green. During a later renovation flyleaves of brown leather were added; they are decorated in gold with centre-piece motifs that complement those on the doublures.

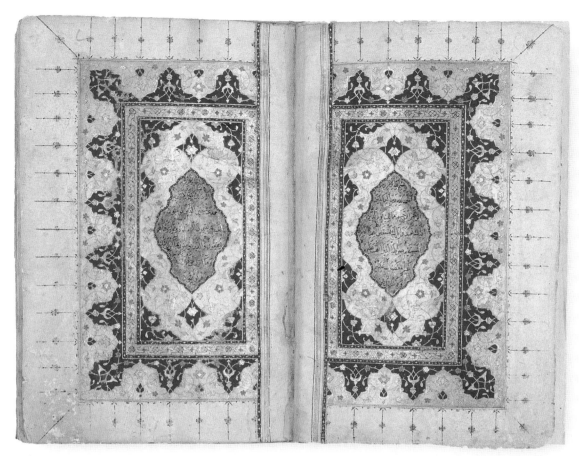

15 folios 1b–2a

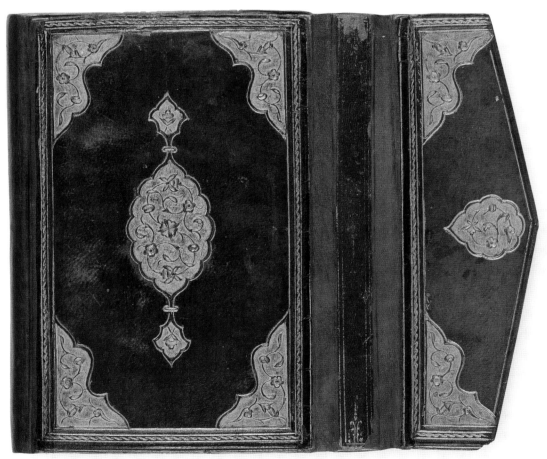

15 binding

The triumph of the Şeyh

The processes that gave rise to the traditional and selective character of 17th-century Qur'an production can be examined in more detail in the case of *naskh*, the main type of script employed. This writing style was one of the group of six calligraphic modes known as the 'Six Pens'. All six modes had been practised by Şeyh Hamdullah,[12] but in general 17th- and 18th-century calligraphers of his school were appreciated for their work in just two, *thulth* and *naskh* – no doubt another example of the selectivity referred to above. It is usual to present the history of Ottoman *thulth* and *naskh* calligraphy as a seamless progression from Şeyh Hamdullah down to the scribes of the first half of the 20th century, such as Hasan Rıza (1849–1920) or Ahmed Kamil (1861–1941). This is, though, an oversimplification, since interest in the Six Pens seems to have declined by the end of the 16th century, perhaps as a corollary of the crisis undergone by the Ottoman state at this time. The main evidence for this comes from 17th- and 18th-century literary sources concerned with calligraphy, principally the *Tuḥfah-i khaṭṭāṭīn* of Müstakim-zade and the works of two predecessors, the *Gulzār-i ṣavāb* ('The rose-garden of proper conduct') of Nefes-zade İbrahim Efendi (d.1650) and the *Dawḥat al-kuttāb* ('Genealogy of the scribes') of Suyolcu-zade Mehmed Necib (d.1758). Suyolcu-zade and Müstakim-zade's entries on 17th-century calligraphers indicate that just one individual, Hasan Üsküdari, was responsible for the transmission of the definitive form of Ottoman *naskh* during the years in question. Hasan therefore seems to have played a pivotal role in the propagation of *naskh* calligraphy until his death in AH 1023 (AD 1614–15), thereby ensuring the eventual triumph of the school of Şeyh Hamdullah.

Hasan's importance is not dependent on the quality of his work, which receives no special praise from Suyolcu-zade and Müstakim-zade.[13] It rests instead on the fact that two of his pupils, Halid Erzurumi and İmam Mehmed Efendi, who died in AH 1040 (AD 1630–31) and AH 1052 (AD 1642–3) respectively, trained all the great *naskh* scribes active in Istanbul in the mid-century, when there was clearly a revival of interest in the subject. One of Suyolcu-zade's most revealing comments concerns Derviş Ali the Elder, who copied cat.18 below and died in AH 1084 (AD 1673–4). 'He learned the Six Pens from Halid Efendi [*sc.* Erzurumi] and met and spoke with a number of masters, profiting thereby, and on this account he earned the right to be called "the second founder". Indeed, this person brought to light the manner of Şeyh Hamdullah *at a time when it was all but forgotten*.'[14] Suyolcu-zade defined Derviş Ali as 'a calligrapher of the reign of Murad IV', and this sultan may have played some part in the revival of the Six Pens. Murad was, however, a devotee of the hand known as *taʿlīq* by the Ottomans and as *nastaʿlīq* elsewhere, which was the one main 'art' script outside the Six Pens tradition.

The sultan's interest in calligraphy in general is indicated by Nefes-zade's dedication to him of the *Gulzār-i ṣavāb*.[15] This work contains a great deal of technical information on the calligrapher's craft, which is prefaced by two series of biographical entries (*ṭabaqāt*), one series covering specialists in the Six Pens,[16] the other devoted to the principal masters of *nastaʿlīq*. In concluding the latter series Nefes-zade excused himself from naming any further scribes by claiming that, 'qualified calligraphers in the *nastaʿlīq* script are numerous in the extreme, unlike true masters of the Six Pens, *who are few and far between*.'[17] A sense of crisis in *naskh* calligraphy is also conveyed by the fact that Nefes-zade offered no information on contemporary *naskh* scribes, not even on Hasan Üsküdari, who was seen as so important in retrospect. Instead, he ended the series devoted to the Six Pens with a notice on his own master, Demirci-kulu Yusuf Efendi, who died in AH 1018 (AD 1609–10).[18] The career of Yusuf Efendi well illustrates the fate of schools of *naskh* calligraphy other than that of Şeyh Hamdullah in the 17th century. According to Nefes-zade, Yusuf first studied

with Abdullah Kırımi, a former pupil of the Şeyh's grandson Derviş Mehmed Efendi, but he then transferred his allegiance to the school of Ahmed Karahisari, the other leading branch of Ottoman *naskh*. He eventually constructed an eclectic repertory of his own by adopting Ahmed Karahisari's form of *thulth*, by modelling his *naskh* hand on that of Celalzade Muhiddin of Amasya, a contemporary, and relative, of Şeyh Hamdullah, and by taking instruction in the Ottoman chancery hand (*dīvānī*) from Tac Bey-zade Mehmed Çelebi. From the 18th-century sources we discover that Yusuf had a number of pupils, of whom Nefes-zade seems to have been the most eminent – Suyolcu-zade claimed he surpassed both his master and his contemporaries.[19] But none of these had pupils of note, and even Nefes-zade's own son, the celebrated calligrapher Nefes-zade İsmail Efendi (d. AH 1090/AD 1679–80), is described as a pupil of Halid Erzurumi, a bearer of the tradition founded by Şeyh Hamdullah.

Revivalism and Ahmed III

The revival in *naskh* calligraphy that can be detected during the mid-17th century reached its peak in the last generation of scribes to flourish in the 17th century, who included Hafız Osman, one of the most distinguished calligraphers in Ottoman history. Hafız Osman, who was responsible for cat.22 below, died in AH 1110 (AD 1698–9), and towards the end of his life he gave instruction to Princes Mustafa and Ahmed, the sons of Mehmed IV, and was appointed calligraphy tutor to the elder prince after his accession as Sultan Mustafa II in 1695. These two princes, and all later scions of the Ottoman dynasty, were taught to write a good hand as part of their formal education, which commenced when they reached the age of seven. The beginning of this education, and entry into the world of adults, was marked by special celebrations on the occasion of the young prince's first reading lesson, known as the *bed'-i besmele*, 'commencement of the *basmalah*'.[20] Such festivities were first recorded as occurring when the future Sultan Ahmed III (*reg.*1703–1730) reached the appropriate age of seven in 1680, and it has been suggested that they were instigated by Feyzullah Efendi, who was tutor to Prince Mustafa before becoming chief mufti in 1671.[21] They may also have owed something to the influence of the Köprülü viziers, not least because Hafız Osman was attached to the household of Köprülü-zade Mustafa Paşa (d.1691) from a young age.[22] The connection is further illustrated by the fact that Mustafa Paşa's elder brother Ahmed Paşa (d.1676) had been a pupil of Hafız Osman's teacher Derviş Ali (see cat.18). Indeed, although the Ottoman sources studied here make much of the role of certain sultans in promoting calligraphy, it is notable that the revival of this art form in the second half of the 17th century coincided with the period when members of the Köprülü family held the office of grand vizier, and their role may have been understated. It may be significant that the Köprülüs were the chief residents of Istanbul, the city where the revival took place, at a time when the sultan preferred to live in Edirne, and that the re-establishment of Istanbul as the primary imperial residence, under Mustafa II and Ahmed III, is precisely the point at which the sultan begins to be portrayed as an active figure in the history of calligraphy.

Ahmed III's training as a prince seems to have given him a great taste for calligraphy, which he practised in several different forms, and in the arts of the book in general: as noted above, his patronage returned the quality of manuscript production to a level that had not been seen for a century. His own work included four copies of the Qur'an, now lost, and a number of monumental inscriptions, as well as album pieces. In one album preserved in the Topkapı Palace Library there is a series of ten compositions in the shape of an Ottoman *ṭughrā*,[23] while two more contain large-format (*jalī*) inscriptions; in one the inscriptions are in *thulth*,[24] and in the second they are in *muḥaqqaq*, another of the Six Pens.[25] The

decoration of these albums, and of other calligraphic specimens by members of the sultan's circle, is of the utmost refinement. It combines traditional Ottoman elements with European motifs, and it was executed in a new range of colours and with a Europeanizing use of modelling.[26] This new court style did not, however, usurp the classical Ottoman manner in Qur'an illumination, and the passage from the 17th to the 18th century is indicated only by minor changes, such as the disappearance of the framing bands from the side panels on the opening pages of text (see cat.26, for example). The quality of 18th-century Qur'an decoration is often high, though, and the brightness of the gold and the precision of the detail gives it a vitality often lacking in 17th-century examples. To this extent at least it reflects the renewed elan of book production associated with Ahmed III.

At the end of his *muḥaqqaq* album Ahmed III recorded that he had modelled his work directly on that of Şeyh Hamdullah,[27] and in this he was following his first calligraphy teacher, Hafız Osman, for, according to Suyolcu-zade, Osman devoted all his efforts to imitation of the Şeyh. As a consequence, he was able to 'revive the Şeyh's style and embellish it'.[28] This observation is confirmed by cat.22 below, for Hafız Osman followed the colophon on folio 27a by the statement, *nuqila ʿan khaṭṭ Ḥamdallāh al-Shaykh raḥimahu Allāh*, that is, 'It was copied after the hand of Şeyh Hamdullah – May God have mercy upon him!' The practice of *naql*, that is, reproducing a manuscript or a composition by one's master or by an outstanding calligrapher of the past, was a long and honourable tradition,[29] and it seems to have been particularly important in the 17th century. As there had been such a decline in *naskh* calligraphy in the earlier part of the century, those such as Derviş Ali and Hafız Osman who sought to restore it to its pristine state used *naql* as one means to this end: it gave them direct contact with Şeyh Hamdullah's own exquisite hand and allowed them to rid their personal styles of any subsequent distortions.

Naql appears to have played a crucial part in the career of one mid-century calligrapher, Mahmud of Tophane (d. *circa* 1670).[30] According to Müstakim-zade, as a young man the future calligrapher held the position of *ser-zâkirân* ('chief repeater of litanies') at the dervish lodge of Şeyh Hasan of Cihangir in Istanbul. After taking part in the rites his lodge conducted on the Laylat al-Qadr one year,[31] Mahmud had a vision of the divine essence,[32] by which he was inspired to take up the study of *thulth* and *naskh* in the manner of Şeyh Hamdullah (with İmam Mehmed Efendi) and *nastaʿlīq* in the style of Mir Imad (with Derviş Abdi Efendi). He then entered service in the Enderun, the inner sanctum of the imperial palace. There he gained access to a Qur'an manuscript in the hand of Şeyh Hamdullah that was kept in the Imperial Treasury and made a facsimile copy of it. Mahmud presented the facsimile to Sultan Mehmed IV, who appointed him his confidential secretary (*kātib al-sirr*) on the strength of the skill he had shown. Mahmud's progression from Sufi to a producer of facsimiles is significant, for Müstakim-zade described Mahmud as copying Şeyh Hamdullah in a spirit of unwavering conformity to his model (*taqlīd*), and *taqlīd* was also used to describe the blind and implicit obedience to and imitation of one's master that allowed a Sufi to attain enlightenment.

In his entries on Ahmed III and the masters of his reign Müstakim-zade related a number of anecdotes that illustrate the cultivation of calligraphy at Ahmed's court. On one occasion in AH 1136 (AD 1723–4), we are told, the sultan summoned a group of eminent scribes to the palace to join his circle of intimates in a calligraphic *salon*. Those present included Hafız Osman's most important student, Seyyid Abdullah of Yedikule (d. AH 1144/ AD 1731–2), and several of Abdullah's own pupils, including Mehmed Rasim of Eğrikapı (d.1756) and Şeker-zade Seyyid Mehmed of Manisa (d.1753). Müstakim-zade quotes several of the odes composed by those present to commemorate the occasion, including an example by Ahmed Nedim (d.1730), the greatest poet of the period.[33] His ode

celebrates the sultan's ability as a calligrapher, as in the distich, 'Those sublime lines you have traced with the nib of your pen – it is fitting that you should hang every one of them on the vault of heaven!' Another reads, 'If Prince Sunqur were alive, I would say to him, "Look at this, then go and snap your pen in two!"' The reference is to the Timurid prince Baysunghur ibn Shahrukh (d.1433), who was a celebrated patron of the arts of the book and a calligrapher in his own right.[34] The palace collections in Istanbul include a number of albums that contain work in his hand and pieces collected by him, and one page must have been the result of the same type of *salon* as that conducted by Ahmed III. It consists of the phrase *bi'l-shukr tadūmu al-niʿam* ('Because of gratitude benefactions continue') written in *riqāʿ* script no less than 18 times by the calligrapher Ahmad al-Rumi, by Baysunghur himself, and by other members of Baysunghur's circle.[35] It is possible, then, that this album page or some similar piece inspired the sultan to hold his *salon*. Such antiquarianism has already been noted in connection with the 18th-century revival in bookbinder's lacquer,[36] and it was also directed towards the work of Şeyh Hamdullah, which was avidly sought out, no matter how remote its location.

In another of his anecdotes Müstakim-zade tells us Ahmed III commissioned Şeker-zade Seyyid Mehmed, one of the participants at his calligraphic *salon*, to go to Medina to make a facsimile of a Qur'an by Şeyh Hamdullah preserved there. After performing the Hajj and executing his commission, Seyyid Mehmed returned to Istanbul after Ahmed had been driven from power (1 October 1730). He therefore presented his work, duly illuminated, to Ahmed's successor, Sultan Mahmud I.[37] Thus it was that a Qur'an copied *circa* 1500 by the founder of the Ottoman *naskh* tradition and preserved in Medina, more than 2000 kilometres from Istanbul, came to inform the *naskh* revival in the Ottoman capital in the early 18th century.

Suyolcu-zade's account continues the story of Seyyid Mehmed a step further.[38] He related that, after Mahmud I was presented with the Qur'an commissioned by Ahmed III, the sultan commissioned a Qur'an of his own, which was to be 'even more beautiful'. The Qur'an Seyyid Mehmed produced on this occasion, and completed in Jumada'l-Ukhra 1146 (November–December 1733), is preserved in the Süleymaniye Library, where it was transferred from the mosque in Istanbul now known as the Yeni Cami.[39] So fine is it that in AH 1291 (AD 1874) Sultan Abdülaziz had a facsimile edition lithographed by the Ministry of Education press in Istanbul for presentation to various grandees.[40] All the copies printed, including one now in the Khalili Collection (cat.16), were illuminated and bound in the manner of a Qur'an manuscript.

A literary tradition

Another of the participants in Ahmed III's calligraphic *salon*, as recorded by Müstakim-zade, was Suyolcu-zade Mehmed Necib, the author of the *Dawḥat al-kuttāb*. In his introduction to the *Dawḥah* Suyolcu-zade acknowledged his debt to Nefes-zade's *Gulzār-i ṣavāb*, produced a century or more earlier. Noktacı-zade İsmail Efendi, who was comptroller (*muḥāsib*) to the chief white eunuch, the Agha of the Gate of Felicity,[41] urged Suyolcu-zade to write a book on calligraphers living and deceased. Showing customary reluctance, Suyolcu-zade replied, 'As you know, the scribe Nefes-zade İbrahim Efendi wrote a work on this subject called the *Gulzār-i ṣavāb*. It meets your requirement.' İsmail Efendi answered that the *Gulzār* was a valuable book, but it omitted the many calligraphers who had practised their art since Nefes-zade's day. Suyolcu-zade accepted the point and began work on his biographical dictionary of calligraphers.[42] In turn Müstakim-zade acknowledged his debt to both Nefes-zade and Suyolcu-zade. In his entry on the latter, for example, he recorded that Suyolcu-zade 'compiled a biographical dictionary of calligraphers called the *Dawḥat al-kuttāb*. The whole of it has been included in summary form in this *Tuḥfah*

16
Lithographed facsimile of a single-volume Qur'an
Istanbul, 1874

343 folios, 19 × 12.3 cm, with
13 lines to the page
Material A crisp, dark-cream
European machine-made paper,
lightly burnished
Text area 12.8 × 6.8 cm
Script The main text in *naskh*, in
black; surah headings in gold *riqā'*,
and inscriptions in marginal
ornaments in gold or white *riqā'*
Scribe al-Sayyid al-Hajj
Muhammad, known as Şeker-zade
Illumination Text frames of a gold
band 0.4 cm wide flanked by two
greenish-gold bands 0.1 cm wide on
folios 1b, 2a, 3b–343a; floral spray
on folio 1b; extensive decoration on
folios 2b–3a; verses marked by gold
whorls enhanced with stippling, or
other small devices enhanced with
stippling and colour; surah headings;
marginal ornaments marking text
divisions and *sajdah*s; decorative
panels preceding the prayers on
folio 341a; gold roundel containing
a stamped device on folio 342b
Illuminator Attributed to 'Abdallah
Dede ibn 'Ali
Documentation A facsimile of
the original colophon and a
contemporary inscription
Binding Contemporary
Accession no. QUR335

1. The original is Istanbul,
Süleymaniye Library, MS.Yeni Cami 3.
2. Habib 1305, p.139; Rado, no date,
p.152.
3. Derman 1982, no.17.
4. Suyolcu-zade, ed. Rifat, p.68.
5. Müstakim-zade, ed. Mahmud
Kemal, pp.419–20. *Cf.* Habib 1305,
p.139; Huart 1908, p.173; Rado, no
date, pp.151–2.
6. Müstakim-zade, ed. Mahmud
Kemal, p.419. *Cf.*Müstakim-zade,
ed. Mahmud Kemal, pp.360–61.
7. For other examples of his work,
see an undated copy of *al-An'ām* in
the Topkapı Palace Library (MS.Y.17;
Karatay 1962, no.1454); and three
*qiṭ'ah*s reproduced by Rado (no
date, pp.151–2).

This book is a lithographed facsimile of a celebrated Qur'an completed in Jumada'l-Ukhra 1146 (November or December 1733) by Şeker-zade Seyyid Mehmed Efendi.[1] The publication was commissioned by Sultan Abdülaziz in AH 1291 (AD 1874) from the Ministry of Education press in Istanbul to supply him with Qur'ans that could be presented as gifts.[2] The result is of very high quality, and a very precise reproduction of the original, as can be seen by comparing folios 338b–339a of cat.16 with the same pages in the original, illustrated by Uğur Derman.[3] The quality of the production and the similarity to a manuscript are emphasized by the rich illumination and binding with which the book was furnished.

The identity of an early owner of this example is given in a note on folio 1a, which reads, 'One of the gifts from God to his slave 'Abd al-Tayyib ibn 'Abdallah, muezzin of the Abode of the Caliphate, on 7 Rajab 1264. This Noble [Qur'an] was decorated by the illuminator 'Abdallah Dede ibn 'Ali in the year 1195.' This note raises as many questions as it answers, as 7 Rajab 1264 in the Hijri lunar calendar is equivalent to 9 June 1848, while AH 1195 is equivalent to AD 1780–81. It may be, though, that 'Abd al-Tayyib was using the Hijri solar calendar, in which 7 Rajab 1264 is equivalent to 22 April 1885, and that the second date is an error for AH 1295 (AD 1878).

The circumstances in which the original 18th-century Qur'an were produced are well-known from the accounts given by Suyolcu-zade and Müstakim-zade (see p.69). It was Seyyid Mehmed's third Qur'an, as he himself recorded in the colophon (folio 342a). According to Suyolcu-zade,[4] the first was a facsimile copy of a Qur'an by Hafız Osman that was kept in the Imperial Treasury, while the second was a facsimile of a Qur'an by Şeyh Hamdullah kept in the Tomb of the Prophet in Medina. The latter was commissioned by Ahmed III, but by the time that the calligrapher had returned Ahmed had been replaced by Mahmud I, who then instructed Seyyid Mehmed to write the third, which was to be even finer. In this case the calligrapher wrote it 'following in the footsteps of the Şeyh' (*muqtafiyan āthār al-Shaykh*), according to the colophon (folio 341b).

Müstakim-zade supplied other details on the calligrapher's life, reported on the authority of Seyyid Mehmed himself.[5] The calligrapher's father, Abdurrahman, had been a wealthy confectioner (*şekerci*) in the town of Manisa in western Anatolia, from which circumstance he had acquired the surname Şekerci- or Şeker-zade. Seyyid Mehmed went to Istanbul, where he trained in *thulth* and *naskh* calligraphy, first with İbrahim Kırımi, then with the more celebrated Seyyid Abdullah of Yedikule, who was tutor in this subject at the imperial palace.

Seyyid Mehmed taught calligraphy and 'was honoured, too, with the post of tutor to the Privy Garden', that is, to the pages, known as *bostancı*s, who worked there.[6] He lived in a house near the Ayasofya mosque and was buried near the grave of Şeyh Hamdullah when he died in Jumada'l-Ula 1166 (March–April 1753). Müstakim-zade criticized him for his preoccupation with *taqlīd*, that is, reproducing his model in every detail, although 'it is generally admitted that he had no equal among his contemporaries'.[7]

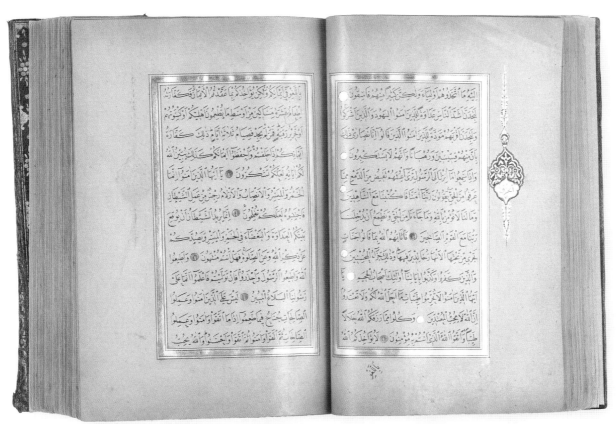

16 folios 63b–64a

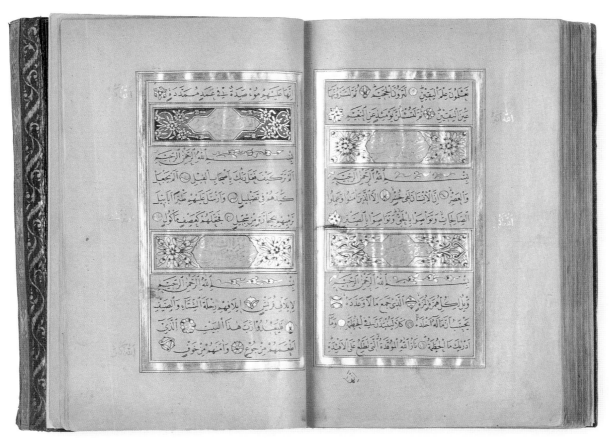

16 folios 338b–339a

of ours.'[43] Both works can, then, be seen as part of a literary tradition, and Müstakim-zade's work in particular can be viewed as the culmination of that tradition. The first draft was begun in AH 1173 (AD 1759–60), a date yielded when the title is treated as a chronogram.[44] This was two years after Suyolcu-zade's death, and Müstakim-zade was able to include a large number of contemporary scribes who flourished after Suyolcu-zade's time or had escaped his notice. As noted above, Müstakim-zade was also able to include many more calligraphers of the past through his use of a wide range of historical sources. It has to be said, too, that Müstakim-zade's work is better arranged. Suyolcu-zade's alphabetical order could be based on any part of a calligrapher's name, while Müstakim-zade always used the given name (*ism*) and then arranged scribes with the same given name alphabetically according to the name of their father, if known.

Müstakim-zade was born in Istanbul in 1719, into a family of *'ulamā'*. His grandfather, the Mehmed Müstakim Efendi from whom he derived his surname, was *qāḍī* of Damascus and Edirne and died in 1712, and his father, Mehmed Emin Efendi (d.1750), was master of a *madrasah* in Istanbul. Both men were closely associated with the Syrian scholar 'Abd al-Ghani al-Nabulusi (d.1731), who was a sheikh of both the Qadiri and the Naqshbandi fraternities. Müstakim-zade, too, was deeply influenced by al-Nabulusi's teachings. His own master was Mehmed Emin of Tokat (d.1745), and through him Müstakim-zade received initiation into the line of the famous Indian Naqshbandi sheikh Ahmad al-Sirhindi (d.1624), whose celebrated Persian letters Müstakim-zade translated into Turkish in the 1770s. Müstakim-zade also underwent the training required for entry into the upper echelons of the Ottoman *'ulamā'*, but at the age of 32 he failed the examination that would have given him access to his chosen career. As a result he withdrew into a life of contemplation and private scholarship, as the result of which he was able to produce an estimated 150 works, making him 'the most productive and versatile Ottoman author of the 18th century'.[45] He lived in straitened circumstances, without a family of his own, until he was awarded a small stipend by Salih-zade Mehmed Emin Efendi during the short period when Salih-zade held the office of mufti of Istanbul (1775–1776).

Müstakim-zade's works include three important *tadhkirah*s. The genre, introduced into Ottoman literature in the first half of the 16th century, takes the form of a series of biographical entries arranged more or less alphabetically, as we have seen. It is to be distinguished from the *ṭabaqāt* genre, to which the biographical section of the *Gulzār-i ṣavāb* belonged, and which is arranged diachronically – by sultan's reigns, for example, as in the famous *Shaqā'iq al-nu'māniyyah* ('Anemones') of Taşköprülü-zade Ahmed Efendi (d.1561). This work was devoted to Ottoman *'ulamā'* and sheikhs of the Hanafi rite, and several anecdotes in the *Shaqā'iq* turn up again in Müstakim-zade's entries.[46] Müstakim-zade also used similar works on literary figures, including the *Tadhkirat al-shu'arā'* ('Memorandum on the poets') of Salim Efendi (d.1743).[47] Müstakim-zade's non-Ottoman sources were accessible to him both directly and indirectly. In the case of the *'Ayn al-'uyūn* of the Cairene polymath Jalal al-Din al-Suyuti (1445–1505), for example, the relationship is direct, as the frequent citations show.[48] An important Persian tradition was available to him indirectly, through a work written by Mustafa Âlî, the *Manāqib-i hunarvarān* ('Exemplary deeds of the virtuosi'), to which Müstakim-zade refers on a number of occasions.[49] The transmission of this information can be traced in some detail.

In Iran in the 15th and 16th century magnificent albums of calligraphy and painting were assembled for Timurid and Safavid rulers and their leading courtiers, and some began with a scholarly preface. These texts, intended to place the contents of the album in context, are an important source on the history of the two arts of calligraphy and painting in Iran, or, at least, on contemporary conceptions of that history. The best-known is the preface composed by the calligrapher Dust Muhammad for an album he created for the Safavid prince Bahram Mirza in AH 951 (AD 1544–5).[50] Another was added by Mir Sayyid Ahmad Mashhadi in AH 972 (AD 1564–5) to the album assembled for Amir Ghayb Beg and completed a year later.[51] Although it has been published as his own work, Mir Sayyid Ahmad's preface reproduces a treatise composed by Qutb al-Din Muhammad Qissah-khwan, which itself began life as the preface for an album commissioned by Shah Tahmasp I, in AH 964 (AD 1556–7).[52] Shah Tahmasp's

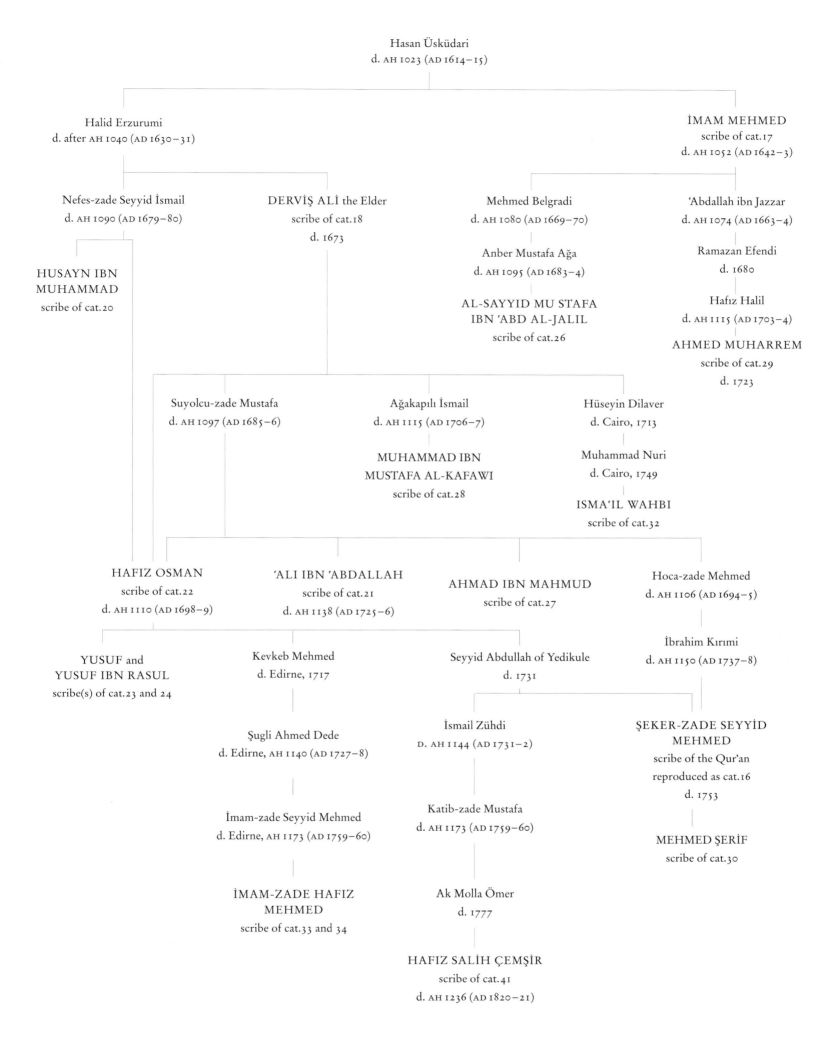

Hasan Üsküdari
d. AH 1023 (AD 1614–15)

Halid Erzurumi
d. after AH 1040 (AD 1630–31)

İMAM MEHMED
scribe of cat.17
d. AH 1052 (AD 1642–3)

Nefes-zade Seyyid İsmail
d. AH 1090 (AD 1679–80)

DERVİŞ ALİ the Elder
scribe of cat.18
d. 1673

Mehmed Belgradi
d. AH 1080 (AD 1669–70)

'Abdallah ibn Jazzar
d. AH 1074 (AD 1663–4)

HUSAYN IBN
MUHAMMAD
scribe of cat.20

Anber Mustafa Ağa
d. AH 1095 (AD 1683–4)

AL-SAYYID MU STAFA
IBN 'ABD AL-JALIL
scribe of cat.26

Ramazan Efendi
d. 1680

Hafız Halil
d. AH 1115 (AD 1703–4)

AHMED MUHARREM
scribe of cat.29
d. 1723

Suyolcu-zade Mustafa
d. AH 1097 (AD 1685–6)

Ağakapılı İsmail
d. AH 1115 (AD 1706–7)

Hüseyin Dilaver
d. Cairo, 1713

MUHAMMAD IBN
MUSTAFA AL-KAFAWI
scribe of cat.28

Muhammad Nuri
d. Cairo, 1749

ISMA'IL WAHBI
scribe of cat.32

HAFIZ OSMAN
scribe of cat.22
d. AH 1110 (AD 1698–9)

'ALI IBN 'ABDALLAH
scribe of cat.21
d. AH 1138 (AD 1725–6)

AHMAD IBN MAHMUD
scribe of cat.27

Hoca-zade Mehmed
d. AH 1106 (AD 1694–5)

İbrahim Kırımi
d. AH 1150 (AD 1737–8)

YUSUF and
YUSUF IBN RASUL
scribe(s) of cat.23 and 24

Kevkeb Mehmed
d. Edirne, 1717

Seyyid Abdullah of Yedikule
d. 1731

ŞEKER-ZADE SEYYİD
MEHMED
scribe of the Qur'an
reproduced as cat.16
d. 1753

Şugli Ahmed Dede
d. Edirne, AH 1140 (AD 1727–8)

İsmail Zühdi
D. AH 1144 (AD 1731–2)

İmam-zade Seyyid Mehmed
d. Edirne, AH 1173 (AD 1759–60)

Katib-zade Mustafa
d. AH 1173 (AD 1759–60)

MEHMED ŞERİF
scribe of cat.30

İMAM-ZADE HAFIZ
MEHMED
scribe of cat.33 and 34

Ak Molla Ömer
d. 1777

HAFIZ SALİH ÇEMŞİR
scribe of cat.41
d. AH 1236 (AD 1820–21)

The school of Şeyh Hamdullah in the 17th and 18th centuries.
The master–pupil relationships of Qur'anic scribes represented in the Khalili Collection

album has not been identified (and may never have been completed), but the text survived in several forms, including the version appropriated by Mir Sayyid Ahmad. One is a 17th-century copy in a miscellany in Tehran, on which the published version of the text is based,[53] while another was the copy that Qutb al-Din had with him when he met Mustafa Âlî in Baghdad in 1585–6.[54] According to his preface, Âlî acquired a copy of Qutb al-Din's work and used it as the basis for the *Manāqib-i hunarvarān*, which he completed in Rabiʿ al-Akhir 995 (March–April 1587), after his return to Istanbul. Âlî wrote the work in Turkish, in a prolix style very different from Qutb al-Din's rapid summary in Persian, and he added information supplied by Qutb al-Din and others on the calligraphers and painters active in Iran since the 1550s.[55] He also complemented the account of the calligraphers and painters of Iran with passages on those active in the Ottoman empire, for which his avowed source was the calligrapher Abdullah Kırımi, who has already been mentioned as the master of Demirci-kulu Yusuf Efendi, who in turn taught calligraphy to the author of the *Gulzār-i ṣavāb*.[56]

Müstakim-zade and the Khalili Collection

The notices that Müstakim-zade extracted from the work of authors such as al-Suyuti and Mustafa Âlî give his work considerable breadth; and a comparison of the relevant entries in the *Tuhfah* with the information given in the colophons of the Qur'ans in the Khalili Collection produced between 1600 and the mid-18th century shows the reliability of his information, at least with regard to the more recent generations of Ottoman calligraphers. The same comparison also establishes the precise location of the great majority of the scribes responsible for the Khalili pieces within the tradition of Şeyh Hamdullah as transmitted by Hasan Üsküdari; and it allows us to construct a chain of transmission in tabular form that includes the scribes of no less than 17 Qur'ans in the Collection (see table). There are exceptions, of course. Mustafa ibn Hüseyin, the scribe of cat.19, has to be excluded because he did not declare an affiliation to a particular master in the colophon of the manuscript, nor is he known from other sources. Yet Mustafa was an official in the imperial treasury when he copied cat.19 in 1655, and his *naskh* hand suggests that he was trained by a palace calligraphy tutor belonging to the school of Şeyh Hamdullah.

The Khalili Qur'ans are set in their context by the entries in Müstakim-zade and are shown to be representative of their age. That age was very different from the 16th century, but the changes that had occurred were in fact favourable to Qur'an production and other forms of calligraphy. By 1600 the expansion of the Ottoman state had all but stopped, as noted above. When there were attempts to expand, great efforts were expended to relatively little effect. Thus the conquest of Crete from the Venetians dragged on from 1645 to 1669 and brought the empire to the brink of disaster in 1656, when the enemy threatened the Dardanelles. It was this event, though, which brought about the appointment of Köprülü Mehmed Pasha as grand vizier, and this in turn led to the consolidation of the imperial system under new management. The Ottoman state in 17th and 18th centuries may be described, perhaps too politely, as a period of institutional maturity in which good administrators were more important than military conquerors. The bureaucratic imperative remained a feature of Ottoman government for the rest of the empire's history, and this is reflected in the prominence given to the art of calligraphy, the bureaucratic art form *par excellence*, in the 17th, 18th and 19th centuries. Indeed, as the government of the empire fell more and more into the hands of the scribal bureaucracy, whose numbers increased to match, calligraphy enjoyed greater and greater eminence. In this aspect of Ottoman art, if in nothing else, the 19th century was a period of excellence. The foundations for that excellence were laid in the 'age of Müstakim-zade', after 1650, when Ottoman *naskh* calligraphy underwent a great revival, having experienced a period of decline. The Qur'ans produced fitted the needs of their time, and their form proved remarkably durable.

1. See, for example, Âlî, ed. and trans. Tietze.

2. Pierce 1993.

3. Âlî, ed. and trans. Tietze, I, p.61.

4. Müstakim-zade, ed. Mahmud Kemal, pp.475–6.

5. Müstakim-zade's text (ed. Mahmud Kemal, p.476) reads, *bin altın dahi bahşayiş-i sultanîye nâil olmuştur. Cf.* the conflicting interpretions offered by Çığ (1951), Rado (no date, p.94) and Huart (1908, pp.13–14).

6. This story has been linked to two Qur'ans in the Topkapı Palace Library. The first (see Çığ 1951) is MS.K.51 (Karatay 1962, no.983), completed in AH 1045 (AD 1635–6). The second (see Rado, no date, p.94) is MS.K.253 (Karatay 1962, no.981), completed in AH 1043 (AD 1633–4). Both seem unlikely candidates, as Murad IV conquered Baghdad in 1639, whereas an anonymous copy in the same library (MS.K.54; Karatay 1962, no.986) was completed 40 days after the sultan's return to Istanbul, on 19 Rabi' al-Awwal 1049. My thanks to Irvin Schick for his help with this matter.

7. *Cf.* Âlî, ed. and trans. Tietze, I, p.61, on the audacity of craftsmen in asking for payment in advance.

8. Topkapı Palace Library, MS.Y.999; Atıl 1987, nos 9a, 9b (illustrated on pp.48–9); Rogers & Ward 1988, nos 15a, 15b.

9. James 1992b, no.8 is an example of the prototype, and no.22 of Istanbul work in the same style.

10. See Raby & Tanındı 1993, nos 37, 38, 40, 41.

11. See, for example, James 1992b, no.57.

12. Suyolcu-zade (ed. Rifat, p.8) says that Hamdullah produced 'many scrolls comprising the Six Pens'. For an example see Topkapı Library, MS.E.H.2086 (Serin 1992, pp.184–9).

13. Suyolcu-zade, ed. Rifat, p.36; Müstakim-zade, ed. Mahmud Kemal, p.157. There is no entry on him in Nefes-zade's work.

14. Suyolcu-zade, ed.Rifat, p.49.

15. The dedication to Murad IV and the entry on him as a calligrapher are absent from the edition by Kilisli Muallim Rifat, but are to be found *apud* Hakkak-zade, ed. Dedeoğlu, columns 112–14; 155–8.

16. It is notable that Nefes-zade still used this term rather than referring simply to '*thulth* and *naskh*', as Müstakim-zade usually did.

17. Nefes-zade, ed. Rifat, p.70; *apud* Hakkak-zade, ed. Dedeoğlu, column 163.

18. Nefes-zade, ed. Rifat, pp.60–61; *apud* Hakkak-zade, ed. Dedeoğlu, columns 152–4. After the entry on Yusuf, Nefes-zade comments that many other masters of the Six Pens were not included because they 'were not up to scratch' but makes an exception in the case of Şerbetçi-zade İbrahim of Bursa, who died a century before Yusuf Efendi, in AH 932 (AD 1525–6).

19. Suyolcu-zade, ed. Rifat, p.10.

20. And 1982, pp.22–5.

21. Faroqhi 1994, pp.613–14.

22. Müstakim-zade, ed. Mahmud Kemal, p.301.

23. Topkapı Library, Istanbul, MS.A.3653, with a binding dated AH 1140 (AD 1727–8); see Atıl 1980, fig.125; Istanbul 1983, no.E.314; Derman 1992, no.86.

24. Topkapı Palace Library, MS.H.2280, which is undated; see Derman 1992, no.83.

25. Topkapı Palace Library, MS.A.3652, dated AH 1136 (AD 1723–4); see Atıl 1980, figs 123–4; Derman 1982, no.14; Istanbul 1983, no.E.315.

26. See Derman 1982, nos 83, 84, 86, for example.

27. See Derman 1982, no.14.

28. Suyolcu-zade, ed. Rifat, p.37.

29. See the explanation given by Mahmud Kemal İnal to Prince Muhammad 'Ali of Egypt, for example (İnal 1955, p.171).

30. Suyolcu-zade, ed. Rifat, p.80; Müstakim-zade, ed. Mahmud Kemal, pp.511–12.

31. The night of 27 Ramadan, when the first revelation of the Qur'an is commemorated.

32. Müstakim-zade used the technical term *mushāhadah*, which in Islamic mysticism means the revelation one receives on attaining the highest degree of perfection in contemplating the divine essence.

33. Müstakim-zade, ed. Mahmud Kemal, pp.76–9.

34. See, for example, Roemer 1990; Gray 1996 (*cf.* also James 1992b, pp.18–23).

35. Topkapı Palace Library, MS.H.2152, folio 31b; see Soucek 1979, p.15, fig.7; Lentz & Lowry 1989, p.115, fig.39; Roxburgh 1996, I, pp.141–3; II, pp.695–6, and fig.30.

36. Khalili, Robinson & Stanley 1996–7, Part One, p.233.

37. Müstakim-zade, ed. Mahmud Kemal, pp.419–20.

38. Suyolcu-zade, ed. Rifat, p.68.

39. Süleymaniye Library, Istanbul, MS. Yeni Cami 3; see Derman 1982, no.17.

40. Habib 1305, p.139; Rado, no date, p.152.

41. On İsmail Efendi, see Suyolcu-zade, ed.Rifat, p.12; Müstakim-zade, ed.Mahmud Kemal, pp.116–17.

42. Suyolcu-zade, ed.Rifat, p.5.

43. Müstakim-zade, ed.Mahmud Kemal, p.437. The marginal annotations in Müstakim-zade's copy of Suyolcu-zade were reproduced by Rifat as footnotes.

44. Müstakim-zade, ed.Mahmud Kemal, p.61.

45. Kellner-Heinkele 1993.

46. See, for example, Taşköprülü-zade, ed.Furat, p.370; Müstakim-zade, ed.Mahmud Kemal, p.113.

47. See, for example, Müstakim-zade, ed. Mahmud Kemal, p.454.

48. See, for example, Müstakim-zade, ed. Mahmud Kemal, p.26.

49. See, for example, Müstakim-zade, ed. Mahmud Kemal, pp.560–61, 562.

50. Topkapı Palace Library, Istanbul, MS.H.2154. For the preface see Bayani 1345–58, I, pp.192–203; Thackston 1989, pp.335–50. See also Roxburgh 1996, I, pp.235–350.

51. Topkapı Palace Library, Istanbul, MS.H.2161. For the preface see Bayani 1345–58, I, pp.50–53; Thackston 1989, pp.353–6. See also Roxburgh 1996, I, pp.384–92.

52. Qutb al-Din Qissah-khwan, ed. Khadiv-Jam, p.676.

53. Qutb al-Din Qissah-khwan, ed. Khadiv-Jam, p.667.

54. Âlî, ed. Mahmud Kemal, p.7; Fleischer 1986, pp.117–18, 127.

55. See Fleischer 1986, p.123, n.36, for examples.

56. Âlî, ed. Mahmud Kemal, pp.7–8. Abdullah Kırımi received a bad notice from Nefes-zade (ed. Rifat, p.58) and Suyolcu-zade (ed. Rifat, p.106). Müstakim-zade (ed. Mahmud Kemal, p.289) is silent on his defects but often ignores the information he supplied to Âlî.

17
Single-volume Qur'an
Probably Istanbul, AH 1050 (AD 1640–41)

336 folios, 20.2 × 13.3 cm, with
15 lines to the page
Material A smooth, cream laid
paper, lightly burnished; there are
approximately eight laid lines to
the centimetre, and no apparent rib
shadows or chain lines
Text area 14.2 × 7.6 cm
Script The main text in *naskh*,
in black, with reading marks in red;
surah headings in white *riqā'*;
marginalia in gold *riqā'*
Scribe Muhammad al-Hafiz, called
al-Imam
Illumination Extensive decoration
on folios 1b–2a; text frames ruled in
gold, black and blue; verses marked
by gold whorls set off with red and
blue dots; surah headings and similar
headings before concluding prayer
(folio 334a) and colophon (folio
335b); marginal devices marking
juz' 8–10 (folios 75a, 85b, 96b)
Documentation A colophon
Binding Contemporary
Accession no. QUR57

1. Topkapı Palace Library,
MS.H.S.322; Karatay 1962, no.980.
2. Topkapı Palace Library, MS.K.253;
Karatay 1962, no.981, where the
scribe was not given; colophon
illustrated at Rado, no date, p.96.
3. Topkapı Palace Library, MS.K.51;
Çığ 1951; Karatay 1962, no.983.
4. Müstakim-zade, ed.Mahmud
Kemal, pp.475–6. See also Suyolcu-
zade, ed.Rifat, p.11, and *cf.* Habib
1305, p.148; Huart 1908, pp.134–5;
Rado, no date, pp.94, 96.

According to the colophon the scribe responsible for this Qur'an was 'Muhammad al-Hafiz, known as al-Imam', that is, İmam Mehmed Efendi, a celebrated calligrapher who received his training before 1615 and continued working until his death in AH 1052 (AD 1642–3). He signed a Qur'an in the Topkapı Palace Library in the same manner as cat.17 some ten years earlier, on 1 Ramadan 1041 (22 March 1631).[1] Another example was signed simply 'Muhammad al-Imam' and dated AH 1043 (AD 1633–4),[2] while a third Qur'an in the same collection, signed 'Hafiz Muhammad, imam of Mecca', in AH 1045 (AD 1635–6), is also counted as his work.[3]

According to Müstakim-zade,[4] İmam Mehmed Efendi was born in Tokat in central Anatolia and was taught calligraphy by Hasan Üsküdari, presumably in Istanbul. As we have seen (p.66), Hasan Efendi, who died in AH 1023 (AD 1614–15), was the main figure in the transmission of the tradition of Şeyh Hamdullah to the calligraphers of the 17th century. Cat.17 exemplifies the fine quality of Mehmed's *naskh* hand, which was the model for a line of Ottoman calligraphers that flourished into the 18th century, as cat.26 and 29 below show. Müstakim-zade also relates an anecdote concerning İmam Mehmed Efendi and Sultan Murad IV (see above, p.61).

Cat.17 opens with a double page of elegant illumination, which is notable for the relative simplicity of its layout. The reduced text area is surrounded by four panels defined by narrow bands of pink strapwork, and these are in turn framed by a wide border with a straight edge. The vertical panels on either side of the text have a row of small gold cartouches, each filled with an s-shaped floral scroll. In the panels above and below the text central gold cartouches inscribed with the surah titles are set on parti-coloured grounds in which areas of blue and a greenish tone of gold are separated by half-palmette motifs in gold; scrolls set with tiny polychrome blossoms form a continuous pattern over both blue areas and gold. The border is composed of the same elements, with gold rather than greenish-gold for the ground, and is framed on the outer sides by a band of red, gold, black and blue rules from which flower-decked 'darts' in red and blue issue into the margins.

The surah headings in the rest of the manuscript are inscribed in white *riqā'* in gold cartouches, which are set within illuminated panels. There are general similarities between this illumination and that of the opening pages, although the motifs separating the areas of different colours (blue and gold or greenish-gold) include cloud bands as well as split palmettes, and the blossoms on the floral scrolls are larger and of a different type (compare cat.19).

The binding is probably contemporary with the text but appears to have been renovated in the second half of the 19th century. The outer covers and the two sections of the flap were produced in an unusual manner. They were covered in the first instance with a layer of leather block-pressed with a continuous pattern of lotus scrolls, and secondly with a layer of brown morocco cut out to form the field of a centre-and-corner composition and a double border of cartouches. This method of production appears to have been an attempt to reproduce the depth and definition of the fine bindings with block-pressed and gilded countersunk elements that were produced in Istanbul from the late 15th century onwards (see cat.15 above).

18
Single-volume Qur'an
Probably Istanbul, AH 1053 (AD 1643–4)

348 folios, 22.5 × 14.5 cm, with
14 lines to the page
Material A polished, thin, cream
laid paper
Text area 14.7 × 7.8 cm
Script The main text in *naskh*, in
black, with reading marks in red;
surah headings and inscriptions in
marginal ornaments in white *riqā'*;
other marginalia in gold *riqā'*;
colophon in black *riqā'*
Scribe Darwish 'Ali
Illumination Extensive decoration
on folios 1b–2a; text frames ruled in
gold, black and red; verses marked
by gold whorls set off with red and
blue dots; surah headings; marginal
ornaments marking text divisions
and *sajdah*s; gilding between the
words of the colophon on folio 348a
Documentation A colophon
Binding Contemporary
Accession no. QUR93
Published Geneva 1995, no.27

1. Müstakim-zade, ed. Mahmud
Kemal, p.336. See also Suyolcu-zade,
ed.Rifat, p.49; and *cf.* Habib 1305,
pp.126–7; Huart 1908, p.137;
Rado, no date, pp.100–101.
2. Topkapı Palace Library, MSS
H.S.330, H.S.367, E.H.128; Karatay
1962, nos 1002, 1004, 1013.
3. Topkapı Palace Library, MSS K.316,
E.H.317, E.H.312–315; Karatay 1962,
nos 995, 1003, 1008, 1014, 1208,
1209.
4. Topkapı Palace Library,
MS.E.H.318; Karatay 1962, no.1015.
5. Topkapı Palace Library,
MS.E.H.241; Karatay 1962, no.1012.
The Topkapı MS.E.H.242 (Karatay
1962, no.1231) is another, undated
copy of the first *juz'* by Derviş Ali,
while MS.H.7 (Karatay 1962, no.1237;
Rado, no date, p.97) is a copy of *juz'*
29. For other published examples of
the calligrapher's work, see Derman
1982, no.12 (a *karalama*); 1992,
no.72 (an album piece).
6. *Cf.* Rado, no date, p.97, where the
margins are filled with floral scrolls
in the *halkârî* technique.

According to the colophon, which follows the end of the Qur'anic text on folio 348a, this Qur'an manuscript was copied by the earlier of two celebrated Ottoman calligraphers called Derviş Ali, and who is therefore identified here as Derviş Ali the Elder. Müstakim-zade tells us that this Derviş Ali was brought up as a slave in the household of a senior Janissary officer, Kara Hasan-oğlu Hüseyin Ağa, and 'in the first bloom of youth' he served as a subaltern officer (*karakullukçu*) in the Janissaries. Subsequently he trained as a calligrapher with Halid Erzurumi, who, like İmam Mehmed Efendi (see cat.17), was a pupil of Hasan Üsküdari and thus a member of the school of Şeyh Hamdullah. Derviş Ali had 'a thousand pupils among the great', including the famous grand vizier Köprülü-zade Fazıl Ahmed Paşa, and he was also a teacher of Hafız Osman, who is counted as the greatest Ottoman calligrapher of the 17th century. He died in Ramadan 1084 (December 1673–January 1674).[1]

Suyolcu-zade and Müstakim-zade report that Derviş Ali copied more than 40 Qur'ans and numerous prayer books and copies of the surah *al-An'ām*, as well as albums of calligraphy (*muraqqa'*) and album pieces (*qit'ah*). This output is reflected in the holdings of the Topkapı Palace Library, where there are at least three Qur'ans produced by him, in AH 1067 (AD 1656–7), AH 1070 (AD 1659–60) and AH 1077 (AD 1666–7),[2] and six copies of *al-An'ām*, with dates between AH 1058 (AD 1648) and AH 1077 (AD 1666–7),[3] as well as a copy of the surah *al-Kahf* made in AH 1080 (AD 1669–70), four years before the calligrapher's death.[4] Another example of his work in the same library is a copy of part 1 of a Qur'an in 30 parts where the first section (to folio 11a) is the work of Şeyh Hamdullah, and the remainder was supplied by Derviş Ali in AH 1076 (AD 1665–6).[5]

Cat.18 was written in a neat *naskh* hand worthy of a calligrapher of Derviş Ali's eminence, and the manuscript also contains some fine illumination. This is particularly so in the case of the marginal devices, which come in a variety of forms – lotus blossoms, medallions, palmettes and arabesques – and all have blue floral 'darts' above and below, whereas the surah headings are relatively simple, consisting of an inscription in white *riqā'* outlined in black with a rectangular panel of gold. The contrast may be due to the addition of the marginal devices at a later date (see p.62 above). The illumination on the opening pages of text has no border elements but is surmounted by a pair of head-pieces.[6] The vertical panels on either side of the text may be compared with those on the opening pages of cat.17, but the horizontal panels are of a quite different design: the shaped gold cartouches containing the surah headings have relatively large gold pendants, for example.

In his entry on Derviş Ali, Müstakim-zade asserted that the calligrapher's work was illuminated by a master called Mustafa Surahi, who was taught his art by an illuminator called Abdullah, who was in turn the freedman and pupil of Kara Mahmud of Yenibahçe. It may be, therefore, that the original illumination found in cat.18 is an example of Mustafa Surahi's work.

The covers are in brown morocco and have stamped and gilded centre-and-corner elements. The doublures are of polished vermilion paper.

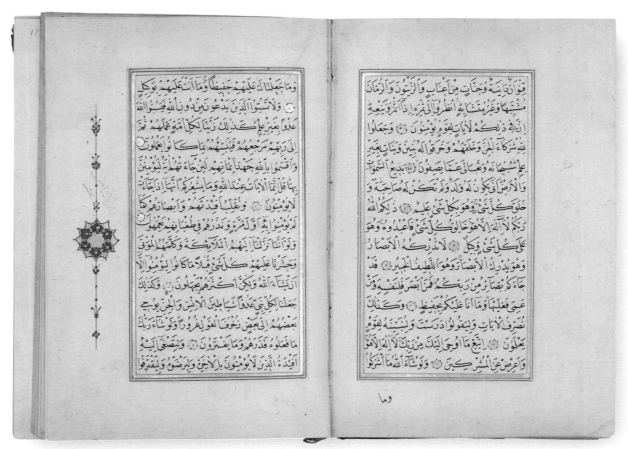

17 folios 74b–75a

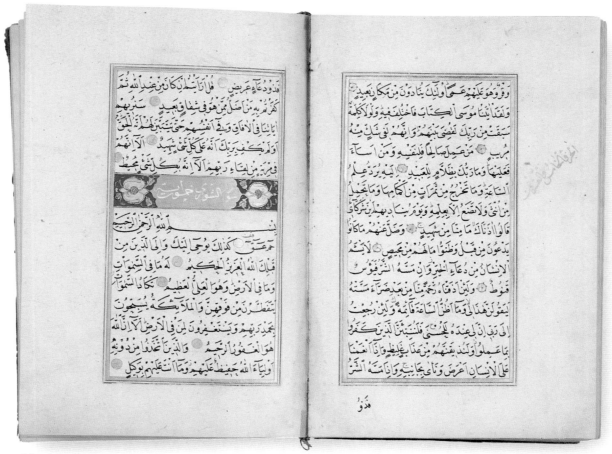

17 folios 259b–260a

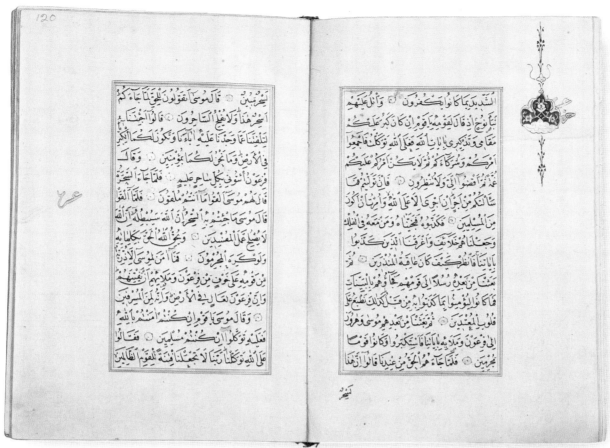

18 folios 119b–120a

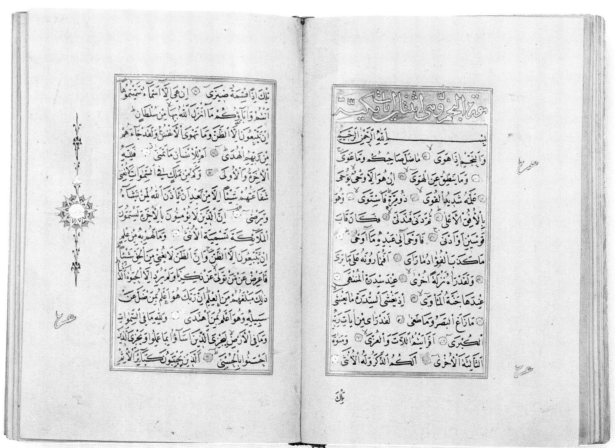

18 folios 296b–297a

19
Single-volume Qur'an
Istanbul, Ramadan 1066 (June–July 1656)

352 folios, 27 × 17.6 cm, with 13 lines
to the page
Material A smooth, dark-cream laid
paper, lightly burnished; there are
approximately eight laid lines to the
centimetre, and no apparent rib
shadows or chain lines
Text area 18.5 × 9.7 cm
Script The main text in *naskh*, in
black, with reading marks in red;
surah headings and inscriptions in
marginal ornaments in white *riqā'*
Scribe Mustafa ibn Husayn
Illumination Extensive decoration
on folios 1b–2a; text frames ruled in
gold and black; verses marked by
gold whorls set off with red and blue
dots; surah headings and a similar
heading for the concluding prayer
(folio 349b); marginal ornaments
marking text divisions and *sajdah*s
Documentation A colophon and a
seal impression
Binding Contemporary
Accession no. QUR90
Published Geneva 1995, no.23

In the colophon on folio 352a this Qur'an is attributed to a scribe who was probably an
official in the Imperial Treasury in Istanbul rather than a professional copyist, and who
was not recorded in the biographical literature on Ottoman calligraphers.

The colophon was written in the mixture of defective Arabic and Ottoman Turkish or
Persian often used by Ottoman officials (compare the colophon of cat.13). It states that
the Qur'an was completed by Mustafa ibn Husayn in Ramadan 1066 and was copied
in the imperial palace, in the building occupied by the Imperial Treasury (*fī khānah-i
Khazīnah-i 'āmirah*), in the time of Sultan Mehmed IV (*reg.*1648–1687). This building
may have functioned to some degree as a scriptorium, as the important manuscripts kept
there were used as models by calligraphers of the standing of Mahmud of Tophane and
Şeker-zade Seyyid Mehmed Efendi (see p.68 and cat.16 above). Beneath the colophon
there is an impression of the seal of a woman called Umm Kulthum, which is dated
AH 1205 (AD 1790–91).

The opening pages of text (illustrated on p.63) have illumination in a format that is
standard in Ottoman Qur'ans of the second half of the 17th century. It is similar to that
seen in cat.17 above, but the wide border has a lobed edge, with a floral 'dart' issuing from
the pointed head of each lobe. In addition, the bands that frame the main elements of the
design are more profuse and are in different colours (here red, yellow and gold), so that
the structure is less clear.

Surah headings are inscribed in white *riqā'* on gold cartouches with pointed ends, from
which polychrome floral scrolls issue over a blue ground. Each *juz'* is marked by a large
and rather splendid device that comes in one of two forms, both executed in gold and blue,
inscribed with the word *al-juz'* in white *riqā'*, and with blue 'finials' above and below.
One type is composed of a lotus-leaf medallion with a teardrop-shaped centre; the other is
made up of concentric rings of gold petals.

The binding is of particularly fine quality. The covers are of red morocco and have
countersunk centre-and-corner elements block-pressed with a design of floral scrolls and
cloud bands, these elements being reserved in a gilded ground. The fore-edge section of
the flap has a pressure-moulded panel bearing a quotation from the Qur'an, 'Which none
shall touch but they that are clean: a revelation from the Lord of the Worlds' (surah LVI,
verses 79–80). The doublures are of plain red morocco, and there are traces of gilding on
the upper edges of the text block.

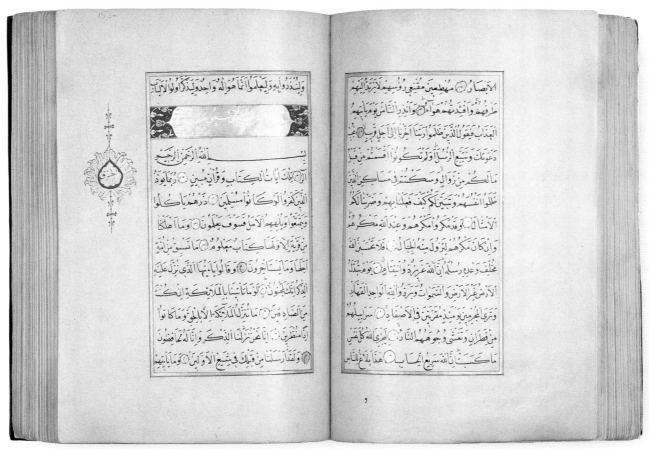

19 folios 152b–153a

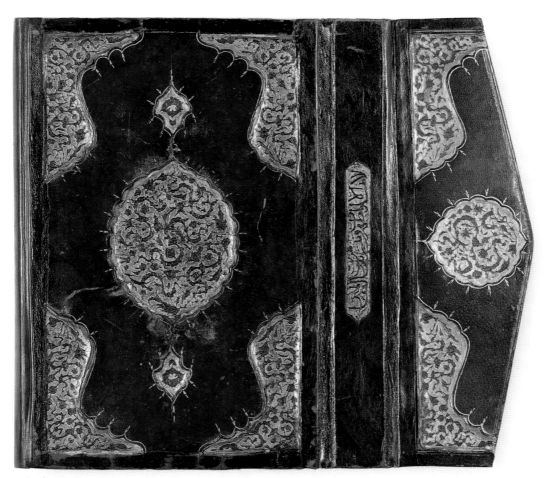

19 binding

20

Single-volume Qur'an

Istanbul or the provinces, AH 1088 (AD 1677–8)

404 folios, 18.9 × 11.5 cm, with
13 lines to the page
Material Polished, thin, buff laid
paper
Text area 11.2 × 6.1 cm
Script The main text in *naskh*, in
black, with reading marks in red;
surah headings and inscriptions in
marginal ornaments in white *riqāʿ*
Scribe Husayn ibn Muhammad
Illumination Extensive decoration
on folios 1b–2a; text frames ruled in
gold, black and blue; verses marked
by gold six-petal rosettes set off with
red and blue dots; surah headings;
marginal ornaments marking text
divisions and *sajdah*s; colophon on
folio 404b written in 'clouds'
reserved in a gold ground
Documentation A colophon
Binding Contemporary
Accession no. QUR271
Published Geneva 1995, no.28

1. Suyolcu-zade, ed. Rifat, p.132;
Müstakim-zade, ed. Mahmud
Kemal, p.129. *Cf.* Habib 1305,
pp.102–3; Huart 1908, p.138;
Rado, no date, p.102.
2. Müstakim-zade, ed. Mahmud
Kemal, p.180. *Cf.* Habib 1305, p.109;
Huart 1908, p.143; Rado, no date,
p.108.
3. See Geneva 1995, p.67.
4. There is a fine example attributed
to the second half of the 16th
century on a Qur'an in the Istanbul
University Library (MS.A.6570);
see Istanbul 1983, no.E.181; Atıl
1987, p.16, no.19; Rogers & Ward
1988, no.25.
5. The absence of examples in the
Topkapı collections has been
attributed to a fire in the stables
there in the late 17th century;
Atasoy 1992, p.114.
6. Żygulski 1989, no.137.
7. Vienna 1983, no.13/1a.
8. Petrasch and others 1991, no.256.

The calligrapher responsible for this Qur'an was Husayn ibn Muhammad (Hüseyin,
the son of Mehmed), a pupil of İsmail Efendi. In the 1670s, when this manuscript was
produced, the leading calligrapher called İsmail was Nefes-zade Seyyid İsmail Efendi,
who died in AH 1090 (AD 1679–80).[1] He was the son of Nefes-zade İbrahim Efendi, the
author of the *Gulzār-i ṣavāb* (see pp.66, 69–70 above), and a pupil of Derviş Ali the Elder
(see cat.18). The younger Nefes-zade had many students of his own, including Hafız
Osman (see cat.22), but Müstakim-zade recorded only one with the name Hüseyin,
and as he did not give this Hüseyin's patronymic, no firm identification can be made.
The calligrapher recorded by Müstakim-zade was Hüseyin Can of Bursa, who served as
a clerk in the government department known as the Galleons Office (*Kalyonlar*) and died
in AH 1107 (AD 1695–6).[2]

The fine illumination on folios 1a–2b is close in many respects to that on the opening
pages of cat.19, but here the polychrome work was replaced by work in contrasting tones
of gold, with black outlines and red highlights. The text area and the four surrounding
panels are defined by brown bands textured in a contrasting colour, while the horizontal
panels containing the surah headings have an inner border of a textured mauve band.
Reduced versions of these horizontal panels, complete with the mauve border, were
employed for the surah headings in the remainder of the manuscript, while the fine
marginal ornaments are of varied form and were executed in pastel colours and gold.

The binding is of brown morocco and was embroidered in metal wire with a centre-
and-corner design surrounded by a wide border, all filled with floral motifs.[3] This
decorative technique was used occasionally for bookbindings from the 16th century or
earlier,[4] but it was probably always more common in other types of leather wares. Later
17th-century Ottoman leatherwork embroidered in metal thread survives in some quantities
in European collections, in the form of saddles, quivers, bow cases and other accoutrements
of war.[5] These were acquired as diplomatic gifts, as in the case of a saddle presented to the
Polish ambassador by Mustafa II,[6] or as booty, as in the case of the saddle of Kara Mustafa
Pasha in Vienna.[7] In some instances the motifs were worked in metal thread against the
background colour, which could be that of tanned leather, of dyed leather or, in the more
lavish examples, of a silk facing, while in others the motifs and background were worked
in contrasting colours within solid blocks of embroidery, as on cat.20 and, for example, a
fine canteen in Karlsruhe.[8]

The fore-edge section of the flap has a pressure-moulded and gilded cartouche filled
with the same quotation from the Qur'an as on the binding of cat.19, 'Which none shall
touch but they that are clean: a revelation from the Lord of the Worlds' (surah LVI, verses
79–80). The red morocco doublures have recessed centre-pieces that were pressure-
moulded with a design of floral scrolls and cloud bands and gilded.

21

Single-volume Qur'an

Cairo, 1 Ramadan 1097 (22 July 1686)

520 folios, 22 × 14.5 cm, with
11 lines to the page
Material A thin, cream laid paper,
lightly burnished; there are
approximately ten laid lines to the
centimetre and no apparent rib
shadows or chain lines. The paper
is so thin that individual folios are
semi-transparent.
Text area 14.7 × 8.6 cm
Script The main text in *naskh*, in
black, with reading marks in red;
surah headings and inscriptions in
marginal ornaments in white *riqāʿ*;
other marginalia in red *riqāʿ*
Scribe ʿAli ibn ʿAbdallah
Illumination Extensive decoration
on folios 1b–2a; text frames ruled in
gold, black and blue; verses marked
by gold six-petal rosettes set off with
red and blue dots; surah headings
and similar headings before the
colophon (folio 514b) and conclud-
ing prayers (folio 515b); marginal
ornaments marking text divisions
and *sajdah*s
Documentation A colophon
Binding Contemporary
Accession no. QUR112

1. The colophon on folios 514b–515b
is followed by a long series of
prayers, on folios 515b–520a.
2. Rado, no date, pp.102–3. Despite
his long residence in Egypt ʿAli was
not recorded among the calligraphers
of that country by Muhammad
Murtada al-Zabidi, the 18th-century
Egyptian historian of calligraphy.
3. Suyolcu-zade, ed. Rifat, p.73, for
example.
4. Suyolcu-zade, ed. Rifat, p.87.
5. Suyolcu-zade, ed. Rifat, p.87;
Müstakim-zade, ed. Mahmud
Kemal, p.341. *Cf.* Rado, no date,
pp.102–3.

The scribe of this manuscript, ʿAli ibn ʿAbdallah, completed his work on Monday,
1 Ramadan 1097, while (temporarily) resident in Cairo (*al-muqīm bi-Miṣr ḥīna'idhin*).[1]
In fact, ʿAli seems to have spent five years or more in Cairo, for another Qur'an he copied
there, in AH 1092 (AD 1681), has been recorded,[2] but he must have gone to Egypt from
Istanbul, where, as he himself declared in the colophon of cat.21, he trained as a calligra-
pher with Suyolcu-zade Mustafa of Eyüp. Mustafa is reported to have died in AH 1097
(AD 1685–6),[3] and this is likely to be correct, as the earliest source for this date is the
calligrapher's own kinsman, Suyolcu-zade Mehmed Necib (see pp.69–70 above). It
would appear from cat.21 that he died in the earlier part of the year, for news of his death
had reached ʿAli in Cairo by 1 Ramadan. Some time after 1687 ʿAli must have returned to
Istanbul, as Suyolcu-zade Mehmed Necib, and after him Müstakim-zade, recorded him as
living in the Kasımpaşa district, where 'he gave lessons to those who desired them, so that
his house was like a school'.[4] ʿAli lived to the age of 70, dying in AH 1138 (AD 1725–6), and
made a copy of the Qur'an for every year of his life. One of these he left in his will to pay
for his burial rites.[5]

In this example ʿAli wrote in a bold, fluid hand which has a number of features, such as
incomplete *mīm* letters, that suggest he wrote at some speed. He did not, however, lose
the clarity that was essential in Qur'an calligraphy. Given ʿAli's training, it is not surprising
that he wrote *naskh* in the style of Istanbul, and comparison with cat.13 shows that in
stylistic terms this manuscript presages the eclipse of Cairo as the centre of an independent
tradition. In the 18th century it became the home of a native sub-school within the
Ottoman tradition, as cat.32 below shows.

The illumination in cat.21 is also similar to Istanbul work of the period (compare cat.19,
for example) but was presumably executed in Cairo. There may well have been Cairene
illuminators working in this style in the later 17th century, but it is also possible that ʿAli
illuminated the manuscript himself, especially since he reputedly specialized in Qur'an
production as a scribe. On the opening pages the narrow vertical panels on either side of
the text are filled with paired undulating scrolls formed of half-palmettes (compare cat.20,
where the red highlights give greater legibility). In the borders the areas of blue and gold
are arranged in an unusual manner, so that the blue ground forms a zigzag pattern
between the gold, and the lobes of the border's edge have been reduced to a straight line
interrupted by triangular points. The surah headings in the remainder of the manuscript
are inscribed in white *riqāʿ* in shaped gold cartouches within illuminated panels that show
considerable variety. The panels, which are framed by coloured bands, have grounds
painted in one or two tones of gold, overlaid with floral motifs of different types, some-
times combined with half-palmettes. A good deal of variety is also found in the marginal
ornaments.

The fine covers are of brown morocco, decorated with recessed centre-pieces pressure-
moulded with cloud-scroll and floral motifs, plain but for a gold outline. During a later
reworking a simple border of gold rules was added, and it was probably at this time that
the exposed edges of the text block were painted with a repeat pattern of sinuous leaves.
The doublures are of maroon morocco with a simple border of gold rules.

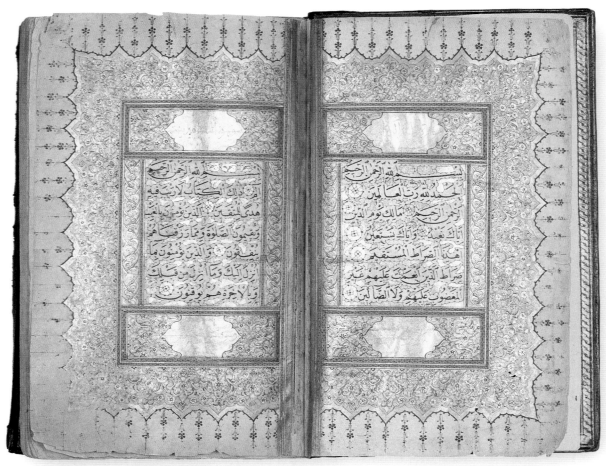

20 folios 1b–2a

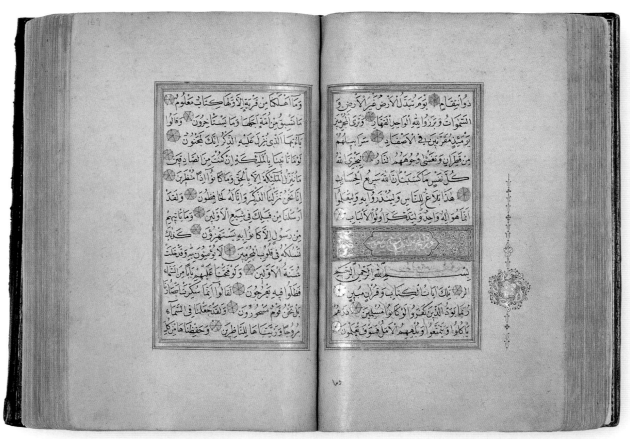

20 folios 168b–169a

21 folios 83b–84a

21 folios 312b–313a

22
Part 30 of the Qur'an

Probably Istanbul, AH 1099 (AD 1687–8)

28 folios, 24.1 × 16.4 cm, with 9 lines
to the page
Material A thick, buff-coloured laid
paper with fibrous inclusions; there
are approximately six lines to the
centimetre, and traces of chain lines
1 to 1.5 cm apart
Text area 14.5 × 8.2 cm
Script The main text in *naskh*,
in black ink
Scribe 'Uthman ibn 'Ali
Illumination A head-piece and other
decoration on folios 1b–2a; text
frames ruled in gold, black and red;
verses marked by gold rosettes,
with outlines in black and highlights
in red, enhanced with pricking;
leaf-based ornaments in the same
technique placed at the end of many
lines; surah headings; additional
decoration on the colophon page,
folio 27a
Documentation A colophon
Binding Contemporary
Accession no. QUR9
Published Christie's, London,
1 April 1982, lot no.161; Geneva
1995, no.26

1. Topkapı Palace Library, Istanbul,
MS.E.H.268; Karatay 1962, no.1485.
2. Geneva 1995, no.166; Safwat 1996,
no.74.
3. Geneva 1995, p.64.
4. MS.H.7; see Rado, no date, p.97.
5. Examples of the former are the
bindings of this manuscript and
cat.19–21 above. Examples of the
latter are Istanbul 1983, no.E.316;
Khalili, Robinson & Stanley 1996–7,
no.190.

The scribe of this Qur'an section was Hafız Osman, the pre-eminent Ottoman calligra-
pher of the 17th century, who was recognized by his successors as the greatest exponent of
the calligraphic tradition established by Şeyh Hamdullah. This manuscript is a witness to
Hafız Osman's emulation of the Şeyh, for the colophon on folio 27a is followed by the
statement, *nuqila 'an khaṭṭ Ḥamdallāh al-Shaykh raḥimahu Allāh*, that is, 'It was copied
after the hand of Şeyh Hamdullah – May God have mercy upon him!' The practice of *naql*
– that is, the reproduction by a calligrapher of a piece by a respected master – was a consis-
tent feature of the Ottoman calligraphic tradition, so that, for example, a copy of the same
Qur'an section made by İsmail Zühdi in AH 1218 (AD 1803–4), when he was already in his
sixties, was also based on an original by Şeyh Hamdullah,[1] while a *qiṭ'ah* in the Khalili
Collection was produced by Mahmud Celaleddin, who died in AH 1245 (AD 1829–30),
after an original by Hafız Osman, who was in turn copying Şeyh Hamdullah.[2]

The production of Qur'ans in 30 sections (*juz'*, plural *ajzā'*) was a longstanding tradi-
tion, and the final part, which contains surahs LXXVIII–CXIV, is commonly known in
Turkish as the *amme cüz'ü*, after the first word of surah LXXVIII ('*amma*, 'concerning
what?'). In this case, however, the final part may have been prepared as an independent
manuscript, for Hafız Osman's primary concern was probably to show his skill in repro-
ducing Hamdullah's hand rather than to create a complete copy of the Qur'anic text.

The script of cat.22 is notable for its regularity, its clarity and the beauty of its propor-
tions and shows Ottoman *naskh* at its best. In addition, the manuscript is written on paper
of excellent quality and is enclosed in a contemporary binding of brown morocco, with
centre- and corner-pieces pressure-moulded with floral scrolls and cloud bands; in their
present, restored condition the motifs are red and are set against a gold ground.

It has been suggested that the illumination is 19th-century work in a historicizing
style,[3] but, given the manuscript's status as an *hommage* to a great calligrapher of the past,
any historical references in the decoration would seem to fit the circumstances of its origi-
nal creation. In fact, though, the design used for the most substantial decorative element,
the head-piece on folio 1b, is typical of Ottoman work of the period, even in its inclusion
of cloud scrolls, for example. These appear in the surah headings of cat.17, for example, as
well as in the head-piece of a manuscript by Derviş Ali, one of Hafız Osman's teachers, in
the Topkapı Palace Library,[4] and on bindings from the 17th and 18th centuries, both those
with pressure-moulded and those with painted decoration.[5]

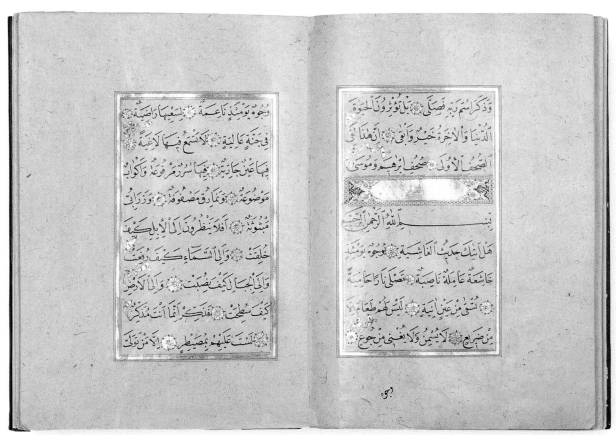

22 folios 13b–14a

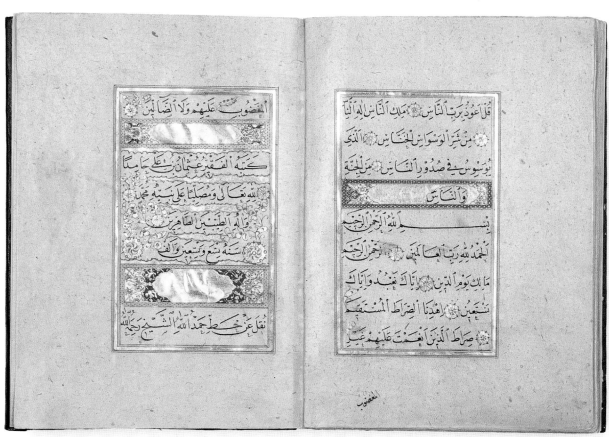

22 folios 26b–27a

23
Single-volume Qur'an

Istanbul or the provinces, AH 1094 (AD 1682–3)

466 folios, 24.8 × 15.5 cm, with
11 lines to the page
Material A thin, cream laid paper,
lightly burnished; there are approxi-
mately 12 laid lines to the centimetre,
and no apparent rib shadows or
chain lines. The paper is so thin that
individual folios are semi-transparent
Text area 16 × 8.9 cm
Script The main text in *naskh*, in
black, with reading marks in red;
surah headings in white (surahs I, II)
or gold *riqāʿ*; other incidentals in
white *riqāʿ*
Scribe Yusuf
Illumination Extensive decoration
on folios 1b–2a; text frames ruled in
gold, black and red; verses marked
by gold six-petal rosettes or gold
whorls, all set off with red, blue and
green dots; surah headings and
similar heading before the conclud-
ing prayer and colophon on folios
465b–466a; marginal ornaments
marking text divisions and *sajdah*s
Documentation A colophon
Binding Contemporary
Accession no. QUR13
Published Geneva 1995, no.29

The copyist of this Qur'an gave his name as 'Yusuf, one of the pupils of Osman, Hafiz
of the Mighty Qur'an', that is, of Hafiz Osman. He may be the same person as Yusuf
ibn Rasul, the scribe of cat.24, who also declared himself a pupil of Hafiz Osman.

The opening pages of illumination are of the standard type for the period, with a wide
border with a lobed edge. In this case, however, the vertical panels on either side of the text
have been replaced by heavy bands of gold strapwork of unequal width: in both cases the
inner band is narrower than the outer. The surah headings on these pages were written in
white *riqāʿ* on gold grounds, but in the rest of the manuscript they are in gold *riqāʿ*, set
in panels notable for the use of natural grounds for the central cartouches, for the fields
on either side filled with floral motifs, executed primarily in gold, and for some of the
framing bands. Other such bands are in tones of gold or black, and all are textured in
a contrasting colour with strapwork and other motifs. The rich and varied marginal
ornaments are in two tones of gold and colours and were inscribed in white *riqāʿ*.

Only the upper cover and flap of the binding survive. They are faced with brown
morocco and have pressure-moulded and gilt centre-and-corner elements set in a central
field, which measures 20 × 10 centimetres on the upper cover. This is surrounded by
a wide border now tooled with two bands of a cable motif in two tones of gold. The
doublures are of red morocco and are painted in gold with the outline of a centre-piece
and a border of rules.

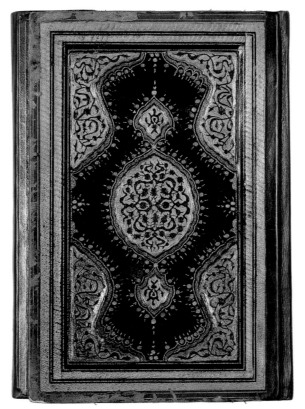

23 upper cover

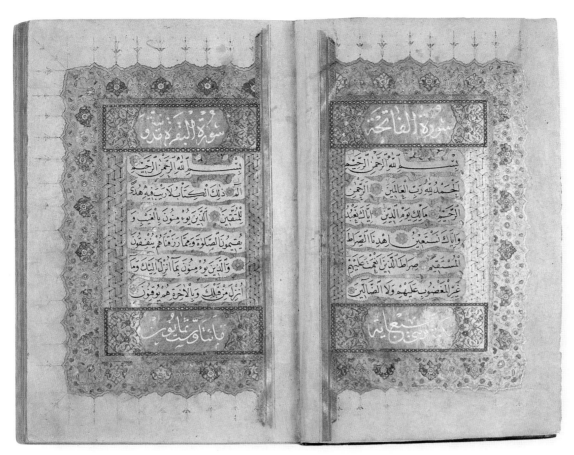

23 folios 1b–2a

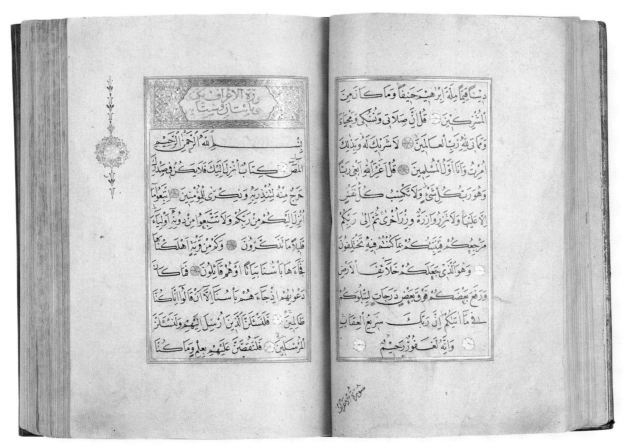

23 folios 107b–108a

24
Single-volume Qur'an
Istanbul or the provinces, *circa* 1700

374 folios, 17 × 11.3 cm, with 14 lines
to the page
Material A fine, very crisp, cream
European laid paper, highly
burnished; there are approximately
12 laid lines to the centimetre, and
chain lines are arranged at intervals
of 2.7 cm
Text area 11.9 × 6.3 cm
Script The main text in *naskh*, in
black, with reading marks in red;
surah headings and inscriptions in
marginal ornaments in white *riqā'*
Scribe Yusuf ibn Rasul
Illumination Extensive decoration
on folios 1b–2a; text frames ruled in
gold and black; verses marked by
gold six-petal rosettes set off with
red and blue dots; surah headings;
marginal ornaments marking text
divisions and *sajdah*s; gold band
separating the Qur'anic text from
the concluding prayer and colophon
on folio 374b
Documentation A colophon
Binding 18th century
Accession no. QUR102

This manuscript is undated, but the scribe described himself in the colophon as a pupil of
Hafiz Osman, who died in AH 1110 (AD 1698–9), and it can therefore be ascribed to the
last third of the 17th century or the first third of the 18th. Furthermore, cat. 23 may be by
the same scribe, and it is dated AH 1094 (AD 1682–3).

The illumination of the opening pages has the traditional blue and gold grounds, but, as
in cat. 23, the blue grounds are reduced to small areas in the borders: there are none in the
horizontal panels containing the surah headings, which are here filled with a combination
of palmette motifs and floral scrolls. The vertical bands either side of the text area are filled
with a row of cartouches containing reverse s-shaped floral scrolls.

Surah headings are in white *riqā'* within plain gold panels framed by coloured panel
bands textured with white or, in the case of white bands, black. Textual divisions are
marked by finely painted marginal ornaments of great variety. The blue finials with floral
motifs are painted with exceptional delicacy.

The binding is of a later date. It is of maroon morocco, and the covers have a central
panel filled with a diaper pattern in gold. The border is tooled in gold with a cable pattern.
The doublures are of paper.

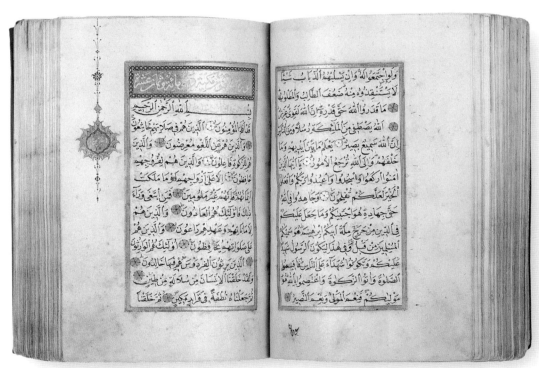

24 folios 202b–203a

25
Single-volume Qur'an

Istanbul or the provinces, Ramadan 1105 (April–May 1694)

360 folios, 43.6 × 28.5 cm, with
13 lines to the page
Material A thick, cream European
watermarked laid paper, lightly
burnished; there are ten laid lines
to the centimetre, and chain lines
arranged at intervals of 3.4 cm. The
watermark is three six-pointed stars
in a crowned shield, with the coun-
termark AG, except on folios 312–19,
where it is a crowned two-headed
eagle with the countermark FZ
Text area 26.5 × 15 cm
Script The main text in *naskh* in gold
outlined in black, with vowels
and other *shakl* signs in black and
reading marks in red; surah headings
in white *riqā'* on folios 1b–2a, else-
where in gold *riqā'* outlined in black
Scribe al-Mudhahhib Sayyid
'Abdallah
Illumination Extensive decoration
on folios 1b–2a; text frames ruled in
gold and red; verses marked by gold
discs set off with blue dots; surah
headings; marginal ornaments
marking *juz'*s and *sajdah*s
Documentation A colophon and
a *waqf* inscription
Binding Modern
Accession no. QUR703

1. Heawood 1950, p.24. The closest
parallel is Heawood 1950, fig.817,
with the countermark EP.
2. Heawood 1950, fig.2278, for
example, was used in London in
1699.
3. Müstakim-zade, ed. Mahmud
Kemal, p.253. *Cf.* Habib 1305, p.117;
Huart 1908, p.155; Rado, no date,
p.131.
4. MS.1565; Arberry 1967, no.209;
James 1980, no.76.
5. MS.1582; Arberry 1967, no.210.
6. MS.M.20; Karatay 1962, no.1279.

This book is extraordinary because of its size – it is roughly four times as large as the
standard Qur'an manuscript of the period – and because the script employed was a gold
naskh outlined in black, a most unusual choice in an Ottoman context. The effect, though,
is not entirely successful. The grandiose illumination of the opening pages, for example,
is merely an expanded version of a design worked out for smaller manuscripts – even the
miniaturized floral motifs have been blown up to many times their normal size. Such
defects presumably came about because the man responsible for copying the Qur'an,
who gives his name as Müzehhib Seyyid Abdullah, was by profession an illuminator
(*müzehhib*) and not a scribe; and because as an illuminator he was not used to working on
this scale. The rather disturbing impression the manuscript gives may also owe something
to the fact that it appears to have been left unfinished. This would explain, for example,
why the surah titles were omitted in instances where the last few words of the preceding
surah were placed in the panels intended for them.

This Qur'an can therefore be seen as a one-off production made under special circum-
stances. It may once have been possible to understand the nature of these circumstances
from an inscription on folio 1a, but this has been obliterated. It may have been a *waqfiyyah*,
since the word *waqf* has been inscribed at the top of every page of the manuscript that
coincides with the beginning of a *juz'*.

Other possible evidence for the history of the manuscript has also proved enigmatic.
The use of European paper for Ottoman Qur'ans seems to have increased from the turn
of the 18th century, and this manuscript offers a particularly clear and consistent example
from the period when this process began, since the watermarked European paper employed
was almost all from a single batch, with each sheet forming a bifolium, due to the size of
the manuscript. The paper cannot be dated with any certainty, however, as the watermarks
and countermarks found here do not occur together in any other published example. All
that we can say is that the watermark found on all but eight sheets – three six-pointed stars
in a crowned shield – shows that the paper is probably from Venetian terra firma,[1] while
the countermark AG is found on papers with other marks used in the 17th century.[2]

Müzehhib Seyyid Abdullah may be another name of Abdullah Efendi of Baruthane,
who was recorded by Müstakim-zade as the illuminator of most of the 100 Qur'ans
copied by Çinici-zade Abdurrahman Efendi, who died in AH 1137 (AD 1724–5).[3] This
Abdullah Efendi was a member of a line of illuminators that flourished from the later 16th
century until the early 18th: he was the son and pupil of Mustafa Beyazi, who was the
pupil of Mustafa Surahi. As we have seen (cat.18), Mustafa Surahi was in turn taught his
art by another Abdullah, who was the freedman and pupil of Kara Mahmud of Yenibahçe.
A Qur'an by Çinici-zade that may well have been illuminated by Abdullah Efendi of
Baruthane is in the Chester Beatty Library, Dublin,[4] and this illuminator is almost
certainly to be identified with the 'Abdallah ibn Mustafa who decorated another Qur'an
in the Chester Beatty Library, which was copied by the celebrated Seyyid Abdullah of
Yedikule (see above, p.69) in AH 1121 (AD 1709–10),[5] and one in the Topkapı Palace
Library copied by Muhammad ibn Abi Bakr in AH 1123 (AD 1711–12).[6]

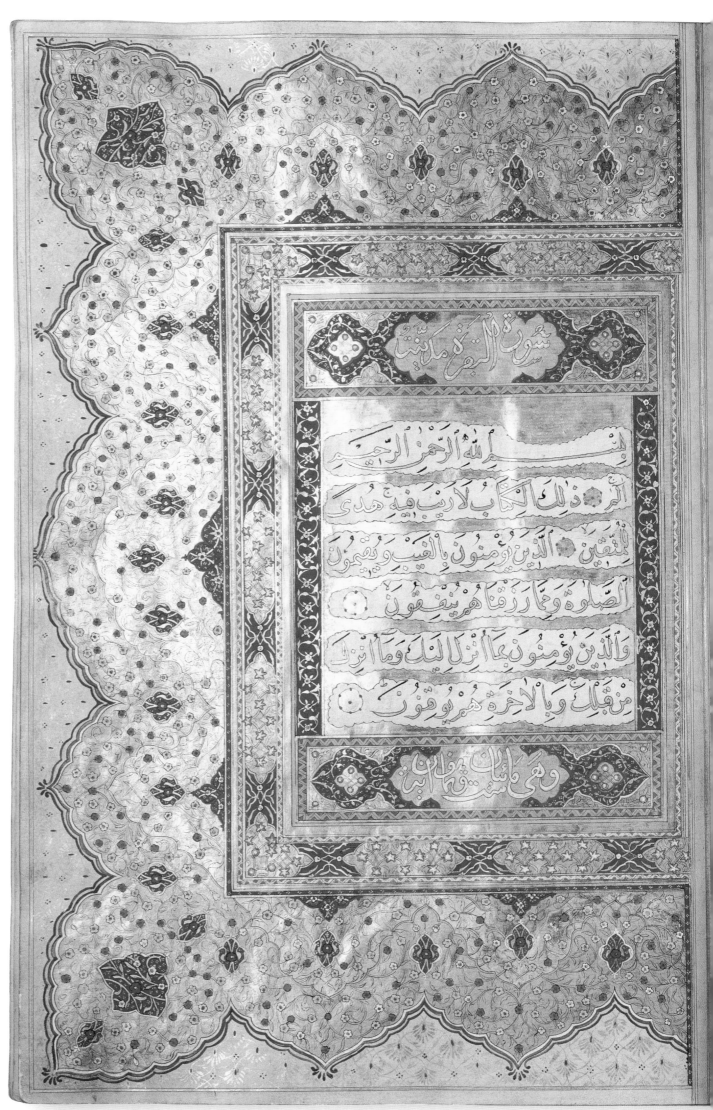

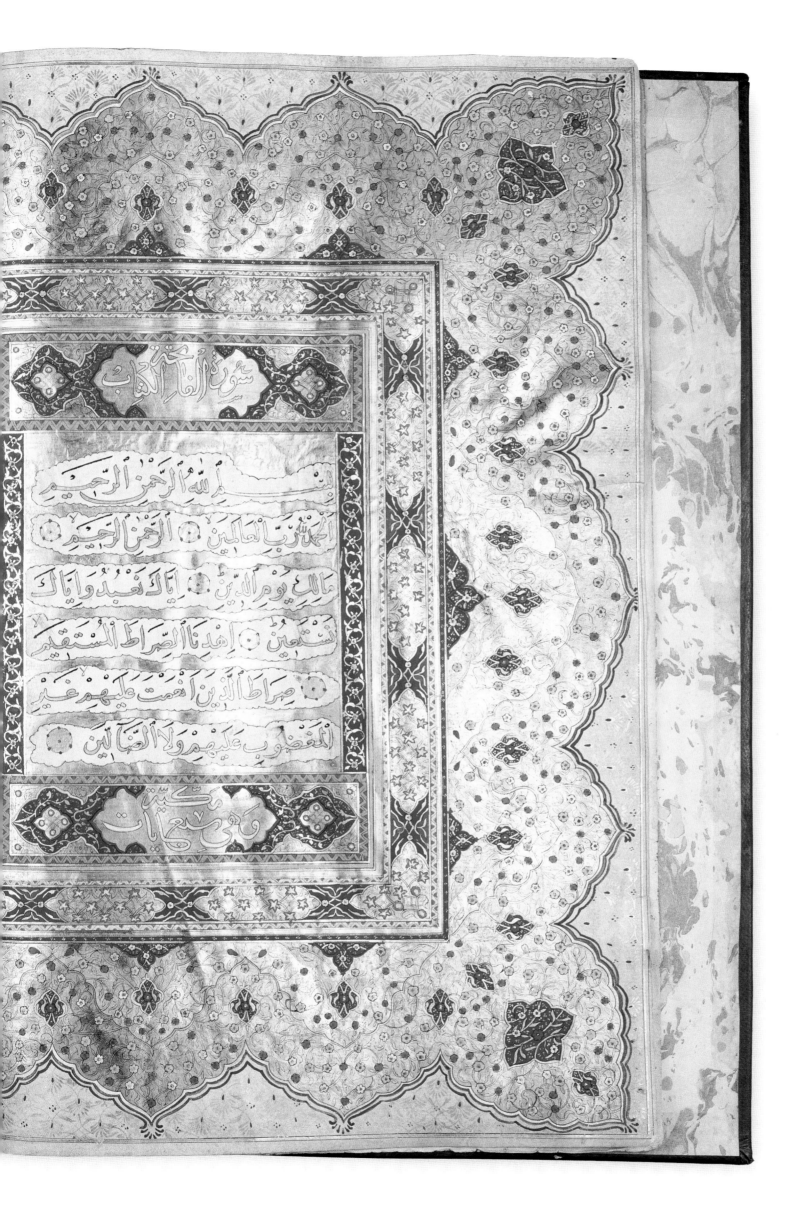

سورة الفاتحة الكتاب

بسم الله الرحمن الرحيم
الحمد لله رب العالمين ٭ الرحمن الرحيم
مالك يوم الدين ٭ اياك نعبد واياك
نستعين ٭ اهدنا الصراط المستقيم
٭ صراط الذين انعمت عليهم غير
المغضوب عليهم ولا الضالين

مكية وهي سبع ايات

26
Single-volume Qur'an

Istanbul or the provinces, AH 1115 (AD 1703–4)

423 folios, 17.8 × 11.2 cm, with 13 lines to the page
Material A thin, cream laid paper, lightly burnished; there are approximately nine laid lines to the centimetre, and no apparent rib shadows or chain lines. The paper is so thin that individual folios are semi-transparent
Text area 11 × 6 cm
Script The main text in *naskh* in black, with reading marks in red; surah headings and inscriptions in marginal ornaments in white *riqā'*; other marginalia in gold *riqā'*
Scribe al-Sayyid Mustafa ibn 'Abd al-Jalil
Illumination Extensive decoration on folios 1b–2a; text frames ruled in gold, black and red; verses marked by gold six-petal rosettes or whorls, all set off with white, red and blue dots; surah headings; marginal ornaments marking textual divisions and *sajdah*s; decoration in gold only below the end of the text on folios 420b, 423a, and below the colophon, also on folio 423a
Documentation A colophon
Binding Contemporary
Accession no. QUR74

1. Müstakim-zade, ed. Mahmud Kemal, p.538. See also Suyolcu-zade, ed. Rifat, pp.83–4; and *cf.* Habib 1305, p.156; Huart 1908, p.139; Rado, no date, p.103.

The scribe responsible for this Qur'an, al-Sayyid Mustafa ibn 'Abd al-Jalil, described himself in the colophon as a pupil of Anber Mustafa Ağa, who is known from other sources to have been a calligrapher and musician employed in the imperial palace in Istanbul.[1] Anber Ağa was himself instructed in calligraphy by Mehmed Belgradi, who was a pupil of İmam Mehmed Efendi, the scribe of cat.17 above. As we can see by comparing the first lines of the surah *al-Shūrā* (XLII), the hand of cat.26 is indeed very close to that of cat.17, although it lacks some of the steady regularity and accomplishment of İmam Mehmed's rendition.

This manuscript was decorated very much in the manner that became standard in the 17th century, although minor variations can be observed. One, also seen in cat.25, occurs on the illuminated opening pages and involves the vertical panels on either side of the reduced text area. In the traditional layout these panels were part of a set of five that formed the core of the composition. In this new version they appear as bands of illumination that increase the width of the text area to match that of the panels above and below; these last should contain the surah headings, although here they are blank. On these pages surah 1 and the beginning of surah 11 were written in 'clouds' reserved in a gold ground, and they are punctuated by verse markers in the form of relatively large polychrome blossoms.

The surah headings, in white *riqā'*, are set within illuminated panels, most of which are framed by a blue, green, magenta, black or orange band textured in white. The heading itself is inscribed in a plain gold cartouche, and the gold ground on either side has floral scrolls in yellow gold with touches of red. Two tones of gold were also used for the marginal ornaments, which are in the form of one of two types of composite blossom.

The contemporary covers, of brown morocco, are decorated with a centre-and-corner composition. The elements were pressure-moulded with a design of cloud bands set over floral scrolls. The ground was gilded, and the scrolls were left in reserve, while the cloud bands also show traces of gilding, perhaps in a tone that contrasted with that of the ground. The doublures, which were probably added when the binding was remade, are of marbled paper.

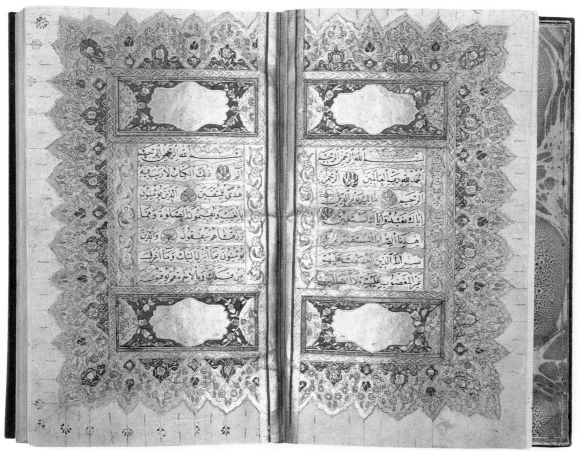

26 folios 1b–2a

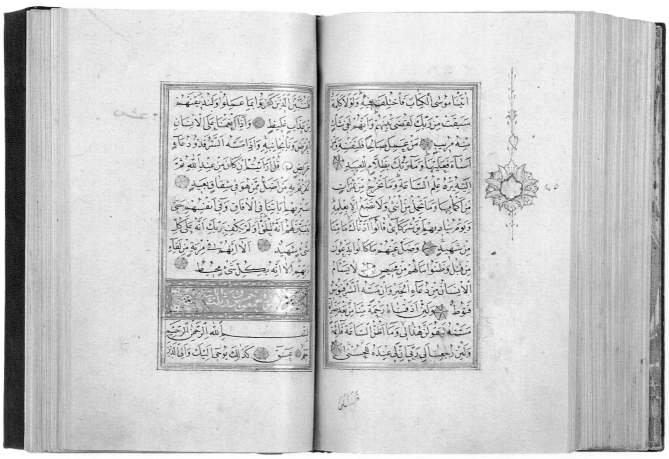

26 folios 328b–329a

27
Single-volume Qur'an
Istanbul or the provinces, AH 1124 (AD 1712–13)

307 folios, 16.7 × 11.2 cm, with
15 lines to the page
Material A smooth, cream European
laid paper, burnished; there are
approximately 16 laid lines to the
centimetre, and chain lines arranged
at intervals of 2.5 cm
Text area 10.6 × 5.8 cm
Script The main text in *naskh* in
black, with reading marks in red;
surah headings, inscriptions in
marginal ornaments, and colophon
in white *riqāʿ*
Scribe Ahmad ibn Mahmud
Illumination Extensive decoration
on folios 1b–2a; text areas framed
by gold, black and red rules; verses
marked by gold six-petal rosettes or
gold whorls, all set off with white,
red and blue dots; surah headings;
marginal ornaments marking text
divisions and *sajdah*s; ornamental
panel on folio 307a containing the
colophon
Documentation A colophon
Binding Contemporary
Accession no. QUR10

1. Müstakim-zade, ed. Mahmud
Kemal, p.89. *Cf.* Rado, no date,
p.106. This information is also given
in a note in a calligraphic hand in
the left-hand margin of folio 307a:
*merhum Eyyûbî Mustafa Efendi
şagirdlerindendir – Tezkiretü'l-
hattâtîn*, 'He was a pupil of the late
Mustafa Efendi of Eyüp [according
to the] *Tadhkirat al-khaṭṭāṭīn*'.
2. Rado, no date, p.107.

This manuscript is one of the earliest Ottoman Qur'ans in which each page ends with a
complete verse. It also has a 15-line format, which became the standard format for
Ottoman Qur'ans in the 19th century. The scribe responsible for it, Ahmad ibn Mahmud,
was a pupil of Suyolcu-zade Mustafa of Eyüp according to Müstakim-zade, who had seen
a Qur'an written by him in AH 1099 (AD 1687–8) and concluded that, 'he was in truth a fine
calligrapher'.[1] Şevket Rado illustrated the last page of a Qur'an by Ahmad and suggested
that it was the one seen by Müstakim-zade, but the colophon is clearly dated AH 1115
(AD 1703–4).[2] The page shown by Rado is, though, very similar to folio 307a of cat.27: in
both cases the colophon, which is preceded by the same short prayer, is written in white
riqāʿ on an illuminated panel with a gold field. In cat.27 the concluding prayer occupies
folios 304b–307a and is separated from the end of the Qur'anic text on folio 303a by two
blank pages (folios 303b and 304a).

The illumination is very similar to that in cat.26, although on the opening pages the
arrangement and type of framing bands is different, and the border has fewer lobes. The
surah headings, in white *riqāʿ*, are contained within narrow gold panels with fragments of
gold foliage at either end and coloured framing bands. The marginal ornaments marking
divisions in the text and *sajdah*s are in six different forms, three of which also occur in
cat.26. They all consist of a small gold cartouche bearing an inscription and surrounded
or surmounted by a combination of leaves, petals, stems and tiny rosettes.

The brown morocco covers have a recessed centre-and-corner composition within
a broad frame, all pressure-moulded with floral scrolls and gilded. The raised bands of
leather on either side of the frame are tooled in gold with a cable motif, and the raised
circular areas between the sections into which the frame is divided are tooled in gold with
rosettes. The doublures are of mid-brown leather with a central rosette and ruled borders
painted in gold. The flap is a modern replacement.

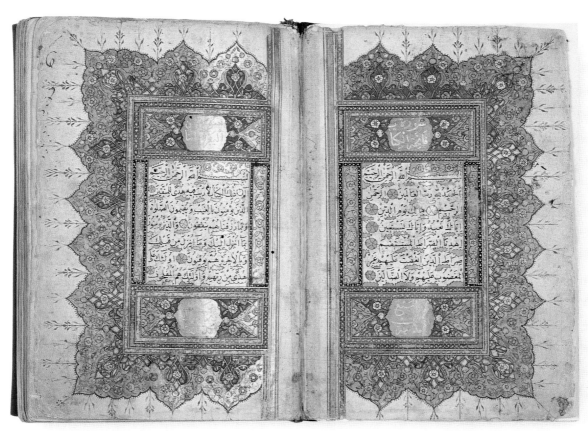

27 folios 1b–2a

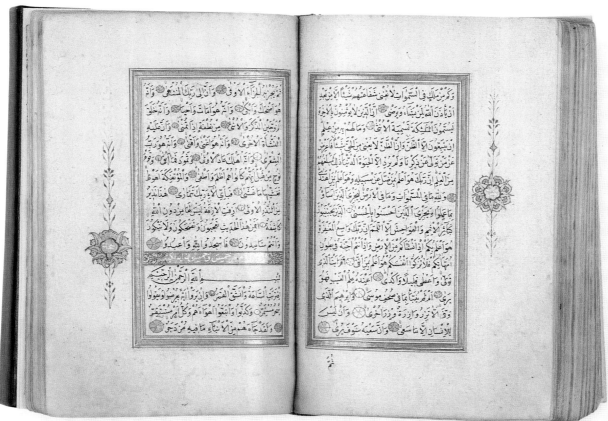

27 folios 264b–265a

28

Single-volume Qur'an

Istanbul or the provinces, AH 1130 (AD 1717–18)

261 folios, 18 × 11.5 cm, with 17 lines to the page
Material A thin, cream laid paper, lightly burnished; there are approximately 11 laid lines to the centimetre, and no apparent rib shadows or chain lines. Identification of mould markings is difficult because of the highly fibrous nature of the pulp
Text area 12.2 × 6.5 cm
Script The main text in *naskh*, in black, with reading marks in red; surah headings and inscriptions in marginal ornaments in white *riqā'*
Scribe Muhammad ibn Mustafa al-Kafawi
Illumination Extensive decoration on folios 1b–2a; text areas framed by gold and black rules; verses marked by gold rosettes or gold whorls, all set off with red and blue dots; surah headings; marginal ornaments marking text divisions and *sajdah*s; areas of decoration in gold only after the end of the Qur'anic text (folio 261a) and the colophon (folio 261b)
Documentation A colophon
Binding Contemporary
Accession no. QUR31

1. Müstakim-zade, ed. Mahmud Kemal, pp.157–8; *cf.* Rado, no date, p.173.

The surname al-Kafawi borne by the scribe of this Qur'an, Muhammad ibn Mustafa, indicates that he was a native of Caffa in the Crimea, which has been known by its Classical name, Theodosia (Feodosiya), since its incorporation into the Russian empire in 1783. In the colophon he also declared himself a pupil of İsmail Efendi, presumably Ağakapılı İsmail Efendi, who died in 1706 or 1707. Müstakim-zade recorded a calligrapher called Muhammad ibn Mustafa al-Kafawi, but he was trained by Mehmed Rasim Efendi and died about AH 1190 (AD 1776–7),[1] and it is therefore difficult to match the two.

The illumination in this manuscript is of the standard type seen also in cat.26 and 27 but is remarkable for the variety and lurid quality of the colours used. On the opening pages the brightness is counteracted by the use of dark-blue grounds in place of the ultramarine pigment seen in the earlier examples. The brown morocco covers have recessed centre-and-corner elements which have been pressure-moulded with floral scrolls and gilded. The doublures are of mid-brown morocco and are painted in gold with the outline of a centre-and-corner composition.

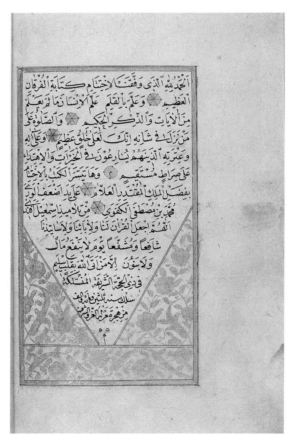

28 folio 261b

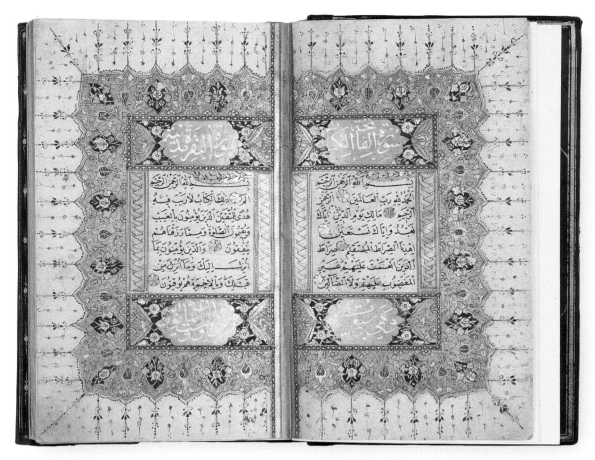

28 folios 1b–2a

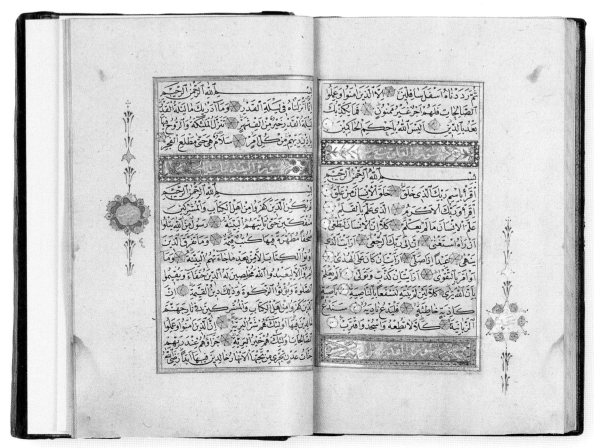

28 folios 258b–259a

29
Single-volume Qur'an
Probably Istanbul, before 1723

427 folios, 14.9 × 9.8 cm, with
13 lines to the page
Material A fine, crisp, light-brown
European laid paper; there are
approximately 16 laid lines to the
centimetre, and chain lines arranged
at intervals of 2 cm. The counter-
mark GA can be seen on folio 203a
Text area 9.9 × 5.3 cm
Script The main text in *naskh*, in
black, with reading marks in red;
surah headings, inscriptions in
marginal ornaments and colophon
in white *riqā'*; other marginalia in
gold and red *riqā'*
Scribe Ahmad Muharram
Illumination Extensive decoration
on folios 1b–2a; text areas framed by
gold and black rules; verses marked
by gold six-petal rosettes set off with
red and blue dots; surah headings;
marginal ornaments marking text
divisions and *sajdah*s; gold band
after the Qur'anic text and ornamental
panel for the colophon, both on folio
427b
Documentation A colophon
Binding Contemporary
Accession no. QUR16

1. Rado, no date, p.131.
2. Müstakim-zade, ed. Mahmud
Kemal, p.100. *Cf.* Habib 1305,
pp.98–9; Huart 1908, pp.153–4;
Rado, no date, p.131. Rado added
that his father was called Daya-zade
Hüseyin.
3. Müstakim-zade, ed. Mahmud
Kemal, p.263.

The scribe responsible for this manuscript was a celebrated *naskh* calligrapher of the late 17th and the early 18th century. Born in Istanbul, he began life with the name Muharrem and was trained as a calligrapher by Hafız Halil Efendi, whose *silsilah* went back through two generations to İmam Mehmed Efendi, who copied cat.17 above. Having established himself professionally as a Qur'an scribe, and now known as Muharrem Hattat, he earned the status of *ḥāfiẓ* by learning the Qur'an by heart. According to Müstakim-zade he changed his name to Hafız Ahmed at this point, although cat.29 and other works by him show that he continued to use the name Muharrem: in the colophon of a Qur'an dated AH 1111 (AD 1699–1700), for example, he placed it before Ahmed,[1] while in the colophon of cat.29 he placed it after. Ahmed Muharrem resided in the Kasımpaşa district of Istanbul, near the *tekke* of Seyyid Osman Efendi, and was buried opposite the *tekke* when he died in Dhu'l-Hijjah 1135 (September–October 1723).[2] His work was continued by his son Abdülkerim Efendi.[3]

The illumination of the opening pages is of the type in which the border is interrupted by large 'hasp' shapes. A fringe of motifs in blue and red runs along the edges of the border, but the main body of the design was executed in tones of gold, with black outlines and the modest use of red, green and orange for emphasis. The vertical panels either side of the reduced text area are filled with bands of gold strapwork, and the texturing of the framing bands includes cable and strapwork motifs. The border elements contain formal arrangements of half-palmettes around a central lotus blossom, from which spring scrolls set with rosettes. Some differentiation between the border proper and the 'hasps' was attempted by the use of colour: in the former touches of red and orange were applied to the filler motifs, and the edging band includes a green line; in the latter the filler motifs have touches of red and green, and the edging band includes an orange line.

The brown morocco covers have recessed centre-and-corner elements pressure-moulded with scrolls set with tiny but varied blossoms and *saz* leaves and gilded. The modern doublures and flyleaves are of glossy paper that is pink in colour.

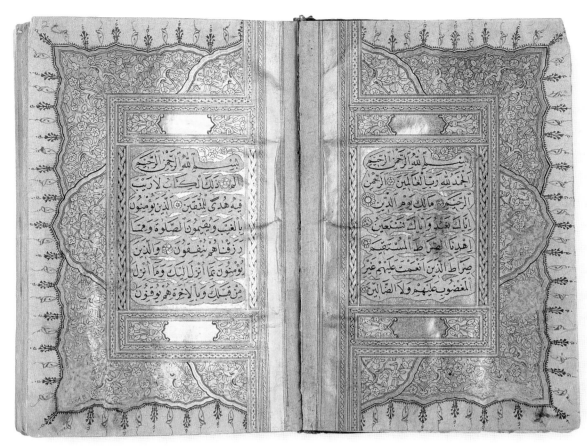

29 folios 1b–2a

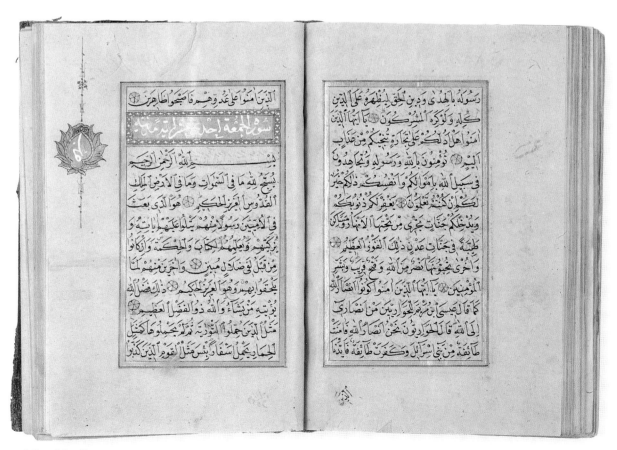

29 folios 387b–388a

30
Single-volume Qur'an
Istanbul or the provinces, mid-18th century

431 folios, 16.9 × 10.9 cm, with
13 lines to the page
Material A crisp, dark-cream laid
paper, highly burnished; there are
approximately ten laid lines to the
centimetre, and no apparent chain
lines or rib shadows. Due to the
thinness of the paper and the high
degree of burnishing, individual
folios are semi-transparent
Text area 10.5 × 5.8 cm
Script The main text in *naskh*, in
black, with reading marks in red;
surah headings and inscriptions in
marginal ornaments in white *riqāʿ*;
other marginalia in gold *riqāʿ*
Scribe Muhammad al-Sharif
Illumination Extensive decoration
on folios 1b–2a; text areas framed
by gold, black and red rules; verses
marked by gold six-petal rosettes or
gold whorls, all set off with red, blue
and pale-blue dots; surah headings
and a similar heading between the
end of the Qur'anic text and the
colophon on folio 430a; marginal
ornaments marking each *juz'* and
sajdah
Documentation A colophon
Binding Modern, but incorporating
original material
Accession no. QUR38

1. Suyolcu-zade, ed. Rifat, p.68;
Müstakim-zade, ed. Mahmud
Kemal, p.419–20. *Cf.* Habib 1306,
p.139; Huart 1908, p.173; Rado,
no date, pp.151–2.

The colophon of this manuscript, on folio 430b, tells us that the scribe was 'Muhammad al-Sharif, a pupil of our master, [known] as Şeker-zade'. He can therefore be identified as Mehmed Şerif, a pupil of the eminent calligrapher Şeker-zade Seyyid Mehmed Efendi (see cat.16). Seyyid Mehmed, who died in 1753, held the position of tutor to the pages of the *bostancı* corps, whose duties included the guarding and tending of the gardens of the Topkapı Palace and other imperial residences along the Bosphorus.[1] It is therefore very likely that Mehmed Şerif was a member of that corps, which would explain the description of Seyyid Mehmed as 'our master'. Mehmed Şerif's hand is of reasonable quality, but he was not able to achieve the impressive regularity and purity of style attained by his master. The illumination, however, is of excellent quality.

The opening pages show a variation of the traditional layout in which the vertical sections of the border are interrupted by large hasp-shaped motifs (compare cat.29). A novelty is the band of strapwork that surrounds the pair of panels above the text but not those below the text. The ground colours are the customary gold and blue, while the tiny blossoms and *saz* leaves and other details were executed in a striking range of colours that includes pink, mauve, orange and a very pale blue.

The surah headings, inscribed in white *riqāʿ* on a gold cartouche, are all set in narrow rectangular panels with floral and arabesque elements disposed on gold or parti-coloured grounds, all surrounded by an inner gold frame and an outer coloured frame textured in a contrasting colour. In most comparable work the parti-coloured grounds are restricted to combinations of blue and gold or of different tones of gold, and a wider range of colours were used for the framing bands only. Here, however, carmine-red and green as well as blue were used for some grounds. The marginal devices mark only the *juz'* divisions and the *sajdah*s – the *ḥizb* divisions are marked by marginal inscriptions in gold *riqāʿ*. The *sajdah* devices are all of the same type, although the colours used do vary, whereas the *juz'* devices are in a multitude of forms none of which occurs more than three times.

One of the original boards has been incorporated in the modern binding as the upper cover. Faced with brown morocco, it has centre-and-corner elements pressure-moulded with floral scrolls that are reserved in a gilded ground. The doublure is of red morocco, decorated with the outline of the centre-piece on the exterior and a ruled border, all in gold.

The text ends on folio 430b, and folio 431a is blank except for a frame of rules. On folio 431b, however, there are notes recording the birth of five children. These do not often survive on Ottoman Qur'ans. The three earlier notes, anonymous but all in the same hand, record the births of İsmail Zühdi on 21 Dhu'l-Hijjah 1259 (12 January 1844), of Ayşe Kerime on 23 Ramadan 1261 (25 September 1845), and of Mehmed Reşid on 4 Rabiʿ al-Akhir 1265 (27 February 1849). The remaining two are signed by Ahmed Refik and record the births of his sons Mehmed Azim, on 16 Ramadan 1285 (31 December 1868), and Mahmud Refik, on 20 Rabiʿ al-Akhir 1288 (9 July 1871). For the last date Ahmed Refik also gave the *malî* equivalent, which was calculated according to the Julian calendar, giving 27 June 1287.

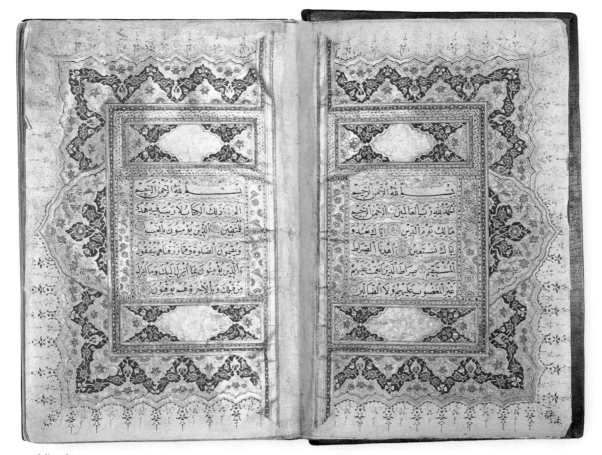

30 folios 1b–2a

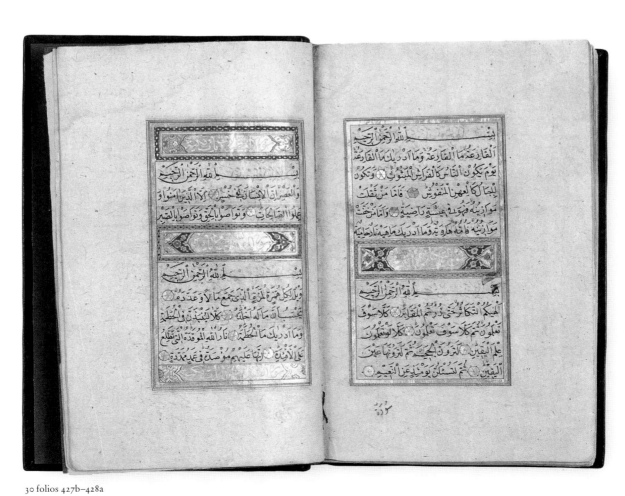

30 folios 427b–428a

31
Single-volume Qur'an
Istanbul or the provinces, AH 1158 (AD 1745–6)

305 folios, 19 × 11.8 cm, with 15 lines to the page
Material A thin, very crisp, cream laid paper, burnished to a gloss; there are approximately 12 laid lines to the centimetre, and no apparent rib shadows or chain lines. Due to the thinness of paper and the high degree of burnishing, individual folios are semi-transparent
Text area 11.7 × 6.3 cm
Script The main text in *naskh*, in black, with reading marks in red; surah headings and inscriptions in marginal ornaments in white *riqā'*; other marginalia in red *riqā'*
Scribe Darwish Muhammad Hindi
Illumination Extensive decoration on folios 1b–2a; text areas framed by gold and black rules; verses marked by gold six-petal rosettes or gold whorls, all set off with white, red and blue dots; surah headings and a similar heading for the concluding prayer on folio 304a; marginal ornaments marking text divisions and *sajdahs*; decoration in gold after the colophon on folio 305a
Documentation A colophon
Binding Contemporary or 19th century
Accession no. QUR168

1. Uzunçarşılı 1948, pp.346–7; see also Findley 1989, pp.63–70, and the sources quoted there.
2. Müstakim-zade, ed. Mahmud Kemal, p.587.
3. Zarcone 1991, pp.172–81.
4. Zarcone 1991, pp.170–72.
5. Müstakim-zade, ed. Mahmud Kemal, p.390.
6. Müstakim-zade (ed. Mahmud Kemal, p.461) also mentioned a Hindi-zade Mehmed Efendi, but he was newly qualified at the time of writing, and it is therefore not possible that he copied a Qur'an as early as 1745–6. Hindi-zade's grandfather, Hindi Mehmed Efendi, can probably be identified with the Hindi Mehmed Efendi who migrated to Istanbul from Herat, became a scribe to the Imperial Council under Sultan Ahmed III and died in AH 1146 (AD 1733–4); see Mehmed Süreyya 1308 – no date, IV, p.228.

According to the long colophon, on folios 304b–305a, this manuscript was written by a copyist called Derviş Mehmed Hindi for an Ottoman bureaucrat. This was Mehmed Efendi, a clerk in the *Başmuhasebe*, or chief accountant's office, which was the largest department of the Ottoman treasury according to sources from the mid-18th century.[1] There can be no doubt that, despite his *nisbah* Hindi ('the Indian'), the scribe Derviş Mehmed learned to write *naskh* in Turkey, since his excellent hand is unequivocally Ottoman. He may have been of Indian descent, or he may have been called Hindi because of some other association, even one so slight as a dark complexion, as in the case of the calligrapher called Ya'kub Hindi.[2] The prefix Derviş suggests that he was an active member of a Sufi brotherhood, and it is possible that his ancestor came to Turkey from India (or Central Asia) because of a connection with one of the major international fraternities such as the Qadiriyyah or the Naqshbandiyyah. There were two 'Indian' Qadiri establishments in Istanbul by the mid-18th century. The older of the two, the Horhor Tekkesi, was founded by Sultan Mehmed II for a dervish called Ishaq of Bukhara and became attached to the Qadiris in the mid-17th century.[3] The second, the Hindiler Tekkesi, or 'Lodge of the Indians', was founded in Üsküdar in 1737 by the Qadiri *shaykh* Feyzullah Hindi (d.1748).[4]

There was also a Hindiler Tekkesi in Edirne, where al-Hajj Tayyib al-Lahawri was *shaykh* until his death in AH 1111 (AD 1699–1700). Tayyib had a son called Ahmed, who moved to Istanbul and then to Mecca, where he performed the duties of a sweeper in the Masjid al-Haram as a proxy for Müstakim-zade and other Sufis in Istanbul. Ahmed's son Mehmed remained in Istanbul, where he became a herbalist with a shop near the Hippodrome, next to the mosque of Firuz Ağa. Mehmed later studied *thulth* and *naskh* calligraphy with Yusuf Efendi of the Ayasofya Medrese nearby and became a copyist. He died in AH 1183 (AD 1769–70).[5] This man, whom Müstakim-zade calls Muhammad Tayyib ibn Ahmad Tayyib, may well have been the scribe responsible for cat.31.[6]

The opening pages of illumination have the standard type of layout, but there are notable variations in the details. The border, for example, has the usual blue and gold grounds – here dark-blue and a very pale tone of gold stippled with groups of three dots. But the blue areas were reduced, and the gold areas increased, to accommodate a row of large cloud band motifs in a vivid mauve, which enclose areas painted an equally vivid green, or black. The surah headings, written in white *riqā'* script, were set in gold cartouches within narrow illuminated bands, the fields of which are filled with fragments of floral scrolls on a pale-gold ground; the blossoms were painted in the range of bright colours seen on folios 1b–2a. These colours also appear in the very varied marginal devices.

The covers, of brown morocco, have recessed centre-and-corner elements pressure-moulded with a design of cloud bands over floral scrolls. This composition is surrounded by a broad frame that appears to be 19th-century work. It is defined by two bands of tooling and filled with a lightly tooled and gilded design of arabesque scrolls and rosettes. The doublures are of red morocco, with designs drawn in gold.

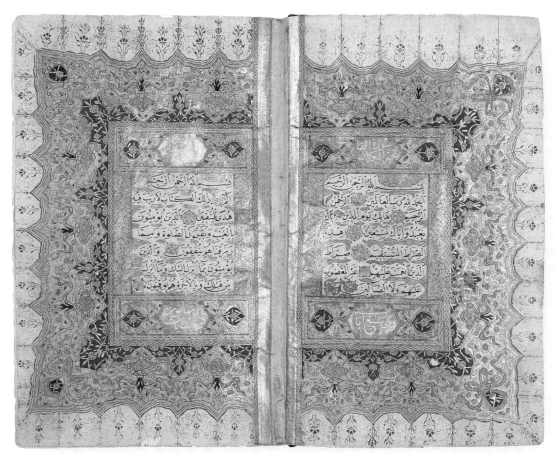

31 folios 1b–2a

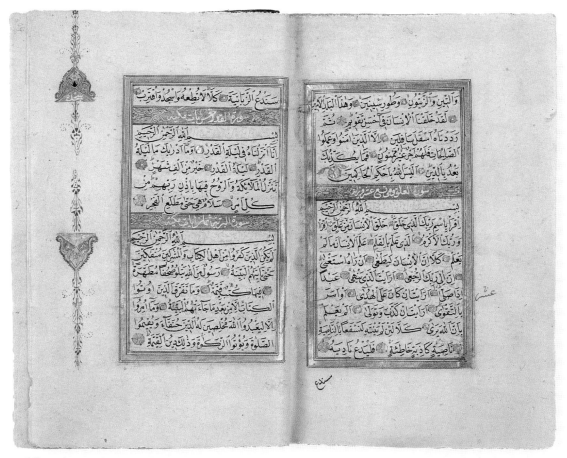

31 folios 300b–301a

32
Qur'an in 30 volumes
Cairo, AH 1165–6 (AD 1751–2)

Each part contains between 20 and 32 folios, 30 × 18.4 cm, with 9 lines to the page
Material A number of watermarked European laid papers, dyed cream and burnished until very smooth and glossy
Text area 15.3 × 8.2 cm
Script The main text in *naskh*, in black, with reading marks in red; surah headings and marginalia in white *riqā'*, now tarnished
Scribe Isma'il Wahbi (al-Misri)
Illumination Extensive decoration on folios 1b–2a of part I; a head-piece and other ornament on folios 1b–2a of parts II–XXX; text areas framed by rules in gold, black, yellow and red (parts I, III, V–VII) or in gold, black, blue and red; there is a simple outer frame of gold and black rules; verses marked by gold six-petal rosettes or less frequently by gold whorls, all set off with stippling and white, red and blue dots, some also with superimposed designs, such as a six-pointed star, in white, blue, red or black; surah headings; marginal ornaments marking *ḥizb*s; the colophons undecorated (II, XII, XIV, XV) or set within a gold roundel (X, XI, XX, XXX) or a gold crescent moon
Documentation A colophon at the end of each section
Bindings Contemporary
Accession no. QUR446

1. Al-Jabarti, p.388.
2. Müstakim-zade, ed. Mahmud Kemal, pp.130–31.
3. A short notice on Isma'il Wahbi also appears in the *Ḥikmat al-ishrāq ilā kuttāb al-āfāq* of his contemporary, Muhammad al-Murtada al-Zabidi (d.1791), who was al-Jabarti's teacher. See al-Zabidi, pp.95–6.

All the sections of this 30-part Qur'an have colophons, but the form varies. In them the scribe referred to himself as 'Isma'il, known as Wahbi', as 'Isma'il, known as Wahbi al-Misri' (in parts V, XXVII), as 'Isma'il Wahbi' (in parts XXIV, XXIX), or as 'Wahbi, called by the name of Isma'il' (in parts IV, VI, XIX). In three instances Isma'il gave the name of his master; he appears as 'the late Sayyid Muhammad al-Nuri' in part XXV, and simply as 'al-Nuri' in parts VII and XII. In two colophons, those of parts I and II, he gave his place of residence as Cairo (*Miṣr al-Qāhirah*), and in all but two (parts XIV and XXIX) he gave the date. In most cases the date is restricted to the year, AH 1165 (AD 1751–2), but in another five the month or the day and month were specified. From this it appears that Isma'il Wahbi began his task in late 1751 and completed the parts in numerical order, for he finished part V on 28 Rabi' al-Akhir 1165 (14 February 1752), part XVII on 23 Sha'ban 1165 (6 July 1752), part XIX in Ramadan 1165 (July–August 1752), parts XXIII and XXIV on 8 and 13 Shawwal 1165 (19 and 24 August 1752), and part XXX 'on Friday night and the night of 'Ashura' in the year 1166'), that is, on the night preceding 10 Muharram 1166 (Friday, 17 November 1752).

Isma'il Wahbi was one of the most eminent scribes of his day and was mentioned by a number of contemporary historians. The longest account we have of him is by 'Abd al-Rahman ibn Hasan al-Jabarti (d.1825 or 1826), who gave the calligrapher's name as Isma'il ibn 'Abd al-Rahman al-Rumi al-Misri.[1] The surnames indicate that Isma'il was a resident of Egypt of Anatolian (Rumi) origin; according to Müstakim-zade, however, he was of Georgian origin.[2] Al-Jabarti wrote, 'He was called Wahbi and was the leading scribe of Cairo. He was a cheerful man, loved by all; a fine, upstanding character who concerned himself with religious knowledge somewhat and studied under the master of his time, Sayyid Muhammad al-Nuri, until he surpassed all his peers. Most scribes of Cairo were his pupils, and he issued *ijāzah*s to many of them. Certain amirs of Cairo asked him to copy out a number of large inscriptions (*alwāḥ*) to be taken to Madinah and hung in the Prophet's Mosque. He did so and was greatly esteemed. He died in AH 1182 (AD 1773–4) in Cairo and was buried with Ibn Abi Jamrah near al-'Iyyashi, in a grave which he had previously prepared for himself.'[3]

The Qur'an is well-written in an Ottoman *naskh* hand. The illumination is provincial, though bright and boldly executed. Each volume opens with an illuminated head-piece, and the spaces between lines of text on the opening folios are filled with work in gold. The opening folios of the first volume also have an elaborate border. The 30 parts are well-bound. The covers are of brown morocco, with recessed centre- and corner-pieces with a gilt ground. The doublures are of red morocco and are undecorated. All these features emphasize the imposition of the Ottoman style of Qur'an production on Cairo, one of the most important provincial centres in the empire. Indeed, cat.32 represents the culmination of a process of acculturation already noted in the context of cat.13 and cat.21 above.

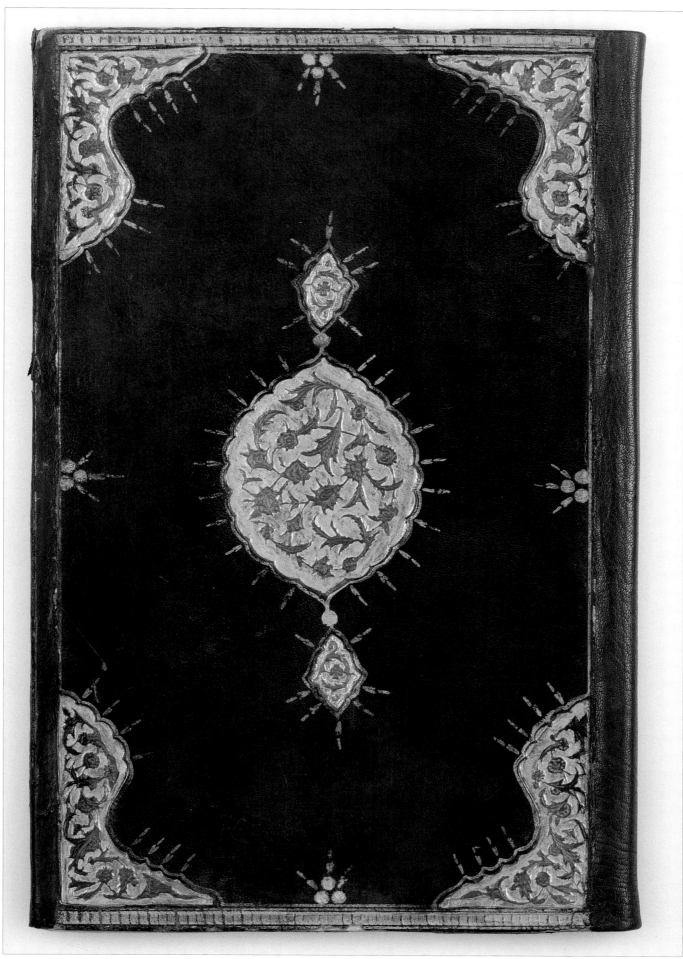

32, part 28, binding

الذِّكْرَى وَقَدْ جَاءَهُمْ رَسُولٌ مُبِينٌ ۞ ثُمَّ تَوَلَّوْا
عَنْهُ وَقَالُوا مُعَلَّمٌ مَجْنُونٌ ۞ إِنَّا كَاشِفُوا
الْعَذَابِ قَلِيلًا إِنَّكُمْ عَائِدُونَ ۞ يَوْمَ
نَبْطِشُ الْبَطْشَةَ الْكُبْرَى إِنَّا مُنْتَقِمُونَ ۞
وَلَقَدْ فَتَنَّا قَبْلَهُمْ قَوْمَ فِرْعَوْنَ وَجَاءَهُمْ
رَسُولٌ كَرِيمٌ ۞ أَنْ أَدُّوا إِلَيَّ عِبَادَ اللَّهِ
إِنِّي لَكُمْ رَسُولٌ أَمِينٌ ۞ وَأَنْ لَا تَعْلُوا عَلَى اللَّهِ
إِنِّي آتِيكُمْ بِسُلْطَانٍ مُبِينٍ ۞ وَإِنِّي عُذْتُ
بِرَبِّي وَرَبِّكُمْ أَنْ تَرْجُمُونِ ۞ وَإِنْ لَمْ تُؤْمِنُوا

33
Single-volume Qur'an
Ottoman, probably Edirne, AH 1168 (AD 1754–5)

339 folios, 18.2 × 12.6 cm, with
15 lines to the page
Material A smooth, cream European
laid paper, burnished; there are
approximately 12 laid lines to the
centimetre, and chain lines arranged
at intervals of 2.5 cm
Text area 14.1 × 7.1 cm
Script The main text in *naskh* in
black, with reading marks in red;
colophon in black *riqā'*; surah
headings in white *riqā'*; marginalia
in red *riqā'*
Scribe Hafiz Muhammad ibn Hafiz
Ibrahim, known as İmam-zade
Illumination Extensive decoration
on folios 1b–2a; text frames ruled in
gold, black and red; verses marked
by gold six-petal rosettes or whorls,
all set off with orangey-red and
blue dots; surah headings; marginal
ornaments marking textual divisions
Documentation A colophon
Binding Late 18th or early 19th
century
Accession no. QUR15

1. Another Qur'an by this calligra-
pher, his twenty-fifth, is in the Salar
Jung Library, Hyderabad. It was
completed in mid-Dhu'l-qa'dah 1175
(June 1762). See Muhammad Ashraf
1962, no.130.
2. Müstakim-zade, ed. Mahmud
Kemal, p.378.
3. Müstakim-zade, ed. Mahmud
Kemal, p.378, n.1.
4. See Derman 1965, especially p.315.
5. Cf. Topkapı Palace Library,
MS.H.7; see Rado, no date, p.97.

The Khalili Collection contains two Qur'an manuscripts written by this calligrapher,
the other being cat.34 below. Cat.33 was completed in AH 1168 (AD 1754–5) and was the
thirteenth copy of the Qur'an the scribe had made, while cat.34 was completed three
years later, in AH 1171 (AD 1757–8). In both manuscripts the scribe gave his name as Hafiz
Muhammad ibn Hafiz Ibrahim, known as İmam-zade, and in cat.34 he named his teacher
as Sayyid Muhammad (Seyyid Mehmed). There were many scribes called İmam-zade
who were active in the mid-18th century, but it seems certain that both cat.33 and 34
are by the same person, since he used a curious, *dhāl*-like letter *zā'* in writing the name
İmam-zade in both colophons.[1]

Müstakim-zade recorded a contemporary of his called Muhammad ibn Ibrahim who
was a *ḥāfiẓ*, a pupil of a Seyyid Mehmed and who could well have produced 13 Qur'ans by
1754 or 1755. He was from Edirne, where he was imam of the Noktacı-zade quarter in the
Kıyık district of the city. The Seyyid Mehmed who taught him calligraphy was the imam
of the mosque of Balaban Paşa, and he gained his licence as a scribe in AH 1114 (AD 1702–3),
when he was 20 years old. From this time on he applied himself as a copyist, producing
Qur'an manuscripts and copies of the *Dalā'il al-khayrāt* and other works.[2] It would seem
highly likely that this scribe was responsible for cat.33 and 34 were it not for a marginal
note in one of the copies of Müstakim-zade's text used for Mahmud Kemal's edition. This
notes that, 'There is another calligrapher in Edirne [called] Muhammad ibn Ibrahim, a
ḥāfiẓ, son of a *ḥāfiẓ*. He calls himself İmam-zade, and he is currently the imam of the
Muradiye.'[3] This second scribe could also be our man. What is clear, though, is that these
two manuscripts were produced in Edirne, which, from the number of scribes active there
mentioned by Müstakim-zade, appears to have been a great centre of production for calli-
graphy in the 18th century.[4]

The illumination of the opening pages is similar in layout to that of cat.18. The text
area is surrounded by the usual four panels, but the wide outer border seen in most 17th-
and 18th-century Qur'ans is missing. In its place we find a crested head-piece of the
type found at the beginning of individual parts of multi-volume Qur'ans (see cat.32,
for example) and in many non-Qur'anic manuscripts. This layout leaves a wide, blank
margin, which in this case is filled with a reciprocal pattern of palmette and lotus scrolls
executed in gold outline and filled with gold wash, known in Turkish as the *halkârî*
technique.[5] A touch of colour was added by placing groups of three dots in red or blue
in the interstices of the design. The surah headings in the manuscript are in white *riqā'* and
are inscribed on gold panels framed by coloured borders. Textual divisions are marked by
illuminated devices of various traditional types in the case of each *juz'* and by inscriptions
in the margin in the case of each *ḥizb*. The latter are in red, in a sketchy hand, and similar
inscriptions mark points in the text at which a prostration (*sajdah*) was required.

The brown morocco covers were tooled and painted in gilt with a centre-and-corner
composition and a triple border, all filled with a pattern of palmette scrolls. The later red
morocco doublures are matched by red morocco 'flyleaves' with the same decoration
painted in gold – a central rose motif enclosed by multiple borders in different tones
of gold. There is no flap.

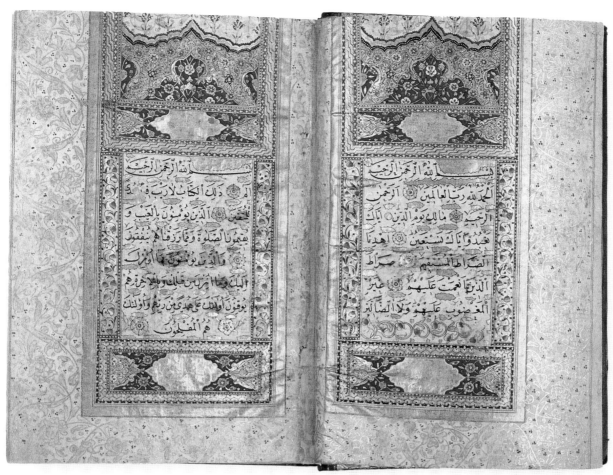

33 folios 1b–2a

33 folios 336b–337a

34
Single-volume Qur'an

Ottoman, probably Edirne, AH 1171 (AD 1757–8)

408 folios, 18 × 11 cm, with 13 lines
to the page
Material A very thin, very crisp,
dark-cream laid paper, lightly
burnished; there are approximately
nine laid lines to the centimetre, and
no apparent rib shadows or chain
lines. The paper is so thin that indi-
vidual folios are semi-transparent
Text area 11.2 × 5.5 cm
Script The main text in *naskh*, in
black, with reading marks in red;
surah headings and inscriptions in
marginal ornaments in white *riqāʿ*
Scribe Hafiz Muhammad ibn Hafiz
Ibrahim, known as İmam-zade
Illumination Extensive decoration
on folios 1b–2a; text frames ruled in
gold, black and red; verses marked
by gold six-petal rosettes or whorls,
all set off with orangey-red and
navy-blue dots; surah headings;
marginal ornaments marking textual
divisions and *sajdah*s; decoration
in gold only around the colophon
on folio 408a
Documentation A colophon
Binding Contemporary
Accession no. QUR18
Published Geneva 1995, no.30

The calligrapher of this manuscript is the same as that of cat.33. Although there are only
three years between the two manuscripts, the style of illumination is entirely different,
indicating that it was the work of different painters.

The opening illuminated pages are a variant of the traditional type in which the side
panels were replaced by filler bands, here containing heavy gold strapwork, and the wide
outer border was interrupted by a 'hasp' shape on either side. The contrast between the
hasps and the rest of the border is heightened by the different colours used. The hasps
are filled with palmette and floral scrolls in white with touches in red, all on a solid gold
ground. The border proper has the same motifs in polychrome on parti-coloured, gold
and blue grounds. In both cases the quality of the execution is high. The surah headings
in the manuscript, which are in white *riqāʿ*, are inscribed within gold cartouches in illumi-
nated panels. The remainder of the panel is filled with fragments of the palmette and
floral scrolls found in the border and 'hasps' on the opening pages, and the whole panel
is framed by a coloured band textured in white. The quality of this work, too, is high, as
is that of the varied marginal devices used to mark each *juz'*, *ḥizb* and *sajdah*.

The contemporary maroon morocco covers are of the classical type, with recessed
centre- and corner-pieces stamped with floral scrolls and cloud bands painted in contrasting
colours. The fore-edge section of the flap has stamped and gilded decoration consisting of
two cartouches containing verses 79–80 from the surah *al-Wāqiʿah* (LVI). The doublures
are of light-brown morocco, painted in gold with the outline of a centre-and-corner
composition. There are later endpapers of marbled paper.

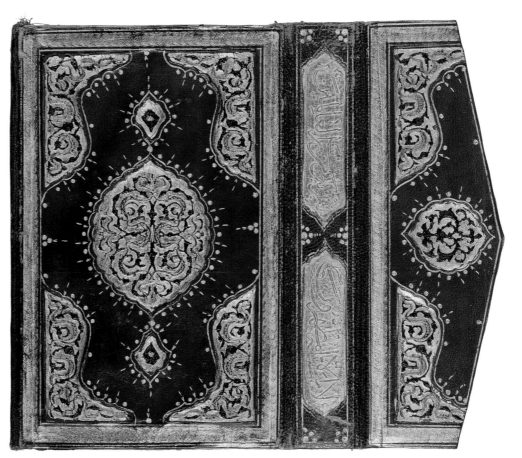

34 binding

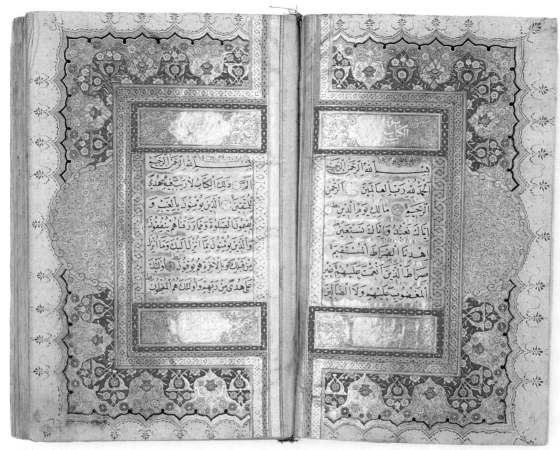

34 folios 1b–2a

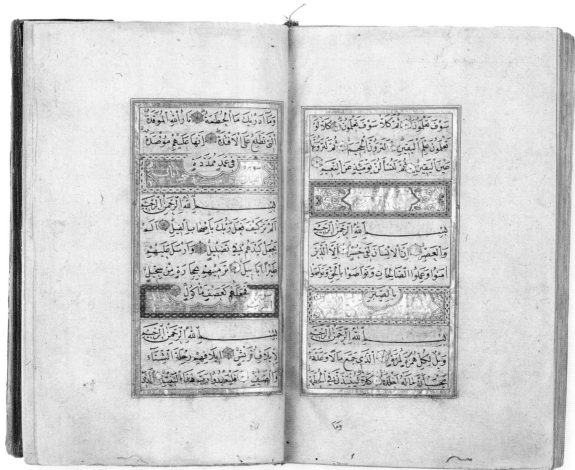

34 folios 405b–406a

35
Single-volume Qur'an
Istanbul or the provinces, 18th century

303 folios, 17.5 × 10.5 cm, with
15 lines to the page
Material A thin, cream laid paper;
there are approximately six laid lines
to the centimetre, and chain lines are
visible 2.5 cm apart
Text area 11.5 × 6.5 cm
Script The main text in *naskh*, in
black, with reading marks in red;
surah headings and inscriptions in
marginal ornaments in white *riqā'*;
other marginalia in gold *naskh*
Scribe al-Sayyid Mahmud ibn
al-Sayyid Hajj Sinan
Illumination Extensive decoration
on folios 1b–2a; text frames ruled in
gold, black and red; verses marked
by gold whorls, set off with
orangey-red and navy-blue dots;
surah headings; marginal ornaments
marking textual divisions (*ajzā'*
only) and *sajdah*s; decorative panels
before and after the colophon on
folios 330b–331a
Documentation A colophon
Binding Contemporary
Accession no. QUR169

1. Müstakim-zade, ed. Mahmud
Kemal, pp.506–7.

The manuscript is undated, but it seems likely that the scribe who produced it was the Mahmud ibn Sinan who was a younger contemporary of Müstakim-zade. Mahmud was from Erzurum, where he was trained by his father, and the firmness of his hand brought him such fame that he came to the attention of Çeteci Abdullah Paşa.[1]

The opening pages are of the traditional type, with floral and palmette scrolls on blue and gold grounds. The side panels have been replaced by filler bands consisting of a repeat pattern of half-palmettes in pink on a gold ground. Along the edge of the border two types of floral spray alternate, one in blue, the other in red. Each *juz'* and each *sajdah* is marked by a marginal device. The forms vary, but they are all standard 18th-century types. Other textual divisions – *ḥizb*s and groups of ten verses – are marked by inscriptions in fine gold *riqā'*. The surah headings are also of a traditional type, in which the heading is set in a gold cartouche flanked by polychrome scrollwork, but the usual framing bands are absent.

The brown morocco binding has recessed centre-pieces with the raised decoration reserved in a gold ground. The corner-pieces and borders were executed in light tooling and painting in gilt. There are doublures of marbled paper.

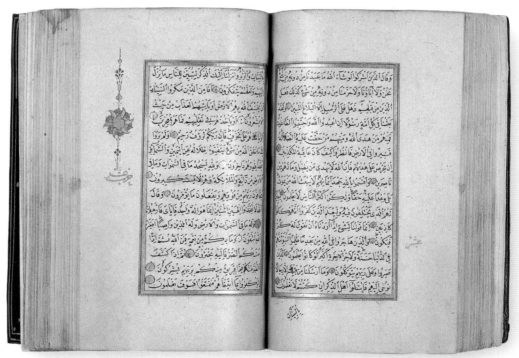

35 folios 136b–137a

36
Single-volume Qur'an

Istanbul or the provinces, AH 1182 (AD 1768–9)

332 folios, 19.9 × 12 cm, with 15 lines
to the page
Material A polished, deep-cream
laid paper, with eight to ten laid lines
to the centimetre
Text area 13.2 × 7.3 cm
Script The main text in *naskh*, in
black, with reading marks in red;
surah headings and inscriptions in
marginal ornaments in white *riqā'*;
other marginalia in red *naskh*
Scribe Sulayman, called Hafiz
al-Qur'an
Illumination Extensive decoration
on folios 1b–2a; text frames ruled
in gold and black; verses marked by
gold six-petal rosettes or whorls, all
set off with orangey-red and navy-
blue dots; surah headings, with a
similar heading for the concluding
prayer on folio 331a; marginal orna-
ments marking textual divisions and
*sajdah*s; decorative panels before
and after the colophon on folios
330b–331a
Documentation A colophon
Binding Contemporary
Accession no. QUR76
Published Geneva 1995, no.32

1. Müstakim-zade, ed. Mahmud
Kemal, p.220.
2. Müstakim-zade, ed. Mahmud
Kemal, pp.212, 222–3.
3. Topkapı Palace Library,
MS.Y.2145; see Karatay 1962,
no.1325.
4. See, for example, Geneva 1995,
no.45, illustration on p.89 (folio 2a).

The scribe responsible for this Qur'an describes himself as 'Sulayman, known as Hafiz
al-Qur'an'. Müstakim-zade has an entry on a contemporary calligrapher called Sulayman
al-Hafiz, who was a native of Istanbul and trained with Damad-zade Süleyman Efendi.[1]
Sulayman al-Hafiz became imam of the Şehzade Mosque and *khaṭīb* of the mosque of
Molla Şeref. He died in Cairo on his way to the Hajj some time before the completion
of Müstakim-zade's work in 1787–8. The identification of the two is not certain, as there
were at least two other contemporary scribes called Süleyman who also enjoyed the status
of *ḥāfiẓ*,[2] and a Qur'an in the Topkapı Library dated AH 1178 (AD 1764–5) was copied by
a Hafiz Süleyman who was one of the scribes serving the Imperial Council.[3]

The Qur'an is finely illuminated, and the layout of the opening pages conforms to
the variant of the traditional type in which the side panels are replaced by filler bands,
here containing undulating floral scrolls on a blue ground. As usual, a small floral spray
springs from the apex of each of the lobes forming the edge of the border, here somewhat
flattened. Between each spray there is a small red flourish, derived from the small cloud
bands that appear in this position in 17th-century manuscripts.[4]

The Qur'an has very fine contemporary covers in dark maroon leather. The recessed
centre- and corner-pieces have a gilt ground, and the pressure-moulded floral-scroll and
cloud-band motifs have been painted red. The borders were produced by a different
technique, which involved light tooling and painting in gold. The doublures and end-
papers are of fine European paper decorated with small floral motifs in green and gold.

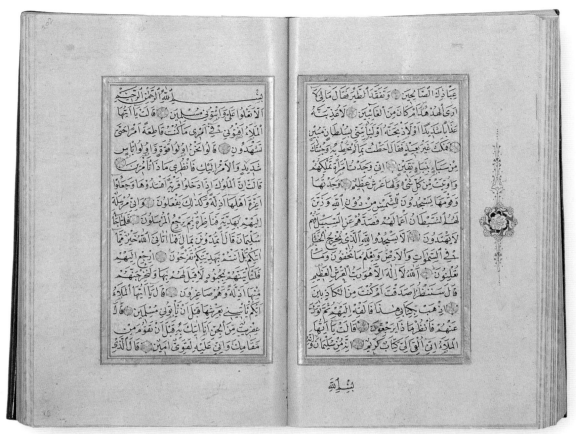

36 folios 201b–202a

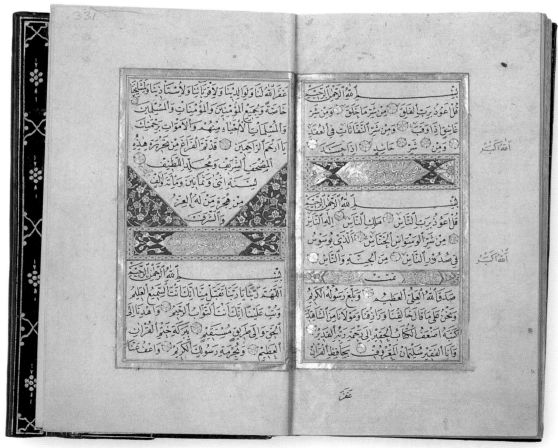

36 folios 330b–331a

37
Single-volume Qur'an
Istanbul or the provinces, AH 1188 (AD 1774–5)

308 folios, 17.2 × 11.3 cm, with
15 lines to the page
Material A thin, dark-cream laid
paper, burnished to a gloss; there are
approximately nine laid lines to the
centimetre, and no apparent rib
shadows or chain lines
Text area 10.5 × 5.6 cm
Script The main text in *naskh*, in
black, with reading marks in red;
surah headings and inscriptions in
marginal ornaments in white *riqā'*;
other marginalia in red and black
naskh
Scribe Muhammad Kutahi
Illumination Extensive decoration
on folios 1b–2a; text frames ruled
in two tones of gold, black and red;
verses marked by gold rosettes, set
off with red and blue dots; surah
headings; marginal ornaments
marking textual divisions and
*sajdah*s; decorative panels before
and after the colophon, on folios
307b–308a, and after the concluding
prayer, on folio 308b
Documentation A colophon
Binding Modern, but incorporating
older material
Accession no. QUR40

The scribe responsible for this manuscript, Mehmed Kutahi, cannot be identified among
the calligraphers of this period recorded by Müstakim-zade, and the same can be said of
the scribes of cat. 38–40. These manuscripts were all produced in the years 1774–1790,
immediately before and after Müstakim-zade's completion of the final draft of his
Tuḥfah-i khaṭṭāṭīn and his death soon after, in 1788. Either these men fell outside his
circle, or, as may be the case with cat. 37 and 39, the information he offers is not sufficient
to identify the scribe among those of the same name mentioned in the *Tuḥfah*. The
literary tradition picks up again with cat. 41, the scribe of which, Hafız Çemşir, died in
AH 1236 (AD 1820–21) and was recorded by 19th-century commentators such as Habib.

The text was written so that the end of each page coincided with the end of a verse and
is set in relatively wide frames of rules that incorporate bands in two tones of gold. The
fine illumination of the opening pages is notable for the use of red as a ground colour, in
addition to the more usual gold and blue, while the marginal devices marking divisions
of the text and the *sajdah*s are in a mixture of styles. Some are in the traditional style, in
which stylized plant-based motifs were worked into forms based on rotating or symmet-
rical arrangements of palmettes, for example, or composite lotus blossoms, while others
incorporate roses, depicted naturalistically on a gold ground.

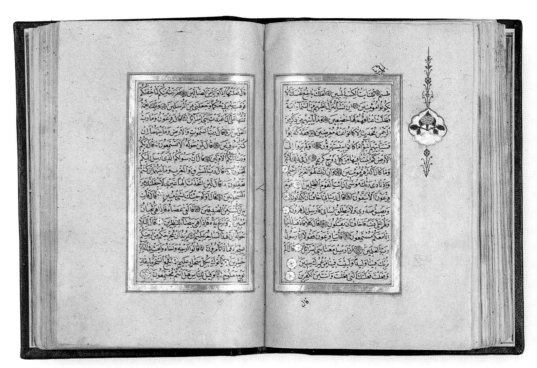

37 folios 184b–185a

38
Single-volume Qur'an

Istanbul or the provinces, AH 1197 (AD 1782–3)

337 folios, 18.5 × 11.8 cm, with
15 lines to the page
Material A smooth, light-brown laid
paper, burnished to a gloss; there are
approximately ten laid lines to the
centimetre, and no apparent rib
shadows or chain lines
Text area 12.5 × 6.2 cm
Script The main text in *naskh* in
black, with reading marks in red;
surah headings and inscriptions in
marginal ornaments in white *riqā'*;
colophon in black *riqā'*
Scribe Khalil al-Rahmi ibn
Muhammad
Illumination Extensive decoration
on folios 1b–2a; text frames ruled in
gold, black and red; verses marked
by gold six-petal rosettes or whorls,
all set off with orangey-red and
navy-blue dots; surah headings;
marginal ornaments marking textual
divisions (*ajzā'* only) and *sajdah*s;
decoration in colours and gold
below the end of the text and below
the colophon, both on folio 337a
Documentation A colophon
Binding Contemporary
Accession no. QUR24

1. Mehmed Süreyya, 1308 – no date,
II, p.301.
2. Müstakim-zade, ed. Mahmud
Kemal, pp.197, 199.
3. Müstakim-zade, ed. Mahmud
Kemal, p.197.
4. Müstakim-zade, ed. Mahmud
Kemal, p.199.
5. Müstakim-zade, ed. Mahmud
Kemal, p.199. *Cf.* Rado, no date,
p.153.

This Qur'an was signed by a scribe called Khalil al-Rahmi ibn Muhammad. It seems very likely that he is to be identified with a calligrapher called Halil Rahmi who was recorded by Mehmed Süreyya.[1] Halil Rahmi, who was born in Safranbolu in north-west Anatolia, became a *mudarris* and died in AH 1211 (AD 1796–7). He was buried in Haydarpaşa. Müstakim-zade recorded five scribes called Halil ('Khalil' or 'Khalil ibn Muhammad') who were alive when cat.38 was copied, but none of these can be identified with Halil Rahmi. Halil Sidqi ibn Muhammad and Halil Nahifi, both natives of Istanbul, can also be excluded because of their second names, their *takhalluṣ*es.[2] Another Halil ibn Muhammad was the son of the grand vizier İvaz Mehmed Paşa (d.1743),[3] but he was himself appointed grand vizier in 1769, and he is therefore unlikely to have copied this Qur'an. The fourth, Nalçacı-zade Halil Efendi, was a resident of Edirne, where he was a student of Haffaf-zade Hüseyin Efendi, qualifying as a calligrapher in AH 1153 (AD 1740–41).[4] The fifth was Seyyid Halil of Dimetoka, a pupil of Bıçakçı-zade Hafız Mehmed Efendi in Edirne; this Halil qualified in AH 1167 (AD 1753–4) and had completed 15 copies of the Qur'an by the time Müstakim-zade wrote the final draft of the *Tuḥfah*.[5]

The opening pages of illumination are of the traditional type, but the colour scheme – predominately gold, with pink and mid-blue framing bands – is distinctive, and a number of changes in the detail of the layout may be observed. Bands of gold strapwork have replaced the panels on either side of the text area, and the lobed edges of the border have been flattened out. The border is decorated with the traditional palmettes and floral scrolls, with details mostly in green. The blue floral sprays protruding into the margin from what were the apices of the lobes are matched by red sprays and flourishes in gold. After the last surah there is a pair of floral vignettes with naturalistically painted roses and other blossoms on a gold ground, and at the bottom of the page is a panel with stylized floral scrolls on a natural ground. The motifs in the former and the colours of the latter give this page a distinctively 18th-century character. Surah headings are in white *riqā'* on gold cartouches flanked by fragments of floral scrolls executed in the same colours as those on the opening pages or in polychrome. Marginal devices in a variety of traditional forms but executed in a vivid range of colours mark each *juz'*.

The brown morocco covers are almost identical to those of cat.39. They have recessed centre- and corner-pieces pressure-moulded with an elegant pattern of lotus scrolls, reserved in a gilt ground. There is a border of gold cabling. The doublures are of green paper.

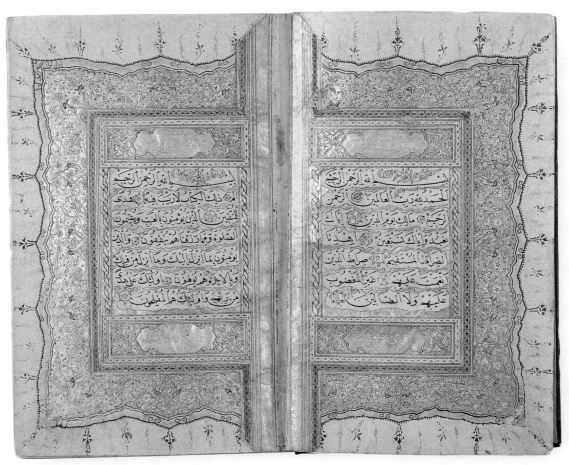

38 folios 1b–2a

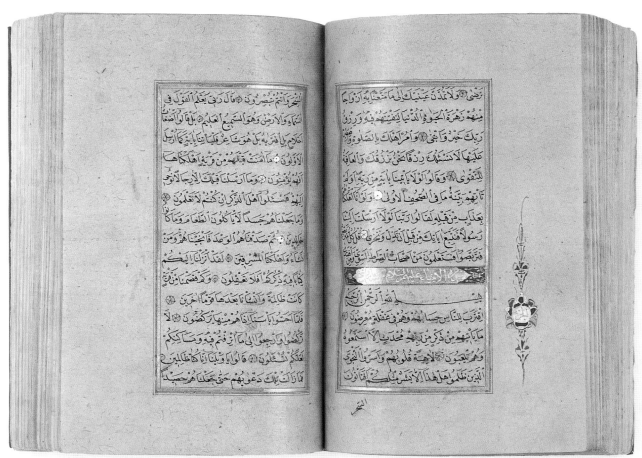

38 folios 177b–178a

39
Single-volume Qur'an

Istanbul or the provinces, AH 1201 (AD 1786–7)

307 folios, 18.8 × 12.2 cm, with
15 lines to the page
Material A smooth, cream European
laid paper, burnished; there are
approximately 16 laid lines to the
centimetre, and chain lines arranged
at intervals of 2.5 cm
Text area 12.2 × 7 cm
Script The main text in *naskh*, in
black, with reading marks in red;
surah headings and inscriptions in
marginal ornaments in red *riqāʿ*
Scribe Salih al-Wahbi
Illumination Extensive decoration
on folios 1b–2a, 306b–307a; text
frames ruled in gold, black and red;
verses marked by gold six-petal
rosettes or whorls, all set off with
orangey-red and navy-blue dots;
surah headings; marginal ornaments
marking textual divisions (*ajzā*') and
*sajdah*s
Documentation A colophon
Binding Contemporary
Accession no. QUR8

The scribe of this manuscript was Salih Vehbi, a pupil of Osman Hilmi Efendi, who used
an arrangement of the text whereby each page ends with a complete verse.

The opening pages of illumination have 'hasp' shapes projecting over the border both at
the sides and top and bottom. The panels either side of the text have been replaced by filler
bands with a repeat pattern of half-palmettes in black on a gold ground. Surah headings

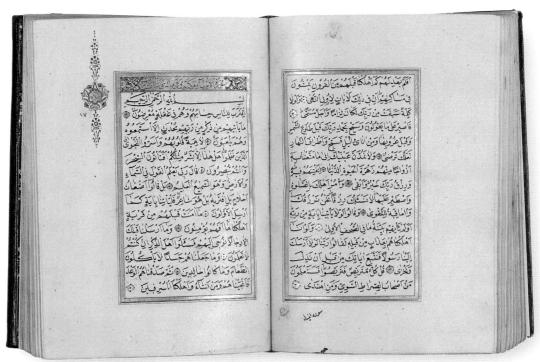

39 folios 161b–162a

are in red *riqāʿ* in gold cartouches flanked by fragments of floral scrolls. There are no
framing bands. The marginal devices marking each *juz*' and each *sajdah* are of the tradi-
tional type, but the gold and colours used are particularly bright.

The most notable feature of the decoration of this manuscript is the illumination on
folios 306b–307a. The text on these two pages consists of the surahs *al-Falak* (CXIII) and
al-Nās (CXIV), a short prayer, and the colophon, and they are arranged within a symmetri-
cal arrangement of two circular and two more or less triangular spaces surrounded by
illumination that fills a rectangular zone equivalent to the text area on the other pages of
the manuscript. The illumination is in three sections. In the middle is a narrow panel of
the type used for surah headings, and in the case of folio 306b the panel bears the heading
of *al-Nās*. Above this the circular text spaces are defined by a gold crescent moon, which
is surrounded by polychrome floral and palmette scrolls on blue and yellow grounds,
arranged to create a blue central field and yellow corner-pieces. The triangular text space
below is flanked by lotus scrolls in gold only on a natural ground.

The fine brown morocco covers are very similar to those of cat.38. They have recessed
centre- and corner-pieces, and borders tooled with cabling, all painted in gold. The lotus-
scroll motifs in the centre-and-corner elements are reserved in the gold ground.

40
Single-volume Qur'an

Istanbul or the provinces, AH 1204 (AD 1789–90)

305 folios, 20.1 × 12.5 cm, with
15 lines to the page
Material A smooth, cream European
laid paper, burnished; there are
approximately nine laid lines to the
centimetre, and chain lines arranged
at intervals of 2.8 cm
Text area 13.5 × 6.8 cm
Script The main text in *naskh*, in
black, with occasional words in red;
surah headings and inscriptions in
marginal devices in white *riqā'*;
other marginalia in gold *riqā'*
Scribe Hasan al-Nuri
Illumination Extensive decoration
on folios 1b–2a; text frames ruled in
gold, black and red; verses marked
by gold whorls set off with orangey-
red and blue dots; surah headings;
marginal ornaments marking textual
divisions (*ajzā'*) and some *sajdah*s;
panels similar to those used for the
surah headings precede the
colophon on folio 304a and the
prayer on folios 304b–305a
Documentation A colophon
Binding Modern
Accession no. QUR33

1. This system of presentation
has been the subject of a study
by François Déroche, as yet
unpublished.

Hasan Nuri, the scribe responsible for this manuscript, used an unusual system for the
presentation of the text, which is a variant of the format that has the end of a verse at the
bottom of each page. Instead of the usual reading instructions being added in red, whole
words have been written in ink of this colour in order to show where the same word or
words appear in symmetrical positions on facing pages. On occasion the text is arranged
within ruled areas of different widths, as on folios 187b–191a, in the surah *al-Shu'arā'* (XXVI).[1]

Folios 1b–2a have illumination similar in layout to the same pages in cat.39, although
the execution is somewhat different, and the side panels have been retained. They consist
of a pattern of interlace in gold, framed by a green band. Surah headings were written in
white *riqā'* in plain gold panels, and other divisions of the text are marked by marginal
medallions in the case of each *juz'*, and inscriptions in gold *riqā'* in the case of each *ḥizb*.

The brown morocco covers have recessed centre- and corner-pieces with pressure-
moulded lotus-scroll motifs reserved in the gold ground, and borders tooled with cabling
and painted in gold. The doublures are of dark-green paper with a stencilled design in
black and red.

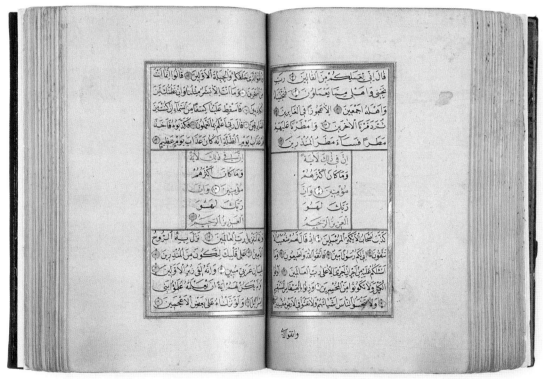

40 folios 189b–190a

41
Single-volume Qur'an

Istanbul or the provinces, AH 1213 (AD 1798–9)

420 folios, 17.2 × 10.1 cm, with
15 lines to the page
Material A fine, cream laid paper
Text area 9.5 × 5.1 cm
Script The main text in *naskh*, in
black, with reading marks in red;
surah headings in exceptionally fine
white *riqā'*; marginalia in gold *riqā'*
Scribe al-Sayyid Salih Chimshir,
known as Hafiz al-Qur'an
Illumination Extensive decoration
on folios 1b–2a, 418b–419b; unusu-
ally wide text frames ruled in gold,
black and red; verses marked by a
variety of rosettes and whorls in
gold and colours; surah headings;
inscriptions in gold marking text
divisions (*ajzā'*)
Documentation A colophon
Binding Modern
Accession no. QUR27
Published Geneva 1995, no.31

1. Habib 1305, p.163. *Cf.* Huart
1908, p.190; İnal 1955, p.352;
Rado, no date, p.195.
2. See İnal 1955, p.353, for example.
3. Another example is Chester
Beatty Library, MS.1580 (Arberry
1967, no.216), which was copied
in AH 1218 (AD 1803–4). See also
Topkapı Palace Library, MS.Y.5691;
Karatay 1962, no.1592.

The scribe of this Qur'an was Seyyid Hafiz Mehmed Salih Çemşir, usually known as
Hafiz Çemşir or Çemşir Hafiz. The late 19th-century commentator Habib reported that
in his younger days Hafiz Çemşir led his life in a dissolute manner, but with the passage
of time he repented and set about making up for his misdeeds. His past behaviour seems
to have given him a certain notoriety, because Habib also tells how Hafiz Çemşir's friends
chided him about what he would do on Judgement Day regarding the crimes he had
committed in the past, and how he would answer for them to his Maker. He replied
that he would 'put all his deeds in a sack and bear it on his shoulders up to the Court of
Account'.[1] His sense of guilt may well have been the driving force behind his very high
rate of Qur'an production (see below).

Hafiz Çemşir was a pupil of Ak Molla Ömer Efendi, and he became a calligraphy tutor
in the imperial palace, but his fame rests on the quantity and consistency of his own work.
This included calligraphic specimens,[2] at least two designs for inscriptions, and a huge
number of Qur'ans, which he wrote with great firmness and speed, as though he were
made of boxwood (*çemşir*), whence his nickname. According to Habib, Hafiz Çemşir was
reported to have written 366 Qur'ans, but Muhsin-zade Abdullah Efendi had told Habib
that in a copy he had seen, the scribe stated that it was his 454th Qur'an. Credence is given
to this improbable figure by cat.41, which was completed more than 20 years before
the scribe's death in AH 1236 (AD 1820–21) and was the 125th copy completed by him,
according to the colophon.[3]

The opening pages of illumination are similar in many respects to those of cat.37. The
vertical bands either side of the text area are filled with polychrome flower chains inter-
spersed with an unusual C-shaped leaf motif in pink. The surah headings in the remainder
of the manuscript have unusually wide framing bands, and the frame of rules around each
text area is also unusually wide. There are marginal devices marking each *juz'*, while *ḥizb*s
and *sajdah*s are indicated by inscriptions in fine gold *riqā'*. The white *riqā'* used for the
surah headings is also very fine.

Following the end of the text there is an appendix explaining the reading notation. This
terminates on folio 418b, where the length of the lines gradually reduces to create a trian-
gular block. The spaces within the text frame on either side of this block are filled with
floral and palmette scrolls on blue grounds textured with white dots and natural grounds
scattered with gold. On the facing page the colophon is contained within a gold crescent
(compare cat.39). The surrounding space is filled with the same type of illumination as
appears on folio 418b, and there are decorative panels of the type used for surah headings
above and below. In the central cartouches there are bunches of naturalistic flowers in
place of the usual inscriptions.

Folio 419b bears a prayer celebrating the arrival of the New Year and asking God's
protection. On folio 420a there is a stylized though well-executed painting of Mecca in an
oval cartouche. Paintings of this type are common in other types of Ottoman manuscript,
such as copies of the *Dalā'il al-khayrāt* of al-Jazuli, but they are rarely found in copies of
the Qur'an.

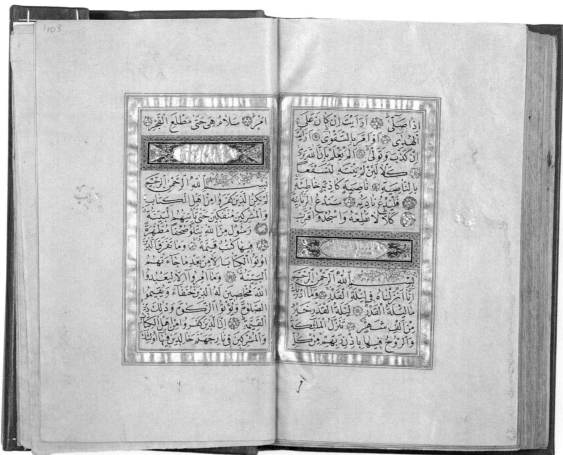

41 folios 407b–408a

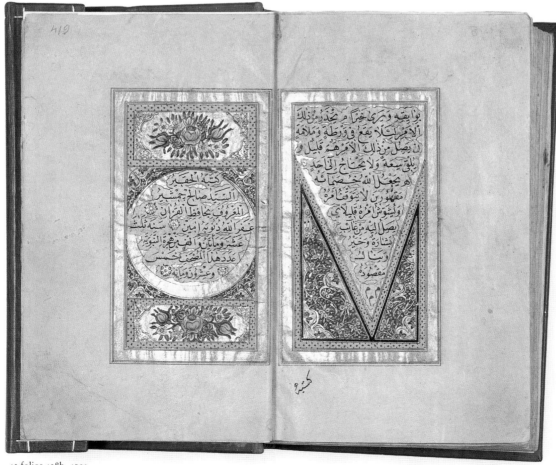

41 folios 418b–419a

Iran. The late Safavid renewal and Ahmad Nayrizi

by Manijeh Bayani and Tim Stanley

Very little attention has been paid to Qur'an production in Iran after 1600, either by specialists in the arts of late Safavid Iran, or by those interested in the formal aspects of Qur'an production in all periods. Thus the exhibition devoted to *Shah 'Abbas and the Arts of Isfahan*, held in New York and Cambridge, Massachusetts, in 1973–4, included only one Qur'an manuscript, a fine specimen from the Museum of Fine Arts in Boston.[1] Similarly, only one example attributed to Iran in the 17th or 18th centuries was shown in the important exhibition of Qur'an material displayed at the British Library in 1976. This manuscript, from the Library's own holdings (Or.MS.13,371), has an interlinear translation dated AH 1141 (AD 1728–9).[2] Naturally, exhibitions held in Iran have included far more examples,[3] and the relevant portions of some manuscript collections in Iran and elsewhere have been published.[4] The entries on individual Qur'ans in these works frequently provide important information on particular scribes or patrons, but the accompanying illustrations are often poor, if they exist at all, and it would be difficult to develop an overall typology on the basis of the descriptions given. In this context there is an understandable tendency to emphasize exceptional pieces. This is the case with a fine Qur'an in the Chester Beatty Library in Dublin (MS.1550) that has twice been attributed to 17th-century Iran.[5] The only grounds given for the attribution are that the manuscript's illumination is a deliberate imitation of Timurid work of the 15th century, and such imitation 'is known to have occurred in the reign of Shah 'Abbās I' (1587–1629).[6] In fact, the type of *naskh* employed is characteristically Indian, and the Timurid features of the illumination would have meant more to the Mughals, who were descended from the Timurids, than to the Safavids, who had helped put an end to the dynasty. The Chester Beatty manuscript may therefore be re-attributed to Mughal India, although our knowledge of Indian Qur'an production in the 17th and 18th centuries is no more advanced. This is in itself an obstacle to the study of contemporary Iranian work, since Indian and Iranian book production were intimately linked in this period (see pp.200–201, below).

Another impediment to a study of the period is the extraordinary frequency with which the Qur'ans produced in the 17th century were remade in the 19th century. It may be that one of the pigments used for creating the multiple rulings around the text in these manuscripts was corrosive and ate through the paper, detaching the text area from the surrounding margin. This corrosive action would have taken full effect by the Qajar period, when the manuscripts would have been all but unusable and had to be renovated. On the basis of the material in the Khalili Collection it seems that this involved remargining, often with paper of a contrasting colour; a complete or partial overhaul of the illumination; and rebinding, usually in lacquer covers. While this means that most of the manuscripts are now in fine condition, it has had the unfortunate consequence of eliminating much of the evidence of their original appearance. It is suggested below (cat.49) that the pigment responsible for this disaster was verdigris.

Late Safavid forms

The main type of 17th-century Qur'an that seems to have escaped this fate is represented by the Boston and British Library Qur'ans referred to above. The Boston Qur'an measures approximately 30 × 20.5 centimetres, and it is therefore slightly smaller than the British Library example (36 × 22.5 centimetres), but the two books have many features in common. In both the text area is framed by multiple rules and is divided by single gold rules into 24 bands, alternately broad and narrow. The 12 broader bands each contain a line of text written in the excellent *naskh* hand typical of Isfahan in the later 17th century and the early 18th, while the 12 narrower compartments contain Persian glosses in a tiny red *nasta'līq* hand. In both cases, too, the surah headings are in white *riqā'* and are set in finely illuminated panels, while the lateral margins on the published pages are filled with ornamental devices marking the end of each group of five and ten verses. The same arrangement of text and interlinear glosses within bands ruled in gold is seen in a number of contemporary examples, including cat.45 below. The illumination of this manuscript differs from that of the two Qur'ans already described in that the surah headings and verse counts are inscribed in gold *riqā'* on a natural ground, which in the case of the surah headings is set with fine floral scrollwork in blue.

The opening pages of the Boston and British Library Qur'ans have not been published, but other contemporary examples, including cat.45, suggest that there was a standard layout for these pages: illuminated panels are set above and below the reduced text area on each page, and there are elaborate crests and richly patterned margins.[7] The detail of the illumination shows some variation, however. Thus the margins of a Qur'an copied by 'Abdallah Yazdi in AH 1109 (AD 1697–8) display lotus scrolls in gold that are similar to those occupying this position in cat.45, but they are combined with a larger palmette scroll executed predominately in blue and gold (compare cat.47).[8] Such variations, taken together with the very high quality of the manuscripts in question, suggest a certain exuberance in Qur'an production in this period, and it seems reasonable to presume that this was due to a renewal of court patronage. The main piece of evidence for this link is the fact that the interlinear glosses found in cat.45 – and the other examples of this type – were composed for Shah Sulayman (*reg.*1666–1694) by 'Ali Riza ibn Kamal al-Din Ardakani in AH 1084 (AD 1673–4). As one would expect with any new form, the Qur'ans in question seem to have been produced within a relatively restricted circle, since Muhammad Hadi ibn Muhammad Amin Shirazi, the scribe who wrote out the interlinear glosses in cat.45 in AH 1106 (AD 1694–5), also supplied the glosses in 'Abdallah Yazdi's Qur'an of 1697–8.

Two undated and unsigned Qur'ans in the Khalili Collection, cat.46 and 47 below, can be attributed to the late Safavid period on the basis of their similarity to cat.45 and the other manuscripts mentioned above. In both, the layout of the text is of the same type as cat.45, but no interlinear glosses were added. In one, cat.46, the narrower bands designed to accommodate the glosses have been left blank, unintentionally heightening the contrast with the wider bands, which have a ground scattered with gold, as in cat.45. In cat.47, on the other hand, the narrower bands were subsequently painted with a running pattern of floral motifs over a solid gold ground. In both the marginalia survive, written in gold *riqā'* in the same manner as in cat.45, but while folios 1b–2a of cat.47 survive in something like their original condition, the opening pages of cat.46 were replaced during the Qajar period, and the late Safavid illumination lost.

The renewed interest in Qur'an production under Shah Sulayman and his successor, Shah Sultan Husayn (*reg.*1694–1722), indicated by the emergence of a splendid form of Qur'an that incorporated interlinear glosses, was not an isolated phenomenon. Royal patronage of religious life intensified during the reigns of these two shahs, with the result that many features of later Iranian religious practice were given their canonical form at this time. The dominant personality in this process was the Twelver Shi'i divine Muhammad Baqir Majlisi (1627–1698), who was the virtual ruler of the country during the last four years of his life, when he held the post of *mullā-bāshī* ('chief mullah') under Sultan Husayn. Majlisi's most important work was the redaction of the entire body of *ḥadīth*s attributed to the Shi'i Imams, which he published in one huge work in Arabic, the *Biḥār al-anwār*, or 'Oceans of lights'. He also translated different sections of the *Biḥār* into Persian, the most celebrated of these books being the *Zād al-maʿād*, 'Provisions for the hereafter', which deals with the Last Things. In doing so, his aim was to make this information available to 'the masses of believers and common Shi'ah' with 'no familiarity with the Arabic language' in the hope that his translations would 'give new life to the hearts and spirits of the dead-hearted people'.[9] A similar intention must have lain behind Shah Sulayman's commissioning of a new set of glosses for the Qur'an from 'Ali Riza Ardakani.

Other 17th-century Iranian Qur'ans in the Khalili Collection were written in *naskh* without interlinear rulings or glosses. These manuscripts are modest in scale, but they are the work of accomplished scribes, some of whom evidently attained a high level of esteem among their contemporaries. This is the case, for example, with Muhammad Ibrahim Qumi, the scribe of cat.50, and 'Abdallah Yazdi, who wrote cat.52 as well as the Qur'an of 1697–8 already referred to; both men were associated with the Safavid court at one time. The lack of contemporary literary or archival sources means, however, that the careers of these and other scribes can only be reconstructed, and their relative importance assessed, by piecing together the information given in the colophons of the manuscripts and other works they produced. At the same time, the original physical character of the manuscripts they wrote is largely lost

because they were subject to major renovation in the 19th century in the manner described above. To judge by what little evidence remains, it seems that these Qur'ans tended to the sumptuous, despite their relatively small size. One indicator is the treatment of the surface of the paper within the text areas, which are, of course, the only parts of these manuscripts to survive. In cat. 52 the surface was coated with gold before the text was written, and in four other examples (cat. 42, 43, 48, 50) the surface was scattered with gold. In one of these (cat. 48) a gold rule was set between each line of text, and in cat. 44 there is interlinear gilding of the *abrī* type.

Ahmad Nayrizi

One result of the renewed interest in Qur'an production under Shah Sulayman and Shah Sultan Husayn was the emergence of Ahmad Nayrizi, the scribe of cat. 53 and 54 below. He is the most celebrated master of *naskh* that Iran has produced, and one of the most prolific. The signed works so far identified include numerous copies of the Qur'an and prayer-books, as well as calligraphic exercises,[10] work in lacquer,[11] and a Qur'anic inscription in the Chihil Sutun palace in Isfahan dated AH 1127 (AD 1715).[12] The inscription in the Chihil Sutun and several other instances noted below show that Ahmad Nayrizi was a leading court calligrapher under Shah Sultan Husayn, but, as with the other scribes mentioned above, this fact and the other details we know of Ahmad's life have had to be extracted from the colophons of his manuscripts and other calligraphic works, since Muhammad Hasan Simsar has shown that the literary tradition regarding his biography, which was initiated by Mirza Sanglakh in the 19th century, is completely unreliable.[13]

In the colophon of a Qur'an he produced in AH 1124 (AD 1712–13) the calligrapher described himself as 'Nayrizi by birth and Isfahani by residence', showing that he was born in the town of Nayriz in Fars from which he derived his *nisbah*.[14] His earliest dated work, a prayer book completed in AH 1087 (AD 1676–7), was signed as 'the son of Sultan Muhammad, Fakhr al-Din Ahmad al-Nayrizi',[15] while his name appears as 'the son of Shams al-Din Muhammad, Ahmad al-Nayrizi' in a Qur'an he finished in Sha'ban 1117 (November–December 1705).[16] From this it appears that his father bore the names (Sultan) Muhammad and the *laqab* Shams al-Din, and that at the beginning of his career Ahmad used the *laqab* Fakhr al-Din. Despite the early connection with Nayriz, the available evidence, as accepted by Simsar, suggests that from the accession of Shah Sultan Husayn at the latest, Ahmad's work as a calligrapher took place entirely in Isfahan. He first mentioned the city in the colophon of a prayer book dated AH 1107 (AD 1695–6),[17] again in the colophon of a manuscript dated three years later,[18] and intermittently during the rest of his active life. In the prayer book of AH 1107 the calligrapher referred to himself as 'Ahmad al-Nayrizi al-Sultani', which strongly suggests that he acquired a personal attachment to Shah Sultan Husayn soon after his accession. Ahmad used the sobriquet al-Sultani again on a *qit'ah* dated Isfahan, AH 1115 (AD 1703–4),[19] but he later dropped it for reasons as yet unknown. He did not use it even when he was working directly for Sultan Husayn, as in the case of the Qur'an of AH 1124, which is dedicated to the shah, and of the same ruler's *vaqfnāmah*, which Ahmad wrote in AH 1129 (AD 1716–17).[20] Ahmad's close association with the court is further illustrated in the colophon of a manuscript in the Khalili Collection, MSS 386, which is dated AH 1128 (AD 1715–16); this shows that he had access to a copy of the *Ṣaḥīfah al-sajjādiyyah* made by Yaqut al-Musta'simi and owned by the shah. It seems likely, therefore, that Ahmad received commissions from the court throughout Shah Sultan Husayn's reign. This period was brought to an abrupt and bloody end in 1722 by the Afghan invasion of Iran, during which Isfahan was besieged and then sacked. At this time Nayrizi took refuge in the house of Hajji Muhammad Sarraf. As a mark of his gratitude Ahmad dedicated a prayer-book to Hajji Muhammad in AH 1142 (AD 1729–30), in which he refers to the incident.[21] Although Safavid court patronage had ceased, Nayrizi continued to produce fine manuscripts for another 20 years and more.

The last work accepted as authentic by Simsar was a prayer book Ahmad completed in AH 1151 (AD 1738–9),[22] but cat. 54 below, which was copied in AH 1153 (AD 1740–41), has a note on the last page of the manuscript recording its presentation to Sulayman Khan Qajar by Muhammad Taqi ibn

Muhammad Hadi al-Husayni of Rasht. Sulayman Khan, who was born in Shiraz in AH 1183 (AD 1769–70), was a cousin of Agha Muhammad Khan (*reg*.1779–1797) and a leading figure in the early days of the Qajar regime. In AH 1200 (AD 1785–6) he was put in command of the army operating against insurgents in Gilan, and as a reward for his success there he was given the title I'tizad al-Dawlah in AH 1204 (AD 1789–90). After the death of Agha Muhammad, Sulayman Khan was a claimant for the throne, but he was defeated by Fath 'Ali Shah (*reg*.1797–1834), who pardoned him and appointed him tutor to his heir, 'Abbas Mirza, in Tabriz.[23] Sulayman Khan appears to have been a book collector of some note, since many of the manuscripts in the Gulistan Library contain notes and impressions of his seal recording his ownership.[24] These include another Nayrizi manuscript, which he made *waqf* in AH 1219 (AD 1804–5), a year before his death in AH 1220 (AD 1805–6).[25] The authenticity of cat.54 can therefore hardly be doubted, and, for the moment, this manuscript may be taken as Ahmad Nayrizi's last recorded work. The date of the calligrapher's death is not known.

To judge by the content of his extant work, which consists of Qur'ans, prayer-books and shorter texts drawn from these sources, Ahmad Nayrizi was a pious man. His religiosity may also have led to his specialization in *naskh*, which by his day had become associated with the Qur'an and other explicitly religious texts in Arabic, in contrast to *nasta'līq*, which we may describe in general terms as the style of script used for texts in Persian.[26] His style of *naskh* has been aptly described as 'a particularly confident one, characterized by exceptionally well-formed letters. Its most striking features are its relatively large size and the wide spacing of the lines of text. Vowels were given exactly the same weight as consonants, with care taken to ensure that the vowel signs were always placed at exactly the same distance above and below the consonants throughout a passage of the text.'[27] The circumstances in which he adopted this hand have still to be analyzed,[28] but there is some evidence that Nayrizi and his contemporaries were influenced by the work of 'Ala' al-Din Tabrizi (*fl.* until 1593), whose work he sometimes copied in later life.[29] Simsar has dismissed the strong tradition that Ahmad Nayrizi was the pupil of Muhammad Ibrahim Qumi, but two pieces of evidence lend some support to the accounts of Mirza Sanglakh and others – at the very least they explain why these authors thought that Muhammad Ibrahim was Ahmad's teacher.[30] The first is a calligraphic specimen in the Khalili Collection. It was written by Visal Shirazi in AH 1258 (AD 1842–3) after a piece written by Ahmad Nayrizi in AH 1120 (AD 1708), in which Ahmad had in turn been imitating an example of the work of Muhammad Ibrahim. In the colophon Ahmad described Muhammad Ibrahim, who had died by that date, as *ustādī wa-stinādī*, 'my master and my support'. The evidence for a master–pupil relationship is not conclusive, however, as Ahmad also used the term *ustādī* to describe 'Ala' al-Din Tabrizi, who, as noted above, flourished in the 16th century.[31] The second piece of evidence is the range of media in which the two men worked. Muhammad Ibrahim was a member of a family that provided some of the leading painters of the late Safavid period and was himself an illuminator as well as a calligrapher (see cat.50). Like the other members of his family, and in line with a growing fashion in the late Safavid period, he decorated lacquer wares with illumination and fine inscriptions. Ahmad Nayrizi, too, decorated lacquerware, as we have seen, and this suggests some connection with a workshop producing such items. In the circumstances, it is possible that the link was provided by Muhammad Ibrahim.

No doubt because of its quality, but also perhaps because he was a leading court scribe who survived the calamity of 1722, Ahmad's *naskh* was held in the highest esteem by later generations. Indeed, his standing was such that students of calligraphy in later times were told that if they wanted to 'become something in writing, endeavour to become like Ahmad Khan Nayrizi.'[32] A second measure of the high regard in which Ahmad Nayrizi's output was held is the notes and seal impressions on his work. For example, while in Karbala' in AH 1233 (AD 1817–8) an Indian Shi'i paid 100 rupees for a manuscript copied by Nayrizi in Isfahan in AH 1112 (AD 1700).[33] The same manuscript later entered the library of Nasir al-Din Shah Qajar and now forms part of the Gulistan Library in Tehran, where there are some 40 published examples of Nayrizi's work. These bear the seal impressions and *ex-libris* of such leading connoisseurs as Mirza Mahdi Khan Astarabadi, the secretary of Nadir Shah, as well as the Qajar rulers

كَانَ عَاقِبَةُ الْمُجْرِمِينَ ۞ وَإِلَى مَدْيَنَ أَخَاهُمْ شُعَيْبًا
قَالَ يَا قَوْمِ اعْبُدُوا اللَّهَ مَا لَكُمْ مِنْ إِلَهٍ غَيْرُهُ قَدْ جَاءَتْكُمْ
بَيِّنَةٌ مِنْ رَبِّكُمْ فَأَوْفُوا الْكَيْلَ وَالْمِيزَانَ وَلَا
تَبْخَسُوا النَّاسَ أَشْيَاءَهُمْ وَلَا تُفْسِدُوا فِي الْأَرْضِ
بَعْدَ إِصْلَاحِهَا ذَلِكُمْ خَيْرٌ لَكُمْ إِنْ كُنْتُمْ مُؤْمِنِينَ
وَلَا تَقْعُدُوا بِكُلِّ صِرَاطٍ تُوعِدُونَ وَتَصُدُّونَ
عَنْ سَبِيلِ اللَّهِ مَنْ آمَنَ بِهِ وَتَبْغُونَهَا عِوَجًا وَاذْكُرُوا
إِذْ كُنْتُمْ قَلِيلًا فَكَثَّرَكُمْ وَانْظُرُوا كَيْفَ كَانَ عَاقِبَةُ
الْمُفْسِدِينَ ۞ وَإِنْ كَانَ طَائِفَةٌ مِنْكُمْ آمَنُوا
بِالَّذِي أُرْسِلْتُ بِهِ وَطَائِفَةٌ لَمْ يُؤْمِنُوا فَاصْبِرُوا
حَتَّى يَحْكُمَ اللَّهُ بَيْنَنَا وَهُوَ خَيْرُ الْحَاكِمِينَ ۞ قَالَ الْمَلَأُ
الَّذِينَ اسْتَكْبَرُوا مِنْ قَوْمِهِ لَنُخْرِجَنَّكَ يَا شُعَيْبُ
وَالَّذِينَ آمَنُوا مَعَكَ مِنْ قَرْيَتِنَا أَوْ لَتَعُودُنَّ فِي مِلَّتِنَا
قَالَ أَوَلَوْ كُنَّا كَارِهِينَ ۞ قَدِ افْتَرَيْنَا عَلَى اللَّهِ كَذِبًا

الجزء
٩

Fath ʿAli Shah and Muhammad Shah. Previous owners also included Prince Farhad Mirza, a grandson of Fath ʿAli Shah, and Mahd ʿUlya, Nasir al-Din Shah's mother. Another, and much less desirable, effect of Nayrizi's high standing is the number of colophons that have been altered to include his name, a number of which have been published by Simsar.[34]

Ahmad Nayrizi is traditionally considered the progenitor of the distinctively Iranian form of *naskh* that had become the standard Qur'anic hand by the beginning of the Qajar period (1779–1924). The truth is that he was only one of a series of calligraphers who made a contribution to the development of the style, which began at an earlier date. This explains why cat. 44, which is dated AH 1082 (AD 1672) is in the same style as Nayrizi's. It also explains a note added by a 19th century Persian calligrapher, Abu'l-Fazl Savaji, to a manuscript by Muhammad Husayn Kazaruni, 'Muhammad Husayn is one of the calligraphers of the early 12th century. He was a contemporary of Mirza Ahmad Nayrizi, one of a group of *naskh* calligraphers whose writings could not be distinguished from that of Ahmad Nayrizi.'[35] Ahmad Nayrizi's role was to perfect the *naskh* hand, just as it had been Mir ʿAli Tabrizi's role to perfect *nastaʿliq*.[36]

One of the two Qur'ans by Ahmad Nayrizi in the Khalili Collection, cat. 53 below, shows that the calligrapher produced copies that differed in format from the two types described above. Cat. 53 measures 30.5 × 21 centimetres and can therefore be compared with cat. 45, but it lacks the division of the text area by gold rules and the interlinear glosses. It is a clear and powerful statement of the original Arabic text alone. The illumination also belongs to a different tradition, marked by the use of a combination of gold, blue and red grounds, which held sway throughout the rest of the 18th century and into the 19th. The sources of this tradition may be sought in a type of Qur'an illumination employed in Iran and Iraq in the 16th century but usually overlooked in favour of the magnificent products of the Shiraz school.[37] Indeed, many items illuminated in this style, especially the individual sections of Qur'ans prepared in 30 parts, have been classed as Ottoman, although their bindings betray their Safavid origins.[38] David James has already commented on the lack of documentary evidence for this period,[39] and the history of this group of manuscripts has yet to be written. Our current ignorance of this subject is yet another impediment to a full understanding of the late Safavid renewal in Qur'an production, which set the tone for the Afsharid, Zand and Qajar periods, when the copying, illumination and binding of Qur'ans was clearly held in the highest esteem.

1. Welch 1973, no.88. The manuscript has a lacquer binding (Pope 1938–9, pl.977B) with a border inscription in gold *riqā'* signed by 'Ali Riza and dated '125'. This figure has been read as AH 1125 (AD 1713), and the scribe identified as 'Ali Riza 'Abbasi (who flourished a century earlier!). It is more likely that the binding was added in the Qajar period, and the date should therefore be read as AH 1205 (AD 1790–91) or AH 1250 (AD 1834–5), when at least two calligraphers called 'Ali Riza were active (Bayani 1345–58, IV, pp.108–9, nos 312, 315). Welch 1973, no.18, is a single folio from a Qur'an of uncertain date.

2. Lings & Safadi 1976, no.146; Safadi 1978, p.64, fig.52.

3. See, for example, Bahrami & Bayani 1328; Gulchin Ma'ani 1347.

4. See, for example, Arberry 1967; Atabay 1351; Déroche 1985.

5. Arberry 1967, no.174 and pl.9; James 1980, no.66.

6. James 1980, p.85. *Cf.* James 1992b, no.5.

7. Christie's, London, 28 April 1998, lot nos 35, 36.

8. Christie's, London, 28 April 1998, lot no.35.

9. Quoted from Hairi 1986, p.1087. On these religious developments in general, see, for example, Algar 1977.

10. Raby 1996, no.160, for example.

11. Robinson, Khalili & Stanley 1996–7, nos 115–17, for example.

12. Simsar 1375, p.108, miscellanea, no.2.

13. Simsar 1375, pp.100–102.

14. Bayani 1345–58, IV, p.20; Atabay 1351, no.114; Simsar 1375, p.106, no.8. As we shall see, Ahmad signed his earliest dated work as Ibn Sultan Muhammad Fakhr al-Din Ahmad al-Nayrizi, while his contemporary 'Abdallah al-Yazdi gave his full name as Ibn Muhammad Muhsin al-Yazdi 'Abdallah (see cat.52). In other words, Ahmad, who we know was born in Nayriz, placed the *nisbah* al-Nayrizi immediately after his own name, whereas 'Abdallah placed the *nisbah* al-Yazdi after his father's name. This suggests that 'Abdallah was a Yazdi by descent but an Isfahani by birth and by residence.

15. Bayani 1345–58, IV, p.31 (under no.65); Atabay 1352, no.326; Simsar 1375, p.105, no.1. Note that Bayani 1345–58, IV, which is devoted to *naskh* calligraphers, was compiled from the author's notes after his death and does not reflect his methods or views.

16. Bahrami & Bayani 1328, no.122; Bayani 1329, no.26; 1345–58, IV, p.20; Atabay 1351, no.6; Simsar 1375, p.106, no.6.

17. Bayani 1345–58, IV, p.21; Atabay 1352, no.216; Simsar 1375, no.3.

18. Bayani 1345–58, IV, p.31; Atabay 1352, no.303 (where the date was read as 1101); Simsar 1375, p.105–6, no.4.

19. Bayani 1345–58, IV, p.26; Atabay 1353, no.12; Simsar 1375, p.107, albums, no.1.

20. Bayani 1345–58, IV, p.28; Simsar 1375, p.108, miscellanea, no.1.

21. Bayani 1345–58, IV, p.23; Atabay 1352, no.248; Simsar 1375, p.107, no.14.

22. Bayani 1345–58, IV, p.29; Simsar 1375, p.108, no.20.

23. Bamdad 1347–51, II, pp.118–24.

24. See Atabay 2535, p.120, for example.

25. Atabay 1352, no.192.

26. See Raby 1996, p.212.

27. Raby 1996, p.212.

28. Mehdi Bahrami, for example, thought that the new style of *naskh* developed during the late Safavid period, exemplified by the work of Ahmad Nayrizi, Muhammad Husayn Kazaruni, Muhammad Riza Shirazi and Nasir Katib Shirazi was a product of Shiraz, no doubt because the *nisbah*s of these calligraphers were all derived from Shiraz or from nearby towns; see Bahrami & Bayani 1328, p.33.

29. See Simsar 1375, pp.100–101.

30. Raby 1996, no.163.

31. Simsar 1375, p.100–101.

32. Rafi'i Mihrabadi 1345, p.156.

33. Atabay 1352, no.304.

34. Simsar 1375, pp.103–4.

35. Bayani 1329, pp.12–13.

36. Bayani 1345–58, II, pp. 441–6.

37. See James 1992b, pp.113–15.

38. Stanley 1996, no.28.

39. Three signed and dated examples were copied in 1571–85 by 'Ali ibn Muhammad ibn Muqaddam (Bayani 1345–58, IV, p.113, no.328); see Jeddah 1991, no.17; James 1992b, nos 49, 51 (the latter written in Karbala').

42
Single-volume Qur'an

Khalajan al-Shiraz, AH 1039 (AD 1629–30)

335 folios, 17.4 × 10.7 cm, with
14 lines to the page
Material The text is on a smooth
paper coloured cream and sprinkled
with gold. Due to the density of the
surface colour, mould markings are
impossible to identify. The margins
and replacement folios are of a crisp,
off-white to grey, burnished laid
paper; there are approximately ten
laid lines to the centimetre, and no
apparent rib shadows or chain lines.
On the replacement folios a central
panel equivalent to the text area has
been coloured cream to match the
original, 17th-century paper
Text area 10.6 × 5 cm
Script Main text in *naskh*, in black,
with reading marks in red; surah
headings in gold *riqāʿ*; restored text
in white *riqāʿ* and black *naskh*;
19th-century marginalia in gold
riqāʿ (text divisions) and black
shikastah (*hadīth* texts)
Scribe ʿImad ibn Ibrahim
Illumination Extensive decoration
in a Qajar style on folios 1b–4b;
text frame of gold, black and blue
rules, and outer frame of one gold
rule; verses marked by gold whorls;
surah headings; marginal ornaments
marking text divisions and *sajdah*s;
hadīth texts in margin in 'clouds',
reserved in gold
Documentation A colophon
Binding Lacquer covers of
circa 1810–20
Accession no. QUR54

1. Christie's, London, 11 June 1986,
lot no.88.
2. A scribe named ʿImad ibn Ibrahim
al-Hasani added marginal notes and
an index of personal names to a copy
of the *Takmilat al-Nafaḥāt* of ʿAbd
al-Ghafur Lari in 1584 (Bayani
1345–58, II, pp.533–4). The script
employed was *nastaʿlīq*, and Mehdi
Bayani presumed that the scribe in
question was the celebrated Mir
ʿImad al-Hasani, and that Mir
ʿImad's father, whom the calligra-
pher did not name in his other
known work, was called Ibrahim.
3. Sotheby's, London, 26 April 1982,
lot no.31.

This Qur'an was written in a fine *naskh* hand by a scribe called ʿImad ibn Ibrahim in 1629,
when he was resident in Khalajan al-Shiraz. This calligrapher, who gave his name as ʿImad
al-Din Hasan ibn Ibrahim in a Qur'an he copied in AH 1036 (AD 1626–7),[1] is not mentioned
in the standard sources, but this manuscript clearly shows him to have been a master of
the *naskh* script in the tradition of Yaqut al-Mustaʿsimi.[2] He appears to have belonged to a
family of scribes, since a man called Karim ibn Ibrahim also wrote a Qur'an while resident
in the village of Khalajan near Shiraz.[3]

The work of ʿImad ibn Ibrahim in cat.42 consists of the text on folios 4–238 and
243–334. The surah headings on these folios are also original. They are in the *riqāʿ* style,
written in gold outlined in black, and are set against the natural, dark-cream ground,
which is decorated with fragments of a floral scroll executed in blue. Each heading is
contained within a rectangular panel formed of two sets of horizontal gold, green and
gold rules; the sides of the panels were formed by the text frame, and the innermost
gold rule of this frame is often broken by the last letter of the surah heading, suggesting
that this rule at least is an original feature.

At the beginning of the 19th century the manuscript underwent a thoroughgoing
renovation, and its current splendid condition is due to this work, which may be
attributed to Shiraz on stylistic grounds and dated *circa* 1818 (see below). The texts
on the first folios (to surah II, middle of verse 8) and on folios 239–42 (surah XXV,
verse 33, to surah XXVI, verse 81) were rewritten; the remainder of the manuscript was
remargined; and a single folio was added at the front and back. In the course of this
restoration some exquisite illumination was also supplied. On folios 2a–3b surah I,
al-Fātiḥah, was written in white *riqāʿ* on a gold ground within a pair of shaped
medallions, each set within an illuminated panel, and the margins are adorned with
scrollwork in gold and colours on a natural ground. The same scrollwork was used for
the margins of folio 3b, which is inscribed with the beginning of surah II, *al-Baqarah*.
This text was also provided with an elaborate head-piece, which contains the title
written in white *riqāʿ*, and the interlinear spaces on this and the facing page, folio 4a,
were filled with tiny floral motifs on gold grounds.

A large number of inscriptions were placed in the margins as part of the renovation.
They include catchwords; notes in *naskh* that supply omissions from the Qur'anic text
made by the original copyist, ʿImad ibn Ibrahim; three prayers in *naskh*, on folios 72a,
77a and 79b; and elegant ornamental devices mark the principal divisions of the text and
the *sajdah*s – these devices contain inscriptions in gold *riqāʿ* on a plain ground decked
with floral elements in blue, echoing the styling of the earlier surah headings. The most
striking of the texts, however, is the *Khavāṣṣ-i suvar* ('Special qualities of the surahs'),
the series of *hadīth*s on the properties of each surah deriving from Shiʿi Imams. Written
in a fine *shikastah* hand and set in illuminated 'clouds', the *hadīth*s were added by an
anonymous scribe in AH 1224 (AD 1809–10), according to a note on folio 332b, but this
appears to be an error for AH 1234 (AD 1818–19), the date given in a note on folio 286b.
It was probably at this time too that the manuscript was rebound with its lacquer
covers, for these are in a style current in Shiraz in the early 19th century.

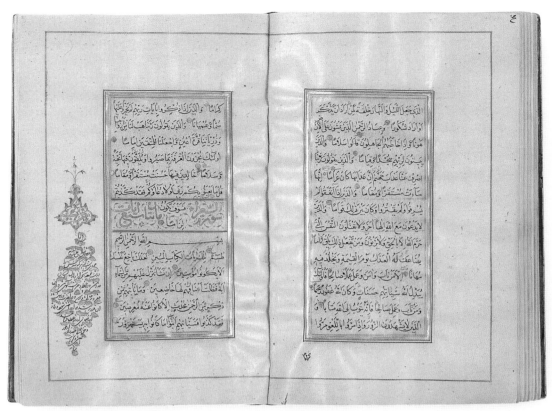

42 folios 199b–200a

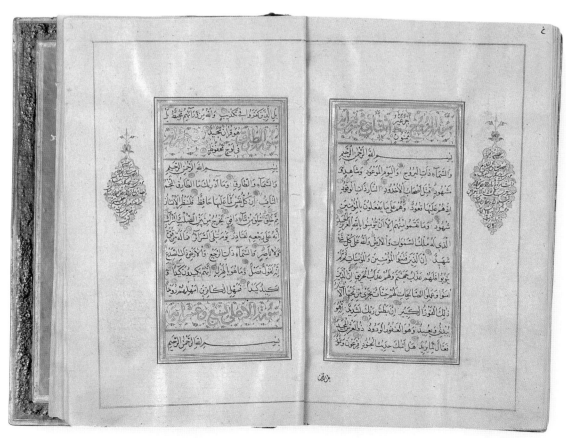

42 folios 325b–326a

43
Single-volume Qur'an

Iran, probably Isfahan, 1 Jumada'l-Ukhra 1074 (1 December 1663)

427 folios, 14.2 × 9 cm, with 12 lines
to the page
Material The text is on a fine, cream,
gold-sprinkled laid paper, with
approximately ten laid lines to
the centimetre. Due to the volume
of gold on the paper, its origin is
impossible to identify. The margins
are of a crisp, light-brown,
burnished European machine-
made paper
Text area 6.9 × 3.6 cm
Script Main text in *naskh*, in black,
with reading notes in red; surah
headings in red *riqā'* (white on folios
1b–2a)
Scribe Ibn Haydar Muhammad
Taqi al-Shushtari
Illumination Ornamental panels
surround the text on folios 1b–2a,
199b–200a, 201b–202a and
425b–426a; text frames of a single
gold rule, a band of floral motifs
0.6 cm wide, and one gold, one black
and one blue rule; outer frame of a
single gold rule; text areas sprinkled
with gold; verses marked by a leaf-
like form in blue; surah headings in
plain panels formed of single gold
rules
Documentation Two colophons
and a record of acquisition
Binding Iranian lacquer covers
of the late 19th century
Accession no. QUR17

1. Sotheby's, London, 11 April 1988,
lot no. 139.
2. Bayani 1345–58, IV, p. 143, no. 455.
3. Najafi 1989, p. 77.
4. Khalili, Robinson & Stanley
1996–7, Part Two, no. 480.
5. I'timad al-Saltanah, *Rūznāmah*,
ed. Afshar, p. 1050.
6. I'timad al-Saltanah, *Al-ma'āthir
wa-l-āthār*, ed. Afshar, p. 42.

The scribe responsible for this copy of the Qur'an is known from three other works.
The earliest is a copy of the *Miftāḥ al-falāḥ* of Baha' al-Din 'Amili made in AH 1069
(AD 1658–9),[1] while the latest is a copy of the *Ṣiḥāḥ fī'l-lughah* of Abu Nasr Isma'il
al-Jawhari completed in Sha'ban 1093 (August–September 1682).[2] The third is a Qur'an
in the Islamic Museum in Cairo, produced in Isfahan in AH 1077 (AD 1666–7) for Hajji
Yusuf, who is described as *mu'tamad al-khawāṣṣ al-ḥaram al-'illiyyah al-'āliyyah
al-salṭanah* [*sic*] *al-khāqāniyyah*, 'entrusted with the noble [ladies] of the elevated,
sublime, sultanic and imperial harem'.[3] It is clear from this that Muhammad Taqi
worked in Isfahan, and that he was connected with the Safavid court.

The Qur'an was prepared in two volumes (folios 1b–200a and 202b–426a, with
folios 200b–202a blank), which are now bound together. The text on the first and last
openings of both volumes is set in illuminated panels with blue, gold and black grounds,
and the text on the other pages is surrounded by a frame containing an undulating stem
set with flowers and leaves, executed in gold, red and blue on a natural ground.

The book was remargined and rebound in the late 19th century. The new margins
were ruled in gold with an outer frame, or *kamand*, and the principal textual divisions
(*juz'* and *ḥizb*) are marked by inscriptions in gold *riqā'*. Catchwords in black were also
added at this stage. A curious feature of this manuscript is the (unreliable) foliation
supplied by the scribe in the bottom left-hand corner of the text area on each verso.

The lacquer covers are decorated with a flower-and-bird composition executed in
a coppery tone of gold on a black ground, scattered with fragments of a conventional
floral scroll in white. The doublures are of red paper. Lacquerwork of this kind was
practised by a number of artists working in Tehran in the later 19th and early 20th
centuries, including Razi Sani' Humayun, who painted a pen box with comparable
decoration in AH 1303 (AD 1886).[4]

On folio 427b, a prayer for the deceased was written in *shikastah* script by Rizaquli
ibn Muhammad 'Ali Qumi Tafrashi on 19 Ramadan 1312 (16 March 1895); this may
have been the Rizaquli Tafrashi who was first secretary to the chief minister in AH 1313
(AD 1895–6).[5] A note in Persian on folio 426b dated AH 1327 (AD 1909–10) records
the purchase of the manuscript for 12 *tūmān*s from an unnamed Jewish dealer and is
accompanied by an impression of the seal of Muhammad Husayn ibn Muhsin, which
is dated AH 1278 (AD 1861–2). The seal may be that of Mirza Husayn Navvab, son of
Muhsin Mirza, who was royal master of the stable on two occasions during the reign
of Nasir al-Din Shah (1848–1896).[6]

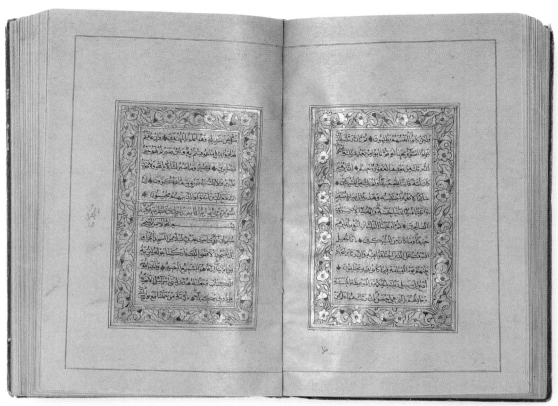

43 folios 190b–191a

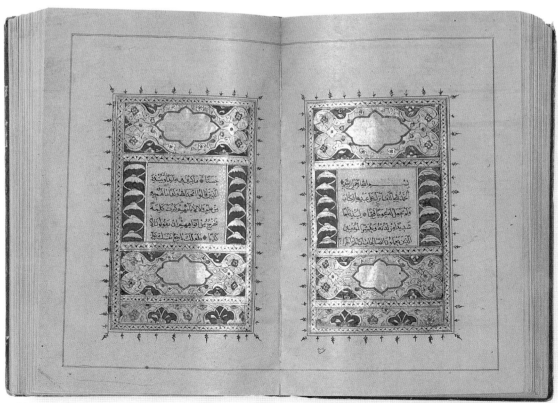

43 folios 201b–202a

44
Single-volume Qur'an
Iran, perhaps Isfahan, 28 Dhu'l-Hijjah 1082 (26 April 1672)

352 folios, 14.4 × 8.8 cm, with 15 lines to the page
Material The text is on a thin, crisp, light-cream burnished paper. It is probably wove, but due to the quantity of pigment on the paper, surface mould markings are difficult to identify. The margins are of a smooth, burnished European machine-made paper, dyed a dark-cream or parchment colour.
Text area 9.5 × 4.8 cm
Script Main text in *naskh*, in black, with reading marks in red; surah headings in gold *riqā'* (white on folios 1b–2a); concluding prayer and colophon in black *riqā'*
Scribe Muhammad Rahim ibn Yusuf 'Ali al-Nishapuri
Illumination Extensive decoration in a Qajar style on folios 1b–2a; text frame of gold, black and blue rules, and outer frame of one gold rule; each line of text in a 'cloud' reserved on a gold ground; verses punctuated by gold whorls with red and blue dots; surah headings; modest illumination on folio 352a–b, after the main text and beneath the colophon
Documentation Colophon and two impressions of an owner's seal
Binding Lacquer covers of *circa* 1800
Accession no. QUR195

1. Bahrami & Bayani 1328, section 2, no.112, p.65; Bayani 1329, p.10; Bayani 1345–58, IV, no.511, p.157; Atabay 1352, no.52.
2. According to the colophon, the text was completed, 'at the end of the day on Wednesday, 28 Dhu'l-Hijjah 1082', but this date fell on a Tuesday. The confusion may have arisen because in Iran the new day begins at sunset, not midnight, and this manuscript was completed 'at the end of the day'.
3. See, for example, Soudavar 1992, nos 110, 111, 114, 115.
4. Atabay 1352, illustration opposite p.392.
5. *Cf.* Khalili, Robinson & Stanley 1996–7, no.72; Majda 1996, p.31, no.22.
6. For a translation of this text, see Safwat 1996, no.40.

The scribe of this manuscript, Muhammad Rahim ibn Yusuf 'Ali al-Nishapuri, is known from one other Qur'an manuscript, which is in the Gulistan Library, Tehran.[1] This was completed on 24 Dhu'l-Qa'dah 1077 (18 May 1667), and Muhammad Rahim stated in the colophon that it was the sixteenth copy of the Qur'anic text he had made. In the colophon of cat.44 he recorded that this was his twenty-fifth Qur'an, and so the scribe must have completed nine copies in the five years between May 1667 and April 1672.[2]

Cat.44 was remargined, repainted and rebound in the mid-19th century, but it is not certain that the surah headings date from this renovation. They were inscribed in gold *riqā'* within panels defined by single gold rules, and in most cases (surahs III–XCII) the field around them was subsequently painted in blue and ornamented with tiny floral motifs in gold, orange and pink. The heading of surah XV, *al-Ḥajar* (folio 147b), was treated in a slightly different manner, in that the blue ground of the panel and the diminutive floral motifs in gold and orange have been overlaid with a continuous pattern of spiralling tendrils, executed in a blueish-white. In the margin beside and above this surah heading there are three illuminated devices of the Qajar period, all with spaces for inscriptions and all left blank. This is the only point in the manuscript where such ornament appears.

From folio 347b onwards varied colours were used for the backgrounds of the surah headings, no doubt because of the large number of headings that appear on the last ten pages of the text. Folios 347b–348a, for example, have five headings, two with the standard blue backgrounds (those of surahs XCIV and XCVI), one (surah XCV) with a mauve ground, and one (surah XCVII) with a pink ground. Blue and mauve or pink grounds also appear on folios 348b–349a and 350b–352a, where the text ends, but on folios 349b–350a all five headings are on blue grounds. Here, however, three of the headings appear to have been executed by a different hand, and in the third of these (surah CII, on folio 350a) the blue ground is restricted to a central cartouche, which is flanked by illumination in a Qajar style on a gold ground. This confused picture suggests that all or some of the panels containing the surah headings have been reworked, but it may be observed that the mauve and pink used towards the end of the manuscript are typical of the style of book illustration and album painting current in Isfahan during the 17th century.[3] This is also supported by the very similar character of the surah headings in a Qur'an copied by Muhammad Ibrahim Qumi in AH 1091 (AD 1680), now in the Gulistan Library.[4]

The lacquer covers have floral decoration of *circa* 1800, but heavily retouched.[5] The doublure of the upper cover is divided into compartments and inscribed in black *naskh* with a *shamā'il-nāmah*, or physical description of the Prophet, with an interlinear Persian translation of the Arabic text in red *nasta'līq*.[6] The doublure of the lower cover has been overpainted in a primitive style with a depiction of 'Ali and his two sons. The repainting and the fact that even though the binding has been trimmed at the bottom it does not fit the text block suggest that it was added to the manuscript comparatively recently.

There is a seal impression on folios 1a and 352b bearing the name Fathallah al-Husayni and the date AH 1277 (AD 1860–61).

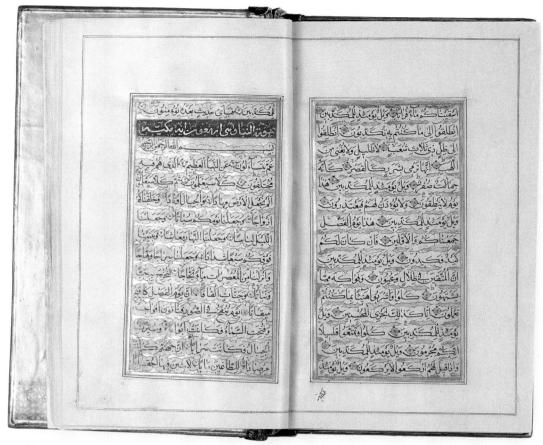

44 folios 338b–339a

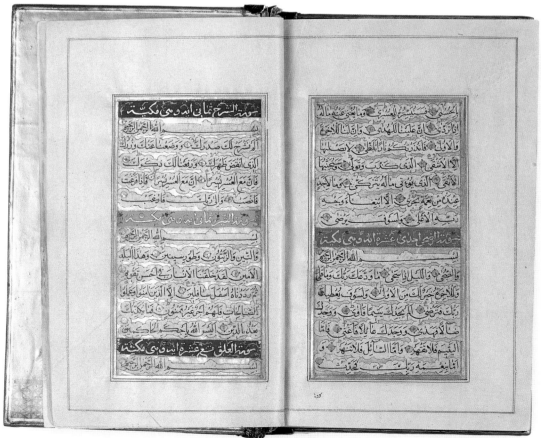

44 folios 347b–348a

45
Single-volume Qur'an

Iran, probably Isfahan, AH 1101 (AD 1689–90)

403 folios, 31.8 × 18.7 cm, with 11
lines of Qur'anic text and 11 lines of
interlinear translation on each page
Material The text is on a crisp laid
paper, dyed a dark-cream to light-
brown colour and lightly burnished;
there are approximately eight laid
lines to the centimetre, and no
apparent rib shadows or chain lines.
The margins are of a smooth, bright-
cream, lightly burnished laid paper,
with approximately eight laid lines
to the centimetre, and no apparent
rib shadows or chain lines
Text area 21.2 × 10.4 cm
Script Main text in *naskh*, in black
with reading marks in red; inter-
linear translation in red *shikastah*;
surah headings and marginal verse
counts and *ḥizb* and *juz'* markers
in gold *riqā'*; other supplementary
texts in gold *naskh* and yellow
riqā' (prayers on folios 1b–3a) and
black *nasta'līq* with rubrications
(preface to translation and marginal
commentary)
Scribes Muhammad Riza al-Shirazi
(main text), Ibn Muhammad Amin
Muhammad Hadi Shirazi (transla-
tion, preface and commentary)
Illumination Extensive decoration
in a late Safavid style on folios
1b–3a; text frame of gold, blue,
purple and black rules and a narrow
outer frame of gold and black rules;
each line of text separated from the
next by a ruling in gold and black;
verses marked by gold whorls;
surah headings; marginal verse
counts and *ḥizb* and *juz'* markers
Documentation Two colophons,
two notes, and seal impressions
Binding Contemporary
Accession no. QUR301
Published Sotheby's, London,
7 April 1975, lot no.193

1. It seems to have been the custom
to place Ardakani's preface at the
end of Qur'ans containing his
glosses; *cf.* Christie's, London,
28 April 1998, lot nos 35, 36, for
example.
2. Bahrami & Bayani 1328, section 2,
p.66, no.114; Bayani 1345–58, IV,
p.159, no.519.
3. Gulchin Ma'ani 1347, pp.240–43,
no.127. The manuscript has a lacquer
binding with an inscription in the
border signed by Ahmad al-Nayrizi
in AH 1117 (AD 1705–6).

This manuscript is an outstanding example of Qur'an production at the end of the 17th century. In its present state its main components are two prayers, to be said before and after reading the Qur'an, on folios 1b–2a; the Qur'anic text itself, with interlinear glosses and a marginal commentary in Persian (folios 2b–401a); a long note on folio 401b in the name of an owner, Husayn 'Ali Khan Mu'ayyir al-Mamalik; and, on folios 402b–403a, a preface to the interlinear translation, from which we learn that it was composed for the Safavid ruler Shah Sulayman (*reg.* 1666–1694) by 'Ali Riza ibn Kamal al-Din al-Ardakani in AH 1084 (AD 1673–4).[1]

According to the colophon on folio 401a the Qur'anic text was written by Muhammad Riza al-Shirazi, who was responsible for two other copies of the Qur'an produced in the 1680s. One, preserved in the Museum of Ancient Iran in Tehran,[2] is dated AH 1094 (AD 1682–3); the other, in the library of the shrine of Imam Riza in Mashhad,[3] was completed in AH 1097 (AD 1685–6). Some or all of a group of calligraphic specimens and a prayer book signed Muhammad Riza and dated between AH 1087 (AH 1676–7) and AH 1114 (AD 1702–3) may also be the work of Muhammad Riza al-Shirazi,[4] although it must be borne in mind that he was only one of a number of calligraphers with this name who were active in Iran in this period.[5] The prayer book, a copy of the *Ṣaḥīfah-i sajjādiyyah* preserved in the Gulistan Library, Tehran, was completed on 28 Rajab 1092 (13 August 1681) for 'the most noble, most exalted, the august, the sublime *navvāb*', and in the colophon Muhammad Riza described himself as 'teacher of the small boys of [my] royal and noble superior' (*mu'allim-i ghulāmān-i kūchak-i sarkār-i khāṣṣah-i sharīfah*). If this Muhammad Riza is Muhammad Riza Shirazi, it would mean that the calligrapher was in Isfahan and had established a link with the Safavid court by the early 1680s. This would accord with the stylistic features and layout of cat.45, which are a product of court culture under Shah Sulayman (see above, p.126).[6]

According to a second colophon on folio 401b the interlinear glosses in cat.45 were completed five years after the main text, in AH 1106 (AD 1694–5), by Muhammad Hadi ibn Muhammad Amin Shirazi, and the same hand was responsible for the preface on folios 402b–403a and the marginal commentary. This calligrapher's earliest recorded work is a copy of the *Uṣūl u furū'* of Kafi which he signed as Muhammad Hadi Shirazi in AH 1091 (AD 1680–1),[7] while his last known work was on the glosses and commentary of a Qur'an that was subsequently donated by Shah Sultan Husayn to the shrine of Shaykh Safi in Ardabil. This work had been left unfinished by a scribe called 'Ali Riza in AH 1082 (AD 1671–2) and was completed by Muhammad Hadi in AH 1111 (AD 1699–1700).[8]

The use of two different types of paper, one for the text area and another for the margins, appears to have been based on æsthetic considerations, and not, as in cat.42–4, the result of a renovation during the Qajar period. This is indicated by the survival of the original binding, whereas cat.42–4 have 19th-century lacquer covers; by the use of the same paper for the margins as for folios 402 and 403, the leaves bearing the preface to the interlinear translation, dated AH 1106 (AD 1694–5); by the presence on the margins of the same grid of impressed guidelines as occurs on folios 402 and 403; and, most importantly, by the continuity in the *shikastah* hand between the interlinear translation, the preface on folios 402b–403a, and the marginal commentary.

The manuscript is remarkable as much for the quality of its illumination as of its calligraphy. The first two pages of text (folios 2b–3a) have magnificent head-pieces, as well as panels of exquisite ornament above and below the text. The margins are filled with scrollwork bearing stylized floral motifs, executed in gold and colours on a natural ground, and small fragments of such scrolls are scattered through the text, which is

4. Bayani 1345–58, IV, p.157, no.512.
5. Among them was Muhammad Riza Tabrizi (d.1706 or 1707), whom his contemporary Muhammad Salih Isfahani called 'the foremost calligrapher of the age' (Bayani 1345–58, III, pp.725–6, no.1040; see also Bayani 1345–58, IV, pp.159–60, nos 522, 523).
6. Indeed, it is possible that cat.45 was commissioned by the shah himself, and that the delay of five years before the addition of the supplementary texts was caused by Sulayman's death.
7. Bayani 1345–58, IV, p.191, no.645; Atabay 1352, pp.62–4.
8. Bahrami & Bayani 1328, section 2, p.70, no.119. For other works by him, see Christie's, London, 24 November 1987, lot no.71; 28 April 1998, lot no.35; Sotheby's, London, 22 November 1985, lot no.423; 23 April 1997, lot no.52.
9. An unusual aspect of this Qur'an is the absence of catchwords and the placing of foliation numbers in the bottom left corner of each verso.
10. Husayn 'Ali Khan, of whom there is a fine portrait in the Khalili Collection (MSS 825; see Vernoit 1997, no.67), played a prominent role in the reigns of Fath 'Ali Shah and Muhammad Shah, and at Muhammad Shah's death in 1848 he was one of the main supporters of his son and successor, Nasir al-Din Shah, holding Tehran against other contenders until his arrival; see Ardakani 1368, p.670; Mu'ayyir al-Mamalik, p.274; Bamdad 1347–51, V, p.128.
11. For Aqa Muhsin (Muhammad Muhsin Isfahani), see Bayani 1345–58, IV, pp.185–6. For Dust 'Ali Khan, see Bamdad 1347–51, I, pp.495–500.

punctuated by more elaborate verse markers than the rest of the text. The prayers on folios 1b–2a, written in gold *naskh*, have a single head-piece of very similar design but painted in a different range of colours; the margins are filled with the same scrollwork, but without the coloured highlights. By contrast the surah headings are relatively modest affairs: as in cat.42, the title is in gold *riqā'*, and the natural background is set with fine blue scrolls. Groups of five and ten verses and the main divisions of the text are noted in the margins in simple gold *riqā'* outlined in black, without the ornamental frames seen in the 17th-century Qur'ans remargined in the 19th century.[9]

The fine covers are of black shagreen and have a recessed centre-and-corner composition and matching border with alternating cartouches and quatrefoils, as well as some decoration painted in gold. The recessed elements are gilt and have pressure-moulded ornament of plant-based motifs. The doublures are of red morocco, with a centre-and-corner composition in leather filigree. In the central medallion and corner-pieces the filigree, worked as scrolls bearing floral motifs, is gilt and set against a ground of mid-blue cloth, while the large pendants to the central medallion have an arabesque design in black on a gilt leather ground.

In the early 19th century the manuscript became the property of Muhammad Taqi ibn Muhammad Husayn, impressions of whose seal, dated AH 1234 (AD 1818–19), appear on folios 1a and 403b. The Qur'an was subsequently purchased, in Jumada'l-Ula 1262 (April–May 1846), by Husayn 'Ali Khan Mu'ayyir al-Mamalik, the treasurer of Muhammad Shah Qajar. The acquisition was marked by the long and elaborately worded inscription on folio 401b, which is not in Husayn 'Ali Khan's hand but is followed by an impression of his personal seal, dated AH 1238 (AD 1822–3). Husayn 'Ali Khan was a son-in-law of Fath 'Ali Shah and, as the inscription affirms, belonged to the family which had held the posts of master of the mint (*mu'ayyir al-mamālik*, 'assayer of the realm') and royal treasurer (*khazīnah-dār-i sulṭānī*) since the reign of Nadir Shah (1736–1747). Husayn 'Ali was the third member of the family to hold these posts, which he inherited on his father's death in 1821 or 1822, and the composer of the inscription hopes that God will continue to grant them to him and to his descendants.[10]

The manuscript seems to have remained in Husayn 'Ali Khan's family for some time after his death in 1857: in a note dated 1861 on folio 1a an unnamed scribe recorded the transfer of the marginal notes to a Qur'an copied by Aqa Muhsin Khwashnivis which belonged to Husayn 'Ali Khan's son Dust 'Ali Khan Mu'ayyir al-Mamalik.[11]

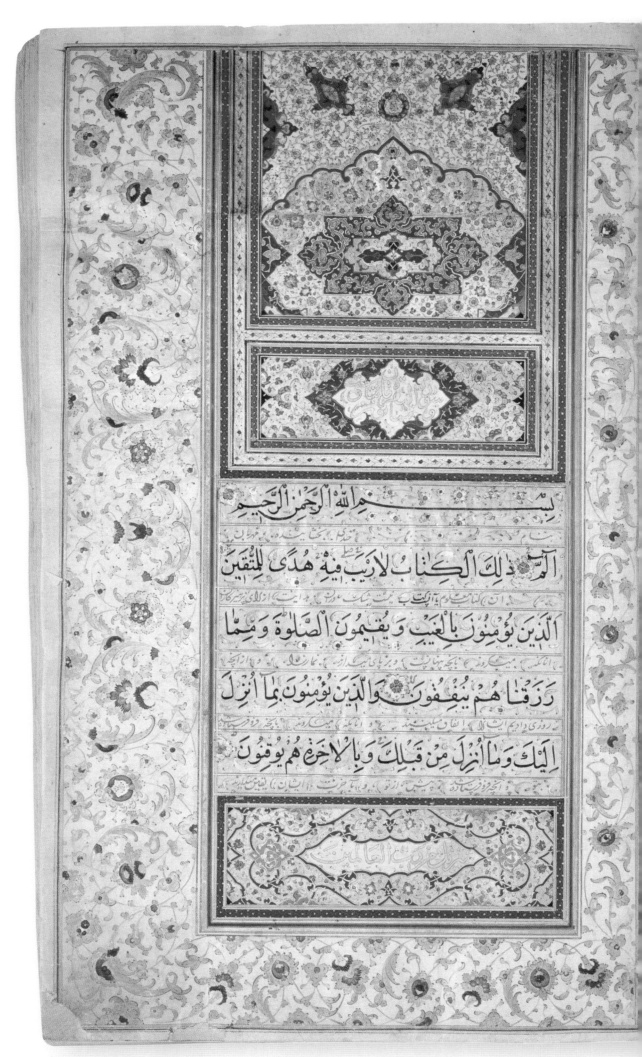

بِسْمِ اللهِ الرَّحْمٰنِ الرَّحِيمِ

الٓمٓ ذٰلِكَ الْكِتَابُ لَا رَيْبَ فِيهِ هُدًى لِّلْمُتَّقِينَ

الَّذِينَ يُؤْمِنُونَ بِالْغَيْبِ وَيُقِيمُونَ الصَّلَوٰةَ وَمِمَّا

رَزَقْنَاهُمْ يُنْفِقُونَ وَالَّذِينَ يُؤْمِنُونَ بِمَا أُنْزِلَ

إِلَيْكَ وَمَا أُنْزِلَ مِنْ قَبْلِكَ وَبِالْآخِرَةِ هُمْ يُوقِنُونَ

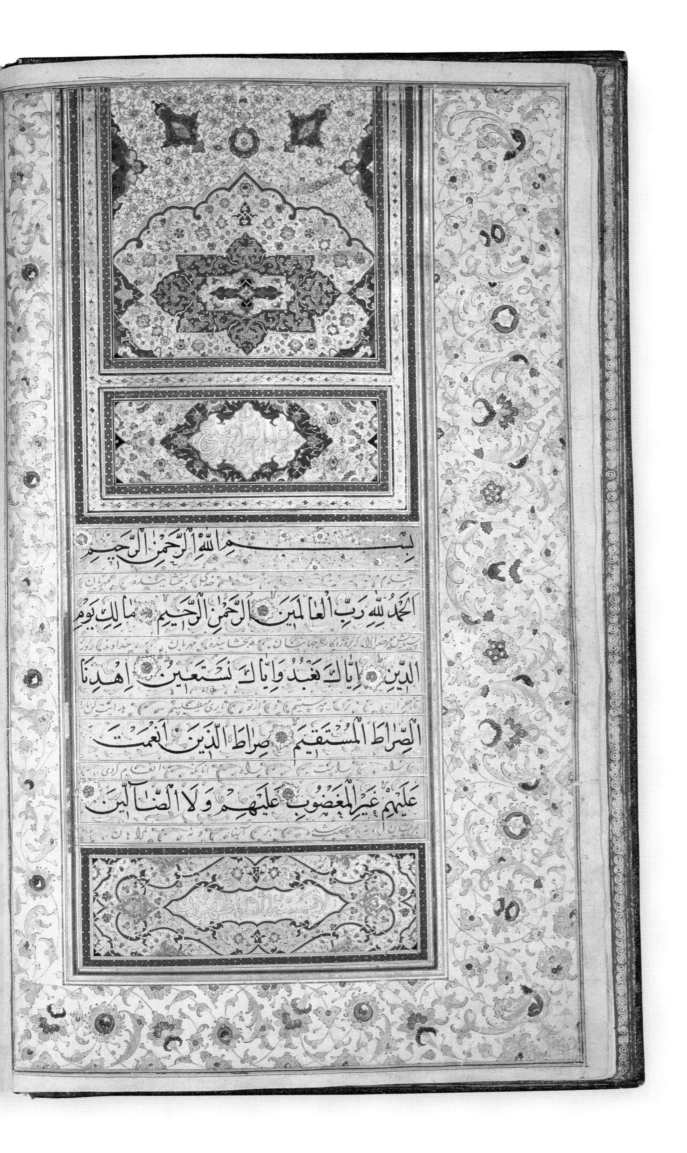

بِسْمِ اللهِ الرَّحْمٰنِ الرَّحِيمِ

الْحَمْدُ لِلهِ رَبِّ الْعَالَمِينَ الرَّحْمٰنِ الرَّحِيمِ مَالِكِ يَوْمِ

الدِّينِ إِيَّاكَ نَعْبُدُ وَإِيَّاكَ نَسْتَعِينُ اهْدِنَا

الصِّرَاطَ الْمُسْتَقِيمَ صِرَاطَ الَّذِينَ أَنْعَمْتَ

عَلَيْهِمْ غَيْرِ الْمَغْضُوبِ عَلَيْهِمْ وَلَا الضَّالِّينَ

اللَّيْلِ وَنِصْفَهُ وَثُلُثَهُ وَطَائِفَةٌ مِنَ الَّذِينَ مَعَكَ

شب و نصفش و ثلثش و گروهی از آنکه با تواند

وَاللَّهُ يُقَدِّرُ اللَّيْلَ وَالنَّهَارَ عَلِمَ أَنْ لَنْ تُحْصُوهُ فَتَابَ

و خدا اندازه میکند شب و روز را دانست که هرگز نتوانید آنرا پس کرد

عَلَيْكُمْ فَاقْرَءُوا مَا تَيَسَّرَ مِنَ الْقُرْآنِ عَلِمَ أَنْ سَيَكُونُ مِنْكُمْ

ارشا پس بخوانید آنچه میسرشود از قران دانست که هرآینه خواهندبود ارشا

مَرْضَى وَآخَرُونَ يَضْرِبُونَ فِي الْأَرْضِ يَبْتَغُونَ مِنْ

بیماران و دیگرانه بسیرخواهندبود در زمین که بجویند از

فَضْلِ اللَّهِ وَآخَرُونَ يُقَاتِلُونَ فِي سَبِيلِ اللَّهِ فَاقْرَءُوا مَا

فضل خدا و دیگرانی کارزارخواهندکرد در راه خدا پس بخوانید آنچه

تَيَسَّرَ مِنْهُ وَأَقِيمُوا الصَّلَاةَ وَآتُوا الزَّكَاةَ وَأَقْرِضُوا اللَّهَ

میسرشود ازان و بپای دارید نماز را و بدهید زکوة را و وام دهید خدا

قَرْضًا حَسَنًا وَمَا تُقَدِّمُوا لِأَنْفُسِكُمْ مِنْ خَيْرٍ تَجِدُوهُ عِنْدَ اللَّهِ

وامی نیکو و آنچه پیش عربیده برای خودتان از خوبی بیابیداش نزد خدا

هُوَ خَيْرًا وَأَعْظَمَ أَجْرًا وَاسْتَغْفِرُوا اللَّهَ إِنَّ اللَّهَ غَفُورٌ

آن بهتر و عظیمه ازراه پاداش و آمرزش خواهید از خدا برستی که خدا امرزنده

رَحِيمٌ

رحیم

بِسْمِ اللَّهِ الرَّحْمَٰنِ الرَّحِيمِ

بنام

يَا أَيُّهَا الْمُدَّثِّرُ ۝ قُمْ فَأَنْذِرْ ۝ وَرَبَّكَ فَكَبِّرْ ۝ وَثِيَابَكَ فَطَهِّرْ ۝

ای جامه درخود جمه برخیز پس بیم ده وپروردکار ترا پس بزرگ گردان و جامه ات را پس پاکیزه کن

رَبِّكَ وَتَبَتَّلْ إِلَيْهِ تَبْتِيلًا رَبُّ الْمَشْرِقِ وَالْمَغْرِبِ لَا إِلَٰهَ

پروردگارت و منقطع شو موحّد سوی او منقطع شدنی پروردگار مشرق و مغرب نیست هیچ

إِلَّا هُوَ فَاتَّخِذْهُ وَكِيلًا وَاصْبِرْ عَلَىٰ مَا يَقُولُونَ وَاهْجُرْهُمْ

جز او پس کارساز گیر او را کارساز و صبر کن بر آنچه میگویند و جدا کن از ایشان

هَجْرًا جَمِيلًا وَذَرْنِي وَالْمُكَذِّبِينَ أُولِي النَّعْمَةِ وَ

جدا کردنِ نیکو و واگذار مرا با تکذیب کنندگان صاحبان نعمت و برخورداری

مَهِّلْهُمْ قَلِيلًا إِنَّ لَدَيْنَا أَنْكَالًا وَجَحِيمًا وَطَعَامًا

مهلت ده ایشان را اندکی بدرستی که نزد ماست بندهای گران و دوزخ و خوراکی

ذَا غُصَّةٍ وَعَذَابًا أَلِيمًا يَوْمَ تَرْجُفُ الْأَرْضُ وَالْجِبَالُ

صاحب گلوگیری و عذابی دردناک روزی که بلرزد در آید زمین و کوهها

وَكَانَتِ الْجِبَالُ كَثِيبًا مَهِيلًا إِنَّا أَرْسَلْنَا إِلَيْكُمْ رَسُولًا

و شوند کوهها تلهای ریگ پراکنده یا بیقرار بدرستی که ما فرستادیم بسوی شما پیغمبری

شَاهِدًا عَلَيْكُمْ كَمَا أَرْسَلْنَا إِلَىٰ فِرْعَوْنَ رَسُولًا فَعَصَىٰ

گواه بر شما چنانکه فرستادیم به فرعون پیغمبری پس نافرمانی کرد

فِرْعَوْنُ الرَّسُولَ فَأَخَذْنَاهُ أَخْذًا وَبِيلًا فَكَيْفَ تَتَّقُونَ

فرعون آن رسول را پس گرفتیمش گرفتنی سخت پس چگونه میترسید پرهیز میدارید

إِنْ كَفَرْتُمْ يَوْمًا يَجْعَلُ الْوِلْدَانَ شِيبًا السَّمَاءُ مُنْفَطِرٌ بِهِ كَانَ

اگر کافر شدید از روزی که میگرداند کودکان را پیران آسمان شکافته گردد بدان باشد

وَعْدُهُ مَفْعُولًا إِنَّ هَٰذِهِ تَذْكِرَةٌ فَمَنْ شَاءَ اتَّخَذَ إِلَىٰ

و عده اش کرده شده بدرستی که این پندیست پس هر که خواست گرفت بسوی

رَبِّهِ سَبِيلًا إِنَّ رَبَّكَ يَعْلَمُ أَنَّكَ تَقُومُ أَدْنَىٰ مِنْ ثُلُثَيِ

پروردگارش راهی بدرستی که پروردگارت میداند که تو برخیزی کمتر از دو ثلث

45 doublure

45 binding

46
Single-volume Qur'an
Iran, probably Isfahan, *circa* 1700

282 folios, 21.2 × 1.26 cm, with
15 lines to the page
Material A smooth, cream laid
paper, lightly burnished; there are
approximately nine laid lines to the
centimetre, and no apparent rib
shadows or chain lines. Due to the
density of the pulp, individual sheets
are semi-opaque
Text area 16.2 × 8.3 cm
Script Main text in *naskh*, in black,
with reading notes in red; marginal
commentary also in black *naskh*;
surah headings and other marginalia
in gold *riqā'*
Scribe Anonymous, with an
appendix by Baha' al-Din
Muhammad ibn Muhammad al-Qari
Illumination Extensive decoration
on folios 1b–5a; each line of text on a
ground scattered with gold, within a
compartment 0.8 cm wide defined
by gold rules, and separated from the
next line by a blank compartment
0.3 cm wide; text frames of gold and
black rules, and outer frames of one
gold rule; verses marked by gold
whorls; surah headings; commen-
tary in the margins of folios 5b–98b
set in shaped compartments with
gold outlines, which are absent
thereafter; other marginalia in
gold script
Documentation A colophon in
the appendix
Binding 19th-century European
leather covers
Accession no. QUR92

1. Bayani 1345–58, III, p.785;
VI, p.248.

This manuscript is of the same type as cat. 45, although on a reduced scale. No interlinear
glosses were supplied, however, so that the narrow bands ruled between the lines of text
have been left blank, and the illumination of the opening pages was lost when new front
matter was added in the 19th century. The Qur'an now opens (folios 1b–2a) with a richly
illuminated table of surah headings. The headings, in gold *riqā'*, are set within eight-sided
figures with blue grounds, arranged in a grid against a gold ground enlivened with floral
scrolls. The margins have a plain ground densely decorated with scrolling flowers and
leaves, in gold outlined in black, with touches of colour. Similar marginal illumination is
found on folios 2b–3a, which are inscribed in gold *riqā'* with a prayer to be read before
starting the Qur'an, and folios 4b–5a, where the main text begins. The main fields of folios
2b–3a have a centre-and-corner composition with blue grounds, interspersed with illum-
ination on a plain ground, and the text appears on the centre-pieces. The text on folios
3b–4a is surrounded by illumination on gold, blue and red grounds. The surah headings,
which are in gold *riqā'* outlined in black, are set on a ground sprinkled with gold within a
narrow panel ruled in gold. The background is enlivened with feint leaf motifs, also in gold.

The manuscript has a substantial appendix. The main text ends on folio 275a, where it
is followed by 13 blank lines. Folios 275b, 276a, 277a, 279b and 280a are also blank, while
folio 276b has been inscribed with a *ḥadīth*; and folios 277b–279a with two prayers.
Folio 280b begins with a *ḥadīth* relating to the efficacy of saying a prayer on finishing
every group of 100 verses, and this is followed by an explanation of how these groups
are marked in the text, which ends, 'I am the humble slave, the sinner Baha' al-Din
Muhammad ibn Muhammad al-Qari.' The prayers to be recited after each one-hundredth
verse are found on folios 280b–281a, and on folios 281b–282a there are instructions on
using the Qur'an for divination, without the key to the symbols employed usually found
with such texts. Folio 282b contains a prayer, and there are traces of an inscription,
which has been erased. Stylistic similarities between the marginal notes and the appendix
texts suggest that the former were also written by Baha' al-Din Muhammad, who may
have flourished in the early 18th century. Mehdi Bayani recorded two signed pieces
that may be relevant. One was by Baha' al-Din Muhammad 'Amili and is dated AH 1128
(AD 1715–16). The second was completed by Baha' al-Din Muhammad al-Hazim, the
son of Muhammad Salih al-'Aqili, in AH 1130 (AD 1717–18).[1]

The manuscript was restored and trimmed before being attached to its present,
European, binding. The covers are faced with red morocco tooled in gold and are lined
with marbled paper.

46 folios 185b–186a

46 folios 273b–274a

47
Single-volume Qur'an

Iran, probably Isfahan, *circa* 1700

245 folios, 24.4 × 15.2 cm,
with 15 lines to the page
Material A smooth, cream laid
paper, lightly burnished; there are
approximately eight laid lines to
the centimetre, and no apparent rib
shadows or chain lines
Text area 16.5 × 8.6 cm
Script Main text in *naskh*, in black,
with reading marks in red; surah
headings and contemporary
marginalia in gold *riqā'*; later
marginalia in red *riqā'*
Illumination Folio 1a decorated
overall with gold scrollwork on a
natural ground; extensive decoration
on folios 1b–2a; each line of text on
a ground scattered with gold, within
a compartment 0.8 cm wide defined
by gold rules, and separated from the
next line by a compartment 0.3 cm
wide filled with floral ornament on
a gold ground; text frames of black,
gold, blue, silver and green rules,
and outer frame of one gold rule;
verses marked by gold rosettes with
touches of green, red and blue;
surah headings
Binding Modern, incorporating
older material
Accession no. QUR244

1. Christie's, London, 28 April 1998,
lot no.35.

Like cat. 46, this anonymous Qur'an can be dated to the late Safavid period on the basis of
its similarity to cat. 45 and other dated examples from the period. In this case, the original
illumination of the opening pages survives, although it has been subject to some restoration,
which may have been necessary because of corrosion of the paper by one of the pigments
employed in the rulings. The illumination of the margins is particularly striking. They
are filled with a pattern of large and elegant palmette scrolls, executed in blue with gold
outlines and details. The spaces between are filled with two tones of gold, overlaid with
diminutive lotus scrolls in a variety of colours. This combination also occurs in a Qur'an
copied by 'Abdallah Yazdi in AH 1109 (AD 1697–8), to which reference has been made
above (p.126).[1] A larger version of the lotus scroll motif fills the head-pieces above the two
text panels. The text was written in 'clouds' reserved in a gold ground, which contrasts
with the greener tone of gold used for the interlinear bands of illumination.

In other respects this Qur'an is very similar to cat.46. They were probably of the
same size in their original form, although cat.46 has been drastically trimmed, and
each has 15 lines to the page. In both cases the text area is divided into 15 wider and
15 narrower bands, and the lines of text were written in the wider bands, on a ground
sprinkled with gold. The narrower bands were left blank in cat.46, but in cat.47 they
are filled with gold and overlaid with a repeat pattern of a red leaf and a rosette. Every
fifth and tenth verse is marked by the words *khams* ('five') and *'ashr* ('ten') in gold
riqā' outlined in black, and other divisions of the text and points where a prostration
was required (*sajdah*s) were recorded in a similar manner. In both cases, too, surah
headings were inscribed in the same type of gold *riqā'* on grounds sprinkled with gold
and set off with fragments of foliage. In cat.46 this foliage has been finished in gold,
but in cat.47 it was executed in sepia.

The manuscript was trimmed slightly, presumably when it was rebound in its present
covers. These are modern, but they incorporate the block-pressed and gilded elements
from an earlier binding. It seems unlikely that this was a Qur'an binding, as the motifs
include a pair of ducks in the centre-pieces. The other elements, all filled with floral
motifs, are pendants to the centre-pieces, corner-pieces and two series of 12 cartouches
from the borders.

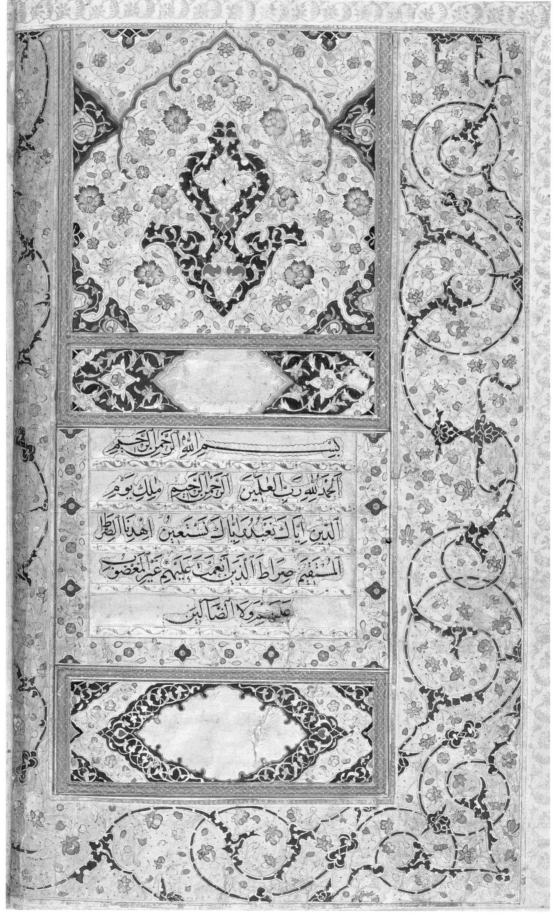

47 folio 1b

48
Single-volume Qur'an
Iran, 17th century

251 folios, 15 × 8.9 cm, with 17 lines to the page
Material The text is on a fine, dark-cream laid paper, lightly burnished and scattered with gold. Due to the small area of exposed paper, the number of laid lines to the centimetre cannot be discerned. There are no apparent rib shadows or chain lines. The margins and replacement folios are of a European machine-made paper of comparable quailty and weight to the original text paper, which has been coloured cream or light brown
Text area 8.9 × 4.6 cm
Script Main text in *naskh*, in black with reading marks in red; texts on folios 1b–2a, surah headings, and marginalia, all added in the 19th-century, in red *riqāʿ*
Illumination Extensive decoration in a Qajar style on folios 1b–3a, 250b–251a; text frame of gold, black and blue rules, with narrower gold and black rules between each line of text; verses marked by gold four-petal rosettes, with touches of red and blue; surah headings in panels illuminated in a Qajar style; a narrow outer frame of gold and black rules, with ornamental devices in the top right and left corners; marginal devices marking each *ḥizb*, *juz'* and *sajdah*
Documentation A birth note
Binding Lacquer covers of the mid-19th century
Accession no. QUR208

1. The note has been all but obliterated and cannot be reproduced.

This small Qur'an was written in a neat *naskh* hand in the 17th century (compare cat.50) and was remargined, re-illuminated and rebound in the 19th century, some time before a note recording a birth was inscribed on the last folio in AH 1291 (AD 1874–5).[1] The new work is of the highest quality, and it shows the esteem in which 17th-century Qur'ans were held in the 19th century. During the restoration of the manuscript, the first two folios, which contained the first surah and verses 1–18 of the second, were replaced, and the text was rewritten in a hand of the same size as the original and in a similar style (folios 2b–3b). The later script has none of the delicacy and precision of the original, however, and it is noticeable that the interlinear rulings added soon after show up the irregularity of the replacement lines, while the original calligrapher's work fits neatly between the rules. This contrast gives us some understanding of why the original was so appreciated.

Folios 1b–2a are filled with magnificent illumination. An index of surahs has been arranged around the central panels; written in red *riqāʿ* within gold cartouches, it is set in green-ruled squares. The central rectangular panels contain roundels in which the prayers to be read at the beginning of the Qur'an are written, also in red *riqāʿ* on a gold ground. Folios 2b–3a are decorated in the same splendid manner. The composition consists of a finely illuminated gold frame around the small text areas, panels above and below this containing the surah headings, a pair of head-pieces and a broad frame along the bottom and lower side. The use of cloud scrolls in this design and the prominence of green suggest that this is Shirazi work.

The text frames, interlinear rulings, surah headings and marginal devices marking each *juz'*, *ḥizb* and *sajdah* were also added at this time, as were the *kamand*s, the narrow gold rules that frame the whole of each opening. In the top right and top left of each *kamand* there is an inscription in red *riqāʿ* within a frame of gold leaves. That on the top right gives the key word for *istikhārah*, that is, using the Qur'an for divination. That on the top left gives the name of the surah. Catchwords were also added at this time, and words missing from the Qur'anic text were written in the margins and sprinkled with gold. Another touch of splendour was added by enclosing the *basmalah* of each surah in a 'cloud' reserved in a gold ground. Folios 250b–251a have text frames and a *kamand* like the rest of the manuscript, and the text frames are filled with illumination centred on two lobed devices containing a prayer written in red *riqāʿ* on a gold ground.

The lacquer covers were painted by the same hand and in the same style as the illumination. The design consists of a centre-and-corner composition surrounded by a frame filled with decorative cartouches, all on a gold ground. In the main field this is set with a double pattern of larger palmette scrolls and smaller lotus scrolls of a 17th-century type. The doublures have a dense pattern of fruiting vines, in gold on a green ground.

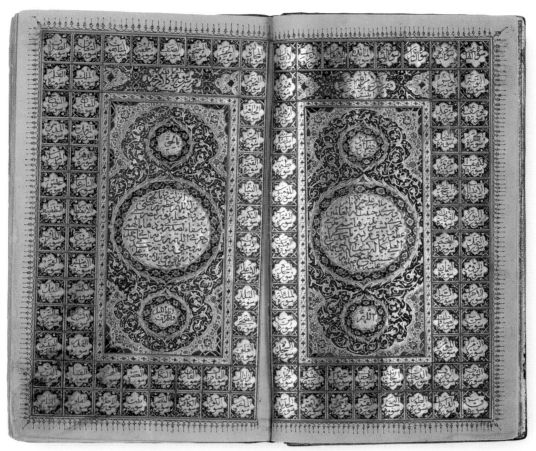

48 folios 1b–2a

48 folios 90b–91a

49
Single-volume Qur'an
Iran, probably 17th century

163 folios, 13.3 × 8.5 cm, with
23 lines to the page
Material A thin, cream laid paper,
lightly burnished; there are approx-
imately 14 laid lines to the centimetre,
and no apparent rib shadows or
chain lines
Text area 10.3 × 5.2 cm
Script Main text in *naskh*, in black
with reading marks in red; surah
headings and inscriptions in
marginal ornaments in red *riqā'*
Illumination Extensive decoration
on folios 1b–2a; text frame of gold,
black, red, green and blue rules;
verses marked by gold rosettes set
off with touches of red, green and
blue; surah headings; a narrow
outer frame of gold and black rules;
marginal devices marking each
ḥizb, *juz'* and *sajdah*
Binding Lacquer covers dated
AH 1219 (AD 1804–5)
Accession no. QUR207

1. During one of the restorations
old paper must have been used,
since the traces of a marginal device
from another manuscript can be
seen at the foot of folio 3a.
2. *Cf.* Atabay 1352, nos 54, 60.
3. See Khalili, Robinson & Stanley
1996–7, nos 69–73, for example.

The Qur'anic text and the concluding prayer written at an oblique angle on folios 163a–
164b were written in a style of *naskh* typical of the 17th century (compare cat. 42, for
example), but the manuscript was repaired at the beginning of the 19th century, when
some of the illumination and the binding were added. The reworking of the illumination
at this time seems not to have been as thorough as in other examples, and further repairs
were executed later in the 19th century, when the remainder of the illumination was added.[1]
The original illumination seems to consist only of the ruled frames around the text areas
and the words *khams* ('five') and *'ashr* ('ten') written in gold *riqā'* in the margins of folios
9b and 12a to indicate the end of groups of five and ten verses, a feature missing from the
rest of the manuscript. The early 19th-century work includes the opening pages of text
(folios 1b–2a),[2] as well as the marginal devices on folios 9b, 10b and 12a, while the orna-
mental elements dating from later in the 19th century include the surah headings and the
majority of marginal devices. Another 19th-century addition is the letters placed in the
top right corner of each opening so that the Qur'an could be used for telling fortunes.

The damage that made the repairs to this manuscript necessary seems to have resulted
from the use of a corrosive green pigment in the preparation of the greenish tone of gold
used as a contrast to yellow gold. Where this colour was employed for the ruled frames
of the text areas, the pigment has eaten through the paper, and the text areas have fallen
out of their margins. This is particularly clear on folio 26, for example, where part of the
ruled frame was not repaired; the inner and outer green-gold rules have eaten through
the paper, leaving the red and blue rules between them attached to a separate strip of
paper. If green gold made with this pigment, which may be verdigris, was in common
use for the rulings around the text in 17th-century Qur'ans from Iran, it would explain
why so many Qur'ans of this period had to be remargined and re-illuminated in the
19th century.

The lacquer binding added at the beginning of the 19th century, when the manuscript
was cut down to fit it, is one of the chief glories of the manuscript. It bears the invocation
Yā Ṣāḥib al-Zamān ('O Lord of the Age!') on the upper cover and the date AH 1219
(AD 1804–5) on the lower cover, which indicates that it is the work of Muhammad
Zaman, the court painter to Muhammad Karim Khan Zand at Shiraz.[3] The covers have
a gold-on-black border surrounding a sparkling red ground, which was painted with a
tangled group of a hazelnuts, fruit blossom and flowers. These are arranged as though
they were growing upwards from the base of the cover, a motif seen in other work of
this painter. The doublures are also fine. The lobed centre-piece and pendants have
groups of flowering plants on a black ground and are set on a brown ground worked
with a fruiting vine scroll in gold. The narrow border has a polychrome floral repeat
pattern on black.

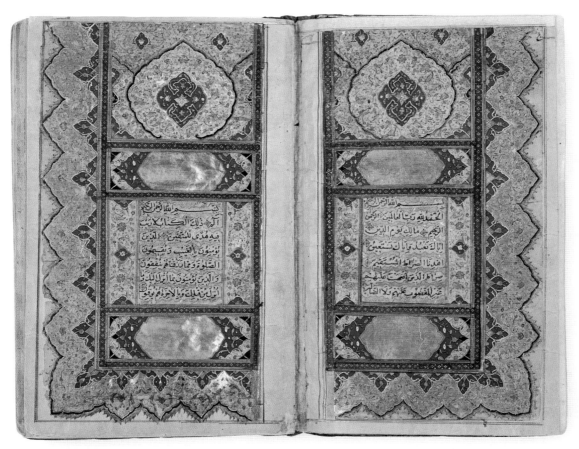

49 folios 1b–2a

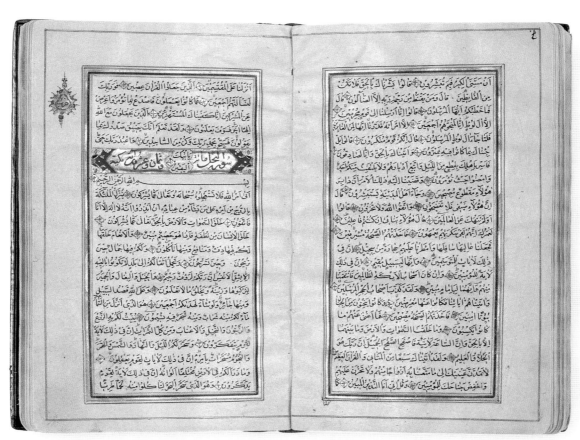

49 folios 69b–70a

50
Single-volume Qur'an
Iran, probably Isfahan, late 17th century

306 folios, 20.8 × 12.2 cm, with 15 lines to the page
Material The text on folios 3–304 is on a smooth, cream, gold-sprinkled paper. Due to the density of pigment on the paper surface, mould markings are impossible to identify. The margins and replacement folios are of a smooth European machine-made paper, coloured cream and lightly burnished
Text area 12.9 × 6.3 cm
Script Main text in *naskh*, in black with reading marks in red; prayers on folios 1b–2a and 305b–306a, surah headings and marginal *ḥizb, juz'* and *sajdah* markers, all 19th-century, in gold *riqāʿ*; marginal *ḥadīth* texts in black *shikastah*; other supplementary texts in red *riqāʿ*
Scribe Muhammad Ibrahim al-Mudhahhib (main text), ʿAbd al-Husayn ibn Muhammad al-Husayni (*ḥadīth* texts)
Illumination Extensive decoration in a Qajar style on folios 1b–3a, 305b–306a; text frame of gold, turquoise, dark-blue, red, green, and black rules; text areas sprinkled with gold (there are gold patches between the lines of text on folio 27a only); verses marked by gold rosettes set off with green, blue and red dots; surah headings in panels illuminated in a Qajar style; an outer frame of gold and black rules, with ornamental devices in the top right and left corners; marginal devices marking each *ḥizb, juz'* and *sajdah*; marginal *ḥadīth* texts in illuminated panels
Documentation Two colophons, five records of births and marriages, an impression of an owner's seal, and a commemorative coin
Binding Lacquer covers of the 19th century
Accession no. QUR55
Published Khalili, Robinson & Stanley 1996–7, no.433

1. Safwat 1996, no.159.
2. Bayani 1345–58, IV, pp.90–91. The error is repeated in Khalili, Robinson & Stanley 1996–7, no.20.
3. Karimzadeh Tabrizi 1985–91, II, pp.638–48.
4. Khalili, Robinson & Stanley 1996–7, Part One, pp.54–7, adding the evidence cited in note 9 below.

The scribe of this Qur'an, who calls himself Muhammad Ibrahim al-Mudhahhib, may be confidently identified with the celebrated calligrapher and illuminator Muhammad Ibrahim Qumi on the basis of work in the same *naskh* hand which he signed as Muhammad Ibrahim al-Mudhahhib al-Qumi; this includes a calligraphic composition in the Khalili Collection produced in 1691.[1] There are no contemporary literary references to Muhammad Ibrahim, and so, as with his contemporaries ʿAbdallah Yazdi and Ahmad Nayrizi, our primary source on his life and work is the documentary inscriptions he added to his work, which includes Qur'ans and other religious manuscripts, calligraphic specimens in *nastaʿlīq* and *shikastah nastaʿlīq* as well as in *naskh*, and lacquer pen boxes and bookbindings. From these it is clear that his father was not called Muhammad Nasir, as Mehdi Bayani thought,[2] but Hajji Yusuf Qumi.[3] He therefore seems to have been the brother of the late Safavid painters Muhammad Zaman and Hajji Muhammad, although the identity of the latter is a matter of dispute.[4]

The earliest recorded example of Muhammad Ibrahim's work is a calligraphic specimen dated AH 1070 (AD 1657–8).[5] There is no other dated example for almost 20 years, but the next oldest piece, a Qur'an in the Astan-i Quds Library, Mashhad, completed on 25 Rabiʿ al-Awwal 1087 (7 June 1676), was the twenty-eighth copy he had made,[6] and we may therefore accept the earlier date. By AH 1092 (AD 1681) Muhammad Ibrahim was employed in the royal scriptorium in Isfahan,[7] and in AH 1097 (AD 1685–6) and AH 1103 (AD 1691–2) he copied two prayer-books for Shah Sulayman himself.[8] His connection with the court must have continued under Shah Sultan Husayn, since he used the title al-Sultani on lacquer wares dated AH 1105 (AD 1694) and AH 1106 (AD 1695–6),[9] although in the following year the title seems to have been transferred to Ahmad Nayrizi, who was reportedly a pupil of Muhammad Ibrahim (see p.128 above). Muhammad Ibrahim's last recorded work is a Qur'an completed towards the end of Rabiʿ al-Akhir 1118 (early August 1706).[10]

In cat.50 the original work of Muhammad Ibrahim is now confined to the main texts on folios 3–304, both the Qur'an itself and a concluding prayer (folios 301b–304b), which is followed immediately by the colophon. The manuscript may originally have had illumination by Muhammad Ibrahim himself, given his use in the colophon of the *nisbah* al-Mudhahhib ('the illuminator'), but this was lost in the extensive renovation to which the book was subject *circa* 1856–7. Other Qur'ans by Muhammad Ibrahim Qumi were also restored in the 19th century. One example, in the National Library, Tehran, was produced in AH 1102 (AD 1690–91) and renovated *circa* AH 1295 (AD 1878), judging by the date of the marginal *ḥadīth* texts added by Muhammad Rashid Bigdili,[11] while another copy, in the library of the Astan-i Quds-i Razavi, Mashhad, was originally produced for a female member of the royal family called Zaynab Begum in AH 1117 (AD 1705–6) and was renovated *circa* AH 1277 (AD 1860–61), again according to the date of the marginal *ḥadīth* texts, which in this case were added by Muhammad Jaʿfar Husayni Asfa.[12]

In the case of cat.50 this process included remargining with a paper of a darker tone of cream; a complete reworking of the illumination; the addition of one prayer at the front of the manuscript (folios 1b–2a) and of two prayers at the back (folios 305a–306a); and rebinding. It also seems to have involved the production of facsimile leaves. A note squeezed into the top right corner of folio 2a reads, *Qur'ān pīsh-i kamtarīn nuh juz' va yak barg kam* ('The Qur'an before me lacks nine fascicules and one leaf'), and the single leaf referred to appears to have been folio 20, as indicated *inter alia* by the presence of the word *uftādah* ('[next leaf] missing') on folio 19b. It is also clear that the text on folio 2b is a facsimile, as it was written on a sheet of the paper used in the

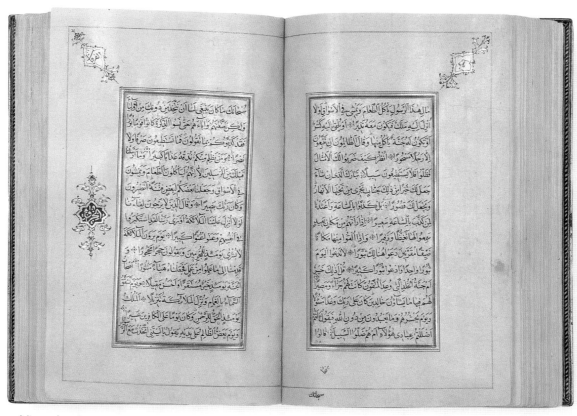

50 folios 177b–178a

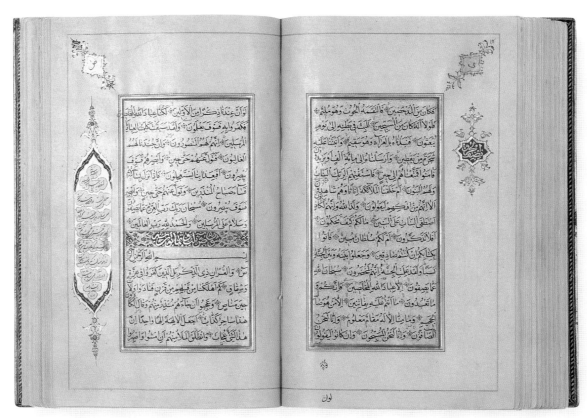

50 folios 222b–223a

5. Bayani 1345–58, III, p.129.
6. MS.110; Gulchin Ma'ani 1347, no.126.
7. Karimzadeh Tabrizi 1985–91, II, p.638.
8. The earlier copy is now in the Khalili Collection (MSS 332). For the second, see Bayani 1345–58, IV, p.128.
9. The earlier piece is Khalili, Robinson & Stanley 1996–7, no.20; the later Sotheby's, New York, 10 December 1981, lot no.314; Karimzadeh Tabrizi 1985–91, II, pp.964–5.
10. Bayani 1345–58, IV, p.128.
11. Bahrami & Bayani 1328, part 2, p.68, no.116.
12. Gulchin Ma'ani 1347, pp.264–7, no.148. This Zaynab Begum may have been the wife of Hakim al-Mulk Ardistani, who built the Nim Avard Mosque in Isfahan in the same year.
13. 'Abd al-Husayn is mentioned as a leading proponent of *shikastah* calligraphy by I'timad al-Saltanah (p.293) and was also responsible for marginal texts in five Qur'ans in the Gulistan Library (Bayani 1329, p.18, no.29; p.26, no.39; Atabay 1351, nos 7, 10, 11, 50, 121).

remargining work, but there is no sign that other leaves bearing the Qur'anic text are replacements, and we must presume that the nine missing fascicules were found.

During the renovation *ḥadīth* texts were written next to each surah heading, within illuminated panels. These end on folio 301a with a colophon in the name of 'Abd al-Husayn ibn Muhammad al-Isfahani (*fl.*1824–1857), which is dated AH 1273 (AD 1856–7).[13] Three other types of marginal inscription were also added. One was a sequence of illuminated *ḥizb*, *juz'* and *sajdah* markers, placed next to the relevant part of the text. Another was the name of the surah, written in the ornamental device in the top left corner of each opening. The third type, the letters written in the complementary device in the top right corner of each opening, relate to use of the Qur'an as a means of telling fortunes (*istikhārah*), and the manuscript now begins, on folio 1a, with a key to these letters.

During restoration of the lacquer covers a gold or silver-gilt commemorative 'coin' was found in the spine. It consists of two thin sheets of metal stamped with the legend, *al-sulṭān 'Alī ibn Mūsā al-Riḍā*, and stuck together. Similar 'coins' of silver, silver gilt and gold were used at weddings and on other festive occasions as a symbol of good luck. At weddings they were thrown at the bride and groom in the manner of confetti, and on other occasions they were given out as symbolic gifts. The legend on this example may connect it with the shrine of Imam Riza in Mashhad.

As presently constituted the manuscript has two pairs of two blank flyleaves of a coarse white laid paper; a third flyleaf at the front is of a European cream wove paper, showing part of a watermark. This last bears notes recording three births and two weddings that occurred between 28 Dhu'l-Hijjah 1324 (1 February 1908) and 28 Mihr 1325 in the Iranian solar calendar (20 October 1946).

51
Single-volume Qur'an
Iran, 20 Jumada'l-Ula 1107 (28 December 1695)

312 folios, 6 × 4 cm, with 15 lines
to the page
Material A thin, dark-cream laid
paper, lightly burnished; there are
approximately eight laid lines to
the centimetre, and no apparent rib
shadows or chain lines. Due to the
uneven distribution of the pulp,
mould markings are difficult to
discern
Text area 4.5 × 2.5 cm
Script Main text in *naskh*, in black
with reading marks in red; surah
headings and marginal verse
counts and *ḥizb* and *juz'* markers
in red *riqā'*
Scribe Ibn Muhammad Hashim
ibn Shams al-Din Muhammad
Riza al-Khwansari
Illumination Extensive decoration
on folios 1b–2a; text frame ruled in
gold and black; verses marked by
gold discs; surah headings framed
by single gold rules
Documentation Colophon
Binding Lacquer covers of the
18th or 19th century
Accession no. QUR184
Published Khalili, Robinson &
Stanley 1996–7, no.107

1. Quoted in Bayani 1345–58,
III, p.725, no.1038.

According to a note at the end of the colophon this miniature manuscript was the one hundred and sixtieth copy of the Qur'an made by Muhammad Riza al-Khwansari, but, despite his prolific output, there is no mention of a calligrapher with this name in the standard works. It is possible, however, that he is to be identified with the poet and calligrapher Muhammad Riza Isfahani mentioned by Mirza Sanglakh.[1] This Muhammad Riza was a relative of Sayyid 'Ali Khan, with whom he studied in Isfahan. He later spent some time in India, where he was a pupil of Abu Turab Isfahani. According to Sanglakh, he received a commission from 'Shah 'Abbas' to design the *nasta'līq* inscriptions for the courtyard of the shrine of Imam Riza in Mashhad – presumably after he had returned to Iran. Mehdi Bayani doubted that he could have worked for Shah 'Abbas I, as he reportedly died in AH 1118 (AD 1706–7). If, however, the shah in question was 'Abbas II (*reg.*1642–1666) then the Muhammad Riza responsible for this work may have been Muhammad Riza al-Khwansari. Muhammad Riza's eminence is indicated by the title *ṣadr al-kuttāb* ('foremost of scribes') that Sanglakh attributed to him, and he was also described as *sarī' al-qalam*, 'swift of pen', which would explain how he had managed to complete 160 Qur'ans by 1695.

The manuscript was written in a minute *naskh* script and has relatively modest decoration. The surah headings are not illuminated, for example, having been inscribed in red *riqā'* on a plain ground. The first two pages of text (folios 1b–2a), however, are set within illuminated frames surmounted by head-pieces, which were rather roughly executed. In the 18th or 19th century the pages of cat.51 were trimmed, and the manuscript was equipped with a new lacquer binding, decorated with floral motifs in gold on a black ground. The doublures have a single hyacinth plant on a gold ground.

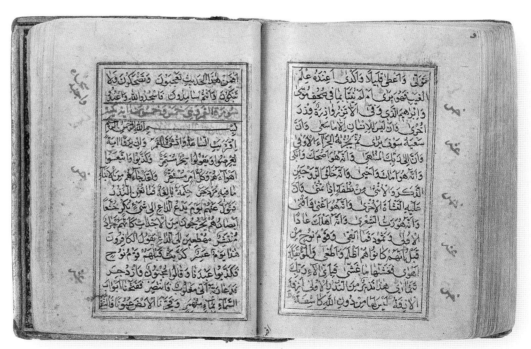

51 folios 297b–298a

52
Single-volume Qur'an
Iran, probably Isfahan, *circa* 1668–91

375 folios, 11.5 × 7.3 cm,
with 14 lines to the page
Material A fine, cream laid paper,
highly burnished; there are
approximately ten laid lines to the
centimetre, and no apparent chain
lines or rib shadows. Due to the
thinness of the paper, and the high
degree of burnishing, individual
folios are semi-transparent
Text area 8.7 × 4.5 cm
Script Main text in *naskh*, in black
with reading marks in red; surah
headings, marginalia and the repair
note, on folio 375b, in red *riqā'*
Scribe 'Abdallah al-Yazdi
Illumination Limited decoration
on folio 1a; extensive decoration on
folios 1b–2a; text area, including
panels containing surah headings,
coloured gold, with the text frame
ruled in a contrasting tone of gold,
in black and in blue; verses marked
by tiny discs of the same contrasting
tone of gold, decorated with blue
and red dots; a narrow outer frame
of gold and black
Documentation A colophon and
a repair note
Binding Early 19th century,
re-using older material
Accession no. QUR691

1. These include Bahrami & Bayani
1328, no.113; items listed under
Bayani 1345–58, IV, pp.85–6, nos 229
and 230; Atabay 1351, no.5; 1352,
nos 168, 163; Christie's, London,
28 April 1998, lot no.35.
2. Bayani 1345–58, IV, p.86; Atabay
1352, no.338. On Muhtasham
al-Isfahani, see Bayani 1345–58,
III, p.618.
3. Bayani 1345–58, IV, p.79, no.222.
4. This Muhammad Baqir may also
have been the wealthy bibliophile
and *mujtahid* Muhammad Baqir
Shafti, also known as Muhammad
Baqir Rashti or Sayyid Bidabadi,
who was born in AH 1180
(AD 1766–7), settled in Isfahan in
AH 1217 (AD 1802–3) and died there
in AH 1260 (AD 1844). See Bamdad
1347–51, III, pp.304–7. He was the
patron of another Qur'an in the
Khalili Collection, produced in
1813 (QUR167; see Part Two of
this catalogue).

'Abdallah al-Yazdi was responsible for six other recorded manuscripts, four of which bear
dates between AH 1079 (AD 1668–9) and AH 1109 (AD 1697–8), and which he signed either
as 'Abdallah al-Yazdi or as Ibn Muhammad Muhsin al-Yazdi 'Abdallah.[1] One of these, a
copy of the *Ṣaḥīfah-i sajjādiyyah* in the Gulistan Library dated AH 1102 (AD 1697–8), has
supplementary texts copied in *nasta'līq* by Mulla Muhtasham Isfahani, a calligrapher who
later executed similar work at the court of Shah Sultan Husayn (*reg.*1694–1722).[2] On this
basis it is possible to attribute a calligraphic specimen in the Malik Library, Tehran, to the
same 'Abdallah.[3] This was signed by 'Abdallah al-Sultanhusayni, 'known as Khwash-hal'
and dated AH 1119 (AD 1707–8). If this ascription is correct, it would appear that by 1707
at the latest 'Abdallah had become a court calligrapher. The script employed is the form
of *naskh* associated with 'Abdallah's contemporary Ahmad al-Nayrizi, and it was written
throughout on a gold ground. The magnificence of the manuscript may also be an indica-
tion that it was intended for the shah. The only other original illumination occurs on the
first two pages of text (folios 1b–2a).

'Abdallah's colophon is followed by a prayer to be read after completing the Qur'an,
and the manuscript ends with an inscription in red *riqā'* recording its restoration. This
was commissioned by Mirza Muhammad Baqir Mutavalli-bashi from 'Ali ibn Tahir
al-Radawi at a cost of 150 *tūmān*s. The patron's title of Mutavalli-bashi ('head trustee
of charitable endowments'), and the restorer's surname al-Radawi (Persian Razavi, that
is, pertaining to Imam Riza) suggest that the personalities involved in the restoration
were attached to the shrine of Imam Riza in Mashhad.[4]

Folio 1a has a cut-down fragment from another manuscript pasted over it, an addition
that was presumably made during 'Ali ibn Tahir's restoration. The fragment bears
illumination in the form of a lobed device composed of palmette scrolls in two tones
of gold on a natural ground. A central, lozenge-shaped area was filled in with blue.
The tips of reciprocal devices can be seen at the top and bottom edges. The original
illumination on folios 1b–2a includes a pair of panels containing the surah headings
placed above the gilded text areas. These elements are surrounded by two sets of four
panels, and these are surrounded in turn by a broad border of floral scrolls on a ground
coloured in two tones of gold. The surah headings were originally inscribe in white
riqā' in plain gold panels, but they were overwritten by the restorer in red *riqā'*.
With the exception of the twenty-second *juz'*, which is marked by a marginal device
illuminated in a sketchy 19th-century style, all textual divisions are indicated by
marginal inscriptions in red *riqā'*. This system includes the use of the letter *'ayn* to
mark each *rukū'* (reverence), in the Indian manner. This suggests that the manuscript
was in India at some point.

The covers are made of gilt leather filigree over red, green and blue grounds, which
must be from the doublures of a much larger binding. The doublures are of brown
morocco, painted in gold with a framework design.

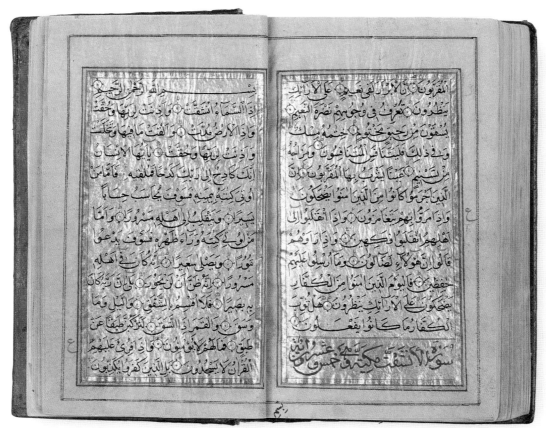

52 folios 364b–365a

52 folio 2a

53
Single-volume Qur'an
Iran, probably Isfahan, AH 1118 (AD 1706–7)

341 folios, 30.5 × 21 cm, with 14 lines to the page
Material A crisp, cream European laid paper, lightly burnished; there are ten laid lines to the centimetre, and chain lines at intervals of 3 cm
Text area 22.2 × 13.1 cm
Script Main text in *naskh*, in black with reading marks in red; surah headings and inscriptions in marginal ornaments in red *riqā'*; the colophon on folio 341a in black *riqā'*
Scribe Ahmad al-Nayrizi
Illumination Extensive decoration on folios 1b–2a; text frame of gold, black, green, red and blue rules; verses marked by gold discs divided into segments by black and red lines and set off with blue and green dots; a pair of fine black rules were also drawn along the inside edge of each page, to disguise repairs; surah headings; a narrow outer frame of gold and black rules; marginal devices marking each *ḥizb*, *juz'* and *sajdah*
Documentation Colophon
Binding Lacquer covers
Accession no. QUR246

This Qur'an is the work of Ahmad Nayrizi, who flourished between AH 1087 (AD 1676–7) and AH 1153 (AD 1740–41), when he produced cat. 54 below. He was the most celebrated exponent of the later Iranian style of the *naskh* script (see pp. 127–30 above). Cat. 53 was written in a large hand, in which the deliberate and uncompromisingly regular character of the style is fully evident, and the colophon, which is in black *riqā'*, is an early witness to Ahmad's residence in Isfahan.

On the first two pages (folios 1b–2a) the text is presented within a 'cloud' reserved in gold and is surrounded by illumination in which mid-blue, gold and carmine-red predominate. Panels above the two text areas contain the surah headings in red *riqā'* on a gold ground, while those below are similarly inscribed with a quotation from the surah *al-Wāqi'ah* (LVI, verses 79–80). This three-part composition is surmounted by a head-piece and framed on two sides by a broad band of illumination. In these elements the traditional floral scrollwork is set mostly on natural grounds. Surah titles were written in red *riqā'* within gold cartouches, and these are flanked by stylized designs in red, blue and gold. The main divisions of the text and the *sajdah*s were also recorded in red *riqā'*, in marginal devices executed in gold, with the outline of composite lotus blossoms or lobed polygonal cartouches.

Corrections to the Qur'anic text were mostly added in the margin by Nayrizi himself, before the manuscript was illuminated, for they were accommodated by the frames of rules enclosing the text areas. An unusual feature of the manuscript is the presence of catchwords in the same hand and in the same size as the main text and with full vocalization.

The 19th-century lacquer covers have a large floral composition on a sparkling brown ground, framed by a triple border filled with contrasting stylized and naturalistic floral patterns. The lacquer doublures are red, with a vine scroll emanating from a central rosette, and a black border.

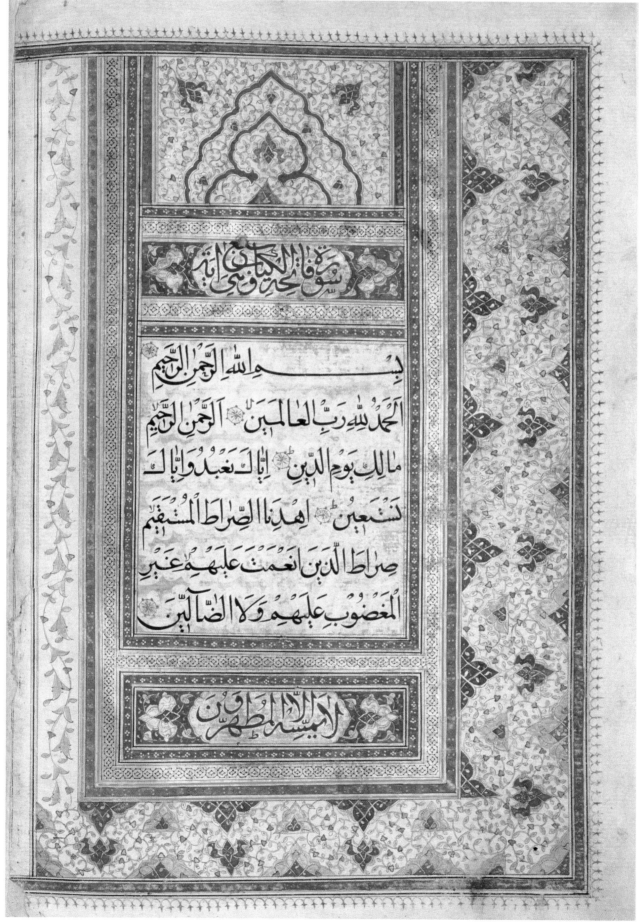

لَعَنَ الْكَافِرِينَ وَأَعَدَّ لَهُمْ سَعِيرًا ۝ خَالِدِينَ فِيهَا أَبَدًا

لَا يَجِدُونَ وَلِيًّا وَلَا نَصِيرًا ۝ يَوْمَ تُقَلَّبُ وُجُوهُهُمْ

فِي النَّارِ يَقُولُونَ يَا لَيْتَنَا أَطَعْنَا اللَّهَ وَأَطَعْنَا الرَّسُولَا

وَقَالُوا رَبَّنَا إِنَّا أَطَعْنَا سَادَتَنَا وَكُبَرَاءَنَا فَأَضَلُّونَا السَّبِيلَا

رَبَّنَا آتِهِمْ ضِعْفَيْنِ مِنَ الْعَذَابِ وَالْعَنْهُمْ لَعْنًا كَبِيرًا

يَا أَيُّهَا الَّذِينَ آمَنُوا لَا تَكُونُوا كَالَّذِينَ آذَوْا مُوسَى

فَبَرَّأَهُ اللَّهُ مِمَّا قَالُوا وَكَانَ عِنْدَ اللَّهِ وَجِيهًا ۝ يَا أَيُّهَا الَّذِينَ

آمَنُوا اتَّقُوا اللَّهَ وَقُولُوا قَوْلًا سَدِيدًا ۝ يُصْلِحْ لَكُمْ

أَعْمَالَكُمْ وَيَغْفِرْ لَكُمْ ذُنُوبَكُمْ وَمَنْ يُطِعِ اللَّهَ وَرَسُولَهُ

فَقَدْ فَازَ فَوْزًا عَظِيمًا ۝ إِنَّا عَرَضْنَا الْأَمَانَةَ عَلَى السَّمَوَاتِ

وَالْأَرْضِ وَالْجِبَالِ فَأَبَيْنَ أَنْ يَحْمِلْنَهَا وَأَشْفَقْنَ مِنْهَا

وَحَمَلَهَا الْإِنْسَانُ إِنَّهُ كَانَ ظَلُومًا جَهُولًا ۝ لِيُعَذِّبَ اللَّهُ

الْمُنَافِقِينَ وَالْمُنَافِقَاتِ وَالْمُشْرِكِينَ وَالْمُشْرِكَاتِ

وَيَتُوبَ اللَّهُ عَلَى الْمُؤْمِنِينَ وَالْمُؤْمِنَاتِ وَكَانَ اللَّهُ غَفُورًا رَحِيمًا

على النَّبِيِّ يَا أَيُّهَا الَّذِينَ آمَنُوا صَلُّوا عَلَيْهِ وَسَلِّمُوا
تَسْلِيمًا ۞ إِنَّ الَّذِينَ يُؤْذُونَ اللَّهَ وَرَسُولَهُ لَعَنَهُمُ اللَّهُ
فِي الدُّنْيَا وَالْآخِرَةِ وَأَعَدَّ لَهُمْ عَذَابًا مُهِينًا ۞ وَالَّذِينَ
يُؤْذُونَ الْمُؤْمِنِينَ وَالْمُؤْمِنَاتِ بِغَيْرِ مَا اكْتَسَبُوا فَقَدِ
احْتَمَلُوا بُهْتَانًا وَإِثْمًا مُبِينًا ۞ يَا أَيُّهَا النَّبِيُّ قُلْ لِأَزْوَا
وَبَنَاتِكَ وَنِسَاءِ الْمُؤْمِنِينَ يُدْنِينَ عَلَيْهِنَّ مِنْ جَلَا
ذَلِكَ أَدْنَى أَنْ يُعْرَفْنَ فَلَا يُؤْذَيْنَ وَكَانَ اللَّهُ غَفُورًا
رَحِيمًا ۞ لَئِنْ لَمْ يَنْتَهِ الْمُنَافِقُونَ وَالَّذِينَ فِي قُلُوبِهِمْ
مَرَضٌ وَالْمُرْجِفُونَ فِي الْمَدِينَةِ لَنُغْرِيَنَّكَ بِهِمْ ثُمَّ
لَا يُجَاوِرُونَكَ فِيهَا إِلَّا قَلِيلًا ۞ مَلْعُونِينَ أَيْنَمَا
ثُقِفُوا أُخِذُوا وَقُتِّلُوا تَقْتِيلًا ۞ سُنَّةَ اللَّهِ فِي الَّذِينَ
خَلَوْا مِنْ قَبْلُ وَلَنْ تَجِدَ لِسُنَّةِ اللَّهِ تَبْدِيلًا
۞ يَسْأَلُكَ النَّاسُ عَنِ السَّاعَةِ قُلْ إِنَّمَا عِلْمُهَا عِنْدَ اللَّهِ
وَمَا يُدْرِيكَ لَعَلَّ السَّاعَةَ تَكُونُ قَرِيبًا ۞ إِنَّ اللَّهَ

54
Single-volume Qur'an
Iran, probably Isfahan, AH 1153 (AD 1740–41)

136 folios, 16.5 × 10.2 cm, with
25 lines to the page
Material A stiff, cream wove paper,
lightly burnished; there are no
visible mould markings
Text area 13.4 × 7.4 cm
Script Main text in *naskh*, in black
with reading marks in red; surah
headings and inscriptions in
marginal ornaments in gold *riqāʿ*
Scribe Ahmad al-Nayrizi
Illumination Extensive decoration
on folios 1b–2a; text frame of gold
and black rules; verses marked by
gold rosettes set off with touches
of red and blue; surah headings;
a narrow outer frame of gold and
black rules; marginal devices
marking each *ḥizb*, *juzʾ* and *sajdah*
Documentation A colophon, a note
recording a gift, and seal impressions
Binding Lacquer covers of the 18th
or 19th century
Accession no. QUR384

1. *Cf.* Bayani 1329, no.26; Atabay
1351, no.18; Irani 1346, p.91; etc.
2. Bamdad 1347–51, II, pp.435–42.

This manuscript was produced by a great calligrapher, and it subsequently belonged to men of eminence. According to the colophon, it was written by Ahmad Nayrizi in AH 1153 (AD 1740–41), making it his last recorded work (see pp.127–8 above). The colophon was written in a minute but well-composed *riqāʿ* hand on folio 136a, squeezed between the last line of text and the frame of the text area. As in the colophons of other Qur'ans by him, including cat.53, the name is vocalized fully as *Aḥmadu 'l-Nayrīzī*.[1]

The illumination and binding may not be contemporary, but they were almost certainly added before 1805. The evidence for this is a note written in Persian, in black *riqāʿ*, on the last page (folio 136b), which records the presentation of the manuscript to Sulayman Khan Qajar, who died in AH 1220, equivalent to AD 1805–6 (see pp.127–8 above). Cat.54 was presented to Sulayman Khan by a man who is called 'the least of *sayyid*s, the son of Hajji Amir Hadi of Rasht' in the note, and 'Muhammad Taqi, the son of Muhammad Hadi al-Husayni' in the accompanying seal impression, which is dated AH 1202 (AD 1787–8). As Rasht, the home of Muhammad Taqi's father, was the capital of Gilan, it is possible that the son made the gift while Sulayman Khan was in that province, but after 1788, the date of the seal.

There are three other seal impressions, but only one of these is partly legible, being inscribed with the title ʿAzud al-Mulk and a date in the 13th century AH (19th century AD). This title was given to two men in this period. The first, Muhammad Husayn ʿAzud al-Mulk, died in AH 1283 (AD 1866–7), when the title was given to a relative of Sulayman Khan called ʿAli Riza Quvanlu, who seems a more likely candidate for ownership of the manuscript. ʿAli Riza was an influential courtier under Nasir al-Din, Muzaffar al-Din and Muhammad ʿAli Shah Qajar and briefly acted as regent for Ahmad Shah (*reg.*1909–1924) before his death at the age of 90 in 1910.[2]

The first pages of text (folios 1b–2a) have very reduced areas inscribed with text, measuring 4 × 3.2 centimetres. These have been set awkwardly in an otherwise very finely illuminated composition designed for a text area measuring 6 × 4 centimetres. The gaps have been filled with areas of plain gold and bands of ornament. The final two pages of text (folios 135b–136a) have the same rulings as the other leaves, but here too the actual text areas are much reduced, measuring 6 × 4.3 centimetres; each contains two illuminated headings and two short texts – surahs CXII and CXIII on one page, and, on the other, surah CXIV and a prayer to be said on completing a reading of the Qur'anic text. The remainder of the area within the rulings is decorated with scrollwork of different types executed in gold and colours on a natural ground. The arrangement of the text on these pages shows considerable sophistication on the part of the calligrapher, which the illuminator was not able to match in one case. The style and excellent quality of the illumination is consistent throughout and is notable for its bright colours, among which gold, red and blue predominate, set off by the highly burnished finish. The verse markers and marginal devices are of the same general types as those used in cat.53, while the surah headings, in gold *riqāʿ*, are set in blue cartouches in illuminated panels that are identical throughout.

The lacquer covers have a large floral composition on a sparkling gold ground, framed by a double border of stylized floral motifs on red and black grounds. A similar double border, but with black and green grounds, occurs on the doublures, where a goldfinch perched on a blossoming sprig from a fruit tree is shown against a red ground.

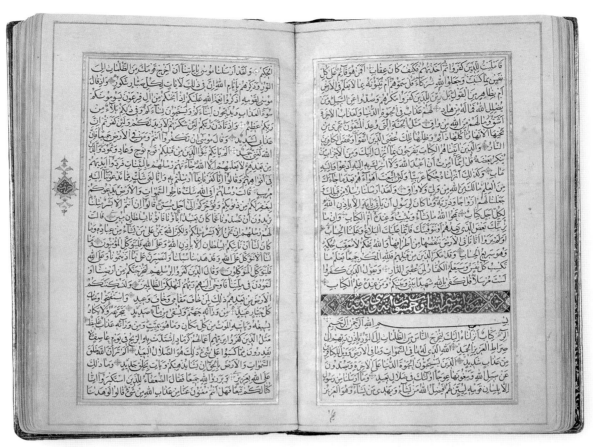

54 folios 54b–55a

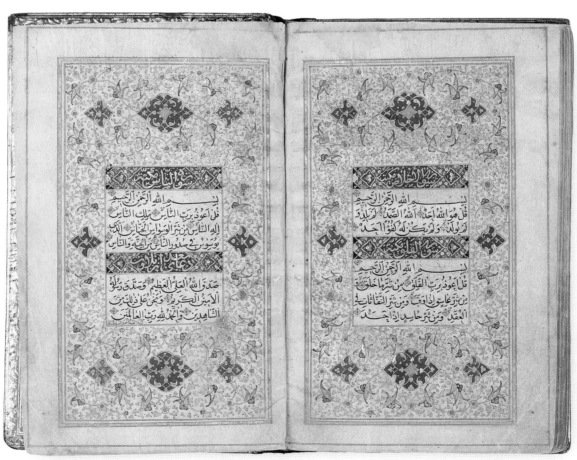

54 folios 135b–136a

55
Single-volume Qur'an
Iran, probably Shiraz, 15 Ramadan 1197 (14 August 1783)

137 folios, 11.2 × 7.2 cm, with
23 lines to the page
Material A thin, off-white, bur-
nished European paper, laid, with
approximately 16 laid lines to the
centimetre, and chain lines arranged
at intervals of 2.1 cm
Text area 8.7 × 4.9 cm
Script Main text in *naskh*, in black
with reading marks in red; surah
headings in white (surahs I, II) or red
riqāʿ; marginalia in red and gold
riqāʿ
Scribe Hajji Ismaʿil Katib Shirazi
Illumination Extensive decoration
on folios 1b–2a; decorated margins
on folios 2b–3a; text frame of gold
and black rules; verses marked by
irregularly shaped gold discs with a
single red dot in the centre of each;
surah headings; an outer frame of
one red rule; marginal illuminations
marking each *ḥizb*, *juzʾ* and *sajdah*
Documentation Colophon
Binding Lacquer covers of the mid-
19th century
Accession no. QUR36

1. Bayani 1345–58, IV, p.36.

The scribe of cat.55, Hajji Ismaʿil Katib Shirazi, clearly specialized in Qurʾan production, as he stated in a note placed beside the colophon (folio 137b) that this was the twenty-eighth copy he had produced. Nevertheless, no scribe of this name is known from other sources unless he is to be identified with a *naskh* calligrapher recorded by Mehdi Bayani as Ismaʿil Shirazi.[1] This man produced a Qurʾan in the Gulistan Library dated AH 1214 (AD 1799–1800). It seems unusual, however, for a scribe to have omitted the title Hajji once he had performed the pilgrimage.

The manuscript is written in a small *naskh* hand, and the first pages of text (folios 1b–2a) are extensively illuminated in a rather sketchy style, primarily in gold, a dull mid-blue, carmine-red and orange. It is clear from the loss of the edges of the composition that the manuscript was cut down at some stage, presumably to match it to its current binding. The surah headings of these pages were written on a gold ground in white *riqāʿ* outlined in black, but in the rest of the manuscript they were inscribed in red *riqāʿ* in narrow gold bands. *Juzʾ* and *ḥizb* divisions are marked in a similar style, by inscriptions in red *riqāʿ* set on gold bands running at an oblique angle between the inner and outer ruled frames (the *jadval* and the *kamand*). Groups of five and ten verses are also indicated in the margin, by inscriptions in gold *riqāʿ* consisting of the words *khams* ('five') or *ʿashr* ('ten').

The margins between the *jadval* and *kamand* on folios 2b, 3a and 137b are illuminated in gold, red and black with an uninspired pattern of a flower within a lozenge. The text on folio 137b consists of the last two surahs, followed by a prayer to be read after a complete reading of the Qurʾanic text, with a heading in Persian in the same style as the surah headings. This is followed in turn by a prayer for strengthening the sight, also with a heading in Persian. The first line of the text (the *basmalah*) is in black *naskh* on a plain ground, but the remaining five lines were written with a thicker nib on a plain gold ground.

The lacquer binding of the mid-19th century depicts a group of flowers on a plain mustard ground, and the main field is surrounded by a polychrome repeat pattern of flowers and leaves on a black ground. The doublures are decorated with a lobed centre-piece and pendants filled with naturalistically depicted flowers on a black ground. They are surrounded by a gold vine scroll on black.

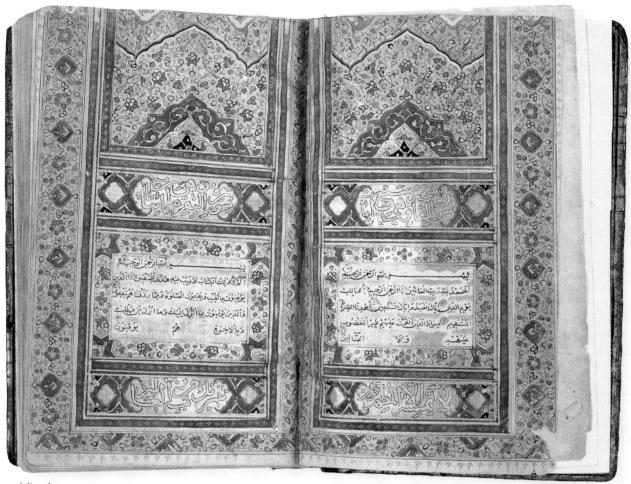

55 folios 1b–2a

55 folios 136b–137a

56
Single-volume Qur'an

Iran, probably Shiraz, AH 1202 (AD 1787–8)

242 folios, 29 × 18.6 cm, with 14 lines of Qur'anic text and 14 lines of translation on each page
Material A crisp, off-white, European laid paper, lightly burnished; there are approximately nine laid lines to the centimetre, and chain lines arranged at intervals of 2.7 cm
Text area 20.5 × 11.7 cm
Script Main text in *naskh*, in black with reading marks in red; interlinear translation in red *nasta'līq* – or *shikastah-nasta'līq* (folios 8a–18b only, in a different hand); surah headings and inscriptions in marginal ornaments in gold *riqā'*; colophon and dedication in black *riqā'*
Scribes Muhsin al-Shirazi al-Husayni (main text), and Asadallah (Persian translation)
Illumination Extensive decoration on folios 1b–4a; decorated margins on folios 4b–5a; text frame of gold, black, blue and green rules; each line of text separated from the next by a ruling in gold and black; verses marked by gold discs divided into four and set off with touches of red and blue; surah headings; each *basmalah* written in a 'cloud' reserved in gold, with gold scrollwork filling spaces in this line and the line below; a narrow outer frame of gold and black rules; marginal devices marking each *ḥizb*, *juz'* and *sajdah*
Documentation Two colophons and a record of commission
Binding Contemporary lacquer covers
Accession no. QUR258
Published Khalili, Robinson & Stanley 1996–7, no.74

1. Sotheby's, London, 16 April 1985, lot no.275.
2. The reading of the *nisbah* is not certain, as the dots on the *yā'* and the *nūn* have been grouped together above the *nūn*.
3. It seems unlikely that this Asadallah was the celebrated *nasta'līq* calligrapher Asadallah Shirazi Katib al-Sultan, who was still alive in AH 1307 (AD 1889–90).
4. For a description of the binding, see Khalili, Robinson & Stanley 1996–7, Part One, p.112.

Like cat.45, this copy of the Qur'an was designed so that the text could be accompanied by interlinear glosses in Persian. The text areas were divided by gold rules into 28 horizontal compartments, alternately wide and narrow, and the Qur'anic text was inscribed in the usual black *naskh* in the 14 wider compartments. This work was accomplished in AH 1202 (AD 1787–8) by a scribe called Muhsin al-Shirazi al-Husayni. He is known from at least one other Qur'an, dated AH 1220 (AD 1805–6), in which he gave his father's name as Muhammad Taqi.[1] The patron is named on folio 241b as Khwajah Muhammad Kazim, son of the late Muhammad Husayn Maymandi,[2] who commissioned it as a gift for his eldest son, Khwajah 'Ali Himmat. The gift is dated 4 Ramadan 1202 (8 June 1788). The Persian glosses were not added until Rabi' al-Awwal 1221 (May–June 1806), almost 20 years later. A colophon placed immediately after the end of the glosses on folio 240b gives the name of the scribe on this occasion as Asadallah.[3] An unusual feature of his work is that he gave translations even for the catchwords.

The manuscript starts (folios 1b–2a) with an index of surah titles, which were written in black or red *riqā'* within a grid of gold and silver squares. This is followed (folios 2b–3a) by a prayer written in gold *riqā'* over gold scrolls within a pair of lobed medallions with cherry-red grounds. The medallions form the centre-pieces of a pair of centre-and-corner compositions in which the pendants to the medallions and the corner-pieces have gold floral scrollwork on blue grounds. The field of the central panels and the surrounding borders are filled with two types of gold scrollwork on natural grounds. The main text of the Qur'an begins on folios 3b–4a, where it is set in 'clouds' reserved in a gold ground decorated with small floral motifs and surrounded by rich illumination over gold and blue grounds, supplemented in the two head-pieces by red and green grounds. Illumination in this style was also employed for the surah headings and the elegant marginal devices marking each *ḥizb*, *juz'* and *sajdah*, which come in a variety of shapes and are inscribed in gold *riqā'* over blue grounds. The illumination of the surah headings was clearly added after the interlinear translation, because there are places where the painted design has been curtailed to accommodate an overrun in the translation, as in the heading of the surahs *'Abasa* and *al-Ḍuḥā* (LXXX and XCIII) on folios 231b and 236b.

The two prayers inscribed on folio 241a, following the Qur'anic text, are presented in the same manner as the rest of the manuscript, but they were not provided with a translation. Instead the narrower compartments between the lines of text were filled with gold scrollwork.[4]

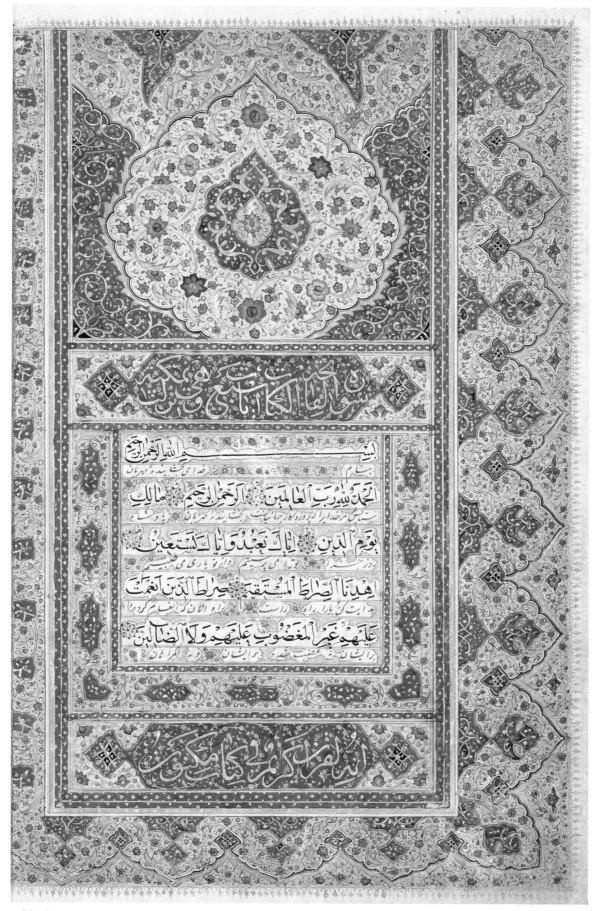

56 folio 3b

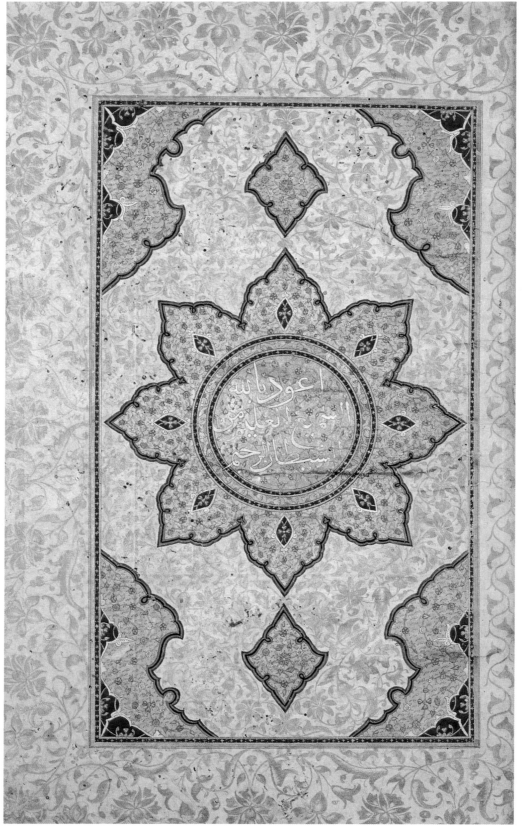

61 folio 2a

India after 1600.
Qur'an patronage and the Mughals

by Manijeh Bayani

In contrast to the examples of contemporary Ottoman and Iranian production illustrated above, the Qur'an manuscripts presented in this section are distinguished by their great variety. Such diversity is to be expected in Qur'an production in pre-Mughal India, since there were several independent centres of Muslim culture at this time, and attempts to meet local or regional demand for fine Qur'an manuscripts led to the development of contrasting styles.[1] On the same basis such variety should have diminished as the Mughals' conquests brought all the centres of Qur'an production under their rule, a process that was finally accomplished in the long reign of the Emperor 'Alamgir, better known as Awrangzeb (1658–1707). It would appear, though, that the patronage of Qur'an manuscripts was a low priority for the three emperors who preceded Awrangzeb, Akbar (*reg.* 1556–1605), Jahangir (*reg.* 1605–1627) and Shah Jahan (*reg.* 1628–1658), who were more interested in miniature painting and *nasta'līq* calligraphy. As a result the influence of the Mughal court on Qur'an production was relatively slight, and very different types of Qur'an continued to be produced throughout the 17th century. Awrangzeb's pious character led him to esteem religious manuscripts written in *naskh*, a script that he practised himself, and it seems that Indian Qur'an production came of age during his reign. The best 18th-century examples, such as cat.68–71 below, are magnificent manuscripts by any standards, and they show distinctively Indian features.

Three connoisseurs

The evidence for the Emperor Akbar's interest in Qur'ans is confined to notes in two copies. One is a fine specimen in the British Library (Add.MS.18,497) with an inscription in Persian stating that it was copied by Hibatallah al-Husayni in Lahore in AH 981 (AD 1573–4) 'for the use of the Sultan', which has been generally accepted as a reference to Akbar.[2] The attribution to Lahore has been doubted, on the grounds that the decoration is so close in style to Shirazi production of the 16th century.[3] It is true that some parts of the decoration of this Qur'an were inspired by Shirazi models, but they were combined with elements of other styles in an eclectic manner that is not seen in manuscripts from Shiraz itself, and some of the pigments used are typical of Indian work. A number of similar Qur'an manuscripts have been attributed to India in the later 16th century,[4] and it seems entirely possible that an offshoot of the Shirazi school was active in northern India during Akbar's reign. In fact, one Qur'an published below, cat.62, shows that manuscripts decorated in the 16th-century Shirazi style were being produced in India in the second half of the 17th century, by which time its products were wildly anachronistic in Iranian terms. The second Qur'an with an association with Akbar is an ancient copy in a Kufic script, formerly in the India Office Library.[5] The manuscript bears a dubious attribution to the third caliph, 'Uthman, as well as an inspection note dated AH 992 (AD 1584), which is accompanied by an impression of Akbar's seal and a valuation at 8 *ashrafī*s (72 rupees). This seems a very low value, and it may be an indication of the low esteem in which such manuscripts were held by Akbar.

Much the same can be said for Akbar's son and successor Jahangir. A Qur'an of Yaqut al-Musta'simi that is now in the Salar Jung Library in Hyderabad contains two notes by this emperor, one added in AH 1023 (AD 1614), when it entered his library, and another added in AH 1029 (AD 1620), when Jahangir gave it as a present to Khwajah Hasan Juybari.[6] In the *Tūzuk-i Jahāngīrī* Jahangir recorded giving another copy of the Qur'an by Yaqut to a man called Sayyid Muhammad on 22 September 1618,[7] but John Seyller has doubted the accuracy of this account because, 'any manuscript written by Yāqūt ... was quite exceptional in the seventeenth century, and so when a Koran penned by this calligrapher and bearing two inscriptions by Jahāngīr is found ..., it is natural to conclude that the manuscript must be the very one mentioned by the emperor in his memoirs'.[8] There is no reason to accept this conclusion, which is based on the presumption that a ruler as rich and powerful as Jahangir can have owned only one Qur'an by Yaqut, whereas, for example, at least 16 signed and dated Qur'anic items by or attributed to Yaqut were still lodged in various buildings within the Topkapı Palace in Istanbul at the end of the Ottoman period.[9] Of course, genuine work by Yaqut is rare, and not all 'Yaqut' Qur'ans owned by the Mughal emperor, or any other Muslim ruler, were necessarily genuine works of the calligrapher, as a Qur'an in the Khalili Collection shows. This manuscript, which has been attributed to Shiraz in the

second half of the 16th century, has a spurious colophon in Yaqut's name, and it was probably as a consequence of this that the book was partially, and magnificently, re-illuminated in a Mughal court style in the mid-17th century.[10] We may therefore accept that Jahangir disposed of at least two Qur'ans attributed to Yaqut, which suggests no more than that he valued them as suitable gifts for deserving subjects.

Shah Jahan seems to have shown a little more interest in the old Qur'ans in the imperial library. He applied his seal to at least two,[11] and he noted the re-accession of the copy that Jahangir had given to Khwajah Hasan Juybari,[12] and the ownership of two others, one of them a magnificent Qur'an in the Khalili Collection dated 1552.[13] Members of his court are known to have commissioned new copies. One example is a Qur'an with interlinear glosses in Persian produced for Ahsanallah Zafar Khan in AH 1044 (AD 1634),[14] while another was copied for a man called Haydar Muhammad 'in the reign of Shah Jahan'.[15] In one case, that of cat.58 below, we have a Qur'an written by a calligrapher closely associated with Shah Jahan's court. Nevertheless, the man responsible, 'Abd al-Haqq Amanat Khan, wrote this manuscript a year or two after he had retired from imperial service, and both literary references and the material evidence, such as the pieces included in albums, show that Shah Jahan's connoisseurship of calligraphy concentrated almost entirely on the *nasta'līq* tradition. This excluded Arabic texts in general and the Qur'an in particular. In one field alone, that of monumental calligraphy, did Shah Jahan and his father and grandfather show a preference for Qur'anic and other Arabic texts and for the Six Pens, the group of writing styles to which *naskh* belongs. Thus Amanat Khan began to design inscriptions in the *thulth* script for Jahangir, as at Akbar's tomb in Lahore, and continued to work for Shah Jahan on the Taj Mahal and other major projects until he retired in 1639 (see pp.178–81 below).

A change of policy

Under Shah Jahan's son and successor, Awrangzeb, the Mughals' religious policy was reversed, and the earlier openness towards Hinduism and other religions, which had developed into an extreme form of eclecticism under Akbar, was replaced by stern militancy. One of the first victims of this change was Awrangzeb's brother Darashukoh, who had been Shah Jahan's heir apparent. After his final defeat near Ajmer in 1659 he was captured and put to death, the pretext for his execution being his 'heretical' views. A note in cat.72 below, written in a minute *nasta'līq* hand and dated 23 May 1659, associates this richly gilded Qur'an with the defeated prince and claims that he was given it by his mother, Mumtaz Mahal, who died in 1631. This is one of the earliest Qur'ans that can be linked to a member of the Mughal dynasty, and only the second, after Hibatallah al-Husayni's Lahore Qur'an of 1573–4, to which an Indian provenance can be attributed. Similar notes appear on cat.60, which was copied by Awrangzeb's daughter, Zinat al-Nisa', and a Qur'an that once belonged to both Awrangzeb and his son Prince A'zam Shah, which is now in the Salar Jung Library (MS.199).[16] This Qur'an, the work of a scribe called Hajji 'Abd al-Samad ibn Hajji Ashraf 'Attar and dated 1686, had been presented to Awrangzeb in 1702 by Ghiyath al-Din, paymaster of the *şūbah* of Ahmadabad. Clearly it had not been commissioned by the emperor himself. Indeed, the earliest Qur'an with an explicit dedication to a ruling member of the dynasty that I have been able to locate is one copied for Muhammad Shah (*reg.*1719–1748) and completed at Shahjahanabad (Delhi) on 23 Ramadan 1143 (1 April 1731).[17] The scribe responsible was Muhammad Riza ibn Muhammad Taqi Tabrizi, who may also have been responsible for cat.67 below.

Despite the lack of Qur'ans explicitly dedicated to the new emperor, Awrangzeb's interest in Qur'ans and *naskh* calligraphy cannot be denied. Through manuscripts and literary references it can be traced to the period before the civil war that brought him to the throne. A Qur'an copied by Ibrahim Sultan, the grandson of Timur, in AH 830 (AD 1427) and now in the Metropolitan Museum of Art contains a long note that Awrangzeb added in AH 1048 (AD 1638–9), for example,[18] and we learn from a later source that in the reign of Shah Jahan a scribe whose name was 'Abdallah, but who was 'better known as 'Abd al-Baqi Haddad', came to India from Iran, where 'in recent times he had borne off the polo ball of precedence' among the writers of *naskh* and 'had made *naskh* the bride of calligraphy by embellishing and adorning it in a new manner.'[19] 'Abd al-Baqi presented Prince Awrangzeb with a Qur'an contained

on a mere 30 folios and other manuscripts he had written and was honoured with the title Yaqut-raqam. That Awrangzeb's interest continued after his accession is shown by the appearance of the seal he used as emperor on a 15th-century Qur'an he had inherited from his father, and on a rare *nasta'līq* Qur'an copied in 1623 or earlier.[20] Awrangzeb also added a note to the Yaqut Qur'an that Jahangir had given to Khwajah Hasan Juybari, recording that he had given it back to Hasan's grandson, Khwajah Muhammad Ya'qub.[21] Other evidence is the more frequent appearance on Qur'ans of notes and seal impressions of Awrangzeb's officials – that is, of men who used the sobriquet 'Alamgirshahi or some other term to show their attachment to him; examples include four copies in the Khalili Collection, among them the Qur'an of 1552 he inherited from his father and cat.60 below.[22]

The emperor was also a *naskh* calligrapher in his own right. According to Muhammad Saqi Musta'idd Khan (d.1724), 'The handwriting of His Majesty in the *naskh* style was exceedingly firm and well-formed, and he showed great energy in writing it. … He could also write the *nasta'līq* and *shikastah* hands very well.' Awrangzeb's competency in *naskh* is confirmed by the specimen of the emperor's hand found in Jahangir's Yaqut Qur'an referred to above.[23] Musta'idd Khan also recorded that Awrangzeb had presented two copies of the Qur'an in his own hand to the Holy Places, after 7000 rupees had been spent on the text area (*lawḥ*), the rulings in gold and silver, and the binding.[24] According to an earlier history, the *'Ālamgīr-nāmah* of Muhammad Kazim (d.1681), the first Qur'an was prepared while he was still a prince, and the second after his accession.[25] Other copies made by him have been reported,[26] though a modern commentator has also stated that Awrangzeb did not sign his work.[27] If this is true, this practice may be attributed to a belief that authorship of a good deed need not, and should not, be made public since God, from whom any reward would come, was omniscient. If this was the general custom in his reign, it would explain our ignorance of court patronage in this period, as it would have left us no colophons or dedications.

Awrangzeb's children, both princes and princesses, were brought up as good Muslims, and we are told that several acquired skills associated with their faith, including *naskh* calligraphy.[28] His eldest daughter, Zeb al-Nisa', was said to have received 30,000 gold coins from Awrangzeb for having learnt the Qur'an by heart, a feat also achieved by Muhammad Sultan, Muhammad Mu'azzam, Badr al-Nisa' and Muhammad Kambakhsh. Muhammad Mu'azzam, who later reigned as the Emperor Shah 'Alam I (*reg.*1707–1712), also learned the art of Qur'an recitation, and Zeb al-Nisa' and Muhammad Kambakhsh were skilled 'in writing various kinds of hand'. Zeb al-Nisa' 'appreciated the value of learning and skill; and all her heart was set on the collection, copying and reading of books and she turned her kind attention to improving the lot of scholars and gifted men. The result was that she collected a library the like of which no man has seen; and large numbers of theologians, scholars, pious men, poets, scribes and calligraphists by this means came to enjoy the bounty of this lady hidden in the harem of grandeur; *e.g.*, Mullā Safi-ud-din Ārdbili by her order took up his residence in Kashmir and engaged in making a translation (into Persian) of the "Great Commentary on the Qurān", which came to be entitled *Zeb-ut-tafāsir*, "The ornament of commentaries". Other tracts and books have been composed in her honoured name.'[29] Evidence of the pious activities engaged in by Awrangzeb's daughters is also provided by cat.60 below. One of them signed this Qur'an enigmatically as 'the daughter of Muhyi'l-Din', and two notes, on folios 1a and 578b, inform us that this was his second eldest daughter, Zinat al-Nisa', whom her father had brought up 'in the knowledge of the doctrines and the necessary rules of the Faith'.[30]

Awrangzeb's legacy

Another indication of a change in patronage under Awrangzeb is the greater notice given to *naskh* calligraphers in literary works. One is the *Mir'āt al-'ālam* ('Mirror of the world'), a general history to 1667 attributed to Muhammad Bakhtavar Khan (d.1685) but actually written by Muhammad Baqa Sarahanpuri.[31] It contains a series of biographical entries on calligraphers back to the time of Ibn Muqlah, who was credited with inventing the modern, 'proportioned' form of *naskh* in the 10th

57
Single-volume Qur'an
Probably India, 17th century

72 folios, 28.5 × 19.6 cm,
with 27 lines to the page
Material A smooth, crisp, dark-
cream laid paper, burnished; there
are approximately nine laid lines
to the centimetre, and no apparent
chain lines or rib shadows
Text area 18.5 × 11 cm
Script Main text in *naskh*, in black,
with reading marks in red; surah
headings in red *riqāʿ*; marginal
inscriptions in red *naskh*
Illumination Extensive decoration
on folios 1b–2a; text frames of gold,
black and blue rules; some verses
marked by gold rosettes (folios
1b–2a) or discs outlined in black;
double outer frames of gold, black
and blue rules with a scroll design in
gold between them; marginal devices
marking the end of each group of ten
verses
Documentation A colophon
Binding Iranian lacquer covers of
circa 1890–1900
Accession no. QUR830
Published Khalili, Robinson &
Stanley 1996–7, no.379

1. See Khalili, Robinson & Stanley
1996–7, no.379.
2. For an example of an Indian
30-page Qur'an, see Arberry 1967,
no.232.

This unusual manuscript has a short colophon that gives only the date of completion, AH 914 (AD 1508–9), which seems improbably early. There is therefore no explicit evidence of when or where it was produced. Nevertheless, a number of minor features, such as the division of the text into quarters of a *juz'* and the use of the letter *ʿayn* to mark each *rukūʿ* (the reverence made by bowing low enough for the palms to touch the knees), indicate an Indian provenance, while the illumination seems to be Indian work of the 17th century. By the late 19th century the Qur'an was in Iran, where it was rebound in fine lacquer covers.[1]

The most striking aspect of cat.57 is its format. Even though the manuscript has evidently been cut down at some stage, the pages are large relative to the size of the script; this is a small, regular *naskh* hand. This fact, combined with the arrangement of the text in 27 lines to the page, means that the calligrapher has been able to include the whole Qur'anic text on a mere 72 folios (143 pages). This format recalls a Qur'an manuscript reportedly presented to the Emperor Awrangzeb by the Iranian calligrapher ʿAbd al-Baqi Haddad, who had contained the full text on a mere 30 folios (see p.173).[2] The compactness of cat.57 was achieved in part by running on the surahs one after another – only a short space within the line was left for the surah headings, which were added in red *riqāʿ*. In many cases the spaces left for the headings were not large enough, and the missing information was placed in the adjacent margin. Divisions of the text, prostrations and some reading instructions were also recorded in the margin, in red *naskh*. Each *rukūʿ* is also indicated by a gold disc with a decorative outline and finials in blue.

On folios 1b–2a the text is surrounded by a band of illumination 2.5 centimetres wide, which was executed in colours that are now dull. The main motif is a series of gold cartouches containing a polychrome lotus-scroll pattern of a type employed in Mughal manuscripts of the 17th century. There is also a large 'hasp' on each side, filled with the same decoration, and a head-piece above the text on folio 1b. The text on these pages is written in 'clouds' reserved in gold. On the remaining pages there is an outer border (*kamand*) 0.9 centimetres wide consisting of an undulating leaf scroll between two sets of gold rules. The leaf scroll was executed in gold on a natural ground, and on folios 2b, 3a and 72b the space between the text area and the *kamand* is occupied by floral motifs in the same technique.

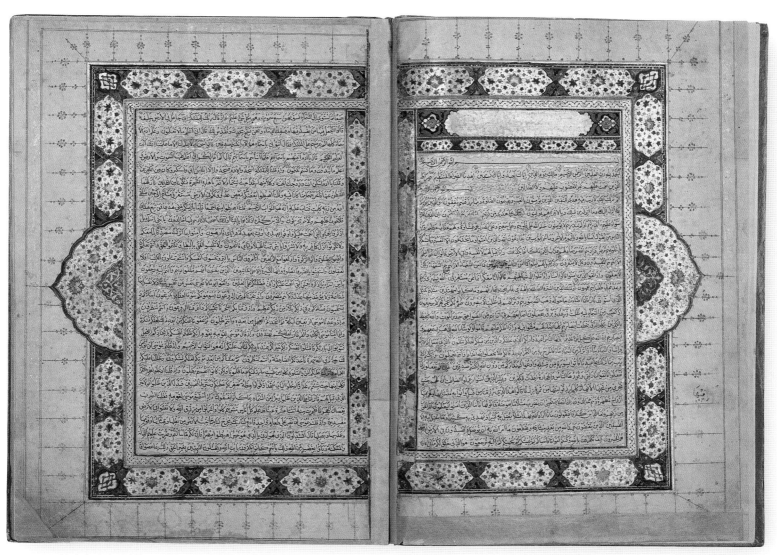

57 folios 1b–2a

century.[32] The majority of Mughal calligraphers listed were famous for their skill in *nasta'līq*; a few were also competent in *naskh* and the other Six Pens;[33] but only four were known for their expertise in *naskh* above all else. One was Amanat Khan, who, as we have seen, flourished under Jahangir and Shah Jahan,[34] while the remaining three were active, at least in part, under Awrangzeb – a modest but definite increase. The scribes in question were Hajji Qasim, who was taught by Fathallah Shirazi and whose own pupils included Prince Awrangzeb himself; Hajji 'Abdallah, who was celebrated for his *thulth* and *riqā'* hands as well as his *naskh*, and who managed to make an excellent copy of the Qur'an during the 15 days of the journey when he was summoned from Lahore to Delhi by Prince Muhammad Mu'azzam; and Sa'id Amrad (probably Muhammad Sa'id Ansari), who had come to India after establishing a reputation in Iran and Mawara' al-Nahr, and who was particularly skilled in writing in gold.[35]

A later and more specialized work is the *Tadhkirah-i khwashnavīsān* ('Memorial of the calligraphers'), the author of which, Ghulam Muhammad Dihlavi, is better known as Haftqalami (d.1823). Haftqalami provided entries on a number of other *naskh* scribes active in Awrangzeb's reign and of his successors down to the reign of the Emperor Akbar II (1806–37); and in these one can trace the development of a *naskh* tradition that had its origins in the patronage available at Awrangzeb's court. In this source, however, the tradition was not shown as a single strand derived from a great figure of the past, as we find in Ottoman and Iranian literature on calligraphy; and two scribes working in one style of *naskh*, that of Qazi 'Ismatallah Khan (see below), were recorded as changing to another, described as *lāhawrī-āmīz* ('mixed with that of Lahore'), because it was preferred by their Rohilla Afghan patrons.[36] There was also foreign competition, especially from the Isfahani school of *naskh* associated with Ahmad Nayrizi (*fl.*1676–1739; see pp.127–31 above). Work in his style was known in India (see pp.200–201 and cat.66 below), and exponents of it were active there in the 18th century.[37]

The first tradition identified by Haftqalami goes back to the 'Abd al-Baqi Haddad referred to above. Before he returned home to Iran, 'Abd al-Baqi trained a number of pupils, most of whom, we are told, also received the title Yaqut-raqam (Khan).[38] One of these pupils was the *thulth* and *naskh* calligrapher Muhammad 'Arif, who, according to Haftqalami's editor, M. Hidayet Husain, received the title Yaqut-raqam Khan from the Emperor Shah 'Alam I and developed a new style of *naskh* that became popular in India.[39] Five of the many pupils of Muhammad 'Arif were named, including his nephew 'Ismatallah, whose follower, Ghulam Husayn Kallu Khan, had been active in Haftqalami's own time.[40] A second tradition begins with the Qazi 'Ismatallah Khan referred to above (see also cat.71 below), who, like 'Abd al-Baqi Haddad, was credited with 'seizing the polo ball of precedence' from his contemporaries and developing a new style of *naskh*. He produced a large number of Qur'ans and other works and died in AH 1186 (AD 1772–3). Qazi 'Ismatallah's school included Hafiz Abu'l-Hasan, who was calligraphy teacher to the future Emperor Akbar II, while another pupil, Mir Imam 'Ali ibn Mir Imam al-Din, and his son and pupil Mir Jalal al-Din, were attached to the heir apparent, Prince Abu'l-Muzaffar, who was to be the last Mughal emperor, Bahadur Shah II (*reg.*1837–1858). The Qazi's pupils also included his elder brother Fayzallah Khan, his nephew 'Ibadallah Khan, and another relative, Miyan Muhammadi, who moved to Lucknow after Qazi 'Ismatallah's death and was employed as calligraphy tutor to the children of Navvab Hasan Riza Khan.[41]

By the time that Haftqalami was writing, in the early 19th century, the calligraphers of the centres in his orbit, such as Lucknow, Rampur and Delhi, were part of a pattern of provincial schools that covered much of the subcontinent. Reference has already been made to Lahore, and others were to be found in Kashmir to the north (see pp.228–9 below), in Sind to the east,[42] and in the Deccan to the south, which, as one would expect, is well-represented in the Salar Jung collection in Hyderabad.[43] These local schools were the heirs of a great Indian tradition that had risen above the stylistic heterogeneity and dependence on Iranian models that characterized the 17th century (cat.57–63, for example) to produce some of the most magnificent manuscripts produced anywhere in the Islamic world in the 18th century (cat.68–71, for example). Unfortunately, however, so little attention has been paid to any aspect of Qur'an production in India that it is difficult to evaluate this evidence in the thoroughgoing manner it deserves.

1. See James 1992b, nos 27–29, 47, 48, 52, 53, for example.
2. Lings & Safadi 1976, no.140; Losty 1982, no.53; Brand & Lowry 1985, no.21; Seyller 1997, p.341.
3. James 1992b, p.214.
4. See, for example, London, British Library, MSS Or.11,544 (Lings & Safadi 1976, no.139; Lings 1976, no.94); Sotheby's, London, 14 December 1987, lot no.234; 23 October 1992, lot no.581.
5. Seyller 1997, p.314.
6. Muhammad Ashraf 1962, no.2; Seyller 1997, p.344.
7. Quoted in Seyller 1997, pp.253–4.
8. Seyller 1997, p.254.
9. Karatay 1962, nos 89–104.
10. James 1992b, no.48.
11. Seyller 1997, p.345.
12. Muhammad Ashraf 1962, no.2; Seyller 1997, p.344. Shah Jahan explained that the Qur'an had been taken from Hasan by Imamquli Khan, who gave it to his brother Nadhr Muhammad Khan; and that it had been seized upon Nadhr Muhammad's flight from Balkh in AH 1056 (AD 1646–7).
13. James 1992b, no.43. The second copy is Sotheby's, London, 13 October 1989, lot no. 94; Seyller 1997, p.342.
14. Muhammad Ashraf 1962, no.340.
15. Sotheby's, New York, 15 December 1978, lot no.216.
16. Muhammad Ashraf 1962, no.57.
17. Christie's, London, 7 April 1995, lot no.47.
18. Seyller 1997, p.340.
19. Haftqalami, ed. Hidayet Husain, p.125. For a Qur'an by him, see Muhammad Ashraf 1962, no.257.
20. Seyller 1997, pp.345, 343.
21. Muhammad Ashraf 1962, no.2. A later note records that on 4 Safar 1152 (13 May 1739 N.S.) the Qur'an was again deposited in the imperial library by 'Abd al-Majid Khan.
22. See also James 1992a, no.31; 1992b, nos 43, 51. Other Khalili manuscripts with such seal impressions are MSS 144, MSS 134. See also Muhammad Ashraf 1962, nos 25, 89, 100; Seyller 1997, pp.321–6.
23. Muhammad Ashraf 1962, illustration facing p.5.
24. Muhammad Saqi Musta'idd Khan, trans. Sarkar, p.318, with corrections. Cf. Muhammad Bakhtavar Khan, ed. Alvi, I, pp.389–90.
25. See Muhammad Bakhtavar Khan, ed. Alvi, I, Introduction, p.53.
26. Ibidem.
27. Chaghatai 1978, p.1128.
28. See, for example, Muhammad Saqi Musta'idd Khan, trans. Sarkar, pp.318–23, which is based on Muhammad Bakhtavar Khan, ed. Alvi, I, pp.390–98.
29. Muhammad Saqi Musta'idd Khan, trans. Sarkar, pp.322–3. See also Leach 1998, no.23.
30. Muhammad Saqi Musta'idd Khan, trans. Sarkar, p.323.
31. Storey 1927–53, part I, section II, pp.132–3.
32. Muhammad Bakhtavar Khan, ed. Alvi, II, pp.462–93.
33. Muhammad Bakhtavar Khan, ed. Alvi, I, pp.479–80 (Ashraf Khan Mir Munshi), 487–8 (Muhammad Nasir), 489–90 (I'timad Khan), 493 (Muhammad Ibrahim Ghafil).
34. Muhammad Bakhtavar Khan, ed. Alvi, I, p.487.
35. Muhammad Bakhtavar Khan, ed. Alvi, I, pp.491–2. A calligraphic specimen in gold naskh signed by Muhammad Sa'id Ansari and dated AH 1080 (AD 1669–70) was recorded in Bayani 1345–58, IV, p.161.
36. Haftqalami, ed. Hidayet Husain, pp.128 (Hafiz Mas'ud), 129 ('Inayatallah Mabrus).
37. See Haftqalami, ed. Hidayet Husain, pp.128 (Hakim Muhammad Husayn), 131 (Muhammad Taqi al-Husayni al-Khatib). I believe that the references to 'Ahmad Tabrizi' in the published edition of Haftqalami's work are a misreading for Ahmad Nayrizi, not least because the famous Ahmad Tabrizi postdated Haftqalami.
38. Haftqalami, ed. Hidayet Husain, p.125.
39. Haftqalami, ed. Hidayet Husain, p.126 and n.1. Cf. Bayani 1347–58, IV, p.173; Raby 1996, no.158; and perhaps Christie's, London, 11 June, 86, lot no.67.
40. Haftqalami, ed. Hidayet Husain, pp.126–7. The other four pupils of Muhammad 'Arif mentioned are Muhammad Afzal, Muhammad 'Askar, Mirza Fazlallah and Zayn al-Din.
41. Haftqalami, ed. Hidayet Husain, pp.127–8, 129. The other pupils mentioned are Mir Gada'i Mughulpuriyah and Mir Karam 'Ali. Other naskh calligraphers mentioned by Haftqalami are Muhammad Sadiq Tabataba'i Murid Khan, who flourished in the first half of the 18th century, and Muhammad Hafiz Khan (d.1780); see pp.107, 111–12.
42. The names of naskh scribes active in Sind occur here and there in the Maqālat al-shu'arā', a biographical dictionary of Sindi poets written by Mir 'Alisher Qani' Tattavi (d. AH 1203/AD 1788–9); see Qani', ed. Rashidi, pp.108–9 (Mir Buzurg Katib), 145–6 (Mir Jan Muhammad Bilgrami), 879 (Ahmad Yar Khan Yakta).
43. See, for example, Muhammad Ashraf 1962, nos 127, 274, 275, 278.

Amanat Khan.
Master calligrapher of the Taj Mahal

by Manijeh Bayani

MSS719, folio 186b detail

Much of our knowledge of the history of Islamic calligraphy derives from the short biographies of prominent scribes included in a variety of literary works from the medieval period onwards. In most cases the authors of these accounts attempted to give examples of each master's output. Sometimes these included a particularly well-known copy of the Qur'an, or of the works of Firdawsi or Nizami. Other writers simply listed the number of manuscripts in a given category that the calligrapher had copied – Qur'ans, *ḥilyah*s, prayer books, albums, and so forth. Special note was made of any monumental examples of the calligrapher's hand. As most calligraphers lived relatively uneventful lives, their association with a major, or even a minor, building was always a matter worthy of mention. Thus we know that Arghun al-Kamili (*fl.* 1300–52) produced the inscriptions for several buildings in Baghdad,[1] and that 'Abdallah al-Sayrafi (*fl.* 1320–46) did the same for many of the monuments of Tabriz,[2] even though few signed monumental inscriptions produced before the mid-16th century survive. Another calligrapher of the first half of the 14th century, Yahya al-Jamali al-Sufi (*fl.* 1330–51), wrote an inscription at Persepolis and a Qur'an for Tashi Khatun, mother of the Inju'id monarch Abu Ishaq, both of which survive,[3] and Şeyh Hamdullah, who died in or before 1520, composed inscriptions that still grace the mosque of Sultan Bayezid II in Istanbul, and authentic examples of his hand on paper can still be found in the same city's libraries.[4] But such instances are the exception.

From the mid-16th century surviving examples of monumental calligraphy by famous masters are more plentiful. Hasan Çelebi, the adopted son of Ahmed Karahisari, designed inscriptions for the Süleymaniye mosque in Istanbul, and many of the Qur'ans and prayer books he produced also survive, though his monumental work has in some cases been subject to various restorations. There are also numerous Iranian examples of monumental inscriptions signed by masters of the mid-16th to 19th centuries, usually executed on tiles. India, too, is rich in signed monumental inscriptions, some painted, others executed in tilework or stone. A substantial portion of these were the work of Iranian émigré calligraphers, such as Jamal al-Din Muhammad ibn Husayn Fakhkhar Shirazi. His father, Jalal al-Din Husayn, was a well-known calligrapher of Shiraz, and there are several examples of his work on paper in public and private collections, including the Khalili Collection.[5] The son migrated to the Deccan, where in the 1590s he produced the inscriptions for many buildings in Hyderabad, capital of the Qutbshahi sultans.[6] At least two examples of his work on paper are also known, one of which was formerly part of a royal Deccani album.[7]

Other calligraphers from Iran were employed at the Mughal courts in northern India, and one of these, 'Abd al-Haqq Amanat Khan Shirazi, enjoyed particular success both as an official in the service of the Mughal emperors and as the artist responsible for the inscriptions on a series of major monuments, including the most famous of all Islamic buildings in India, the Taj Mahal in Agra. Although 'Abd al-Haqq's activity as a designer of monumental inscriptions is now well-documented,[8] his work on paper has remained a matter for speculation. It is most unlikely that 'Abd al-Haqq copied manuscripts for a living, given the high status he enjoyed,[9] but the offices he held appear to have included that of head of the royal library, and he may well have copied books in that capacity. None, however, has yet been identified, and the only manuscript so far discovered that bears the name of 'Abd al-Haqq as scribe is a Qur'an in the Khalili Collection, cat. 58 below, which is therefore of some importance; it was completed in AH 1050 (AD 1640–41), towards the end of the calligrapher's life, when he was living in retirement near Lahore.[10]

From 'Abd al-Haqq to Amanat Khan

'Abd al-Haqq Amanat Khan was the brother of Shukrallah Afzal Khan Shirazi (1570–1639), a Persian man of letters who emigrated to India by 1608.[11] Their father's name is given as Qasim, and it has been suggested that he was the Qasim Katib who made a copy of the *Khamsah* of Nizami in Shiraz in 1584.[12] This is not unlikely, as throughout the 16th century Shiraz was famous for its scribal families, whose activities extended over several generations.[13] When Shukrallah moved to India, he gained the patronage of 'Abd al-Rahim Khan Khanan, the celebrated courtier of the Emperor Jahangir (*reg.* 1605–1627),

and in 1611 or thereabouts he became the personal secretary of Prince Khurram, the future Emperor Shah Jahan (*reg.* 1628–1657).[14] ʿAbd al-Haqq must have accompanied Shukrallah to India, or followed very soon after, and he evidently took immediate advantage of the exalted connections his brother established, for his earliest work was on a project the Emperor Jahangir initiated about 1608. This was the final stage in the construction of the tomb at Sikandra, near Agra, of Jahangir's father, Akbar, who had died in 1605, and ʿAbd al-Haqq was responsible for the long dedicatory inscription which frames the arch of the main gateway. The work, completed in AH 1022 (AD 1613–14), was executed in relief in white marble, and it shows that ʿAbd al-Haqq had acquired some facility in the grand tradition of monumental *thulth*.[15]

During Jahangir's reign ʿAbd al-Haqq was appointed to an important position in the emperor's library, as is shown by the presence of impressions of his seal on manuscripts that once formed part of this collection.[16] An impression of a seal from this period which bears the legend, *ʿAbd al-Haqq ibn Qāsim al-Shīrāzī*, and the date AH 1037 (AD 1627–8) is found, for example, on the *Razm-nāmah* manuscript commissioned by the Emperor Akbar in 1582 and now in Jaipur,[17] and the same seal was used on

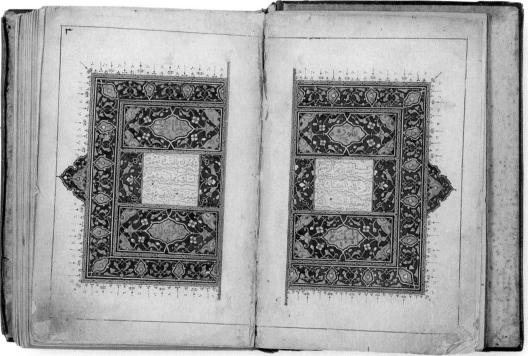

58 folios 2b–3a

a copy of the *Dīvān* of Hafiz of AH 975 (AD 1570) in the Khalili Collection (see p. 178). ʿAbd al-Haqq's connection with the library continued in the reign of Shah Jahan, for a seal engraved with the legend, *ʿAbd al-Haqq Shāhjahānī*, was used on a copy of the *Dīvān* of Jami which once belonged to this emperor and is now in the Gulistan Library in Tehran.[18] Two other manuscripts in the Gulistan Library,[19] as well as a history of Herat in the British Library,[20] carry impressions of another seal, engraved with the words, *Amānat Khān Shāhjahānī*, and the date AH 1042 (AD 1632–3). ʿAbd al-Haqq must have had this seal made following his acquisition of the title Amanat Khan, which, as we shall see, occurred in June 1632.[21] This sequence of seal impressions suggests that ʿAbd al-Haqq held a post in the royal library continuously from the late 1620s well into the 1630s. Indeed, it seems more than likely that ʿAbd al-Haqq's post at this time was that of head of the library, firstly because he was the designer of inscriptions for the buildings erected by the Mughal emperors during this period, and secondly because he achieved relatively high rank in the course of the 1630s.

In the meantime ʿAbd al-Haqq's brother, Shukrullah, had acquired great distinction. Given the title Afzal Khan in 1615, he was a mainstay of Shah Jahan's cause during the struggle for the Mughal throne

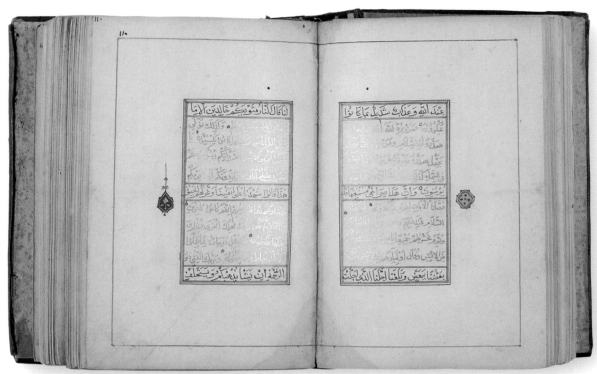

58 folios 109b–110a

in 1627–8 and was rewarded with the post of first minister (*dīvān-i kull*), and eventually with the second-highest military rank Shah Jahan ever bestowed.[22] It was no doubt Shukrallah's continued pre-eminence that guaranteed 'Abd al-Haqq's position and led to his involvement in affairs of state, on an occasional basis at least. His name first appears in the historical literature in connection with events in 1631, when he was given the task of escorting the Iranian envoy Muhammad 'Ali Beg to Burhanpur, where Shah Jahan was in residence.[23] His name appears again in connection with Shah Jahan's reception of a group of nobles on 8 May 1632, and on 19 June 1632 'Abd al-Haqq was given the military rank (*manṣab*) of a commander of 900 infantry and 200 cavalry, as well as the title Amanat Khan.[24] A year later, in July 1633, he received further promotion, to the *hazārī* rank, that of commander of 1000 infantrymen. As Wayne E. Begley has remarked, 'These honours not only symbolized the high regard in which the emperor held him, but the promotion in military rank guaranteed him a considerable permanent income. Although the official histories do not intimate the reasons behind them, it is possible that the honours may have had something to do with 'Abd al-Haqq's appointment as calligrapher of the Taj Mahal, as well as for his diplomatic services to the state.'[25] A later honour, however, the gift of an elephant on 19 December 1637, was expressly connected to 'Abd al-Haqq's work on this building.[26]

From Agra to Saray-i Amanat Khan

The erection of the Taj Mahal was prompted by the death at Burhanpur on 17 June 1631 of Shah Jahan's beloved wife Mumtaz Mahal (who was also known as Taj Bibi, according to a note in cat. 72 below), and work on the tomb and its surrounding buildings began in January 1632. 'Abd al-Haqq was charged with the task of composing the inscriptions on the mausoleum, both inside and out, on the stone marking Mumtaz Mahal's grave, and on the gatehouse and mosque that form part of the complex. The inscriptions consist primarily of a series of Qur'anic quotations, executed in the *thulth* style and arranged in bands that frame the main architectural elements. According to a contemporary historian, 'Abd al-Hamid Lahawri, 'Adorning the inside and outside of this sacred tomb are numerous inscriptions – consisting of chapters and verses of the Koran, dwelling on the mercifulness of Allāh; His ninety-nine names; and prayers taught by the Prophets and Imams – so wondrously written that they astound not only the residents of earth but also the inhabitants of Heaven.'[27] 'Abd al-Haqq probably supervised their execution in marble inlay, and his contributions to the decoration of the building

have completion dates of AH 1046 (AD 1636–7) and AH 1048 (AD 1638–9). During the years 1636–8 'Abd al-Haqq also worked on the inscriptions on the three mihrabs in the Madrasah-i Shahi Mosque at Agra, two of which bear his signature.[28] But 'Abd al-Haqq's work at Agra came to a stop before the greater of the two projects, the Taj Mahal, was complete. The calligrapher seems to have left Agra some time in 1638, perhaps in connection with Shah Jahan's own move from the city in that year. 'Abd al-Haqq's departure occurred after the inscriptions of the mausoleum itself had been completed, but before the gatehouse was finished. In the event this part of the complex had to be completed after the calligrapher's demise.[29]

'Abd al-Haqq spent the period after 1638 in Lahore, where his brother Afzal Khan died on 17 January 1639. According to the chronicler Chandrabhan Brahman, who had been a protégé of Afzal Khan, 'Abd al-Haqq was so grieved by the death of his brother that, 'resigning service and giving up office and rank, he sought the nook of retirement' and led a life of absolute seclusion.[30] He took up residence in a village he had founded one day's journey south of Lahore, and there he built a great caravanserai, the Saray-i Amanat Khan. This was completed in AH 1050 (AH 1640–41), the date which appears in the dedicatory inscriptions executed in tile mosaic that frame the western entrance to the building.[31] The date of 'Abd al-Haqq's death is variously given as AH 1050 (AD 1640–41), which was clearly derived from the date on the caravanserai (see below), and as the sixteenth and eighteenth years of Shah Jahan's reign, equivalent to AH 1052 (AD 1642–3) and AH 1054 (AD 1644–5) respectively,[32] but it seems to have occurred around 1642.[33] The longest obituary devoted to him was provided by Muhammad Bakhtavar Khan's 'ghost writer', Muhammad Saqa Burhanpuri, in the *Mir'āt al-'ālam*, which was composed under Shah Jahan's successor, Awrangzeb. 'Amanat Khan, the learned brother of Afzal Khan. His *naskh* was the best of all calligraphers. He wrote the inscriptions on the tomb of Mumtaz Mahal in Agra and was rewarded in AH 1047 [AD 1637–8] with an elephant and a robe of honour. He built a *ribāṭ* and gardens close to the capital, Lahore, and wrote the inscriptions on the gateway in *naskh*. He died in AH 1050 [AD 1640–41] and was buried in the garden he had built near his house.'[34] His place of interment is almost certainly to be identified with a small ruined tomb lying just south of his caravanserai,[35] where he very probably copied cat. 58 below.

1. Qazi Ahmad, trans. Minorsky, pp.60–61. See also Thackston 1989, p.339, n.18; Stanley 1996, pp.27–30.
2. Qazi Ahmad, trans. Minorsky, pp.62–3. See also Thackston 1989, p.340, n.22; Soucek 1985.
3. James 1988, pp.162–73; Blair 1996.
4. Serin 1992.
5. Bayani 1329, p.6, no.6; Atabay 1351, pp.89–91; Bayani 1345–58, IV, p.52, no.138; James 1992b, pp.184–9, no.45.
6. Yazdani 1921; Bilgrami 1927; but see also James 1992b, p.184, n.3.
7. Dublin, Chester Beatty Library, MS.225, folio 6a; see James 1987. The other example is an unpublished page in the Polier Album in Berlin (Islamisches Museum, MS.74,599, folio 36, K 26,11; James 1992b, p.184, n.3).
8. Begley 1978–9; 1983, pp.173–9; 1985, nos 53, 59.
9. Begley 1978–9, p.24, and n.63.
10. I would like to thank Robert Skelton for his help in identifying the scribe.

11. Begley 1978–9, p.12, n.18.
12. Binyon, Wilkinson & Gray 1933, no.223; Begley 1978–9, p.24, and pl.21.
13. James 1992b, pp.144–5.
14. Begley 1978–9, p.12, n.19.
15. Begley 1978–9, p.10; Begley 1983, no.53.
16. Seyller 1997, p.255. Many examples are given in Seyller's appendix A, pp.280–334.
17. Maharaja Sawai Man Singh II Museum, Jaipur, MSS AG 1683–AG 1850; see Begley 1978–9, p.24, n.63; Seyller 1997, appendix A, pp.307–8, and the sources cited there.
18. Bayani, no date, pp.297–9, no.528, especially p.299; Atabay 2535, I, pp.189–92, no.80.
19. For the first, see Bayani, no date, pp.184–6, no.444. For the second, see Bayani, no date, pp.317–18, no.547; Atabay 2535, I, pp.204–5, no.86.
20. MS.Add.16,704, dated AH 1002 (AD 1593–4); Begley 1978–9,

p.24, n.63.
21. Begley 1978–9, pp.14–15.
22. Begley 1978–9, p.13.
23. Begley 1978–9, p.14.
24. For a brief description of the Mughal ranking system, see Richards 1991.
25. Begley 1978–9, p.15.
26. Begley 1978–9, p.16.
27. Quoted in Begley 1978–9, p.32.
28. Begley 1978–9, pp.26–9, and pls 22–6.
29. Begley 1978–9, pp.17–20.
30. Quoted in Begley 1983, p.176.
31. Begley 1978–9, pp.29–30, and pls 27–33; 1983, pp.173–8.
32. Muhammad Bakhtavar Khan, ed. Alvi, p.487; Shahnavaz Khan, ed. 'Abd al-Rahim & Miraz Ashraf 'Ali, II, p.790; 'Abd al-Hamid Lahawri, ed. Kabir al-Din Ahmad & 'Abd al-Rahim, II, p.737.
33. Begley 1978–9, p.31.
34. Muhammad Bakhtavar Khan, ed. Alvi, p.487.
35. Begley 1983, pp.176–7, and pl.16.

58
Single-volume Qur'an

India, probably Saray-i Amanat Khan, AH 1050 (AD 1640–41)

512 folios, 13.9 × 9 cm, with 11 lines to the page
Material A smooth, cream laid paper, lightly burnished; there are approximately eight laid lines to the centimetre, and no apparent rib shadows or chain lines
Text area 7 × 4 cm
Script Both main text and surah headings in *naskh*
Scribe Amanat Khan al-Shirazi
Illumination Extensive decoration on folios 1b–3a; text frame of gold, black and blue rules, and outer frame of one blue rule, replaced on folios 3b–4a and folios 311b–312a by a band of gold scrollwork; text area divided into five compartments by gold and black rules; verses punctuated by blue circlets; marginal devices marking every fifth and tenth verse; colophon on folio 512a in an ornamental roundel, the margins of this page and folio 511b filled with gold scrolls
Documentation Colophon, seal impression and library notes
Binding Leather covers, probably contemporary
Accession no. QUR614

1. The use of lines of text in the same style of script and of the same length within ruled compartments links this Qur'an to cat.72 below and supports the dating of the latter to the first half of the 17th century.
2. See Begley 1978–9, fig.1, for example. One point that has yet to be clarified is his description of himself as *samī jāmi' al-Qur'ān*, 'namesake of the Collector of the Qur'an', a reference to the caliph 'Uthman.
3. The documentation on this page is now obscured by restoration and cannot be reproduced.

The scribe of this Qur'an was 'Abd al-Haqq Amanat Khan Shirazi, who designed the inscriptions on the Taj Mahal (see pp.178–81 above). Although several examples of his monumental calligraphy are known, the Khalili Qur'an is the only example of his work on paper so far identified. The manuscript was copied in the same year as the building of Amanat Khan's caravanserai south of Lahore, where he was living in retirement. Its modest size suggests that Amanat Khan made this copy of the Qur'an for his own use, and, as the calligrapher died shortly after the completion of this manuscript, some time between 1641 and 1645, it may well have been his last work. In its modesty it stands in great contrast to his grandiose architectural inscriptions, which were designed to glorify his imperial masters.

The first two openings contain the first surah of the Qur'an (folios 1b–2a) and the beginning of the second surah, to the start of verse 3 (folios 2b–3a). On each page there are three short lines of text written in gold and set in 'clouds' outlined in blue and reserved in grounds hatched in red. The text is surrounded by panels illuminated in a distinctive, archaic style, predominately in gold and blue. The text areas of the third opening have 11 lines in gold, and there is a narrow band of gold scrollwork around the edge of the page. In the rest of the manuscript the text area on each page is divided into five compartments. The first and fifth contain a line of text in blue, the second and fourth, three lines in gold, and the third, one line in orange. All vocalization is in the same colour as the script.[1] Surah headings are in the same size of *naskh*, in blue or orange. The hand is not especially distinguished, perhaps due to the age of the calligrapher, and to the fact that he was more at home working on a larger scale. Each fifth and tenth verse is marked by a small marginal device in gold and blue: for five verses it is a lobed roundel with a blue ground and a point at the top furnished with a blue 'finial'; for ten verses, a four-lobed figure with a gold ground.

On folio 311b there are eight lines of text, and a blank central compartment. The *basmalah* of surah CXIV, which occupies the first line, is in blue, but the text of the surah (lines 2–4) is in black, as is the text of the prayer that occupies lines 5–8. All these texts were written in 'clouds', outlined in orange and reserved in a gold ground. The same treatment has been applied to the colophon, which was written in a slightly larger hand, in blue outlined in gold, within a roundel. The roundel and the margins of this and the preceding page are edged with the same band of gold scrolls as folios 3b–4a, and the margins are filled with gold scrollwork. It is notable that Amanat Khan wrote his name in the same style as in his architectural inscriptions, with the long final *yā'* (of al-Shirazi) running back through the uprights of *alif* and *lām*.[2]

Folio 1a contains some notes and the impression of a seal typical of those used by important Mughal officials.[3] Only a small part of this is legible, but it is not too fanciful to suggest that it reads, [*Amāna*]*t Khān* [*Shāhja*]*hā*[*nī*] ('Amanat Khan Shahjahani').

The binding, which has no fore-edge flap, is of brown morocco and has simple tooled borders and stamped centre-pieces filled with an arabesque design. The doublures are of gold-flecked paper.

59
Single-volume Qur'an
India, 17th century

244 folios, 15.6 × 9.2 cm,
with 18 lines to the page
Material A smooth, dark-cream
laid paper, lightly burnished; there
are approximately ten laid lines to
the centimetre, and no apparent
rib shadows or chain lines
Text area 10.5 × 4.9 cm
Script The main text in *naskh*, in
black, with reading marks in red;
surah headings in white *riqā'*
Scribe Hajji Ibrahim
Illumination Extensive illumination
on folio 1b–2a; text area scattered
with gold and surrounded by
frames of gold, black and blue rules;
verses marked by gold discs; surah
headings; marginal devices marking
divisions of the text
Documentation A colophon
Binding Contemporary
Accession no. QUR91

This fine manuscript, which, like cat. 58, is of modest dimensions, was copied by Hajji
Ibrahim, a scribe who is otherwise unknown. The text was written over a ground
scattered with gold, except on folios 1b–2a, where the spaces between the text are filled
with red gold. The same tone of gold was used for the floral scrolls that fill the margins
of these pages, which are otherwise lacking the illuminated compositions usually seen on
the opening folios of Qur'ans of this quality. As in all other cases, the surah headings here
were written in white *riqā'* in plain gold panels. Other divisions of the text were similarly
recorded in gold discs placed in the margin. The discs have outlines and finials in blue.

The red morocco binding is of comparable refinement. It has a wide, plain border
defined by rules painted in yellow, and the outer edge is painted black. The inner field
has inset centre-and-corner elements that have been block-pressed and gilded. The
block-pressed designs consist of scrollwork and symmetrical compositions set with
relatively large, rosette-like flowers. The doublures are plain.

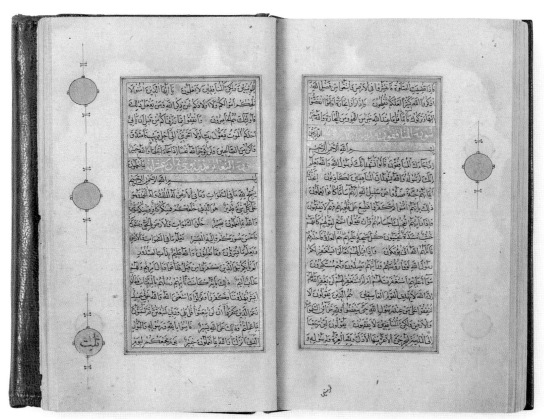

59 folios 224b–225a

60
Single-volume Qur'an

India, in or before AH 1080 (AD 1669–70)

578 folios, 22 × 14 cm,
with 11 lines to the page
Material A very thin, very crisp,
off-white laid paper, burnished and
glossy; there are approximately 16
laid lines to the centimetre and no
apparent rib shadows or chain lines
Text area 14.5 × 8.1 cm
Script The main text in *naskh*,
in black, with reading marks in
red; surah headings in white *riqā'*;
marginal inscriptions in a free hand,
possibly later additions
Scribe [Bint] Muhyi'l-Din
Illumination Extensive decoration
on folios 1b–2a, 575b–576a; orna-
mental head-pieces on folios 2b,
576b; richly decorated borders
on folios 103b–104a, 197b–198a,
265b–266a, 345b–346a, 417b–418a,
487b–488a; text areas framed by
gold, black and blue rules, and an
outer frame consisting of a band of
meander scrolls 0.5 cm wide, in gold
throughout, with touches of blue
and red on folios 2b–3a; each line
of text in a 'cloud' reserved in a gold
ground, within a compartment 1 cm
wide defined by gold and black
rules, and separated from the next
line by a blank compartment 0.3 cm
wide; verses punctuated by small
gold discs, occasionally set off with
coloured dots or divided into
segments; surah headings; marginal
ornaments marking text divisions,
*sajdah*s, and *rukū'*s
Documentation A colophon, three
attributions, seal impressions
Binding Modern
Accession no. QUR417

1. For an Imamvirdi who was
fawjdār of Gavilar and who was
given the title Khan by Awrangzeb
in 1666, see Muhammad Bakhtavar
Khan, ed. Alvi, I, pp.102, 339.
2. Muhammad Bakhtavar Khan,
ed. Alvi, I, p.396. Zinat al-Nisa'
never married (*ibidem*, n.2).
3. There may be further evidence
of the interest of Zinat al-Nisa' in
the Qur'an in a magnificent 16th-
century copy in the Khalili
Collection (James 1992b, no.43).
This manuscript appears to have
been kept in the womens' quarters
of Awrangzeb's household in the
lifetime of Zinat al-Nisa'; it bears
an inscription by a Khwajah
Muhammad Khan, and he may

The identity of the scribe who wrote this Qur'an is obscured by damage to the colophon,
but three notes written by a Mughal courtier soon after the Qur'an was completed show
that the calligrapher was Princess Zinat al-Nisa', a daughter of the Emperor Awrangzeb
(*reg*.1658–1707), and the illuminator was her elder sister's – and perhaps her own – tutor,
an Iranian from Isfahan called Mawlana Muhammad Sa'id. In general such attributions
must be treated with caution, but the details provided in the notes in cat.60 accord well
with the evidence of contemporary literary sources.

The damage to the colophon, written in Persian on folio 578a, means that only the
words, *Kātib-i Qur'ān-i majīd* [...] *Muhyī'l-Dīn*, that is, 'The scribe of the Glorious
Qur'an [is ...] Muhyi al-Din', are clear. In the damaged area there is space for one word,
from which only the vowel *kasrah* survives. That word was probably *bint*, 'daughter of',
since at an early stage the colophon, laconic even in its original state, was supplemented
by the three notes referred to above, which are found on folios 1a, 578a and 578b. These
are in a crude *nasta'līq* hand, and all three are accompanied by the impression of the
seal of 'Imamvirdi, slave of 'Alamgir Shah', which bears the date AH 1074 (AD 1663–4).
'Alamgir Shah was the name taken on his accession by Prince Awrangzeb, whose other
names were Abu'l-Muzaffar Muhammad Muhyi'l-Din.[1]

The note on folio 578a, written immediately beneath the word *Muhyī'l-Dīn* in the
colophon, consists of the single word *Awrangzeb*. It is a gloss on the name Muhyi'l-Din,
showing that it refers to the Emperor, and it does not imply that Awrangzeb actually
copied the Qur'an. Nevertheless, to make it seem that he did, the beginning of the
note on folio 1a was later obliterated, and another hand added the word *kitābat-i* ('the
writing of') in its place. This makes a nonsense of the remainder, which reads, '[...] the
Emperor Muhyi'l-Din Awrangzeb 'Alamgir, Zinat al-Nisa', AH 1080' (AD 1669–70).
Again, the missing word was probably a term for 'daughter of', perhaps *bint*. The third
note, on folio 578b, has not been tampered with. One part reads, 'Zinat al-Nisa',
daughter of Dilras Banu Begam, first wife of Emperor Awrangzeb 'Alamgir, AH 1080.'
Zinat al-Nisa', the second of Awrangzeb's three daughters by Dilras Banu, was born in
1643 and was noted for her piety, having received a thorough religious education under
her father's guidance.[2] Cat.60 shows that the education of Zinat al-Nisa' included the
acquisition of a fine *naskh* hand, and that she made at least one copy of the Qur'an.[3]

The other part of the third note reads, 'Illumination of Sayyida Ashraf, pupil of Aqa
'Abd al-Rashid Daylami'. Sayyida Ashraf can be identified with Mawlana Muhammad
Sa'id, a figure in Isfahani literary life who was trained in calligraphy by 'Abd al-Rashid
Daylami, a nephew of 'Imad al-Hasani, and wrote poetry under the pen-name Ashraf.[4]
Muhammad Sa'id was the son of Mawlana Muhammad Salih Mazandarani, and his
mother was a daughter of the great Shi'i divine Mawlana Muhammad Taqi Majlisi
(1594–1659); he was thus the nephew of Muhammad Baqir Majlisi (see above, p.126).
Soon after the accession of Awrangzeb he left Isfahan for India,[5] where the Emperor
appointed him tutor to his eldest daughter, Princess Zeb al-Nisa'. In AH 1083 (AD 1672–3),
after more than a decade of service, he returned to Isfahan, but he was enticed back to
India, where he died at a great age in AH 1116 (AD 1704–5).[6] The date AH 1080 (AD 1669–70)
given in the notes on folios 1a and 578b may therefore be the date when the Qur'an was
written by Zinat al-Nisa' and illuminated by Sayyida Ashraf, or it may be the date when
it came into Imamvirdi's possession. He was clearly impressed by his acquisition and
hastened to clarify its imperial provenance.

The text of surah *al-Fātihah* (1) is arranged in two panels on folios 1b and 2a and
is surrounded by panels of illumination and a wide border, all set with arabesque and
floral motifs on blue and gold grounds. The other colours used were white, orange-red,

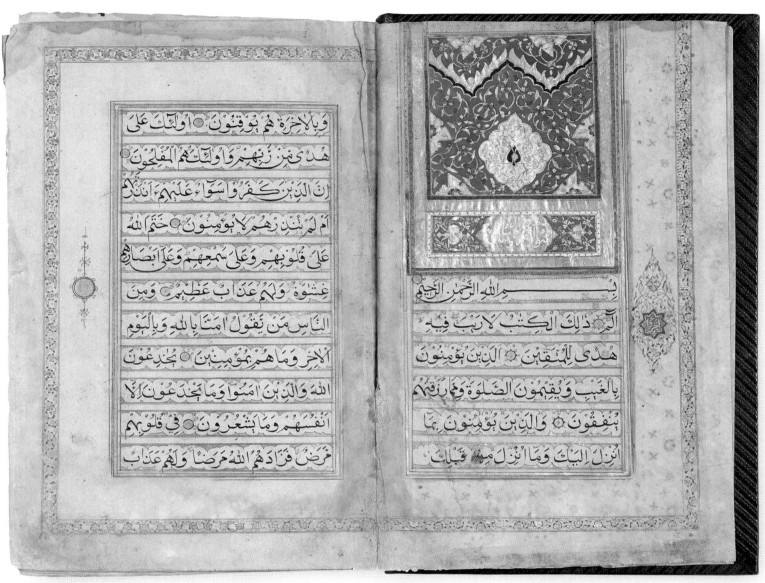

بِسْمِ اللهِ الرَّحْمنِ الرَّحِيمِ

الم ذلِكَ الْكِتَبُ لَا رَيْبَ فِيهِ هُدًى لِلْمُتَّقِينَ الَّذِينَ يُؤْمِنُونَ بِالْغَيْبِ وَيُقِيمُونَ الصَّلَوةَ وَمِمَّا رَزَقْنَهُمْ يُنْفِقُونَ وَالَّذِينَ يُؤْمِنُونَ بِمَا أُنْزِلَ إِلَيْكَ وَمَا أُنْزِلَ مِنْ قَبْلِكَ

وَبِالْآخِرَةِ هُمْ يُوقِنُونَ أُولَئِكَ عَلَى هُدًى مِنْ رَبِّهِمْ وَأُولَئِكَ هُمُ الْمُفْلِحُونَ إِنَّ الَّذِينَ كَفَرُوا سَوَاءٌ عَلَيْهِمْ أَأَنْذَرْتَهُمْ أَمْ لَمْ تُنْذِرْهُمْ لَا يُؤْمِنُونَ خَتَمَ اللهُ عَلَى قُلُوبِهِمْ وَعَلَى سَمْعِهِمْ وَعَلَى أَبْصَارِهِمْ غِشَاوَةٌ وَلَهُمْ عَذَابٌ عَظِيمٌ وَمِنَ النَّاسِ مَنْ يَقُولُ آمَنَّا بِاللهِ وَبِالْيَوْمِ الْآخِرِ وَمَا هُمْ بِمُؤْمِنِينَ يُخَادِعُونَ اللهَ وَالَّذِينَ آمَنُوا وَمَا يَخْدَعُونَ إِلَّا أَنْفُسَهُمْ وَمَا يَشْعُرُونَ فِي قُلُوبِهِمْ مَرَضٌ فَزَادَهُمُ اللهُ مَرَضًا وَلَهُمْ عَذَابٌ

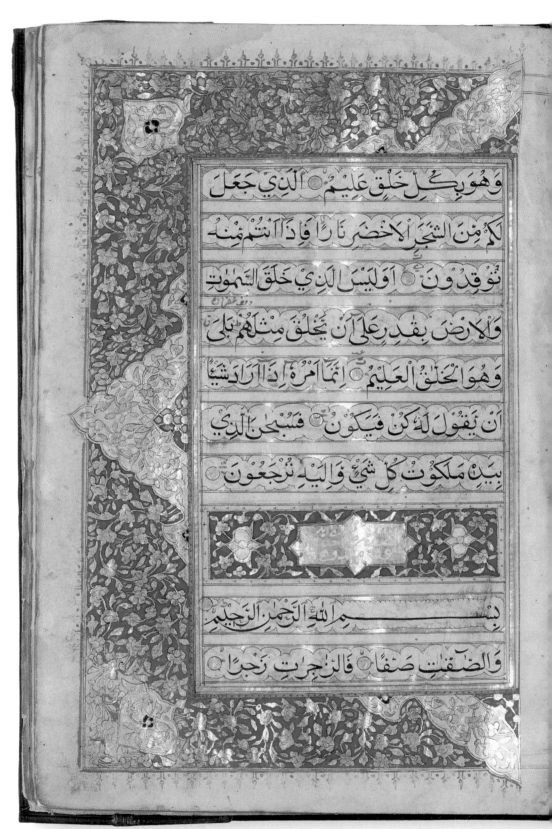

لَهَا مَالِكُوْنَ ۞ وَذَلَّلْنَاهَا لَهُمْ فَمِنْهَا رَكُوْبُهُمْ
وَمِنْهَا يَاكُلُوْنَ ۞ وَلَهُمْ فِيْهَا مَنَافِعُ
وَمَشَارِبُ ۗ أَفَلَا يَشْكُرُوْنَ ۞ وَاتَّخَذُوْا
مِنْ دُوْنِ اللّٰهِ اٰلِهَةً لَّعَلَّهُمْ يُنْصَرُوْنَ
لَا يَسْتَطِيْعُوْنَ نَصْرَهُمْ ۙ وَهُمْ لَهُمْ جُنْدٌ
مُّحْضَرُوْنَ ۞ فَلَا يَحْزُنْكَ قَوْلُهُمْ ۘ اِنَّا نَعْلَمُ
مَا يُسِرُّوْنَ وَمَا يُعْلِنُوْنَ ۞ اَوَلَمْ يَرَ
الْاِنْسَانُ اَنَّا خَلَقْنَاهُ مِنْ نُّطْفَةٍ فَاِذَا هُوَ
خَصِيْمٌ مُّبِيْنٌ ۞ وَضَرَبَ لَنَا مَثَلًا وَّ
نَسِيَ خَلْقَهٗ ۚ قَالَ مَنْ يُّحْيِ الْعِظَامَ وَهِيَ
رَمِيْمٌ ۞ قُلْ يُحْيِيْهَا الَّذِيْٓ اَنْشَاَهَآ اَوَّلَ مَرَّةٍ

have been the eunuch of that name who was in her service.

4. Bayani 1348–58, III, pp.743–5, no.1077, which is based on an article by Ahmad Gulchin Ma'ani in the *Nāmah-i Āstān-i Quds*. See also, amongst others, Nasrabadi, pp.181–2; Azad, pp.116–18.

5. Just as the future Afzal Khan was followed to India by his brother, the future Amanat Khan (above, pp.178–81), so Muhammad Sa'id accompanied or was accompanied by his brothers Mawlana 'Ali Naqi and Mawlana Muhammad Husayn (see Nasrabadi, pp.182–3). 'Ali Naqi died in the year in which Nasrabadi wrote this part of his *Tadhkirah*, which was also the year that Muhammad Sa'id returned to Isfahan, that is, AH 1083.

6. Cat.60 is illuminated in an Indian rather than Safavid style, but this does not contradict the attribution to Muhammad Sa'id, as Iranian painters who emigrated to India often worked in the local style, a well-known example being Farrukh Beg; see Welch 1985, pp.221–5, no.147.

7. See James 1992b, nos 30–38, for example.

green, pink and a dull black. The first words of surah II are written on the next page, beneath a head-piece painted in these colours, with the addition of a carmine-red. This sequence is repeated towards the end of the manuscript: the text of surahs CXIII and CXIV on folios 575b and 576a is surrounded by illuminated panels and borders, in which pale-blue and mauve were also used, and the prayer that fills folios 576b–578a begins with an ornamental head-piece. The illumination on folios 1b–2a was executed with a free hand but is clearly derived from the type of Qur'an decoration current in centres such as Herat, Bukhara and Tabriz in the earlier 16th century,[7] but the other compositions include some elements, such as areas of floral decoration in gold-on-gold and gold-on-blue, that are typical of other Indian work (compare cat.72–5). Gold-on-blue designs also fill most of the panels in which the gold cartouches containing the surah headings are set – other colours were used in a few examples. The cartouches are edged with orange-red, and the panels with a pink, or more rarely red, border textured with a cross-and-dot motif. In addition, the openings containing the beginnings of six surahs – *al-Mā'idah* (V), *Yūnus* (X), *Banī Isrā'īl* (XVII), *al-Shu'arā'* (XXVI), *al-Ṣāffāt* (XXXVII), and *Qāf* (L) – have borders illuminated primarily in blue and gold. These divide the Qur'anic text into seven roughly equal sections, although they do not correspond to the standard divisions of the text into sevenths (*sub'*).

The presentation of the text on other pages is also notable for its richness and complexity. Each line of *naskh* text is set in 'clouds' reserved in gold within a compartment of its own formed by single gold rules outlined in black. These rules also form narrower, blank bands between the lines of text, and these may have been intended for Persian glosses, as in some 17th-century Qur'ans from Iran (see cat.45). The text area is framed by multiple gold, black and blue rules, and there is a wider outer frame (*kamand*) in the three outer margins. The *kamand* is filled with a scrolling leaf motif in gold only which is seen in this position in other Indian Qur'ans (*e.g.* cat.58, folios 511b–512a). A gold disc with a blue outline and 'finials' marks each *rukū'*. In some cases the disc is inscribed with a letter *'ayn* in white, and occasional omissions of the marker are supplied by a red letter *'ayn*. *Juz'*, half- and quarter-*juz'* and *sajdah* markers consist of shaped cartouches with a blue ground. They are inscribed in gold and surrounded by a formal arrangement of floral motifs in gold, blue and red.

61
Single-volume Qur'an

India, AH 1097 (AD 1685–6)

312 folios, 32 × 19 cm, with 15 lines
to the page
Material A thin, cream laid paper,
lightly burnished; there is a high but
indeterminate number of laid lines
to the centimetre, and no apparent
rib shadows or chain lines. The
paper is so thin that individual folios
are semi-transparent
Text area 23.4 × 13.4 cm
Script Main text in a combination of
thulth (lines 1, 15), *muḥaqqaq* (line
8) and *naskh* (lines 2–7, 9–14), all in
black, with reading marks in red;
surah headings in white *riqāʿ* out-
lined in black, the *basmalah*s that
follow in *musalsal*; frontispiece
inscribed in *naskh*, and surah 1 in
muḥaqqaq, both in white outlined in
black; marginalia in gold *riqāʿ*
Scribe ʿAbd al-Rahman, son of Nur
al-Din Muhammad Ahmadabadi
Illumination Extensive decoration
on folios 1b–4a; text areas framed by
gold, blue and black rules and
divided into nine compartments by
gold and black rules, five compart-
ments sprinkled with gold and con-
taining text in different styles, four
lateral compartments filled with
scrollwork in gold; verses marked
by gold rosettes set with red and
blue dots; surah headings; marginal
devices marking divisions of the text
and *sajdah*s
Illuminator ʿAbd al-Rasul, son of
Nur al-Din Muhammad
Ahmadabadi
Documentation A colophon
Binding Modern
Accession no. QUR227

1. See, for example, James 1992b, nos
39, 40.
2. Ivanow 1925, pp.679–80, no.1433.
3. See also Muhammad Ashraf 1962,
no.269.

This manuscript, like cat.62 and 63, is something of an art-historical curiosity. It has many of the characteristics of Iranian Qur'ans, and more specifically Shirazi Qur'ans, of the 15th and earlier 16th centuries, before the high Safavid style was introduced into Qur'an illumination in the mid-16th century.[1] A relatively late example of the earlier style is to be found in a Qur'an written by ʿAbd al-Qadir al-Husayni, who may well have migrated from Shiraz to India before the new style took hold (see p.200 and cat.64 below). We may therefore presume that the older, Turcoman-period style was transmitted to India before the mid-16th century and survived there until the late 17th century, when cat.61 was produced. The attribution to India is based in part on the identity of the scribe and illuminator named in the colophon on folio 312b. They were two brothers, ʿAbd al-Rahman and ʿAbd al-Rasul, whose father, Nur al-Din Muhammad, bore the *nisbah* Ahmadabadi, suggesting that he or one of his ancestors came from Ahmadabad in Gujarat. The character of the script also supports an Indian attribution, as it evinces several orthographic peculiarities that also occur in cat.63, for example. One notable mannerism is the placing of dots of varying shapes and sizes in the loops of letters in the *muḥaqqaq* style (compare cat.62, folios 51b–52a). The execution of the illumination, too, is distinctively Indian, especially in the colours employed, predominately gold, dark-blue, white, orange-red and pink.

The illuminator of cat.61 was probably the ʿAbd al-Rasul who copied a large Persian – Arabic dictionary, the *Ashhar al-lughāt*, in AH 1105 (AD 1693–4), the 37th year of the reign of the Emperor Awrangzeb.[2] In this work he was assisted by his two sons, Ahmad Rahmatallah and Gul Muhammad, which suggests the existence of a family atelier of copyists and illuminators that flourished for at least three generations.[3]

The opening pages of the book (folios 1b–2a) are lavishly illuminated with a centre-and-corner composition in which the central medallions are inscribed with surah *al-Wāqiʿah* (LVI), verse 80, and a short prayer (illustrated on p.170). The central fields and the outer borders have rich floral scrollwork in gold. The text of the opening surah extends over folios 2b–3a and was written in white *muḥaqqaq* on gold within a lavishly illuminated frame. The third opening contains the beginning of surah II, which is preceded by an elaborate head-piece. On these two pages the text is written in 'clouds' reserved in a gold ground, and the lateral compartments are filled with decoration. The margins are also illuminated, with loose scrolls in gold.

The main text is presented in the complex format that combines different styles of script within ruled compartments of different sizes. As a result, the surah headings vary in size and presentation according to where they occur on the page. They were all inscribed in a distinctive white *riqāʿ* on a gold ground strewn with polychrome floral elements, while in the larger examples the gold ground takes the form of a cartouche with shaped ends, flanked by areas of dark blue. Divisions of the text and the prostrations (*sajdah*) were first marked by inscriptions in gold *naskh*, which were supplemented by ornamental devices mostly in the same style as the surah headings. These devices have a variety of forms, including a lobed roundel indicating the end of every tenth verse; an eight-pointed star for each *sajdah*; and a 'cloud-collar' motif for each *juzʾ*.

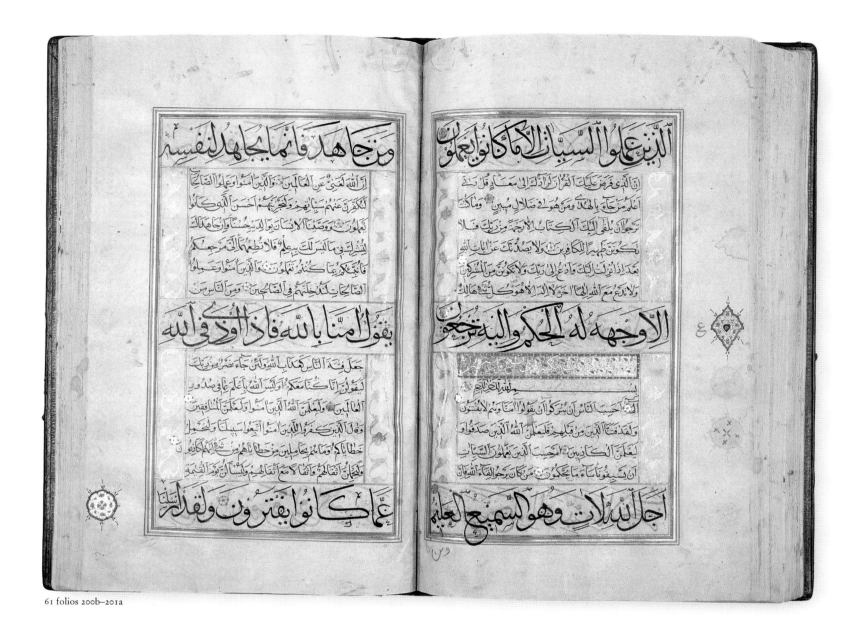

62
Single-volume Qur'an
Probably India, *circa* 1654–86

303 folios, 34.7 × 23.5 cm, with
15 lines to the page
Material A crisp, dark-cream laid
paper, lightly burnished; there are
approximately ten extremely feint
laid lines to the centimetre, and no
apparent chain lines or rib shadows
Text area 22.7 × 14 cm
Script The main text in a combina-
tion of *thulth* (lines 1, 8, 15) and
naskh (lines 2–7, 9–14); the *thulth* in
gold, outlined and vocalized in
black, with reading marks in red; the
naskh in black, with reading marks
in red; surah headings in a hand with
features of *naskh* and *riqā'*, in red or
blue; marginalia in the same hand, in
red, or in true *riqā'*, in red or gold
Scribe al-Marjan al-Islami
Illumination Extensive illumination
on folios 1b–2a; text frames ruled in
gold, black, red, blue and a colour
that has tarnished, and an outer
frame of gold and black rules; text
area divided into nine compartments
by gold and black rules; *naskh* com-
partments sprinkled with gold;
lateral compartments filled with a
block-stamped design in a pale gold
colour (folios 2b–7b), brown (folios
32b–33a) or red, overlaid with
designs in gold on folios 51b–52a;
verses punctuated by gold whorls
(rosettes on folios 1b–2a) with red
and blue dots; surah headings that
occur within the *naskh* text in com-
partments defined by gold and black
rules; *basmalah* set off with floral
motifs in colours that have now tar-
nished; marginal devices marking
text divisions and *sajdah*s
Documentation A colophon
Binding Contemporary
Accession no. QUR833

1. Bahrami & Bayani 1328, part two,
pp.63–4, no.110 (signed as 'Jamal
al-Din, better known as Marjan
al-Islami'); Christie's, London,
14 October 1997, lot no.57 (signed
'al-Marjan al-Katib al-Islami').
2. Bayani 1345–58, IV, p.205, no.684
(signed 'Marjan al-Islami'). See also
Sotheby's, London, 22 October
1993, lot no.119.
3. James 1992b, nos 39, 40.
4. *Cf.* James 1992b, nos 35, 43, 46, 49,
50.

The quality of the calligraphy, the combination of large and small scripts (compare cat.61) and the illumination of the opening pages give this manuscript the appearance of a Shirazi Qur'an of the 16th century, but it was probably produced in India, where the influence of Shirazi book production was strong, in the second half of the 17th century. The colophon on folio 303b contains no date, but a scribe of the same unusual name produced Qur'ans dated AH 1065 (AD 1654–5) and AH 1085 (AD 1664–5),[1] as well as a calligraphic specimen written in AH 1097 (AD 1685–6).[2] The odd wording of the colophon – 'Written by the poor and delinquent al-Marjan al-Islami' – suggests that Marjan had an uncertain grasp of Arabic, in which his name is not normally written with the definite article, and this is borne out by the colophons found on his other work. But he was a calligrapher of consid-erable skill, both in his *naskh*, which is similar to that used by the Shirazi scribe Ruzbihan Muhammad al-Tab'i,[3] and in his large and excellent *thulth* hand.

As has been noted above, the illumination on the opening pages has the appearance of 16th-century Shirazi work, although it lacks the characteristic 'Chinese cloud' motifs (see cat.63). On folio 1a there are two superposed head-pieces of different design, which were combined in this manner so that the two texts they contain – the title of surah 1 in the upper head-piece, and the *basmalah* in the lower – are aligned with the first and middle lines of text in the rest of the manuscript. The third line on this page in the larger script (that is, the last) contains the title of surah 11, which is usually placed at the top of folio 2a. The text in *thulth* on these two pages is set in 'clouds' reserved in a gold ground, and in the case of the two *basmalah*s the 'clouds' have a mid-blue ground. The lateral compartments that flank the text in *naskh* is filled with illumination similar to that of the head-pieces, and the margins are filled with gold scrollwork on a natural ground.

The rest of the manuscript has a rich appearance, due to the six lines of gold *thulth* on each opening, the numerous gold rules and the marginal devices. Most of the latter consist of a gold disc with a border of red dots and blue 'finials', inscribed in red. The markers for each *juz'* and half-*juz'* are lobed ovals and lobed fan-shaped figures respectively. A final element in the decoration is the stamped pattern of flowers and leaves, mostly in red, filling the compartments flanking the *naskh* text. These may have been intended as the base design for more impressive illumination, as occurs on folios 51b–52a, which contain surah IV, verses 128–41. Here the printed scrolls have been enlivened with designs in gold. The additional ornament on these pages also includes the composite lotus blossom in gold and colours placed in the margin, adjacent to the end of verse 140.

The covers are very worn but were once splendid examples of a type of leather binding current in Iran in the 16th century.[4] The recessed central panel is surrounded by a border set with recessed cartouches. All the sunken areas were stamped and gilded, but the only element that is still recognizable is the Qur'anic quotation (surah LVI, verses 79–80) found in four of the border cartouches. The doublures are of red morocco set with a centre-and-corner composition executed in exquisite gilded filigree on blue and green grounds.

اعد لهم سعيرا خالدين فيها ابدا

ولياً ولانصيرا ۝ يوم تقلب وجوههم في النار يقولون يليتنا
اطعنا الله واطعنا الرسولا ۝ وقالوا ربنا انا اطعنا سادتنا
وكبراءنا فاضلونا السبيلا ۝ ربنا اتهم ضعفين من
العذاب والعنهم لعنا كبيرا ۝ يا ايها الذين امنوا لا
تكونوا كالذين اذوا موسى فبراه الله مما قالوا وكان
عند الله وجيها ۝ يا ايها الذين امنوا اتقوا الله وقولوا قولا

سديدا يصلح لكم اعمالكم ويغفر

ومن يطع الله ورسوله فقد فاز فوزا عظيما ۝ انا عرضنا الامانة
على السموات والارض والجبال فابين ان يحملنها واشفقن
منها وحملها الانسان انه كان ظلوما جهولا ۝ ليعذب الله
المنافقين والمنافقات والمشركين والمشركات ويتوب الله
على المؤمنين والمؤمنات وكان الله غفورا رحيما ۝
سورة الساجد خمس وخمسون ايه

بسم الله الرحمن

63
Single-volume Qur'an

India, perhaps Golconda, 17th century

425 folios, 39.6 × 25.8 cm,
with 12 lines to the page
Material A smooth, cream laid
paper, lightly burnished; there are
approximately eight laid lines to
the centimetre, and no apparent
rib shadows or chain lines
Text area 27.9 × 16 cm
Script Main text in *naskh*, in black,
with reading marks in red; surah
headings and marginal *juz'* and
half-*juz* markers in blue *riqā'*; *ḥizb*
markers in red *riqā'*; other marginalia
in various styles, in red and blue;
concluding prayer in black *tawqī'*
Illumination Central roundel
on folio 1a; extensive decoration on
folios 1b–2a; text frames of gold,
red, black and blue rules; text area
sprinkled with gold; verses punctu-
ated by gold whorls set off with blue
and red dots; surah headings and
*basmalah*s on grounds set with floral
motifs in gold, with no outlines
Binding Leather covers of the
17th or 18th century
Accession no. QUR106

1. *Cf.* James 1992b, no.52, for
example.
2. See Muhammad Ashraf 1962,
pl. opposite p.210, for example.
3. See Zebrowski 1983, p.159, fig.121,
for example.
4. From folio 400a onwards the
gold rule forming the base of the
basmalah compartment is lacking.
5. The marginalia include a letter
'ayn in red, indicating that a *rukū'*
had to be performed, accompanied
by a number, which shows how
many verses are to be read before
the next *rukū'*. The same feature
occurs in cat.68.

The text of this large and impressive Qur'an was written in a bold *naskh* hand that has a number of idiosyncratic features. These include a notable degree of inconsistency in the shapes of certain letters, especially *alif* and *hā'*. Thus when the letter *hā'* occurs at the beginning of a group of letters its shape varies between one that is normal in Qur'anic *naskh* (folio 2b, line 4, *razaqnāhum*) and the 'Persian' form, more common in *nasta'līq* (folio 2b, line 6, *hum*). A particularly prominent mannerism of this type is the way the letter *yā'* in the word *al-raḥīm* in the *basmalah* was smoothed out into an arch shape, without the normal 'tooth' (Arabic *kursī*; Persian *dandānah*). Another feature is a tendency to run letters together (folio 160b, line 6, *jazā'uhu*), and in the phrase *'alā kulli shay'in* all three words are combined (folio 297b, line 6; folio 357a, line 11). On many occasions, too, final letters extend into the margins (folio 10a, lines 2, 10, for example).

The manuscript begins with an illuminated roundel, which appears to have become a distinctively Indian feature by the 16th century. The roundel, 7.5 centimetres in diameter, occurs in the middle of folio 1a and has a blank centre designed to take the name of the owner in seal form.[1] It was once matched by an illuminated device in each corner of the page, but only traces of these remain. On this page there are also traces of an impression of a crowned seal of the type used by the Qutbshahi sultans of Golconda,[2] and this, and the fact that the style of illumination appears to derive from one current in Golconda in the last decade of the 16th century,[3] suggests that cat.63 was produced in the Deccan. The illumination surrounding the text on folios 1b–2a includes large hasps with a gold ground on three sides, which contain Chinese cloud motifs and polychrome blossoms. The margins are filled with gold scrollwork on a small scale, which all but obscures the blue 'tassels' that edge the illumination. The surah headings, in blue *riqā'*, and the *basmalah*s that usually follow were set within separate compartments ruled in gold and filled with gold scrollwork on a natural ground.[4] The compartments containing the surah headings are divided by cusped lines, suggesting a central cartouche.[5]

The text ends on folio 425a, and on folio 425b there is a prayer written in black *tawqī'*, followed by the phrase, *Tammat al-Qur'ān bi-'awn Allāh al-Malik al-Mannān* ('The Qur'an has reached completion with the help of God, the Beneficent King'), presented in the manner of a surah heading. This is followed in turn by the beginning of a *fālnāmah*, that is, instructions on how to use the Qur'an for telling fortunes, which formerly had a sheet of paper pasted over it. It seems from this that the Qur'an was once owned by someone who objected to its use for divination: he or she must have removed the subsequent folio(s), which may have contained a colophon. The presence of the *fālnāmah*, which is in Persian, may be taken as evidence that the manuscript was produced in a Shi'i context, which in turn gives added support to an attribution to Golconda.

The covers are of maroon shagreen and are inlaid with a centre-and-corner composition in stamped and gilded leather. This composition includes double pendants above and below the centre-piece and 'hasp' motifs at the sides, one each on the short sides, and three each on the long sides. The doublures are of plain red leather.

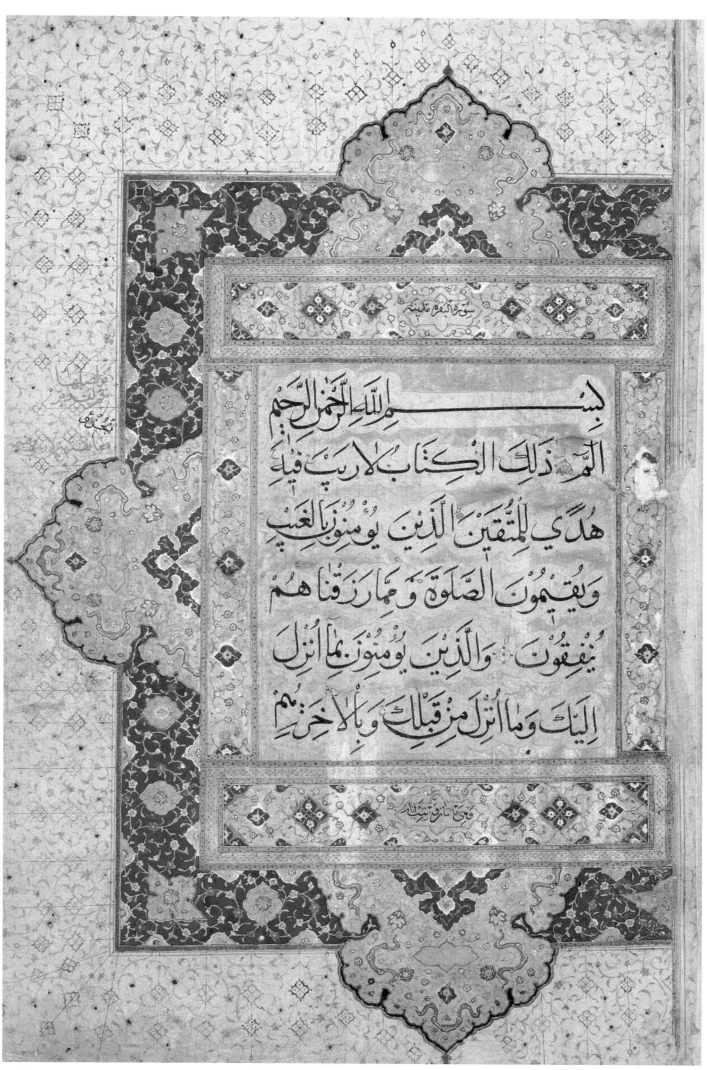

بِسْمِ اللَّهِ الرَّحْمَنِ الرَّحِيمِ
الٓمٓ ۚ ذَٰلِكَ الْكِتَابُ لَا رَيْبَ ۛ فِيهِ ۛ
هُدًى لِّلْمُتَّقِينَ الَّذِينَ يُؤْمِنُونَ بِالْغَيْبِ
وَيُقِيمُونَ الصَّلَاةَ وَمِمَّا رَزَقْنَاهُمْ
يُنفِقُونَ وَالَّذِينَ يُؤْمِنُونَ بِمَا أُنزِلَ
إِلَيْكَ وَمَا أُنزِلَ مِن قَبْلِكَ وَبِالْآخِرَةِ

بمه

رين الأولين ۞ لكنا عباد الله المخلصين ۞

كفروا به فسوف يعلمون ۞ ولقد سبقت

كلمتنا لعبادنا المرسلين ۞ انهم لهم المنصو

وان جندنا لهم الغالبون ۞ فتول عنهم حتى

حين ۞ وابصرهم فسوف يبصرون ۞ افبعذابنا

يستعجلون ۞ فاذا نزل بساحتهم فساء صباح

المنذرين ۞ وتول عنهم حتى حين ۞ وابصر

فسوف يبصرون ۞ سبحان ربك رب العزة عما يصفو

وسلام على المرسلين ۞ والحمد لله رب العالمين

سورة ص مكية وهي ثمان وقانون آية

بسم الله الرحمن الرحيم

ص والقرآن ذي الذكر ۞ بل الذين كفروا

أَمْ خَلَقْنَا الْمَلَائِكَةَ إِنَاثًا وَهُمْ شَاهِدُونَ

أَلَا إِنَّهُمْ مِنْ إِفْكِهِمْ لَيَقُولُونَ ۞ وَلَدَ اللَّهُ

إِنَّهُمْ لَكَاذِبُونَ ۞ أَصْطَفَى الْبَنَاتِ عَلَى الْبَنِينَ

مَا لَكُمْ كَيْفَ تَحْكُمُونَ ۞ أَفَلَا تَذَكَّرُونَ

أَمْ لَكُمْ سُلْطَانٌ مُبِينٌ ۞ فَأْتُوا بِكِتَابِكُمْ

إِنْ كُنْتُمْ صَادِقِينَ ۞ وَجَعَلُوا بَيْنَهُ وَبَيْنَ

نَسَبًا وَلَقَدْ عَلِمَتِ الْجِنَّةُ إِنَّهُمْ لَمُحْضَرُونَ

اللَّهِ عَمَّا يَصِفُونَ ۞ إِلَّا عِبَادَ اللَّهِ الْمُخْلَصِينَ

فَإِنَّكُمْ وَمَا تَعْبُدُونَ ۞ مَا أَنْتُمْ عَلَيْهِ بِفَاتِنِينَ

إِلَّا مَنْ هُوَ صَالِ الْجَحِيمِ ۞ وَمَا مِنَّا إِلَّا لَهُ مَقَامٌ

مَعْلُومٌ ۞ وَإِنَّا لَنَحْنُ الصَّافُّونَ ۞ وَإِنَّا لَنَحْنُ الْمُسَبِّحُونَ

وَإِنْ كَانُوا لَيَقُولُونَ ۞ لَوْ أَنَّ عِنْدَنَا ذِكْرًا

India and Iran. A complex relationship

by Manijeh Bayani and Tim Stanley

The decoration of most of the 17th-century Indian Qur'ans described above (cat.58, 60–63) is characterized by illumination in styles derived from 15th- and 16th-century Iranian sources. These styles, which are themselves very diverse, had long gone out of use in their homeland, and this creates the impression that 17th-century India was a living museum of outmoded styles of Qur'an illumination from Iran. The contrast with figurative painting could not be greater, since the 17th century was a period when Indian artists displayed great originality, achieved by assimilating elements from a variety of sources. It also stands in contrast to the pattern of intense cultural exchange between India and Iran during this period, which can be detected in everything from poetry to portraiture. Indeed, there is evidence that Indian models, Qur'anic and non-Qur'anic, had considerable influence on Qur'an production in Iran, at least towards the end of the century. The most splendid Qur'an of the later Safavid period in the Khalili Collection, cat.45 above, has an elongated format of the type found in Indian Qur'ans at least as early as the 15th century, and its binding, faced with black shagreen and set with gilt recessed elements, is much closer in form to 17th-century Indian examples (compare cat.58, 59, 63, for instance) than to established Iranian traditions. Other Indianizing elements may have included the use of paper of a contrasting tone for the margins ('field-and-margin' work; see cat.71), and the vibrant and lustrous style of illumination. A counterbalance to this movement of artistic concepts from India to Iran is provided by the example of cat.67 below, which was produced in India by a scribe of Iranian birth or descent, following the model of cat.45. In other words, the relations between India and Iran were so intense that the formulation of the Indianized style of Qur'an manuscript represented by cat.45 in Isfahan was soon followed by the export of this style to India.

A similar tale of men, concepts and manuscripts going to and fro between India and Iran in the 16th to 18th centuries is provided by the three copies of the Five Surahs published below as cat.64–6. The first of these items was produced by 'Abd al-Qadir al-Husayni, a leading calligrapher of Shiraz in the mid-16th century. Two Qur'ans by him were donated by Qutbshahi sultans of Golconda to the shrine of the Imam Riza in Mashhad, and a third was acquired by the Emperor Awrangzeb, perhaps after his conquest of the Deccan. 'Abd al-Qadir's links with India were therefore strong, and there is some evidence, such as the Indian features of a Qur'an by him in the Khalili Collection (QUR248), to suggest that he may have emigrated there. Both this Qur'an and cat.64 were produced in a similar, complex format in which the lines of text on each page were written in a variety of styles (and sizes) of script within ruled compartments of different sizes. This is precisely the format that was still being used by al-Marjan al-Islami, the scribe of cat.62, in the second half of the 17th century – many years after it had dropped out of use in Iran.

The second copy of the Five Surahs, cat.65, is very different in appearance, as it was written in gold and white on a text area dyed an attractive tone of chocolate brown. The attribution of this diminutive manuscript to India is supported by the type of illumination used for the head-piece on folio 1b, and by the existence of album leaves mounted with pages written in gold on a ground of the same colour, although in the *nasta'līq* rather than the *naskh* style. The pages bear excerpts from the *Sayings* of the Mughal emperors' great ancestor, Timur, as well as the signature of Nur Jahan, the wife of the Emperor Jahangir, and the date AH 1029 (AD 1619–20).[1] Numerous other 17th-century calligraphic specimens intended for, or re-used in, albums were executed in light colours on grounds tinted or painted a dark colour, and it therefore seems likely that the use of paper tinted a dark colour for the text areas of manuscripts became fashionable in India in the first half of the 17th century under the influence of album production. In the second half of the century we find manuscripts being produced in a similar style to cat.65 in Isfahan, by calligraphers of the standing of Muhammad Ibrahim Qumi (*fl.*1657–1706) and Ahmad Nayrizi (*fl.* 1676–1741). Nayrizi continued to work in this manner in the 18th century, and a prayer book by him in the Khalili Collection (MSS 402, folios 18–33) is written in his dramatic *naskh* hand on paper tinted chocolate-brown. It is dated AH 1118 (AD 1706–7).

Another colour favoured by the calligraphers of the Isfahan school for the text areas of the manuscripts they produced in this style was a deep indigo blue. This can be seen in the third copy of the Five

Surahs, cat.66. Unlike cat.64 and 65, cat.66 has a colophon and other inscriptions that link the manuscript to events in Iran and India, although at first sight the information provided does not seem very forthcoming. The scribe responsible for copying the manuscript in AH 1184 (AD 1770–71) is not known from other sources, and it is therefore unclear whether his name should be read as Ibn Muhsin Faydallah or Muhsin ibn Faydallah. The dedication, which precedes the colophon and was written in Persian, in the same hand as the main text, is equally enigmatic: 'It was written in response to an instruction, informed by a knowledge of divine truths and points of saintly erudition, from the King of the Mysteries of Allah – May God grant him peace!' The key information is found in a second inscription, on folio 2a, which states that in AH 1203 (AD 1788–9) the manuscript came into the possession of Muhammad Khalil, the son of Sultan Dawud Mirza, the son of Shah Sulayman II Safavi. This pedigree needs some explanation. Muhammad Khalil's grandfather, Mir Sayyid Muhammad, was a grandson of the Safavid ruler Shah Sulayman I through his daughter Shahrbanu Sultan Begum, and he was a nephew and son-in-law of Shah Sultan Husayn. Sayyid Muhammad's father was the custodian (*mutavallī*) of the shrine of the Imam Riza in Mashhad, and Sayyid Muhammad inherited this post during the reign of Nadir Shah Afshar (1736–1747). In 1748 Nadir Shah's grandson Shahrukh (who was also a grandson of Shah Sultan Husayn) set himself up as the independent ruler of Khurasan, with Mashhad as his capital. In 1750, however, Sayyid Muhammad deposed and blinded Shahrukh and assumed the style of Shah Sulayman II. His reign lasted only a matter of weeks before he was himself deposed and blinded, and Shahrukh restored.[2] Sayyid Muhammad died in Mashhad in AH 1169 (AD 1755–6), but after his deposition his son Sultan Dawud Mirza had taken refuge in India, where he gained the protection of the governor of Bengal, Allahvirdi Khan Mahabatjang, and settled in the capital, Murshidabad. His son Muhammad Khalil joined him there in AH 1192 (AD 1778–9), after he had completed his studies in Isfahan. Sultan Dawud died in Murshidabad in AH 1203 (AD 1788–9), while Muhammad Khalil lived on until AH 1220 (AD 1805–6), engaged in literary pursuits, including the composition of his *Majmaʿ al-tawārīkh* ('Convention of chronicles').[3] The type of *naskh* employed in cat.66 indicates strongly that it was produced in Isfahan, and the manuscript's later history suggests that the 'King of the Mysteries of Allah' of the dedication is a reference to a descendant of Sayyid Muhammad in the role of claimant to the Safavid succession. This man may well have been Sultan Dawud, since the date of Muhammad Khalil's acquisition of the manuscript (presumably by inheritance) coincides with that of Sultan Dawud's death.

When Muhammad Khalil arrived in Murshidabad in the late 1770s, the political situation in Bengal had changed radically since his father had settled there. Mahabatjang's death in 1756 had been followed by the brief but momentous governorship of Siraj al-Dawlah, who attempted to remove the British from Calcutta. The British counterattack, culminating in the disastrous battle of Plassey in 1757, led to the establishment of their hegemony over Bengal, and eventually, in 1765, to direct rule of the province by the East India Company. From this date English-speakers began to replace Persian-speakers as the main cultural interlocutors of the Muslims of India, and the longstanding relationship between the civilizations of India and Iran gradually lost its complexity and vitality. As we shall see in Part Two, the break was particularly clear-cut in the case of Sind, where the import of fine Qur'ans from Iran for the region's Talpur rulers was ended by the British conquest in 1843.

1. Soudavar 1992, no.139; Leach 1998, no.25.
2. On Mir Sayyid Muhammad and his family, see Gulistanah, ed.

Razavi, pp.37–57; Muhammad Khalil, ed. Iqbal, pp.90–137. *Cf.* Bamdad 1347–51, II, pp.124–6; Avery 1991, pp.60–61.

3. Bamdad 1347–51, vi, pp.118–19 (on Sultan Dawud), pp.233–4 (on Muhammad Khalil), and the sources given in note 2 above.

64
Five surahs
Shiraz or Golconda, mid-16th century

24 folios, 17 × 11 cm, with nine
lines to the page
Material A thick, dark-cream
laid paper, burnished; there are
approximately eight laid lines to
the centimetre, and no apparent
rib shadows or chain lines.
Identification of mould markings
is difficult, due to the highly fibrous
nature of the pulp.
Text area 10.8 × 6.5 cm
Script The main text in a combination
of *muḥaqqaq* (lines 1, 9), *naskh*
(lines 2–4, 6–8) and *thulth* (line 5);
the *muḥaqqaq* and *thulth* in gold,
outlined in black; the *naskh* in black;
the reading marks and corrections
in in red are a later addition; surah
headings in white *riqāʿ* (XLVIII, LXVII,
LXXVIII) or gold *muḥaqqaq* (LVI),
all outlined in black; colophon in
gold *riqāʿ* outlined in black
Scribe ʿAbd al-Qadir Husayni
Shirazi
Illumination Head-piece on folio
1b, which is a replacement; text
frames ruled in gold, black, green
and blue; text area divided into nine
compartments by gold and black
rules; verses punctuated by gold
whorls (rosettes on folio 9b) with
black dots; surah headings; supple-
mentary illumination on folio 8b
Documentation A colophon
Binding Modern
Accession no. QUR280

1. Qazi Ahmad, trans. Minorsky,
p.67.
2. The other is Muhammad
Ashraf 1962, no.284.
3. Gulchin Maʿani 1347, nos 88,
89. Two other Qurʾans by him
are nos 90, 91.
4. Sotheby's, London, 27 April
1994, lot no.17. In 1736
Awrangzeb's son Muhammad
Shah gave it to Mutahavvir Khan.
5. Stuttgart 1993, p.15, figs 7–11,
is a spectacular example.
6. James 1992b, no.47.
7. Karatay 1962, nos 469, 509. The
remaining published item by ʿAbd
al-Qadir is Sotheby's, London,
28 April 1993, lot no.156, which
contains the sayings of ʿAli ibn
Abi Talib.

This manuscript contains the five surahs *Yāsīn* (XXXVI), *al-Fatḥ* (XLVIII), *al-Wāqiʿah* (LVI), *al-Mulk* (LXVII) and *al-Nabaʾ* (LXXVIII) and was copied by one of the leading calligraphers of 16th-century Shiraz, ʿAbd al-Qadir ibn Sayyid ʿAbd al-Wahhab al-Husayni al-Shirazi. We know from Qazi Ahmad that ʿAbd al-Qadir produced monumental inscriptions in *thulth*,[1] and at least 11 manuscripts by him have so far been identified; cat.64 is one of two copies by him of a selection of five surahs.[2] None of his work is dated, but it is clear that he flourished before 1562, when Sultan Ibrahim Qutbshah of Golconda (*reg.*1550–1581) donated a Qurʾan from the hand of ʿAbd al-Qadir to the Astan-i Quds-i Razavi in Mashhad. Another Qurʾan by the same scribe was donated to the same institution by Sultan ʿAbdallah Qutbshah (*reg.*1626–1672) in AH 1051 (AD 1641–2),[3] showing that ʿAbd al-Qadir was esteemed by the rulers of Golconda. It is clear from this that the calligrapher had some link with Golconda, which is in accord with his own Shiʿi leanings; and it appears that after the fall of Golconda to the Mughals in 1687, the Emperor Awrangzeb came to share the local rulers' high regard for ʿAbd al-Qadir's work, as another Qurʾan by him bears an impression of Awrangzeb's seal dated 1703.[4] The link with the Deccan induced Gulchin Maʿani to claim that ʿAbd al-Qadir emigrated there. Moreover, while some of the manuscripts he copied were decorated in the style current in Shiraz in the mid-16th century,[5] a Qurʾan by ʿAbd al-Qadir in the Khalili Collection (QUR248) has several features that suggest it was produced in India.[6] Because of the limited amount of illumination in cat.64, it is not possible to say at present whether it was produced there or in Shiraz. ʿAbd al-Qadir's work was also appreciated in Ottoman Turkey, judging by the presence of two Qurʾans by him in the Topkapı Palace Library, one of which was made *waqf* by Sultan Selim III (*reg.*1789–1807).[7]

The illumination of cat.64, although restricted in extent, is very fine. The first folio of the manuscript is a replacement, but the head-piece inscribed with the title of the surah *Yāsīn*, which has a blue ground set with white palmette scrolls, seems to be an accurate reproduction of the original, as the surah *al-Fatḥ* is preceded by a heading on a gold ground set with very similar green palmette scrolls. The heading of the surah *al-Wāqiʿah*, however, is on a natural ground, while those of the surahs *al-Mulk* and *al-Nabaʾ* are on a plain gold ground. This variation in treatment reflects the overall layout of the pages, which are divided into seven compartments in order to accommodate text in two sizes of script: the heading of the surah *al-Wāqiʿah* occurs in the ninth line on the page, which would normally have been occupied by a line of *muḥaqqaq*, while those on gold grounds occur where lines of *naskh* would have been written. The closest parallel to the head-piece on folio 1a is, however, to be found on folio 9b, where the compartments containing the lines of *muḥaqqaq* and *thulth* have blue grounds set with white, red or green palmette scrolls. The reason for this special treatment is presumably to be found in the contents of the text written on this page. This consists mostly of verse 6 of the surah *al-Fatḥ*, which promises punishment for hypocrites and polytheists.

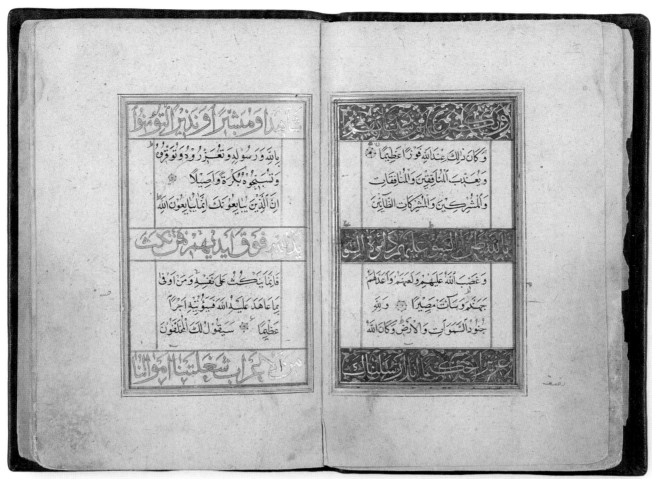

64 folios 9b–10a

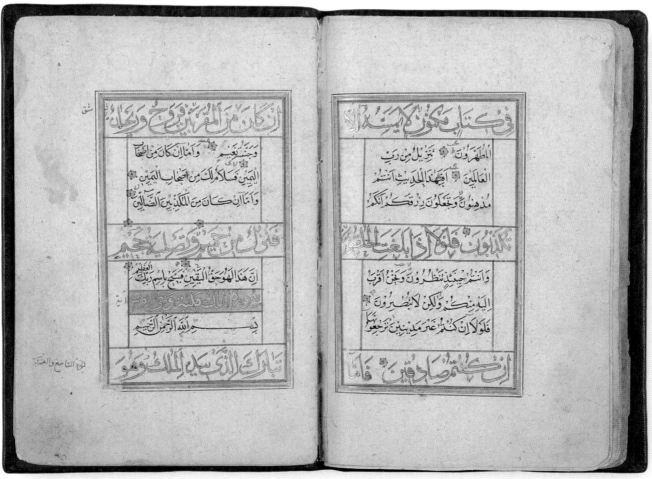

64 folios 18b–19a

65
Five surahs

Northern India, first half of the 17th century

34 folios, 13.1 × 8.3 cm,
with seven lines to the page
Material The text area is of a very
crisp wove paper, dyed chocolate-
brown and lightly burnished; no
rib shadows are apparent. The
margins are of a crisp, dark-cream
laid paper, lightly burnished;
there are approximately ten laid
lines to the centimetre, and no
apparent rib shadows or chain lines
Text area 8.4 × 4.7 cm
Script The main text in *naskh*, in
gold, vocalized in white; there are
no reading marks; surah headings
in white *riqāʿ* on gold grounds
Illumination Head-piece on folio 1b
Binding Perhaps contemporary
Accession no. QUR326

1. Leach 1998, no.25. See also
Soudavar 1992, no.139.
2. *Cf.* Tirmizi 1979.

This small but refined manuscript contains the same sequence of surahs as cat.64. The
text is written in gold and white on a text area that has been dyed chocolate-brown. A
close parallel is to be found in an album leaf in the Khalili Collection (MSS 954), which is
mounted with a page from a copy of the *Malfūẓāt*, or 'Sayings', of Timur.[1] Made by Nur
Jahan, the wife of the Emperor Jahangir, in AH 1029 (AD 1619–20), the leaf has *nastaʿlīq*
calligraphy in gold on a chocolate-brown ground. More of the history of cat.65 would
once have been clear, as folio 1a once bore the impression of a large, round seal of the
type employed at the Mughal court, but this has been obliterated by gold paint.[2]

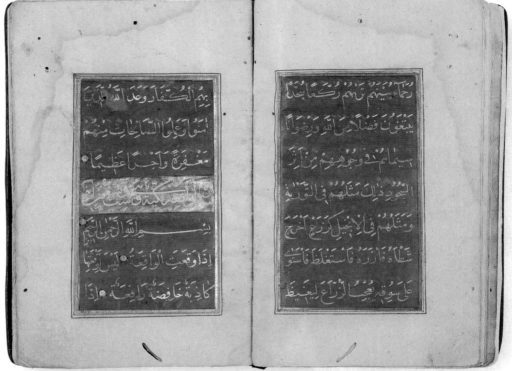

66 folios 2b–3a

Folio 1b is decorated with a head-piece containing the title of surah *Yāsīn*. It is
surmounted by a crest in which the main feature is a broad band of gold set with poly-
chrome lotus scrolls (compare the 'hasp' motifs on cat.57, folios 1b–2a, for example).
The dark-brown leather covers have outer borders tooled in gilt and inner borders of
multiple gold rules. The main fields are also gilt. They consist of rectangles cut from a
sheet of leather that has been pressure-moulded with a continuous design of circular
lobed devices filled with palmette scrolls, set against a field filled with lotus scrolls.

66
Five surahs

Probably Isfahan, AH 1184 (AD 1770–71)

18 folios, 19.7 × 12.6 cm,
with 10 lines to the page
Material The text is on a crisp, dark
paper dyed dark-blue. It is probably
laid, but due to the density of the
colour, mould markings cannot be
identified. The margins are of a crisp,
cream laid paper, lightly burnished;
there are approximately ten laid lines
to the centimetre, and no apparent
chain lines or rib shadows
Text area 14 × 9 cm
Script Main text in *naskh*, in gold,
white, pink, blue, yellow, red or
green; surah headings in *riqā'*, in
a contrasting colour; colophon
in gold *riqā'*
Scribe Ibn Muhsin Faydallah,
or Muhsin ibn Faydallah
Illumination Decorative head-piece
on folio 2b; text frame of gold, black,
red and blue rules; verses marked
by gold rosettes set off with touches
of red, white and blue
Documentation A colophon and
a note and a seal impression
recording ownership
Binding Modern
Accession no. QUR400

1. Bayani 1345–58, IV, pp.185–6.

This manuscript contains the same sequence of surahs as cat.64 and 65. Each opening
has text written in ink of a different colour on text areas stained dark blue, while the
surah headings were written in a colour contrasting with that of the main text, on a plain
ground, except for the first, that of surah XXXVI, which was inscribed in an illuminated
head-piece. This type of presentation has 17th-century precedents, including a prayer
book in the Khalili Collection (MSS332) copied in gold on dark blue by order of Shah
Sulayman Safavi in AH 1097 (AD 1685–6). The calligrapher responsible was Muhammad
Ibrahim Qumi, who worked in Isfahan (see cat.50), and it seems that the scribe of cat.66

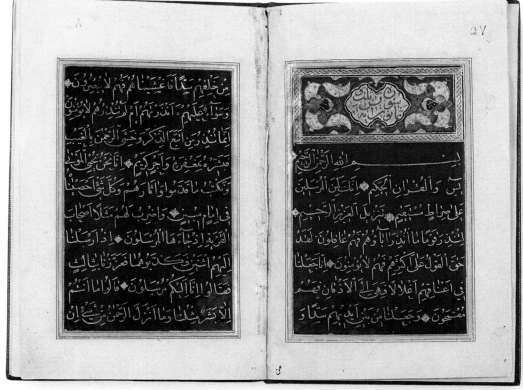

65 folios 19b–20a

is an unrecorded member of the Isfahan school of calligraphy. His name can be read in
two ways, either as Ibn Muhsin Faydallah or as Muhsin ibn Faydallah. If it is the former,
he may have been the son of the celebrated calligrapher Muhammad Mushin al-Isfahani,
who flourished between AH 1123 (AD 1711–12) and AH 1158 (AD 1745).[1]

The colophon is preceded by a note in Persian in the same hand referring to the
patron enigmatically as 'the King of the Mysteries of Allah'. A note in red *shikastah*
on folio 2a, however, shows that by AH 1203 (AD 1788–9) the manuscript was in the
possession of Muhammad Khalil, a Persian literary figure resident in India, and the
grandson of a Safavid pretender to the throne of Iran. It is possible, therefore, that
the enigmatic wording of the dedication is a reference to Muhammad Khalil himself
or to another member of his family (see p.201 above). On the same page as the
colophon there is an impression of an oval seal in the name of Muhammad Husayn
ibn Muhammad, which is dated AH 1206 (AD 1791–2).

67
Single-volume Qur'an
India, probably Hyderabad, first half of the 18th century

390 folios, 31 × 18.7 cm,
with 12 lines to the page
Material A crisp, very smooth,
cream laid paper, burnished to a
gloss; there are approximately nine
laid lines to the centimetre. Due to
the density of the pulp, individual
sheets are semi-opaque
Text area 21.5 × 10.3 cm
Script The main text in *naskh*, in
black, with reading marks in red;
surah headings and marginal
inscriptions in gold *riqāʿ*
Scribe Muhammad Riza
Illumination Extensive decoration
on folios 1b–2a; text frames of gold
and black rules, and outer frames of
gold and black rules, the margins
within filled with lotus scrolls in
gold on a natural ground; each line
of text and the surah headings set
within 'clouds' reserved in a gold
ground, the 'clouds' sprinkled with
gold; verses marked by gold whorls;
surah headings in compartments
defined by gold and black rules;
marginal inscriptions marking each
fifth and tenth verse, *ḥizb*, *juz'* and
sajdah in 'clouds' reserved in the
scrollwork
Documentation A colophon
Binding Iranian lacquer covers
of the 19th century
Accession no. QUR62

1. Bayani 1345–58, IV, p.159, no.518;
see also Atabay 1352, pp.236–8,
no.108.
2. Our thanks to Helen Loveday for
this information.
3. Christie's, London, 27 April 1995,
lot no.47.
4. Muhammad Ashraf 1962, nos 122,
124–7. See also Christie's, London,
4 July 1985, lot no.132, dated AH 1158
(AD 1745–6).

This fine Qur'an was copied by a scribe called Muhammad Riza, according to the first line of the colophon on folio 390a. The second line appears to have been erased and replaced by a line in a slightly smaller, more characteristically Indian hand which gives the scribe's *nisbah* as Tabrizi and the date of the manuscript as AH 1044 (AD 1634–5). The amender of the colophon clearly wished to associate the manuscript with an important Iranian calligrapher of the 17th century, probably the Muhammad Riza Tabrizi who was the son of ʿAli Riza ʿAbbasi, the arch-rival of ʿImad al-Hasani.[1] This dating does not, however, accord with the stylistic features of the Qur'an. Cat.67 is similar in format and calligraphy to cat.45, which was copied in Isfahan in AH 1101 (AD 1689–90), and the illumination is also similar to but less refined than that of cat.45. Deviations from this norm include the Deccani-style floral scrolls on folios 1b–2a, which incorporate a more naturalistic type of lotus blossom than is usual in Iranian work, while the paper is of a heavy type quite different from the two papers used for cat.45, and it too can be attributed to India.[2] It therefore seems likely that cat.67 was produced in India by a scribe who specialized in Qur'ans in the late Safavid style, and it cannot have been produced before the beginning of the 18th century.

The scribe responsible for cat.67 may have been Muhammad Riza ibn Muhammad Taqi Tabrizi. He produced the earliest Qur'an with an explicit dedication to a ruling member of the Mughal dynasty, which was commissioned by Muhammad Shah (*reg.*1719–1748) and was completed at Shahjahanabad (Delhi) on 23 Ramadan 1143 (1 April 1731).[3] It would appear that this Muhammad Riza later moved to Hyderabad in the Deccan and began to append the Sufi sobriquet Miskin al-Qalandar to his name. Muhammad Riza attained a high level of productivity. Four Qur'ans from his hand in the Salar Jung Library are dated Hyderabad, AH 1153 (AD 1740–41), AH 1155 (AD 1742–3), AH 1157 (AD 1744–5) and AH 1159 (AD 1746), and he recorded that they were his forty-second, fifty-fifth, sixty-seventh and seventy-fifth Qur'ans respectively. Another, dated Chinnapatan Pet, AH 1154 (AD 1741–2), was his fifty-second Qur'an.[4]

Cat.67 now sports a 19th-century Iranian lacquer binding, more notable for its size than for the quality of the drawing. It is decorated with a floral composition rising from the base line against a plain black ground. The doublures are decorated with a small group of narcissi on a red ground. The binding overlaps the text block slightly, in the manner of European books, and may have been added to the manuscript at a recent date.

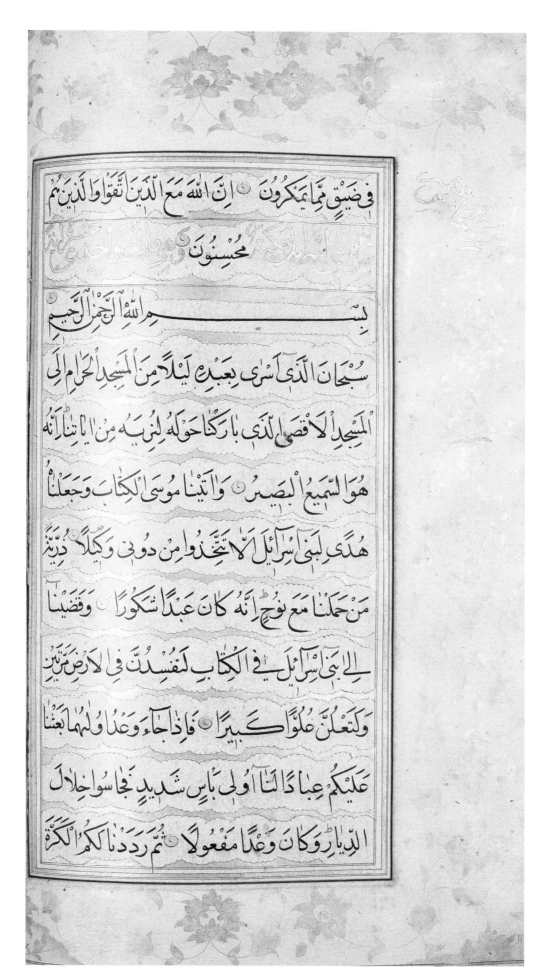

فى ضَيْقٍ مِمَّا يَمْكُرُونَ ۞ إِنَّ اللَّهَ مَعَ الَّذِينَ اتَّقَوْا وَالَّذِينَ هُمْ

مُحْسِنُونَ ۞

بِسْمِ اللَّهِ الرَّحْمَنِ الرَّحِيمِ

سُبْحَانَ الَّذِي أَسْرَى بِعَبْدِهِ لَيْلًا مِنَ الْمَسْجِدِ الْحَرَامِ إِلَى

الْمَسْجِدِ الْأَقْصَى الَّذِي بَارَكْنَا حَوْلَهُ لِنُرِيَهُ مِنْ آيَاتِنَا إِنَّهُ

هُوَ السَّمِيعُ الْبَصِيرُ ۞ وَآتَيْنَا مُوسَى الْكِتَابَ وَجَعَلْنَاهُ

هُدًى لِبَنِي إِسْرَائِيلَ أَلَّا تَتَّخِذُوا مِنْ دُونِي وَكِيلًا ۞ ذُرِّيَّةَ

مَنْ حَمَلْنَا مَعَ نُوحٍ إِنَّهُ كَانَ عَبْدًا شَكُورًا ۞ وَقَضَيْنَا

إِلَى بَنِي إِسْرَائِيلَ فِي الْكِتَابِ لَتُفْسِدُنَّ فِي الْأَرْضِ مَرَّتَيْنِ

وَلَتَعْلُنَّ عُلُوًّا كَبِيرًا ۞ فَإِذَا جَاءَ وَعْدُ أُولَاهُمَا بَعَثْنَا

عَلَيْكُمْ عِبَادًا لَنَا أُولِي بَأْسٍ شَدِيدٍ فَجَاسُوا خِلَالَ

الدِّيَارِ وَكَانَ وَعْدًا مَفْعُولًا ۞ ثُمَّ رَدَدْنَا لَكُمُ الْكَرَّةَ

68
Single-volume Qur'an
India, perhaps Golconda or Hyderabad, before 1710

485 folios, 28.2 × 17.9 cm, with
11 lines to the page
Material A smooth, cream laid
paper, lightly burnished; there are
approximately 11 laid lines to the
centimetre, and no apparent rib
shadows or chain lines
Text area 18 × 10 cm
Script Main text in *naskh*, in black,
with reading marks in red; surah
headings in gold *riqā'*; marginal
inscriptions in gold *riqā'* or, when
part of an illuminated device, white
naskh; other texts in *naskh* and
nasta'līq
Scribe Muhammad 'Arab
Illumination Extensive decoration
of different types on folios 2b–6a,
481b–482a; text frames of gold,
black, green and blue rules, and
outer frames of gold and black rules;
text areas sprinkled with gold, sup-
plemented by gold scrollwork at the
beginning of each *juz'*; verses
marked by gold whorls; surah head-
ings; marginal devices marking divi-
sions of the text
Documentation Colophon, seal
impressions, and a record of
ownership
Binding Contemporary
Accession no. QUR216

1. An Iranian émigré calligrapher
called Mulla Muhammad 'Arab
Shirazi worked for two bibliophile
sultans of Golconda, Muhammad
Qutbshah (*reg.*1612–1626) and
'Abdallah Qutbshah
(*reg.*1626–1672). For 'Abdallah,
Muhammad 'Arab worked with four
other scribes on a collection of
Persian poetry and prose, the
Favā'id-i qutbshāhī, and his contri-
bution is dated AH 1040
(AD 1630–31), while a poem in praise
of this ruler preserved in the
Archaeological Museum, Delhi, is
signed 'Arab Shirazi and dated
AH 1041 (AD 1631–2). See Bayani
1345–58, II, pp.428–9, no.595;
Welch 1985, pp.318, 319, no.124.
2. A two-volume Qur'an in the Salar
Jung Library was copied in Arkat in
1730; see Muhammad Ashraf 1962,
no.121.

This exceptionally sumptuous manuscript was written by a scribe who gave his name as
Muhammad 'Arab in the undated colophon.[1] An early owner, who may well have been the
manuscript's original patron, was Muhammad Husayn ibn Muhammad Haydar Kudrah,
whose name appears in an inscription on the following page. Written in an excellent
nasta'līq hand, in the form of a poetic *qit'ah*, the inscription is dated 27 Ramadan 1122
(19 November 1710), in the fourth year of the reign of the Mughal emperor Shah 'Alam I
(*reg.*1707–1712), and gives Muhammad Husayn's residence as 'the walled city of Arkat
[Arcot]'. This city, situated in the Carnatic, passed into Mughal hands at the end of the
17th century, during the campaigns that also extinguished the Qutbshahi dynasty, and in
1703 it became the capital of the nawabs of Arkat.[2] The manuscript is remarkable for the
quality of its calligraphy, which is set off by exquisite, and extensive, illumination, and it
seems likely that it was produced in an established centre of book production. The most
likely candidates are the former Qutbshahi capitals in the Deccan, Golconda and Hyderabad.

The illumination is particularly rich on folios 2b–4a, which contain prefatory matter,
on folios 4b–6a and 481b–482a, which contain the beginning and end of the Qur'anic
text, and on the openings that coincide with the beginning of a *juz'*. The prayer on folios
2b–3a was written in gold, in five lines of a large *naskh* hand set within 'clouds' reserved
in a gold ground and is overlaid with polychrome floral scrolls. The text is surrounded
by panels with a gold ground and those at the top and bottom are filled with a Persian
text in white *nasta'līq*, which recommends reading the prayer before and after reciting
the Qur'an. The margin between the text frame and the outer frame, or *kamand*, is filled
with a diaper pattern of leaves and flowers, executed in gold with touches of green and
red. The next two pages (folios 3b–4a) contain a richer and yet more extraordinary
composition, which presents two Qur'anic quotations, one from surah *al-Isrā'* (XVII,
verse 88), the other from surah *Āl 'Imrān* (III, verse 53). These are in a large, deep-blue
nasta'līq, set within 'clouds' that follow the outlines of the letters. The 'clouds' are
reserved in a gold ground decorated with a flowering tree motif. The text panels are set
within rectangles covered with fine floral scrolls on blue and gold grounds, and the same
decoration is used in the outer borders, the scalloped edges of which are trimmed with
gold petals. The margins are filled with blue 'finials' alternating with gold floral sprays.

The illumination on folios 4b–5a and folios 481b–482a is in the same style, but the
motifs are smaller, and the effect even more sumptuous, with a different repertory of
motifs used in each case. The text on these pages is also set within 'clouds' reserved
in a gold ground which is overlaid with floral scrolls of different types. This theme is
continued on folios 5b–6a, where the scrollwork was executed in blue and white. In
addition, the margins are filled with scrolls on a larger scale, executed in gold with
touches of green. On these pages, too, the marginal inscriptions are in deep-blue.

The text areas of an opening where a *juz'* begins are filled with one of a variety of
floral patterns in gold, and the line in which the first words of the *juz'* occur is treated
in very much the same manner as a surah heading – even to the extent that the first
words of a *juz'* are written in gold *naskh*. Both types of 'heading' were written in
'clouds' reserved in a gold ground worked with polychrome scrolls, within panels
defined by gold and blue rules. They are accompanied by illuminated devices in the
margin. These consist of an ornamental roundel with a gold ground and blue 'finials'
in the case of surah headings, and a shaped lozenge with a blue ground in the case of the
first words of a *juz'*; the latter are inscribed in white *naskh* with the number of the *juz'*.

The headings of the final surahs are also accompanied by a *takbīr* in gold. Inscriptions
in the same style mark every fifth and tenth verse, every eighth of a *juz'*, and a number
of other text divisions, reading instructions and prostrations (*sajdah*s). There is also a

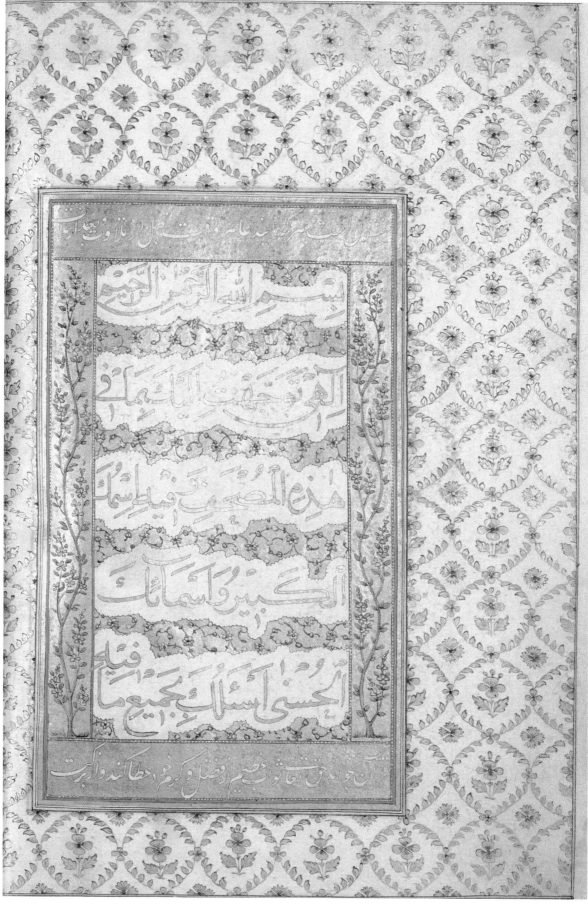

68 folio 2b

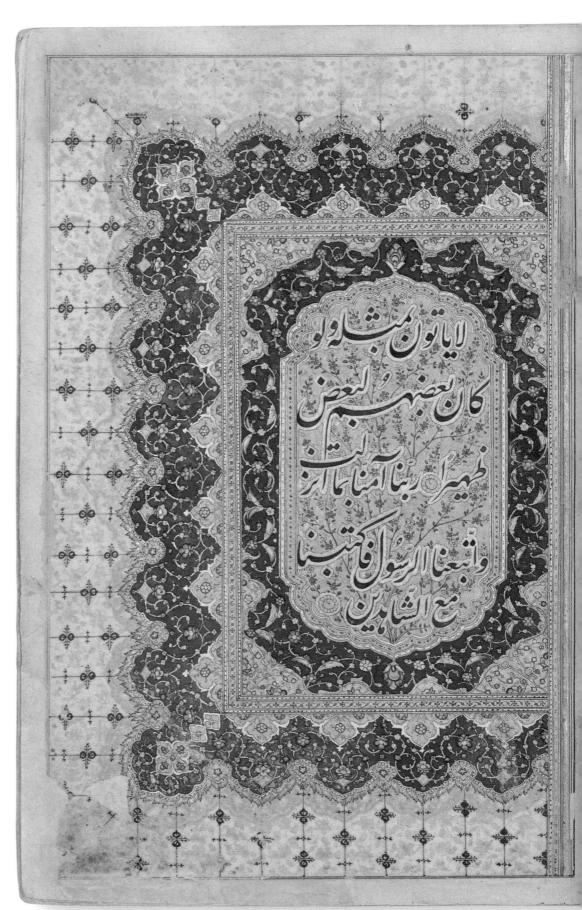

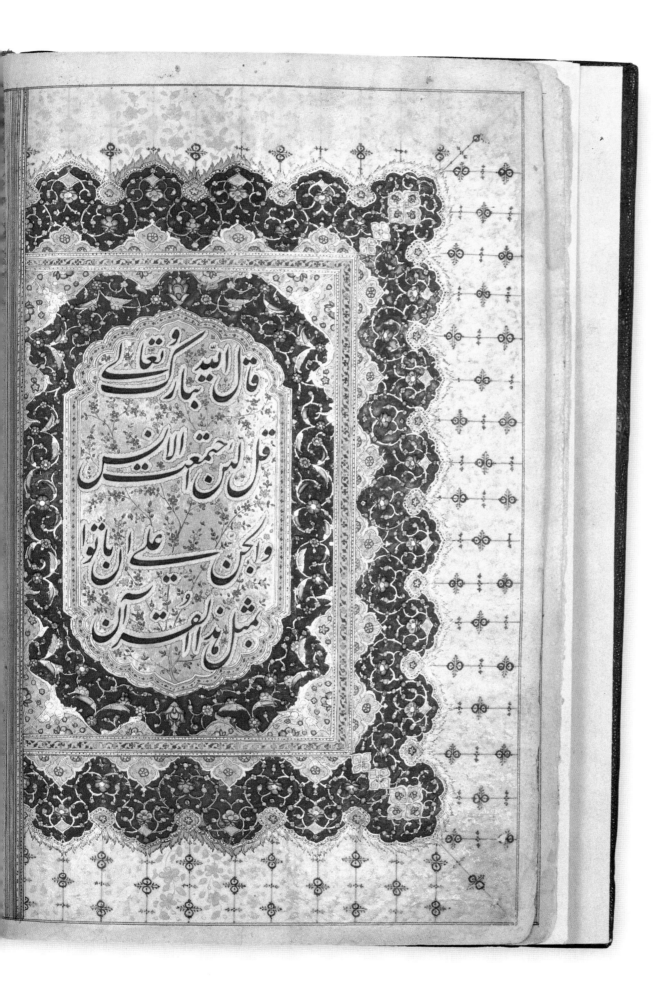

قال الله تبارك وتعالى

قل لئن اجتمعت الانس

والجن على ان يأتوا

بمثل هذا القرآن

sequence of illuminated devices marking *rukū*'s; as in cat.63 they consist of the letter *'ayn* and a number that indicates how many verses are to be read before the next *rukū'*. In cat.68 this data was noted in gold within a roundel decorated with blue scrolls on a natural ground and framed by a gold band that forms a point at the top. Folios 482b–484b contain a prayer to be read on the completion of the Qur'an, which is followed by the colophon. Opposite, on folio 485a, is the calligraphic panel bearing the ownership inscripton referred to above. On folios 6b, 7a, 484a and 485a is an impression of a seal dated AH 1243 (AD 1827–8), which is engraved with the legend, *al-khāṭī al-rājī Shaykh-'Alī*, or, 'The sinner, the supplicant, Shaykh 'Ali'. On folio 485b the record of a birth in AH 1260 (AD 1844) is accompanied by an astronomical observation and an astrological chart.

The binding, which probably dates from the early 18th century, is of black shagreen, decorated with a modest border design in gold. There are modern paper doublures.

يَوْمَ الْقِيَامَةِ وَالسَّمَوَاتُ مَطْوِيَّاتٌ بِيَمِينِهِ

سُبْحَانَهُ وَتَعَالَى عَمَّا يُشْرِكُونَ ۝ وَنُفِخَ فِى الصُّوْ

فَصَعِقَ مَنْ فِى السَّمَوَاتِ وَمَنْ فِى الْأَرْضِ إِلَّا

مَنْ شَاءَ اللّٰهُ ثُمَّ نُفِخَ فِيهِ أُخْرَى فَإِذَا هُمْ قِيَامٌ يَنْظُرُونَ

وَأَشْرَقَتِ الْأَرْضُ بِنُورِ رَبِّهَا وَوُضِعَ الْكِتَابُ

وَجِاْىءَ بِالنَّبِيِّنَ وَالشُّهَدَاءِ وَقُضِيَ بَيْنَهُمْ بِالْحَقِّ وَ

هُمْ لَا يُظْلَمُونَ ۝ وَوُفِّيَتْ كُلُّ نَفْسٍ مَا عَمِلَتْ وَهُوَ

أَعْلَمُ بِمَا يَفْعَلُونَ ۝ وَسِيقَ الَّذِينَ كَفَرُوا إِلَى

جَهَنَّمَ زُمَرًا حَتَّى إِذَا جَاؤُهَا فُتِحَتْ أَبْوَابُهَا وَقَالَ

لَهُمْ خَزَنَتُهَا أَلَمْ يَأْتِكُمْ رُسُلٌ مِنْكُمْ يَتْلُونَ

عَلَيْكُمْ آيَاتِ رَبِّكُمْ وَيُنْذِرُونَكُمْ لِقَاءَ

يوما

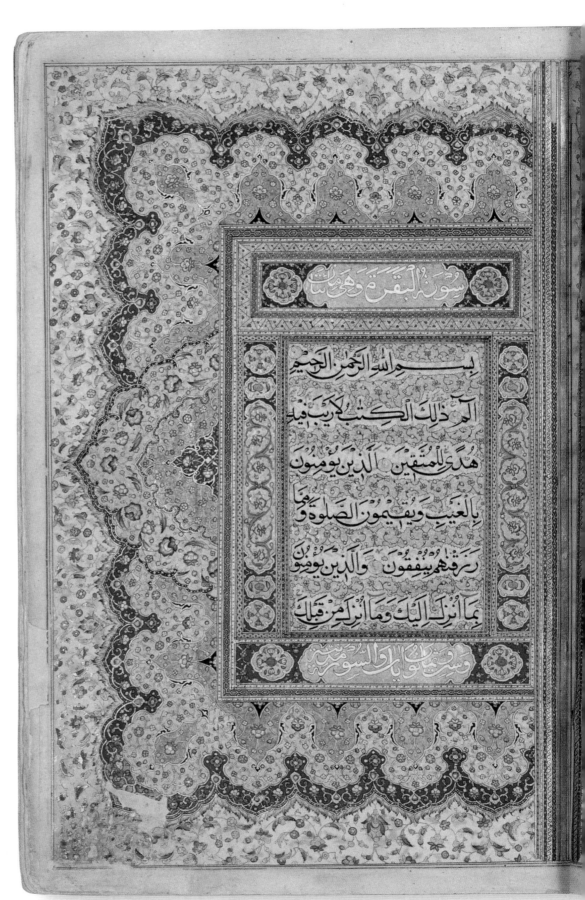

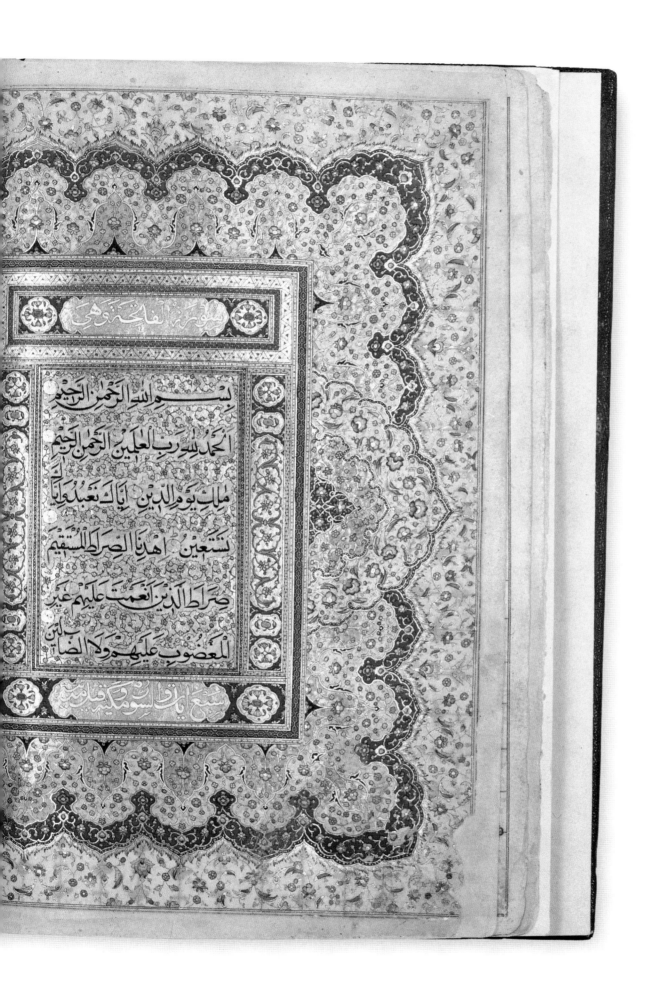

سورة الفاتحة وهي

بسم الله الرحمن الرحيم

الحمد لله رب العالمين الرحمن الرحيم

ملك يوم الدين اياك نعبد واياك

نستعين اهدنا الصراط المستقيم

صراط الذين انعمت عليهم غير

المغضوب عليهم ولا الضالين

سبع آيات السورة مكية فارسي

69
Single-volume Qur'an
India, before 1764

707 folios, 34.1 × 21.5 cm,
with nine lines to the page
Material A very crisp, light-brown
laid paper, burnished; there are
approximately eight laid lines to
the centimetre, and no apparent
rib shadows or chain lines
Text area 23.6 × 12.5 cm
Script Main text in *naskh*, in black,
with reading marks in red; inter-
linear translation in red *nasta'līq*;
surah headings and the inscriptions
in the marginal devices in white
riqā'; marginal commentary in
black *nasta'līq*, with Qur'anic
quotations in red
Scribe Anonymous, with an appen-
dix by Muhammad Ja'far
Illumination Extensive decoration
on folios 1b–2a; illuminated head-
piece on folio 2b; text areas framed
by gold, black and blue rules; verses
marked by gold discs with touches
of red and blue; surah headings;
marginal devices marking divisions
of the text; marginal commentary
in 'clouds' reserved in a gold ground,
in illuminated boxes, some with
additional gold floral decoration;
outer frames of gold and black rules
Documentation A colophon in
the appendix
Binding Modern, incorporating
older material
Accession no. QUR165

1. On the same folio there is another
note, dated Thursday, 15 Safar 1355
(7 May 1936), in which the age of the
Qur'an is calculated to be 177 years;
this was clearly based on the
colophon on folio 707b.

This large and beautifully executed Qur'an was probably produced in the mid-18th century. The evidence for this is as follows. The main text ends on folio 706a and is succeeded on folios 706b–707b by prayers to be recited after reading the Qur'an, written in a different hand. At the bottom of folio 707b there is a colophon, which appears to relate to the prayers. It gives the scribe's name as Muhammad Ja'far, and the date as AH 1178 (AD 1764–5).[1] A second piece of documentary evidence is the impression of an irregularly octagonal seal on folio 1a. This bears the legend, *munavvar shud Siddīq az nur-i Razzāq*, 'Siddiq was illuminated by the light of the Provider', and the date AH 1161 (AD 1748). The colophon, at the foot of folio 706a, does not give the name of the scribe or the date but consists of the phrase, 'The whole of "There is no god but God; Muhammad is the messenger [*rasūl*] of God" has been completed.' It is possible that hidden within this there is a reference to the scribe's name, which may have been Muhammad Rasul, for example.

The illumination of the opening folios (folios 1b–2a) is a beautiful example of later Mughal work, subtle in colour and delicate in treatment. These pages contain the first surah only, and the text areas are divided into five wider and five narrower bands by gold and black rules. The wider bands contain the Arabic text, written in 'clouds' reserved in a gold ground decorated with flowers and scrolls. The narrower bands contain the interlinear translation, written on a plain ground. Each text area is extended at the top by a blank panel with a plain gold ground, and above and below there are ornamented panels. All three elements (and the two outer borders) are framed by bands of strapwork in gold, and they are surrounded on four sides by a wide band of illumination on a blue ground. This consists of polychrome 'vignettes' composed of palmette scrolls linked by gold scrollwork bearing rosettes and feathery leaves. There is an outer border on three sides divided into areas of blue and gold by palmette scrolls; both are overlaid with polychrome lotus scrolls. The same elements are used in the two 'hasps' that interrupt this outer border. The whole composition is edged with a repeating pattern of finials and lotus blossoms in blue.

A fine head-piece in the same style precedes the beginning of the second surah on folio 2b, and similar polychrome ornament occurs at either end of the panels containing the surah headings. These were inscribed in white *riqā'* on gold cartouches, while gold discs inscribed in the same manner were placed in the margin to mark every *rukū'*, *hizb* and *sajdah*. The main text is accompanied by interlinear glosses in Persian. Executed in red *nasta'līq*, they are not separated from the main text by rules, as was usual by this date. There is also a marginal commentary in black *nasta'līq* within illuminated settings. These texts give the reason for the revelation of each surah and state whether the surah in question was 'abrogative' (*nāsikh*) or 'abrogated' (*mansūkh*). Such information would only have been of interest to Qur'anic scholars or students, and this manuscript was presumably designed for use in an institution of higher learning.

The covers are modern, but they incorporate some of the block-pressed and gilded elements from an earlier binding, notably the corner-pieces and pendants.

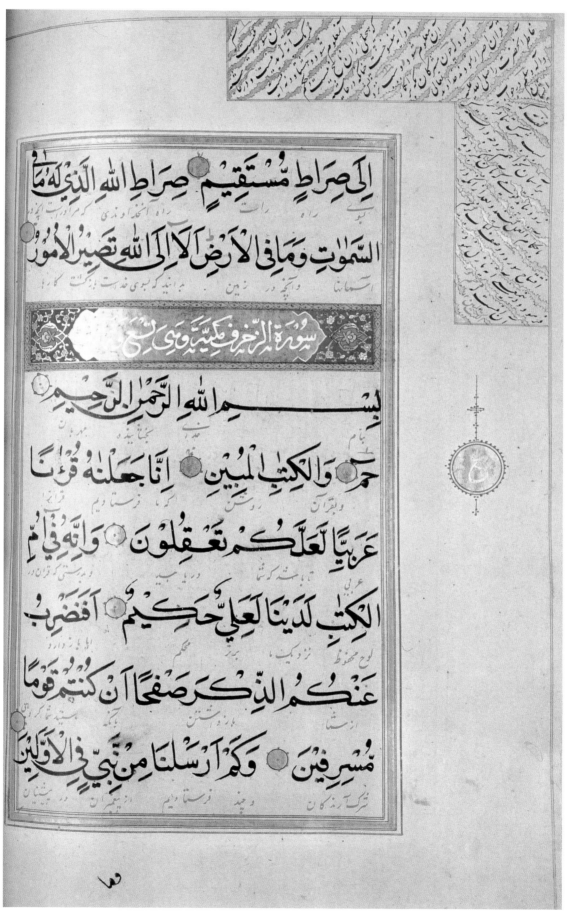

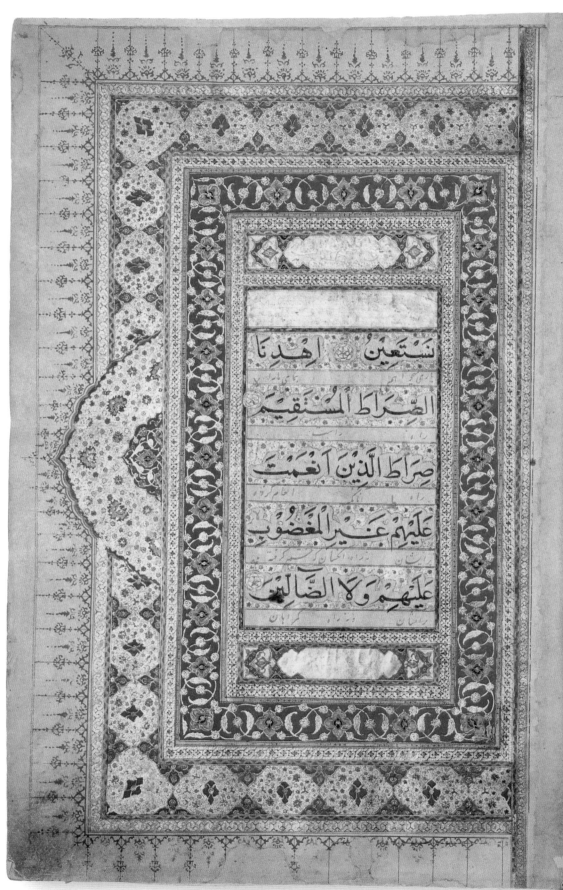

69 folios 1b–2a

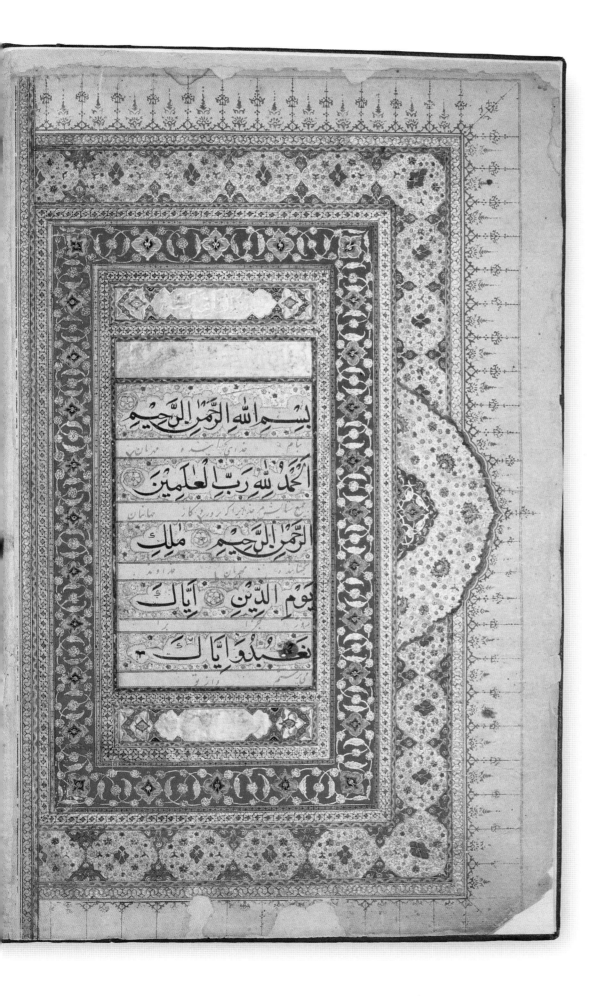

70

Single-volume Qur'an rebound in two volumes

Hyderabad, Deccan, 1780–82

598 folios, 37.2 × 23 cm,
with nine lines to the page
Material A crisp, cream, laid paper,
burnished; there are approximately
eight laid lines to the centimetre,
and no apparent chain lines or
rib shadows
Text area 25.4 × 13.5 cm
Script Main text in *naskh*, in black,
with reading marks in red; inter-
linear translation in red *nasta'līq*
as far as folio 212a; surah headings
and the inscriptions in the marginal
devices in white *riqā'*; marginal
commentary in black *nasta'līq* as
far as folio 42b
Scribe 'Ismatallah, entitled Uzi
(Awzi?) Beg al-Bukhara'i
Illumination Extensive decoration
on folios 1b–3a, 272b–275a,
593b–594a; each line of text on a
ground scattered with gold, within a
compartment 2 cm wide defined by
gold and black rules, and separated
from the next line by a plain com-
partment 1 cm wide; text frames of
black, gold, and red rules, and two
outer frames of gold and black rules;
verses marked by gold discs set
off with red and blue dots; surah
headings; marginal devices marking
divisions of the text; all catchwords,
and the marginal commentary as
far as folio 22b, are surrounded
by gold outlines
Documentation Colophon
Bindings Contemporary
Accession no. QUR424

1. In 1799 the present Residency in
Hyderabad was built in what had
been I'tiqad al-Saltanah's garden;
see Hyderabad 1954, pp.52, 77;
index, p.2. We are grateful to Robert
Skelton for this information.
2. Haftqalami, ed. Hidayet Husain,
p.126 and n.2. For an example of
his work, see Falk & Archer 1981,
p.111, no.178. On Muhammad 'Arif,
see p.176 above.
3. Haftqalami, ed. Hidayet Husain,
p.127.
4. 'Ismatallah's name may have been
inspired by the existence of an 'Ismat
or 'Ismatallah Bukhari or Bukhara'i,
a panegyrist at the courts of Timur
and Sultan Khalil in the late 14th and
early 15th century; Rypka 1968,
p.274. His title of Uzi Beg, or Awzi
Beg, may have been derived from the
Turkish word *öz* ('genuine'), which

According to the elaborate colophon of this Qur'an, it was commissioned by Vafadar Khan Bahadur I'tiqad al-Saltanah Shamshir Jang from the scribe 'Ismatallah Uzi (Awzi?) Beg Bukhara'i during the reign of Nizam 'Ali Khan Asafjah of Hyderabad (1762–1802). Work on the manuscript started on 4 Jumada'l-Ula 1194 (8 May 1780), and the production process, including the copying and correction of the main text, the illumination, ruling and binding, was completed on Thursday, 1 Rabi' al-Awwal 1196 (14 February 1782). Despite the splendour of the manuscript, almost nothing is recorded about the patron and the scribe.[1] Two 18th-century scribes called 'Ismatallah were recorded by Haftqalami, but the first, the nephew and pupil of the celebrated calligrapher Muhammad 'Arif Yaqut-raqam Khan, died in the reign of the nawab Shuja' al-Dawlah of Avadh (1754–1775),[2] and the second, Qazi 'Ismatallah Khan, died in AH 1186 (AD 1772–3).[3] If these dates are correct (see cat.71), neither could have been responsible for cat.70.[4]

The opening pages (folios 1a–2b), which contain only the first surah, are richly illuminated in a manner similar to the opening pages of cat.69. The main exceptions in terms of the layout are the absence of the 'hasps' in the outer border, which is considerably wider, and the way in which the outermost gold band, here filled with a repeating floral pattern, extends across from one page to the other, interrupting the vertical bands that run close to the spine. The latter is a significant deviation from the classical format, as vertical bands continuing to the edge of the opening pages occur in most fine Qur'ans of the later Islamic period, from Istanbul to India. Despite this deviation, it is clear that many elements of the ornament on folios 1b–2a were derived from the classical style of Qur'an illumination, including the use of polychrome lotus scrolls and white palmette scrolls over blue and gold grounds in the outer border.

Elsewhere in the manuscript, however, the style employed is notably less classical. The head-piece that marks the beginning of the second surah on folio 2b, for example, has blue, gold and yellow grounds, and the wide illuminated border that surrounds folios 2b and 3a has gold lotus scrolls on a dark-lilac ground. In its original, single-volume format the middle of the manuscript was also marked by illumination – in this case, the compartments for the first and last lines of text on folio 272b and the facing page (now folio 274a) were filled with ornament on gold, blue and yellow grounds, and the margins of these pages and of the two following pages (now folios 274b–275a) were furnished with wide, brightly decorated bands. The first of these two openings was later split, so that the right-hand half (folio 272b) now forms the verso of the penultimate folio of the first volume, and the left-hand half forms the recto of the second folio of the second volume (folio 274a). During this work a single folio containing a prayer was added to the end of the first volume (folio 273), and a folio (unnumbered) bearing a second copy of the first surah was added to the beginning of the second volume. These pages, which are of an inferior paper with a high acid content, were illuminated in imitation of their facing pages, although in the case of folio 273a this painting was left unfinished.[5]

The last two surahs were arranged within a heavily ornamented composition on folios 593b–594a, while folio 594b was ruled but left blank. This is followed (on folios 595a–598a) by prayers, a *ḥadīth*, and the colophon, which was written in a mixture of Persian and Arabic. No mention was made in the colophon of the commentaries and the Persian translation, which are incomplete. It therefore seems likely that these were added at a later stage.

The surah headings are in white *riqā'* on plain gold cartouches, set in panels with polychrome decoration at either end. The name of the surah and the first word of the surah were also noted in black in the top right-hand corner of each verso, together with

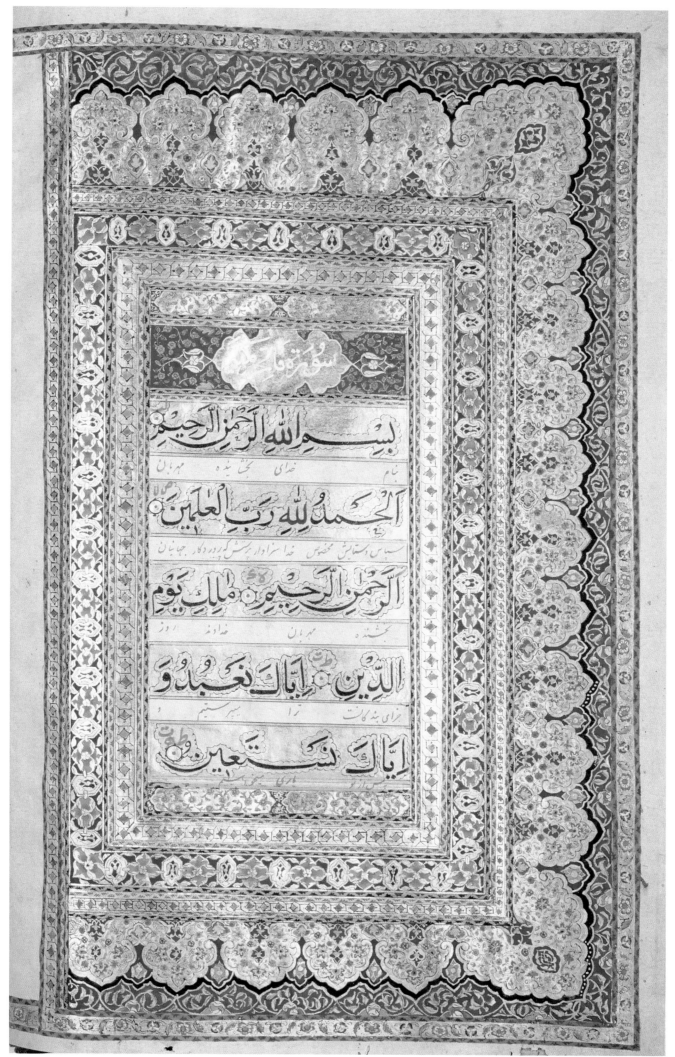

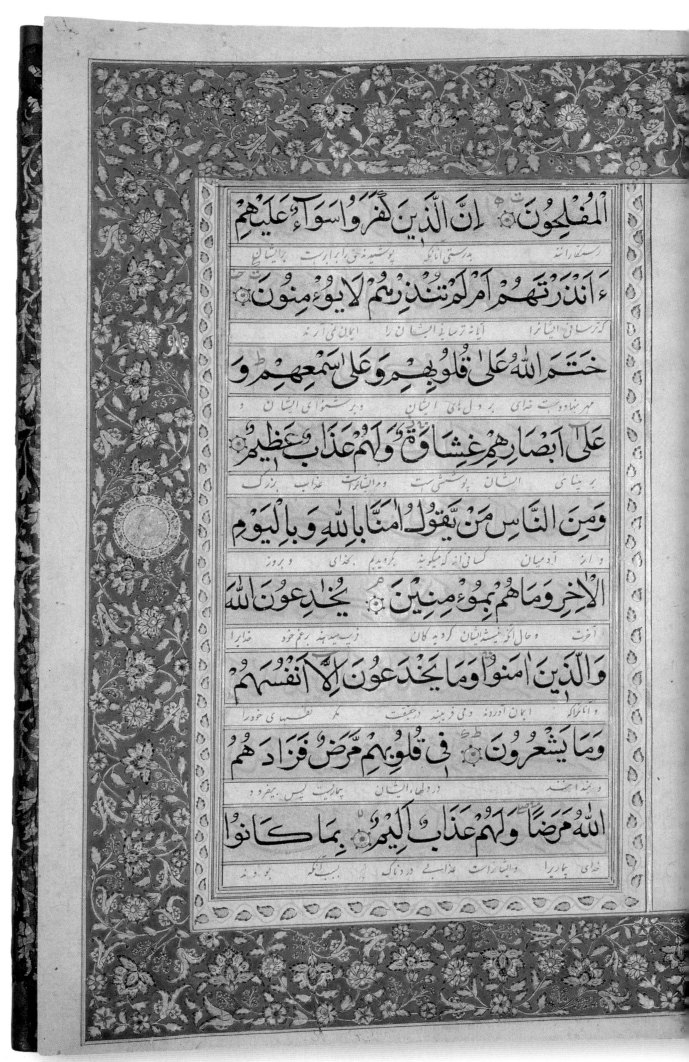

ٱلْمُفْلِحُونَ ۝ إِنَّ ٱلَّذِينَ كَفَرُوا سَوَآءٌ عَلَيْهِمْ

رستگارانند مُ بدرستی آنکه پوشیده می دارند برابرست برایشان

ءَأَنذَرْتَهُمْ أَمْ لَمْ تُنذِرْهُمْ لَا يُؤْمِنُونَ ۝

کو ترسانی ایشان را آیا ترسانیده ای ایشان را ایمان نمی آرند

خَتَمَ ٱللَّهُ عَلَىٰ قُلُوبِهِمْ وَعَلَىٰ سَمْعِهِمْ ۗ وَ

مهر نهاده است خدای بر دل های ایشان و بر شنوای ایشان و

عَلَىٰٓ أَبْصَٰرِهِمْ غِشَٰوَةٌ ۖ وَلَهُمْ عَذَابٌ عَظِيمٌ

بر بینایی ایشان پوشش ست و مر ایشان راست عذاب بزرگ

وَمِنَ ٱلنَّاسِ مَن يَقُولُ ءَامَنَّا بِٱللَّهِ وَبِٱلْيَوْمِ

و از آدمیان کسی ست که میگوید گرویدیم بخدای و بروز

ٱلْءَاخِرِ وَمَا هُم بِمُؤْمِنِينَ ۝ يُخَٰدِعُونَ ٱللَّهَ

آخرت و حال آنکه نیستند ایشان گرویده کان فریب میدهند خدا را

وَٱلَّذِينَ ءَامَنُوا وَمَا يَخْدَعُونَ إِلَّآ أَنفُسَهُمْ

و آنانرا که ایمان آوردند و نمی فریبند درحقیقت مگر نفسهای خودرا

وَمَا يَشْعُرُونَ ۝ فِى قُلُوبِهِم مَّرَضٌ فَزَادَهُمُ

و نمیدانند در دلهای ایشان بیماری ست پس بیفزود

ٱللَّهُ مَرَضًا ۖ وَلَهُمْ عَذَابٌ أَلِيمٌۢ بِمَا كَانُوا

خدای بیماری و ایشان راست عذابی بدرد ناک ببسبب آنکه بودند

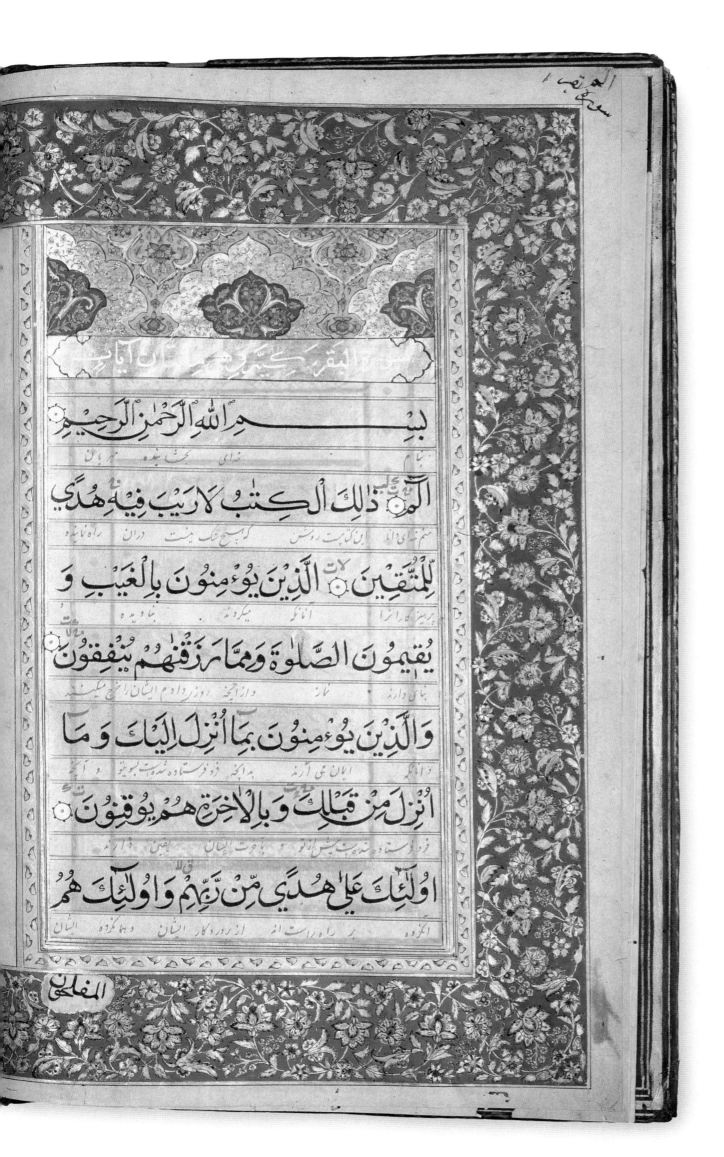

بِسْمِ اللهِ الرَّحْمٰنِ الرَّحِيمِ

الٓمٓ ذٰلِكَ الْكِتٰبُ لَا رَيْبَ فِيهِ هُدًى

لِّلْمُتَّقِينَ الَّذِينَ يُؤْمِنُونَ بِالْغَيْبِ وَ

يُقِيمُونَ الصَّلٰوةَ وَمِمَّا رَزَقْنٰهُمْ يُنْفِقُونَ

وَالَّذِينَ يُؤْمِنُونَ بِمَآ أُنْزِلَ إِلَيْكَ وَمَا

أُنْزِلَ مِنْ قَبْلِكَ وَبِالْأٰخِرَةِ هُمْ يُوقِنُونَ

أُولٰٓئِكَ عَلٰى هُدًى مِّنْ رَّبِّهِمْ وَأُولٰٓئِكَ هُمُ

is the first element in the modern ethnonym Uzbek, or from the Arabic *awz*, meaning 'a mode of reckoning drawn from the lunar motions' (Steingass). This second explanation is supported by the colophon, which includes three elaborate chronograms of a type that would have appealed to a man versed in the more esoteric branches of Islamic science.

5. This hypothesis is supported by the catchword on folio 272b, which relates to the beginning of the text on folio 274a and not that on folio 273a.

a folio number in red. A white letter *'ayn* written on a gold disc with a floral border and blue finials marks each *rukū'*, while other text divisions are similarly rendered but in shaped medallions. These were first marked by inscriptions in red, but most of these were lost when the manuscript was trimmed as part of the production process.

The two sets of covers are of red morocco, painted in gold with a border, a corner-and-centre composition and a lotus scroll design that fills the main fields. The fore-edge section of the flaps has a block-pressed cartouche containing a Qur'anic quotation (LVI, verse 80). The block used for this was dated AH 1185 (AD 1771–2). Nevertheless, the Qur'an acquired its present, two-volume format some time after it was completed. The doublures are of red morocco painted in imitation of leather filigree work with a central medallion and pendants in gold and light and dark blue.

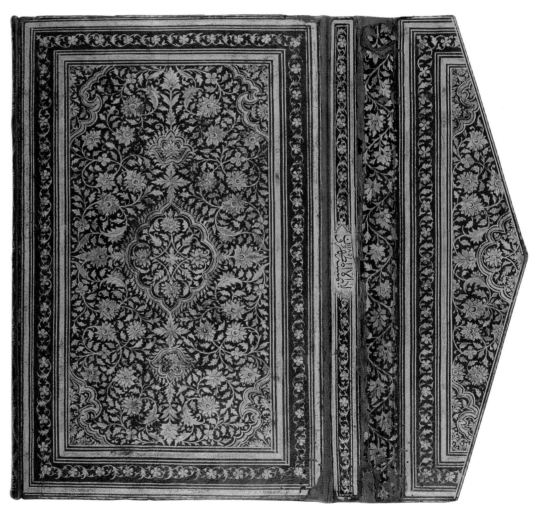

70 binding

71
The final volume of a seven-volume Qur'an

India, probably AH 1197 (AD 1782–3)

161 folios, 25 × 14.3 cm,
with seven lines to the page
Material The text area is made of
a smooth, light-brown laid paper,
very lightly burnished; there are
approximately nine laid lines to
the centimetre, and no apparent rib
shadows or chain lines. The margins
are made of a crisp, off-white to
cream laid paper, burnished; there
are approximately 12 laid lines to
the centimetre, and no apparent
rib shadows or chain lines
Text area 18.8 × 10.6 cm
Script Main text in *naskh*, in black,
with reading marks in red; surah
headings and the inscriptions in
the marginal devices in white *riqā'*
Scribe 'Ismatallah Khan
Illumination Head-piece on folio
1b; interlinear gilding on folios
1b–2a; text frames of gold, black,
orange and blue rules, and outer
frames of one gold rule; verses
marked by gold discs outlined in
black; surah headings; marginal
devices marking divisions of the text
Documentation Colophon
Binding European
Accession no. QUR70

1. The leaves containing surah LXIII,
verse 8, to surah LXIV, verse 8 are
missing after folio 73; and those
containing surah XCIII, verse 3,
to XCVI, verse 3, after folio 150.
2. See cat.73 and Lings & Safadi
1976, no.148, for example.
3. Haftqalami, ed. Hidayet Husain,
p.127.

This manuscript was written in a bold, Indian form of *naskh*, on pages composed of two types of paper in the style known in Persian as 'field-and-margin' (*matn u ḥāshiyah shudah*) work. This is also an Indian feature, as are the elongated format of the manuscript; the type of verse markers, marginal devices and surah headings employed; and such features of the script as the bend to the right in the letter *alif* in the word *qāla* on folio 4a, line 7, and the joined form of *fatḥah* and *ḍammah*. Cat.71 contains the Qur'anic text from the surah *Qāf* (L) to the end of the last surah, *al-Nās*,[1] which is approximately one-seventh of the whole text, and it presumably formed the last volume of a Qur'an in seven volumes. Such a format is relatively rare at this date, but the end of each seventh of the text was marked with elaborate illumination in some single-volume Qur'ans from Mughal India.[2]

The colophon is in the name of 'Ismatallah Khan, and it was originally dated AH 1197 (AD 1782–3), but most of the second figure has been crudely scraped away so that the date now appears as AH 1097 (AD 1685–6). The manuscript is clearly by a different hand from cat.70, but, as in the case of that Qur'an, it is not possible to identify cat.71 as the work of one of the two scribes called 'Ismatallah recorded by Haftqalami. This is because cat.71 was completed in AH 1197 (AD 1782–3), while Haftqalami stated that the 'Ismatallah who was the nephew of Muhammad 'Arif Yaqut-raqam Khan died before 1755, and that Qazi 'Ismatallah Khan died in AH 1116 (AD 1772–3).[3] But if the date Haftqalami gave for the death of Qazi 'Ismatallah Khan is wrong, he would seem to be a likely candidate as the scribe of cat.71, especially since in the colophon our 'Ismatallah Khan described his condition in 1782–3 as one 'of feebleness and old age'.

The manuscript starts (folio 1b) with a head-piece illuminated in gold, blue, orange and green. Though not as fine as 17th-century work, it follows the same style. The surah headings are in white *riqā'* on plain gold panels, and other text divisions are marked in the margin by a gold disc inscribed in white *riqā'* with the letter *'ayn* (marking *rukū'*) or the name of the text division. A curious feature is that catchwords were written in a smaller script above the last word on each folio, and not in the margin, below the text area.

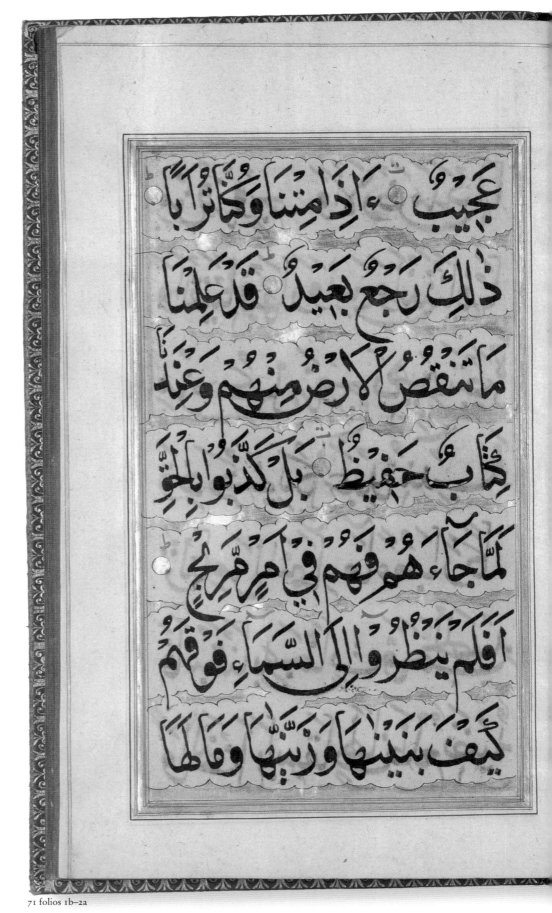

عَجِيبٌ ۞ اِذَا مِتْنَا وَكُنَّا تُرَابًا

ذَلِكَ رَجْعٌ بَعِيدٌ ۞ قَدْ عَلِمْنَا

مَا تَنْقُصُ الْاَرْضُ مِنْهُمْ وَعِنْدَنَا

كِتَابٌ حَفِيظٌ ۞ بَلْ كَذَّبُوا بِالْحَقِّ

لَمَّا جَاءَهُمْ فَهُمْ فِى اَمْرٍ مَرِيجٍ

اَفَلَمْ يَنْظُرُوا اِلَى السَّمَاءِ فَوْقَهُمْ

كَيْفَ بَنَيْنَاهَا وَزَيَّنَّاهَا وَمَا لَهَا

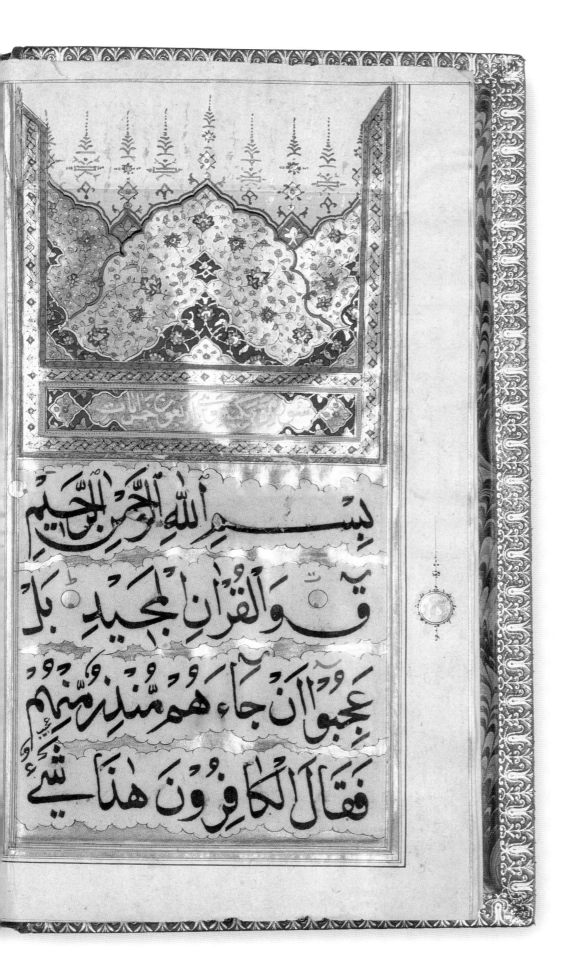

بِسْمِ اللَّهِ الرَّحْمَٰنِ الرَّحِيمِ

قٓ ۚ وَالْقُرْآنِ الْمَجِيدِ ۞ بَلْ عَجِبُوا أَن جَاءَهُم مُّنذِرٌ مِّنْهُمْ فَقَالَ الْكَافِرُونَ هَٰذَا شَيْءٌ

The 'Kashmiri' style

by Manijeh Bayani and Tim Stanley

Cat.72–9 below belong to a broad group of Indian Qur'an manuscripts that are generally attributed to the northern, predominately Muslim province of Kashmir, where they are thought to have been produced in the 18th century. Kashmir had its first Muslim ruler as late as 1320, but the region seems to have been a centre for the production of Islamic manuscripts for much of its subsequent history. This tradition may have been initiated under Sultan Zayn al-ʿAbidin (*reg.*1420–1470), who made Persian the official language of Kashmir, and who is credited with introducing crafts related to manuscript production such as bookbinding and papermaking. It certainly existed by the 16th century: the text of an illustrated copy of the *Būstān* of Saʿdi was completed there as early as AH 911 (AD 1505–6), and an illustrated *Khamsah* of Nizami dated AH 977 (AD 1569–70) has also been attributed to the region.[1] After the Emperor Akbar's annexation of Kashmir in 1586, the disappearance of local patronage caused poets, painters and scholars to leave Kashmir and seek employment at the Mughal court. Kashmiri scribes joined this emigration, and a number of the most outstanding Mughal *nastaʿlīq* calligraphers of the 17th century were of Kashmiri origin, including Muhammad Husayn Zarrin-qalam and Muhammad Murad Shakar-qalam.[2] Nevertheless, a strong tradition of book production survived – or was revived – in the 18th century. A French visitor, Victor Jacquemont, recorded that in 1831 there were some 700 to 800 copyists in Kashmir. They worked only to order, transcribing copies of the Qur'an, the *Shāhnāmah* and 'a very small number of other books which are the objects of a small but regular trade', which had been more extensive before the Sikh conquest in 1819.[3] The Kashmiri scribes of the 18th century appear not to have signed the Qur'ans they copied, nor did they record for whom they were made, although, as we shall see, two Qur'ans copied in Kashmir in the mid-18th century do bear dates. Colophons were more common in the Kashmiri illustrated manuscripts in St Petersburg studied by A.T. Adamova and T.V. Grek, but only one of these, that in a copy of the *Dīvān* of Hafiz giving the date AH 1211 (AD 1796–7), was accepted as genuine; the others have been obliterated or present dates that are impossibly early.[4]

The earlier of the two dated 18th-century Qur'an manuscripts already mentioned was copied in AH 1162 (AD 1749).[5] Although the quality of the work is not as high as that of cat.73–5, this Qur'an shares many features with the Khalili manuscripts, from the bold, neat *naskh* hand in which it was written, to the verse markers in the form of gold discs outlined in black, and the surah headings written in blue over gold. The margins of each page are divided into sections by rulings to accommodate a Persian commentary, written in diagonal lines. The phrase from the Qur'anic text that was to be commented upon was written in red in the same style as the main text, while the commentary itself is in black, in *nastaʿlīq*. At the same time, interlinear Persian glosses have been supplied, also written in *nastaʿlīq*, but in red. The second dated 18th-century example, which is preserved in the Gulistan Library in Tehran,[6] provides a link with Kashmir, as its colophon reads, *Hādhā'l-muṣḥaf al-karīm ba-taʾyīd-i rabbānī dar khiṭṭah-i Kashmīr zeb-i taḥrīr yāft sanah 1173*, 'With divine support this Noble Qur'an was embellished with writing in the land of Kashmir in the year 1173 [AD 1759–60].'

It is striking that all three dated manuscripts known to us were produced in the period when the Mughals were replaced by the Durrani Afghans as the rulers of Kashmir. The Afghans were first invited to intervene in Kashmir in 1747 and finally conquered the province in 1752. As a result Kashmir gained a measure of stability but became a remote province of a short-lived empire that showed no great interest in cultural innovation. It is therefore no surprise to find that the Kashmiri manuscripts produced after *circa* 1740 – both the Qur'ans referred to above and the illustrated manuscripts published by Adamova and Grek – are often not of the highest quality. In the case of the illustrated manuscripts a direct comparison can be made with the more sophisticated Mughal court production of the period in the form of a fine copy of the *Shāhnāmah* in the Khalili Collection. This was written in 1791, probably in Delhi, and has been associated with the patronage of the Emperor Shah ʿAlam II (*reg.*1759–1806).[7] The 28 illustrations were carefully executed, with a great deal of precise detail, and they show a conscious realism in the arrangement of the figures within a receding setting, and in the drawing of the individual faces.[8] The St Petersburg Hafiz manuscript of 1796–7, on the other hand, has

miniatures with much simpler, flatter compositions, and the execution tends to be sketchy.[9] Similar comments can be made about the illumination of the Kashmiri group. Several have poorly executed versions of the type of polychrome illumination found in cat.76–8,[10] but the best example, in a copy of Nizami's *Khusraw and Shirin*,[11] has a great deal in common with the Qur'an of 1749 described above: the first page of text is dominated by a head-piece with gold floral scrolls running over blue and yellow grounds, framed by gold bands set with a running lotus pattern in pink and blue. Nowhere, though, does the illumination of the dated Qur'ans or the illustrated manuscripts match the superb quality of the decoration found in cat.73–5. The execution is more peremptory, and the quality of the materials is lower, a very obvious difference being the use of yellow and blue grounds in place of the gold and blue grounds of the Khalili pieces.

On this basis it seems unlikely that cat.73–5 were produced in Kashmir after *circa* 1740. Indeed, as the 18th-century dated pieces appear to be loose renditions of a familiar type, whereas the Khalili pieces, especially cat.73, are clearly very close to the original model, we may suggest that cat.73–5 were produced before *circa* 1740 in Kashmir or, more likely, in an important Mughal centre of production in the Great Plains. But how long before 1740 were they made? The illumination in cat.60, which was copied by Princess Zinat al-Nisa' in the third quarter of the 17th century, is in a mixed style that may be seen as the predecessor to the gold-and-blue work found in cat.73–5. We might therefore presume that the 'Kashmiri' gold-and-blue style was originated later in the reign of the princess's father, Awrangzeb, which would accord well with the information on this emperor's patronage of Qur'ans gathered above (pp.172–3). The existence of cat.72, and its attribution to the period before 1659, therefore presents a problem, for this Qur'an, too, is decorated with very fine work in the 'Kashmiri' gold-and-blue style. If the attribution of cat.72 is correct, and the illumination is contemporary, the appearance of this style must have occurred in the first half of the 17th century or earlier. This divergence from the prevailing view that work of this type dates from the 18th century may seem extreme, but the study of Indian Qur'an production is in its infancy, and such revisions are to be expected. A similar case is that of the so-called Bihari Qur'ans, which are customarily attributed to the 15th century on the basis of examples dated between 1399 and 1483, but this practice is challenged by two Bihari Qur'ans with much later dates. One is in the Bibliothèque Nationale in Paris (Arabe 472) and was copied in AH 1034 (AD 1624–5),[12] while the other, which was sold in the same city in 1994, has a marginal commentary signed by Mawlana 'Ala' al-Din Muhammad and dated AH 1012 (AD 1603–4).[13]

1. Adamova & Grek 1976, p.12.
2. Bamzai 1962, pp.507–16, 531. But note an unpublished calligraphic specimen in the Khalili Collection (MSS 688) that was signed by Muhammad Darvish Rangin-qalam Sultani in baldah-i Kashmīr, i.e. Srinagar, in AH 1057 (AD 1647).
3. Quoted in Parmu 1969, pp.415–16. The extent of this trade is perhaps indicated by a Kashmiri Qur'an that seems to have been collected in Khuqand in 1890 (Paris 1994, no.65).
4. Adamova & Grek 1976, pp.7–8.

See Stchoukine and others 1971, no.73, for an illustrated manuscript dated Kashmir, 1830.
5. Sotheby's, Geneva, 25 June 1985, lot no.44.
6. Atabay 1351, no.37. *Cf.* also Christie's, London, 14 October 1997, lot no.67, which contains a note recording a birth in AH 1187 (AD 1773–4).
7. Leach 1998, no.43. One of the two colophons states that the section in question was completed on 18 Sha'ban 1205, 'in the 23rd year since the exalted accession', and it is this

use of the regnal date that suggests that the scribe was working in Delhi, one of the few centres where such information would have had even symbolic significance in 1791.
8. See the miniature illustrated at Maddison & Savage-Smith 1997, Part One, p.28, for example.
9. Adamova & Grek 1976, pls 18–22.
10. Adamova & Grek 1976, pls 1, 6, 41, 76.
11. Adamova & Grek 1976, pl.55.
12. Déroche 1985, no.549.
13. Ader Tajan, Hôtel Drouot, Paris, 23 March 1994, lot no.372.

72
Single-volume Qur'an
Northern India, before 1659

154 folios, 27.2 × 15.5 cm,
with 23 lines to the page
Material A thin, crisp, off-white
to grey laid paper, burnished; there
are approximately 16 laid lines to
the centimetre, and no apparent
rib shadows or chain lines
Text area 19.3 × 9.4 cm
Script Main text in *naskh*, in black,
with reading marks in red; surah
headings in blue *riqā'*; marginal
commentary in *nasta'līq*, in black,
with rubrications; divisions of the
text and *sajdah*s recorded in red *riqā'*
Illumination Extensive decoration
on folios 1b–2a, 70b–71a, 153b–154a;
text areas gilded in two tones of
gold; groups of gold, black and blue
rules used to sub-divide the text area,
for the double text frame, which is
filled with a floral repeat pattern
on a gold ground, and for the outer
frame; verses marked by gold discs
outlined in black; surah headings;
marginal ornaments marking text
divisions; marginal commentary
written in 'clouds' reserved in
gold, with patches of blue and gold
illumination filling spaces in the text
Documentation A note recording
a gift
Binding Modern
Accession no. QUR61

1. See Leoshko 1989, p.53, for
example.
2. See, for example, Qani', ed.
Rashidi, pp.500–514, no.548.
3. The note is not in Darashukoh's
own hand, for examples of which
see Qani', ed. Rashidi, illustrations
to no.548; Kühnel 1972, p.70, fig.72;
Sotheby's, London, 17 July 1978,
lot no.9. Darashukoh was a pupil
of 'Abd al-Rashid al-Daylami, the
nephew and pupil of Mir 'Imad;
see Bayani 1328, p.11; Bayani
1345–58, I, p.185, no.310; and
p.184 above.
4. See Qani', ed. Rashidi, pp.504–8,
n.3 (no.10 in the list on p.508).
5. See, for example, James 1992b,
nos 27, 28.
6. See, for example, James 1992b,
no.53.

The dating of this Qur'an is based on a note inscribed on folio 1a. Written in a minute *nasta'līq* hand on 1 Ramadan 1069 (23 May 1659), it states that the manuscript was formerly used for Qur'an recitations 'in the presence of the queen of the world, Mumtaz Mahal, known as Taj Bibi'. Because Prince Darashukoh greatly admired the book, Mumtaz Mahal 'bestowed it upon her beloved son with special pleasure'. Mumtaz Mahal, the wife of the Mughal emperor Shah Jahan (*reg.*1628–1657), died in 1631. The note was therefore added posthumously, but during the lifetime of her son Darashukoh (1615–1659), by someone who was aware that Mumtaz Mahal was known familiarly as Taj Bibi. This is an important piece of information, since it explains why Mumtaz Mahal's mausoleum, which has been discussed above (pp.178–81), is known as the Taj Mahal. Previously the only evidence for this came from the accounts of contemporary travellers such as Peter Mundy, who referred to the lady as 'Taje Mahal'.[1]

Darashukoh was the eldest son of Shah Jahan, and his father clearly favoured him as his successor. He was with his father in Agra in September 1657 when the emperor fell ill, and in the contest for the throne precipitated by Shah Jahan's illness Darashukoh was charged with defending the *status quo* against his three brothers. His armies in the east saw off Shah Shuja''s invasion from Bengal in February 1658, but those in the south were overcome by the remaining two brothers, Muradbakhsh and Awrangzeb, who joined forces at Ujjain and marched on Agra. Darashukoh met them outside the city, at Samugarh, on 8 June 1658 and was soundly defeated. Awrangzeb was able to imprison both his father and Muradbakhsh and make himself emperor, while Darashukoh regrouped at Deorai near Ajmer, where he was attacked and again defeated by Awrangzeb on 23 March 1659. Fleeing east towards Qandahar, Darashukoh took refuge with a Baluchi march-lord, Malik Javan, who eventually betrayed his guest. Darashukoh was taken to Delhi, where he was beheaded on 10 September, having been condemned for heresy.[2] The note on cat.72 would therefore appear to belong to the period when the prince was a refugee in Baluchistan, and it was presumably added after the Qur'an had passed out of his possession.[3]

The information in such notes cannot be accepted without hesitation, but in this case there is no internal evidence suggesting that it is a later addition, designed to mislead. In fact, the greatest objection to the dating proposed here for cat.72 is the character of the illumination, which is of a type previously associated with the 18th century. This general dating is challenged above (p.229), and the objection is also countered to some extent by the unusual presentation of the text, which is not known from any dated 18th-century Qur'an and may be judged archaic even in a 17th-century context. The most striking feature is the solid gold grounds on which the text is set throughout, and it may be that this Qur'an is to be identified with a 'gilded and illuminated' copy of the Qur'an used by Darashukoh which was at one time in the library of the nawab Husam al-Din Haydar in Comilla in eastern Bengal.[4] The presentation of the text is also unusual in the division of the text area into three compartments divided by blue rules. The upper and lower compartments contain 11 lines each and have grounds covered with a lighter, greenish tone of gold, while the middle compartment contains one line only, and the ground is a darker, yellower gold. The script employed in all three compartments is of the same size, but the division appears to be a vestige of the practice of writing the first, middle and last line of text on a page in a larger hand. The larger lines were often set in ruled compartments of their own (compare cat.58, which dates from the same period).

The text area on each page is surrounded on the three outer sides by a border with a polychrome floral repeat pattern on a gold ground, and this separates the main text from the commentary in Persian, which was written at oblique angles in black *nasta'līq*, with

Qur'anic quotations in red. The commentary is frequently interrupted by complex devices in blue and gold marking each quarter of a *juz'*. There is an outer frame of gold, black and blue rules, but, whereas in most other examples these outer rules form a *kamand*, a three-sided frame, here they surround the text area and marginal inscriptions on four sides. Surah headings are in blue *riqā'* on plain gold cartouches set in blue panels decorated with floral patterns in gold, and bordered with narrow black bands textured with groups of white dots. A letter *'ayn* in red marks each *rukū'*, and the same hand supplied inscriptions recording each quarter of a *juz'* and each *sajdah*. Most of these features existed before the 17th century. The marginal commentary written at oblique angles, for example, is found in so-called Bihari Qur'ans from the Sultanate period.[5] The strongly vertical format of the manuscript – the text area is more than twice as long as it is wide – must also have been current in India at this period, as it had been in earlier times,[6] since it appears to have been transmitted from there to Iran in the second half of the century (see p.200 above).

Folios 1b–2a, 70b–71a and 153b–154a are sumptuously illuminated. In all three cases the reduced text area is surrounded by a broad frame, which is overlaid by 'hasp' motifs that protrude from the top and sides. The frame and the 'hasps' are divided into areas of blue and gold, both of which are decorated with refined floral scrolls in gold outlined in black. If the dating of this Qur'an before 1659 is correct, it is the earliest example with this type of illumination, which is also seen in a less developed form in cat.60, and in its full glory in cat.73.

The covers were made in the 20th century by Muhammad Yusuf Sahhaf, who has left his name stamped in gold on the front doublure, but they incorporate gilt leather elements from an old binding. This had a centre-piece with pendants framed by a border of cartouches. The centre-piece contains the *shahādah* written in a decorative fashion around the name Muhammad. The *shahādah* also appears in four of the border cartouches, but written in clear *thulth*. The other cartouches and the pendants to the centre-piece are decorated with floral patterns. The two sections of the flap and the doublures are similarly decorated. The inscriptions on the doublures consist of *Allāhu kāfiyun* ('God is sufficient') in the centre-piece, and a Qur'anic quotation, *tanzīlun min Rabbi al-'ālamīna*, 'A revelation from the Lord of the Worlds' (surah LVI, verse 80, and surah LXIX, verse 43), in the corner cartouches of the border.

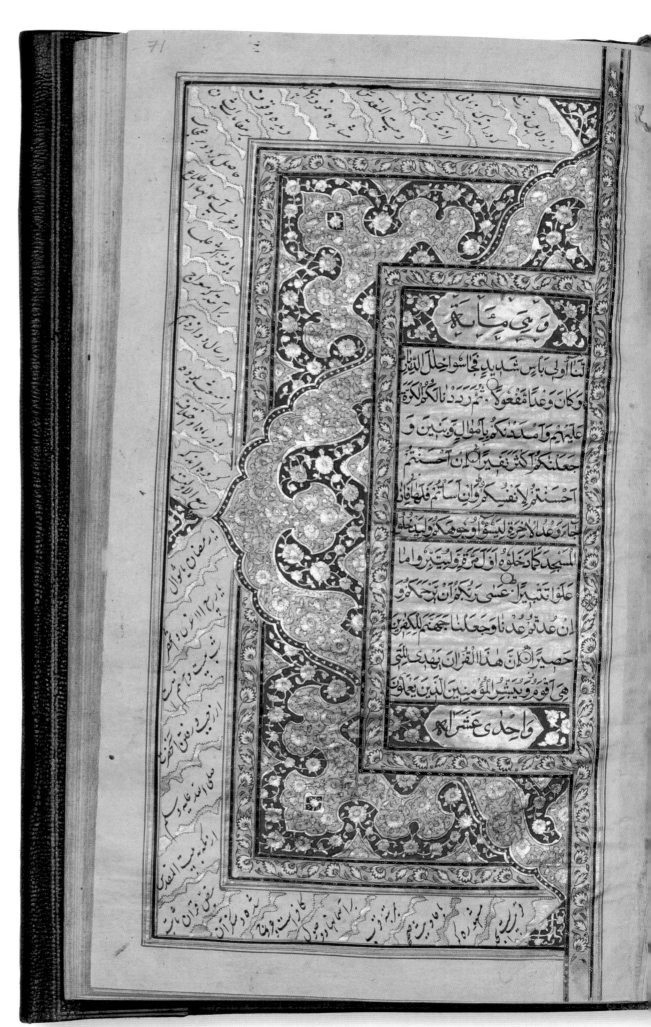

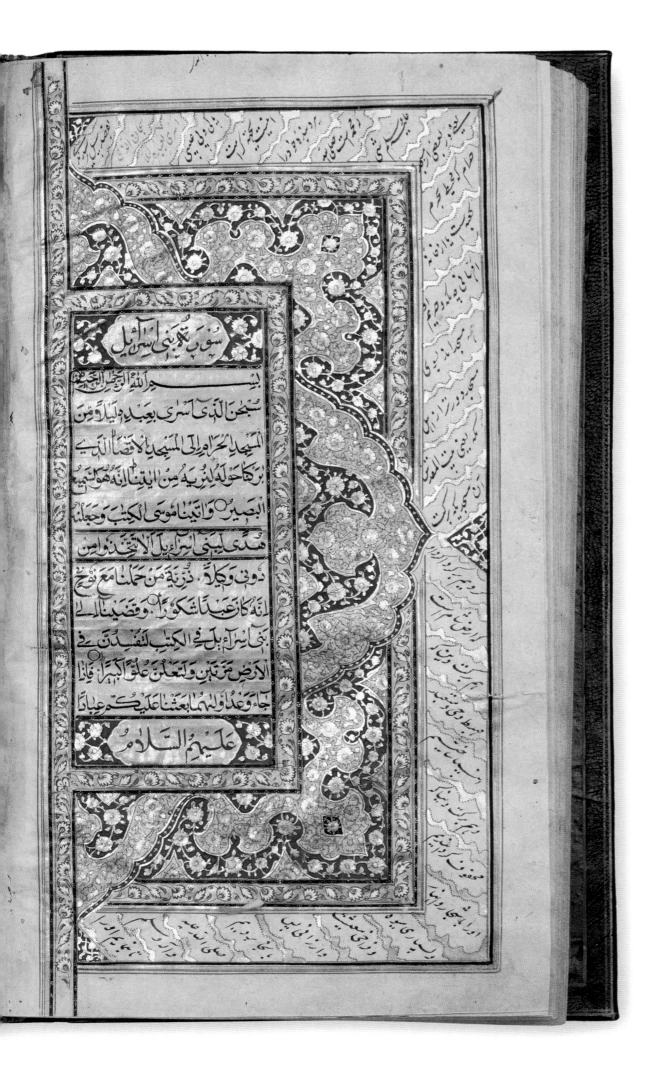

سورة بنی اسرائیل

بسم الله الرحمن الرحیم

سبحن الذی اسری بعبده لیلا من المسجد الحرام الی المسجد الاقصا الذی بارکنا حوله لنریه من ایتنا انه هو السمیع البصیر ۝ واتینا موسی الکتب وجعلنه هدی لبنی اسراءیل الا تتخذوا من دونی وکیلا ۝ ذریة من حملنا مع نوح انه کان عبدا شکورا ۝ وقضینا الی بنی اسراءیل فی الکتب لتفسدن فی الارض مرتین ولتعلن علوا کبیرا ۝ فاذا جاء وعد اولهما بعثنا علیکم عبادا

علیهم السلام

أَظْهَرَ لَقَاؤُكُمْ وَقُلُوبِهِنَّ وَمَا كَانَ لَكُمْ أَنْ تُؤْذُوا رَسُولَ اللَّهِ وَلَا أَنْ تَنْكِحُوا
أَزْوَاجَهُ مِنْ بَعْدِهِ أَبَدًا إِنَّ ذَلِكَ كَانَ عِنْدَ اللَّهِ عَظِيمًا إِنْ تُبْدُوا شَيْئًا
أَوْ تُخْفُوهُ فَإِنَّ اللَّهَ كَانَ بِكُلِّ شَيْءٍ عَلِيمًا لَا جُنَاحَ عَلَيْهِنَّ فِي آبَائِهِنَّ وَلَا
أَبْنَائِهِنَّ وَلَا إِخْوَانِهِنَّ وَلَا أَبْنَاءِ إِخْوَانِهِنَّ وَلَا أَبْنَاءِ أَخَوَاتِهِنَّ وَلَا نِسَائِهِنَّ
وَلَا مَا مَلَكَتْ أَيْمَانُهُنَّ وَاتَّقِينَ اللَّهَ إِنَّ اللَّهَ كَانَ عَلَى كُلِّ شَيْءٍ شَهِيدًا إِنَّ
اللَّهَ وَمَلَائِكَتَهُ يُصَلُّونَ عَلَى النَّبِيِّ يَا أَيُّهَا الَّذِينَ آمَنُوا صَلُّوا عَلَيْهِ وَسَلِّمُوا
تَسْلِيمًا إِنَّ الَّذِينَ يُؤْذُونَ اللَّهَ وَرَسُولَهُ لَعَنَهُمُ اللَّهُ فِي الدُّنْيَا وَالْآخِرَةِ وَ
أَعَدَّ لَهُمْ عَذَابًا مُهِينًا وَالَّذِينَ يُؤْذُونَ الْمُؤْمِنِينَ وَالْمُؤْمِنَاتِ بِغَيْرِ مَا
اكْتَسَبُوا فَقَدِ احْتَمَلُوا بُهْتَانًا وَإِثْمًا مُبِينًا يَا أَيُّهَا النَّبِيُّ قُلْ لِأَزْوَاجِكَ وَ
بَنَاتِكَ وَنِسَاءِ الْمُؤْمِنِينَ يُدْنِينَ عَلَيْهِنَّ مِنْ جَلَابِيبِهِنَّ ذَلِكَ أَدْنَى أَنْ
يُعْرَفْنَ فَلَا يُؤْذَيْنَ وَكَانَ اللَّهُ غَفُورًا رَحِيمًا لَئِنْ لَمْ يَنْتَهِ الْمُنَافِقُونَ وَالَّذِينَ
فِي قُلُوبِهِمْ مَرَضٌ وَالْمُرْجِفُونَ فِي الْمَدِينَةِ لَنُغْرِيَنَّكَ بِهِمْ ثُمَّ لَا يُجَاوِرُونَكَ
فِيهَا إِلَّا قَلِيلًا مَلْعُونِينَ أَيْنَمَا ثُقِفُوا أُخِذُوا وَقُتِّلُوا تَقْتِيلًا سُنَّةَ اللَّهِ
فِي الَّذِينَ خَلَوْا مِنْ قَبْلُ وَلَنْ تَجِدَ لِسُنَّةِ اللَّهِ تَبْدِيلًا يَسْأَلُكَ النَّاسُ
عَنِ السَّاعَةِ قُلْ إِنَّمَا عِلْمُهَا عِنْدَ اللَّهِ وَمَا يُدْرِيكَ لَعَلَّ السَّاعَةَ تَكُونُ قَرِيبًا
إِنَّ اللَّهَ لَعَنَ الْكَافِرِينَ وَأَعَدَّ لَهُمْ سَعِيرًا خَالِدِينَ فِيهَا أَبَدًا لَا يَجِدُونَ وَلِيًّا
وَلَا نَصِيرًا يَوْمَ تُقَلَّبُ وُجُوهُهُمْ فِي النَّارِ يَقُولُونَ يَا لَيْتَنَا أَطَعْنَا اللَّهَ
وَأَطَعْنَا الرَّسُولَا وَقَالُوا رَبَّنَا إِنَّا أَطَعْنَا سَادَتَنَا وَكُبَرَاءَنَا فَأَضَلُّونَا السَّبِيلَا
رَبَّنَا آتِهِمْ ضِعْفَيْنِ مِنَ الْعَذَابِ وَالْعَنْهُمْ لَعْنًا كَبِيرًا يَا أَيُّهَا الَّذِينَ آمَنُوا
لَا تَكُونُوا كَالَّذِينَ آذَوْا مُوسَى فَبَرَّأَهُ اللَّهُ مِمَّا قَالُوا وَكَانَ عِنْدَ اللَّهِ وَجِيهًا
يَا أَيُّهَا الَّذِينَ آمَنُوا اتَّقُوا اللَّهَ وَقُولُوا قَوْلًا سَدِيدًا يُصْلِحْ لَكُمْ أَعْمَالَكُمْ وَ
يَغْفِرْ لَكُمْ ذُنُوبَكُمْ وَمَنْ يُطِعِ اللَّهَ وَرَسُولَهُ فَقَدْ فَازَ فَوْزًا عَظِيمًا إِنَّا
عَرَضْنَا الْأَمَانَةَ عَلَى السَّمَاوَاتِ وَالْأَرْضِ وَالْجِبَالِ فَأَبَيْنَ أَنْ يَحْمِلْنَهَا

73
Single-volume Qur'an
Northern India, *circa* 1650–1730

400 folios, 31.6 × 19 cm,
with 13 lines to the page
Material A smooth, cream laid
paper, lightly burnished; there
are approximately 12 laid lines to
the centimetre, and no apparent
rib shadows or chain lines
Text area 21.1 × 11.8 cm
Script Main text in *naskh*, in black,
with reading marks in red; surah
headings in blue *riqā'*; the interlinear
translation in red *nasta'līq*; the
marginal commentary in black
nasta'līq, with rubrications;
other marginalia in red *riqā'*
Illumination Extensive decoration
on every page of text, with addi-
tional features on folios 1b–3a,
70b–71a, 132b–133a, 179a–180a,
233b–234a, 285b–286a, 335b–336a,
397b–398a, 399b–400a; each line
on a ground scattered with gold,
within a compartment 1.1 cm wide
defined by gold and black rules,
and separated from the next line
by a plain compartment 0.5 cm wide;
verses marked by gold discs outlined
in black (rosettes on folios 1b–2a);
surah headings; text areas framed
by a border 1.2 cm wide defined by
two sets of gold and black bands; a
second border 3 cm wide is defined
by two sets of rules (the inner rules
gold and black, the outer rules gold,
black and blue) and filled with
illumination on a natural ground;
marginal devices marking divisions
of the text; the commentary and
most other marginalia written in
'clouds' reserved in gold grounds
Documentation A seal impression
Binding Modern
Accession no. QUR143

1. This impression is too feint
to be reproduced.
2. Lings & Safadi 1976, no.148,
for example.
3. Adamova & Grek 1976.

This exceptionally fine manuscript is similar to cat.72 in some respects, and the presence on folio 393a of the impression of an oval seal dated AH 1121 (AD 1709–10) suggests that it was produced some time in the 17th or 18th century.[1] Qur'ans of this type are generally attributed to Kashmir and dated to the 18th or 19th century,[2] but it is difficult to believe that magnificence on this scale was the product of the periods of Sikh (1819–1846) and then Hindu rule there, and the illustrated manuscripts produced in Kashmir under Afghan governors (1752–1819) have illumination in styles closer to cat.77 and never of the quality of cat.73.[3] It therefore seems reasonable, especially in view of the connection with cat.72, to attribute this Qur'an to an Indian centre under Mughal rule and to a time when Mughal culture retained its vigour.

The manuscript starts (folios 1b–2a) with a fine double page of illumination. The reduced text areas contain the first surah only and were ruled in gold and black into five wider and five narrower bands. The main text was written in the wider bands over grounds scattered with gold and within 'clouds' reserved in gold grounds decorated with floral scrolls. As in the rest of the book, the narrower bands were used for a Persian translation in red *nasta'līq*. The surrounding illumination is divided into sections by gold bands textured with floral repeat patterns in black with highlights in red, and these sections are sub-divided into areas of blue and gold by palmette scrolls in gold. The blue and gold fields are both overlaid with lotus scrolls in a brighter tone of gold. One of the compartments within this scheme frames the text area on two sides and contains a Persian commentary in *nasta'līq*, written on a slant. There is interlinear gilding similar to that in the text area, and the triangular areas left blank by the slant in the script are filled with illumination in blue and gold. Similar work in blue and gold is found in the head-piece above the beginning of the second surah on folio 2b, although here small areas of black were introduced, and the dividing bands are textured with strapwork designs. The main text on these pages is also presented within 'clouds' reserved in a gold ground. Otherwise the decoration is similar to that in the rest of the manuscript.

There the main text is written on a gold-scattered ground within the wider bands. The commentary, which has interlinear gilding throughout, surrounds the text area on three sides, within a border 1.2 cm wide. This is defined by two sets of gold and black rules, the latter textured with groups of four dots, in white. This border also accommodates the marginalia indicating divisions of the text and the *rukū'*s and *sajdah*s. These marginalia consist of inscriptions in red *riqā'*, with an ornamental device for each quarter of a *juz'*. The devices are based on a lobed figure with double pendants, all in blue and gold, but no doubt due to the narrowness of this border only half of the full device is shown, as though it were projecting from beneath the text. A second, outer border, 3 cm wide, is defined by two sets of gold rules and is filled with lotus scrolls in gold and colours on a natural ground. At the centre of each side and at the top and bottom centre of each opening a 'hasp' motif protrudes into the outer margin.

Surah headings were written in blue on gold cusped cartouches, bordered with further gold illumination on blue grounds. Some headings cover parts of one or two lines (see folio 394b, for example), and they often include the number of words in each surah. Catchwords were positioned not at the bottom of the page, but to the side, close to the spine.

The text is divided into seven unequal sections, each of which ends with further double pages of illumination in the same rich style as folios 1b–2a. At the end of section 1, which is associated with the beginning of the surah *al-Mā'idah* (v) on folios 70b–71a, the text area was reduced and the space between it and the border containing the commentary was filled with blue and gold illumination, which includes four 'hasps'

that project into the commentary area. At the end of section 2, which coincides with the end of the surah *al-Tawbah* (IX) and the beginning of the surah *Yūnus* (X) on folios 132b–133a, the text area is only slightly reduced and the commentary has been dropped, allowing the creation of a double border of illumination. On folios 179b–180a, which mark the end of section 3 and the beginning of the *sūrat Banī Isrā'īl* (XVII), there is a similar arrangement, but the commentary was inserted between the two illuminated borders. The gold areas around the text are further decorated with fine floral scrolls in black.

On folios 233b–234a, where section 4 ends, and the surah *al-Shu'arā'* (XXVI) begins, there is no commentary, but only the inner border has blue and gold illumination. The outer border is filled with the pattern of polychrome lotus scrolls on a natural ground found in the rest of the manuscript. On folios 285b–286a, which contain the ends of section 5 and the surah *Yāsīn* (XXXVI) and the beginning of the surah *al-Ṣāffāt* (XXXVII), there are again two borders separated by the commentary. On folios 335b–336a, where the end of section 6 coincides with the beginning of the surah *Qāf* (L), the text areas are surrounded by an arrangement of illuminated panels, the commentary, and one narrow and one broad border. At the end of the text, on folios 397b–398a, the two last surahs are arranged one to a page and are surrounded by a wide inner and narrower outer borders. The former is furnished with large 'hasps' and has the commentary written along its outer edge. Folios 398b–399a are blank, while folios 399b–400a contain a prayer to be said on concluding the Qur'an, which was provided with a fine blue-and-gold head-piece and a ruled border filled with lotus scrolls in gold on a natural ground. The outer margin is plain.

أَقْسَطُ عِنْدَ اللَّهِ فَإِنْ لَمْ تَعْلَمُوا آبَاءَهُمْ فَإِخْوَانُكُمْ

فِي الدِّينِ وَمَوَالِيكُمْ وَلَيْسَ عَلَيْكُمْ جُنَاحٌ فِيمَا

أَخْطَأْتُمْ بِهِ وَلَكِنْ مَا تَعَمَّدَتْ قُلُوبُكُمْ وَكَانَ اللَّهُ

غَفُورًا رَحِيمًا ۞ النَّبِيُّ أَوْلَى بِالْمُؤْمِنِينَ مِنْ أَنْفُسِهِمْ

وَأَزْوَاجُهُ أُمَّهَاتُهُمْ وَأُولُو الْأَرْحَامِ بَعْضُهُمْ أَوْلَى

بِبَعْضٍ فِي كِتَابِ اللَّهِ مِنَ الْمُؤْمِنِينَ وَالْمُهَاجِرِينَ

إِلَّا أَنْ تَفْعَلُوا إِلَى أَوْلِيَائِكُمْ مَعْرُوفًا كَانَ ذَلِكَ

فِي الْكِتَابِ مَسْطُورًا ۞ وَإِذْ أَخَذْنَا مِنَ النَّبِيِّينَ

مِيثَاقَهُمْ وَمِنْكَ وَمِنْ نُوحٍ وَإِبْرَاهِيمَ وَمُوسَى

وَعِيسَى ابْنِ مَرْيَمَ وَأَخَذْنَا مِنْهُمْ مِيثَاقًا غَلِيظًا ۞

لِيَسْأَلَ الصَّادِقِينَ عَنْ صِدْقِهِمْ وَأَعَدَّ لِلْكَافِرِينَ

عَذَابًا أَلِيمًا ۞ يَا أَيُّهَا الَّذِينَ آمَنُوا اذْكُرُوا نِعْمَةَ

اللَّهِ عَلَيْكُمْ إِذْ جَاءَتْكُمْ جُنُودٌ فَأَرْسَلْنَا عَلَيْهِمْ

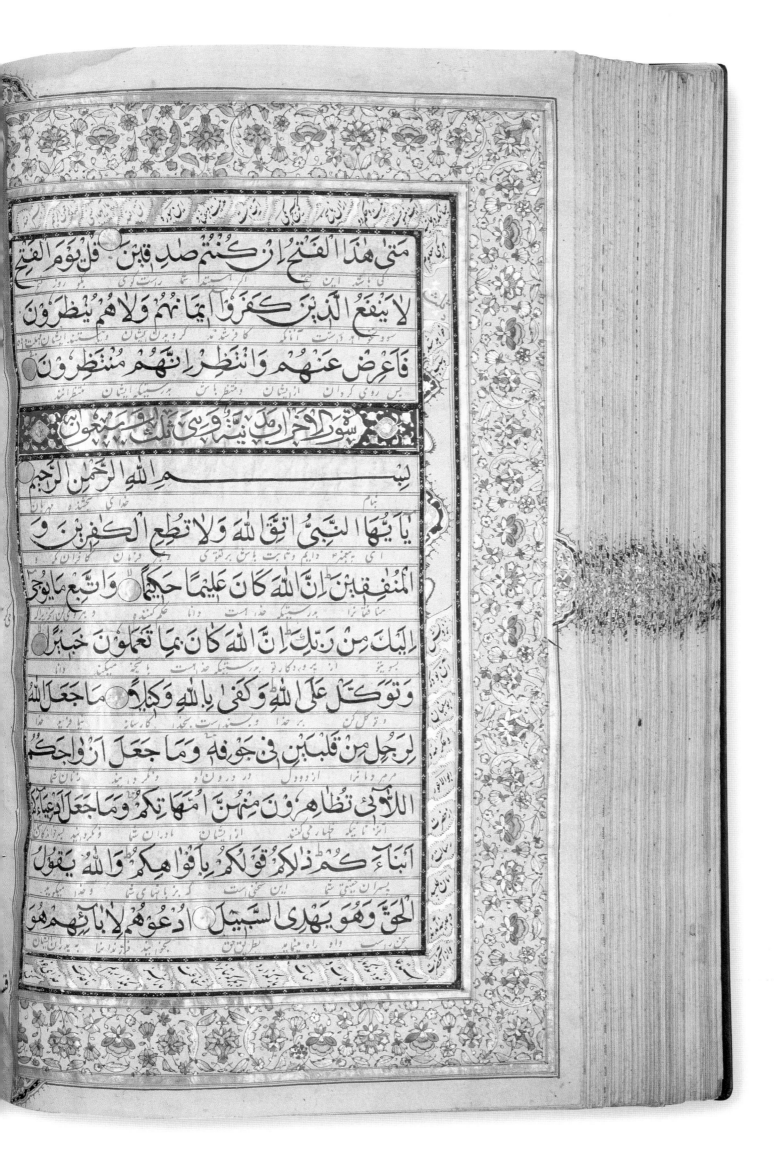

مَتَىٰ هَٰذَا الْفَتْحُ إِن كُنتُمْ صَٰدِقِينَ ۝ قُلْ يَوْمَ الْفَتْحِ

لَا يَنفَعُ الَّذِينَ كَفَرُوٓا إِيمَٰنُهُمْ وَلَا هُمْ يُنظَرُونَ

فَأَعْرِضْ عَنْهُمْ وَانتَظِرْ إِنَّهُم مُّنتَظِرُونَ ۝

سُورَةُ الْأَحْزَابِ مَدَنِيَّةٌ وَهِيَ ثَلَاثٌ وَسَبْعُونَ

بِسْمِ اللَّهِ الرَّحْمَٰنِ الرَّحِيمِ ۝

يَٰٓأَيُّهَا النَّبِيُّ اتَّقِ اللَّهَ وَلَا تُطِعِ الْكَٰفِرِينَ وَ

الْمُنَٰفِقِينَ إِنَّ اللَّهَ كَانَ عَلِيمًا حَكِيمًا ۝ وَاتَّبِعْ مَا يُوحَىٰ

إِلَيْكَ مِن رَّبِّكَ إِنَّ اللَّهَ كَانَ بِمَا تَعْمَلُونَ خَبِيرًا ۝

وَتَوَكَّلْ عَلَى اللَّهِ وَكَفَىٰ بِاللَّهِ وَكِيلًا ۝ مَّا جَعَلَ اللَّهُ

لِرَجُلٍ مِّن قَلْبَيْنِ فِي جَوْفِهِۦ وَمَا جَعَلَ أَزْوَٰجَكُمُ

اللَّٰٓئِي تُظَٰهِرُونَ مِنْهُنَّ أُمَّهَٰتِكُمْ وَمَا جَعَلَ أَدْعِيَآءَ

كُمْ أَبْنَآءَكُمْ ذَٰلِكُمْ قَوْلُكُم بِأَفْوَٰهِكُمْ وَاللَّهُ يَقُولُ

الْحَقَّ وَهُوَ يَهْدِي السَّبِيلَ ۝ ادْعُوهُمْ لِءَابَآئِهِمْ هُوَ

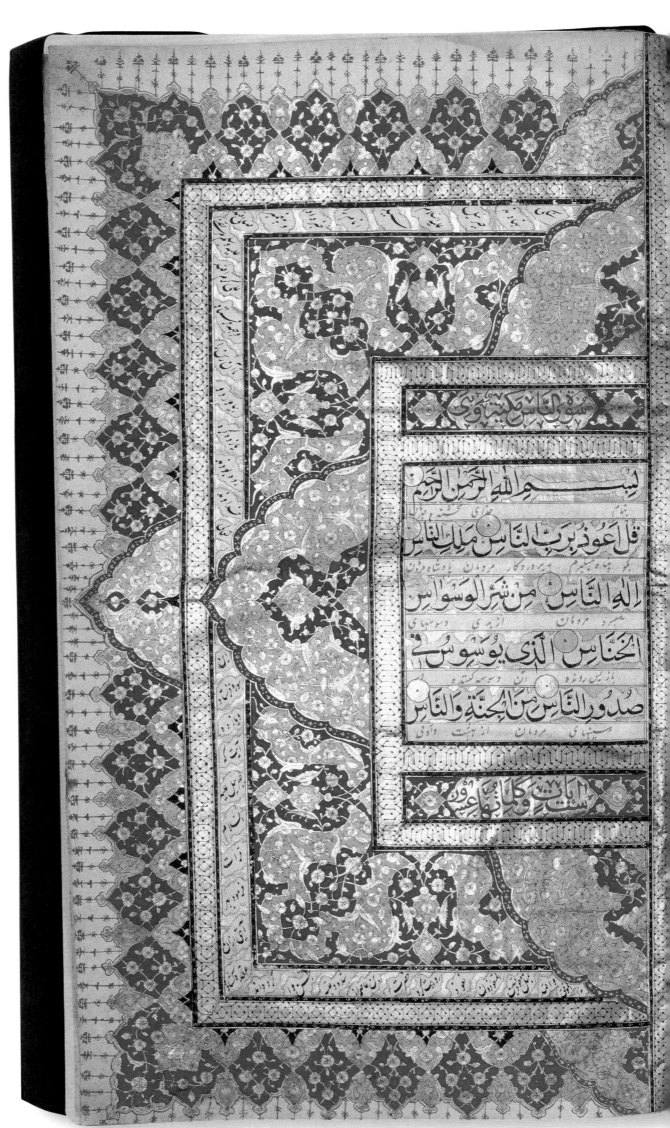

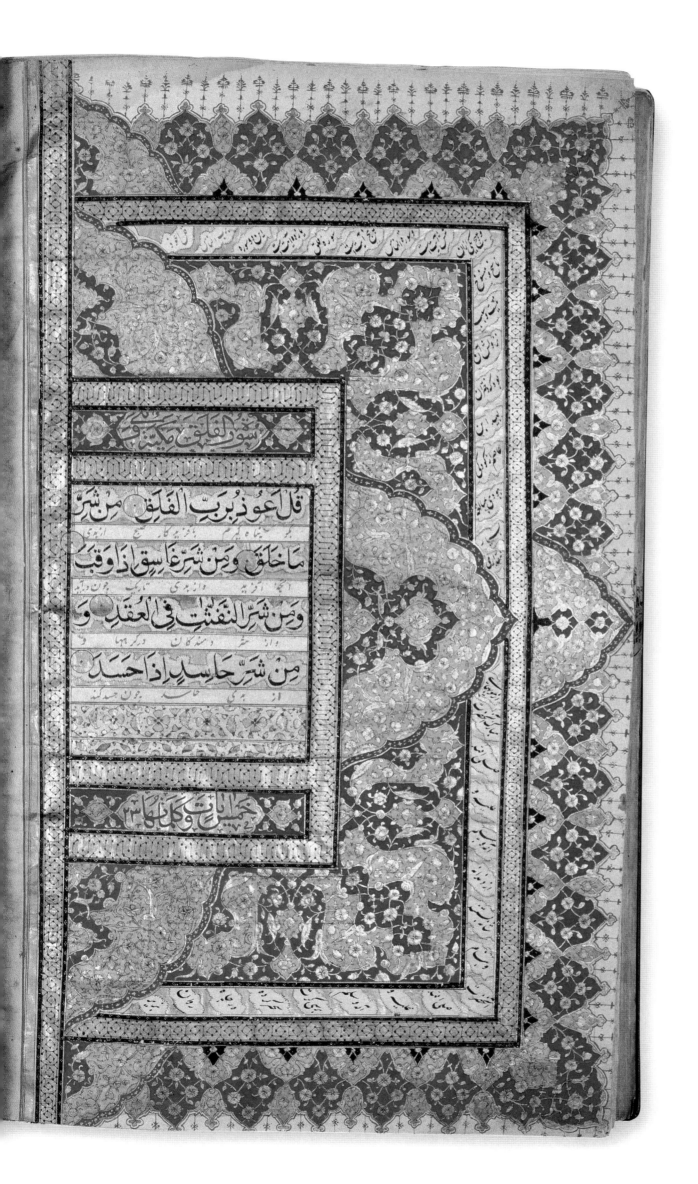

سورة الفلق مدنیة وهی

قُلْ أَعُوذُ بِرَبِّ الْفَلَقِ ۝ مِن شَرِّ
مَا خَلَقَ ۝ وَمِن شَرِّ غَاسِقٍ إِذَا وَقَبَ ۝
وَمِن شَرِّ النَّفَّاثَاتِ فِي الْعُقَدِ ۝ وَ
مِن شَرِّ حَاسِدٍ إِذَا حَسَدَ ۝

74
Single-volume Qur'an
Northern India, 18th century

204 folios, 10.1 × 5.5 cm,
with 20 lines to the page
Material A thin, off-white laid
paper, lightly burnished; there
are approximately 12 laid lines
to the centimetre, and no apparent
rib shadows or chain lines
Text area 6.8 × 2.9 cm
Script Main text in *naskh*, in black,
with reading marks in red; surah
headings in blue *riqā'*; most
marginalia in blue *riqā'*, some in
red (folios 171b, 172a, 180a, 194b,
197b); 19th-century additions in
gold *riqā'* (folios 1b–2a), red *riqā'*
and black *naskh* (folios 200b–201a),
and red *riqā'* and black *naskh* and
nasta'līq (folio 201b)
Illumination Extensive decoration
on every page of text except folio
201b (a 19th-century addition),
with additional features on folios
1b–2a (another 19th-century
addition), 2b–3a, 90b–91a,
199b–200a; each line within a
compartment 0.3 cm wide defined
by gold and black rules; verses
marked by gold discs outlined in
black; surah headings; text areas
framed by a border 0.9 cm wide
defined by two sets of gold, black
and blue rules, filled with a repeating
floral pattern in colours and gold on
a natural ground; marginal devices
marking divisions of the text
Documentation A colophon relating
to the 19th-century additions
Binding Indian lacquer covers
of the 18th century
Accession no. QUR363

1. Identical instructions are found
in QUR321, which is dated AH 1244
(AD 1828–9); see Part Two of this
catalogue.

The original, Indian manuscript begins on folios 2b–3a, where the text, presented in 'clouds' reserved in gold, is surrounded by a fine double-page illuminated composition in gold and blue, close in style to those in cat.72. A gold band decorated with a repeating pattern of polychrome flowers and leaves was used to articulate the design. Similar illuminated double pages mark the beginning of the *sūrat Banī Isrā'īl* (XVII), close to the middle of the text, on folios 90b–91a (compare cat.72), and the end of the Qur'anic text, on folios 199b–200a. The surah headings are in the same rich style (compare cat.73), and the titles were written in blue on a gold ground, in a decorative form of *riqā'* in which upright letters form lobed arches (compare cat.75).

Each line of text is separated from the next by black and gold rules, and the text area is surrounded by gold, black and blue rules. On folio 3b the margin is filled with lotus and other floral motifs in gold on a plain ground. On folio 4a similar motifs, but executed in gold and colours, are contained by an outer border (*kamand*) of gold and black rules. On folio 4b the outer border is composed of gold, black and blue rules, and the space between the text frame and the outer border is filled with lotus scrolls in gold and a variety of colours, on a plain ground (compare cat.73). A similar illuminated frame surrounds the text on every other page, but the motif is a repeating lotus pattern executed in gold, with black outlines and highlights in red and green. On folio 60b the upper part of this illuminated border was replaced by a prayer ('I take refuge in God from the fire and from the evil wrought by infidels and from the wrath of the Almighty. Glory belongs to God and to His messenger'), written in black *naskh* in a 'cloud' reserved in gold.

On folio 4b the illuminated border contains a marginal device, presumably designed to indicate a division of the text, but it was left uninscribed. In all other cases marginal devices and inscriptions marking divisions of the text and prostrations were placed in the outer margin. Inscriptions in blue consisting of the word *khams* ('five') or *'ashr* ('ten') record every fifth verse and every tenth verse, while single letters *'ayn* mark the *rukū'*s. Similarly, the words *rub'* ('quarter'), *nisf* ('half') and *thalāthah* ('three[-quarters]') indicate each quarter of a *juz'* and are accompanied by a gold half-teardrop-shaped device with a blue border, which is attached to the outer border, as though the border half-obscured it (compare cat.72, 73). The same motif is used to mark the beginning of each *juz'*. In this case it is accompanied by the word *al-juz'*, sometimes written in an ornamental fashion, and the number. In one instance, the beginning of the fourth *juz'* on folio 21a, the first few words are in red.

At the top of each page there is another short inscription in blue, surrounded by a lobed outline in gold. Those on the right-hand page of each opening usually record the *juz'* number, while those on the left-hand page give the title of the surah. Towards the end of the manuscript both inscriptions give the title of the surah, and they are duplicated where more than one surah heading appears on a page. Where mistakes were made in copying the Qur'anic text, they were covered over with gold, and the missing section was written on a gilded area in the margin. This gilded area was outlined in red.

The quality of this Qur'an was clearly appreciated in early 19th-century Iran, as it was adapted for use there by, for example, the addition of illuminated opening folios (1b–2a) containing a prayer to be said before reading the Qur'an, and by placing one of seven combinations of letters in the top right-hand corner of each opening so that the manuscript could be used for telling fortunes. The key to these combinations is given on folio 201b.[1] The Qajar illumination on folios 1b–2a incorporates a border imitating the marginal decoration in the Indian part of the manuscript, and this also appears on folio 200b, where it surrounds a text area laid out like the rest of the manuscript, with each

73 folios 194b–195a

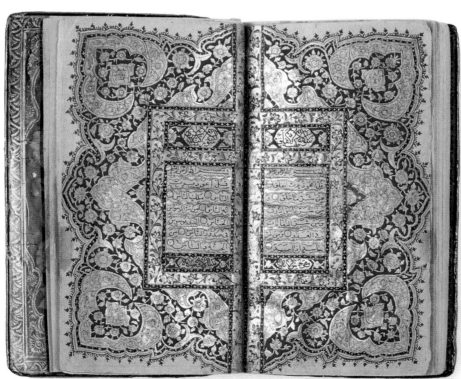

73 folios 199b–200a

line separated by gold rules. The text here is a prayer to be said at the points in the text where a prostration was required, and another to be said after reading the Qur'an. The headings are in a typically Qajar style, in red *riqāʿ* on a plain gold ground. The prayers are completed on folio 201a, but in a different hand, and the illuminated border is closer to the Indian work in the rest of the manuscript, but this also seems to be Qajar work, as it ends with the date 26 Shaʿban 1241 (5 April 1826).

The lacquered covers are decorated with a centre-and-corner composition with dark and gold grounds. Each element is filled with floral motifs of different types. The centre-pieces, for example, have a spray of irises on gold, while the corner-pieces have stylized lotus scrolls in gold on a dark ground. A similar motif on a green ground appears in the corner-pieces of the doublures, which frame a dark ground filled with a bouquet of flowers. The spine was also decorated with floral motifs in gold and colours on red leather. There are similarities between the motifs used here and those used in the marginal decorations surrounding each page of text, which suggests that the binding is contemporary with the text.

75
Single-volume Qur'an

Northern India, late 17th or early 18th century

426 folios, 17.2 × 10.2 cm,
with 13 lines to the page
Material A thin, cream laid paper,
lightly burnished; there are
approximately 14 laid lines to
the centimetre and no apparent
rib shadows or chain lines
Text area 12.1 × 6.2 cm
Script Main text in *naskh*, in black
or blue, with reading marks in red;
surah headings in white *riqā'*;
marginalia in red and blue *riqā'*
Illumination Extensive decoration
on folios 1b–2a, 425b–426a; each
line of text presented in a 'cloud'
reserved in a gold ground, with
the exception of the first line of
each *juz'*, which is on a solid gold
ground; verses marked by gold discs
outlined in black; surah headings;
text frames of black, gold and blue
rules, and outer frames of gold
and black rules; marginal devices
marking divisions of the text
Binding Indian lacquer covers
of the 18th or 19th century
Accession no. QUR396

1. The headings often include the
number of words and letters in
each surah, which appears to be
an Indian tradition.

The manuscript opens (folios 1b–2a) and closes (folios 425b–426a) with a double page of illumination in which gold and blue predominate. The only other colour employed is black, which is stippled with groups of small white dots when used as a background. Decoration in a similar style was used for the panels containing the surah headings, which were written in the ornamental form of *riqā'* used for the same purpose in cat.74.[1] The general character of this work is very similar to that in cat.73, and cat.75 can therefore be dated to the same period.

The main text was written in a neat *naskh* hand, and each line of text is set in a 'cloud' reserved in a plain gold ground. Most of this script is in black, but the first line of each *juz'* is in blue and is set against a solid gold ground within a compartment formed by gold and black rules above and below. This is accompanied in the margin by an inscription in red recording the number of the *juz'* and a device in blue, black and gold, which consists of a medallion with eight pointed lobes and a pair of palmette-shaped pendants. The three are set two centimetres apart and are linked by a blue line decorated with subsidiary motifs in gold and blue (compare cat.72, 73). The same device marks each quarter-*juz'*, and each *sajdah* is recorded in the margin mostly in red but occasionally in blue *riqā'*. The letter *'ayn* in either red or blue *riqā'* marks *rukū'*s. The name of the surah is written in red on the top left-hand corner of each opening, while the first word of each *juz'* is written in the top right-hand corner.

The lacquer covers are probably of a later date. The central field is black and is covered with trails of small flowers, rising from the base. The spaces between these motifs are set off with tiny leaf-like forms in gold. The maroon borders are filled with an undulating floral scroll in gold. The doublures have a red ground and black border, and the main composition is that of a vase set in a niche, although the treatment of the flowers is identical to that on the exterior of the covers.

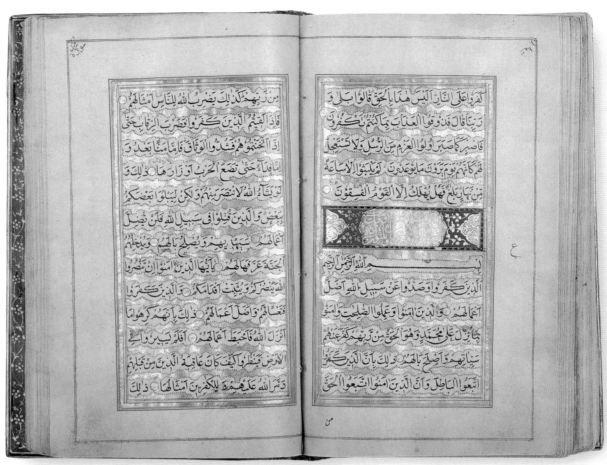

75 folios 353b–354a

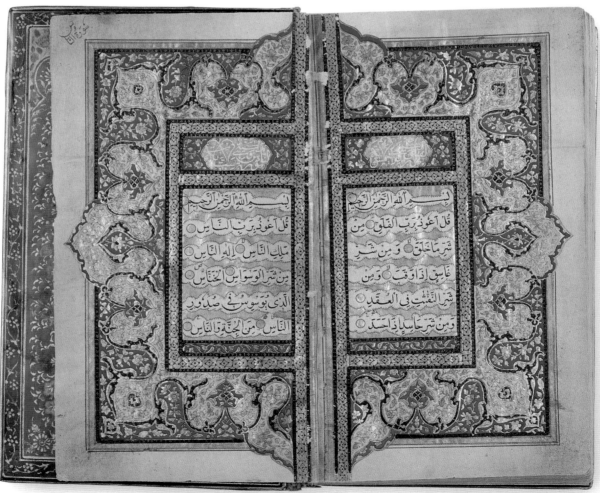

75 folios 425b–426a

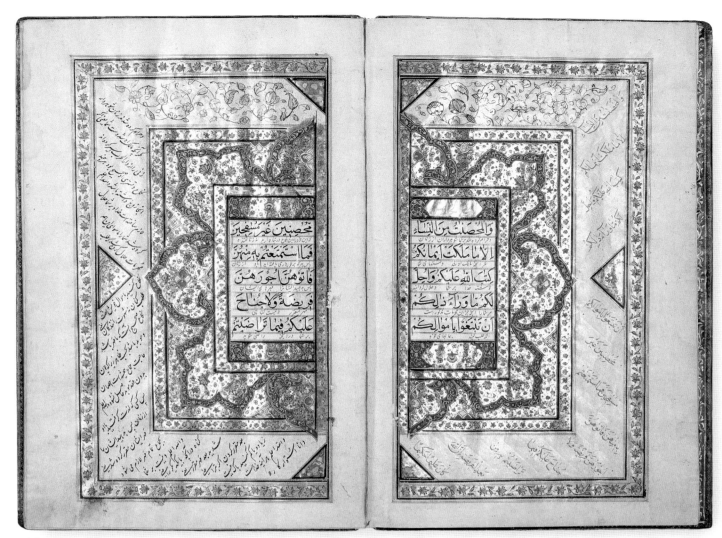

76 folios 1b–2a

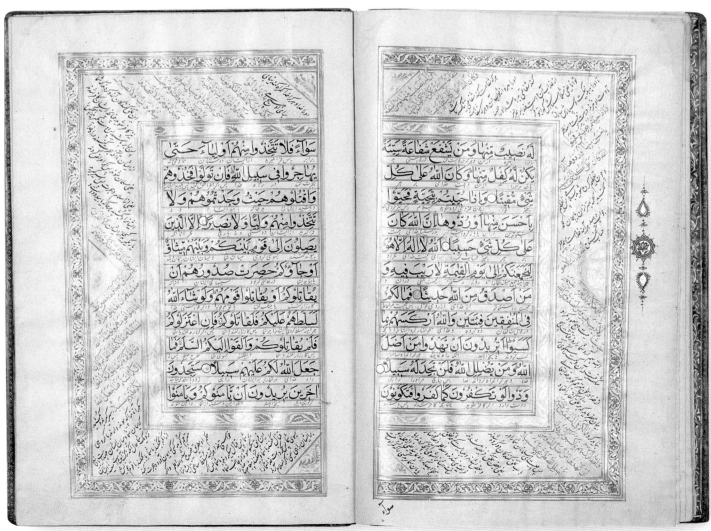

76 folios 11b–12a

76

Part 5 of a Qur'an in 30 parts

Northern India, probably Kashmir, 18th century

21 folios, 23 × 15 cm, with
11 lines to the page
Material A thin, very crisp,
cream laid paper, burnished to a
gloss; there are approximately
12 laid lines to the centimetre,
and no apparent rib shadows or
chain lines. It is very similar in
character to Persian paper of the
18th and 19th centuries, although
somewhat more fibrous
Text area 11.9 × 6.8 cm
Script Main text in *naskh*, in
black, with reading marks in red;
interlinear translation in red
nasta'līq; heading for part 5 in
white *riqā'*; marginal commentary
in red *naskh* and black *nasta'līq*
Illumination Extensive decoration
on every page of text, with additional
features on folios 1b–2a; each line on
a ground scattered with gold, within
a compartment 0.7 cm wide defined
by gold rules, and separated from
the next line by a plain compartment
0.3 cm wide; verses marked by gold
discs; text areas framed by a border
1 cm wide defined by two groups of
gold and black rules and filled with
a design in gold on a natural ground;
the outer border the same, but filled
with a design in gold and colours on
a natural ground; marginal commen-
tary written at an oblique angle on
a ground scattered with gold, with
triangular areas of decoration in
gold on a natural ground to fill gaps
created by the angling of the lines;
devices in outer margins marking
divisions of the text
Binding Kashmiri lacquer covers
of the 18th or 19th century
Accession no. QUR347
Published Christie's, London,
11 October 1988, lot no.56; Khalili,
Robinson & Stanley 1996–7, no.209

1. See Adamova & Grek 1976,
for example.

This Qur'an section shares many features with the group of Qur'ans with gold-and-blue illumination published above (cat.72–5), but the lavish illumination on folios 1b–2a is marked by the use of polychrome motifs on predominately gold grounds. This work is much closer in style to the decoration of later 18th- and early 19th-century manuscripts produced in Kashmir,[1] and on these grounds and, on the basis of the distinctively Kashmiri style of lacquer binding to which it is attached, cat.76 may be attributed to Kashmir (compare cat.77, 78).

Only five lines of text are included in the central panels on folios 1b–2a, which are much smaller than the text areas in the rest of the manuscript. These panels are surrounded by a broad band of illumination, and the space between this and the outer frame is filled with a section of Qur'anic text, in red *naskh*, followed by an explanatory translation in Persian, in black *nasta'līq*, which supplements the Persian interlinear glosses. This part of the margin is scattered with gold, as it is elsewhere in the manuscript, and the upper sections, which contain no text, are filled with floral scrollwork in gold and black. The outer frame and the triangular 'thumb-pieces' within the margins are filled with floral motifs over gold grounds. In the gold cartouche above the text on folio 1b, the title of the *juz'* has been written in white *riqā'*, and the other three cartouches on this opening have been filled with floral motifs.

The remainder of the manuscript is also richly decorated, predominantly in gold, which is used in seven different ways: scattered, firstly, over the broader bands within the text area that accommodate the lines of the main text, and, secondly, over the inner margins, where the explanatory translation was written; thirdly, for the interlinear rulings within the text area; fourthly, for the verse markers; fifthly, for the frame around the text areas, which consist of two sets of gold and black rules separated by a running leaf-scroll pattern in gold only; sixthly, for the outer frame, which is formed from similar double sets of rules and is filled by floral scrollwork executed in colours and gold; and, seventhly, for the 'thumb-pieces', which have leaf motifs in gold only. The first quarter (folio 6b), and the middle (folio 11b) of the section are marked by diminutive devices in blue and gold filled with a single flower head.

The central panel of the lacquer covers is filled with rows of flowering plants on a red ground, and the border consists of a repeating flower and leaf pattern on a yellow ground. The doublures are decorated with a bouquet of flowers on an orange ground, framed by a lobed arch and surrounded by a border filled with scrolling flowers and leaves on a black ground.

77
Single-volume Qur'an

Northern India, probably Kashmir, 18th century

951 folios, 32.7 × 19.3 cm,
with nine lines on each page
Material A thin, crisp, cream laid
paper, burnished; there are
approximately 13 laid lines to
the centimetre, and no apparent
rib shadows or chain lines.
Identification of mould markings
is difficult, due to the highly fibrous
nature of the pulp
Text area 16.5 × 8.4 cm
Script Main text in *naskh*, in black
on a gold-scattered ground, with
reading marks in red; the *ex-libris*,
surah headings and colophon in
white *riqāʿ*, the colophon overwritten
in black; the interlinear translation
in red *nastaʿlīq*; the marginal
commentary in black *nastaʿlīq*,
with Qurʾanic quotations in
red *naskh*, all on gold-scattered
grounds; other marginalia in *riqāʿ*,
in white and two tones of red
Illumination An *ex-libris* on folio
1a; extensive decoration on folios
1b–2a, 426b–427a, 949b–950a;
verses marked by gold discs outlined
in black; the text areas sub-divided
by gold and black rules and
surrounded by broad ornamental
frames; outer frames of gold, black
and blue rules; a variety of marginal
devices marking divisions of the text
Documentation An *ex-libris* and
a colophon
Binding Kashmiri lacquer covers
of the late 19th century
Accession no. QUR354
Published Khalili, Robinson &
Stanley 1996–7, no.210

1. *Cf.* the *ex-libris* of James 1992b,
no.52. This was added to the
manuscript by Janibeg of Sind,
who ruled in 1585–1591.
2. Falsafi 1371, I–II, p.341; III,
pp.863–6.
3. Falsafi 1371, I–II, p.531.
4. Zambaur 1927, pp.261–2.
5. For a description of the binding,
see Khalili, Robinson & Stanley
1996–7, no.210.

The styles of script and illumination of this manuscript and its format are of types popular in India in the 18th and 19th centuries, but the *ex-libris* and colophon link it explicitly to the early 17th century. The *ex-libris* on folio 1a consists of a central roundel with a gold ground set with polychrome floral scrolls and a border of palmette-shaped elements illuminated in the same, bright style as the rest of the manuscript.[1] The text in the central roundel, which was inscribed in white *riqāʿ*, reads, 'It was written by order of the sultan who is like Alexander in glory, the monarch whose every whim is executed, Shah ʿAbbas Safavi Bahadur Khan – May God cause his reign to last for ever and [ensure] the continuance of his dominion!' According to the colophon, which follows a prayer to be read on concluding the Qurʾan (folios 950b–951b), the manuscript 'was written with the aid of God, the Beneficent King, and presented to the Emperor of Iran on the occasion of the arrival of his august retinue on the most holy ground [of Mashhad], by order of his excellency, the pivot of grandeur and magnificence, Farhad Beg. Nasr Harati wrote it in the year 1010.' This information relates to Shah ʿAbbas I's pilgrimage from Isfahan to Mashhad in AH 1010 (AD 1601–2), which he accomplished on foot,[2] and the Farhad Beg referred to was presumably Farhad Beg Charkas Qushchi, master of the hunt to Shah ʿAbbas. He was later accused of attempting to assassinate his master with the help of Prince Safi and was executed in AH 1022 (AD 1613–14) or AH 1023 (AD 1614–15).[3]

Given the physical characteristics of the manuscript, it is clear that it was not copied at the beginning of the 17th century, and it is probably an 18th-century textual (but not a formal) facsimile of a Qurʾan presented to Shah ʿAbbas I when he entered Mashhad on foot. The production of such a Qurʾan in India may have been the result of the presence there of a descendant of the Safavid shahs. One such was the Muhammad Khalil who owned cat.66 above; another was Abuʾl-Fath Muhammad Shah, the great-grandson of Shah Sultan Husayn (*reg.*1689–1722), who took up residence in Lucknow in AH 1209 (AD 1794–5).[4] The date of this incident is very much in accord with the stylistic character of the manuscript, but even if there is no connection with Abuʾl-Fath Muhammad Shah, the nature of the inscriptions suggests that the patron of cat.77 was from a Shiʿi centre in India such as Lucknow, or one of the two Hyderabads, in the Deccan and Sind.

The body of the manuscript has a layout designed to accommodate an interlinear translation and a marginal commentary, both in Persian. The central text area is divided by gold and black rules into nine wider and nine narrower compartments. The wider compartments contain the Arabic text in a large, characteristically Indian form of *naskh*, while the narrower compartments contain the translation in small red *nastaʿlīq*. The text area is surrounded by a band filled with a floral repeat pattern on a plain ground, and this is surrounded in turn by a broad area within which the Persian commentary was written diagonally in black *nastaʿlīq*, with the Qurʾanic quotations in red *naskh*. Surah headings were written on gold cartouches set within panels illuminated with a variety of motifs, and the name of the surah was recorded in red *riqāʿ* within an illuminated device at the top of the right-hand page of each opening. In the top right-hand corner of the same page there is a code giving the character of the opening when used for casting fortunes.

There is supplementary illumination at the beginning, in the middle and at the end of the Qurʾanic text. On folios 1b–2a, for example, the text of the first surah, *al-Fātiḥah*, is inscribed in reduced text areas. These are surrounded by a broad illuminated border with gold and blue grounds, defined by gold bands containing a repeating lotus-bud motif.[5]

بسم الله الرحمن الرحيم
خدای مهربان بخشنده

الحمد لله رب العالمين
سپاس مر خدای پروردگار جهانیان

الرحمن الرحيم ملك يوم
مهربان بخشنده پادشاه روز

الدين اياك نعبد واياك
جزا تو را می پرستیم و خاص ارا تو

إِذْ أَوَى الْفِتْيَةُ إِلَى الْكَهْفِ

چون جاى كرفت جوانان

فَقَالُوا رَبَّنَا آتِنَا مِن لَّدُنكَ

پس گفتند اى پروردگار ما بده ما را از نزد خود خود

رَحْمَةً وَهَيِّئْ لَنَا مِنْ أَمْرِنَا

و مهيا ساز براى ما از كار ما

رَشَدًا ۝ فَضَرَبْنَا عَلَىٰ آذَانِهِمْ

راستى پس بها ديم ما بر كوشهاى ايشان

فِى الْكَهْفِ سِنِينَ عَدَدًا

در غار سالها ذات عدد

ثُمَّ بَعَثْنَاهُمْ لِنَعْلَمَ أَيُّ الْحِزْبَيْنِ

پس بر انگختيم تا بنميم كه از دو گروه

أَحْصَىٰ لِمَا لَبِثُوا أَمَدًا ۝ نَحْنُ

شماره كاه دارد مدت اندازه مدت درنك ايشان ما

نَقُصُّ عَلَيْكَ نَبَأَهُم بِالْحَقِّ

ميخوانيم بر تو خبر ايشان بدرستى

إِنَّهُمْ فِتْيَةٌ آمَنُوا بِرَبِّهِمْ وَزِدْنَاهُمْ

ايشان جوانان بودند كروديدند بپروردگار خود و بفزوديم ايشان را

78
Five surahs

Northern India, probably Kashmir, AH 1229 (AD 1814)

30 folios, approximately 20 × 15 cm,
with nine lines of text on one side
Material Dark-cream, transparent
parchment
Text area 14.5 × 10.2 cm
Script Main text in *naskh*, in black;
surah headings in red *riqā'*;
marginalia in black *naskh*
Scribe Ghulam 'Ali
Illumination Extensive decoration
on folios 1a and 30b; each line of
text framed by a single blue rule
and separated from the next line
by a gold band 0.5 cm wide, outlined
in black; the text area framed by a
similar gold band outlined in black
and framed by red and blue rules;
outer frames of one blue rule;
verses marked by gold discs
outlined in black; surah headings
Documentation A colophon
Binding Modern
Accession no. QUR500

This manuscript contains the same selection of five surahs as cat.64–6. It was copied
on parchment so fine as to be transparent. As a consequence the scribe, Ghulam 'Ali, was
able to write on only one side of each folio. The text area on each page is divided into nine
compartments by a framework of gold bands that resembles an abacus, with a line of text
in each compartment. There are a number of noteworthy features. One is the composition
of the *basmalah*, in which the word *Allāh* and the first half of *al-Raḥmān* were written
above the elongated *sīn* of *bi'sm*. Another is the way the text has been corrected in two
places (folios 14b and 28a) – by washing off the original wording and rewriting it. A third
is the placing of the name of the surah, written in black *naskh*, in the top right corner of
each written page. Other marginalia consist mainly of inscriptions marking *rukū's*.

The first and last pages (folios 1a and 30b) have illumination in the style current
in Kashmir in the 18th and 19th centuries. On folio 1a the text area contains only five
short lines of text, which are framed by a head-piece and a wide border on three sides.
These elements have gold and black grounds overlaid with polychrome and gold floral
scrolls. The head-piece incorporates the surah titles, written in red on white and black
cartouches, which are, unusually, supplemented by invocations to God and Muhammad.
On folio 30b, where the ornament consists of two types of polychrome floral scroll on
gold grounds, the text area is divided into two parts. The upper section is filled with five
magic squares related to the five surahs included in the manuscript, while the lower section
contains four short lines of text within a broad frame. The first three lines are the end of
the last surah in the selection, *al-Mulk* (LXVII), and the fourth consists of the words,
tamma bi-l-khayr ('It finished well'). The colophon appears in the lower margin.

78 folio 30b

78 folio 1a

79
Qur'an in 30 parts
India, AH 1303 (AD 1885–6)

Between nine and fifteen folios in each *juz'*, all 24 × 13.5 cm, with 16 lines to the page
Material A very crisp, off-white laid paper, burnished to a gloss; there are approximately 13 laid lines to the centimetre, and no apparent rib shadows or chain lines
Text area 17.5 × 8.5 cm
Script Main text in *naskh*, in black, with reading marks in red; interlinear translation in red *nasta'līq*; surah headings in blue *riqā'*; marginalia in red *naskh* verging on *riqā'*
Illumination Extensive decoration on part 1, folios 1b–2a; head-pieces on parts 2–30, folio 1b; each line of text within a compartment 0.7 cm wide defined by single gold rules, and separated from the next line by a blank compartment 0.3 cm wide; text areas framed by gold, black and blue rules; outer frames also in gold, black and blue; verses punctuated by gold discs; surah headings; marginal devices marking divisions of the text; colophons presented on a plain gold field, usually in the form of a disc
Documentation A colophon at the end of each section
Binding Cloth covers, perhaps contemporary
Accession no. QUR445

1. The Baha'is first attempted to win converts in India in the 1870s, but they had no success until the 1960s; see Smith 1989, p.453.

The continuing prestige of the late Mughal style of Qur'an manuscript, with illumination in blue and gold and each line of text set in a gold-ruled compartment (compare cat.73–5), is shown by this example from late 19th-century India. It was ordered by a gentleman called Salih Baha'i, the son of Hibatallah, the son of Haydar 'Ali, the son of Qasim Ji and was completed in AH 1303. Salih Baha'i's name and lineage appear in the colophon of every volume, while the date appears only in the colophon of the last volume. In each case an attempt was later made to overpaint the second part of Salih Baha'i's name, no doubt because of the association it suggested with the Baha'i movement, the successors of the heretical Babi movement in Iran.[1]

Part 1 begins (folios 1b–2a) with a double page of illumination predominately in blue and gold, which was clearly derived from models such as cat.73. Head-pieces in the same style occur at the beginning of each subsequent part. The text area is divided by gold rules into horizontal bands, alternately wider and narrower. Each wider band contains a single line of text, and on folios 1b–2a of part 1 and on folio 1b of the remaining 29 parts each line is set within a 'cloud' reserved in gold. The narrower bands are generally blank, but Persian interlinear glosses have been added in red *nasta'līq* on folio 13a of part 26 (surah L, *basmalah* and verses 1–5) and folio 5b of part 27 (surah LIII, *basmalah* and verses 1–20).

In some respects this Qur'an is similar to contemporary Iranian production (see Part Two). Thus the outer frame of rules (*kamand*) around each opening has small cartouches in the upper corners, formed usually of an arabesque motif in gold. The right-hand cartouche contains the number of the part (*juz'*), and the left-hand cartouche, the name of the surah, both in red, in a form of *naskh* that incorporates occasional features of *riqā'*. Towards the end of the Qur'anic text, where the surahs are short, and several appear on the same page, extra cartouches were supplied. Marginal inscriptions in the same type of red *naskh* record each quarter-*juz'*. Most are set in leaf- or *butah*-shaped cartouches (these also surround the catchwords), and all are accompanied by a marginal ornament similar to those in late Mughal Qur'ans – a small lobed medallion in gold and blue with long 'finials' set with triple pendants. Other marginalia, such as the blue letters *'ayn* marking *rukū's* in volumes I–X, are later additions. Surah headings occur in panels that extend the full width of the text area; in panels inserted within a line, between the end of one surah and the beginning of the next; or in two short panels at either end of a line, divided by the last word or words of the previous surah. In all cases the title is written in blue *riqā'* on a gold ground, and the panels are framed by a black band textured with groups of four tiny white dots. In the full-width panels the gold ground is presented in the form of a cartouche flanked by areas of blue and gold illumination.

Each part is bound in mid-blue glazed cloth printed with a Europeanizing design in red. This includes two medallions; one contains the name of the patron as it appears in the colophons but in *tughrā* form, the other, his initials in the Latin alphabet, SHHC. A printed label gives the number of the part and the the first word or words.

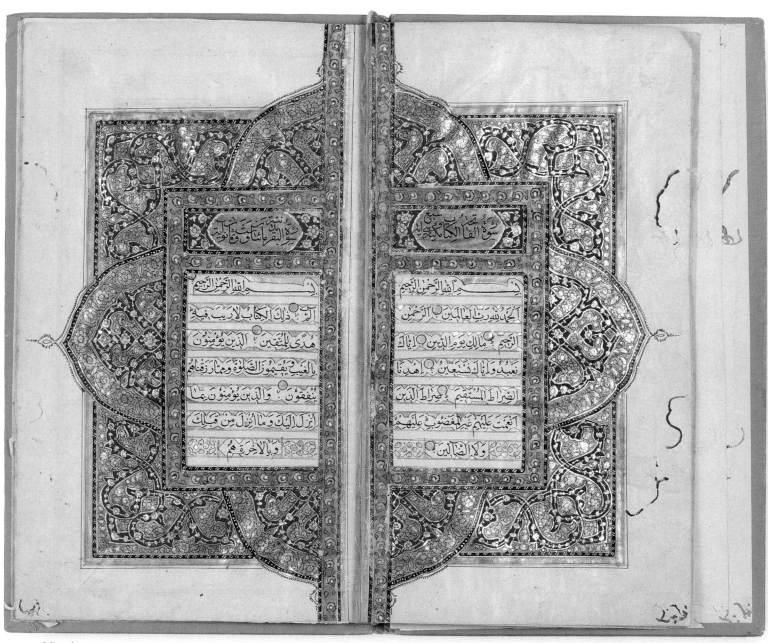

79 part 1, folios 1b–2a

Documentation

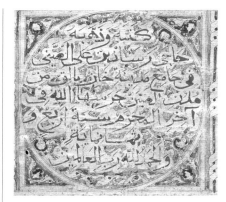

Cat. 1 folio 56b (detail)

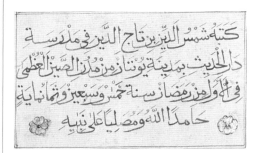

Cat. 2 folio 50a (detail)

Cat. 3 part 30 folio 52b (detail)

Cat. 5 part 30 folio 53a (detail)

Cat. 5 folio 7a (detail)

Cat. 5 folio 8a (detail)

Cat. 5 folio 283b (detail)

Cat. 5 folio 290a (detail)

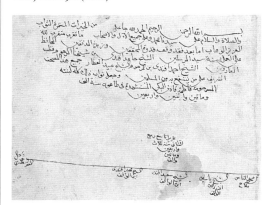

Cat. 13 folio 1a (detail)

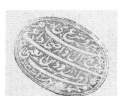

Cat. 13 folio 21a (detail)

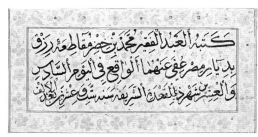

Cat. 13 folio 302b (detail)

Cat. 14 folio 1a (detail)

Cat. 14 folio 207a (detail)

Cat. 16 folio 1a (detail)

Cat. 16 folio 341a (detail)

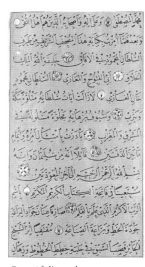

Cat. 16 folio 341b

Cat. 16 folio 342a

Cat. 17 folio 335b (detail)

Cat. 18 folio 348a (detail)

Cat. 19 folio 352a (detail)

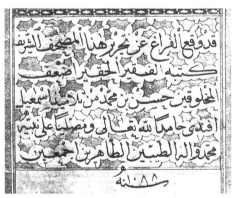

Cat. 20 folio 404b (detail)

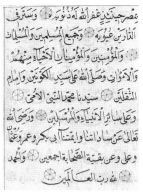

Cat.. 21 folio 515b

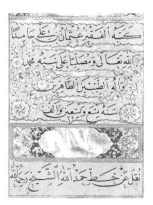

Cat. 22 folio 27a (detail)

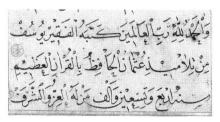

Cat. 23 folio 466a (detail)

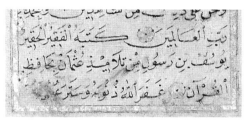

Cat. 24 folio 374a (detail)

Cat. 25 folio 360a (detail)

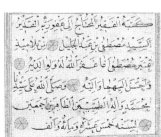

Cat. 26 folio 423a (detail)

Cat. 27 folio 307a (detail)

Cat. 21 folio 515a

Cat. 28 folio 261b (detail)

Cat. 29 folio 427b (detail)

Cat. 30 folio 430b (detail)

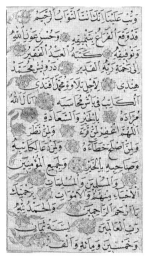

Cat. 31 folio 304b (detail)

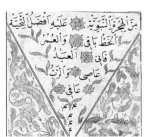

Cat. 31 folio 305a (detail)

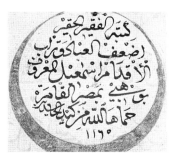

Cat. 32 part 1 folio 23b (detail)

259

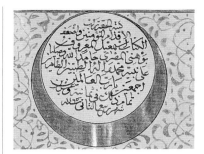

Cat. 32 part 5 folio 23a (detail)

Cat. 32 part 17 folio 23b (detail)

Cat. 32 part 19 folio 24b (detail)

Cat. 32 part 23 folio 25b (detail)

Cat. 32 part 24 folio 23a (detail)

Cat. 32 part 25 folio 25a (detail)

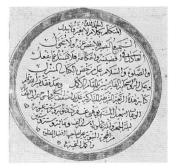

Cat. 32 part 30 folio 31b (detail)

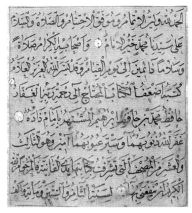

Cat. 33 folio 339a (detail)

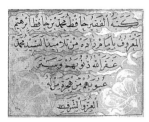

Cat. 34 folio 408a (detail)

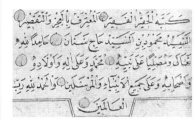

Cat. 35 folio 302a (detail)

Cat. 36 folio 330b (detail)

Cat. 36 folio 331a (detail)

Cat. 37 folio 308a (detail)

Cat. 38 folio 337a (detail)

Cat. 39 folio 307a (detail)

Cat. 40 folio 304a (detail)

Cat. 41 folio 419a (detail)

Cat. 42 folio 286b (detail)

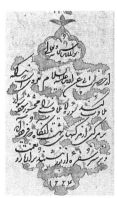

Cat. 42 folio 332b (detail)

Cat. 42 folio 334a (detail)

Cat. 43 folio 426a (detail)

Cat. 43 folio 426b (detail)

Cat. 43 folio 427b

Cat. 44 folio 1a (detail)

Cat. 44 folio 352b (detail)

Cat. 45 folio 1a (detail)

Cat. 45 folio 401a (detail)

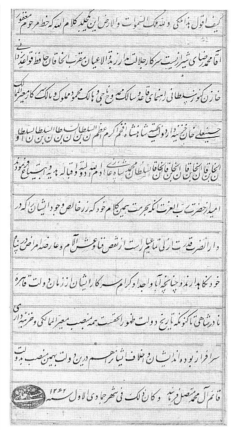

Cat. 45 folio 401b

Cat. 45 folio 403b (detail)

Cat. 46 folio 280b (detail)

Cat. 49 binding (details)

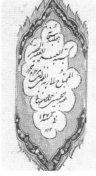

Cat. 50 folio 301a (detail)

Cat. 50 folio 304b (detail)

Cat. 50 commemorative 'coin' found in binding

Cat. 51 folio 312b (detail)

Cat. 52 folio 375a (detail)

Cat. 52 folio 375b (detail)

Cat. 53 folio 341a (detail)

Cat. 54 folio 136a (detail)

Cat. 54 folio 136b

Cat. 55 folio 137b (detail)

Cat. 56 folio 240b (detail)

Cat. 56 folio 241a (detail)

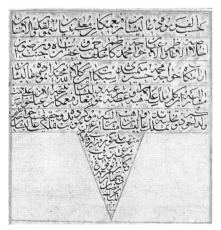

Cat. 56 folio 241b

Cat. 57 folio 72b (detail)

Cat. 58 folio 512a (detail)

Cat. 54 folio 244b (detail)

Cat. 60 folio 1a (detail)

Cat. 60 folio 1a (detail)

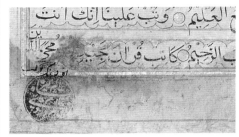

Cat. 60 folio 578a (detail)

Cat. 60 folio 578b (detail)

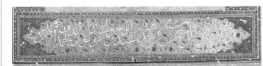

Cat. 61 folio 312a (detail)

Cat. 62 folio 303b (detail)

Cat. 64 folio 24b (detail)

Cat. 66 folio 2a (detail)

Cat 66 folio 18a (detail)

Cat. 67 folio 390a (detail)

Cat. 68 folio 484b (detail)

Cat. 68 folio 485a

Cat. 69 folio 706b (detail)

Cat. 70 volume II folio 597a (detail)

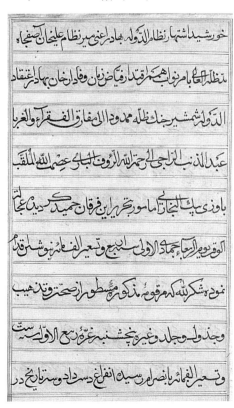

Cat. 70 volume II folio 597b

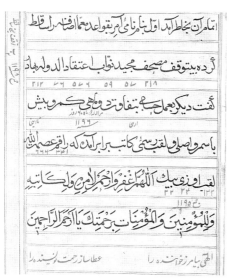

Cat. 70 volume II folio 598a (detail)

Cat. 70 binding of volume II

Cat. 71 folio 161a (detail)

Cat. 72 folio 1a (detail)

Cat. 74 folio 201a (detail)

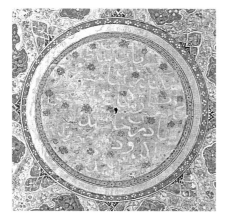

Cat. 77 folio 1a (detail)

Cat 77 folio 951b (detail)

Cat. 78 folio 30b (detail)

Cat. 79 part 30 folio 15a (detail)

Cat.79 part 28 front cover

Concordances

Concordance by catalogue number

cat.1	QUR974	cat.47	QUR244
cat.2	QUR960	cat.48	QUR208
cat.3	QUR992	cat.49	QUR207
cat.4	QUR133	cat.50	QUR55
cat.5	QUR706	cat.51	QUR184
cat.6	QUR110	cat.52	QUR691
cat.7	QUR109	cat.53	QUR246
cat.8	QUR104	cat.54	QUR384
cat.9	QUR149	cat.55	QUR36
cat.10	QUR434	cat.56	QUR258
cat.11	QUR175	cat.57	QUR830
cat.12	QUR265	cat.58	QUR614
cat.13	QUR146	cat.59	QUR91
cat.14	QUR103	cat.60	QUR417
cat.15	QUR46	cat.61	QUR227
cat.16	QUR335	cat.62	QUR833
cat.17	QUR57	cat.63	QUR106
cat.18	QUR93	cat.64	QUR280
cat.19	QUR90	cat.65	QUR326
cat.20	QUR271	cat.66	QUR400
cat.21	QUR112	cat.67	QUR62
cat.22	QUR9	cat.68	QUR216
cat.23	QUR13	cat.69	QUR165
cat.24	QUR102	cat.70	QUR424
cat.25	QUR703	cat.71	QUR70
cat.26	QUR74	cat.72	QUR61
cat.27	QUR10	cat.73	QUR143
cat.28	QUR31	cat.74	QUR363
cat.29	QUR16	cat.75	QUR396
cat.30	QUR38	cat.76	QUR347
cat.31	QUR168	cat.77	QUR354
cat.32	QUR446	cat.78	QUR500
cat.33	QUR15	cat.79	QUR445
cat.34	QUR18		
cat.35	QUR169		
cat.36	QUR76		
cat.37	QUR40		
cat.38	QUR24		
cat.39	QUR8		
cat.40	QUR33		
cat.41	QUR27		
cat.42	QUR54		
cat.43	QUR17		
cat.44	QUR195		
cat.45	QUR301		
cat.46	QUR92		

Concordance by accession number

QUR8	cat.39	QUR208	cat.48
QUR9	cat.22	QUR216	cat.68
QUR10	cat.27	QUR227	cat.61
QUR13	cat.23	QUR244	cat.47
QUR15	cat.33	QUR246	cat.53
QUR16	cat.29	QUR258	cat.56
QUR17	cat.43	QUR265	cat.12
QUR18	cat.34	QUR271	cat.20
QUR24	cat.38	QUR280	cat.64
QUR27	cat.41	QUR301	cat.45
QUR31	cat.28	QUR326	cat.65
QUR33	cat.40	QUR335	cat.16
QUR36	cat.55	QUR347	cat.76
QUR38	cat.30	QUR354	cat.77
QUR40	cat.37	QUR363	cat.74
QUR46	cat.15	QUR384	cat.54
QUR54	cat.42	QUR396	cat.75
QUR55	cat.50	QUR400	cat.66
QUR57	cat.17	QUR417	cat.60
QUR61	cat.72	QUR424	cat.70
QUR62	cat.67	QUR434	cat.10
QUR70	cat.71	QUR445	cat.79
QUR74	cat.26	QUR446	cat.32
QUR76	cat.36	QUR500	cat.78
QUR90	cat.19	QUR614	cat.58
QUR91	cat.59	QUR691	cat.52
QUR92	cat.46	QUR703	cat.25
QUR93	cat.18	QUR706	cat.5
QUR102	cat.24	QUR830	cat.57
QUR103	cat.14	QUR833	cat.62
QUR104	cat.8	QUR960	cat.2
QUR106	cat.63	QUR974	cat.1
QUR109	cat.7	QUR992	cat.3
QUR110	cat.6		
QUR112	cat.21		
QUR133	cat.4		
QUR143	cat.73		
QUR146	cat.13		
QUR149	cat.9		
QUR165	cat.69		
QUR168	cat.31		
QUR169	cat.35		
QUR175	cat.11		
QUR184	cat.51		
QUR195	cat.44		
QUR207	cat.49		

Bibliography

Early sources

'Abd al-Hamid Lahawri, ed. Kabir al-Din Ahmad
& 'Abd al-Rahim
 'Abd al-Ḥamīd Lāhawrī, *Pādshāhnāmah*,
 edited by Mawlavī Kabīr al-Dīn Aḥmad and
 Mawlavī 'Abd al-Raḥīm, two volumes,
 Calcutta, 1866, 1872.

Âlî, ed. Mahmud Kemal
 Muṣṭafā 'Ālī, *Manāqib-i hunarvarān*, edited by
 İbnülemin Mahmud Kemal, Istanbul, 1926.

Âlî, ed. and trans. Tietze
 Muṣṭafā 'Ālī's Counsel for Sultans of 1581,
 edited and translated by A. Tietze, two
 volumes, Vienna, 1979, 1982.

al-Jabarti
 'Abd al-Raḥmān al-Jabartī, *Ta'rīkh 'ajā'ib
 al-āthār fīl-tarājim wa-l-akhbār*, I, Beirut,
 no date.

al-Zabidi
 Muḥammad al-Murtaḍā al-Zabīdī, *Ḥikmat
 al-ishrāq ilā kuttāb al-āfāq*, in 'Abd al-Salām
 Hārūn, editor, *Nawādir al-makhṭūṭāt*, v, Cairo,
 1954, pp.50–99.

Azad
 Mir Ghulam 'Ali Azad Bilgrami, *Ma'āthir
 al-kirām*, II, *Sarv-i Āzād*, Hyderabad, 1930.

Gulistanah, ed. Razavi
 Abu'l-Hasan ibn Muḥammad Amīn
 Gulistānah, *Mujmal al-tawārīkh*, edited by
 Mudarris Raḍavī, Tehran, [1320].

Haftqalami, ed. Hidayet Husain
 *The Tadhkira-i-Khushnavīsān of Mawlānā
 Ghulām Muhammad Dihlavī*, edited by
 M. Hidayet Husain, Calcutta, 1910.

Hakkak-zade, ed. Dedeoğlu
 Muṣṭafā Ḥilmī, known as Ḥakkāk-zāde, *Mīzān
 al-khaṭṭ*, edited by A. Dedeoğlu, Istanbul,
 1986.

Ibn Khaldun, trans. Rosenthal
 Ibn Khaldun, *The Muqaddimah. An
 Introduction to History*, translated by F.
 Rosenthal, second edition, three volumes,
 Princeton, NJ, 1967.

I'timad al-Saltanah, *Al-ma'āthir wa-l-āthār*, ed.
Afshar
 Muḥammad Ḥasan Khān I'timād al-Salṭanah,
 Al-ma'āthir wa-l-āthār, edited by Ī. Afshār and
 published as volume I of *Chihil sāl-i tārīkh-i
 Īrān dar dawrah-i pādishāhī-yi Nāṣir al-Dīn
 Shāh*, Tehran, 1363.

I'timad al-Saltanah, *Rūznāmah*, ed. Afshar
 *Rūznāmah-i khāṭirāt-i I'timād al-Salṭanah,
 vazīr-i intibā'āt dar avākhir-i dawrah-i nāṣirī,
 marbūṭ bah sālhā-yi 1292 tā 1313 hijrī qamarī*,
 edited by Ī. Afshār, second edition, Tehran,
 1350.

Mu'ayyir al-Mamalik
 Dūst 'Alī Khān Mu'ayyir al-Mamālik, *Rijāl-i
 'aṣr-i nāṣirī*, Tehran, 1361.

Muhammad Bakhtavar Khan, ed. Alvi
 Muḥammad Bakhtāvar Khān, *Mir'āt al-'ālam*,
 edited by S.S. Alvi, two volumes, Lahore, 1979.

Muhammad Khalil, ed. Iqbal
 Mīrzā Muḥammad Khalīl Mar'ashī Ṣafavī,
 Majma' al-tawārīkh, edited by 'A. Iqbāl,
 Tehran, 1328.

Muhammad Saqi Musta'idd Khan, trans. Sarkar
 Muḥammad Saqi Musta'idd Khan, *Maāsir-i-
 'Ālamgīrī*, translated by Sir J. Sarkar, Calcutta,
 1947.

Müstakim-zade, ed. Mahmud Kemal
 Sulaymān Sa'd al-Dīn ibn Muḥammad Amīn
 ibn Muḥammad Mustaqīm, known as
 Müstaḳīm-zāde, *Tuhfah-i khaṭṭāṭīn*, edited by
 İbnülemin Mahmud Kemal, Istanbul, 1928.

Nasrabadi
 Mīrzā Muḥammad Ṭāhir Naṣrābādī Iṣfahānī,
 Tazkirah-yi Naṣrābādī, Tehran, 1317.

Nefes-zade, ed. Rifat
 Al-Sayyid Ibrāhīm ibn Muṣṭafā ibn Nafas,
 known as Nefes-zāde, *Gulzār-i ṣavāb*, edited
 by Kilisli Muallim Rifat, Istanbul, 1939.

Qani', ed. Rashidi
 Mīr 'Alīsher Qāni' Tattavī, *Maqālāt al-shu'arā'*,
 ed. S.H. Rāshidī, Karachi, 1957.

Qazi Ahmad, trans. Minorsky
 Qāḍī Aḥmad ibn Mīr Munshī al-Ḥusaynī,
 Gulistān-i hunar, translated by V. Minorsky as
 Calligraphers and Painters, Freer Gallery of
 Art, Washington, DC, 1959.

Qutb al-Din Qissah-khwan, ed. Khadiv-Jam
 [H.] Khadīv-Jam, 'Risālah-ī dar tārīkh-i khaṭṭ
 va naqqāshī az Quṭb al-Dīn Muḥammad
 Qiṣṣah-khwān', *Sukhan*, XVII/6–7, 1346,
 pp.666–76.

Shahnavaz Khan, ed. 'Abd al-Rahim & Mirza
Ashraf 'Ali
 Ṣamṣām al-Dawlah Shāhnavāz Khān, *Ma'āthir
 al-umarā'*, edited by Mawlavī 'Abd al-Raḥīm
 and Mawlavī Mīrzā Ashraf 'Alī, three volumes,
 Calcutta, 1888–91.

Suyolcu-zade, ed. Rifat
 Muḥammad Najīb ibn 'Umar, known as
 Suyolcu-zāde, *Dawhat al-kuttāb*, edited by
 Kilisli Muallim Rifat, Istanbul, 1942.

Taşköprülü-zade, ed. Furat
 'Iṣām al-Dīn Abū'l-Khayr Aḥmad ibn
 Muḥammad, known as Taşköprülü-zāde,
 *Al-shaqā'iq al-nu'māniyyah fī 'ulamā'
 al-dawlah al-'uthmāniyyah*, edited by A.S.
 Furat, Istanbul, 1985.

Modern studies

Abbott 1938
 N. Abbott, 'Maghribī Koran Manuscripts of
 the Seventeenth and Eighteenth Centuries',
 *American Journal of Semitic Languages and
 Literatures*, LV, 1938, pp.61–5 and plate.

Adamova & Grek 1976
 A. Adamova and T. Grek, *Miniatyury kash-
 mirskikh rukopisey/Miniatures from
 Kashmirian manuscripts*, Leningrad, 1976.

Algar 1977
 H. Algar, 'Shi'ism in Iran in the Eighteenth
 Century', *Studies in Eighteenth Century
 Islamic History*, edited by T. Naff and R.
 Owen, Carbondale and Edwardsville, IL,
 London and Amsterdam, 1977, pp.288–302.

Allen 1979
 J. de V. Allen, 'Siyu in the 18th and 19th
 Centuries', *Transafrica Journal of History*, VIII,
 1979, pp.11–35.

Allen 1981
 —, 'Swahili Book Production', *Kenya Past and
 Present*, no.13, 1981, pp.17–22.

And 1982
 M. And, *Osmanlı Şenliklerinde Türk Sanatları*,
 Ankara, 1982.

Arberry 1967
 A.J. Arberry, *The Koran Illuminated. A hand
 list of the Korans in the Chester Beatty
 Library*, Dublin, 1967.

Ardakani 1368
 *Ta'līqāt-i Ḥusyan Maḥbūbī Ardakānī bar
 Al-ma'āthir wa-l-āthār dar aḥvāl-i rijāl-i
 dawrah va darbār-i nāṣirī*, edited by Ī. Afshār
 and published as volume II of *Chihil sāl-i
 tārīkh-i Īrān dar dawrah-i pādishāhī-yi Nāṣir
 al-Dīn Shāh*, Tehran, 1368.

Atabay 1351
 B. Atabay, *Fihrist-i qur'ānhā-yi khaṭṭī-yi
 Kitābkhānah-i salṭanatī*, Tehran, 1351.

Atabay 1352
 —, *Fihrist-i kutub-i dīnī va mazhabī-yi
 khaṭṭī-yi Kitābkhānah-i salṭanatī*, Tehran, 1352.

Atabay 1353
 —, *Fihrist-i muraqqa'āt-i Kitābkhānah-i
 salṭanatī*, Tehran, 1353.

Atabay 2535
 —, *Fihrist-i dīvānhā-yi khaṭṭī-i Kitābkhānah-i
 salṭanatī*, two volumes, Tehran, 2535.

Atasoy 1992
 N. Atasoy, *Splendors of the Sultans*, edited and
 translated by T. Artan, Memphis, TN, 1992.

Atıl 1980
 E. Atıl, editor, *Turkish Art*, Washington, DC,
 and New York, 1980.

Atıl 1987
 —, *The Age of Süleyman the Magnificent*,
 Washington, DC, and New York, 1987.

Avery 1991
 P. Avery, 'Nādir Shāh and the Afsharid Legacy',
 The Cambridge History of Iran, VII, *From
 Nadir Shah to the Islamic Republic*,
 Cambridge, 1991, pp.3–62.

Bahrami & Bayani 1328
 M. Bahrāmī and M. Bayānī, *Rāhnumā-yi ganjī-*

nah-i Qur'ān dar Mūzah-i Īrān-i bāstān,
two parts bound in one volume, Tehran, 1328.

Bamdad 1347–51
M. Bāmdād, *Sharḥ-i ḥāl-i rijāl-i Īrān dar qarn-i 12, 13, 14 hijrī*, six volumes, Tehran, 1347–51.

Bamzai 1962
P.N.K. Bamzai, *A History of Kashmir. Political, Social, Cultural. From the Earliest Times to the Present Day*, Delhi, 1962.

Bayani 1328
M. Bayānī, *Fihrist-i namāyishgāh-i khuṭūṭ-i khwash-i nastaʿlīq*, National Library, Tehran, 1328.

Bayani 1329
—, *Fihrist-i namūnah-i khuṭūṭ-i khwash-i Kitābkhānah-i shāhanshāhī-yi Īrān kih namāyish gudhāshtah shudah ast*, Tehran, 1329.

Bayani 1345–58
—, *Aḥvāl va āṣār-i khwashnavīsān*, four volumes, Tehran, 1345–58; reprinted in two volumes, Tehran, 1363.

Bayani, no date
—, *Fihrist-i nātamām-i tiʿdādī az kitābhā-yi Kitābkhānah-i salṭanatī*, Tehran, no date.

Begley 1978–9
W.E. Begley, 'Amanat Khan and the calligraphy on the Taj Mahal', *Kunst des Orients*, XII, 1978–9, pp.5–60.

Begley 1983
—, 'Four Mughal Caravanserais Built During the Reigns of Jahangir, and Shah Jahan', *Muqarnas*, I, 1983, pp.173–9.

Begley 1985
—, *Monumental Islamic Calligraphy from India*, 1985.

Berg 1965
C.C. Berg, 'Djāwī', *Encyclopaedia of Islam*, second edition, II, Leiden, 1965, p.497.

Bilgrami 1927
A.S. Bilgrami, *Landmarks of the Deccan*, Hyderabad, 1927.

Binyon, Wilkinson & Gray 1933
L. Binyon, J.V.S. Wilkinson and B. Gray, *Persian Miniature Painting*, London, 1933.

Bivar 1959
A.D.H. Bivar, 'Arabic Documents of Northern Nigeria', *Bulletin of the School of Oriental and African Studies*, XXIII, 1959, pp.324–49.

Bivar 1960
—, 'A Dated Koran from Bornu', *Nigeria Magazine*, no.65, June 1960, pp.199–205.

Bivar 1968
—, 'The Arabic Calligraphy of West Africa', *African Language Review*, VII, 1968, pp.3–15.

Blair 1996
S.S. Blair, 'Yahya al-Sufi', *The Dictionary of Art*, edited by J. Turner, London, 1996, XXXIII, p.482.

Brand & Lowry 1985
M. Brand and G.D. Lowry, *Akbar's India. Art from the Mughal City of Victory*, The Asia Society Galleries, New York, 1985.

Bravmann 1983
R.A. Bravmann, *African Islam*, Smithsonian Institution, Washington, DC, 1983.

Brockett 1987
A. Brockett, 'Aspects of the Physical Transmission of the Qur'ān in 19th-century Sudan. Script, decoration, binding, paper',

Manuscripts of the Middle East, II, 1987, pp.45–67.

Brown 1988
H. Brown, 'Siyu: Town of the Craftsmen. A Swahili cultural centre in the eighteenth and nineteenth centuries', *Azania*, XXIII, 1988, pp.101–13.

Chabbouh 1956
I. Shabbūḥ, 'Sijill qadīm li-Maktabat Jāmiʿ al-Qayrawān', *Majallat Maʿhad al-Makhṭūṭāt al-ʿArabiyyah*, II/2, 1956, pp.339–72.

Chabbouh 1989
Al-makhṭūṭ / Le manuscrit, exhibition catalogue by I. Chabbouh, Bibliothèque Nationale de Tunisie, Tunis, 1989.

Chaghatai 1978
M.A. Chaghatai, 'Khaṭṭ, iv. In Muslim India', *Encyclopaedia of Islam*, second edition, IV, Leiden, 1978, pp.1126–8.

Çığ 1951
K. Çığ, 'Sultan IVüncü Murad'ın bir Kur'anı Kerimine ve bir sözüne 1000'er altun verdiği hattat', *Tarih Dünyası*, III, no.23, 1951, pp.982–3.

Copenhagen 1996
Sultan, Shah and Great Mughal. The History and Culture of the Islamic World, exhibition catalogue, National Museum, Copenhagen, 1996.

De Blois & Stanley, forthcoming
F. de Blois and T. Stanley, *Learning, Poetry and Piety. Manuscripts from the Islamic world*, The Nasser D. Khalili Collection of Islamic Art, VII, London, forthcoming.

Derman 1965
M.U. Derman, 'Edirne Hattatları ve Edirne'nin Yazı San'atımızdaki Yeri', *Edirne. Edirne'nin 600. Fethi Yıldönümü Armağan Kitabı*, Ankara, 1965, pp.311–19.

Derman 1982
—, *Türk Hat Sanatının Şâheserleri*, [Ankara], 1982.

Derman 1992
—, editor, *İslam Kültür Mirâsında Hat San'atı*, IRCICA, Istanbul, 1992.

Déroche 1985
F. Déroche, *Catalogue des manuscrits arabes. Deuxième partie. Manuscrits musulmans, I/2, Les Manuscrits du Coran. Du Maghreb à l'Insulinde*, Bibliothèque Nationale, Paris, 1985.

Déroche 1992
—, *The Abbasid Tradition. Qur'ans of the 8th to 10th centuries AD*, The Nasser D. Khalili Collection of Islamic Art, I, London, 1992.

Digby 1975
S. Digby, 'A Qur'an from the East African Coast', *Art and Archaeology Research Papers*, no.7, April 1975, pp.49–55.

Erzini, forthcoming
N. Erzini, 'Ottoman Influence on the Arts of the Book in Morocco During the Saadian Dynasty. Three Manuscripts from the Scriptorium of the Sultan Ahmad al-Mansur adh-Dhahabi', forthcoming.

Falk & Archer 1981
T. Falk and M. Archer, *Indian Miniatures in The India Office Library*, London, 1981.

Falsafi 1371
N. Falsafī, *Zindagānī-i Shāh ʿAbbās-i Avval*, fifth printing, five volumes bound as three, Tehran, 1371.

Faroqhi 1994
S. Faroqhi, 'Crisis and Change, 1590–1699', Part II of *An Economic and Social History of the Ottoman Empire, 1300–1914*, edited by H. İnalcık and D. Quataert, Cambridge, 1994, pp.411–636.

Findley 1989
C.V. Findley, *Ottoman Civil Officialdom. A Social History*, Princeton, NJ, 1989.

Fleischer 1986
C.H. Fleischer, *Bureaucrat and Intellectual in the Ottoman Empire. Mustafa Âli (1541–1600)*, Princeton, NJ, 1986.

Gallup & Arps 1991
Golden Letters. Writing Traditions of Indonesia / Surat Emas. Budaya Tulis di Indonesia, exhibition catalogue by A.T. Gallup and B. Arps, London and Jakarta, 1991.

Geneva 1995
J.M. Rogers, *Empire of the Sultans. Ottoman art from the collection of Nasser D. Khalili*, Musée d'art et d'histoire and the Nour Foundation, Geneva, 1995.

Granada & New York 1992
Al-Andalus. The Art of Islamic Spain, edited by J.D. Dodds, Alhambra, Granada, and Metropolitan Museum of Art, New York, 1992.

Gray 1996
B. Gray, 'Timurid, II. Family members, 7. Baysunghur', *Dictionary of Art*, London, 1996, XXX, pp.921–2.

Gulchin Maʿani 1347
A. Gulchīn Maʿānī, *Rāhnumā-yi ganjīnah-i Qur'ān*, Mashhad, 1347.

Habib 1305
Habib, *Hat ve Hattâtân*, Constantinople, 1305.

Hairi 1986
A. Hairi, 'Madjlisī, Mullā Muḥammad Bāḳir', *Encyclopaedia of Islam*, second edition, V, Leiden, 1986, pp.1086–8.

Heawood 1950
E. Heawood, *Watermarks, mainly of the 17th and 18th centuries*, Monumenta chartæ papyraceæ historiam illustrantia, I, Hilversum, 1950.

Houdas 1886
O. Houdas, 'Essai sur l'écriture maghrébine', *Nouveaux Mélanges orientaux. Mémoires, textes et traductions publiés par les professeurs de l'Ecole spéciale des langues orientales vivantes à l'occasion du septième Congrès international des orientalistes réuni à Vienne (septembre 1886)*, Paris, 1886, pp.85–115.

Huart 1908
C. Huart, *Les Calligraphes et les miniaturistes de l'Orient musulman*, Paris, 1908; reprinted Osnabrück, 1972.

Hyderabad 1954
The Chronology of Modern Hyderabad from 1720 to 1890, Central Record Office, Hyderabad, 1954.

İnal 1955
M.K. İnal, *Son Hattatlar*, Istanbul, 1955.

Israeli 1997
R. Israeli, 'al-Ṣīn, 4. History of Islam in China from ca. A.D. 1050 to the present day', *Encyclopaedia of Islam*, second edition, IX, Leiden, 1997, pp.622–5.

Istanbul 1983
The Anatolian Civilisations, III,

Seljuk/Ottoman, Topkapı Palace Museum, Istanbul, 1983.

Ivanow 1925
W. Ivanow, *Concise Descriptive Catalogue of the Persian Manuscripts in the Curzon Collection, Asiatic Society of Bengal*, Calcutta, 1925.

James 1980
D. James, *Qur'ans and Bindings from the Chester Beatty Library*, London, 1980.

James 1981
—, *Islamic Masterpieces of the Chester Beatty Library*, Leighton House Gallery, London, 1981.

James 1987
—, 'The "Millennial" Album of Muhammad-Quli Qutb Shah', *Islamic Art*, II, 1987, pp.243–54.

James 1988
—, *Qur'āns of the Mamlūks*, London, 1988.

James 1992a
—, *The Master Scribes. Qur'ans of the 10th to 14th centuries AD*, The Nasser D. Khalili Collection of Islamic Art, II, London, 1992.

James 1992b
—, *After Timur. Qur'ans of the 15th and 16th centuries*, The Nasser D. Khalili Collection of Islamic Art, III, London, 1992.

Jeddah 1991
Ma'raḍ al-muṣḥaf al-sharīf/The Holy Quran in manuscript, Bernard Quaritch Ltd, Jeddah, 1991.

Jones 1987
R. Jones, 'Piracy, War, and the Acquisition of Arabic Manuscripts in Renaissance Europe', *Manuscripts of the Middle East*, II, 1987, pp.96–110.

Karatay 1962
F.E. Karatay, *Topkapı Sarayı Müzesi Kütüphanesi. Arapça Yazmalar Kataloğu*, I, *Kur'an, Kur'an ilimleri, Tefsirler*, Istanbul, 1962.

Karimzadeh Tabrizi 1985–91
M.A. Karimzadeh Tabrizi, *Aḥvāl va āsār-i naqqāshān-i qadīm-i Īrān*, three volumes, London, 1985–91.

Kellner-Heinkele 1993
B. Kellner-Heinkele, 'Müstaḳīm-zāde', *Encyclopaedia of Islam*, second edition, VII, Leiden, 1993, p.724.

Khalili, Robinson & Stanley 1996–7
N.D. Khalili, B.W. Robinson and T. Stanley, *Lacquer of the Islamic Lands*, The Nasser D. Khalili Collection of Islamic Art, XXII, two parts, London, 1996–7.

Kühnel 1972
E. Kühnel, *Islamische Schriftkunst*, second edition, Graz, 1972.

Leach 1998
L.Y. Leach, *Paintings from India*, The Nasser D. Khalili Collection of Islamic Art, VIII, London, 1998.

Lentz & Lowry 1989
T.W. Lentz and G.D. Lowry, *Timur and the Princely Vision. Persian Art and Culture in the Fifteenth Century*, Arthur M. Sackler Gallery, Smithsonian Institution, Washington, DC, and the Los Angeles County Museum of Art, 1989.

Leoshko 1989
J. Leoshko, 'Mausoleum for a Princess', Chapter Three of P. Pal and others, *The Romance of the Taj Mahal*, Los Angeles

County Museum of Art, 1989, pp.53–87.

Lewcock 1976
R. Lewcock, 'Architectural Connections Between Africa and Parts of the Indian Ocean Littoral', *Art and Archaeology Research Papers*, no.9, April 1976, pp.13–23.

Lézine 1971
A. Lézine, *Deux villes d'Ifriqiya. Etudes d'archéologie, d'urbanisme, de démographie. Sousse, Tunis*, Paris, 1971.

Lings 1976
M. Lings, *The Qur'anic Art of Calligraphy and Illumination*, London, 1976.

Lings & Safadi 1976
— and Y.H. Safadi, *The Qur'an*, British Library, London, 1976.

Losty 1982
J.P. Losty, *The Arts of the Book in India*, British Library, London, 1982.

Luo 1994
Luo Xiaowei, 'China', in *The Mosque. History, Architectural Development and Regional Diversity*, edited by M. Frishman and H. Khan, London, 1994, pp.208–23.

Maddison & Savage-Smith 1997
F. Maddison and E. Savage-Smith, *Science, Tools and Magic*, Nasser D. Khalili Collection of Islamic Art, XII, two parts, 1997.

Majda 1996
T. Majda, *Sztuka perska okresu kadżarskiego, 1779–1924*, Zamoyski Museum, Kozlowka, 1996.

Mannuni 1969
M. Mannūnī, 'Tārīkh al-muṣḥaf al-sharīf bi-l-Maghrib, 1. Al-wirāqah al-muṣḥafiyyah', *Majallat Ma'had al-makhṭūṭāt al-'arabiyyah*, XV/1, 1969, pp.1–47, and pls 1–6.

Marçais 1960
G. Marçais, 'Ghāniyah, Banū', *Encyclopaedia of Islam*, second edition, II, Leiden, 1965, pp.1007–8.

Mehmed Süreyya 1308– no date
Mehmed Süreyya, *Sicill-i Osmanî, yahud Tezkire-i Meşâhîr-i Osmanî*, three volumes, Istanbul, 1308–11, fourth volume, Istanbul, no date.

Moritz 1905
B. Moritz, editor, *Arabic Palaeography. The Collection of Arabic Texts from the First Century of the Hidjra till the Year 1000*, Publications of the Khedivial Library, XVI, Cairo, 1905.

Muhammad Ashraf 1962
Muhammad Ashraf, *A Catalogue of the Arabic Manuscripts in the Salar Jung Museum & Library*, II, *The Glorious Qur'an, Its Parts and Fragments*, Hyderabad, 1962.

Munich 1982
Das Buch im Orient. Handschriften und kostbare Drucke aus zwei Jahrtausenden, Bayerische Staatsbibliothek, Munich, 1982.

Najafi 1989
S.M.B. Najafi, *Āsār-i īrānī dar Miṣr/Iranische Kunstschätze in Ägypten/Iranian Art Treasures in Egypt*, Cologne, 1989.

Norris 1993
H.T. Norris, 'al-Murābiṭūn, 1. Origins and history in North Africa', *Encyclopaedia of Islam*, second edition, VII, Leiden, 1993, pp.584–6.

Paris 1982
*De Carthage à Kairouan. 2000 ans d'art et

d'histoire en Tunisie*, Musée du Petit Palais, Paris, 1982.

Paris 1987
Splendeur et majesté. Corans de la Bibliothèque Nationale, Institut du Monde Arabe and Bibliothèque Nationale, Paris, 1987.

Paris 1990
De l'Empire romain aux villes impériales. 6000 ans d'art au Maroc, Musée du Petit Palais, Paris, 1990.

Paris 1994
De Bagdad à Ispahan. Manuscrits islamiques de la Filiale de Saint-Pétersbourg de l'Institut d'Etudes orientales, Académie des Sciences de Russie, Musée du Petit Palais, Paris, 1995.

Paris 1995
Itinéraire du Savoir en Tunisie. Les temps forts de l'histoire tunisienne, Institut du Monde Arabe, Paris, 1995.

Parmu 1969
R.K. Parmu, *A History of Muslim Rule in Kashmir, 1320–1819*, Delhi, 1969.

Petrasch and others 1991
E. Petrasch, R. Sänger, E. Zimmermann and H.G. Majer, *Die Karlsruher Türkenbeute*, Munich, 1991.

Pierce 1993
L.P. Pierce, *The Imperial Harem. Women and Sovereignty in the Ottoman Empire*, New York and London, 1993.

Pope 1938–9
A.U. Pope, editor, *A Survey of Persian Art from prehistoric times to the present*, six volumes, Oxford, 1938–9.

Qaddumi 1987
G.H. Qaddumi, *Variety in Unity*, Dar al-Athar al-Islamiyyah, Kuwait, 1987.

Raby 1996
J. Raby, 'The Nayrizi Tradition. *Naskh* in Safavid and Qajar Iran', in Safwat 1996, pp.212–27.

Raby & Tanındı 1993
— and Z. Tanındı, *Turkish Bookbinding in the 15th Century. The Foundation of an Ottoman Court Style*, edited by T. Stanley, London, 1993.

Rado, no date
Ş. Rado, *Türk Hattatları*, Istanbul, no date.

Rafi'i Mihrabadi 1345
A. Rafī'ī Mihrābādī, *Tārīkh-i khaṭṭ va khaṭṭāṭān*, Tehran, 1345.

Ricard 1933
P. Ricard, 'Reliures marocaines du XIIIe siècle. Notes sur des spécimens d'époque et de traditions almohades', *Hespéris*, XVII, 1933, pp.109–27.

Ricard 1934
—, 'Sur un type de reliure des temps almohades', *Ars Islamica*, I, 1934, pp.74–9.

Richards 1991
J.F. Richards, 'Manṣab and Manṣabdār', *Encylcopaedia of Islam*, second edition, VI, Leiden, 1991, pp.422–3.

Riyadh 1985
The Unity of Islamic Art, Islamic Art Gallery, King Faisal Center for Research and Islamic Studies, Riyadh, 1985.

Roemer 1990
H.R. Roemer, 'Bāysonghor, Ghīāth al-Dīn', *Encyclopaedia Iranica*, IV, London and New York, 1990, pp.6–9.

Rogers & Ward 1988
　　J.M. Rogers and R.M. Ward, *Süleyman the Magnificent*, British Museum, London, 1988.

Roxburgh 1996
　　D.J. Roxburgh, *'Our Works Point to Us'. Album Making, Collecting, and Art (1427–1565) Under the Timurids and Safavids*, Ph.D. dissertation, University of Pennsylvania, 1996.

Rypka 1968
　　J. Rypka, *History of Iranian Literature*, edited by K. Jahn, Dordrecht, 1968.

Safadi 1978
　　Y.H. Safadi, *Islamic Calligraphy*, London, 1978.

Safwat 1996
　　N.F. Safwat, *The Art of Pen. Calligraphy of the 14th to 20th Centuries*, The Nasser D. Khalili Collection of Islamic Art, V, London, 1996.

Sālim 1978
　　A.I. Sālim, 'Kenya', *The Encyclopaedia of Islam*, second edition, IV, Leiden, 1978, pp.885–91.

Serin 1992
　　M. Serin, *Hattat Şeyh Hamdullah. Hayâtı, Talebeleri, Eserleri*, Istanbul, 1992.

Seyller 1997
　　John Seyller, 'The Inspection and Valuation of Manuscripts in the Imperial Mughal Library', *Artibus Asiae*, LVII, 1997, pp.243–349.

Sijelmassi 1987
　　M. Sijelmassi, *Dhakhāʾir makhṭūṭāt al-khizānah al-malikiyyah bi-l-Maghrib. Al-Khizānah al-ḥasaniyyah/Enluminures des manuscrits royaux au Maroc. Bibliothèque al-Hassania*, Paris and Casablanca, 1987.

Simsar 1375
　　M.Ḥ. Simsār, 'Aḥmad-i Nayrīzī', *Dāʾiratuʾl-maʿārif-i buzurg-i islāmī*, VII, Tehran, 1375, pp.100–108.

Smith 1989
　　P. Smith, 'Bahai Faith, IV. The Bahai Communities', *Encyclopaedia Iranica*, III, London and New York, 1989, pp.449–54.

Soucek 1979
　　P.P. Soucek, 'The Arts of Calligraphy', *The Arts of the Book in Central Asia, 14th–16th Centuries*, edited by B. Gray, Paris and London, 1979, pp.7–34.

Soucek 1985
　　— 'Abdallāh Ṣayrafī', *Encyclopaedia Iranica*, I, London, Boston and Henley, 1985, p.203–5.

Soudavar 1992
　　Art of the Persian Courts. Selections from the Art and History Trust Collections, exhibition catalogue by A. Soudavar, New York, 1992.

Stanley 1996
　　T. Stanley, *The Qurʾan and Calligraphy. A selection of fine manuscript material*, Bernard Quaritch Ltd, catalogue no.1213, London, 1996.

Stchoukine and others 1971
　　I. Stchoukine and others, *Verzeichnis der orientalischen Handschriften in Deutschland*, XVI, *Illuminierte islamische Handschriften*, Wiesbaden, 1971.

Stern 1960
　　S.M. Stern, 'Abū Yazīd al-Nukkārī', *Encyclopaedia of Islam*, second edition, I, Leiden, 1960, pp.163–4.

Storey 1927–53
　　C.A. Storey, *Persian Literature. A Bio-bibliographical Survey*, I, *Qurʾānic Literature; History and Biography*, two parts, London, 1927–53.

Stuttgart 1993
　　Die Gärten des Islam, exhibition catalogue edited by H. Forkl, J. Kalter, T. Leisten and M. Pavaloi, Linden-Museum, Stuttgart, 1993.

Tanaka 1996
　　T. Tanaka, 'China, II. Architecture, 4. Religious buildings, (iv) Islamic', *The Dictionary of Art*, VI, London, 1996, pp.676–7.

Tanındı 1990
　　Z. Tanındı, 'Topkapı Sarayı Müzesi Kütüphanesi'nde Ortaçağ İslam Ciltleri', *Topkapı Sarayı Müzesi. Yıllık*, IV, 1990, pp.102–49.

Thackston 1989
　　W.M. Thackston, translator, *A Century of Princes. Sources on Timurid History and Art*, Cambridge, MA, 1989.

Tirmizi 1979
　　S.A.I. Tirmizi, *Edicts from the Mughal Harem*, Delhi, 1979.

Trimingham 1959
　　J.S. Trimingham, *Islam in West Africa*, Oxford, 1959.

Tunis 1986
　　30 Sanah fī khidmat al-turāth/30 Ans au service du patrimoine, exhibition catalogue, Institut National d'Archéologie et d'Art, Tunis, 1986.

Uppsala 1982
　　Koranen, Universitetsbibliothek, Uppsala, 1982.

Uzunçarşılı 1948
　　İ.H. Uzunçarşılı, *Osmanlı Devletinin Merkez ve Bahriye Teşkilâtı*, Ankara, 1948.

Van den Boogert 1989

N. van den Boogert, 'Some Notes on Maghribi Script', *Manuscripts of the Middle East*, IV, 1989, pp.30–43.

Vernoit 1997
　　S. Vernoit, *Occidentalism. Islamic Art in the 19th Century*, The Nasser D. Khalili Collection of Islamic Art, XXIII, London, 1997.

Vienna 1983
　　Die Türken vor Wien. Europa und die Entscheidung an der Donau 1683, Historisches Museum, Vienna, 1983.

Welch 1973
　　A. Welch, *Shah ʿAbbas and the Arts of Isfahan*, Asia House Gallery, New York, and Fogg Art Museum, Harvard University, Cambridge, MA, 1973.

Welch 1985
　　S.C. Welch, *India. Art and Culture, 1300–1900*, Metropolitan Museum of Art, New York, 1985.

Witkam 1989
　　J.J. Witkam, 'Manuscripts & Manuscripts, 6. Qurʾān fragments from Ḍawrān (Yemen)', *Manuscripts of the Middle East*, IV, 1989, pp.155–74.

Yazdani 1921
　　G. Yazdani, 'Inscriptions of the Qutb Shahi Kings in Hyderabad City and Suburbs', *Epigraphia Indo-Moslemica*, 1917–18, Calcutta, 1921, pp.43–56.

Zambaur 1927
　　E. de Zambaur, *Manuel de généalogie et chronologie pour l'histoire de l'Islam*, Hanover, 1927; reprinted Osnabrück, 1976.

Zarcone 1991
　　T. Zarcone, 'Histoire et croyances des derviches turkestanais et indiens à Istanbul', *Anatolia Moderna/Yeni Anadolu*, II, *Derviches et cimetières ottomans*, Paris, 1991, pp.137–200.

Zebrowski 1983
　　M. Zebrowski, *Deccani Painting*, London, 1983.

Żygulski 1989
　　Z. Żygulski, *Sztuka islamu w zbiorach polskich*, Warsaw, 1989.

Index

THE SPLENDORS
OF ARCHAEOLOGY

THE AMERICAN UNIVERSITY IN CAIRO PRESS

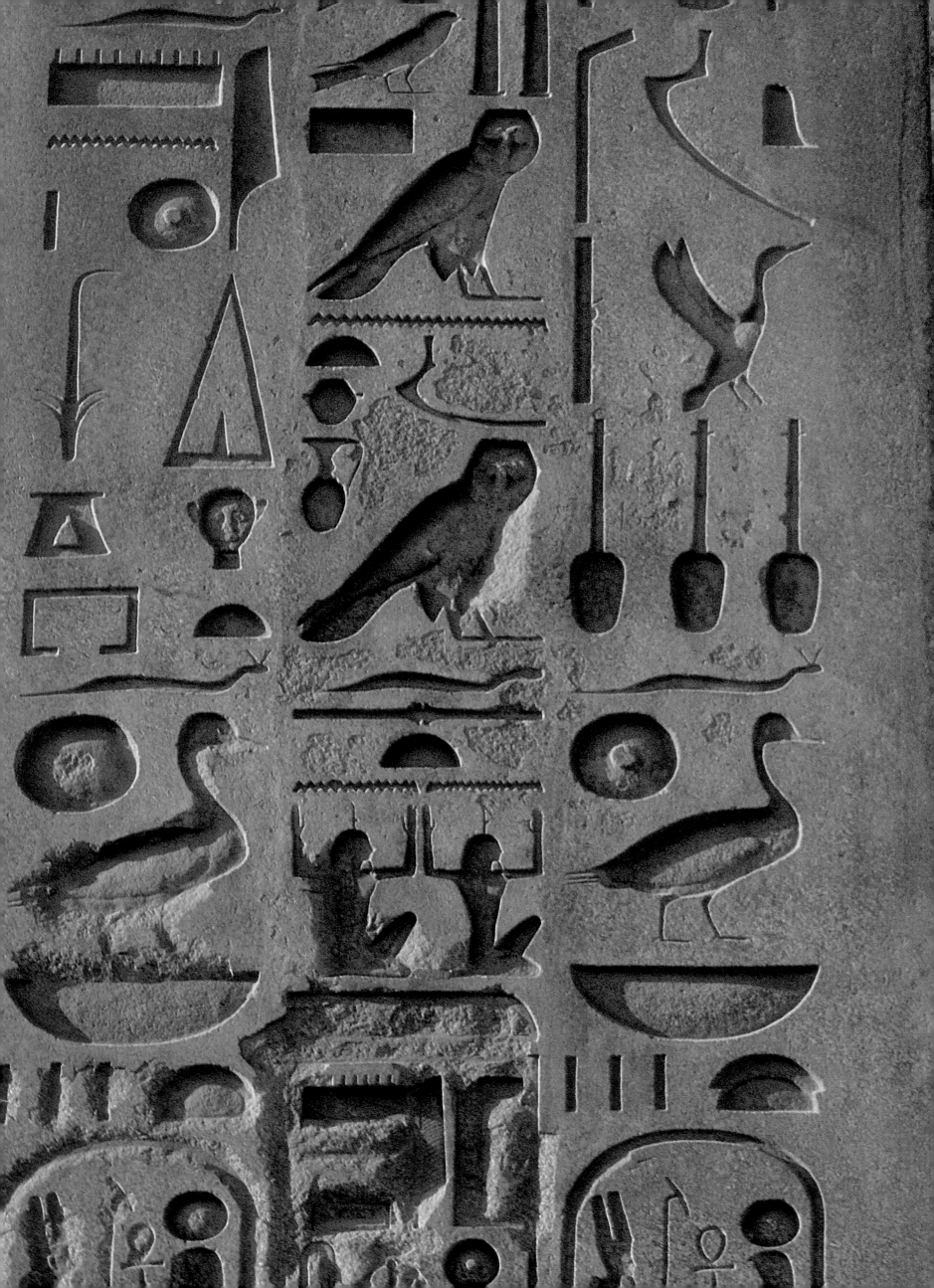

THE SPLENDORS OF ARCHAEOLOGY

Texts
Maria Ausilia Albanese,
Fabio Bourbon,
Guido Massimo Corradi,
Sara Demichelis,
Furio Durando,
Maria Longhena,
Sarah Kochav,
Giuseppina Merchionne,
Desideria Viola,
Francesco Tiradritti

Editors
Fabio Bourbon
Valeria Manferto De Fabianis

English translation editor
Irene Cumming Kleeberg

Translation
C.T.M. Milan

Graphic design
Patrizia Balocco, Anna Galliani,
Paola Piacco, Clara Zanotti

First published in Egypt in 1998 by
The American University in Cairo Press
113 Kasr el Aini Street
Cairo, Egypt

© 1998 White Star S.r.l.

This edition published by arrangement with
White Star S.r.l., Vercelli, Italy

6

CONTENTS

1 The work of Phydia, this slab of Ionian frieze that adorned the cell of the Parthenon, showing Poseidon, Apollo and Artemis seated, is a masterpiece of classical Greek art, of which it may be considered an ideal paradigm.

2-3 Portrayed for eternity in the stone of the temple of Luxor, Ramses II looks solemnly on at the unstoppable passage of time.

4-5 The Colosseum is the most grandiose monument of Ancient Rome, regarded as the symbol of the city itself in the course of the centuries.

6 This splendid bas-relief on the Stupa 1 of Sanchi, linked to a thousand years of Buddhist art, is typical of the elaborate and extremely rich decorative tastes of India.

7 Discovered in 1860 by a group of French botanists, Angkor was the superb capital of the Khmer empire, in the modern Kampuchea, between the 9th and 13th centuries. In the photograph, the ineffable face of the Buddha Avalokitikvara gazes upon the infinite from the height of the northern gate, still locked in the embrace of the vegetation.

INTRODUCTION

How many times have we asked ourselves, "What happened to these people?" How many times, seeing pictures of the past or of archaeological digs, or visiting those excavations ourselves, have we been caught up in the magic and mystery of the past, wanting to know how these people lived, how they thought, what their daily lives were like?

How often while watching a documentary on television, perhaps, or leafing through the pages of a magazine showing, for instance, pictures of Pompeii, have we been suddenly curious about those people, their culture, and wanted to know more? And when we ask ourselves these questions we should go further. We should also ask, "What did they think of their predecessors, what questions did they ask about their own past, these people who are our predecessors, ancestors of we who are living in the here and now?" These questions have been part of mankind's consciousness down through the centuries. The Romans, seeing the pyramids at Giza in Egypt, asked themselves about the pharaohs who had built them. In the same way, the Aztecs, wandering through the immense remains of Teotihuacan, asked themselves what had become of the builders of the deserted metropolis.

We ask and have always asked these questions because when we think of the innumerable generations that have preceded us we are aware that our history, existing as it does only for a brief period of time, makes sense only if we realize that it is not isolated and encapsulated on its own, but rather part of an endless and infinite sequence that has shaped not only the past and the present but will also shape the future.

People soon realized that if they wanted to know themselves well they would have to not only find out what had happened before them but also leave behind evidence of themselves for those destined to follow after. It is for exactly this reason that history has always attempted to clear up the events of the past, always questioning, always asking that question, "What really happened? What is really the truth here?"

Furthermore, history has always seen itself as being responsible not only for finding out the truth behind the events of the past but also understanding to the greatest extent possible the meaning and reasons behind these events. This ongoing research means that even the smallest detail is useful, every piece of evidence is of inestimable value including documents of all kinds whether they be inscriptions, parchments, papyrus or, later, paper. But those are not the only pieces of evidence that are of value.

Also important are monuments, statues, everyday objects, weapons, cooking utensils and even jars. All these things are useful to history in its attempt to produce a more complete picture and to clarify our visions of the part and, in this most difficult of tasks, archaeology is our closest ally.

The meaning of the word archaeology, coming as it does from the Greek, is literally "the science of ancient things". This means that archaeology is the discipline that studies the civilization of the past by seeking out buried evidence.

Archaeology takes fabled cities and the memories of past struggles, victories, conquests, and defeats and removes them from the mists of obscurity and brings them back to our knowledge. But it does more. It also deals with the knowledge of the daily events of people who suffered, rejoiced and loved, just as we do. Archaeology brings to light the more or less grandiose remains of the efforts of these people, their aspirations and beliefs, their opinions on life and death. Archaeology gives back to us the art of the past and helps us understand how that art was produced. Archaeology also reconstructs the battlefields of the past and reveals the weapons used by armies reduced themselves to dust many centuries ago.

Archaeology shows us the boleuterion of Pyrene and reveals how the Greeks ran their political affairs. It rips the towering pyramids of Tikal from the green embrace of the jungle and helps us imagine the religious ceremonies of the Mayans. It rebuilds for us the stupas of Taxila and demonstrates the evolution of Buddhism. If we look at it in just those terms alone, archaeology is far from the boring subject that some people consider it to be.

8 top Both solemn and elegant in appearance, the so-called "Prince of the Lilies" is one of the best-known figures from the great wall friezes that adorn the city-palace of Knossos, the cradle of Minoan civilization.

8 bottom This splendid portrait of a woman decorates the back of a silver mirror found in the House of Manandrus in Pompeii. Some of the most important finds in the Roman world come from that buried city.

It is more than just a heap of stones put back together, or a tedious scattering of shards and fragments, or drawings of the plans of four broken walls. It is the rediscovery, rather, of our very essence as human beings, the heady perfumes of spaces we have never tasted, the passionate discovery of different solutions to the same problems. When we stop thinking of archaeology as a trite jumble of architectural remains, or a succession of glass cases full of uninteresting, precisely catalogued objects, and view it as the magnificent adventure it can be we will find both it and ourselves transformed as we move into a journey through time. Archaeology opens windows on scenes we had never imagined, or surprises us by revealing the precious secrets of the little things of life, of forgotten customs, of gestures repeated down through the ages to our time.

Every day, in some part of the world, archaeologists provide us with the answers to a thousand questions, transforming the past into a living, breathing reality, capable of changing the way we look at our present. Our desire to know how the Romans ate, how they dressed and how they decorated their homes, how they entertained themselves or spent their evenings is not a mere exercise of idle imagination. The attempts to discover how ancient China

8-9 A crossroads of different cultures, Petra was the capital of the Nabatians. In its rock monuments such as the "Convent" shown here the styles of Syrian art can be seen along with those imported from the Greco-Roman world.

9 below Even the great heroes of history had their weaknesses. This colossus of Amenhotep III, in front of the passage leading from the first courtyard to the great colonnade in the temple of Luxor, was usurped by Ramses II.

heated and lighted its buildings is not just an empty gesture.

To find out how the Incas were able to cut immense stone blocks without using metal tools is as concrete and important an activity as learning to use a computer. Studying and answering these questions helps us to understand a little more about ourselves. Finding out that Roman matrons used umbrellas or carried handbags, that Egyptian women used anti-wrinkle creams and dyed their hair is not just an entertaining pastime, but helps us learn that desires and hopes as well as solutions often remain the same throughout time and place and are part of what makes us belong to the group known as homo sapiens. It is impossible to think about our world in the here and now without imagining a past, and we cannot think of the world of the past in any other way than as something similar to our own, with the needs, habits and ways of life which seem to have always been part of being human. Archaeology is, to paraphrase Thucydides, a possession for eternity, as it offers us the keys to universal understanding, with which we can face the future knowing that at any time we might find ourselves meeting

identical or similar realities to those that existed in earlier times. Even more, archaeology is above the ethics, politics and religion, as it expresses no assessments or judgments, but merely states what has existed in time and place. From this enormous ocean of information and data we can distill an understanding that is both true and universal.

Archaeology tells us, in fact, that in different times and places men worshipped different gods in identical ways, fought different wars for the same ideals and built different structures in the same attempt to dominate the elements. It tells us that some civilizations have emerged while others have fallen, that at every latitude men have built bridges to cross rivers, at every longitude they have built roofs to protect themselves and offer shelter to themselves and their descendants. Archaeology tries to answer our initial question "What happened to them?" and provide an answer to the much more difficult "What is going to happen to us?"

It also tells us what mistakes have been made and how often. It is a warning and a source of hope, as it explains that over and over after every defeat there is a rebirth. Overall, archaeology allows us to understand, and this is its great teaching, that beyond religion, language and race man is simply the "naked ape" described by the great English ethnologist Desmond Morris, a monkey who came down from the trees over a million years ago and is still struggling.

As we leaf through the pages of this book, observing temples and fortresses, we will see that everything has been built to respond to the same needs, in the forests of Kampuchea as on the high plains of Peru. The washing facilities in the palace of Masada, on the

Dead Sea, are surprisingly similar to those we use every day. The Etruscans poured out the same wine that delights our palates today while the monks of Borobudur sent the same prayers upward to the heavens as those recited every day by the disciples of the Dalai Lama.

A single book is certainly not enough to explain the wonders of archaeology and, in the broadest sense, the wonder of the ancient civilizations. However, this book, which offers an overall and updated view of archaeological research on the five continents, takes us back to the past in a fascinating way, thanks to the remarkable photographs and drawings and the texts with their brief but comprehensive discussion of the main centers of development of the most important cultures in the world.

The selection of the sites to be included and those to leave out was by no means easy and, inevitably, a subjective one. Considering the non-technical nature of the book, we have given preference to the sites that best represent the various civilizations in terms of their visual appearance.

Fabio Bourbon

10-11 Dancers, saints, princes and courtesans populate the temple of Borobudur, showing how life was lived in Java between the 8th and 9th centuries AD. In archaeology, entire books are often written in stone.

10 top left The enigmatic eyes of one of the colossal statues of Nemrut Dagh in Turkey seems to suggest the many secrets that archaeology still keeps to itself.

10 top right Another mysterious expression, this time found in a jadeite mask found in Xochicalco in Mexico.

10 bottom The moai of Easter Island are perhaps the quintessential example of the mysterious.

12-13 On the plain of Pagan in Burma stand over 2,000 Buddhist temples and monuments, built between 1057 and 1287. Almost hidden by the surrounding vegetation, these form one of the most fascinating and distinctive archaeological panoramas in the world.

14-15 Palenque, which was discovered at the start of the 19th century, was one of the most important Mayan cities. In terms of architecture, it is one of the basic stopping points in the history of this ancient civilization. Some of its monuments have yet to be freed from the jungle.

EUROPE
Introduction

Europe, the ancient mother of western civilization, has a history dating back thousands of years, a history that can only be told through the marvels of the famous archaeological sites that reveal the past which we would otherwise never know. While the well-known places continue to justify their fame, there are other places, less well-known, which almost take us by surprise with their revelations about the history of this area of the world. And these treasures are not only to be found in archaeological sites. Many of the elements of the past can be found, rightly or wrongly, in museums not only in Europe but throughout the world.

Consider this section of this book, then, as an introduction to what can be seen in Europe, what can be learned. For those who are just beginning to view archaeology as an accessible field of knowledge the well-beaten tracks to Carnac and Stonehenge, Mycenae and Athens, Rome and Pompeii can be seen here. And even those who have already visited these sites will find new information about these places. Furthermore, these examples can inspire visits to other destinations, less well known, in the future. Those wishing to go further should consider the Viking fort of Fyrkat in Denmark, the Greek houses of Ampurias in Spain, the remains of the Gallic Masada, the green Alesia in France, or the Roman remains of Aosta and Aquileia, Carsulae and Herdoniae, Piazza Armerina and Venosa, in Italy, the rock-salt mines of the Celts in Hallein and Hallstatt, in Austria, Diocletian's palace in Split, Croatia, or the solitary Kassope in Epyrus. Every discovery is worth the trip.

The history of ancient Europe is full, rich and fascinating. The little known history before Greek and Rome made their civilizations felt is especially interesting.

No one is sure when man first appeared, although some scholars believe that paleontological finds in France and Spain date back to one and one-half or two million years ago. The first humans who definitely lived on the continent are believed to be Homo Erectus who was apparently present in Spain, France, Germany and Italy between 300,000 and a million years ago during the Early Paleolithic Age, an extremely long period of alternating ice and thaw. These early humans lived in small groups of individuals who knew how to make rudimentary stone tools, and ate vegetables and the remains of prey left behind by larger predators. They began to hunt themselves only in the Middle Paleolithic Age (300,000-30,000 years ago), in communities of the most primitive form of Homo Sapiens, also known as Neanderthal Man, in Germany. They organized the production of more advanced and varied stone tools and found out how to butcher their often enormous prey.

It is at this time that we find the first traces of religion.

The gradual stabilization of the climate after this long ice age led to the start of the short but culturally fascinating Late Paleolithic Age (30,000-13,000 years ago) with the appearance of modern man, *Homo sapiens sapiens*, in a large part of the continent and with significant cultural differences from one region to another. Stone tools reached high levels to back up well-organized hunting, fishing and gathering operations. The evolution of the Late Paleolithic cultures is clear in the production of primitive works of art, based on nature and magical themes, with wall paintings in the caves, etchings and sculptures in horn, bone, ivory from mammoths and stone. Here, too, can be seen the development of more complex rituals and customs.

The end of the ice age about 11,000 BC, followed by the emergence of a very favorable climate throughout Europe led to more abundant and accessible resources with the transformation of the Paleolithic cultures into Mesolithic. The introduction of more refined hunting techniques, such as the invention of the bow and arrow, the uses of fire, the production of small flint tools with a great variety of uses combined with the widespread gathering of food in abundance including legumes, land and sea mollusks, freshwater fish and wild berries to change life further. From Portugal to the Volga and Scandinavia to Trentino, the Iron Gates to the Appenines, a number of communities tried out the first forms of semi-sedentary living. The revolution of the Neolithic Age, with the domestication of wild animals and the cultivation of cereals and legumes, herding and settlement, reached Europe from the

16-17 *The Parthenon in Athens, built between 447 and 432 BC, stands as the symbol of the perfection of design and structure achieved by the architects of classical Greece.*

16 left *The pictorial legacy still found on the walls of Pompeii is truly extraordinary, especially when we consider that painting was the most original expression of Roman art.*

17 bottom left *This unusual Sphinx, dating back to the second half of the 6th century BC, stood on a votive column in front of the temple of Apollo in the sanctuary at Delphi.*

17 top right *The famous Mouth of Truth, shown here, dates from the 4th century BC and is kept in the portico of Santa Maria in Cosmedin, Rome. It is actually a cover in the form of a mask.*

Near East in the 7th millennium BC. The first villages of European Neolithic shepherds and farmers date back to 6,800 BC, and were located on Crete and in Thessaly, in Greece. The Neolithic age emerged shortly afterward in the Balkans. Rudimentary building developed in this period to house communities whose economy, for the first time in history, aimed at the production of food surpluses. Archaeological finds point to the development of the culture of the time. Tools made of polished stone and obsidian, an extremely sharp volcanic glass, indicate widespread trade by both land and sea, while pottery shows the need to hold stores of food in the villages, many of which have defensive walls around them of one type or another. Important cultures were scattered throughout Europe in the Early, Middle and late Neolithic Ages. In these we can see the presence of social and economic hierarchies, possible matriarchal descent, developed forms of religion and works of art that indicate the existence of abstract ideas. This period is the period of the first monumental expressions in European architecture. Between the 5th and 3rd millennia BC, and with rare but important examples in the Bronze Age, these appeared in Brittany and the British Isles as well as in the Iberian Peninsula, Scandinavia, Puglia and Sardinia in the form of stunning megalithic complexes which were both sanctuaries and funeral shrines.

A second revolution superimposed itself on that of the Neolithic age with the gradual adoption of copper in Europe in the same areas where the first agricultural and pastoral cultures had sprung up, at times with the appearance of gold and silver. This was the start of the Copper Age which, after a long experimental phase, brought about deep economic and social changes in the communities. The control of the sources of the metal, the techniques and finished products created deep gulfs between those who could make use of metal tools and those who had to continue using stone tools or objects made from bone, horn or wood. From Greece to the Balkans, as far as Central Europe and the Alps, rich in resources, and the Mediterranean shores, two cultural groups emerged, distinguished on the basis of the fossil-guide of pottery. Communities which were involved in transformation activities developed into communities which were able to exchange a wide range of products, from textiles to metal objects. The long period of the Bronze Age also opened in Greece and the Balkans, with the extremely rapid development of new technologies for the forging of objects in metal alloys which were much more resistant than those of pure copper. This period saw the first true population boom in Europe, the first and probably vast migrations of people, and the explosion of trade. This was also the time when types of settlements began to evolve. In the Greece of the 3rd millennium BC, for instance, we can see architecture first beginning to hint at the grandiose designs of the millennium to come. This was also the age of the Europe of Stonehenge in Britain and Tarxien in Malta, of the last, enormous megaliths, of myriad cultures that meet and at times clash, especially at the end of the 3rd and the start of the 2nd millennium BC as the cultures travel throughout the continent by land, following the paths beaten out by herds of animals, and sea.

The 2nd millennium, during which copper metallurgy spread throughout the continent, saw the first stage in the migration of Indo-European people, a migration which continued for several centuries. Here we see the definition of cultural types that we can often recognize as the predecessors of historic civilizations, such as the proto-Celtic and Mycenean civilizations, and the broadening of the cultures as a result of the interaction of cultures and races. This is also the period when the Mediterranean basin was systematically used as a trading route and the first maritime powers emerged. The Aegean was ahead of the times, with the development of the Cycladic, Minoan and Mycenean civilizations, due to a highly developed economy based on the vast circulation of goods well beyond the limits of the settlements of these people. The introduction of primitive systems of writing in Crete and Mycenae, the spread of trade exchanges and the emergence of a geographical and economic panorama in which east and west are involved are just as important as the flourishing mining cultures of the Alps and central and west Europe, from the Celts of the Hallstatt area to the Sardinians and the various cultural layers of the Bronze Age in the Iberian Peninsula.

The Europe of the historic civilizations emerged from the crisis that marked the end of the millennium. From the 10th-9th centuries BC on, in fact, after a brief but traumatic series of events, the characters of the peoples of Europe began to define themselves as Greeks, Etruscans, Romans, Italics, Gauls, Germans, Iberians, Illyrians, Dacians and the ethnic minorities from the east (the Phoenicians and the Carthaginians in the western Mediterranean). This is the history we know best, the history of the dreams of the universal empire, the philosophies and ideologies, the history of Greece and Rome.

Furio Durando

CONTENTS

CHRONOLOGY

Upper Paleolithic
and Mesolithic
(ca. 45,000-6,800 BC)

Rock paintings of Lascaux
(ca. 17,000-16,000 BC)

Rock paintings of Altamira
(ca. 12,000 BC)

Neolithic and the first
spread of copper
(ca. 6800-3500 BC)

First megalithic
alignments at Carnac
(3000 BC)

Protohistory
(ca. 2800-1220 BC)

Formation of the Minoan
civilization
(ca. 2800-2000 BC)

First Minoan city-palaces
(ca. 1700-1450 BC)

Foundation of the
megalithic sanctuary
of Stonehenge
(ca. 1800 BC)

Destruction and
reconstruction of the
Minoan city-palaces
Achaean invasion
of Greece. Flourishing
of Mycenae
(ca. 1700-1450 BC)

Collapse of the Minoan
civilization
(ca. 1450 BC)

Mycenaean domination of
trade in the Mediterranean
(ca. 1450-1250 BC)

Trojan war
(ca. 1250-1220 BC)

Indo-European invasions
and end of the Mycenean
civilization
(1220-1120 BC)

Foundation of the first
urban centers in Greece
(1100-900 BC)

The Etruscans settle within
the boundaries of the
modern Tuscany and
Latium
(ca. 800 BC)

Foundation of Rome
(753 BC)

Royal period in Rome
(753-509 BC)

Foundation of the Olympic
Games
(776 BC)

Foundation of the first
Greek colonies in
southern Italy
(770-708 BC)

First "constitutions"
in Athens and Sparta
(ca. 754-753 BC)

Other Greek colonies
founded in southern Italy
(688-648 BC)

First Etruscan burial
paintings
(600 BC)

Fire at the sanctuary
of Apollo in Delphi
(548 BC)

Banishment of Tarquin the
Proud and foundation
of the Republic in Rome
(509 BC)

Struggles between
Patricians and Plebeians in
Rome
(509-343 BC)

Democratic constitution
in Athens
(508-507 BC)

The "Temple of Neptune"
built in Paestum
(ca. 500 BC)

First revolt against the
Persians in Ionia
(499-494 BC)

The Romans defeat the
Latins in the battle of Lake
Regillus
(496 BC)

The tribunes of the people
created in Rome
(494 BC)

First Persian War
(490 BC)

Second Persian War
Battle of Imera between
Greeks and Carthaginians
(480 BC)

STONEHENGE

CARNAC

LASCAUX

TARQUINIA

ROME HADRIAN'S vVILLA

POMPEII PAESTUM

ATHENS

MYCENAE

KNOSSOS

Second revolt against
the Persians in Ionia
(479 BC)

Establishment of the
Delian-Attic League
(478 BC)

Naval battle of Cuma
between Greeks and
Etruscans
(474 BC)

War of Athens against
Aegina and Corinth
(464-455 BC)

The laws of the 12 Tables
are issued in Rome
(451 BC)

Peace treaty between
Greeks
and Persians
(449 BC)

Hegemony of Pericles in
Athens
(449-429 BC)

Ichtynos, Callicrates and
Phydia rebuild the
Parthenon in the form
we see it today
(448-438 BC)

Peloponnesian War
(431-404 BC)

The temple of Athena Nike
built on the Acropolis
of Athens
(430-410 BC)

Wars between Greeks
and Carthaginians in Sicily
(409-392 BC)

Spartan rule of Greece
(404-379 BC)

Rome destroys the city
of Veii and cancels out the
Etruscan threat
(396 BC)

The Gauls burn Rome
(390 BC)

The plebeians are admitted
to the consulship in Rome
(367 BC)

Greece submits to Philip II
of Macedonia
(356-338 BC)

Philip II makes Macedonia
the first power of Greece
(359-336 BC)

The Romans fight the
Sannite wars
(343-290 BC)

Reign of Alexander III
the Great
(336-323 BC)

Division of the empire
of Alexander the Great
and formation of the
Hellenic kingdoms
(322-281 BC)

The Romans defeat
Pyrrhus
(285 BC)

Macedonian absolute
monarchy in Greece
(276-239 BC)

First Punic War between
Romans and Carthaginians
(264-241 BC)

The Romans occupy
Cisalpine Gaul
(222 BC)

Second Punic War between
Romans and Carthaginians
(218-201 BC)

Rome liberates the Greeks
from Macedonian rule
(200-196 BC)

The Romans establish
the Hispanic provinces
(197 BC)

The Basilica Emilia is built
in the Roman Forum
(179 BC)

Third Punic War and
destruction of Carthage
by Rome
(149-146 BC)

Seige and destruction
of Corinth. Rome reduces
Macedonia and Greece
to provinces
(147-146 BC)

Caius Gracchus
assassinated in Rome
(121 BC)

Rome conquers southern
Gaul
(121-125 BC)

Marius defeats the Teutons
and Cimbers
(102-101 BC)

The Social War rages in
Italy
(91-88 BC)

Dictatorship of Silla in
Rome
(82-78 BC)

Consulship of Pompey
and Crassus
(70 BC)

The plot of Catiline
(63 BC)

First triumvirate
(60 BC)

Caesar conquers Gaul
(58-51 BC)

Start of the Civil War
(49 BC)

Battle of Pharsalus
and death of Pompey
(48 BC)

Caesar defeats the
supporters of Pompey at
Munda
(45 BC)

Assassination of Caesar
(44 BC)

Second triumvirate
(43 BC)

Octavian defeats Antony
in the battle of Actium
(31 BC)

Octavian receives the title
of Augustus
(27 BC)

The Augustan Forum
inaugurated in Rome
(2 AD)

Death of Augustus
(14 AD)

Empire of Tiberius
(14-37)

Empire of Caligula
(37-41)

Empire of Claudius
(41-54)

The Romans occupy
Britannia
(44)

Empire of Nero
(54-68)

Empire of Vespasian
(69-79)

The Colosseum built
in Rome
(75-80)

Empire of Titus
(79-81)

Eruption of Vesuvius and
destruction of Pompeii
(79)

Empire of Trajan
(98-117)

Trajan conquers Dacia
(101-106)

The Trajan Forum
inaugurated in Rome
(112)

Empire of Hadrian
(117-138)

The Pantheon rebuilt
in Rome
(118-128)

Empire of Antoninus Pius
(138-161)

Empire of Marcus Aurelius
(161-180)

Empire of Septimus
Severus
(193-211)

Empire of Caracalla
(211-217)

The baths of Caracalla built
in Rome
(216)

Empire of Alexander Severus
(222-235)

Aurelian rebuilds the walls
of Rome
(271)

Empire of Diocletian
(284-305)

Diocletian sets up
the tetrarchy
(293)

Crisis of the tetrarchy
(306)

Constantine defeats
Massensius in the battle
of Ponte Milvius
(312)

Constantine unites the East
and West
(324)

Constantinople becomes the
capital of the Roman Empire
(330)

Death of Constantine and
division of the empire
(337)

Constance II reunites
the empire
(353-361)

Valens defeated
at Hadrianopolis
(378)

Empire of Theodosius
(379-395)

Alaricus sacks Rome
(410)

Attila comes down into Italy
(452)

Fall of the Western Roman
Empire
(476)

Europe
Europe

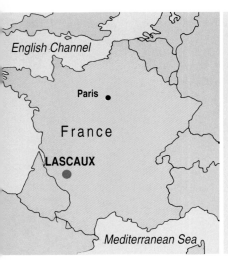

English Channel

Paris •

France

LASCAUX

Mediterranean Sea

LASCAUX
PREHISTORY'S
SISTINE CHAPEL

A Room of
 the Felines
B Nave
C Apse
D Trench
E Passageway
F Axial
 gallery
G Rotunda
H Entrance

20 left In Lascaux the animals figures were drawn with surprising skill and attention to anatomical detail. Note the muzzle of a cow shown here.

20 top center Galloping horses shown on the cave walls all have disproportionate bodies when they are compared to the length of the legs of the horses.

20 bottom center It is believed Paleolithic man performed magical rites to guarantee abundant game. For this reason some experts say they painted the animals they would meet when hunting.

20 top right The cattle painted on the walls of the so-called Hall of the Bulls have truly impressive dimensions. Some examples are as long as 15 feet.

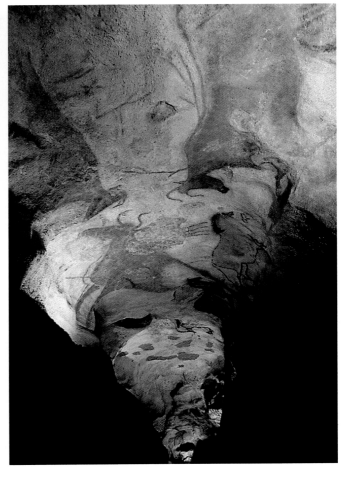

Despite its reputation as an academic discipline archaeology has often proved to be one in which the most spectacular finds have been revealed almost, or actually, by chance. In many cases discoveries which have changed the entire way in which the past is viewed have been made by amateurs. These amateurs can be divided into two groups. There are those who, through an interest in the past, pursued their beliefs and found lost civilizations, and there are those who literally stumbled upon a lost and forgotten site.

The chief of the amateurs who pursued their own theories is undoubtedly Heinrich Schliemann, whose refusal to be discouraged by experts led to the discovery of the location of ancient Troy. There have been many other examples. One of the most astonishing of the accidental examples is that of the caves discovered by four young men from Montignac, near Lascaux, France. On September 8, 1940, these young men, out walking in the forest, came across a deep hole. They made a brief exploration and on September 12 the 17 year old Marcel Ravidat, an apprentice mechanic, returned with three other friends, and went down into a dark hole several feet deep and into a huge natural cavity where he was joined by his friends. Since they only had a box of matches with them they couldn't see very much nor explore very far, so the next day they came back again, this time with an oil lamp.

Using the lamp, they discovered that the main grotto was a room about one hundred feet long, at the end of which there was a natural hallway, narrow but high enough so they could walk in it upright. Here they first discovered a number of designs drawn on its walls in various colors. A few steps further, and by the light of the lamp they made out a number of strange animals of all sizes drawn with some skill.

They realized at once what they had

20-21 Near the figures of many of the painted animals we can see geometric designs which so far defy interpretation. In some cases they may be arrows, in others magical symbols.

21 top The extraordinary wall paintings at Lascaux were produced using charcoal black and a number of colored earths with tremendous skill, reproducing the shades of the animals' coats with outstanding realism.

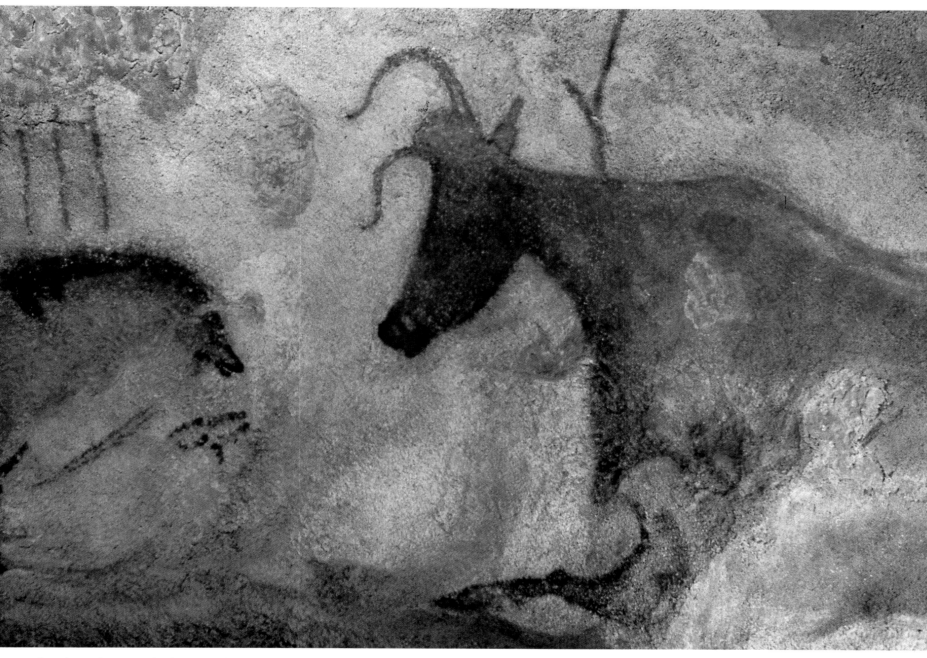

found as other caves had previously been found in the Dordogne area, decorated with wall paintings which had received wide publicity, and they knew they had found caves which had been inhabited by prehistoric men. They explored every angle of the caves, shouting each time they came across a new drawing. It was only when the oil for the lamp grew low that they decided to return to the outside. The next day they returned to the site, each with a good lamp, and continued to make discoveries. At the bottom of what was to become known as The Well, a steep dank

hole which he was determined to explore, Ravidat found a picture of a wounded bison, charging a man with outstretched arms, at the end, while on the right a rhinoceros seemed to be walking away. This is an unusually realistic drawing which is one of the rare scenic drawings in Paleolithic art. Over the days that followed hordes of young people visited the caves until Ravidat was able to convince the schoolmaster, Leon Laval, to visit by showing him sketches of the drawings in the caves.

Laval immediately realized the value of

the discovery and got in touch with Abbot Henri Breuil, one of the great experts of that time on cave drawings who, after inspecting the site, told the academic world, calling the site "The Sistine Chapel of Prehistory."

Four years later, a film was made about Lascaux and following World War II ever-increasing numbers of tourists began to come to visit the caves. By the 1950s it was clear that the presence of thousands of people was leading to the deterioration of the pigments in the drawings. In 1960 a green algae began to spread over the cave

22 top *The wall paintings in Lascaux show several bisons, animals which were once common on the European plains. During archaeological excavations on the floor of the cave remnants of animals, pigments used for paints, and a number of lamps, probably filled with oil or animal fat, were unearthed. With these lamps the people of Lascaux were able to eliminate the darkness of the cave and produce their works.*

walls with devastating effects, an algae which took ten years to remove so the colors could be restored.

The caves were closed to the public in 1963 and later, permanently sealed. Today, visitors can see a replica of the caves, dug out a short distance from the original and painted faithfully to replicate the original. This same solution has also been put into effect at the caves in Altamira in Spain.

Lascaux owes its fame to the extraordinary quality of the paintings which date from the Upper Paleolithic Age, between sixteen and seventeen thousand years ago.

The caves have an overall area of less than one hundred twenty square yards. One of the most interesting features is the uniformity of the paintings which seem to have been executed within a brief period of time by the same group of artists. The so-called round room, nearest the entrance, shows a group of bison, horses and deer, traced with remarkable realism in charcoal and ochre. The side gallery

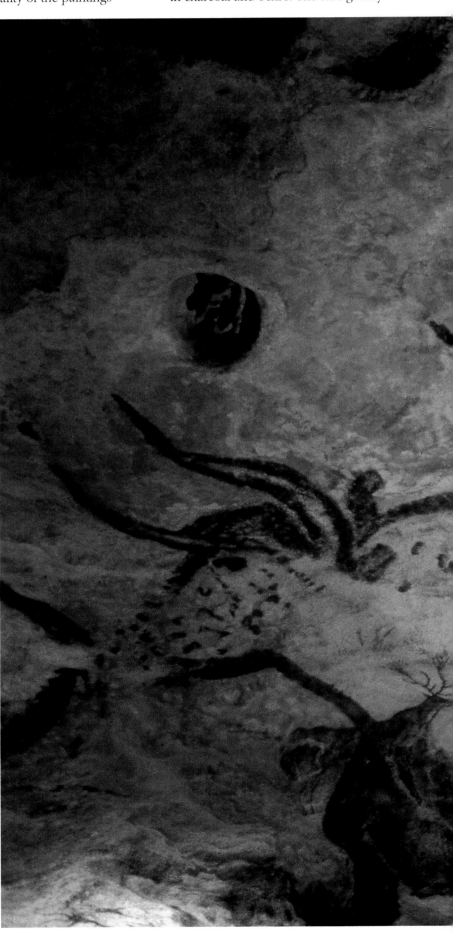

22 center *On one of the walls is a painting in black charcoal which some experts say shows a man with open arms being killed by a bison. The animal has been wounded and its inner organs are spilling out of it.*
Not all scholars agree on this interpretation. Some say it shows a victorious hunter with the prey he has just killed. In any case, the highly realistic scene is unusual in Paleolithic art.

22 bottom *Deer were also shown on the walls of the cave. This splendid one shows an imposing display of antlers.*

22-23 *The extraordinary wall paintings of Lascaux belong to the period of prehistory known as "Magdalenian", from the name of the French area, La Madeleine, where prehistoric art showed considerable development.*

shows deer, horses and cattle, while in the passage and nave we can see, although these pictures are drawn with less accuracy, bulls, cows, ibex and deer. The Room of the Felines has pictures of felines, of course, as well as drawings of countless other animals, including rhinoceroses. The only reindeer drawn at Lascaux is in the area called the apse which is covered with many unfinished drawings. The well we have already described. Throughout the caves, the animal figures are shown together with abstract signs including lines, squares, and rectangles which are not yet interpreted. Some scholars believe that the paintings indicate that Paleolithic man performed magical rites and ritual dances in front of them, including, possibly, sacrifices to the gods, in return for successful results during hunting expeditions.

This would mean that the caves were an ancient center of worship. If this is indeed the case, it is perhaps only fitting that the caves should be once again hidden from curious mankind.

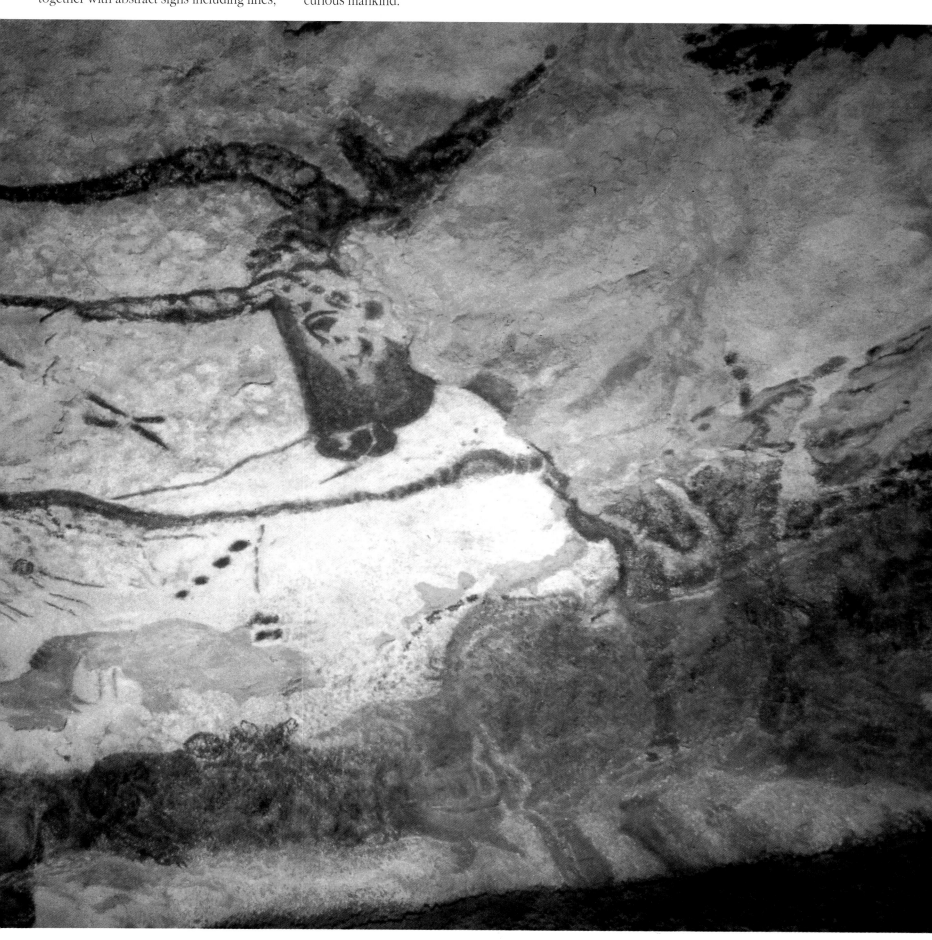

CARNAC, THE MENHIR VILLAGE

During Neolithic times, when man began to use tools made from shaped stones, the so-called megalithic civilization grew and spread outward. Many traces of this civilization remain in the form of burial sites and major monuments formed by enormous stone blocks and slabs with relatively simple decorations.

Most typical of this age are *dolmens* and *menhirs.* Both words are from the Celtic and mean table and standing stone, respectively. The tables are individual or communal tombs, formed by vertical stone columns set in the ground and supporting a huge horizontal slab, while the menhirs are single monoliths, usually elongated and set vertically in the ground. They are usually found in isolated positions or, more rarely, in rows or circles. In that case they are usually referred to as *cromlechs.* These sometimes are connected with burial sites in which case they act as grave markers, but otherwise they are difficult to both interpret and date.

There are also doubts about the meanings of these megalithic stone circles. Some believe they were boundary markers for primitive areas of worship, meeting areas or, as in the case of Stonehenge, astronomical observatories, although these too are generally believed to be linked with religious ceremonies. Throughout Europe there are several hundred monuments of this kind in the British Isles, Scandinavia, France, Spain, Italy and Malta. The most famous is,

probably, England's Stonehenge, described elsewhere in this book, but the most impressive in the world in terms of size is undoubtedly at Carnac, a village on the south coast of Brittany in France.

The main megaliths at Carnac are arranged in three groups known as Menec, Karmario and Kerlescan. There are 1,099 menhirs in 11 rows, with a total length of over 3,000 feet in the first of these sites, 1,029 menhirs in 10 rows with a length of over 3,000 feet in the second, and the third, with 594 menhirs in 13 rows, about 2,700 feet long. There are smaller groups, somewhat damaged, at Petit-Menec, Kerzhero and Sainte'Barbe, and isolated stones throughout the area. At Kermario there is also a dolmen, while the Kerlescan group is closed by a cromlech with 39 elements, still relatively intact. Near Locmariaquer, about 10 miles or so from the main village, is Table des Marchands, an enormous dolmen with traces of sculpture and remains of what is called the "Fairy's Stone", the largest menhir known, originally over 60 feet high. As a comparison, the obelisk in front of the temple of Luxor in Egypt is almost 70 feet high but that was built by Ramses II in the 13th century BC when the great stones at Carnac were already over 1200 years old. These figures speak for themselves. The average weight of the stones is one to two tons, but many are much bulkier. Unfortunately, much of what we see today is only the remains of what must have been an extremely dramatic sight. Many of the monoliths were taken away in past centuries and used as building materials. The Belle-Ile lighthouse, for instance, contains menhirs from Petit-Menec. Down through the centuries there was a great deal of speculation over the methods by which the Carnac menhirs were carried and placed, but a few years ago a group of about 200 volunteers demonstrated with relative ease how a block weighing 32 tons could be moved. If we consider that a menhir 12 feet high weighs between 10 and 12 tons, we should also consider that the number of

laborers used to create these monuments may not have been as large as sometimes imagined.

The tools that seem to have been most necessary for Neolithic man to create these monuments were stout ropes and good quality wood for slides, rollers and levers. By using inclined surfaces, it is theorized that even the most massive menhirs could have been placed in position.

The blocks are either bare of all decoration or only have the most rudimentary designs. The stones are from the area. It is believed that the construction of these complexes must have taken place during periods of the year devoted to major religious gatherings, so that the work was carried out over a number of decades, with the work supervised by priests and experienced foremen who were able to maintain the original goals of the work. Although we believe we now understand how the stones were built, we have yet to understand their meaning. Through the middle of the 19th century the ruins were believed to be of Celtic or Druidical orign and connected with some form of ancestor worship.

A few of these widely circulated ideas include that they were landing places for spaceships, pentagrams with menhirs indicating the symbols, or, indeed, enormous writing yet to be deciphered, setting out the laws of a lost society. Thanks to modern methods of dating, we now know these spectacular megalithic monuments were built around 4500 years ago and it is believed by most scholars that a religious meaning was central.

There are some who have attempted to provide an astronomical significance to this site (as to others, as discussed elsewhere in this book) but the incomplete nature of the rows of stones and the cromlechs that close them at the ends have made it impossible to prove. Perhaps, it has been jokingly suggested, the best answer is the ancient popular legend that the rows of menhirs were built by a powerful group of "little people" who once ruled the Earth before the dawn of civilization.

STONEHENGE, MEGALITHS OF THE GIANTS

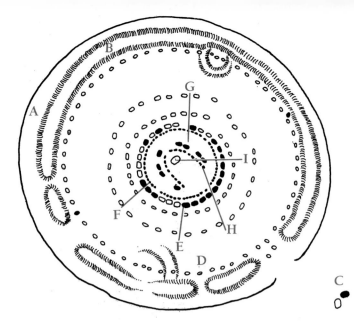

A Ditch
B Earthworks
C Heel stone
D Round holes
E Stone circle
F Blue stone circle
G Triliths
H Blue stones
I Altar stone

The stones still standing are marked in black

26 A tremendous effort was needed to build Stonehenge, especially since when the monument was begun wheeled carts did not exist. The stone blocks were probably taken to the site using sledges hauled by hundreds of people, then put into position using rollers, tree trunks, levers and wooden beamed structures.

Stonehenge, a few miles from Salisbury in the English county of Wiltshire, is a megalithic stone complex that dates back to the period between the Neolithic and the Bronze Ages. Despite its imposing appearance and its fame throughout the world only a limited part of the structure still stands. This consists of a gigantic *cromlech*, the name given to flat stones resting horizontally on upright similar stones, and a number of other monoliths, large single stones. This monument has always fascinated visitors and in the past was actually feared. There remain many doubts as to its origins and purpose and many fantastic explanations have been developed.

The first time that Stonehenge is mentioned is in a history of the kings of Britain which was written by Godfrey of Monmouth around 1136. Unfortunately, his account is both unsatisfactory and improbable as he says it was built by giants in the far distant past in Ireland and subsequently brought to Stonehenge by Merlin, the magician of the King Arthur legend, using his magical powers to move the enormous stone blocks. Godfrey also said the stones had miraculous healing abilities and could cure many illnesses.

This superstition that Stonehenge has healing power is still found in some groups today. In the past, the Church was forced to face the magic of Stonehenge, with Pope Gregory I ordering in 601 AD that this temple of the ancient Britons not be destroyed, but sanctified with holy water.

As time passed, the theory that the stones were the remains of a temple came to be more and more accepted, but no one seemed able to solve the bigger question which was who were the people who built it? One theory, not very logical, was that the construction was Roman and the elementary shapes were deliberately designed, almost as an insult, for the unsophisticated inhabitants of the British Isles. Another theory was that the builders were invaders from Scandinavia, and still others said it was the work of the Druids.

The first scholar who realized its functional importance, if not its origins, was John Smith who worked out its significance as a calendar in 1771, based on a number of fairly elementary astronomical observations. In the middle of the 19th century, as a result of some archaeological discoveries in Greece,

there was tremendous enthusiasm for the theory that the great stone circle had been erected by the Myceneans, who were believed to have the technical knowledge needed to move and put into place such huge blocks of stone. Scholars considered the possibility that it was built by the Greek conquerors while poets and painters, including Lord Byron and John Constable, attracted not so much by the scientific discussions as by the romantic appearance of the ruins in the obscure green Wiltshire fields, were also fascinated by it.

It wasn't until the end of the 19th century that the construction of the megalithic circle was accepted as being the work of ancient native peoples. With the development of modern dating techniques it was possible to reach a conclusion about the age of the monument. Carbon 14 dating showed that the monoliths were raised four or five hundred years before the Mycenean monuments, eliminating that theory. During the 1950s, work carried out by R.J.C. Atkinson demonstrated that the complex had been built over a number of different stages.

Originally it was thought that there had been three distinct phases, but today it is generally believed that there were four. During the first stage, in the second half of the 3rd millennium BC, the site was made up of a circular ditch 110 yards wide, with a mound of earth on either side. The entrance to the sacred circle was marked by two monoliths, while a third, which is still on the site and known as the Heel Stone, was outside the enclosed area. Later, fifty-six holes were dug along the inner edge of the earth mound. There is still controversy over the purpose of these holes although the discovery of remains of bones suggests they may have been cremation sites. During the third stage, which

26-27 The aerial photograph shows the structure of the site. During the summer solstice, the first rays of the sun cross the circle and touch the Heel Stone. During the winter solstice, the rays pass between the two triliths at the end of the inner "horseshoe".

27 top Unfortunately, most of the megaliths that made up this great astronomical observatory disappeared in medieval times, when Stonehenge was used as a type of quarry for building materials.

was between the end of the third millennium and the beginning of the second BC, eighty blue stones, which had been formed by volcanic activity and brought from quarries hundred of miles away, were built in a horseshoe shape in two rows.

The most spectacular stage in the construction of the monument is believed to have taken place in the 16th or 15th century BC when the blue stones were removed and thirty large monoliths made of local sandstone took their place. These were arranged in a circle and united by enormous crossbeams of the same sandstone. Approximately forty blue stones were used to form a second circle within the first, and in the midst of these five huge triliths (two monoliths with a third on top), each over twenty feet high, were raised in a horseshoe formation. The focal point of the structure

was occupied by a single flat stone block, called the altar stone, which was separated from the triliths by another horseshoe of blue stones. The astronomer Fred Hoyle discovered that the entire structure had been built as a kind of instrument for forecasting eclipses. This could possibly have been used to give power to religious leaders who, by showing their ability to predict such exceptional events could achieve both prestige and power. Today, although many of the mysteries of Stonehenge have been revealed, we are still unable to explain how the great monoliths, some of which weighed fifty tons, were moved into their positions, although the work at Carnac in France (see that section in this book) may offer a suggestion. In any case, archaeologists are able to confirm that the men of the period had the technology necessary to perform this task.

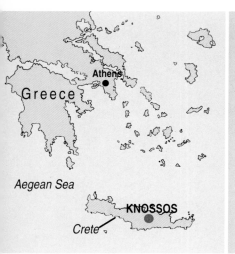

KNOSSOS
AND THE THRONE OF MINOS

28 top This magnificent rhyton, a vase used in religious ceremonies, featuring a bull's head profile with gilded horns, is made of soap stone, hard stone and mother-of-pearl. An exceptional find, it dates back to 1500 BC.

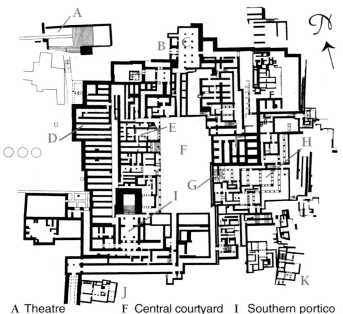

A Theatre
B North entrance
C Colonnaded hall
D Warehouses
E Throne room
F Central courtyard
G Great stairway
H Megaron of the king
I Southern portico
J High priest's house (southern house)
K South eastern house

In the 16th century BC Knossos lay between the northern coast of Crete where today the capital, Heraklion, lies and the hills to the south where the river called Katsabà, known as Kairatos to the ancients, runs. It is believed that at this time the landscape was an orderly one with isolated white houses, small rural villages and large farms. About seven miles from the Aegean, on a gentle, rolling hill, was what is believed to be the most fascinating architectural complex in the western world of the 2nd millennium BC, the enormous "city palace" known as Knossos with nearby residences of aristocrats and rich merchants and a network of paved roads. It is believed that at least eighty thousand, and perhaps as many as one hundred thousand, people inhabited this city with at least ten thousand living in the palace alone.

28 center This view of the residential area of the southern section of Knossos shows us the remains of the restored Southern House. In the center of the image is a decorative motif that recurs in the architecture of the biggest and most famous Minoan city-palace. This is a huge pair of stylized bull's horns, perhaps one of the symbols of power.

28 bottom These large terra-cotta jars, called pithoi, are still in their original place where they were used to store foodstuffs in the palace warehouses.

28-29 The Corridor of Processions started from the western entrance to the city-palace of Knossos and was lined with friezes. Today we can see what these looked like in excellent copies that have been placed on the walls of the restored porticoes.

29 bottom This detail from the group of frescoes along the walls of the Corridor of Processions shows the strong sense of nature, the vibrant colors, and the fine details that are typical of Minoan art.

This city combined agriculture with stone quarrying and metal work of all kinds and also sent forth a large merchant fleet to the rest of the world.

Knossos is known not only through the archaeological research that has been made on its site but also through the Greek mythology in which it plays such a major role. Minos, for instance, the cruel sovereign who forced King Aegus of Athens to pay annual tribute with young lives, Daedalus, inventor of the Labyrinth (the "city palace" itself, some experts believe), Theseus and Ariadne who fought against the Minotaur, the monster of the Labyrinth, are all figures who were based in Knossos.

Crete itself is rich in archaeological sites, but Knossos is the most outstanding of them all. A great deal of the credit for our present knowledge of Knossos should go to a determined Englishman named Arthur J. Evans, who over many decades excavated every site he could find that belonged to the same period in the "city palaces" in other areas of the island, thus establishing a basic record of the splendid flourishing of this important Mediterranean island during the Bronze Age.

In addition, his work supplied the chronological base for the study of the development of Cretan civilization unknown until that point, which Evans himself called "Minoan" after King Minos. Restoration and conservation work began as a result of his discoveries but unfortunately this was carried out in an arbitrary and unscholarly way that is typical, perhaps, of early archaeological work.

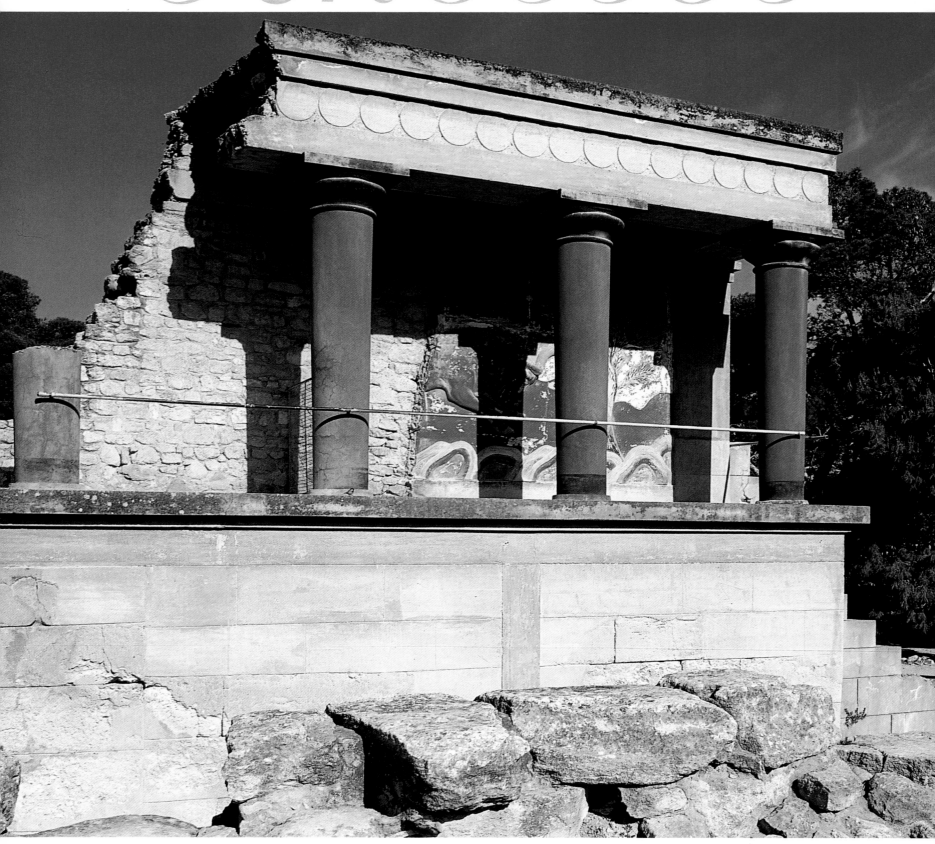

30-31 The remains, carefully restored, of a portico decorated with frescoes from the Neo-Palatial period can be found down from the northern entrance to Knossos.

The shape of the columns, originally made of wood, is typical of Minoa. The downward tapered cylindrical column rested on a low plinth and held up the entablature by a simple swollen ring capital.

The colors used in the restoration are identical to the original ones.

The so-called "city palace" was a structure extending for tens of thousands of square miles with over a thousand rooms and connections running through two, three or four floors, built around a central courtyard as large as a soccer field.

Crete's history began toward the end of the 3rd millennium BC. At this time it became commercially dominant over the flourishing islands of the Cyclades, sailing through the Aegean and eastern Mediterranean seas with a large merchant fleet and carrying its power toward mainland Greece and the Peloponnese as is indicated by several myths.

31 top One of the most famous of
the frescoes that miraculously
escaped the catastrophes that
struck the second city-palaces of
Crete is this fragment showing a
young woman, nick-named "The
Parisian", dating back to the
17th century BC. Note the lively,
natural way in which the
clothing, hairstyle and make-up
are depicted here.

31 bottom This enameled
statuette, found in a votive
deposit in the temple of Knossos
and dated about 1500 BC, is one
of the not unusual impressive
images of the Serpent Goddess or
one of her priestesses. It is believed
this had a divine influence to
generate life and fertility and had
some similarity with the
Mycenean Lady of the Animals.

In this time, it laid the foundation for what was to be recognized even in ancient times as the first "thalassocracy" through its activity as a maritime power that by constant development earned both respect and admiration through the centuries and established trading bonds even with such distant nations as the Egypt of the pharaohs and the Middle Eastern kingdoms.

At the start of the Bronze Age, between 2000 and 1750 BC, the first city-palaces emerged in Mallia, Phaestos and Knossos. These vast royal residences, in which hundreds and sometimes thousands of people lived also had places of worship, administrative areas and space for warehousing and shops belonging to craftsmen and merchants. It is believed that they were an expression of the power and prestige of absolute sovereigns who, some scholars believe, had privileges and power similar to that of the Egyptian pharaohs. It has been suggested that the name Minos actually referred to this type of ruler rather than to an actual individual halfway between history and legend. This suggestion makes a good deal of sense. There are many experts who believe that this kind of ruler provided the drive toward the transformation of Crete, an island that was rich in many resources, into the first true Mediterranean maritime power. The safety under which the Cretans lived and worked appears to have been total, as there is a lack of defensive structures around the palace complexes. It is not so clear as to how Cretan society was stratified.

At a fairly early date, the dominant role of a number of centers on the island was established. These centers went on to divide the control of the territory and to handle the profits from the production and trading operations, based on the exchange of foodstuffs and items made by skilled craftsmen including potters, ebony carvers,

metalworkers and goldsmiths who worked and sold their goods in the shops in the city-palaces. Between 1750 and 1700 BC an early form of hieroglyphic script, which may have been used primarily for religious purposes, was abandoned and replaced by the still undeciphered Linear A script which, one theory goes, may have been used mainly for accounting purposes in the city-palaces. Around 1700 BC, however, for reasons that are not entirely clear although most experts consider a series of catastrophic earthquakes the most likely, the city-palaces were destroyed and then rebuilt in even more extended and luxurious forms.

It is from these later complexes, which mark the beginning of what is called the neo-palatial phase of Middle Minoan III, that the typical features of the city-palaces such as the one in Knossos have been defined. It was at this point that they were ornamented with elaborate porticoed antechambers and corridors with stepped open spaces which are usually viewed as the prototypes for open-air theaters, although it is not clear whether they were meant for religious rites or theatrical performances. At this time we can also see the creation of a variety of residential models, including lesser palaces that were perhaps owned by aristocrats or rich merchants, farm-villas in the country (the finest remaining one is considered to be that of Haghia Triada, near Phaestos), and rural centers that show a demographic

32-33 In the throne room of Knossos we can still see the well-preserved chairs along the walls of this room at right angles to the simple but dignified alabaster throne. The room is at the level of the great central courtyard. Exact copies of the frescoes from the Neo-Palatial period, showing griffins crouching among high stems of flowers, fragments of which were found during the excavations, help reproduce the elegant atmosphere of this room. The dominant color is the red of the background, perfectly suited to the dignified setting.

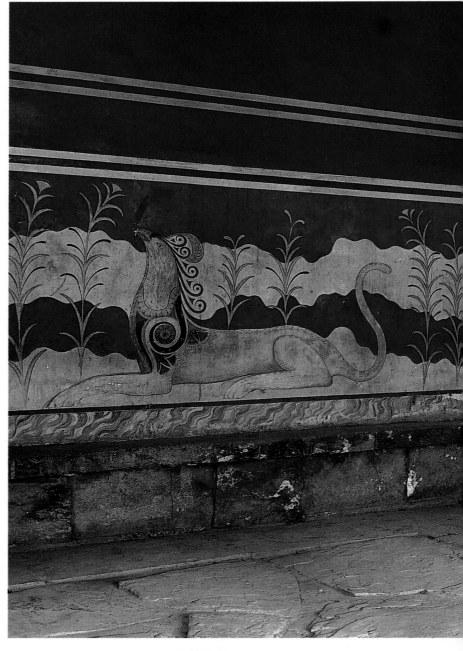

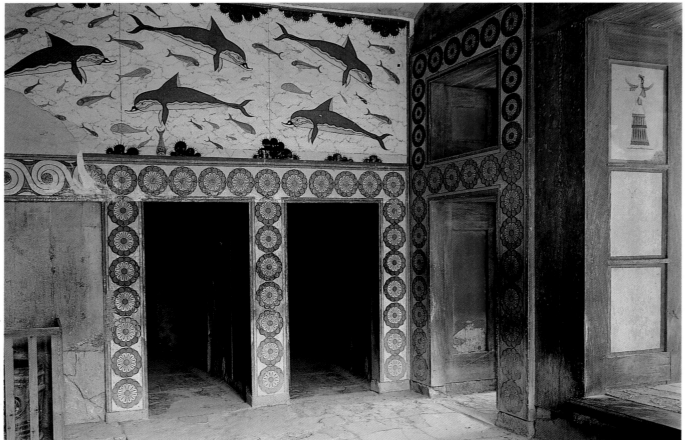

32 bottom This famous fresco showing a school of dolphins and shoals of fish leaping among the waves, together with lively floral friezes, decorates the walls of the Queen's Apartment, a comfortable residential complex with a large private bathroom.

33 top right These frescoes date from the same period as those shown above. The motifs show two-lobed shields in bull's skin and are somewhat reminiscent of the custom of hanging shields and banners from the walls of aristocratic residences.

33 bottom right The different floors of the city-palace at Knossos were connected by broad, monumental stone stairways such as the one in this photograph of the stairway that used to lead from the central courtyard to the level above the nearby throne room.

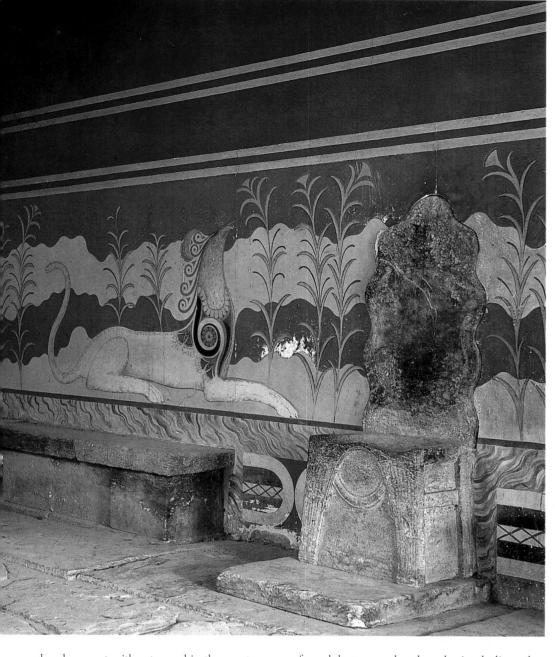

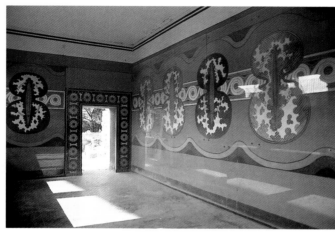

development without equal in the western world of the period.

Dwellings and tombs were often decorated with imported luxury goods, including royal gifts from the East and Egypt. Paved roads, as in Knossos, connected the smaller towns to the city-palaces and complexes of religious or funerary importance.

The Minoan influence extended to the southern Cyclades. In Thira, called Santorini today, the site of Akrotyri contained a flourishing town with houses of up to four floors in height, decorated with frescoes and other signs of wealth all of which were only to be wiped out by a terrible catastrophe. Some time between the first half of the 16th century and the middle of the 15th century BC the active volcano which had formed the island exploded and covered Thira in the way Pompeii was later, burying it in a layer of over fifty yards of ashes. The inhabitants were, apparently, able to abandon the island in time, as up to now no bodies have been

found, but several archaeologists believe that the decline of the Cretan civilization was one of the side effects of this terrible event. In addition to the showers of ash there were earthquakes and tidal waves and a frightening darkening of the skies, similar to what happened on the Caribbean island of Montserrat in 1997, which may have led to significant changes in climate.

It was, therefore, a weakened Crete which was subjected between 1450 and 1400 to the increasing expansion of Mycenae in the Aegean and the invasion which ended the independence of the political entities that centered on the city-palaces. When we study the structure of the palace of Knossos we see a surprising ability to design and plan a colossal complex of over a thousand rooms, built on two, three or four floors, with staircases, porticoed corridors and ramps for carts. The residential structures were built around open courtyards which not only introduced light into them but also provided

good ventilation. There was, in addition, a huge, almost perfectly rectangular courtyard at the center of the entire complex. This indicates a building that was planned from the start and completely unfortified. There was definite logic in the distribution of the functions throughout the various wings of the city-palace. This is illustrated by the position of the warehouses and shops to the west, the extremely formal position of the throne room at courtyard level with the alabaster throne of the sovereign and the benches at the side for councilors still intact today, and the location of what are called the servants' quarters alongside the royal chambers. These royal chambers have bathing facilities which are both efficient and sumptuous.

The restoration work we referred to above includes reproductions of parts of the complex of Knossos in plaster painted in what are believed to be the original colors. In the load bearing structure, these

emphasize the practical and effective combination of stone blocks and shards with a very solid wooden framework supported by widespread use of what is considered the typically Minoan wooden column. This column, which tapers strongly toward the base and is fitted with a low collar-shaped top and stone base, supported airy porticoes and bright open courtyards in the most frequented and spectacular public areas. These were decorated with many magnificent frescoes which are now in the Archaeological Museum of Heraklion. They have been replaced on the original site with faithful copies.

It seems apparent that this was a civilization that delighted in the spectacular as can be seen by the sinuous but not casual routes taken by the corridors. These corridors were apparently used for processions as were the connecting ramps between the floors and wings of the city-palace. These were not only panoramic but also seem to have been designed to break up the compact nature of the architecture by introducing variations in the surrounding landscape, looking both out from and in toward the city-palace. It is here that we see the triumph of the refined architectural decoration of this civilization and the Cretans' great love of bright colors. Here we can walk along the so-called royal road, which is completely paved, from the flat area of the theater's terraces, which are

actually more suited for standing than seated spectators, and a structure called the "royal stage" toward the monumental western gate. Here what is called the Corridor of Processions begins. It is decorated with copies of the frescoes, including the Prince of Lilies, a masterpiece of Minoan painting. Although there are many rooms in the city-palace whose purpose has yet to be defined, there are two which cause no such problems. These complexes face each other. One is a construction that Evans believed was a mortuary chapel, and the other is the

luxurious royal apartment, which has elegant service and accessory areas and is decorated with a number of famous frescoes including the so-called Frieze of the Dolphins. Although it is difficult to actually visit the residential complexes excavated by Evans and his successors, we can see them around the city-palace and they have contributed to scholars' understanding of residential models in the Middle and Recent Minoan Periods as well as when they are viewed in relation to the burial areas of Gypsades, Zafer Papoura, Kephala, Isopata and those near Heraklion.

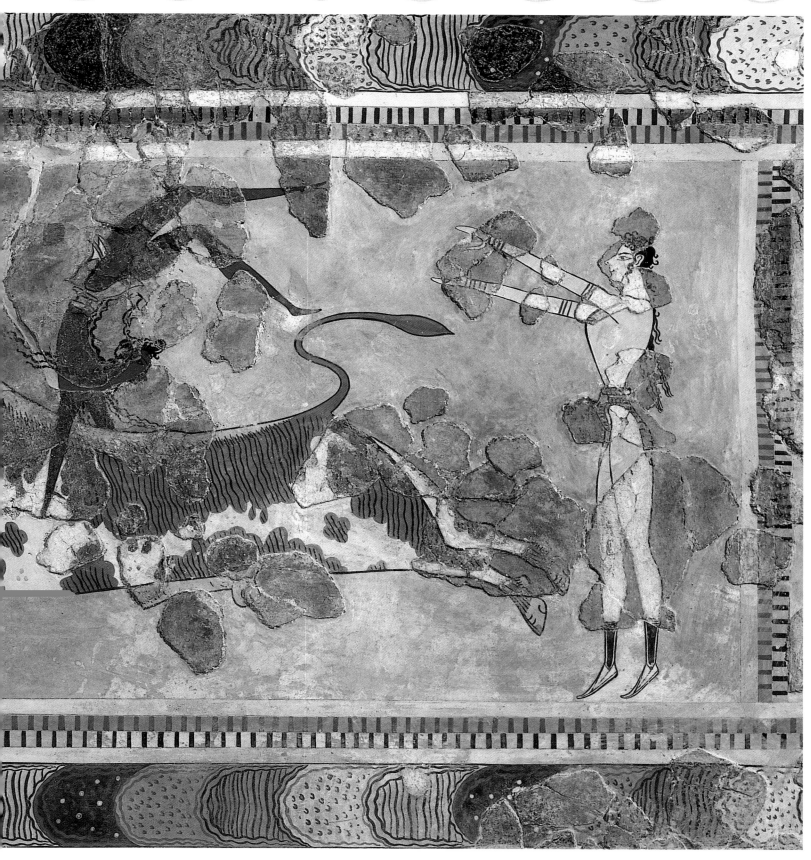

34 bottom The elegant, famous outline of the "Prince of the Lilies" walks in a solemn procession. Originally, this probably showed a sacrificial victim being led by a rope. Minoan artists loved curved lines as is clearly shown in this fresco which is on a stucco plaque and presents the figure in slight relief.

34-35 This is without doubt the most famous fresco in Knossos. It shows a certain sensitivity to three dimensions and is of three young men playing a dangerous game of agility on the back of a powerful bull. The bull's profile has been deliberately exaggerated to further stress the youths' bravery.

35 bottom On the left complex hairstyles and extravagant costumes combine with grace and fascination in these frescoes of two high-caste women from the palace of Knossos. On the right, an admirable naturalism is seen in this figure of a young man walking while carrying a heavy vase in his hands.

MYCENAE
AGAMEMNON'S GOLDEN ROCK

A Gate of the Lions
B Burial circle
C Temple
D Palace of the Atrides
E Megaron
F North gate
G House of columns
H South gate

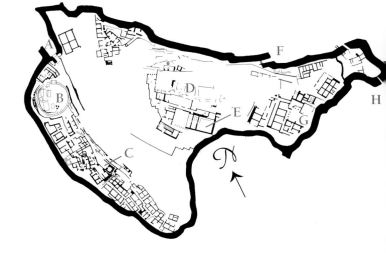

36 left One of the finest examples of Mycenean painting is this fragment showing the so-called "Dame of the Court". It is believed to date from the 13th century BC.

36-37 In this aerial view of the excavation at Mycenae we can clearly see at the top of the arcopolis the huge area occupied by the royal palace of the Atrides.

37 top In this detail from Burial Circle A, we can see the outer corridor and the tombs which were excavated by the amateur archaeologist Heinrich Schliemann in 1876.

The road to Mycenae is marked by an uneven row of eucalyptus trees and citrus groves. As we near Mycenae the walls of the acropolis inside which the Atrides ruled are hard to distinguish from the virgin rock of the hill from which the enormous blocks used to build them were quarried. The walls are dominated by two bare summits of this rock. In August 1876, Heinrich Schliemann, the amateur explorer who was famous for the discovery of Troy and the Mycenean civilization, thrilled to the same sight when he returned to Mycenae to begin his first excavations after his 1868 journey and comments on the excavations of 1874. He followed the route Pausanias, the Spartan general, took toward the middle of the 2nd century. This route was illustrated in his book on Greece which acted as the main guide book and essential reading for the cultured tourists who came to visit the Greek antiquities in the 18th and 19th centuries. Sixty workers in three teams each had brought to light the partially buried, colossal walls, the superb Lions' Gate and the royal tombs. With this work, Mycenae Polychrysos, the "rich in gold" city referred to by Homer began to

37 bottom The long artificial gallery dug out of the northern side of the hill of Mycenae to reach the water reserves of the Spring of Persela is one of the finest examples of Mycenaean architecture between the 14th and 13th centuries BC. It is especially impressive because of its large overlapping stone blocks using the false arch technique. A long series of low stairways drops down for almost 400 feet to the spring, making it impossible to capture the city by cutting off its water supply.

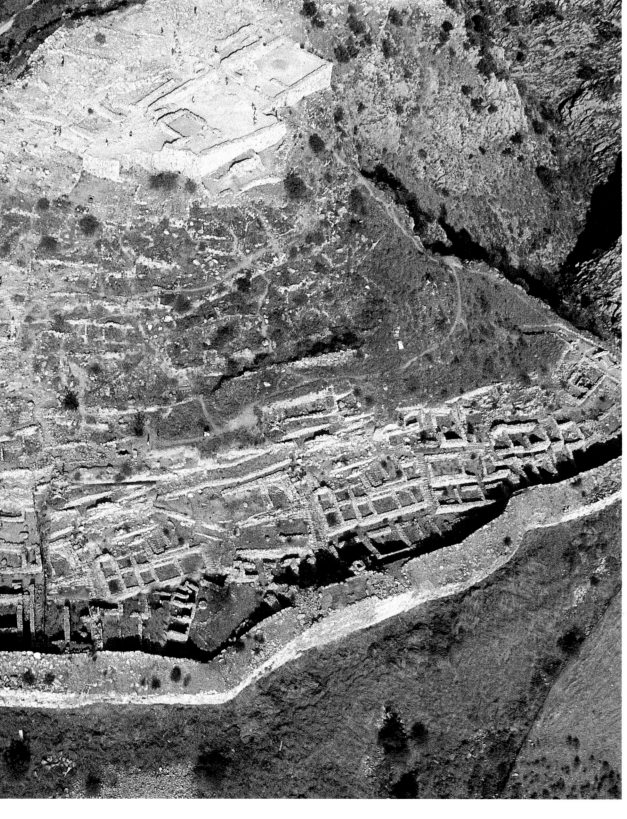

emerge from the past and with the city the records of a people Schliemann called Myceneans. These people were Indo-Europeans who came and settled in Greece between the 20th and 16th centuries BC. They spoke a language very similar to the future Greek dialect which was found on texts drawn on clay tablets and called Linear B. Linear B was a distant archetype of later alphabets. Mycenean civilization flourished from the 16th to the end of the 13th century BC. From the Peloponnese to Phthiotis and Crete as well as in Argolis and Laconia small settlements were founded on natural farm areas near fertile plains or valleys, usually close to good natural harbors. These expanded under the guidance of rulers called Wanakes, who were the top rank of a social hierarchy kept stable through the possession of land and weapons. The key to the widespread and high levels of success of this developing civilization was the combination of an agricultural and pastoral economy with the

38 top left Mycenae's Gate of the Lions takes its name from the huge monolithic block over the crossbeam of the main entrance to the fortified citadel which dates back to the 13th century BC. Two lionesses face each other with their forelegs on the plinth of a Minoan column, symbol of the palace of Atrides.

38 center left The entrance to the greatest Mycenean tholos tomb, known as the Treasure of Atreon, opens up at the end of a long access road bounded by large blocks of stone.

38 bottom left The road leading to the tomb of Egistes is of great interest from a structural point of view. Much of it was dug out from the rocky terrain of the hill.

38 top We can clearly see the Minoan origins of Mycenean painting in this fresco showing a young woman (14th century BC), but the style is less lively than that seen in the energetic art of Crete.

39 An unusual aerial view of the main entrance to Mycenae, with the ramp passing over the Gate of the Lions. To the right we can see Burial Circle A, with the famous tombs excavated by Heinrich Schliemann.

transformation of raw materials, both precious and non-precious, into sought-after finished products including highly refined ceramics and superb gold, silver, and bronze objects. Thanks to an enterprising merchant navy these products were spread from the Iberian Peninsula to the valley of the Po, from central and southern Italy to the coasts of Syria and Palestine and the island of Cyprus, from the Balkans to Egypt and the kingdom of the Hittites. This distribution was, of course, of supreme importance in establishing Mycenae.

In viewing Mycenae the deep ideological, technical, structural and decorative differences between the typical Mycenean "city fortress" and the Minoan "city palaces" can be clearly seen. James G. Frazer, in his book Pausanias and Other Greek Sketches (1900) compared Mycenae to the "gloomy stronghold of some old brigand, a lord of Skye or Lochaber."

It can also be said that there is a similarity between the austere walls and towers of the Mycenean palaces, which are much less extensive than those of the Cretans, and a number of Italian medieval villages which grew up around the castle of a feudal lord. Mycenae owes a great deal of the preservation of its ruins to the crisis and rapid decay that took place in the 12th century BC, during the Doric invasion. Although the acropolis shows signs of continued inhabitation up to 468 BC, the year of destruction by Argos, and there are some modest Hellenic remains, the Doric invasion did not lead to later cities or quarters being built on the area as has happened in so many other ancient cities.

The sturdy triangle of walls surrounding the acropolis was built between the middle of the 14th and the end of the 13th century BC, using almost regular rows of blocks of stone without mortar. The final stage of development also included the so-called Burial Circle A inside the walls. This was an artificial circular platform, reinforced by a high wall made of small stones. This is where Schliemann and the Greek archaeologist Stamatakis found, almost intact, six chambered tombs containing gold, silver and bronze burial treasure and ceramics. Schliemann attributed this treasure to Agamemnon and other figures from the saga of

Mycenae

40 top left This famous goblet in gold plate, attributed by Schliemann to the mythical King Nestor of Pylos, comes from one of the trench graves of Burial Circle A.
It owes its exceptional value more to the precious material from which it is made than to its design, as the techniques used were ones that Mycenean goldsmiths, sculptors and pottery makers were leaving behind at this time.

40 bottom left This golden seal ring from nearby Tyrinthos, showing a procession honoring the goddess of fertility, gives us an idea of the Mycenean goldsmith's art in the 15th century BC.

40 right This superb iron dagger has a blade of gold and silver and a golden handle. It is a typical product of 16th century BC Mycenean art and was found in tomb 5 of Burial Circle A.

the Atrides immortalized by the Oresteia of Aeschylus. Actually, it is now believed that the dating of the tombs should have been much earlier than the presumed reign of Agamemnon, during the period when Mycenae first flourished, in the 16th century BC.
The access route to the city was the same then as that still used today, the Lions' Gate, which was given its name from the relief which was sculpted on the ten foot high triangular block over the entrance. This shows two lionesses, facing each other in heraldic fashion, at the sides of a column whose origins are clearly Minoan.
The secondary access was through the North Gate. Both gates were placed at the end of long narrow passages between the main walls and an outer wall, thereby forcing any aggressors to be exposed to defensive forces on the parapets. A small doorway remains in the north eastern corner of the walls. As in the case of the nearby artificial gallery, which was built to guarantee access to the water supply and the Gate of Perseus even if there were a siege, this doorway is placed much lower down than the acropolis and was created

using the "false arch" technique. Large blocks of stone were placed from a height of six feet upwards with a progressive ledge to the point where the two top parts touched and discharged their counter-thrusts to the underlying elements at each side down to ground level.
The Lions' Gate is a good example of a typical Mycenean technical-structural architectural solution, the so-called "discharge triangle." Above the large gates, whether they had single stone direct bearings or block posts, the architects left an empty triangular space at the segment of the monolithic architrave above the gate opening. The heavy blocks, carved as necessary and placed in a progressive ledge formation, discharged their weight to the ends of the architrave, thus providing the necessary stability to the structure.
The royal palace dominated the residential quarters which were found along the slopes of the acropolis and outside the walls. This was a complex of buildings, partially terraced, built over a primitive citadel from the 17th-15th centuries BC. There are a

number of private and service rooms around the basic Bronze Age residential model. The remains show the horizontal design of this model with its double-columned portico, vestibule and great hall with stucco floor, Minoan style wall frescoes and a large central hearth in the middle of four columns.
Mycenae also offers what are probably the best examples of burial architecture from this civilization. The trench tombs in Circle A are from the 16th century BC. These are underground chambers lined with small blocks or slabs of stone, covered by slabs resting on wooden beams and earth used as

41 The funeral mask of Agamemnon (16th century BC), given the incorrect name by which it is still known today by Schliemann, shows a stylized portrait of an old Mycenean prince, buried in the rich tomb V of Burial Circle A.

a seal. From the 15th century BC onward, the tholoi, or "false cupola," tombs appeared in Mycenae in the form of huge circular chambers beneath a tumulus of earth, which may be based on a Cretan archetype. The most famous of these is the so-called Treasure of Atreum, dated around 1330 BC. A corridor, measuring over 100 feet long and 18 feet wide runs between steep walls made from huge rectangular blocks. The blocks are in even rows leading to the wide façade where there is a gate which is 15 feet high by 10 feet wide. The discharge triangle is above the broad architrave.

From the entrance, we reach the huge circular hall. This is over 90 feet high and has a diameter of 45 feet. Thirty-three rings of blocks which have been shaped and stuccoed take on a perfectly concave shape. They are placed on top a continuous ledge all the way to the top of the structure, where all the thrusts of the system are blocked and discharged downward to the base.
A small burial chamber dug directly from the rock is at the right of the entrance. The inside of the great tholos was probably decorated by bronze wall decorations. Just as interesting, although they are smaller and in

poor condition, are nearby tholoi which some believe may be those of Clytemnestra, Agamemnon's unfaithful wife, and Aegestes. The excavation at Mycenae resulted in the discovery of many treasures from Circle A, including the death masks found by Schliemann on the faces of the bodies buried there, the golden crockery, the jewels and ornate daggers, the fine ceramics that were known to have been exported by the Myceneans throughout the Mediterranean as well as interesting examples of cult and votive objects and fragments of the frescoes that decorated the palace.

ATHENS, *WHERE PERFECTION WAS THE GOAL*

42-43 Symbol of the ancient city and the splendors of the age of Pericles, the acropolis of Athens stands out against the intensely blue sky of Attica, dramatically emphasizing the imposing, elegant profile of the Parthenon, the finest temple of the ancient world, a masterpiece by the architects Callicrates and Ichthynus and the sculptor

Phydia. At the foot of the southern side of the hill is the temple of Herod Atticus and the sanctuary complex of the god Dionysus, with the famous theater where Aeschylus, Sophocles, Euripides, Aristophanes and other great dramatists presented their plays. In the background on the right is the hill of Likavitos, one of the best places from which to view Athens.

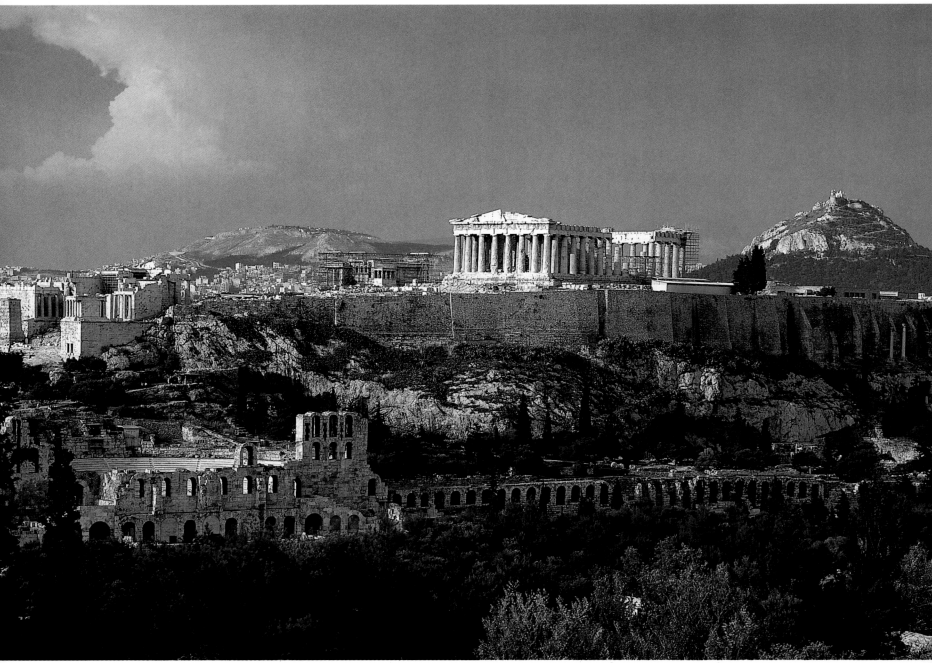

A Acropolis
B Parthenon
C Theatre of Dionysus
D Odeon Hereos Atticus
E Porticoes
F Olympieion
G Pnice
H Efesteion
I Market place
J Stoà of Attalos
K Library of Hadrian
L Roman market place

43 top left This bronze head of a goddess with its sweet expression is typical of Attic art between the end of the 5th and the middle of the 4th century BC. It can be found in the National Archaeological Museum in Athens.

Beneath the very modern sky of Athens, with its atmospheric pollution typical of crowded cities, there remain museums and archaeological sites that have been rescued and continue to display many of the most important remnants we have telling of the history of this symbol of Greece and Greek culture.

The famous Acropolis is almost 500 feet high and surrounded by bare rocks. This space was inhabited from Neolithic times, dedicated to Athena. It was the religious heart of the city from the 10th century BC although almost no trace remains of the Doric temples of Athene Polyades, the "protector of the city", the first of which was built around 565 BC and measured 100 Attic feet long. A few painted statues from the gable still remain. The second of these temples, which had a double row of columns and elegant Ionian proportions, was built under the tyrannical reign of Hypia and Hyparchos. A few of the marble figures from the gable of this temple remain. Following the sack of the Acropolis by the Persians in 480 BC, the ruins of these and other lesser religious buildings and works of art which had given Athens its reputation as a living museum of the faith were buried in the trenches of the so-called Persian Fill. The amazing heritage that had been concealed in this way was found in excavations on the site that took place from 1886-1887.

What we see today is the extraordinary result of the Athenian civilization of the 5th century BC when the city, at the height of its democratic government, devoted its efforts under the leadership of Pericles, who headed the government, to the construction of a society which aimed for a learned perfection of philosophy utilizing mathematics and the sciences which finally synthesized into an artistic creation.

In the period between 449 and 447 BC Pericles continued, in a more elaborate manner, a building project which had been set up during the government of Kymon. He drew up the ideological and material guidelines for this, arranged for the financing

43 top right The great temple of Herod Atticus, built during the reign of Hadrian, rests against the southern slopes of the acropolis in sight of the hill of Pnika and the port of Piraeus.

44 center right The elegant temple of Athena Nike, which dates from around 430-420 BC, is almost intact. It was designed by the architect Callicrates in Ionian style with a front colonnaded plan.

43 bottom The monumental porticoes of the acropolis in Athens, designed by the architect Mnesicles (437-433 BC) are a grand prelude to the dramatic sight of the Parthenon.

44 top This section from the Ionian frieze that adorned the inner section of the Parthenon enables us to see the superb artistic levels reached by the skilled sculptor Phydia. Notice how the impetuous rhythm with which the young horsemen launch themselves into the race or, possibly, parade in honor of Athena has been realistically transferred to the beautiful white marble from the quarries of Mount Pentelis, a few miles from Athens.

44-45 In this impressive view of the Parthenon from the western side we can see its proportional and aesthetic elegance. This side leads to the Ionian colonnaded hall which contained an extremely old cult image of Athena. On the front is shown the myth of Cecrops and the dispute between Poseidon and Athena for the protection of the city.

required and turned the supervision of the site and of many of the plans over to the man considered the greatest artist of the ancient world, the Athenian Phydia. Phydia hired the services of architects, sculptors and leading painters as well as a great number of obscure craftsman. All were equally proud to be considered worthy of belonging to the group of both known and unknown contributors to the masterpieces of the Acropolis.

The Parthenon (built between 447 and 432 BC) and dedicated to Athene Parthenia (parthenia means virgin in Greek), was the work of Callicrates, who had been responsible for the Kymon project, and Ichthynos, who used a good deal of the platform already prepared on the southern side of the Acropolis and the large quantities of architectural materials that were available. The result is a splendid Doric eight-column temple. The measurements are such that each element and space is part of a system producing perfect harmonic proportions. This building not only satisfied the requirements of the religion and enhanced the building as an example of absolute

entrance portico we see the building at an angle which places its profile on the southern side of the hill, toward Piraeus and the sea. There are also several optical adjustments which were made by the designers of this building which cancel the effects of the imperfect view that the human eye can manage. The slightly convex shape of the pedestal avoids the illusion of concavity, while the impression of spatial expansion is eliminated by the special placing of the columns with respect to their axis.

The sculptures in the temple were

beauty but also had a philosophical role as an expression of the understanding of being itself. As an example, in the peristasis, denser and closer to the walls of the inner part of the temple, the ratio between the lower diameter of the column and the interaxis is 4:9 as between the façade and its height up to the horizontal cornice of the gable. Studies have shown that there seems to have been a base module of 10 Attic dactyls (around 23 inches) long. All the proportional ratios between the parts and between the parts and the whole are based on this module. This immense edifice also contained the colossal gold and ivory statue of Athene Parthenia, the work of Phydia, which was in the central section of the temple. Unfortunately, we only know about it from contemporary descriptions and through a number of small scale copies such as the Athene of Varvakion or part models, such as the Medusa Rondanini. The location itself of the Parthenon helps to accent its perfect harmony of measurements and proportions. As soon as we cross the

45 top This fragment from the Ionian frieze of the Parthenon shows the figures of Poseidon, Apollo and Artemis seated on the acropolis, to which the Pan-Athenian festival, honoring Athena, is headed. This is yet another example of the unequaled quality of Phydia's art.

45 bottom An impressive collection of Greek inscriptions from the 6th century BC up to the Roman period was found in the acropolis of Athens. All of these describe public and private monumental building work, administrative deeds and religious acts, although they are often only fragments.

masterpieces made by Phydia and his assistant. On the gables are told the tale of two myths of great importance to the city. These are the birth of Athene from the head of Zeus and the dispute between the goddess and Poseidon over the possession of Attica. Some groups of marble figures remain, showing the very high level both of idealization and freedom in showing human figures which was achieved by Phydia. The square spaces of the Doric frieze of the peristasis, which has been the subject of a great deal of discussion by scholars concerning its proto-classical style and the number of artists who were believed to have worked on it, showed the eternal struggle between good and evil, civilization and barbarism, justice and injustice through myth and epic, including the Killing of the Giant on the east, the Destruction of Troy on the north, the Killing of the Amazons on the west, and the stories of Erechtheus and Theseus (including the Killing of the Centaur) to the south. The long Ionian frieze of the inner part of the temple is a splendid example of the stylistic perfection of Phydia. It describes the Games and the Great Procession of the four yearly Panathenian Festival, when all the aspects of the religion,

46 top From this impressive picture showing the western and southern sides of the Erecteon the complexity of the building is clear. It was built at the northern edge of the acropolis toward the end of the 5th century BC and was mainly dedicated to Poseidon. An olive tree grows today at the same point where one given to the city by Athena was venerated.

46 center The eastern face of the Erecteon stands in full dignity, its six Ionian columns testifying to the skill of Greek architecture. On the right is the northern portico. Legend says that the mark of Poseidon's trident was concealed in the rock.

46 bottom The Caryatids of the lodge on the southern side of the Erecteon wear elegant Ionic clothing. There is something almost casual in the way they stand, forming a harmonic contrast to the grandiose dignity of the nearby Parthenon.

46-47 This spectacular view of the Erecteon from its western side shows how complex this unusual building is. It had at least two floors, and possibly more, with details on them showing religions of various different extremely ancient origins.
The entire scene is united by the Ionian architecture, with its slender columns and the remaining friezes of the entablature.

politics and ideology of the Athenian community were celebrated and enhanced. Between 437 and 433 BC the architect Mnesicles built the Propiles, a monumental entrance to the Acropolis of elegant and dignified proportions. A six-column Doric entrance precedes an extended vestibule which is divided into three aisles by rows of Ionian columns and closed by a wall with five doors, crossed by four low steps and a central ramp for vehicles and animals. On the eastern side is the symmetrical counter-pronaos, an ideal place for viewing the

Phydian bronze statue of Athene Promachus, now lost but known to have been over 20 feet high, and the Parthenon. On the northwestern side of the Propiles we can still see the small porticoed wing that was by the art gallery, well-known for its collection of paintings. The gracious, four-columned marble Ionian temple of Athene Nike, based on an old design by Callicrates which dates back to around 450 BC, was built on the southwestern bastion of the Acropolis to celebrate the ephemeral victories of Athens during the first stages of the Peloponnesian War.

47 bottom This detail of the sixth column from the left of the eastern portico of the Erecteon gives us the chance to admire the fine styling of the Ionian capital in this building.
The scrolls graphically underline the profile and the abacus has a pearl motif, while the top of the stem is adorned with plant decorations.
All these touches enrich the column as an example of the chiseller's art rather than as a load-bearing element.

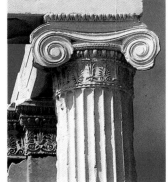

The final building that was built on the Acropolis, known as the Erecteon, was built before 400 on an ancient meeting place which had been used by different and very ancient religions dating back to before Athene was recognized as a multifaceted divinity. This building was apparently designed by Callicrates, Mnesicles or Philocles and, from its T-shaped plan, it appears that it followed ritual demands and ancient models. The six-columned Ionian pronaos on the east is older than the cult religious center part in which the ancient xoanon of Athene Polyades was placed. On the northern side, a high, six-columned Ionian portico was dedicated to one of the prodigies of Poseidon during the dispute with Athene while, on the west, an olive tree donated by the goddess was venerated. At the southern side is the Lodge of the Caryatids, which tradition says is the tomb of the mythical King Cecrops. Watching over the site are six statues of elegantly dressed young women replacing the original ones and an excellent example of a post-Phydian interpretation of a typically Ionian ornamental element, the Caryatid. The famous theater of Dionysus, the protector of the dramatic games of the Great Dionysian festivals, is on the south of the Acropolis.

48 left Two views of the Theseion complex, a six-columned Doric temple dedicated to Ephestus, the Greek god of fire. It was built at the same time as the Parthenon and has elements in common with it. This complex is set in a gently sloping area set back from the marketplace.

48 bottom left There are three hills to the southwest of the acropolis, Mousion, Pnika and Nymphon. One of the most interesting remains of Roman Athens, the monument to Julius Antiochus Philopappus, Roman consul and citizen of Attica is on the first of these three hills. This monument, built between 114 and 116 AD, is an excellent example of the classic style in Hadrian's time.

48 bottom right Near the Roman marketplace is a very well-preserved octagon called the "Tower of the Winds" after the figures on the upper frieze. Actually, it is a large hydraulic clock made by Andronikos Kyistes in the 1st century BC.

48-49 Here are seen the terraces, orchestra pit and stage of the famous theater of Dionysus on the southern slopes of the acropolis, still showing some of its marble covering and sumptuous shapes which date from the time of Alexander the Great. Although this was not the biggest theater in Greece, it was definitely the greatest in terms of the works staged in it.

The visible structures in this sacred enclosure date back to 330 BC but were rebuilt during the Roman period. Here immortal masterpieces of classical Greek theater were performed. The imposing theater of Attic Herod, from the imperial Roman age, is still used for theatrical performances today. Across the hill of Areopagos is the agora, the great market place and the administrative and economic center of the city. Among the remains that can be dated from the days of the tyranny to the late Roman period are the modern reworking of the great portico of Attalos II of Pergamon (2nd century BC), the site of the Museum of the Agora and, almost opposite, the six-column Doric temple of Ephestos, still intact. This is of the same date as the Parthenon and was built in marble by an architect who had obviously carefully

studied the Acropolis, as can be seen by the dimensions and proportional ratios. The building was placed in an area that had housed bronze sculptors and pot makers, and perhaps was built for their use. The area that was occupied by the potters (Kerameikos) is an archaeological area of unusual interest as it is connected to a huge burial area, the Dipylon. Spectacular remains from both the Hellenic and, above all, Roman, periods can be found on the hills to the southwest of the Acropolis (for instance, the monument of Philopappos), in the area of the Roman square with the Tower of the Winds by Andronikos Kyrriste and, to the south of the acropolis, where the emperor Hadrian ordered the completion of the enormous double-columned Corinthian temple of Zeus Olympio.

49 bottom left This chair, set in a prominent position in the theater of Dionysus, was reserved for the priests devoted to this god during events staged during the great Dionysian festivals.

49 bottom right The many works of art that speak of the god Dionysus and his story reveal to us, living today, the importance that this god had in the past. We can still see these works in his theater.

PAESTUM, GODS AND HEROES

A Walls
B Temple of Hera I ("Basilica")
C Temple of Hera II ("Temple of Poseidon the God")
D Underground temple
E Temple of Athena ("Temple of Ceres")

50-51 Although called the Temple of Poseidon the God, this building was actually dedicated to Hera around the middle of the 5th century BC. It is the most elegant sacred building in ancient Poseidonia. Its shape, which is based on Doric styles of architecture, also shows the influence of the proto-classical period.

50 bottom left Ancient Greek painting is reflected in the various figures, some very plain and others quite sophisticated, with which the inhabitants of Paestum decorated the tombs of their dead during the classical period.

50 bottom right This fine aerial photograph shows the perfect alignment, apparently for ritualistic reasons, of the two Temples of Hera in Paestum, the Basilica and the Temple of Poseidon the God. All were built within a century of each other from the middle of the 6th to the middle of the 5th century BC in the Doric style. They are extremely well preserved.

Poseidonia, a sub-colony of Sibari, in what is now southern Italy, was founded on the plain of Sele near the Tyrrhenian Sea in the first half of the 7th century BC. It flourished for over two centuries before falling into the hands of the Lucani. It acquired its better known name, Paestum, in 273 BC, when it became a Roman colony. Today, it is considered by many to be one of the most fascinating archaeological sites of the Greek, Italic and Roman worlds, not only due to its three well-preserved temples but also because of an exceptional fairly recent discovery.

It was on the late afternoon of June 3, 1968, during an archaeological dig carried out by Mario Napoli in the northern necropolis, that the Tomb of the Diver, a work which has become a symbol of Paestum, was brought to light and thereby gave us the oldest known record of Greek mural painting and one of only a very few examples which have survived over the centuries.

Mario Napoli described the discovery with these words. "Right from the start it was clear that the discovery was something exceptional. From the outside, the tomb appeared to be well looked after and we observed that the joints were very precise and adjusted and perfected with stucco work that guaranteed perfect holding. . . The tomb faced in the normal direction, east to west.

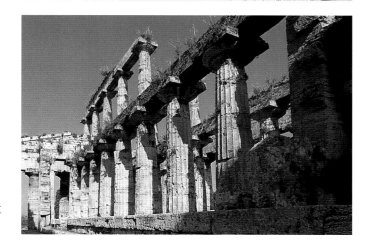

51 top left This magnificent bronze hydria, a masterpiece of Greek metal work dated 510 BC, was found along with other precious works of art in the treasure of the Heroon, a colonnaded sanctuary of a type common in the Greek world and used to venerate heroes from the mythical past of the city.

51 right Another two views of the temple of Hera II (also known as the Temple of Poseidon the God). These give us the chance to notice the vigorous harmony of the structure and the division of the central religious areas into three naves with a double row of columns. A similar plan was used at the end of the 6th century BC in Aegina, on the Gulf of Saronika.

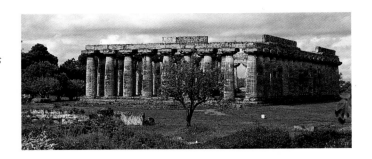

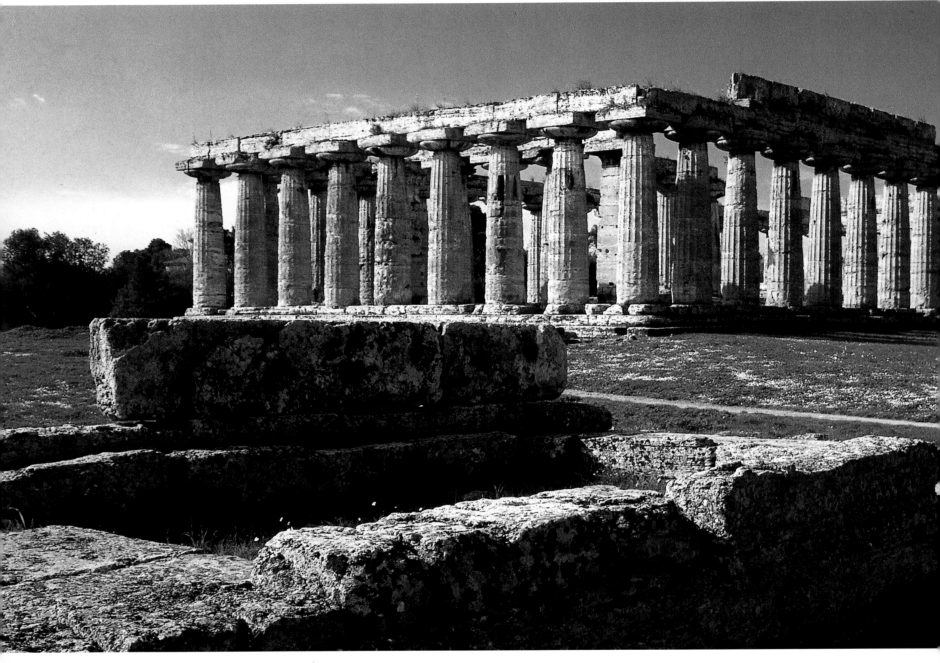

"In the inside, there was no trace of earth and the base was formed by the natural limestone of the area. There was little left of the body and what there was decayed rapidly in contact with the air. The traces left enabled us to note that the head was facing eastward. The paintings were in an excellent state of conservation. . .but we realized in a very rapid succession of sensations and feelings the clearest and most immediate sign of the exceptional nature of the find which was the fact that frescoes had been applied not only to the four sides of the coffin but also to the cover. This was something absolutely new and unprecedented, a most remarkable find. . ."
Analysis of the burial treasure made it possible to date the tomb to around 480 BC

due to the presence of a typical lekythos with Attic palms from that period.
The frescoes, on plaster in which the artist had carved out the original sketch, show a festive aristocratic party on the side walls while the ceiling has the unusual subject of a naked young man diving from what might be a type of trampoline into the water.
The party scene on the longer sides shows ten semi-nude male figures, crowned with fronds and semi-reclining, as was the custom, on klines or divans at low garlanded tables. The short sides show a young servant pouring wine and a flautist guiding two men.
On the northern side the two reclining men on a divan on the right are in a definitely affectionate pose. Their intense

expressions, caressing gestures, and the words they seem to be softly whispering to each other are all part of a simple but nevertheless elegant refinement.
There is a lyre in the hands of the figure on the left which suggests there was a musical background. At the center is another pair of male figures. The guest to the right looks toward the two lovers and seems to be telling them something while he holds up a kylix which is identical to the one with which his companion is throwing wine toward the single figure on the divan to the left.
The unknown artist has shown a moment of the final toast of the banquet in a fresh, realistic manner. In its context the toast celebrates not only the aristocratic tradition of this type of gathering as a tribute to

53 top left The pottery of Paestum shows a variety of refined styles and colors. This splendid amphora by a potter working from 360-330 BC shows the birth of the goddess of beauty from the foam of the sea.

53 top right Statuettes such as this one, from the 5th century BC, represents the cult of Demestra, goddess of the harvest and of fertility. It shows the goddess seated on a throne with a pomegranate in her left hand.

53 center Another spectacular view of the Basilica shows what might be considered the rather inharmonious relationship between the different parts of the building. Excessive length, solid columns, heavy undecorated Doric friezes are typical of the earliest and largest religious buildings of Magna Graecia. These buildings are worthy of the experiments taking place in Greece at the time although the work of architects in the colonies was also important.

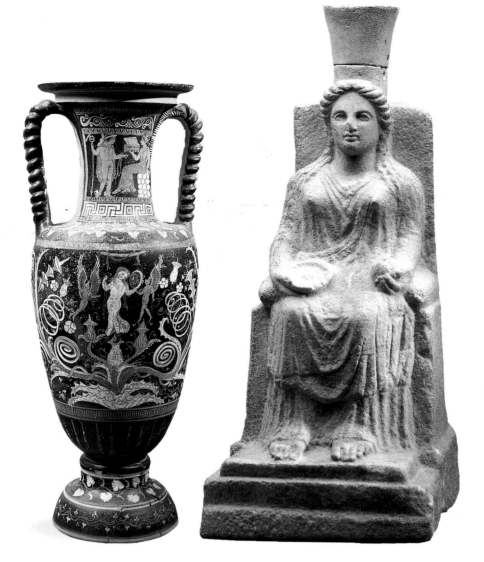

friendship that bonds guests with wine, a refined and expensive product, but also acts as a clear and painful metaphor of life on earth, a melancholy elegy for the pleasure and joy of living which will inevitably be destroyed by death.
In order to fully understand these paintings and the highly refined cultural level for which they were designed, we must interpret the figure on the ceiling correctly. If we decide against the hypothesis that the diver, realistically leaping from the trampoline toward the water in a natural setting with two small stylized trees represents a deceased sportsman (many athletes from Poseidonia took part in the Olympic Games) we can only conclude that the dive symbolizes the soul's journey toward the hereafter. A dive into the

53 bottom The elegant outline of the Temple of Ceres (actually dedicated to Athena around 510-500 BC), is exceptionally well preserved in the northern sacred area of the town. The building is an airy, harmonious structure combining the imposing Doric style with the Ionian columns in the portico. The measurements of the building are exactly the same as those of the 100-foot temples of mainland Greece.

54 top left This figure of a young servant pouring wine to the guests appears on one of the short sides of the Temple of the Diver.
At his shoulder is a great scrolled bowl, similar to those in use in Paestum between the end of the 6th century and the start of the 5th.

54 top right From the tomb of the Black Horseman, also from the classical period in Paestum, comes this painted slab. Its distinctly natural style, perfectly set into its surroundings, is evidence of an important school of painting.

54-55 The joyous atmosphere of the aristocratic party shown here can be summed up in this scene which is from one of the slabs on the long sides of the Tomb of the Diver.
The musician has just finished playing his barbyton, a type of zither. Beside him, two men reclining on the same couch, resume their conversation while the music of a double flute begins on another couch. A man beside the flute player looks as if he is trying to remember the words of the song.

54 bottom On the slab opposite are these two men playing the game of kottabos with good-natured sprinkling of wine among the guests. Those in the scene hold wine goblets with a stem and a low, wide cup. These goblets are identical to the wine cups used at the time which have often been found in the burial treasures of the Paestum tombs and were produced by the finest of Athenian craftsmen.

55 top The slab which covered the Tomb of the Diver, which gives its name to this precious tomb, continues to fascinate with its picture of a mysterious plunge into the water by a naked young man. Some believe it is a metaphor for the voyage of the dead in the afterlife.

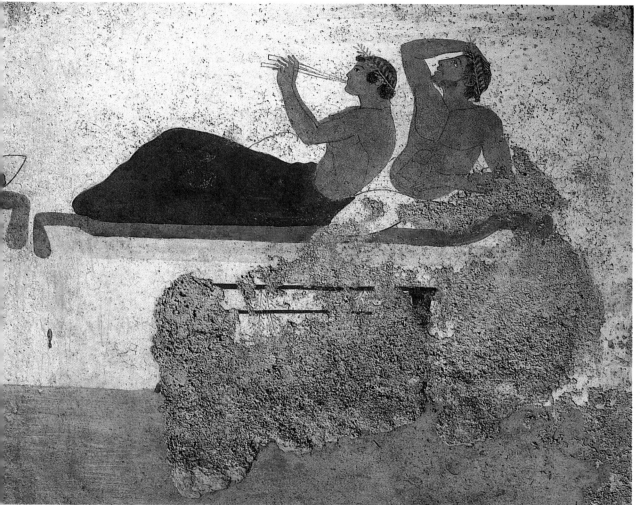

taken on an intense dark blond shading over time. The harmony of its proportions shows strong links with the grandiose temple of Zeus Olympio in Olympia, the work of Libon of Elydes. The Temple of Poseidon is a classic six-columned Doric structure in whose colonnade interwoven designs that capture light and shade soften the sharp edges and the heavy thickness of the columns. This combination, despite the basic heaviness of the structure, produces an effect of lightness. The decoration of the entablature and the central religious area make this a fine example of the way in which outside models influenced architecture at this period.

Further along the ancient Via Sacra are the Roman forum and the extensive remains of republican and imperial Paestum followed by what is called the Temple of Ceres, although it was actually dedicated to Athena. This was built around 500 BC in the classic proportions of a hundred ancient feet but it was also influenced by both the Ionic and the Doric styles.

The Archaeological Museum at this site contains vast documentation covering decades of research. One outstanding feature is the reconstruction of the Doric four-columned thesauros dating from 540 BC and the finds from the later (510 BC) temple of the Sanctuary of Hera on the Sele with their series of sculpted areas which are basic to the history of ancient art in the western colonies. But there is much more. The museum also includes examples of the rich production of votive and ornamental pieces, precious examples of statues which indicate a distinct local school, and copious pottery imports. And finally, there are the luxurious and beautifully made bronze vases which were found in the so-called heroon of the square, an underground sanctuary, which can be dated to 510-500 BC, in association with an amphora with black figures showing the Deification of Hercules.

unknown, then, in a breath of purification that looks back to the philosophy of Pythagoras and his doctrine on the reincarnation of the soul.

This tomb is not the only source of interest for the visitor to Paestum. In its network of streets which are still surrounded by Greek walls reworked during the Lucanian and Roman periods, we can see both the original Greek colonial pattern which was based on a pragmatic right-angled arrangement and the later Roman plan.

As we arrive at the city from the main entrance its visual impact is unforgettable. This city was dedicated to Poseidon but was also very devout toward both Hera and Athena. Facing from east to west and placed very close together are the two temples of Hera, commonly known as the Basilica and the Temple of Poseidon.

These originally were part of a single religious complex and both are still in excellent condition. The first is the oldest religious building in Poseidonia (probably dating to between 550 and 530 BC) and its stuccoed building of local brown limestone rests on a broad platform of about 150 by 75 feet with a colonnade of 9 by 18 columns, a rare example of a nine-columned Doric temple. Traditional ancient elements, such as the division of the religious center into two naves, the massive size of the load bearing elements of the building, and the overall heaviness of the structure are mixed with strong influences from both Ionian and Asia Minor civilizations.

The Temple of Poseidon is the biggest and best preserved sacred building of Poseidonia. It was built around 460-450 BC in the typical local limestone which has

TARQUINIA, *THE AFTERWORLD* PAINTED ON THE ROCK

A The city today B The Etruscan city C Etruscan tombs

Tarquinia, the city of the mythical Tarcontes and considered one of the stars of the southern Italian area of Etruria imposed its rulers, Tarquinius Priscus and Tarquinius Superbus on Rome. Still mainly buried in the enormous plain known as the Plan di Civita and surrounded by its huge necropolis it is in a perfect setting for its steep profile of medieval towers and bell towers, with the River Marta descending through sheer volcanic rock toward the sea over the arid ancient Etruscan landscape. The city has inspired enthusiastic writing about it. G.W. Dennis, in a book called *Cities and Cemeteries of Etruria* published in 1848 reported himself to be thrilled by it. D.H. Lawrence also wrote about it, but unfortunately with little regard for accuracy.

The city was founded in the distant past, perhaps in the 10th but certainly in the 9th century BC. It was one of the cradles of the culture known as Villanovan, the first phase of the Etruscan civilization (10th to 8th century BC) and was marked by many burials performed by incineration inside molded double-cone clay urns that were decorated with etched or printed geometric motifs. Its position between the sea, which meant it was able to have traffic with the Greeks and Phoenicians, and the mineral deposits of central Tyrrhenian Italy, as well as rich soil and excellent defenses at the site made it one of the most dynamic centers in the area, both ready to receive and to transform the cultural and economic changes taking place in the surrounding Mediterranean and Italic areas to its own advantage. Tarquinia was one of the first Etruscan cities to abandon the Villanovan model and to accept and develop the forms of the Middle Eastern phase in Mediterranean civilization. This was linked to an increasing consolidation of power in the hands of certain aristocratic families during the 7th century BC. In the 6th century BC, the city seems to have played a major role in the creation of a balance of

56 top This splendid fragment of pottery with its pair of winged horses dates to the 4th century BC. It was a decoration on the wooden entablature of the huge temple known as the Queen's Plow, probably actually dedicated to Juno.

56 bottom The wall paintings in what is called the Baron's Tomb (510-500 BC), with their pictures of ornamental trees, show the farewell to the dead noble.

power with an Etruscan-Punic axis against the Greeks and in the establishment of the Etruscans as the major Tyrrhenian Sea power. In addition, it was in a flourishing trade area and was able to attract people with both economic and cultural skills, including artists. During this period the city grew enormously and became known both then and in the following centuries as unique in Italy for the incredible number of underground chambered tombs it had. These are covered in multicolored mural paintings and were basic to the passing on of knowledge for the development of ancient painting which was introduced and cultivated here, probably primarily by either Greek or Greek-trained artists.

The crisis that followed the Greek victory at Cuma in 474 BC, the end of the Tyrrhenian dominance and the loss of power to the ascendant Rome led to a period of comparative decadence, during which the entrepreneurial, commercial and craft economy that had characterized this civilization gradually gave way to an agrarian-pastoral economy which was based on land ownership and the concentration of power in the hands of the aristocracy. Later wars with Rome (4th century BC) followed by the city itself becoming part of the Roman Republic made it a major center among the Roman allies, so that it kept a reasonable level of splendor to the start of the 1st century BC, after which Etruscan

56-57 The influence of the elegant Ionian style Etruscan-Archaic painting is shown in the wall paintings of what is known as the Tomb of the Lioness (530-520 BC). The man reclining on a luxurious couch, covered by a fabric edged with embroidered dolphins and seabirds, is obviously an aristocrat.

57 top This dark, beautiful head crowned with precious diadems, was expertly portrayed by an artist, almost certainly Greek, of the 3rd century BC. The person portrayed looks into the far distance with a rather gloomy expression. The masterly use of the brush of the artist faithfully shows us the hairstyle and ornaments of the period.

57 bottom In another scene from the Tomb of the Lioness two dancers are shown entertaining guests at a banquet.
The scene serves not only as a melancholy farewell to life on this earth but also as a reminder of the aristocratic background of the deceased and his family.

civilization was completely absorbed by the Romans.

Visiting Tarquinia today means, first of all, discovering the exceptional heritage of its painted tombs. A few of these deserve special mention due to the excellent state of preservation of their wall paintings. The Tomb of the Auguries is especially famous. Its name comes from the Etruscan priests whose job it was to foresee the future by interpreting the flight of birds. It consists of a single chamber, dating to 520 BC. A sumptuous wall design by a painter who may be Greek-Ionian, possibly from Phokeios, or Etruscan-Ionian shows a sequence of athletic contests, spectacles and ceremonies in honor of the deceased

noble, all celebrated under the guidance of the auguries. Wrestling scenes alternate with scenes of mourning and with the not entirely understood bloody game of Phersu which may be a gladiatorial battle honoring the deceased.

The Tomb of the Baron is slightly more recent, dating from between 510 and 500 BC. This is the work of a Greek-Ionian artist, a composed and well-balanced scene that we can view as the deceased leaving for the after-world, if we consider this to be symbolized by the stamping horses which are held back with reins. Here again is evident the strong, lively coloring of Etruscan painting and the tendency to fill in the figures although

57

without suggesting a third dimension. Etruscan tombs, which are considered a residence for the hereafter, at times show decorations that underline the architectural structures of a house, thus providing us with precious information on the history of residential building. This is the case, for instance, with the ceiling of the Bartoccini Tomb (520 BC) and the Tomb of the Chariots (490 BC) which has walls showing a splendid banquet below a frieze of athletic and equestrian contests. Another of the city's most famous tombs, called the Tomb of Hunting and Fishing, dates to around 510 BC It takes its name from the well-known and unique hunting and fishing scenes with their animated figures and their strong sense of the relationship between the figures and the landscape. This tomb may have been created for a wealthy aristocratic customer involved in both maritime trading and the typical leisure pursuits of his class.

The Tomb of the Bulls perhaps dates back to 550 BC. The back wall of the main chamber shows a rare epic scene of Greek derivation, perhaps with some funereal significance. The scene shows the ambush by Achilles of the young Trojan prince Troilus. Troilus had rashly gone into the sacred wood of Apollo Thymbaios to reach a fountain where the Thessalian hero had hidden himself. The landscape is highly stylized and the scene shows the moment just prior to the tragedy. This scene is clearly understandable. Another, on the other hand, showing various figures in extremely realistic erotic positions is not so easily explained.

The 4th and 3rd century BC paintings from the Tombs of the Ogre I, II, and III are part of the classical and Hellenistic phase of Etruscan art. These tombs belonged to the very important Velcha and Spurina families. The first tomb shows the scene of an aristocratic banquet with newlyweds in beautiful clothes. Here, the melancholy, fascinating profile of Velia Velcha is considered particularly beautiful. On another wall, the horrible figure of the underground demon Charun, known as Charon by the Greeks and Romans, is a reminder of death and, in a sense, of the Etruscan decline itself. The stylistic refinement of the metalworking suggests it was produced by someone under the influence of the Greek world, perhaps Taranto.

The Tomb of the Ogre III shows an unusual scene, with strong colors and a certain naiveté which is, however, interesting for its attempts at realism. It shows the blinding of Polyphemus by Ulysses and his companions, as explained in captions above the figures of Cuclu (Cyklops) and Uthusie (Odysseus).

One of the last painted tombs of Tarquinia is the aristocratic one of Typhone (200-150 BC), which belonged to the Pumpu family. This rectangular tomb has a sequence of graded steps and a sturdy central pillar. From this protrude the poorly preserved remains of naked winged demon figures with expressions as of beings seeing an hallucination and with hats in the form of serpents. The plastic nature of the bodies and the extreme expressions are reminiscent of the baroque of Pergamon.

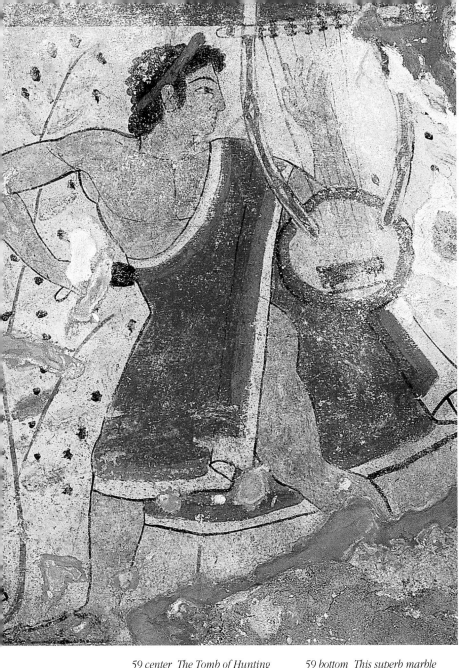

58-59 The splendid paintings from the Tomb of the Leopards date from 480-470 BC and are among the most important found in Tarquinia. Here is shown a celebration of some kind in which a guest at a banquet is entertained by two musicians. One plays a double flute, the other a barbiton, a stringed instrument with the soundbox made from a turtle shell.

59 top This scene is from the simple but famous Tomb of the Augurs (520 BC). It shows the custom, clearly of aristocratic Greek origin, of holding sporting contests in honor of the deceased.
Two naked wrestlers face each other while on the left a soothsayer follows the flight of the birds from the right to interpret what their passage portends.

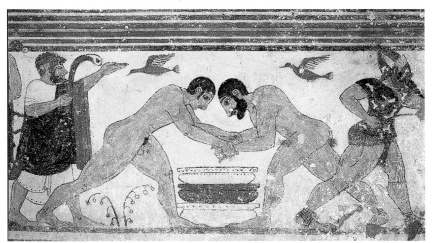

59 center The Tomb of Hunting and Fish (late 6th century BC) has vivid paintings which tell strong stories. In this detail of the scene which gave its name to this burial complex in Tarquinia the dynamic figures are outstanding against the contrast of the heavy background.

59 bottom This superb marble sarcophagus, now in the National Archaeological Museum of Tarquinia, is from the last quarter of the 4th century BC.
It is the tomb of an aristocrat, whose body is shown on the cover. The coffin shows a relief illustrating the battle of the Amazons.

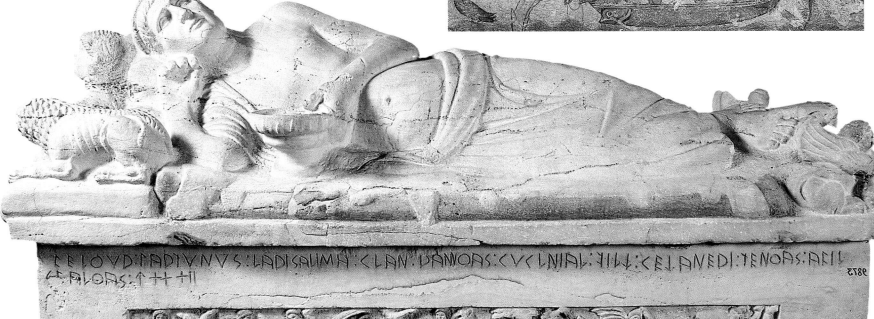

Italy
Rome
POMPEII
Tyrrhenian Sea
Mediterranean Sea

POMPEII,
A CITY REBORN

61 *This famous fragment from a fresco from Pompeii, now in the National Museum in Naples, shows a young married couple. The woman holds a waxed tablet and the man has a rolled up scroll in his hand. This exceptionally lifelike portrait is believed to be that of Pacuius Proculus and his wife. It is believed that he was a freed slave who became rich as the owner of a bakery in the town. He may have become a magistrate, judging from certain electoral slogans found on the walls. Whether or not this is correct, it is interesting to see the clear prosperity of the middle classes during the first Imperial Roman age. After accumulating wealth from trade or politics, this class became the dominant force in society. The portrait shows the high degree of emancipation of Roman women, exceptional in the ancient world.*

60 left This aerial view of Pompeii shows how the Temple of Jupiter was flanked by two tiled honorary arches, originally covered in marble. One was dedicated to Tiberius and the other to Germanicus.

60 top right The Forum, seen here facing the side with the public building, consisted of three large adjacent spaces which housed the main courtrooms and was the center around which the political, economic and religious life of Pompeii revolved. Around the square was a continuous portico supported by Doric columns, partly surmounted by a second colonnade in Ionian style.

60 bottom right The Temple of Jupiter, which occupied the southern side of the Forum area, was a large building in Corinthian style built on a high podium.

One August morning, during the first year of the reign of the Roman Emperor Titus, Pacuius Proculus was suddenly awakened by a deep, resounding tremor, a type of boom that he had felt once before in his life, as a boy. He was annoyed by the tremor, but gave it no further thought. Vesuvius had been misbehaving for some days and a few similar minor tremors had already alarmed his servants. In fact, he wasn't worried in the least. Occurrences of this kind were fairly frequent in Campania, in what was later to become Italy. Anyway, it would be ridiculous to neglect his work for something so trivial. Seventeen years earlier, under Nero, the situation had been different. That had been a real earthquake. Then the columns of the temples had collapsed, the roofs had opened up, and the statues of the family gods had crashed to the ground. This morning it was only when his wife, normally such a calm woman, begged him to follow her to the inner courtyard of the house to see for himself that Pacuius felt

A Temple of Apollo
B Temple of Jupiter
C Forum
D Building of Eumachia
E House of the Vettii
F Triangular forum
G Central Baths
H Gladiators' barracks
I Theatre
J Odeon
K House of Centenary
L House of Paquius Proculus
M Great Gymnasium
N Amphitheatre

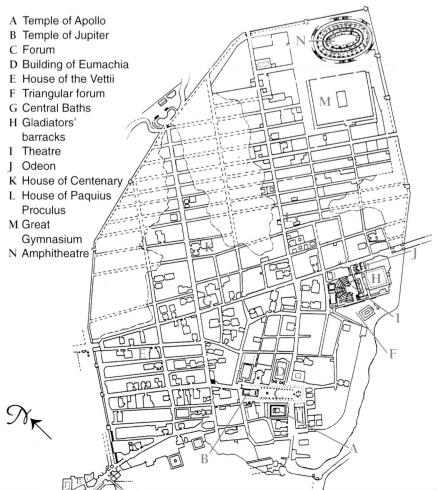

62 The Temple of Apollo, dating to the 2nd century BC, is located near the Forum, in the center of a 48-columned courtyard. In front of the portico, on one of the long sides, was a bronze statue of Apollo with a bow, now replaced by a copy.

63 top left The sanctuary dedicated to Apollo was being restored following the earthquake of 62 AD. The columns, originally Ionian, were changed to Corinthian and the bare architrave was covered with a layer of plaster and decorated with a frieze of griffins and festoons. These changes have almost disappeared today, so the complex has a more ancient appearance.

63 bottom left The remains of the Basilica, dating from the end of the 2nd century BC, are in the western corner of the Forum. This is one of the oldest remaining examples of this type of building. It was used as a courtroom and for business, evolving over the centuries until it became the first form of Christian architecture.

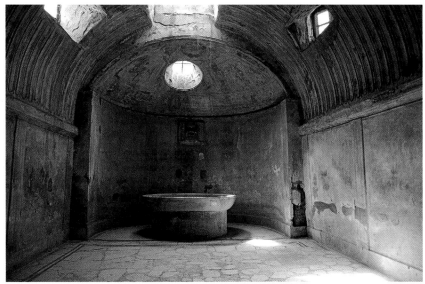

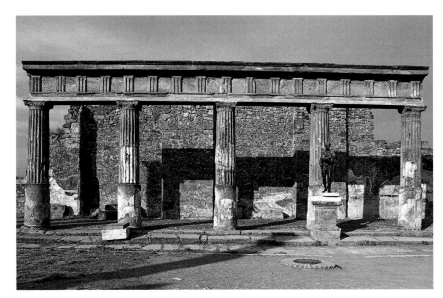

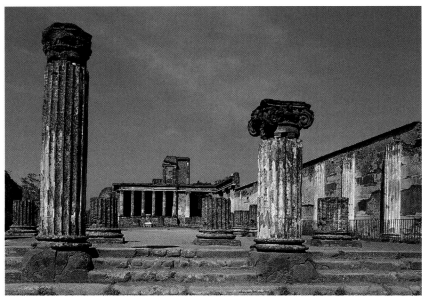

nervous in spite of himself. A huge cloud was rising from Vesuvius, a vast column of dense black smoke moving skyward and then expanding so that it took on a profile similar to that of a pine tree.

However, always the businessman, he felt there was no time to lose looking at Vesuvius. Business called and this spectacular sight was no excuse for making a late start. He left his wife alone in the house with the servants, trying to remain calm even as the earth continued to tremble and, gradually, a fine shower of ash, initially light and hardly visible, began to cover the flower beds. She was slightly comforted by the unexpected return of her husband Pacuius, but then her worst fears were confirmed when a terrible noise drowned out every other sound. The ornaments in the house jingled and the flames of the oil lamps in front of the household gods flickered. The whole house shook as if ready to break up at any moment. Howls and screams could be heard from the street. The sky had suddenly gone dark and the air was heavy and dense with a strong smell of sulfur that seemed to suck out both breath and strength. Pacuius went as pale as death itself. His wife understood then that it was all true: the gods had turned their backs on Pompeii! At that moment she knew that if they wanted to go on living they would have to take flight immediately, leaving all their possessions behind and without looking back.

We'll never know whether Pacuius and his wife, whose famous portrait was found in Pompeii, were really in Pompeii on that terrible day to witness the horrendous catastrophe, or if they were able to save themselves, unlike many other inhabitants of the town, whose bodies, contorted in their death throes, were gradually discovered by archaeologists and filled with plaster to show how they appeared in death.

One thing that we do know is that many of the inhabitants of Pompeii were never aware of the appalling fate the volcano held in store for their town. They didn't want to abandon their houses immediately. Indeed, many of them were still repairing the damage caused by the earthquake of 62 AD. They died in the hundreds, suffocated by the death-dealing clouds from the cracks that opened along Vesuvius, trampled underfoot by terrified horses, or killed by falling masonry.

We know many of the details of these frightening events due to Pliny the Younger

63 top right Together with the Via Nola, the Street of Abundance was one of the two main east-west roads in the city, crossing the entire street network. This important road linked many central points in the city and was heavily traveled. It not only had private houses but also shops of every kind, inns, eating houses, brothels and private clubs.
On the top floor of the house of Popidius Montanus, the club of the latruncularians, chess players of the time, was found.

63 bottom right The bath complex near the Forum was the smallest but also the most elegant in Pompeii. It was decorated with multicolored stucco, marble and mosaics.
In spite of its small size it contained everything for the complete bathing ritual (dressing rooms and rooms for cold, lukewarm and hot baths), divided into separate areas for men and women.
The photograph shows a view of the caldarium, the hottest room, with its great marble bath.

64 top In this aerial view, we can see the Forum (top), the Stabian Baths (center) and the theater with adjoining odeon for music (left). The Stabian Way crosses the Street of Abundance at the corner of the bathhouse.

64 center Built in 80 BC, the amphitheater of Pompeii is the oldest building of this kind. Unlike those that followed it, the stairs in this building were on the outside and there were no passages under the arena.

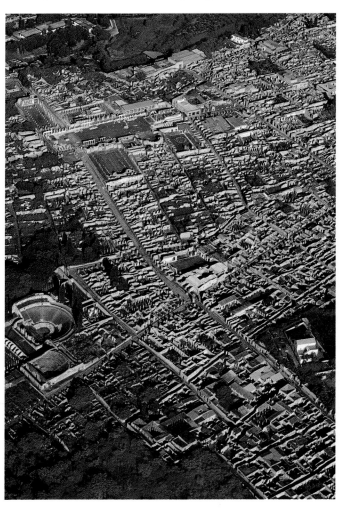

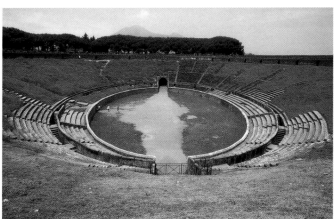

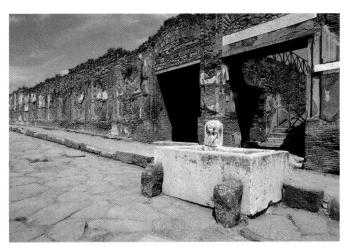

64 bottom Public fountains were built at frequent intervals on the streets of Pomeii.
Over 40 have been found so far, usually no more than 85 or so yards apart. This means that people without a water supply system of their own always had a supply point not far from their houses. The picture shows the fountain of Abundance, which gave its name to the street on which it is built.

64-65 This famous mosaic, dating back to the 1st century BC and signed by a Greek artist, Dioscuris of Samos, was discovered in the so-called Villa of Cicero. It shows some characters from the traveling musicians of the cult of Cybele.

65 top This mosaic shows a number of actors preparing to perform. One of them is playing the tibia, an instrument similar to a flute.

65 bottom The Great Theater was built between the 3rd and 2nd centuries BC and was extended in the Augustan period as the result of a generous donation from the Olconii family.
The construction fully reflects the influence of the Greek style. The arena, which could hold up to 5,000 spectators, rests against a natural slope and is not raised on a brick foundation as was typical of later Roman architecture.

whose letters to his friend Tacitus gave his friend and, later, us a clear and reliable history of the facts as they happened. He himself risked his life during the dramatic flight from Misenum, several miles away. He was luckier than his famous uncle, Pliny the Elder, who was asphyxiated in Stabia, where he had gone in an attempt to help a friend and his family.

The brilliant eighteen year old nephew

described the terror that gripped the people living around Vesuvius during those hours of tragedy. Translated from the Latin it reads roughly, "You could hear the screams of the women, the cries of the children and the shouts of the men. Some cried out the names of their parents, others called to their children or their spouses, whom they recognized by their voices. There were those who wept over their destiny, others over their loved ones. Some, out of great fear of death, invoked it, many raised their fists to the gods, others proclaimed that there were no more gods, and that the last night of the world had come."

In this way, on August 24, 79 AD, Pompeii ceased to exist, under a merciless rain of ash and stones, which continued to fall for another four days. The same destiny came to Herculaneum, Stabia, and Oplontis. Naples, Sorrento and Nola were severely damaged by the massive earthquake. Emperor Titus immediately sent aid to the survivors, but the once prosperous, fertile

discussed the tragedy almost sixteen hundred years earlier and Pliny the Younger's account of it.

It was at about the same time, the early 1600s, that a German scholar, Lukas Holste, in charge of the Vatican library, wrote that ancient Pompeii must be where the modest town known as Civita stood. In the decades that followed, a few sporadic finds led to the discovery of Herculaneum, but the location of Pompeii remained a mystery. During the middle ages the name of the buried city had been forgotten by the local people, and some of the humanists of the 16th century confused it with Stabia. It was, however, while excavations were taking place to find Stabia on behalf of Charles of Bourbon that the first remains of Pompeii were brought to the surface by the Abbot Mantorelli in 1748. Twenty-five years later an inscription was found which left no doubt that the discoveries so far made of ruins and household objects definitely belonged to Pompeii. The ruins were visited

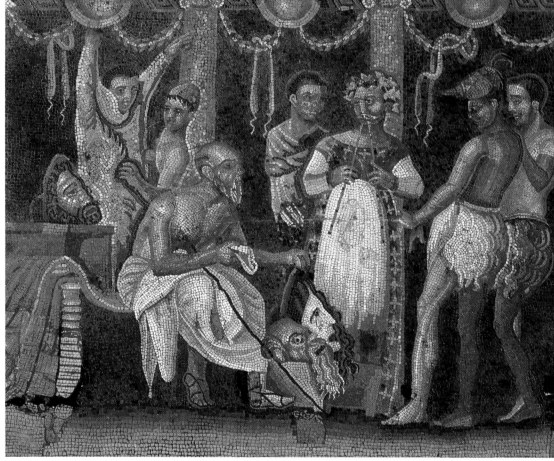

countryside had been transformed into a desolate, sterile landscape.

No one returned to live in Pompeii and little by little the city became almost forgotten, although Pliny the Younger's vivid description of the catastrophe did survive down through the centuries. In fact, with time, the actual location of Pomeii was forgotten. In December 1631 the same horror was repeated and while long processions of refugees made their way toward Naples and safety commentators

by many distinguished people of the times, among them Théophile Gautier, Horatio Nelson and Giuseppe Garibaldi. Some scholars criticized the excavation methods at the time but their visits further publicized the discoveries.

Nevertheless, it wasn't until the second half of the 19th century that systematic excavation work began. Little by little, the digging came to be accompanied by restoration, gradually perfected over the years and using more and more advanced

66-67 In the rooms to the side of a shrine in the gardens of the House of the Golden Bracelet, a number of magnificent frescoes in the Third Style were found, showing gardens in bloom and many different types of birds.

66 bottom This painting, which shows two theatrical masks, was part of the very rich wall decorations found in the House of the Golden Bracelet. The house is in the western section of Pompeii, next to the city walls.

technology so that experts can identify even the types of trees and shrubs grown in the gardens of Pompeii. Amedeo Maiuri, director of the excavations from 1924 until his death in 1961, not only worked to free the buildings from the solidified ash but also stressed the importance of taking every possible step to protect the finds as they were unearthed.

Although about a fifth of the site is still unexplored, Pompeii is probably the most famous archaeological site in the world. It tells of a culture and lifestyle of a major city whose existence was snuffed out almost in a moment, a city that was fossilized without the gradual abandonment and decay typical of other urban centers during Roman times. Today, we know that Pompeii was founded on the outer southern reaches of Vesuvius at the end of the 8th century BC by a group known as the Oscan people. They were

followed by the Etruscans and later by the Greeks. Toward the end of the 5th century the city was taken by the Samnites who held it until 310 BC when they became allied with Rome.

It was during the Samnite period that those centers essential to public life, including the forum, the so-called Triangular Forum complex, the Basilica, the Gymnasium, the Spa Complex of Stabia, as well as the houses with their atriums and the imposing fortifications were built. Over time, the old and new inhabitants intermarried and both Latin and Oscan became official languages of the colony. Later, the city was promoted to municipal status and the inhabitants had all the privileges of Roman citizenship. In 80 BC, after the Civil War, it became a colony with the name Cornelia Veneria Pompeianorum and, thanks to the patronage of the Silla political party,

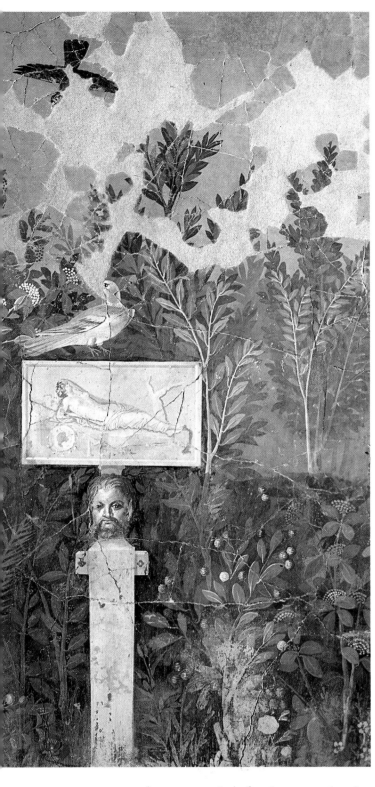

67 *The two details shown on this page are also from decorations found in the House of the Golden Bracelet. They were produced with the finest fresco technique with the color spread on plaster while it was still wet. The wall paintings of Pompeii have shown a resistance to wear and tear over the centuries that surpasses even those from the Renaissance. The true nature of the technique for the application of colors and the exceptional quality of the Roman paintings have yet to be fully explained although there does seem to be little doubt that the calcium carbonate film that formed over the color as the lime in the plaster reacted with the air played a basic role.*

The materials used to obtain the different pigments are, however, known, from Spanish cinnabar for bright red to copper oxides for the greens and resinous carbon for black. Two paint factories have been found in Pompeii.

underwent a period of major renovation. It was during this time that a number of major public buildings were erected, including the baths, the odeon, a building for musical performances, the capitolium of the forum and the amphitheater, which held 20,000 spectators. It was at this time that the streets were paved with stone.

From 27 BC on, an intense period of Romanization took place and it was during this time that new artistic and architectural models were introduced that reflected the official Roman culture. During the Julian-Claudian period the gymnasium was built alongside the amphitheater, as well as the market, the Eumachia Building, the temple of Fortuna Augusta and the so-called temple of Vespasian, but the basic layout of the city remained more or less the same.

As in Rome, Pompeii was organized in quarters, or insulae, and Larian shrines were

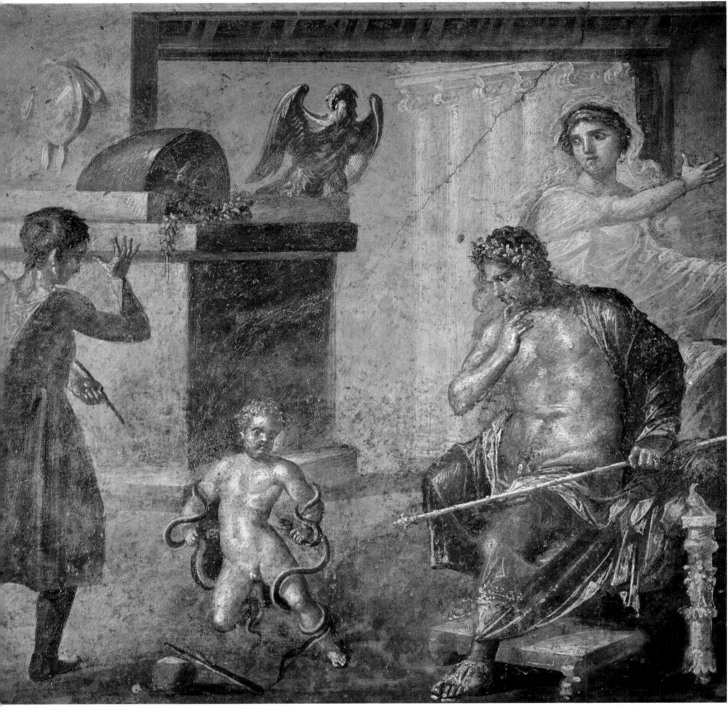

placed at the crossroads. The names of these quarters can often be found on the electioneering messages painted on the outside walls of the houses.

More than 40 fountains have been discovered along the streets, usually placed about 80 or so yards apart. The water supply came from a number of deep wells dug from the base of lava and volcanic rock on which the city was built as well as on the aqueduct built during the time of Emperor Augustus. The water entered the city near the Gate of Vesuvius, where a large collection tank, known as the *castellum aquae* was placed which distributed it through the main city pipes. The pipes were made of lead and ran underneath the roads. From these pipes the water was channeled into private houses.

Pompeii's daily water consumption must have been enormous, as was the case in all Roman cities. Only the poorest people had no running water, but they had access to the public fountains.

Pompeii had two forums which were the centers of city life. In these places people gathered to listen to speeches by politicians, to discuss business and, of course, simply to chat. The first of these forums, which was surrounded by a Doric colonnade with an Ionian portico, has its buildings laid out in a logical way although they were built around

it at different times. The capitolium and courthouse were at the shorter sides, and the courtyard was surrounded by the temples, the basilica, the covered market, two memorial arches and the Eumachia building, which was dedicated to Eumachia, priestess of Venus, and patroness of the corporation of weavers and dyers, the city's major industry. The second forum, which was in a cramped triangular space, was also used as a theater. Its oldest section dated back to the 2nd century BC and also contained the odeon, which was a small covered theater. The remaining public buildings included gymnasiums and bathhouses.

68 top In the lower part of the House of the Vettii, one of the most luxurious residences in Pompeii, is an elegant frieze with a black background showing cupids involved in various activities. Here they are preparing perfumes.

68 bottom This fresco painting, showing Hercules as a child strangling the serpents sent by Hera, decorates a room in the House of the Vettii, which belonged to two rich merchants of excellent taste.

68-69 and 69 bottom These superb wall paintings are also from the House of the Vettii. Although the villas of Pompeii seem opulent to us, sparse furnishings must have made the rooms seem bare, an

explanation for the need to cover every wall with decorations. The richness of the decorations was, of course, in proportion to the wealth of the householder and the ability of the craftsmen.

Pompeii, however, is famous most of all for its private buildings. There is no other place, with the possible exception of Herculaneum and Ostia, where we can find such a complete understanding of the Roman house with all its features, from its basic structures to its decoration and even its household ornaments. The evolution of the domus, the most common type of residence in Pompeii, began in the 4th century BC with Samnite construction with Tuscan entrance halls and enormous façades and moves on to the houses of the Republic, which reflected the Greek influence, with elegant inner courtyards, plaster walls and decorated façades.

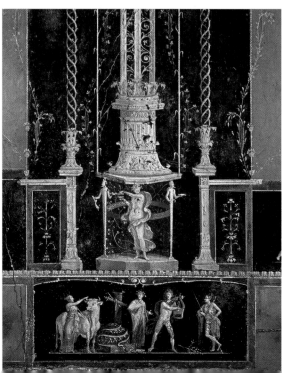

By the time of the Empire, the houses had complex, extensive plans, finely painted walls, balconies and elaborate ornamental gardens. The wall paintings, many of which have been preserved, also reflect the development of Roman taste and especially of decorative taste. The so-called First Style, which was dominant between 200 and 80 BC, was influenced by the Greeks and was a colored plaster imitation in relief designed to look like square blocks of marble. In the 1st century BC the Second Style was dominant. This was based on perspective, with architectural or landscape decorations. The Third Style, fashionable until around 40 AD, was ornamental, flat, and more schematic. The Fourth Style, which was in vogue following the earthquake of 62 AD, was almost fantastic in its conception and rich in optical illusions. The local aristocracy lived in elegant, enormous houses which often had colored marble or mosaic floors. Some of these houses included shops opening onto the street which were rented out to freed slaves or run by slaves for selling their masters' products, such as foodstuffs, to the public. Trade was a major part of life in Pompeii, especially along what is now called the Via dell'Abbondanza or Street of Abundance, one of the main streets. Buildings included workshops, dye works, taverns serving drinks, inns and brothels and gaming houses.

The elegant preservation of the furniture, silverware, pots and pans, lamps, glassware and tools in general is extraordinary in both the houses and the shops.

Another fascinating feature of Pompeii are the many inscriptions, the painted signs, the election posters and graffiti which can still be seen on the walls of the city, giving us further insight into the life of this lively town until the moment when, on the 5th of February in 62 AD, a disastrous earthquake struck the town and other nearby cities, including Herculaneum.

The reliefs which are part of the household shrine of Lucius Cecilius Jocundus in Pompeii show several buildings in the town as the wave of the earthquake was felt. The damage was so severe that, over fifteen years later, reconstruction and repair was still going on.

Prior to this earthquake the population had been around twenty thousand. After the earthquake the population was cut in half. Trade, which had been the major activity of Pompeii, was replaced with construction and an accompanying speculation in property. There was no lack of money. The city became almost one enormous building site. But it was all to no purpose. With the terrible eruption of Vesuvius on that dreadful day in August of 79 AD the city was literally annihilated, bombarded without stop for four days by a combination of stones and ash which reached several feet. Many people, overcome by toxic gases, fell to the ground in a variety of positions and were buried under the volcanic materials. The prints in the rocks left by their bodies are the most dramatic testimony to the tragedy of Pompeii.

At least two thousand people, perhaps more, were unable to save themselves and died here. We can see them today as anonymous, reconstructed plaster statues, lying in the way and where they died. Whether or not a citizen such as Pacuius Proculus and his wife are among them we can never know.

70-71 The Villa of Mysteries was built in the middle of the 3rd century BC and then extended and enriched over the years. It owes its name to the famous frieze showing the most important stages in a rite of initiation into the Dyonisian mysteries.

This extraordinary fresco, with 29 life-size figures, was painted by an artist from Camania in the 1st century BC. It covers the walls of a room entered through a single door. Since the rites themselves are not known, interpretation of the scenes is difficult. Although the

paintings in Pompeii have been conserved in excellent condition, they no longer have the brilliance that made them shine like mirrors, a brilliance written about by writers of the period. We do not know how this brilliance was achieved.

Italy

ROME

Thyrrhenian Sea

ROME, A UNIVERSAL CAPITAL

A Tomb of Hadrian
B Tomb of Augustus
C Field of Martis
D Stadium of Nero
E Pantheon
F Theatre of Pompey
G Portico of Octavia
H Theatre of Marcellus
I Temple of Capitoline Jupiter
J Arx
K Trajan's Forum
L Baths of Constantine
M Baths of Diocletian
N Castra Praetoria
O Baths of Trajan
P Colosseum
Q Temple of Venus and Rome
R Palatine
S Circus Maximus
T Baths of Caracalla
U Porticus Aemilia

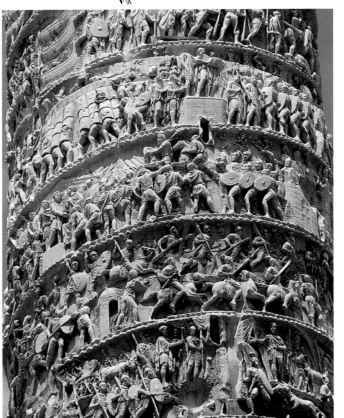

Symbol of a metropolis, a huge, complex city with buildings zooming upward to the sky in a seemingly infinite number of styles. A melting pot of races and nationalities, a maze of streets alive with bustling activity, never-ending traffic and an almost neurotic feeling. The constant movement of businessmen and women, children, housewives, noisy workers on building sites, beautiful women, handsome men, rich and poor. In short, a tremendous confusion of noise and color, a cacophony of languages and variety of customs, fashionable shops and humble grocery stores, trendy night clubs and sleazy bars, all set in a dramatic architectural backdrop which almost demands extravagance. New York? No.

This is Rome. The Big Apple of the ancient world, the first true megalopolis in human history. It was a city with everything anyone could imagine. It was a city with the best bathhouses in the empire, the best libraries, theatrical performances by the best companies, shops supplied with the best merchandise every day, excellent doctors, learned lawyers. There was something for everyone in Rome. During the imperial period, which was when most of the monuments admired today were built, the Eternal City must have been a truly amazing sight. It was a city constantly growing, with over a million inhabitants in the 4th century AD, not including slaves and recent immigrants. Architects were forced by this increasing population to build ever upward, with some buildings reaching six, seven or more floors. The numerous shops, called *tabernae*, made the city seem almost like a giant bazaar with officially licensed traveling peddlers, moving through the crowds shouting out their wares, adding to the impression that anything anyone wanted could be bought in Rome.

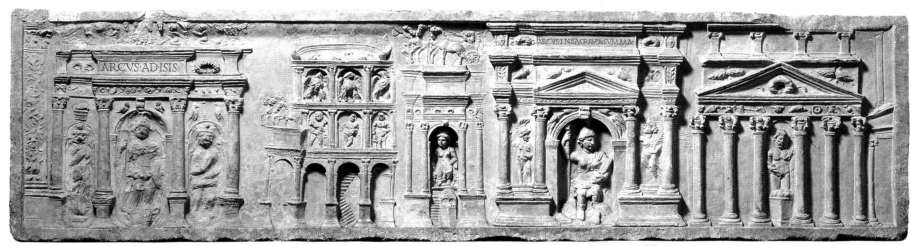

The tabernae sold a little of everything, from groceries to fabrics, cushions to crockery, jewelry to books. There were also many services available, including laundries, dyeworks, tanneries, bakeries and workshops of blacksmiths, shoemakers, potters, carpenters, glassmakers, carvers and knifemakers. In the *tabernae argentariae* exchange of foreign currency could be arranged. These banks also offered deposit services and loans at interest, as well as the opportunity to make investments in businesses. Those who were involved in legal action or had important business to discuss had a choice of various spots in the city to go to for just that purpose. Rome was packed with public works of every kind, including those for extravaganzas and special shows. Leisure was just as central to the life of ancient Rome as it is to us today. There were almost innumerable choices of ways in which to spend leisure time for all classes. They could wander through the forums and various places of business or drink and gamble in forerunners of the modern bar. The working day finished early, afternoons tended to be long, and the evenings were not considered safe times to be out after dark.

74 top The arch of Septimus Severus was built in the Roman Forum to celebrate the victories of the emperor in the east.

74 center Among the most impressive monuments in the Roman Forum is the House of the Vestals, the convent of the priestesses who guarded the fire sacred to Vesta, goddess of the hearth. This burned in the nearby circular white marble temple.

74 bottom Constantine's arch was completed in 315 to celebrate the emperor's victory over Massensius in the battle of Ponte Milvius. The arch has three openings, about 80 feet high, and is in an isolated position near the Colosseum. Many of the parts of this arch were taken from older buildings. A few reliefs made specifically for it were clearly done in something of a hurry.

One popular way of spending the time between work and dinner was the bathhouse, which can still be seen in the modern city, two of which, those built by Caracalla and Diocletian are outstanding. Going to the baths was an everyday habit for both rich and poor, young and old, men and women. During the imperial period entrance was free or at least much less than the cost of a loaf of bread. The rooms were arranged in accordance with the order of the operations. First came the dressing room or *apodyterium*, followed by the hot bath or *calidarium*, then an intermediate room with lukewarm temperatures, called the *tepidarium*, and finally the cold bath or *frigidarium*. The pool, called the *natatio*, was usually outside.

All around the main rooms were smaller ones, used as saunas, for the application of oils and ointments, massage, and hair removal. The gymnasiums, which were usually part of the bathhouse structure, were also important and these complexes included libraries, reading and meeting rooms and snack bars. These very popular public health facilities were not just about health and fitness but also social centers, where people got together for pleasure, to talk about politics, sport and business. Other major attractions for the Roman population were the circus and amphitheaters. Public spectacle in Rome was always used for political and electoral propaganda so that it was one of the most valuable tools in keeping absolute imperial power. As these shows became more important in this role, they became more and more frequent with a growing number of public holidays to which they were linked.

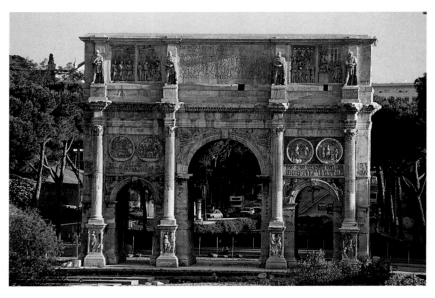

R o m e

74-75 *The Roman Forum was not only a place to celebrate the personal victories of the leaders but also for political and business discussions, religious ceremonies and a marketplace. In the photograph, to the left of the Temple of Antonius and Faustina, we can see the rebuilt section of the Temple of Vesta in the center and the three remaining columns of the Temple of Discuros on the right. Behind this is the Arch of Titus, built in 81 to celebrate the victories of Vespasian and his son over the Judeans.*

75 bottom *In the circles of Hadrian which decorate Constantine's Arch, two of which are shown here, the head of the emperor was replaced with that of the new leader, who became the ruler of Rome after defeating and killing his rival Massensius. The honorary arch built to celebrate an important figure is one of the most typical architectural features of Roman civilization. Arches can also be of religious significance or a means of marking the boundaries of a city.*

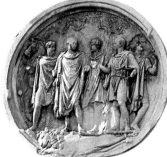

Rome

76 top This marble relief adorned one of the finest palaces on Rome's Palatine hill.

76 bottom According to tradition, Romulus founded the city of Rome on the Palatine hill where the emperors later built their palaces. In the foregrounds are the remains of the Domus Augustana, built by Augustus. The long structure in the center is the Domitian stadium.

76-77 The last of the Forums built in Rome, the one built by Trajan in 112 with booty from the Dacian wars, was also the most grandiose. It was built by Apollodorus of Damascus who introduced the transverse position of the Ulpian Basilica in relation to the rest of the complex and the great semi-circle of the Trajan Markets, a group of tabernas arranged on six floors.

They could last for hours, even a whole day, as was the case with the gladiatorial combats. Although these events usually took place during the day they were sometimes held by night using torches for lighting.

The games in the circus were the most ancient and took place in the Circus Maximus which could hold 250,000 spectators on wood scaffolding and stone terraces. Among the most popular events were the chariot races, in which special, lightweight vehicles drawn by two, three or four horses raced in a counter-clockwise way at great speed, skimming the central platform and doubling at the two ends of the track where three conical pillars stood. What rules there were were made to be broken and there was a definite attempt to force the competing chariots off the track and overturn them.

Events in the amphitheater were viewed even more passionately. This building, named the Flavian Amphitheater and known today as the Colosseum was worthy of a city as grand as Rome. It was opened in 80 AD, elliptical in shape with a circumference of 1700 feet and a height of just about 150 feet. It could hold 50,000 to 70,000 spectators. Underneath the arena, which was paved with a wooden platform covered in sand, were the underground passageways used for the various services needed for the different events, including machinery needed to change scenery. Spectators were protected from the sun by large sheets of canvas, raised and lowered by special squads from the navy. This stadium was used for the famous hunting of wild animals from all over the empire and for gladiatorial contests, in which trained fighters fought for their lives. The games were considered a great social occasion, and the audience dressed to express the importance of the event.

77 bottom The Trajan Forum contains a column built to celebrate the victory of the emperor over the Dacians. It is 100 feet high. The stem is decorated with a continuous spiral covered with reliefs containing about 2,500 figures which were originally multicolored and show the main episodes of the military campaign in great detail. The column was originally topped by a statue of Trajan but now it bears a statue of Saint Peter which was placed there in 1587. The cubic podium, 30 feet high and covered with friezes, contains the funerary remains of the emperor.

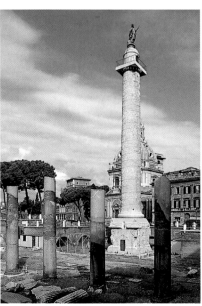

78 top The gladiators, here shown in a famous mosaic found in Tuscolum and now in the Galleria Borghese in Rome, were the property of an impressario who trained and equipped them at his own expense. Only the most skilled fighters, after a long career, were ever freed but they usually stayed in the field as trainers. Freedom is symbolized by a wooden sword.

78-79 and 78 bottom The Colosseum, used for gladiatorial games and wild animal hunts, was exceptionally large, the biggest of the Roman amphitheaters. The pictures show the shape of the building whose load bearing domed shaped structures in travertine rock were connected by brick and tile walls. From above, the complex system of underground passages that ran beneath the arena can be clearly seen.

Theatrical performances had smaller audiences even though Rome had such splendid theaters as the Marcellus, upon whose foundations the noble Orsini family built their 16th century palace. The imperial Romans preferred somewhat unrefined theatrical performances with scantily clad actresses rather than the great classics of the past.

Rome was known and honored throughout the world but it suffered from many of the problems typical of today's big cities, including traffic problems. When the situation got desperately out of hand, the authorities prohibited movement of traffic during the day except, for instance, of garbage trucks and those carrying building materials for public works. This meant it

A lightweight carriage was used for the fast *cursus publicus*, the name of the public transportation service. Litters and vehicles of every kind were seen on the streets. Life was lived mainly outdoors in Rome and the noise continued all through the day and on into the night when carriages loaded with goods and heavy materials could travel the streets.

Serious problems for the authorities included waste disposal and street cleaning and the prevention of accidents including fires. The fire department was a group of watchmen in military uniform who were equipped with ladders, buckets, fire blankets and pumps that connected to the public fountains.

Water supply was always of major concern

was necessary to set aside parking areas for both vehicles and horses, thus starting a new and still-present business. However, traffic continued to remain a problem in Rome because most trading activities took place in the open and the stalls blocked both the streets and doorways. Four-wheeled passenger carriages fought for road space with the much heavier goods carts or with the smaller two-wheeled chariots used by farmers to take their goods to market.

for Rome. The city, which was supplied by eleven reservoirs, was able to draw on a enormous amount of water every day during the 3rd and 4th centuries AD. This capacity permitted a daily consumption that was actually double what is now available. Of course, the bathhouses, fountains and other public services used a good proportion of the total supply. In Rome at its most splendid there were 856 public bathhouses, 2 spots where mock naval battles were staged, and 1,352 fountains

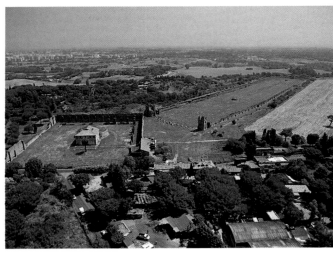

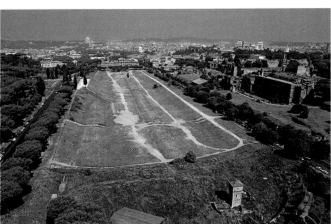

80 top Built in 309 outside the city walls, the Circus of Massensius is one of the best conserved in the Roman world. It is over 550 yards long.

80 center The Circus Maximus dates back to the royal period in Rome and was rebuilt several times. It was the biggest building for public performance in Rome. During Trajan times It was 660 yards long. Although experts disagree, most believe it could hold 250,000 spectators and, on special occasions, up to 320,000.

80 bottom left The Theater of Marcellus was completed in 13 BC on the orders of Augustus, who dedicated it to his nephew and original heir, who had died two years before. This theater, it is believed, could hold between 15,000 and 20,000 spectators.

and ponds as well as other water-based activities. The most advanced sewage system in the ancient world effectively removed filthy water.

The problem of overcrowding was not, however, limited to traffic and the water supply. During the time of Cicero (106 BC-43 AD) Rome looked as if it were suspended in air, someone said, due to the height of its buildings. Under Augustus they went higher still. The state did occasionally intervene to control building but more often than not with relatively little effect. Augustus himself, who said he had been given a city of bricks and left it made of marble, was unable to solve the general situation of overcrowding and congestion in the poorer quarters.

Fires and building collapses were among the most common incidents. The upper floors of the buildings were often based on wooden frameworks supporting lightweight masonry structures which were both quick and cheap to build but also very fragile and highly inflammable. It was, strangely perhaps in view of his generally bad reputation, Nero who deserves the credit for stopping this state of affairs and partially renovating the city.

The terrible fire of 64 AD which destroyed so much of the city led to the issuing of strict laws against unauthorized building. Property owners were forced to ensure that specific safety regulations were followed. Buildings could be no taller than twice the width of the road, wood ceilings were forbidden, broad porticoes had to be built at the front and the houses had to be separated from each other. Rome was never a planned city. During the imperial age, although it was the greatest city of the ancient world, the first true world capital, it was both chaotic and shapeless in form. The inhabitants were crowded into what little space was left free after the imperial palaces, markets, gardens and countless public buildings were built. In the 4th century AD it is estimated there were about 1,800 private houses in the city and another 44,000 apartment houses. These huge apartment houses were the most common type of housing in Rome.

They were built of brick with a tile covering and usually had shops on the ground floor

81 bottom The aerial photograph shows the imposing remains of the Baths of Diocletian, the largest in the Roman world. This enormous complex was built entirely of tiles between 298 and 306. It could be used by 3,000 people at once. In 1566 Michelangelo transformed the frigidarium, about 95 yards long and 90 feet high, into the church of Saint Mary of the Angels.

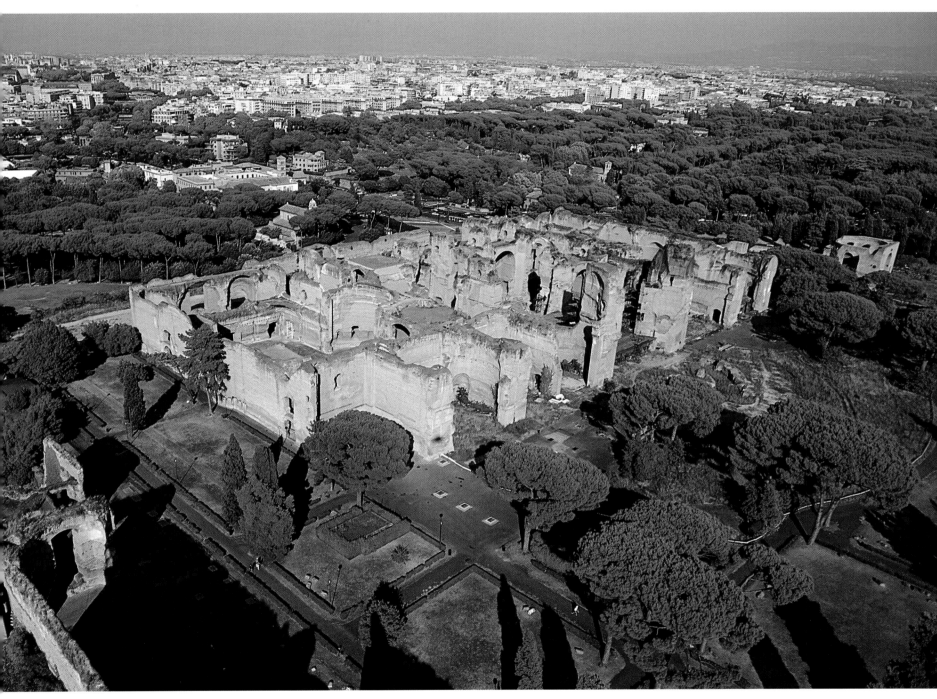

80 bottom right Among the many works of art in the Baths of Caracalla, the marble group of the Farnese Bull is outstanding. This is a precious copy from the Antonine period of a Greek original by Apollonius of Thralles.

80-81 The Baths of Caracalla were begun in 212 by Septimus Severus in 212 and opened four years later by his son, for whom they are named. These baths were among the most luxurious in Rome. They stretched over an enormous area and could hold 1,600 people.

82 top This temple near the Boarian Forum owes its current appearance to the rebuilding of its fa(ade in the 1st century BC.

82 center The Great Mausoleum of Augustus as it appears today. It is a circular building over 280 feet in diameter. On top of this mausoleum was a mound of earth planted with cypresses. In the center of this there was probably some type of cylindrical structure topped with a golden statue of the emperor.

82 bottom The Ara Pacis Augustae, a monument of great historic and artistic value, was completely rebuilt in the late Thirties in a special area in front of the tomb of Augustus. The altar with its sumptuous sculpted decorations was built on the wishes of the Senate in gratitude for the peace throughout the Roman world following victories in Spain and Gaul. It was dedicated in a ceremony in 9 BC.

looking onto the streets. The more comfortable apartments faced an inner courtyard. Other apartments were reached by staircases and opened onto inner landings. Toilets were sometimes shared. When they were they were on the ground floor. When apartments had individual toilets they were in suitable small rooms and served by the same sewage pipe. Examples of these buildings have almost entirely disappeared in Rome although in Ostia there are many remaining apartments of this type.

Because of the density of the population in Rome apartment buildings there often reached as high as 100 feet. There were no dividing lines between different sections in Rome, so that luxurious residences were often built alongside extremely uncomfortable and fragile buildings, connecting with each other by narrow alleys. Only the wealthy lived in spacious, comfortable houses. Most of the population was in small houses or, much more often, rented apartments of varying quality. The attic floors and the cellars, the areas under the stairs and even the storage areas of the shops were often lived in by slaves and poor citizens.

Despite this it is important to remember that Rome and Roman towns in general provided a quality of life for the citizens that disappeared later and was not realized again until the end of the 18th century. The imposing remains that we can still see today bear witness to an economic wealth and quality of life unachieved until very recently.

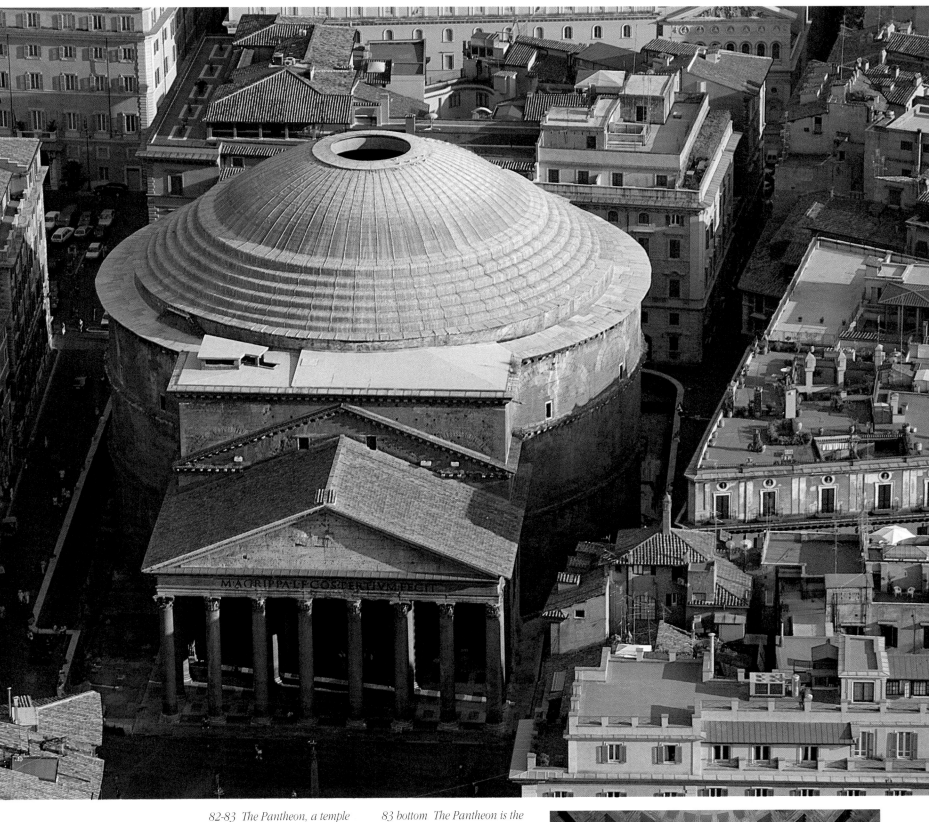

82-83 The Pantheon, a temple dedicated to all the gods that protected the Julian family, was built through the generosity of Agrippa, son-in-law of Augustus, in 27 BC. Following a fire, it was rebuilt in its present form on the orders of Hadrian. The building is made up of a cylindrical body with the pronaos supported by sixteen monolithic Corinthian columns.

83 bottom The Pantheon is the best preserved Roman building and a crowning glory of universal architecture.
Its cupola, with a diameter of over 140 feet, is the largest ever built without the use of reinforced concrete.
Inside, the structure is enriched with five rows of paneling.

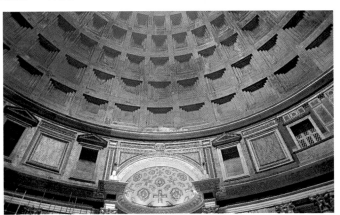

Rome

R o m e

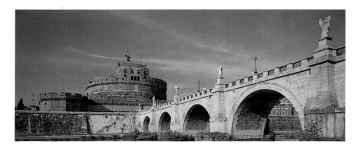

84 top In front of Hadrian's tomb, today known as Castel Sant' Angelo, the River Tiber flows under the elegant Ponte Elio, built by Hadrian to link his tomb to the field of Martius.

84 center The Fabricio Bridge connects the island of Tiberina to the left bank of the Tiber. The oldest bridge in Rome, it was built in 62 BC and measures 200 feet long.

This, then, is the side of Ancient Rome that we should keep in mind along with the history, the battles the writing and the drama. It was also a major urban center and, as such, it speaks to us today in a language we understand as clearly as if it were our own. As we have said, the problems of Ancient Rome are the problems we face today. The overcrowding in the poorer centers of our cities that contrasts so dramatically with the wealthy areas was

visible in Rome, too. In many of our urban centers wealth and poverty live almost side by side. We, like Rome, face problems of ensuring sound healthy water supplies and we, like Rome, luxuriate in the creation of more and more places where we can indulge our bodies' desires for cleanliness and health. But it is, perhaps, in the homes of the ordinary people, in the apartment houses rising above the skyline of Ancient Rome and reflected everywhere in the world today, that we can see ourselves most clearly. Throughout the world people live in multistoried buildings, neighbor next to and above and below neighbor in this way which we tend to think unique to our age but which the Romans knew, too. They, too, suffered from noise at night but contrasted it with the stimulation of life in a large city. We have seen how the Romans loved, enjoyed, almost demanded entertainment and there, too, we have an echo in our own lives. Despite the fact that we have television and radio to entertain us we go to see sports ourselves. Our stadiums are filled, our children wear caps supporting their favorite teams. We cheer for one side or one individual over another. How is this different from Rome? The theater is a rich part of our lives, whether it is the theater as represented by the movies or the live stage. We, too, like the Romans have a choice of either spoken or musical performances. And, although many of us pride ourselves on our level of appreciation for high culture, often that is not the most successful at the box office. Rome was then and now is now and yet, as we have stressed throughout this book, we can see ourselves today in the life of the past.

84 bottom The marble pyramid of Caius Cestius, alongside the Porta San Paolo, is the original tomb of this praetor and tribune who died in 12 BC. The building, inspired by models that became fashionable after the conquest of Egypt, is covered with marble squares and is over 115 feet high. It was incorporated within the Aurelian walls nearly three centuries after being built.

84-85 The enormous mausoleum Hadrian built for himself and his successors was changed over the centuries into what is now known as Castel Sant' Angelo. The great cylindrical structure, which was on a huge four-sided base topped with a mound of earth planted with cypresses, was topped by a high podium, on which there may have been a group of statues or a bronze equestrian statue.

Rome

85 top The tomb of Cecilia Metella, daughter-in-law of the triumvir Crassus, is the most famous monument on the Appian Way. This tomb dates to the last decade of the republican period and was turned into a fortress in medieval times.

85 bottom left Originally, the two arches of the Porta Maggiore were not part of the Aurelian Walls but of the aqueduct built in 52 AD under Claudius. Lead water pipes ran along the top.

85 bottom right With a single opening flanked by towers, the Gate of Saint Sebastian opens onto the Aurelian Walls, which ran around the city for almost 12 miles. The walls, begun in 271 under Aurelian, were completed by Probus.

HADRIAN'S
SUMPTUOUS VILLA

A Theater
B Circular temple
C Triclinii
D Hospitalia
E Courtyard of the Libraries
F Maritime theatre
G Peristilium
H Room of the Doric pillars
I Golden Square
J Guards' barracks
K Pecile
L Aquarium
M Nympheon
N Building with three exedras
O Small rooms
P Small bath-house
Q Great bath-house
R Vestibule
S Canopy

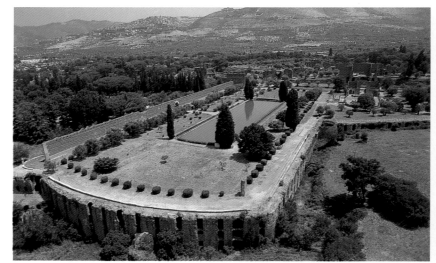

Hadrian was one of the great historical figures of all time. Roman emperor, he was born in 76 AD in Italica in Spain, and was still very young when he held his first public offices which were granted to him because of his strength of character and military bravery.

A versatile man, he was a restless, romantic spirit, a deep thinker, a poet, and a refined admirer of Greek civilization.

Appointed successor to Trajan, the man who had carried Rome to its furthest frontiers, he was appointed emperor in 117 AD when he was governor of Syria, when he was just over 40 years old.

He returned to Rome where he embarked on a complex program for consolidating the political and military system of the empire. He visited Germany, France and Britain, where he arranged for the building of the

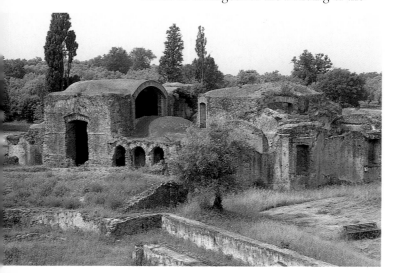

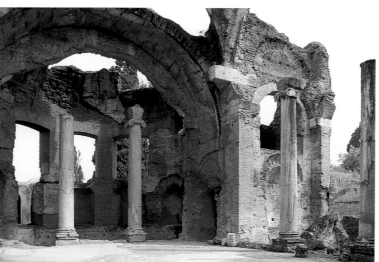

famous "Hadrian's Wall", as well as Spain, Africa, and the East.

He was back in Rome in 134 AD and from that time until his sudden death in 138 he devoted his energies to the administrative reform of Italy and fiscal reorganization of the provinces. The place he loved most was Tivoli, where he went to escape from the stress of his office.

Ancient Tibur, the city founded originally by the Latins to the southeast of Rome, became during the time of Augustus one of the most fashionable resorts for wealthy Romans. Among those who stayed in Tivoli were Cassius, Horace, Catullus, Augustus, and Hadrian.

As well as the pleasant nature of the area, visitors were also attracted by a famous statue of Hercules, the Oracle of Sybil and

the sulfur springs, believed to have healing powers, nearby.

Today, of course, Tivoli is famous above all for its grandiose Hadrian's Villa, placed in a spacious plain among the slopes of the Tiburtine Hills to the southwest of the town. The huge complex of buildings fills an enormous area and is one of the most impressive archaeological parks in all Italy, a country noted for its historical remains. Built on the site previously occupied by a villa from the Republican period, Hadrian's Villa blends harmoniously into the surrounding landscape in such a way that it looks almost as if it grew there naturally. It was, however, quite deliberately planned. It has been described by B. Cunliffe as "a studied architectural landscape".

Building work on the villa began in 118 and

86 top left In his luxurious villa near Tivoli, Hadrian wanted reminders of the monuments he had seen during his long travels to the four corners of the empire, especially Egypt and Greece. The Pecilis, here seen from above, is named after a great porticoed square in Athens.

86 bottom left and 86 right Hadrian was a genius with many talents including those of an architect. In his elaborate residential complex he experimented with advanced building techniques, making wide use of cupolas and semi-cupolas such as those in the Small Bath House (center) and the Great Bath House (below).

86-87 The aerial photograph shows the huge size of the residential complex built by Hadrian. In the foreground are the remains of the square portico with the so-called aquarium. To the left is the Small Bath House, to the right the Guards' Barracks and the circular structure of the Maritime Theater. In the background is the great pool of Pecilis.

87 bottom This delicate mosaic from Hadrian's Villa was produced using extremely small chips of glass-like material. It is the copy of a work by Sosos of Pergamon. Hadrian, who is said to have spoken Greek perfectly, was a great admirer of ancient Hellenic culture.

87

88-89 Some experts believe that the Maritime Theater, surrounded by a portico and moat, was actually the small villa where Hadrian went to meditate alone, away from the rest of the world. It is probable that the residence of Augustus on the Palatine Hill and, even earlier, the palace of Dionysius the Elder in Syracuse were used for similar purposes. However, a fairly recent theory by the Swiss scholar Henri Stierlin is that the structure was actually a complex cosmic symbol at the center of which was the wooden dome of a planetarium.

89 top This red marble faun, a precious copy of a bronze Hellenic original, was found in Hadrian's Villa. It is now in Rome's Capitoline Museum. Hadrian was a highly cultured man and in his luxurious residence he built up an extraordinary art collection, most of which was lost during the Renaissance. In the middle of the 16th century, for example, Cardinal Ippolito d'Este financed major excavations at the site of the villa with a view to finding as many sculptures and other works as possible to decorate his own elegant villa near Tivoli.

went on for over ten years, while Hadrian was traveling and inspecting the various provinces of the empire.

The villa can almost be interpreted as representing an anthology of memories of these travels and a symbol of the immense territory unified by the emperor.

Hadrian, a great lover of both art and Greek tradition, took his inspiration from famous objects of the past, freely imitating the places and monuments that he remembered best. This explains the great variety of the structures flanking the residential part of the complex which is quite unusual in Roman architecture. Originally, the work consisted of simply restructuring and extending the existing buildings to which a spa and gymnasium complex and an official banqueting hall

were added.

All the rest, including warehouses, porticoes, swimming pools and theater were built as the site took on its final, monumental dimensions, completed in 133 AD.

The entire area had a system of underground passages, some of which were suitable for wheeled traffic. This was apparently a kind of independent service network, designed to avoid disturbing events going on above.

The main entrance to the villa was from the north, by a side road from the Tiburtine Way, running alongside the Vale of Tempe, named because of its similarity to a place of the same name in Thessaly. This was the site of the dormitory for the Praetorian guards who watched the entrance.

Nearby were two rooms which are known as libraries although they actually were summer dining rooms. They are part of the oldest section of the building. At the rear of one of these are the remains of the Maritime Theater, one of the most impressive parts of the entire complex. This is formed by a curved wall with porticoes on the inner side which separate the structure from the rest of the villa and a space which marks off a circular island, once linked by two small bridges. On this artificial island there is a miniature villa for rest and relaxation built around a courtyard with a fountain and complete with a small bathhouse complex. This is believed to be copied from the residence of Augustus on the Palatine Hill which was influenced by the palace of Dionysius the Elder in Syracuse.

It is important to know that Hadrian's Villa was originally designed as a government building with all the facilities necessary so that it could back up or even replace the imperial palace in Rome.

This sumptuous residence could not only house all the public functions of the emperor but it also guaranteed privacy, keeping Hadrian away from the court that surrounded him in Rome and from the control of the senate.

Here he was also able to put his own architectural ideas into practice, ideas which at times seem to combine classics with an almost Baroque richness along with eager use of new building methods.

Hadrian's villa

89 bottom Shown is a view of the circular portico that surrounds the Maritime Theater, whose name is due to an imaginative interpretation by 19th century archaeologists.

According to the contemporary archaeologist Henri Stierlin, however, the island represents the Earth, the channel at its edge is the Ocean, known to the Greeks as Chronos, god of time and father of Zeus. In the hall at the center of the structure which was covered by the wooden dome of the planetarium, Hadrian went from time to time to carry out his studies in astronomy and meteorology, practice divination and make horoscopes.

The villa is famous for its use of curved surfaces and the variety of domes of all types, including semi-spherical, segmented, and pointed in combination with design details that carefully play with light and shade.

The central part of the villa extends beyond the Maritime Theater.

It includes the courtyard of the libraries, the palace, the Nymphs' Shrine, the hall of the Doric pillars with the guards' barracks off to the side, and finally the Golden Square which is surrounded by a large peristyle and double naved portico.

The hall of the Doric pillars leads to the area known as the Throne Room, probably a kind of assembly room for the formal

world, occupying a narrow valley and consisting of a long hall with its short, convex side decorated with a colonnade and highly decorated architrave.

Other colonnades flank the long sides of the valley and were originally decorated with imitations of famous Greek statues. The valley is closed off by a great semi-circular hall covered by a segmented, flat and concave semi-cupola. This was a refined, imposing summer dining area.

The plan seems to take its inspiration from those of the Egyptian temples and fits in well with the adjacent stretch of water. In ancient times, Alexandria had been linked to the city of Canopus and its famous temple of Serapis by a canal. The canal and

the city were famous for their celebrations and banquets, an echo of which we can also find in the famous Nilotic mosaic of Palestrina.

Antinous, the handsome favorite of the emperor, was drowned in the Nile in Canopus, an event that plunged Hadrian into a deep depression.

This may explain why the finest statues of the young man were found here, alongside the faithful imitations of the Caryatids of Erectheus.

Many other copies of famous sculptures, such as the imitation of Venus of Knidos by Praxiteles, were in various sections of the villa, reflecting the emperor's great love of collecting.

The richness of these finds and the ease of access to the ruins made Hadrian's Villa a favorite destination for scholars and antiquarians during the Renaissance. Unfortunately, this means that a great deal of the fine heritage from this villa is now scattered throughout Europe in museums and private collections.

This continued until 1873 when the first Italian government-sponsored excavations began. Today, Hadrian's Villa is visited by thousands of tourists every year and continues to be studied by scholars. It is a fitting memorial to a complex and extraordinary man.

sittings of the imperial court.

The northern side of the Golden Square consists of an eight-sided vestibule covered by one of the most famous examples of a segmented cupola. To the south, the large, complex, semi-circular Nymphs' Shrine is found, perhaps a summer dining area for the emperor.

Against the western wall of the Philosophers' Hall, at the Maritime Theater, is one of the short sides of the Peciles, a spacious square surrounded by porticoes which forms a Greek-inspired area designed specifically for walking and learned conversation.

Toward the east is another series of buildings, the most famous of which are the stadium and summer banqueting hall for official occasions.

Other areas include the small and great bathhouses, the vestibule and, finally, the Canopus. This is one of the most famous architectural complexes of the ancient

90 top Along the edge of the basin occupying the central part of what is called the Canopy is an elegant colonnade of copies of famous Greek statues.

90 bottom Several statues of Antinous, Hadrian's favorite who drowned in the Nile during a voyage to Egypt with the emperor, were found near the Canopy.

91 Hadrian's skill as an architect is clear in the elaborate layout of the Canopy, which occupies an artificial valley to the south of the residential complex. In this monument the emperor intended to copy the Temple of Serapides at Canopus in Egypt and the canal that linked that town with Alexandria. In the foreground the great semi-cupola of the Serapeon stands out.

AFRICA
Introduction

The Sahara divides North Africa like an immense sea of sand. Like an ocean, it can only be crossed with method and great knowledge. Even today, a journey in the vast expanse of dunes that is the Sahara is an adventure in every sense.

In the distant past, the emergence of the desert meant the separation of the African peoples who occupied the territories along the Mediterranean shores from those who lived in the interior of the continent. North and south began to develop independently of each other, giving rise to ways of life and culture that went on as time passed to differ irreversibly from each other.

Between the Mediterranean and the rest of Africa, however, there remained one point of contact to the east. The fast flowing Nile runs between the rocks of the high desert plains of the Sahara for hundreds of miles, creating a corridor of fertile land that links Lake Victoria with the Mediterranean. The good living conditions created by the annual flooding of the river were at the basis of the development along its banks of one of the most ancient civilizations on earth.

People, probably coming from the southern edges of the Sahara, settled near the fertile land along the Nile around 6,000-7,000 years ago. They then moved up along the river, gradually changing from a mainly semi-nomadic lifestyle in which they survived by hunting, fishing and the fruit and vegetables they were able to pick to a sedentary one which enabled them to develop an economy based on agriculture and the breeding of animals. The trading relationships with the Mesopotamian regions led to fast technological and cultural development. Between the middle and the end of the 4th millennium the people living between the First Cataract on the Nile and the shores of the Mediterranean grouped into a single state. And, scholars believe, Egyptian civilization showed from the beginning the features that were to distinguish it in the almost three thousand years of its history.

This civilization also built the earliest cities on the African continent. The foundation of the first capital of a unified Egypt was considered such an important event that it has become a legend. According to this legend, Memphis was attributed to Menes, the first man to put himself in the place of the gods as leader of Egypt. For this reason, the city always retained a role of primary importance throughout the history of the Pharaohs.

The desert not far from the town was chosen as the site of the rulers' tombs. These imposing funerary complexes were built in various locations, including an area stretching for about 40 miles. With the founding of the Ancient Kingdom, these were transformed into that most spectacular of monuments, the pyramid, so unique and extraordinary that it has become the symbol of the entire Egyptian culture.

Today, Cairo, overcrowded and suffering from a severe housing shortage, has spread out to touch the high plain on which the pyramids of Cheops, Chefren and Mycerine stand. Giza is no longer the name of just this historic site, but also a densely populated area of the capital of modern Egypt, with concrete houses stretching far out along earth roads. The road that leads to the archaeological site is flanked by bars and taverns where frantic nightlife goes on in this metropolis full of contradictions which is in constant balance between east and west, old and new.

Nevertheless, the first sight of the pyramids at Giza is always unforgettable. Their imposing structure and sacred aura cancel out everything around them. Overwhelmed by their amazing presence in the desert, there is no space in the viewer's eye for anything else.

Memphis, the capital of Egypt for centuries, later lost this role to Thebes, called by the Egyptians Uaset or "the powerful" and corresponding to modern Luxor. It was from this city that the rulers of the XI dynasty came (2150-1050 BC) who united Egypt again after a period of territorial division and internal disputes between bordering mini-states.

92-93 The rock temple of Abu Simbel, in Lower Nubia, is not only the most famous monument of Ancient Egypt after the pyramids, but was also a personal triumph for the most powerful of the pharaohs, Ramses II. Dug entirely from sandstone around 1260 BC, the sanctuary is 125 feet wide and reaches over 100 feet in height.

The funerary complex built by Mentuhotep II at the base of the natural amphitheater of Deir el-Bahri dates back to the beginning of this period. The remains of sacred buildings at Karnak, site of the temple dedicated to Amon, god of the city, date to roughly the same time. With the ascent of the Theban dynasty to the throne of Egypt, the cult of Amon spread throughout the country, with the result that the temple of Karnak expanded over time as each ruler added something to what his predecessors had already built.

Today, Karnak is a monument without equals. As one walks through it one moves backward in time. From the Ptolemaic pylon we reach the buildings of Thutmose III through 300 yards of halls, columns, obelisks, statues and walls covered in painted scenes and inscriptions, attesting to nearly fifteen hundred years of human history.

Thebes had its period of maximum splendor when the Pharaohs were at their most powerful, during the New Kingdom. Many monuments were built by the rulers of the 18th, 19th and 20th dynasties in this opulent capital that governed a vast territory. The mountain overlooking Luxor was chosen as the burial place of the rulers, whose final resting place was dug out from deep in the rocky banks of a gorge where a roaring river flowed during the rainy season. It was here, in 1922, that the intact tomb of Tutankhamen was found, together with the most splendid burial treasure ever discovered. On the eastern bank of Thebes are the ruins of the temple of Luxor, once connected to Karnak by an avenue lined with sphinxes, five miles long. The greatest building expansion took place under Ramses II, who had scenes of the battle he had fought against the Hittites in Qadesh painted on the outer walls of the first pylon. The same scenes and inscriptions can also be found on the walls of the first columned room in the Greater Temple at Abu Simbel, dug out of the rock over 300 miles south of Luxor. Here Ramses II celebrated his greatness, deifying himself while still alive, and enhancing his own glory with symbols and allusions which become more and more explicit as we approach the inner part of the temple. The smaller rock sanctuary, dedicated to his wife, simply repeats the message of the greatness and divinity of Ramses II.

Abu Simbel is in the region known as Nubia, whose northern boundary is marked by the modern town of Aswan. Not far from here, the history of the Egypt of the Pharaohs came to an end. The temple complex dedicated to Isis, once standing on the island of Phylo and now on Agilkia, where it was moved during the 1970s to prevent its being flooded as part of the amazing engineering work involved in building the Aswan Dam, is one of the most important centers of worship in the Egypt of the later period. On its walls, among the many inscriptions referring to the devotion of Egyptian, Greek, Roman and Merotic pilgrims to the wife of Osiris, there is one from the August 24, 394 BC, believed to be the most recent hieroglyphic ever found. Although Egypt dominates African archaeology, with its wealth of famous monuments, there are other regions that show signs of a more recent but equally glorious past. The coasts of North Africa enjoyed a period of extraordinary vitality from the start of the first millennium BC and reached their maximum splendor in the beginning of the first millennium AD. At this time they were provinces of the Roman Empire, lively, dynamic centers of culture and birthplaces of many figures who made important contributions to the growth and development of Roman civilization. One of these cities is Leptis Magna in Libya. The ruins of this city may be said to testify more than those of any other city to the coast of North Africa at the dawn of our age as one of the most crucial meeting points in human history.

Francesco Tiradritti

92 top The scroll with the name of Nephertari appears several times in the tomb of the Great Royal Spouse of Ramses II, the most spectacular of the underground tombs in the Valley of the Kings. The hieroglyphics were deciphered in 1822 by Jean François Champollion, who was then 32 years old. In 1824 he published his basic Precis du système hyeroglyphique.

93 bottom Emblem of the Egyptian civilization, the Sphinx emerges from the desert sands in front of the pyramid of Chefren at Giza. The enormous leonine body, dug out of a spur of limestone and almost 190 feet long, has the face of the pharaoh. Its mysterious face, unchanging over the centuries, has watched the rising sun for thousands of years.

Africa

Africa

LEPTIS MAGNA

CHRONOLOGY

Paleolithic and Neolithic period
(60000-3000 BC)

Pre-dynastic Period in Egypt
(3300-2920 BC)

Proto-dynastic Period
(2920-2670 BC)

I Dynasty
(ca. 2920-2770 BC)

II Dynasty
(ca. 2770-2670 BC)

Ancient Kingdom
(2670-2150 BC)

III Dynasty
(ca. 2670-2570 BC) Main
rulers: Sanakht, Djoser,
Sekhemkhet.

IV Dynasty
(ca. 2570-2450 BC)
Main rulers: Snefru,
Cheope, Chefren,
Mycerene.

V Dynasty
(ca. 2450-2300 BC)
Main rulers: Userkaf,
Sahura, Neferirkara,
Neuserra, Unas.

VI Dynasty
(ca. 2300-2150)
Main rulers: Teti,
Pepi I, Merenra, Pepi II.

1st Intermediate Period
(2150-2100 BC)

Middle Kingdom
(2100-1750 BC)

XI Dynasty
(ca. 2100-1955 BC)

XII Dynasty
(ca. 1955-1750)

2nd Intermediate Period
(1750-1640 BC)

**Period of Hyksos
domination**
(1640-1550 BC)

XIII-XVII Dynasties
(ca. 1750-1550 BC)

New Kingdom
(1550-1076 BC)

XVIII Dynasty
(ca. 1550-1295 BC)
Main rulers:
Thutmose I, Thutmose III,
Hatshepsut, Amenophi II,
Thutmose IV, Amenophi III,
Amenophi IV/Ekhnaton,
Tutankhamen, Horemheb.

XIX Dynasty
(ca. 1295-1188 BC)
Main rulers:
Ramses I, Sethi I,
Ramses II, Merneptah.

XX Dynasty
(ca. 1188-1076 BC)
Main rulers:
Ramses III, Ramses IV,
Ramses IX, Ramses X,
Ramses XI.

XXI Dynasty
(ca. 1076-945 BC)

XXII Dynasty
(ca. 945-828 BC)

XXIII Dynasty
(ca. 828-742 BC)

XXIV Dynasty (Saitic)
(ca. 742-712 BC)

XXV Dynasty
(ca. 712-664 BC)
Main rulers: Shabaka,
Taharqa.

XXVI Dynasty
(ca. 664-525 BC)
Main rulers:
Psammetico I, Psammetico
II, Amasi.

1st Persian Period
(ca. 525-405 BC)

XXVII Dynasty (Persian)
(ca. 525-405 BC)

XXVIII Dynasty
(ca. 405-399 BC)

XXVIX Dynasty
(ca. 399-380 BC)

XXX Dynasty
(ca. 380-343 BC)
Main rulers:
Nectanebo I, Nectanebo II.

2nd Persian Period
(343-332 BC)

Macedonian Dynasty
(ca. 332-304)
Main rulers
Alexander the Great,
Philippus Arrideus,
Alexander IV.

Ptolemaic Dynasty
(ca. 304-30 BC)

**Destruction of Carthage and
start of Roman rule in
Africa**
(146 BC)

**Cyrenaica becomes a
Roman province**
(74 BC)

**Caesar annexes the
province of Numidia**
(46 BC)

**Egypt becomes a Roman
province**
(30 BC)

**Mauretania becomes a
Roman province**
(40 AD)

**Vespasian proclaimed
emperor at Alexandria**
(69)

**Septimus Severus born in
Leptis Magna**
(146)

**The army of Queen Zenobia
occupies Lower Egypt, but
is pushed back**
(268-270)

**Under Constantine, Egypt
becomes a diocese**
(324-337)

**Egypt becomes part of the
Byzantine empire**
(395)

**Egypt is occupied by the
Arabs**
(640)

CONTENTS

SAQQARA
AND GIZA

KARNAK
WESTERN THEBES · LUXOR
THE NUBIAN TEMPLES · PHILAE
THE NUBIAN TEMPLES
ABU SIMBEL

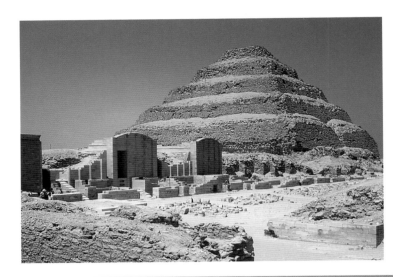

SAQQARA AND GIZA, *BURIAL GROUNDS OF MEMPHIS*

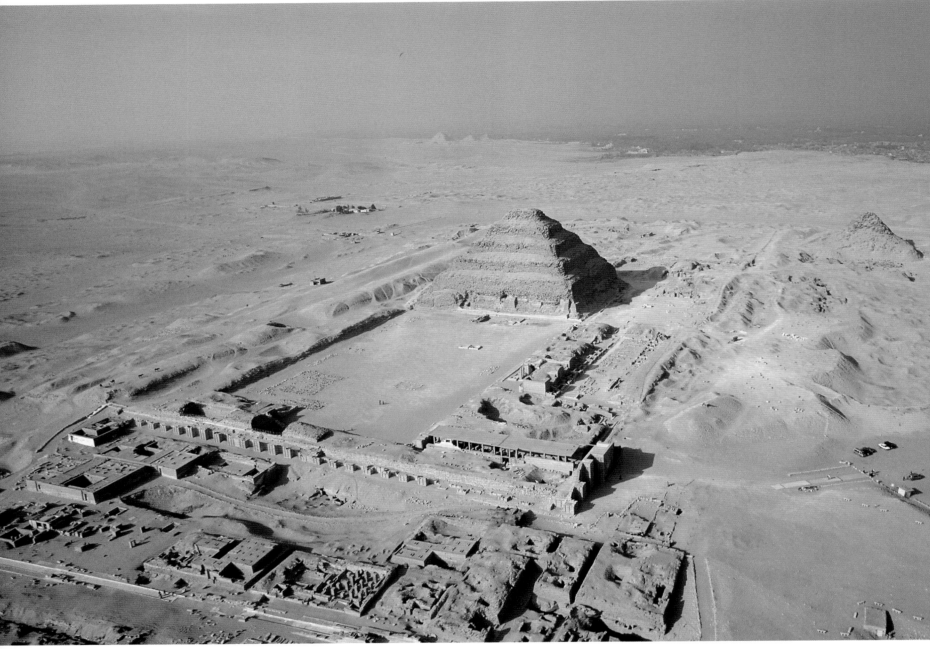

96 top The pyramid of Djoser, in Saqqara, almost 190 feet high, is the result of five successive additions to an initial mastaba built over a burial trench 93 feet deep.

96-97 The stepped pyramid, here seen from the northwest, dominates the archaeological site of Saqqara and is incorporated in a monumental group of buildings that form the so-called "complex of Djoser", which extends over an area of 38 acres.

A Burial complex of Djoser
B Pyramid of Userkaf
C Pyramid of Teti
D Monastery of St. Jeremiah
E Tomb of Horemheb
F Tomb of Maya
G Pyramid of Unas
H Burial complex of Horus Sekhemkhet

The founding of Memphis, the most ancient capital of the land of the pharaohs, is attributed to Menes, mythical sovereign believed by the Egyptians to have united the country into one kingdom. Even though the role of political and administrative center later passed on to other cities, Memphis kept its pre-eminence and authority long afterward.

The Nubian ruler Pye (750-712 BC) for instance, after sailing all the way up the Nile to the north of the fourth cataract, only considered his journey over when he entered the temple of Ptah, patron of Memphis. With this, Pye believed he had conquered all of Egypt as he had reached its deepest heart, where the royal leadership of the Pharaohs had lasted for millennia. It didn't matter to the Nubian king that descendants of Menes continued to rule to the north, for the true essence of Egypt was in Memphis. Today, little remains of the past glory of Memphis. Among the palm groves of Mit Rahina, 20 miles south of Cairo, an extensive heap of rubble covers the remains of a huge temple complex, very difficult to recognize as the temples have been repeatedly ransacked over the course of the centuries. Many of the stones, used in building the sanctuaries for the Egyptian gods, are now found in the buildings of Islamic Cairo. And yet, Memphis must have been very beautiful, if we are to believe the many descriptions of the Ramses papyri dating from the 14th and 13th centuries BC, saying such things as "Nothing can be compared to Memphis. . . Its granaries are bursting with grain and barley, its lakes are covered in flowers and lotus blossoms, the oil is sweet and fat abounds. . ."

The most important testimony to the greatness of the Pharaohs' Memphis are its tombs, stretching out over a strip of desert more than 24 miles long, to the west of the Nile, from Abu Roash, just north of Giza, to Dahshur, about 10 miles south of Saqqara. The rulers of the II dynasty were the first to exploit the desert sands to the west of Saqqara as a site of royal burial. Only a few traces remain of their tombs, spacious enclosures with a tomb in the center, now barely visible beneath the desert sands. Before these tombs, the area had been used as a cemetery by functionaries who lived during the I-dynasty, while the government of the pharaohs was still in formation and whose bureaucratic headquarters had been set up in Memphis. The tombs of these functionaries could compete with and even exceed in size those of their rulers, who were buried in Abydos in Upper Egypt, the area from which the ruling house originally came. The III-dynasty ruler Djoser (2630-2611 BC) may have decided to have his tomb built upon the infrastructure of a previous royal burial place. The entire funerary complex, designed by the architect Imhotep, was revolutionary for its time. The fulcrum of the structure was the Stepped Pyramid, around which a complex of buildings developed which were used as a backdrop for the jubilee festivals of the sovereign. One of the innovations was the building material used by Imhotep. The funerary complex of Djoser must be the first building of importance constructed entirely in stone. The abandonment of reeds, wood and Nile lime was sudden and the formal language of the structures develop from the oldest buildings in these materials. The stone architecture reveals the reference models from which its inspiration is taken.

For example, the columns are reproductions of bundles of reeds which are not completely detached from the walls to the rear, and the top parts of the outer walls show decorative designs inspired by the mud-coated reed palisades. The initial plan was altered on various occasions. The stepped pyramid takes its origins from a tomb which was similar to the one of previous dynasties. This was raised five times, by superimposing five other tombs of decreasing size to reach a total height of almost 200 feet. To the south of the sovereign's tomb a spacious courtyard opens up. This is where the most important of the ruler's jubilee celebrations took place. Djoser's funerary monument set up a process of transformation in the conception of the royal tomb in Egypt. Within the space of a few generations this led to the pyramid form which is now so familiar to us. An important stage in this development took place during the reign of Snefru (2575-2250 BC), when three pyramids were built. The first of these was erected well to the south of Memphis, in the Meidum area, while the other two, known as the "double sloping pyramid" and the "red pyramid" were located in Dahshur, about 10 miles from the capital. The last of these, despite its excessive slope, was used as a prototype for the Great Pyramid of Cheops, the son and successor of Snefru, in Giza. With Cheops (2550-2528 BC), the royal cemetery moved north, to Giza and Abu Roash. It was the rulers of the V-dynasty who once again selected Saqqara as the burial ground. To them, we owe above all the continuation of the Egyptian religion of deifying the sun,

which had already emerged during the reign of Chefren. The interests of Userkaf (2465-2458 BC) and his successors were mainly in the construction of temples dedicated to the sun. Ruins of these temples can still be admired today at Abu Ghorab, between Giza and Saqqara. The return to Saqqara as the site of the last resting place shows the evident desire of these rulers to move away from tradition. The remains of the pyramid of Userkaf are not far from the funerary complex of Djoser and show a willingness to create an ideal connection with the famous III-dynasty sovereign. The design of the pyramid reached its final form under Userkaf. From a costly structure built entirely in limestone it moved toward a funerary chamber covered with a mound mainly of rubble with an external covering of limestone slabs. The monumental appearance of the royal tomb is in this way

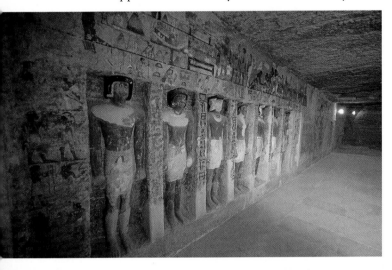

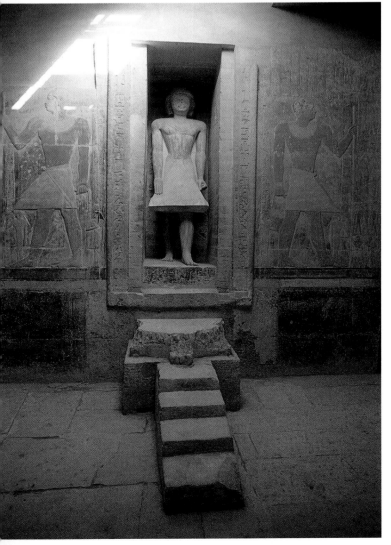

guaranteed with a reduced expenditure of energy. The successors of Userkaf chose to be buried north of Saqqara in Abu Sir. Here, among the remains of the bare brick buildings annexed to the funerary temples, numerous papyrus documents were found showing useful light on the administration of this remote age. Unas, the last ruler of the V-dynasty, chose Saqqara once again as his burial place. His pyramid is now only rubble, but the walls of his funerary apartments contain the inscriptions of the Texts of the Pyramids for the first time. This is a collection of texts that would have been of use to the dead king when he arrived in the next world. A great variety of subjects are covered, from the hymns to the gods to incantations against snakes and other magical texts still not understood by us. In Saqqara, as well as the pyramids of the VI-dynasty rulers, are the tombs of the functionaries who lived between this dynasty and the previous one. These are divided into a number of rooms, just like the houses they had lived in when they were alive. The walls are decorated with painted reliefs showing scenes from everyday life. These are works of very high artistic quality and provide us with a very precise picture of ordinary life, with all its customs and unpredictable events, both serious and amusing. The tomb of Ty is especially notable in this sense, while the tombs of Mereruka and Kagemni are considered less original and vivid although, in a sense, richer.

The necropolis of Saqqara was used continuously during the periods when Memphis no longer dominated all Egypt. Many tombs of functionaries linked with Akhenaton and Tutankhamon date to the New Kingdom. Among these, splendid decorations in the Amarnian style can be found in the tomb of General Horemheb (1319-1307 BC) who was soon to take power and become Pharaoh. During the reign of Ramses II (1290-1224 BC) the total repositioning of the Apis bulls, a few miles north of the Djoser funerary complex, took place on the order of Prince Khaemuaset.

The cult of the bull had been practiced since remote antiquity and it was mentioned in the burial treasure of Hemaka, the functionary who lived under the ruler Den in the I-dynasty. In this period, the bull was considered a personification of the generating force of nature. As time passed, it came to be seen as the earth manifestation of the protector god of Memphis, Ptah. The cult was seen as offering salvation and this led to its wide-spread popularity in Egypt in the late period. When the bull died, it received honors identical to those given the ruler. It was subjected to the complex ceremony of mummification and buried with a rich treasure in a large stone sarcophagus with long, deep galleries. During the Greco-Roman Period, the place was known as Serapeus and was mentioned in the accounts of many travelers who visited the Nile Valley at this time. Among these was Strabo, whose description influenced the Frenchman Auguste Mariette (1821-1881) to carry out a number of excavations in an attempt to bring the entrance to Serapeus to the light. After considerable effort, he succeeded in 1851. With this discovery, the systematic, scientific exploration of the tombs of Memphis, the most ancient capital of the Egypt of the Pharaohs, began.

98 top left The western wall of the tomb of Irukaptah, in the Saqqara site, is adorned with eight large multicolored statues of relatives of the dead.

98 bottom left In the mastaba of Mereruka, in Saqqara, in a deep niche of the six-columned hall, we see the life-size statue of the deceased in front of an offering table. Alongside the niche are two other images of Mereruka.

98 top right Inside the mastaba of Ptah-Hotep, in Saqqara, are sumptuous multicolored bas-reliefs. In the foreground on the right, Ptah-Hotep is shown seated and wearing the skin of a feline as he sniffs perfume from a stone container.

98 bottom right This splendid battle chariot is shown in a multicolored bas-relief in the necropolis of Saqqara.

99 In the pyramid built by Unas, last king of the V-dynasty, the walls of the inner chambers are covered with hieroglyphics in the first known example of them. These contain invocations and magical formulas, the Texts of the Pyramids, which helped vanquish the evil powers the soul of the pharaoh would meet in the afterlife on his journey toward meeting with the sun god Ra.

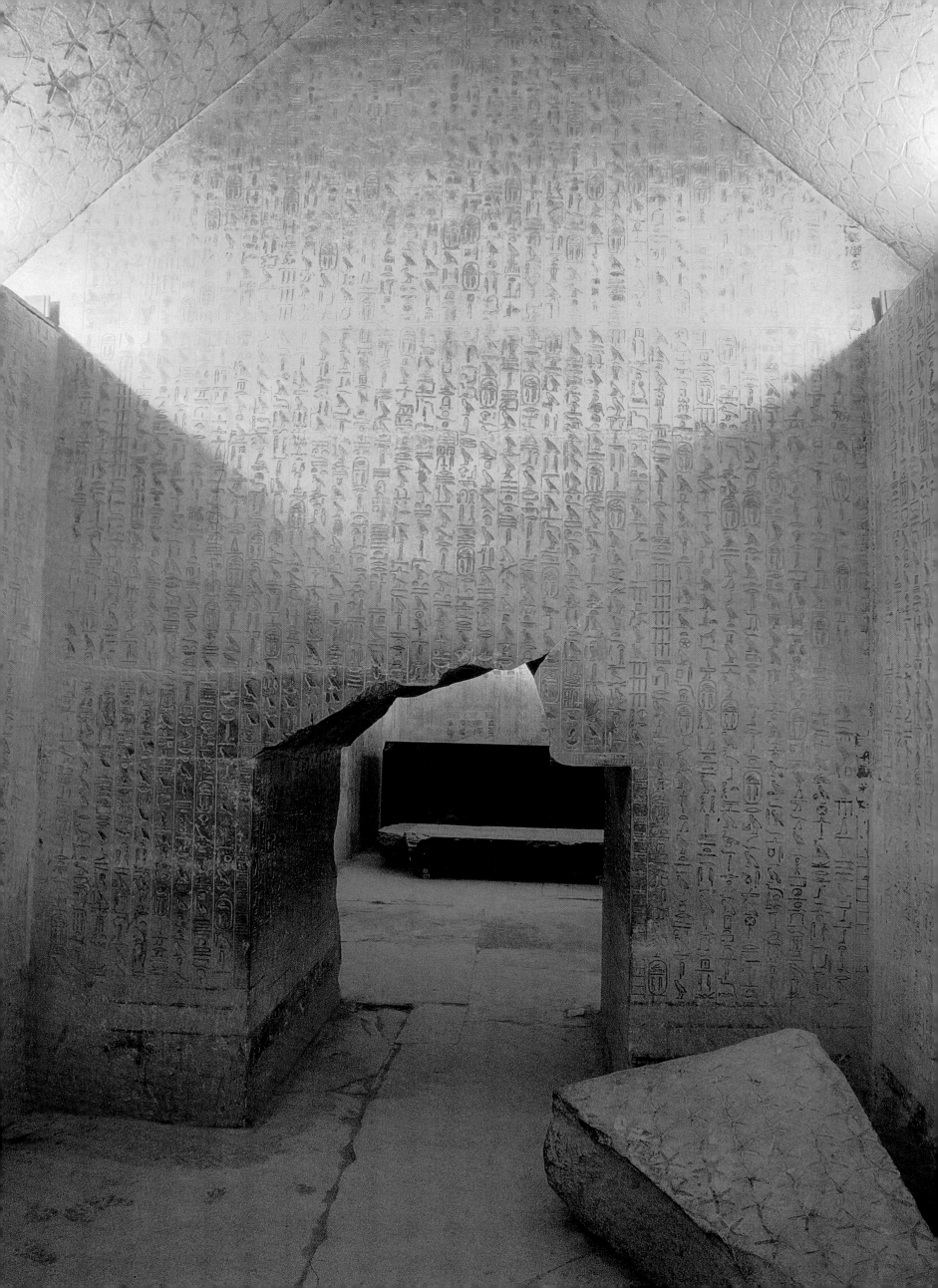

A Downstream Temple
B Temple of the Sphinx
C Sphinx
D Eastern Cemetery
E Satellite pyramids
F Ditch of the solar boats
G Pyramid of Cheops
H Western Cemetery
I Second solar boat
 (still to be unearthed)
J Funerary Temple
K Pyramid of Chefren
L Funerary Temple
M Pyramid of Mycerene
N Satellite pyramids
O Procession ramps
P Museum of the
 solar boat

The construction of the Pyramid of Cheops marked the transfer of the royal tombs to the north of Memphis, on the plateau of Giza. The funerary monument of the successor to Snefru was included among the seven wonders of the ancient world and, with its height of nearly 500 feet, is undoubtedly one of the most fascinating monuments in the history of the world. Often wrongly believed to be the highest architectural achievement of Egyptian culture, this is merely one more stage in the development of the Egyptian funerary monument. The rulers continued to be buried in pyramids but with smaller dimensions and less expensive building methods up to the Middle kingdom and beyond. Nevertheless, the Great Pyramid has always thrilled the imagination and all kinds of legends have been built around it, from those reported by Herodotus to some of the absurd tales that continue to arouse the interest of the news media today. All this is because, separated as it is from the culture that produced it, this enormous mound of stone, concealing the mummy of the ruler, loses its real meaning and leads us to make up theories developed without taking into account the great distances in both time and space between our way of

100 top left This ivory statue, found at Abydos and now in the Cairo Museum, is the only image we have of Cheops, the pharaoh who had the largest of all the Egyptian pyramids built and who ruled from 2550 to 2528 BC.

100-101 About 50 miles from the center of Cairo, at the edge of a high desert plain, the three pyramids of Cheops, Chefren and Mycerene are aligned from northeast to southwest in size order.

100 top right The Sphinx, 190 feet long, was sculpted at the time of Chefren by modeling a limestone rock that was in front of the eastern side of the pharaoh's pyramid. A male figure and a symbol of the sun god, it also was the image of the deified king.

thinking and that of the Egyptians of almost 5,000 years ago.

The pyramid, like many other symbols of Egyptian culture, is open to many interpretations. It is a sign in the desert, a marker of the body of the deceased ruler. Its ordered geometric perfection is an impressive contrast to the disorder that surrounds it. Even after his death, the sovereign continued through the pyramid to play the role as a defender of order (cosmos) against the invasion of disorder (chaos). This dogma, which is basic to understanding the royal nature of the pharaoh and extends to all of Egyptian civilization from its beginnings to the end, can be used as a key to interpretation and help us understand why the pyramid shape itself was chosen to mark the burial site of the ruler. The pyramid is also reminiscent of a mountain, the first hill of earth that emerged from the primordial seas and from which the entire process of creation originated. The pyramid can also be compared to a materialization of the sun's rays, come down to bathe the earth with their light. Finally, the pyramid can be seen as all this and more. And it owes its success among the Egyptians, so keen to detect signs that could conceal more than one meaning, to this ability to give rise to a whole series of readings. In the final analysis, the pyramid is exactly this, a sign. Around the pyramid of Cheops the functionaries who had served under him also had their tombs built. In an age when eternity was the exclusive prerogative of the sovereign, being close to him in the Afterlife was the only hope for a life after death.

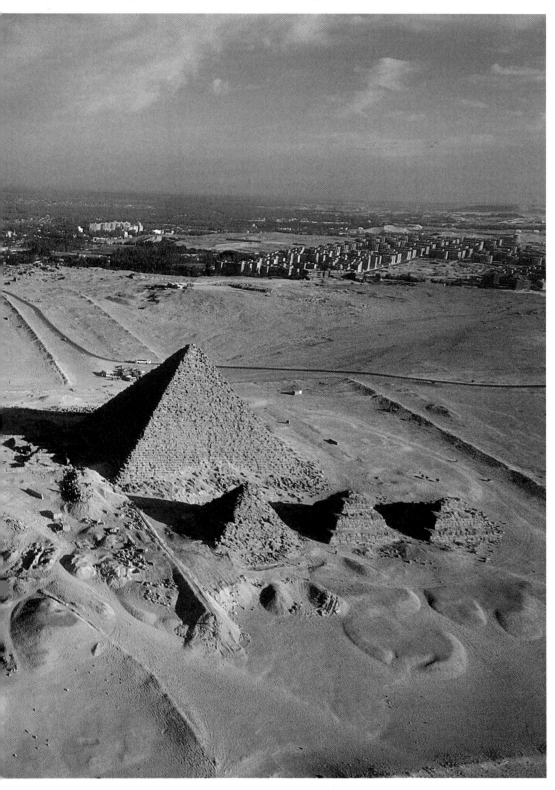

101 top The sacred face of the Sphinx is more than 13 feet wide and still keeps traces of color.

101 center This picture gives some idea of the long galleries that are inside the pyramid of Cheops.

101 bottom In a trench near the pyramid of Cheops, an intact ship was found in 1954, measuring 142 feet long and just over 16 feet wide. This ship was reassembled after 16 years of work and is now on display near its original site in a modern building.

Giza

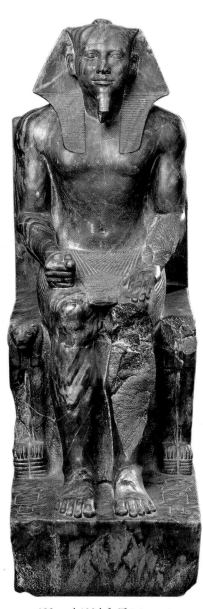

103 top right This aerial photograph gives an excellent view of the summit of the pyramid of Chefre, which was once topped by a pramidion.

103 bottom right In this view of the archaeological site of Giza, the shadow of the pyramid of Chefre stretches to the pyramid of Cheops behind.

Cheops also wanted the body of his mother, Hetepheres, wife of Snefru, originally buried in the sands of Dahshur, beside him. Her tomb was discovered along the eastern side of the Great Pyramid and although the body of the queen was never found it was possible to recover part of her burial treasure. The furniture is covered in gold leaf, and the vases used for her toilet were also in gold while two of her bracelets were silver. All these objects, together with an alabaster sarcophagus, are now in the Egyptian Museum in Cairo. Along the southern side of the pyramid of Cheops, a sailing vessel made from Lebanese cedar was recently found. This had been taken apart and placed with care at the bottom of a trench covered in slabs of limestone. It shows signs of wear and must have been placed close to the pyramid for the possible use of the ruler on voyages after his death.

102 and 103 left This imposing diorite statue of Chefren (2520-2494 BC) was found in 1860 by the French archaeologist Auguste Mariette in the temple downstream from the pyramid of Chefren, in Giza.

103 center This famous group of statues, discovered in the temple downstream from the pyramid of Mycerene in Giza, shows the pharaoh flanked by two gods. On the left is the goddess Hathor, who is linked to abundance and fertility, and to the right is the tutelary divinity of the 17th administrative district of Upper Egypt. Upper Egypt is identified by the symbol on the head of the god.

Restored and perfectly reconstructed, it is now exhibited in a special museum at the foot of the pyramid, above the ditch in which it was found. Research on the site has proven the existence of another trench, containing the pieces of a second vessel, but it was decided not to open this trench. The pyramid of Chefren (2520-2494 BC) is smaller than that of his father Cheops, but as it is built on a slight rise it looks slightly higher. Its summit still shows part of the white limestone covering that was systematically removed from the base and from the other pyramids for use in some of the buildings of Cairo during the Arab period. The burial complex of Chefren is in better condition than that of Cheops. On the eastern side of the pyramid we can still see the remains of the temple where the rites for the deceased ruler were held. From here, across a downward-sloping covered ramp, it was possible to reach what is called the "downstream temple", where the body of the ruler was mummified and purified. This structure consists of granite

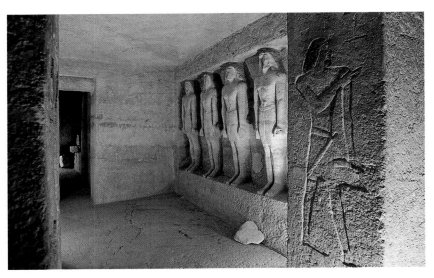

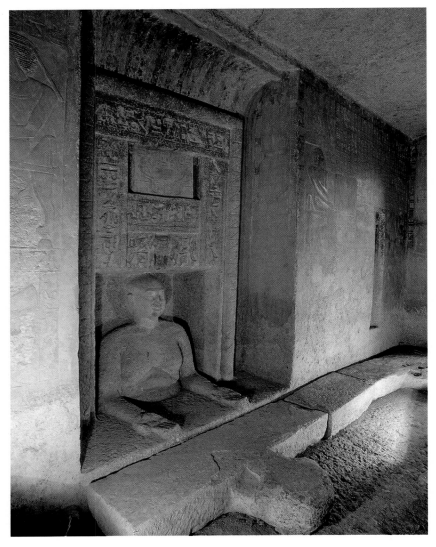

blocks weighing several tons, whose red color contrasts with the white of the alabaster floors.

The emptiness of the halls is balanced by the heaviness of the walls, pillars and architrave, and is a clear example of IV-dynasty work. Inside this temple a beautiful diorite statue of Chefren was found. The ruler is seated on a throne and a falcon, a symbol of the god Horus, is behind him. The wings of the falcon embrace the head of the king in the usual gesture of protection and have a variety of geometric designs illustrating trends in abstract art during this period of Egyptian history.

Alongside the downstream temple was a mound of limestone, all that remained of a place where the building stone for the pyramid of Cheops was obtained. The shapeless mass of rock was worked and transformed by the craftsmen of Chefren into a fantastic animal, with the body of a lion and a human head, the personification of the power of the sovereign. Later, the colossal statue was deified and identified with the god Ra-Harakhti, the morning sun. During the XVIII-dynasty (1550-1295 BC), a temple was dedicated to it, and Thutmose IV (1401-1391 BC) had it freed from the sand after being told in a dream to do so. The first Greek travelers identified the huge sculpture with a being from their own fantastic mythology as the Sphinx. The Islamic people called it Abu el-Hol, meaning "Father of Fear", and it is still known by this name today.

The pyramid of Mycerene, although smaller than that of his immediate predecessors, had its base covered in slabs of syenite, the special quality of granite found at Aswan. The summit was covered on the outside with limestone slabs.

In later periods, especially during the reign of the Ramses rulers, the granite was reused as sculpture material. The burial complex of Mycerene was richly decorated with statues of the ruler, many of which were found during excavations.

The so-called "Triad of Mycerene" where the king is shown between the goddess Hathor and the personification of an Egyptian region is especially famous.

104 top and 105 bottom The mastaba of the functionary Merynepher Qar, in the necropolis of Giza, is outstanding for the series of statues of the deceased and his family. These are sculpted in haute-relief on the southern wall of the first room where there are also a number of fine bas-reliefs.

104 bottom In the mastaba of Idu, also in the cemetery of Giza, are numerous haute-relief statues of the deceased.
The false pillar at the center of the eastern wall of the great hall is also decorated with the image of Idu, shown with his hands open and pointed upward to receive offerngs.

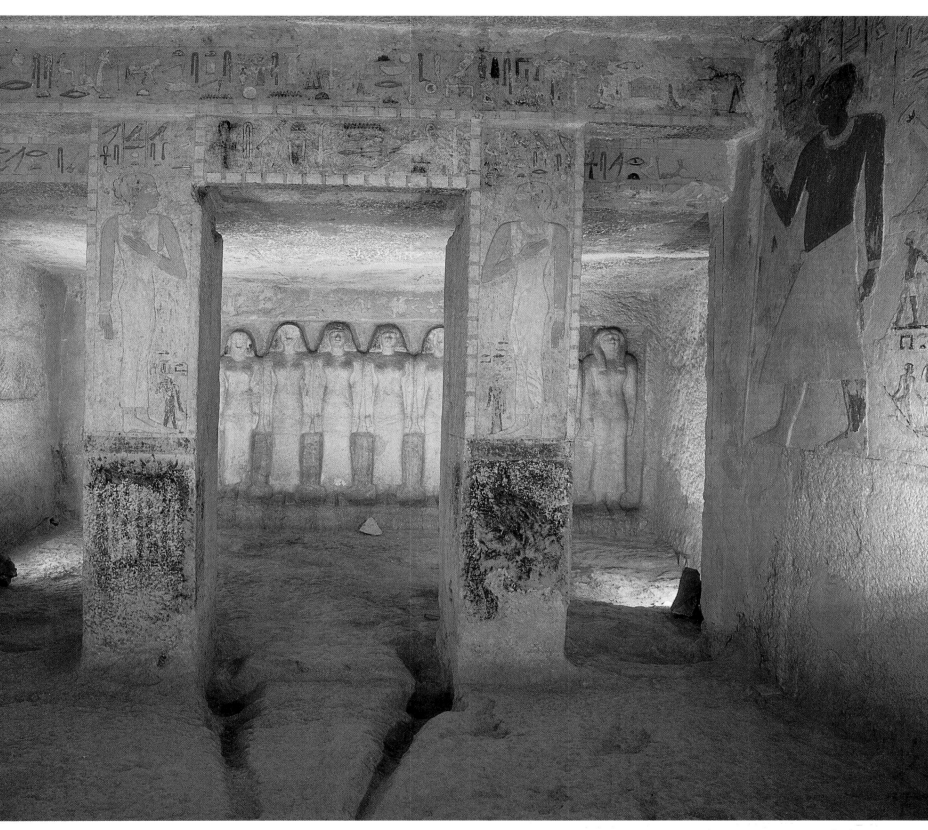

104-105 The mastaba of Queen Meresankh, wife of Chefren, is one of the finest tombs in Gisa. The exceptional quality of the multicolored bas-reliefs are especially noted. In a deep niche dug out of the northern wall of the second room, there are ten large haute-relief statues showing female figures, decreasing in size from left to right. Although there are no inscriptions, it is believed these show the dead woman with her mother and her eight daughters.

The greatest masterpiece of the art of this period is a sculpture that shows Mycerene and his wife. She has her arm around her royal spouse in a gesture of affection, rare in the works of art of this period.

With the end of the Ancient Kingdom and the beginning of a period of a divided Egypt, Memphis lost the primary role it had held from the very start of Egyptian history. From that point on, the plateau of Giza was almost completely abandoned as a burial site. It came to be used once again during the 1st millennium and during the same period the pyramid of a wife of Cheops was identified as the burial site of Isis, to which goddess a temple was built and dedicated along the eastern side.

Mediterranean Sea

Egypt

Cairo

Red Sea

KARNAK

KARNAK,
THE KINGDOM OF AMON

Karnak is the great temple complex which developed around the sanctuary dedicated to the god Amon of Thebes, situated to the north of the modern city of Luxor. The complex also includes the temple of Montu to the north and the temple of Mut to the south. A ceremonial street links Karnak with the temple of Luxor, about two miles further south, and with a pier on the Nile, from which processions started out for the royal temples on the opposite bank. During the New Kingdom (1552-1069 BC), the temple of Karnak became the most important religious center of ancient Egypt. Retracing the history of the temple means going back through a great deal of Egyptian history, as nearly all the rulers of the age were involved in both the architectural and decorative work that made the temple, first built on a base from the Middle Kingdom of 1991-1785 BC, a combination of different styles illustrating Egyptian art through the

106 left The first pylon of the temple was built at the time of the pharaoh Nectanebo I (378-361 BC) and left unfinished. The enormous structure has a 370 foot front and is 144 feet high. On the façade eight large channels can be seen into which huge pennants on standards were placed.

A Access road with serpent-headed sphinxes
B Walls of Amon
C Temple of Ramses III
D Great colonnaded hall
E Obelisks
F Uagit (small colonnaded room)
G Courtyard of the Middle Kingdom
H Akhmenu
I Temple of Ptah
J Sacred Lake
K Temple of Opet
L Temple of Khonsu
M Seventh pylon
N Eighth pylon
O Ninth pylon
P Tenth pylon
Q First pylon (of Nectanebo I)
R Second pylon
S Third pylon
T Fourth pylon

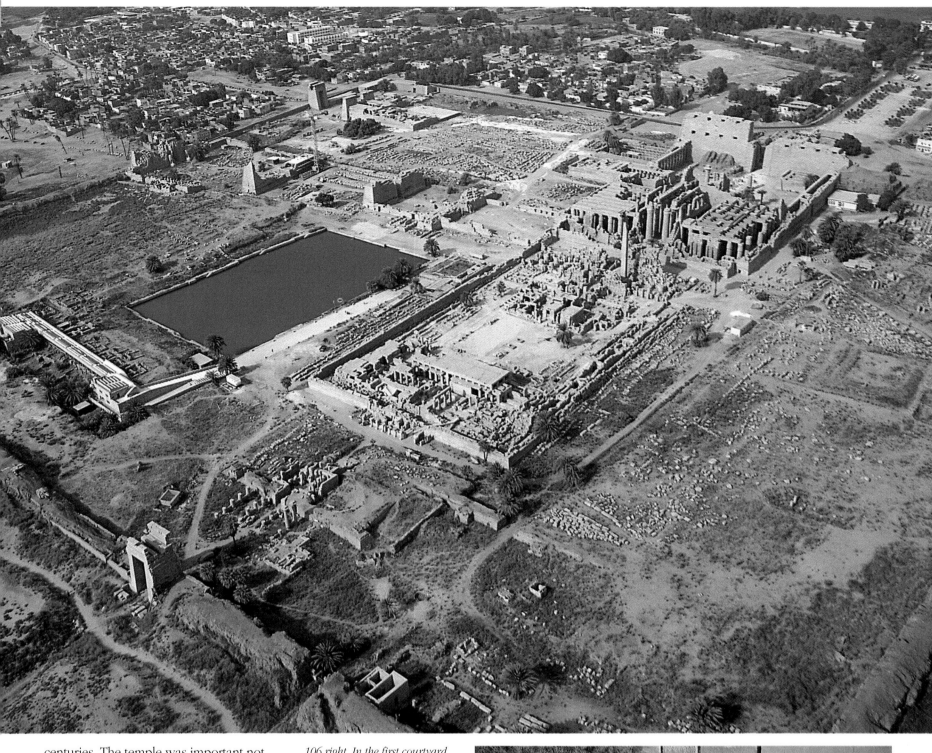

centuries. The temple was important not only religiously but also economically in direct proportion to the prestige it enjoyed. Each time an Egyptian temple was built it was given possessions and income to guarantee the support of the priests and ceremonies. Continuous donations and tributes from the rulers made Karnak the most important economic center in the country, a state within a state.

The oldest building, of which only traces remain, dates to the period of Sesostris I (XII-dynasty, 1962-1928 BC), who had a limestone temple built inside a wall facing southwest. The front section contained a sacred garden surrounded by colonnaded rooms while the sanctuary itself consisted of three rooms in a line. This nucleus was virtually unchanged until the start of the XVIII-dynasty. Throughout the New Kingdom and into later periods up to the times of Ptolemy the original part

106 right In the first courtyard of the temple is an enormous statue of Ramses II, 45 feet high. The image of the queen consort is sculpted at the feet of the pharaoh.

106-107 The temple of Amon-Ra, seen here in a spectacular aerial view taken from the east, covers an area of 360,000 square yards. The complex of Karnak, called Ipet-isut by the ancient Egyptians, was built in stages over a period of 1,600 years, from the time of Sesotris I (XII-dynasty) to the reign of Nectanebo I (XXX-dynasty). The temple is built on two axes running from east to west and north to south which are believed to stand for the sky and earth and divine and royal power. The sacred lake, begun under Thutmose II and completed on the order of

Taharqa (690-664 BC) was supplied from underground springs. This lake supplied water for the purification rites and was a place where the sacred birds of the temple could swim.

107 bottom The famous Valley of the Sphinxes leads to the first

pylon, where the main entrance to the temple opens up. The spyhinxes were given rams' heads because this animal was sacred to Amon. They hold a statue in their legs which represents the mummy of the pharaoh Ramses II.

108 top This portrait shows Thutmose II wearing the insignia of royalty. These include the nemes, the striped canvas headdress, and the urea, the cobra that stood for both light and royalty.

108 bottom left Papyrus shaped capitals top the 122 columns holding up the huge crossbeams of the colonnaded hall which was built during the time of Sethi I (1304-1290 BC) and Ramses II (1290-1225 BC).

108 bottom right The stems of the columns in the colonnaded hall are entirely covered in bas-relief showing the pharaoh and dignitaries.

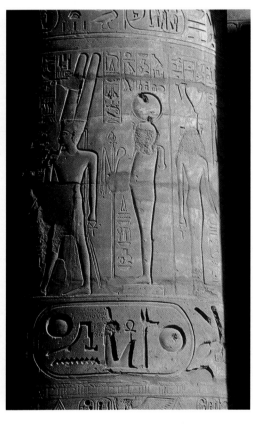

progressively expanded and was modified along east-west and north-south axes. A great number of monumental entrances were added in classic Egyptian pylon form and with two imposing blocks of stone towering upward to frame the central passage. In the end there were ten of these, with six along the main axis and four others on the extension of the axis toward the south.

Thutmose I built pylons four and six in front of the temple of Sesostris I with a colonnaded hall between the two. Two obelisks were erected in front of the first pylon. Hatshepsut and Thutmose III further extended the complex, adding more rooms of worship to the building of Sesostris I. Hatshepsut built the famous red chapel, which was to house the sacred boat that contained the statue of Amon during processions. The chapel consisted of two

rooms and was built with black granite and red quartzite blocks on which scenes from the procession of Amon during the Theban festivals were reproduced in relief. This chapel was torn down by Thutmose III who replaced it with a new sanctuary dedicated to the texts of his Annals. The stone blocks from the red chapel were later reused by Amenhotep III in the foundations of a new pylon entrance (the third on the east-west axis). The Franco-Egyptian center at Karnak, which is presently responsible for all the archaeological work on the site, has recently started on the reconstruction of the chapel in the Karnak open-air museum. Thutmose III later had a new pylon structure built between the two of Thutmose I (the fifth on the east-west axis) and, with Hatshepsut, added to the building on the south, in the direction of the temple of Mut, with two new pylons, the seventh and eighth.

Karnak

108-109 *The seventh pylon, which is almost entirely destroyed, was built along the north-south axis by Thutmose III (1468-1436). This axis, running as it does parallel to the Nile, symbolizes the terrestrial or earthly axis while the east-west direction stood for the celestial or divine. In front of the pylon were some colossal statues of the pharaohs, of which only the bottom sections remain.*

109 top *One of the series of Osiris in the courtyard of the so-called "Chapel of the Hall", built by Ramses III and located in the southwestern corner of the courtyard in front of the second pylon. The walls of this temple are covered with bas-reliefs. It was used as a resting place for the sacred vessels of the Theban triad, used during the great religious processions.*

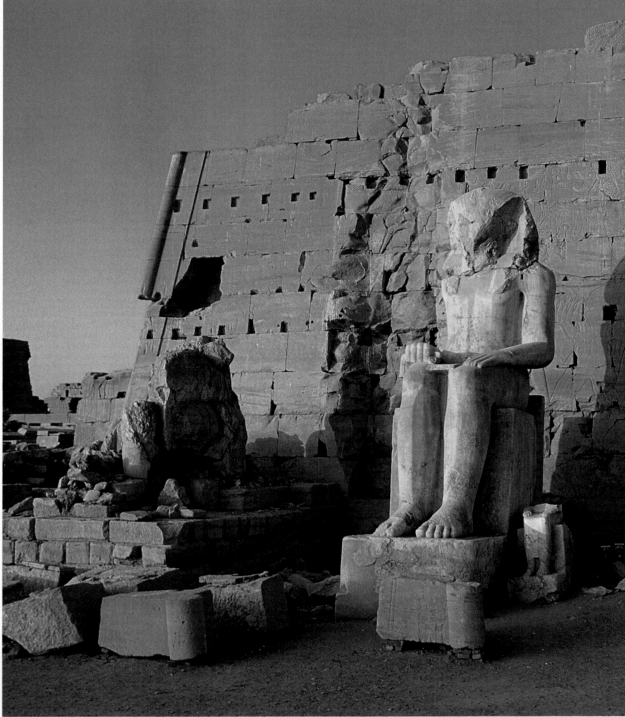

To the east of the building of Sesostris I, Thutmose III had a special construction put up, known as Achmenu and dedicated to the cult of the deified king who was venerated as a manifestation of the god Amon. This building consists of a central nave supported by a double row of ten columns, somewhat similar in shape to tent pegs, and surrounded on all sides by pillars that form the naves off to the sides. To the north of this room were rooms dedicated to the cult of Amon, two of which were known as the botanical garden. These were rooms which Thutmose III had decorated with reliefs reproducing the flora and fauna of Syria which had been brought to Egypt by the king in the twenty-fifth year of his reign.

Amehotep III had the third pylon built. This is about 45 yards high and was built using materials from various older buildings. He also began work on the tenth pylon on the processional road to the south. This was rebuilt by Horemheb at the end of the XVIII-dynasty who also erected pylons nine and two. The most extraordinary building in Karnak, however, has to be attributed to the first of the Ramses. This is the famous colonnaded hall which is between the second and third pylon and measures 114 yards wide and 57 yards deep and contains 134 columns. The central nave, raised above those to the sides, is supported by 12 bell-shaped columns 75 feet high while the other columns are 48 feet high. The inner walls are decorated with scenes showing the various stages in the daily ritual of worship and the outer walls show scenes of battle. Ramses III greatly enriched the temple of Chonsu, son of Amon and Mut, in the southeastern area of the complex.

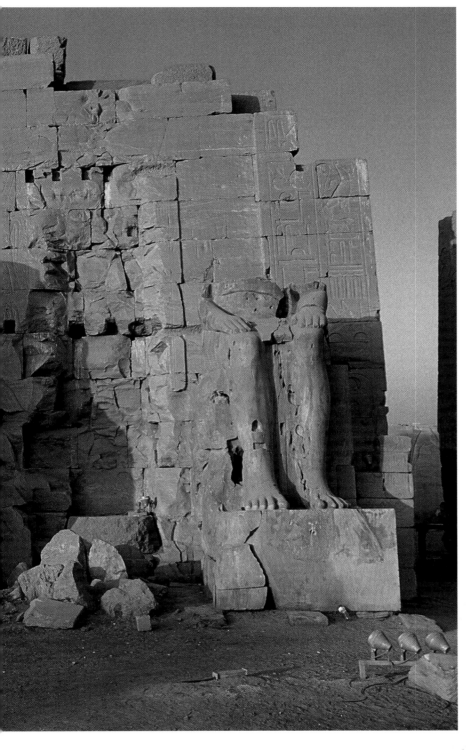

110 top left In the courtyard between the sixth pylon and the most sacred area are two elegant pink granite pillars built by order of Thutmose III. On these are sculpted the lotus, symbol of Upper Egypt and shown in the photograph, and the papyrus, symbol of Lower Egypt.

110 top right The god Amon-Ra who, with his wife Mut and son Khonsu formed the so-called Theban Triad, was the main divinity worshipped in the temple of Karnak.

110 bottom Countless figures of gods adorn the imposing façade of the second pylon, built on behalf of the pharaoh Horemheb (1319-1307 BC). Unfortunately, Coptic monks who had taken over the temple chipped off the faces in early Christian times.

110-111 The eighth pylon was begun along the north-south axis by Queen Hatshepsut (1490-1468 BC) and was completed by her successor, Thutmose III (1468-1436 BC).

111 bottom left The sphinxes in front of the first pylon were placed in their current position after they were removed from the entrance to the second pylon.

111 top right The so-called "Hall of the Feasts" is part of the complex of buildings built on the order of Thutmose III, to the east of the courtyard of the Middle Kingdom, to house jubilee celebrations.

111 bottom right Behind the eighth pylon, from left to right, are the colonnaded hall and the first pylon.

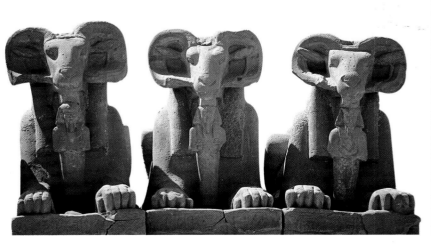

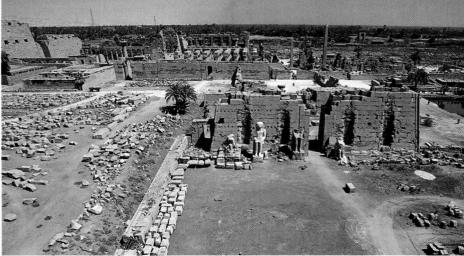

112 left On the two heraldic pillars of Upper and Lower Egypt, built by Thutmose III, are elegant bas-reliefs showing scenes of homage to Isis and Osiris.

112-113 This bas-relief, which shows the sacred vessels, is on the outside of the southern wall of the chapel of Philippus Arrideus. He was a half-brother of and successor to Alexander the Great (323-317 BC) and had this building, a copy of a chapel dating back to the time of Thutmose III, built.

Once a year, during the festival of Opet, the vessels of Amon-Ra, Mut and Khonsu were taken out on the Nile and sailed up the river to the "Southern Harem of Amon" or Ipet-resit, or the temple of Luxor.
Here the union of Amon and the queen was celebrated, which ended with the birth of a son, thus confirming the divine origins of the pharaoh. The festival ended with the return of the sacred vessels to the temple of Karnak.

In addition, we should mention the monumental kiosk that Taharqua (XXV-dynasty, 690-664 BC) built in front of pylon two, and the religious building near the sacred lake. Finally, during the XXX-dynasty (380-343 BC) the great surrounding wall was built from bare brick. This wall can still be seen, with its monumental gates to the north and in front of the temple of Chonsu. The Ptolemy rulers and the Romans decorated some parts of the existing buildings and built a number of small chapels. Domitian (emperor 81-96 AD) was the last Roman emperor to build in Karnak. To the north of the temple dedicated to Amon is another complex dedicated to Montu, the divine warrior, who had been venerated in this area before the ascent of Amon. To the south is a complex dedicated to the goddess Mut, the wife of Amon. This was built for the most part under Amenhotep III and has yet to be thoroughly excavated.

113 top and bottom Hundreds of the bas-reliefs with long hieroglyphic inscriptions cover virtually every surface of the immense temple complex. The main subjects are the countless images of the divinities worshipped by the Egyptians or scenes in which the pharaohs pay homage to the gods. These figures, like the capitals and many other architectural features of the sanctuary, were painted in bright colors, most of which have unfortunately been lost.

Mediterranean Sea

Egypt

Cairo

Red Sea

LUXOR

LUXOR,
ETERNAL BEAUTY

A Sphinx-lined road of Nectanebos I
B Shrine of Serapi
C Obelisk
D Pylon of Ramses II
E Shrine of Hatshepsut
F Mosque
G Courtyard of Ramses II
H Great colonnade
I Courtyard of Amenophi III
J Position of the hide
K Other colonnade
L Room of birth
M Shrine of the sacred vessel of Alexander
N Sanctuary of Amenophi II

Ancient Thebes, now Luxor, is situated in Upper Egypt, about 300 miles to the south of Cairo. This ancient city was built on the eastern bank of the Nile, with the tombs and important temple complexes on the western side. During the Ancient Kingdom (c. 3150-2200 BC) Thebes played a secondary political role and only became a provincial capital at the end of the VI-dynasty (c. 2460-2200 BC). During the First Intermediate Period (c. 2460-2200 BC) it was the nerve center of the expansion policy that led the Theban princes to reunite the entire country under Mentuhotep II as a result of which it became the capital. In the Middle Kingdom that followed (1990-1785 BC) the capital was transferred to the north, but Thebes continued to be the administrative center of Upper Egypt and the rulers continued to

114 top The photograph shows a detail of one of the enormous seated statues of Ramses II in front of the pylon of the temple.

114 bottom left This sacred head of Ramses II was part of the other four colossal statues that stood in front of the temple.

114 bottom right The surviving pink granite obelisk before the pylon of the temple has a long commemorative head of Ramses II on the four sides which stretches over three columns. The two scrolls at the bottom bear the name of the great ruler who was so important in extending the empire.

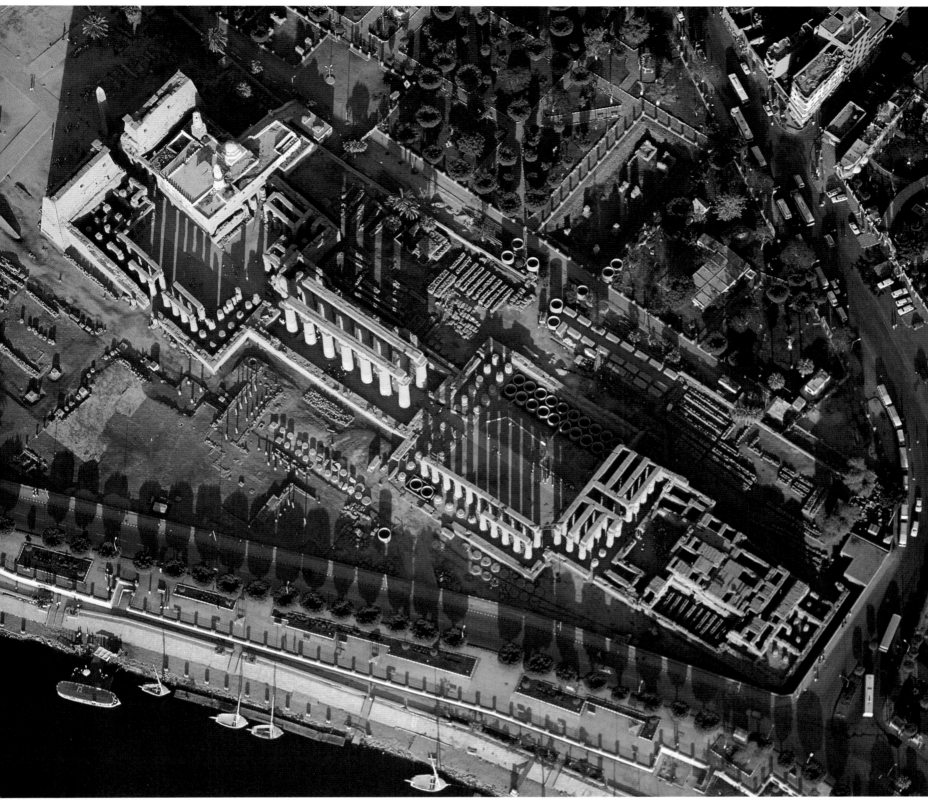

view it as of being of major importance as can be seen from various architectural projects. The Second Intermediate Period (c. 1785-1550 BC) brought about a new split in Egypt, with the southern part remaining under the control of Thebes which eventually was once again the starting point for the movement which led to the reunification of the country. It was, however, during the XVIII-dynasty (1552-1295 BC) that the city enjoyed its greatest prosperity, as the grandiose complexes testify. This was also the period when the Valley of the Kings was created on the western bank of the Nile behind the rocky amphitheater of Deir el-Bahari as a burial ground for sovereigns. The Amarnian religious reform promoted by the pharaoh Ikhnaton led to the transfer of both the capital and royal tombs to the city of Amarna briefly. However, the period of restoration that followed not only led to the return of Thebes to the role of religious capital of the country but it is also likely that the administrative center was transferred to the north, first to Memphis and then to Pi-Ramses. In spite of its distance from political power, Thebes retained its importance in the religious life of Egypt and this is where kings were crowned, receiving divine legitimacy in the temples, and this is where they were buried.

During the third Intermediate Period (1069-332 BC), a genuine theocracy developed around the great temple of Amon in Karnak. This went on to further extend its control over the southern part of

114-115 The temple structure is clearly visible from this aerial view which shows the pylon and courtyard built by Ramses II, the colonnade dating from the end of the XVIII-dynasty, the courtyard of Amenhotep III, the court and the sanctuary itself.

115 bottom The great courtyard built on the orders of Ramses II was bounded by 74 papyrus-shaped columns, arranged in a double row. Sixteen statues of the pharaoh are still standing in the spaces between the columns.

116 top This avenue of sphinxes with human heads, in front of the temple, was built during the reign of the pharaoh Necthanebes I (380-362 BC), replacing part of the dromos with ram-headed sphinxes built by Amenhotep III (1386-1349 BC).

Unfortunately, as modern Luxor has been built on top of the ancient city, only a small part of the ceremonial avenue connecting the sanctuary at Luxor with the one at Karnak, about two miles away, can be followed today.

116-117 The pylon of the temple, with a face measuring over 200 feet, was built by Ramses II and decorated with bas-reliefs commemorating the victory of the ruler in the battle of Qadesh against the Hittites in 1274 BC. In front of this were two obelisks, only one of which remains. The other was given to France by the Egyptian viceroy and erected in the Place de la Concorde in 1836. The remaining obelisk is over 75 feet high.

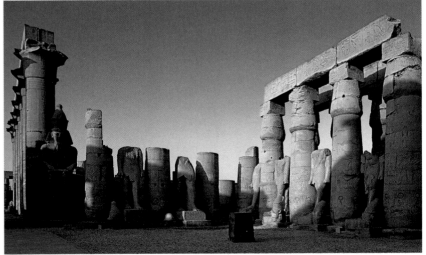

116 bottom The courtyard of Ramses II is almost 190 feet long and 165 feet wide. Somewhat surprisingly, this is not on the axis of the oldest part of the temple. It seems probable this break in alignment was in order to include in the complex a small temple built by Thutmose III to hold the sacred vessels used in processions.

Luxor

117 top *The two colossal granite statues that flank the entrance to the temple (the one on the left is shown here) are over 50 feet high on a base of about four feet. Ramses II is shown with the crowns of Upper and Lower Egypt.*

117 bottom *This bas-relief shows Ramses II making offerings to the gods. The walls of the courtyard are covered with many scenes showing sacrificial ceremonies, the vassals of the pharaoh, and the ruler himself.*

other rulers, notably Tutankhamen and Ramses II. The temple faces north to south and is connected by an avenue of sphinxes to the temple of Karnak, with which it had close religious connections. The building, dedicated to the cult of Amon of Karnak, was built for the great Theban festivals in honor of the god.

On those occasions, the statue of the god Amon was led in procession on the sacred barge from Karnak to Luxor where special rites were celebrated in the temple of Luxor. Some of these rites were certainly designed to confirm the power of the ruler taking part in the ceremony.

The original temple consisted of a great courtyard with a double row of columns opening out into a space called a pronaos made up of 32 papyrus-shaped columns. This led to the colonnaded hall, the hall where offerings were made and the sanctuary that housed the barge of Amon, flanked by two sanctuaries for the barges of Mut and Chonsu, with their annexes to the sides. Behind this sanctuary there was a further religious complex dedicated to a local form of veneration of Amon. This complex consisted of a transverse colonnaded hall, a sanctuary and three chapels.

Later, Tutankhamen built an imposing access colonnade in front of the courtyard, consisting of a double row of seven columns with bell-shaped capitals. Ramses II extended this even further, with another courtyard in front of the colonnade with a double row of columns and statues of the king in the middle. Access to this courtyard was from a huge entrance in pylon form in front of which there were two obelisks. The western obelisk was moved to Paris in 1836 and is still to be seen there today in the Place de la Concorde. The outside of the temple was occupied by the Romans who used it as an encampment surrounded by walls. It is from the Latin castra, camp, that the Arabic name of Al-Uksur is derived, leading ultimately to Luxor.

the country. Nevertheless, Thebes retained its importance up to the late period and was only reduced to a subordinate city within its own province during the time of the Ptolemaic rulers (332 BC-30 AD). The remains of the ancient city, built on the eastern bank of the Nile, are almost completely buried by the modern town of Luxor. Two important temple complexes have survived. These are the great temple of Karnak and, less than two miles to the south, the temple of Luxor. This was begun by Amenhotep III and extended by

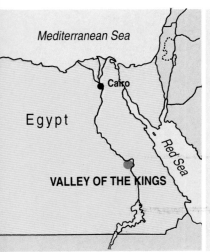

WESTERN THEBES, THE PHARAOHS' LAST HOME

A Karnak
B Luxor
C Malqatta
D Site of the palace of Amenophes III
E Temple of Ramses III
F Medinet Habu
G Temple of Merneptah
H Colossi of Memnon
I Temple of Thutmose IV
J Ramesseum
K Temple of Thutmose III
L Temple of Ramses IV
M Temple of Sethi I
N Temple of Mentuhotep
O Temple of Hatshepsut
P Valley of the Kings
Q Valley of the Queens
R Deir El-Medina

On the west bank of the Nile at Thebes, where the cultivated zone meets the desert, were a number of temples dedicated to the cult of Amon and the dead kings. The oldest of these temples is that of Mentuhotep (XI-dynasty, 2100-1955 BC) built at the foot of the rocky amphitheater of Deir el-Bahari. This consisted of an access ramp leading to a courtyard enclosed by walls on three sides, which in turn led to a terrace. At the center of the terrace there was probably a colonnade with a mastaba in the center. The temple also included an inner part dug from the rock with a long corridor leading to the king's tomb. The temples to the rear, all dating from the New Kingdom, have no royal burial chambers. The separation of the place of funeral worship and the burial site in the Valley of the Kings is one of the changes made during this period, and seems to be

the result of the transformation in the Egyptian view of death. At Deir el-Bahari, beside the temple of Mentuhotep II from which it takes its inspiration, is the temple of Queen Hatshepsut. This includes three terraces resting against the mountain, connected with each other by an access ramp. The last terrace was occupied by various chapels dedicated to the most important gods worshipped in the temple. The scenes on the walls tell the story of the divine birth of the queen and the great deeds of her reign, such as the expedition to the county of Punt and the transport of two great obelisks for the temple Karnak. The temples at the rear are all similar in structure to buildings of the same period that were dedicated to divine worship. All that remains of the temple of Amenophes III are two colossal statues, the famous Colossi of Memnon, which flanked the entrance.

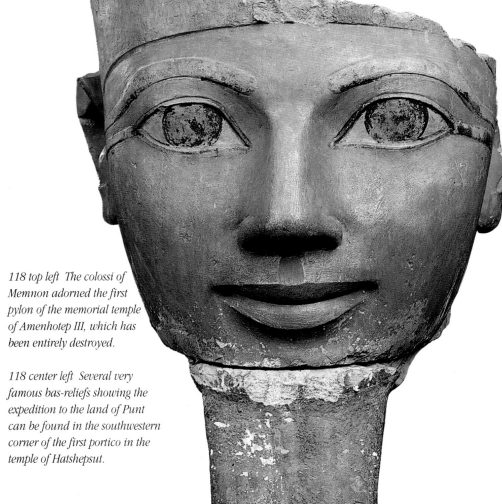

118 top left The colossi of Memnon adorned the first pylon of the memorial temple of Amenhotep III, which has been entirely destroyed.

118 center left Several very famous bas-reliefs showing the expedition to the land of Punt can be found in the southwestern corner of the first portico in the temple of Hatshepsut.

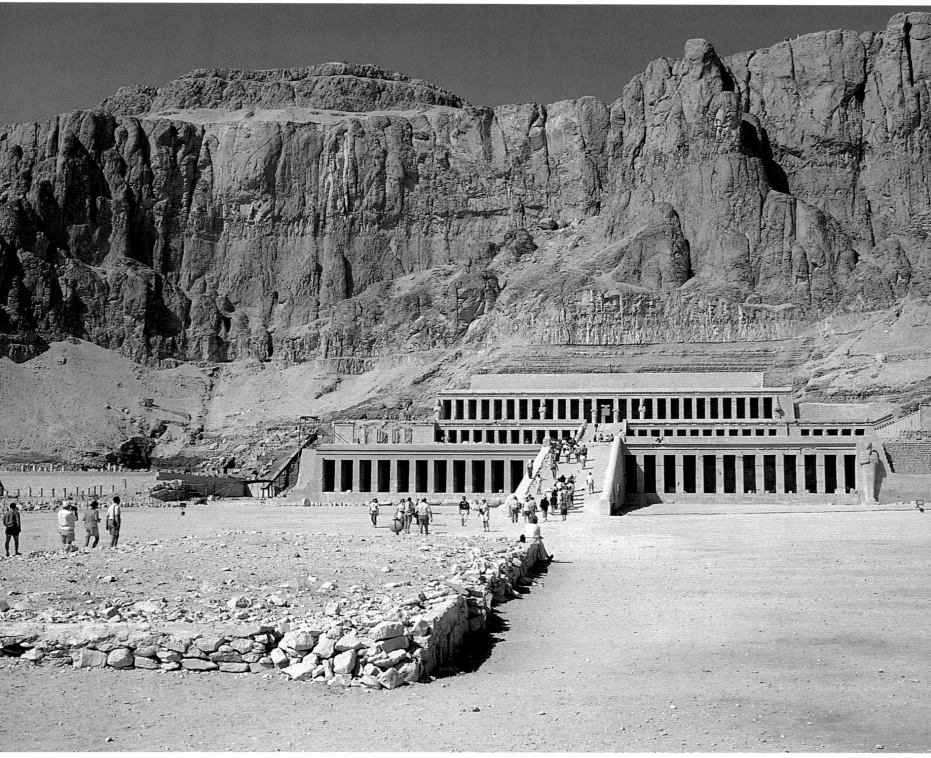

118 bottom left The intermediate portico in the temple of Hatshepsut, also known as the "portico of Punt", is held up by a row of square pillars and decorated on the north with scenes showing the divine birth of the queen. On the south, it is decorated with images of the famous expedition to Punt.

118 right This splendid painted limestone head shows Hatshepsut with the false beard that was one of the symbols of royalty. It belongs to one of the colossal statues of Osiris in the upper portico of Deir el-Bahari. There are only a few statues in which the queen appears in women's clothing.

118-119 The spectacular temple of Queen Hatshepsut rises from the base of a valley sacred to the goddess Hathor. The building, a succession of three terraces with deep porticoes resting on the rock wall, is the work of the famous architect Senenmut.

119 top On the supporting wall of the first terrace of the temple of Hatshepsut, in Deir el-Bahari, the effigy of the god Horus appears several times in the form of a falcon. Behind, we can see some of the surviving Osiristyle statues of the queen.

Western Thebes

Western Thebes

The funerary temple of Ramses II, known as the Ramesseum, is surrounded on three sides by an imposing complex of bare brick warehouses.

The temple itself has two courtyards and a large colonnaded hall which leads through three antechambers to a sanctuary dedicated to the cult of Amon. The complex of rooms to the south was used for the cult of the ruler.

To the south of the Ramesseum is the most imposing architectural complex of the western bank, which is known as Medinet Habu.

Inside the surrounding walls are temples, warehouses, houses and tombs, all made of bare brick, a genuine town which was inhabited up to the 9th century AD. The oldest of the temples is the one dedicated to Amon, built by Hatshepsut and Thutmose III, and altered from that point all the way through to the Ptolemic period.

Behind this is the huge funerary temple of Ramses III, a larger version of the Ramseon. Against the southern side of the first courtyard is a palace that was used by the king during the religious celebrations that took place in the temple at certain times during the year.

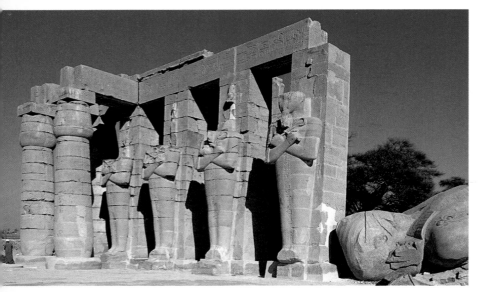

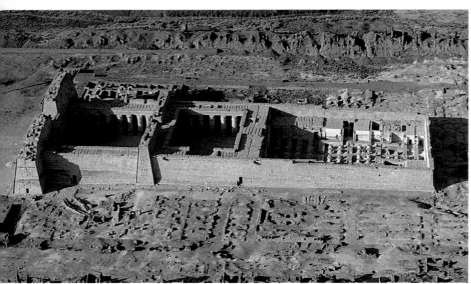

120 top left In this aerial view can be seen the second courtyard and the colonnaded hall of the Ramesseum, the memorial temple built on the orders of Ramses II.

120 center left In the first court of the Ramesseum was the colossal monolithic statue of the pharaoh, 66 feet high. Today it is only fragments.

120 bottom left The memorial temple of Ramses III, in Medinet Habu, is the best preserved in Western Thebes.

120 top Splendid bas-reliefs adorn what remains of the great colonnaded hall of the Ramesseum (left). The poor condition of the temple is the result of the fact that in ancient times it was simply used as a source of building materials. This superb black granite head of Ramses II (right) was one of the statues of the pharaoh as Osiris which rested on the pillars of the second courtyard in the Ramesseum. The temple was known for its imposing form.

120-121 The first pylon of the temple of Medinet Habu, over 200 feet long, is decorated with bas-reliefs commemorating the victories of Ramses III. The ruler is shown sacrificing his enemies before the gods Amon-Ra (left)

and Amon-Ra-Harakhti (right). Inside the right-hand structure of the pylon is a staircase that leads to the terrace above the great portal. The channels on the façade were used to hold flagpoles from which the divine insignia flew.

121 bottom left The pillars of the second courtyard in the temple of Medinet Habu are decorated with scenes of the pharaoh making ritual offerings before various gods.

121 bottom right The stems of the columns in the second courtyard of the temple of Medinet Habu are covered with bas-reliefs and hieroglyphics. Clear traces of bright coloring remain which give us today an idea of the vibrant colors of Egyptian temples.

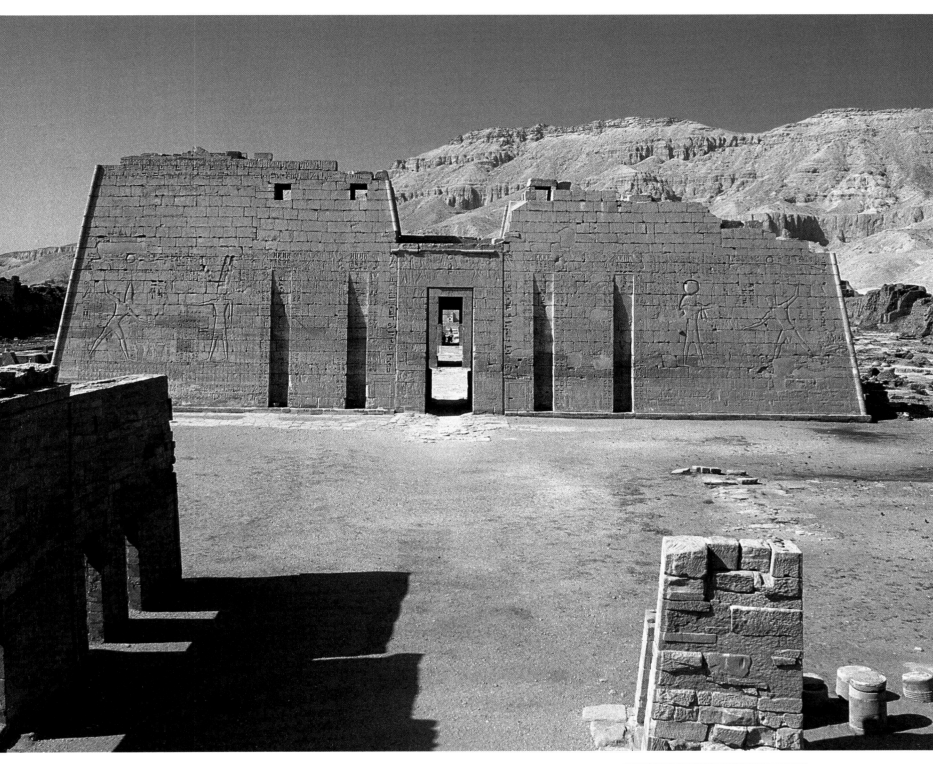

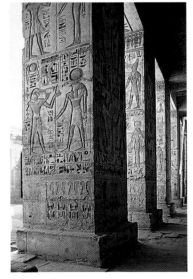

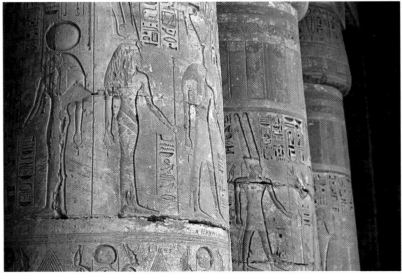

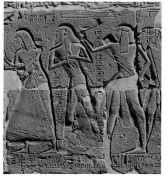

Western Thebes

122-123 One of the best known bas-reliefs in the memorial temple of Medinet Habu, sculpted in the western wall of the first pylon, shows a realistic picture of Ramses III in his war carriage, hunting wild bulls in the swamps, followed by a group of young princes.

122 bottom left and 122 bottom center On the left hand side of the door of the second pylon in the temple of Medinet Habu, a bas-relief shows the enemies captured in battle by Ramses during the eighth year of his reign.

122 bottom right The second courtyard in the temple of Medinuet Habu was bordered by Osiric pillars, most which have lost the statue that rested on them.

123 top To the east of the first pylon of the temple of Ramses III is a small temple dedicated to Amon which dates to the XVIII-dynasty. The pylon, shown here, was added in the time of Ptolemy.

123 center Unfortunately, all that remains today of the great colonnaded halls of the temple of Medinet Habu are the bases of the columns.

123 bottom The various portals of the temple of Medinet Habu follow each other in a way that creates a dramatic perspective.

124 top left In this view of the Valley of the Kings the entrance to the tomb of Tutankhamen, beneath the tomb of Ramses VI, can be seen.

124 top right This small wooden shrine covered in gold plate was found in the tomb of Tutankhamen, holding up a statue of the god Anubis in the shape of a jackal.

124 bottom right The statues of four guardian gods protect each side of this great wooden chest, covered in gold plate. The chest held four vessels containing the inner organs of Tutankhamen.

124 bottom left Second only to the funeral mask in fame is this, the royal throne from the tomb of Tutankhamen.

The tombs of the kings were situated in a valley that opens onto the mountain of Thebes behind the rocky amphitheater of Deir el-Bahari. The Valley of the Kings contains 62 tombs, in which the kings from the XVIII- to the XX-dynasty (1550-1076 BC) are buried with certain aristocrats connected with the court. The tombs, dug out of the rock, consist of a long corridor which goes into the mountain as far as the chamber containing the sarcophagus.

125 top The solid gold mask of Tutankhamen, now in the Cairo Museum, rested directly on the face of the mummy of the king to give him magical protection. It weighs 225 pounds and is decorated with colored vitreous paste and semi-precious stones. The portrait of the king is a highly classical one. He has the ceremonial beard, a broad collar made up of 12 concentric rows of turquoise, lapis lazuli, coraline and amazonite, and the nemes headdress in which the yellow of the gold is broken by bands of blue vitreous paste. On the front are the royal urea and the vulture's head, symbols of Uaget and Nekhbet, the gods which protect Lower and Upper Egypt.

125 bottom The burial chamber in the tomb of Tutankhamen, today containing only the red quartzile sarcophagus with the first sarcophagus and the mummy of the king inside, is the only one that is decorated. On the wall in the picture we can see the pharaoh in three different scenes. On the right, Tutankhamen is shown as Osiris, in the center he is in front of the goddess Nut and, on the left, head covered with the nemes and accompanied by his ka, he presents himself before Osiris, lord of the afterlife.

The structure and dimensions differ from one dynasty to another. The axis of the tombs was initially curved, then straightened out, while the access corridor, which originally ran straight to the chamber of the sarcophagus, was broken by a ditch from the time of Thutmose III onward. This was a barrier against thieves and a collection point for rainwater. It also had a special religious meaning, symbolizing the passage from the world of the living to the world of the dead and was therefore important for the rebirth of the deceased. The destination point of the corridors was the chamber with the sarcophagus, preceded by an antechamber. Around these two main halls were various secondary chambers where burial treasure was stored. All the burials that took place extended the structure and decorations for the oldest tombs. This continuous growth stopped with Ramses III, after whose burial

126 top The two images shown here, taken from the Book of the Doors, decorate a hall in the tomb of Ramses III.

126 center In Ramses VI's tomb, the hall of the sarcophagus is decorated on the walls with texts and figures from the Book of the Earth, an important anthology of magical and religious texts.

126 bottom This detail is part of the splendid astronomical ceiling that decorates the hall of the sarcophagus in the tomb of Ramses IV. The images, golden yellow on a black background, show the Book of Day and the Book of Night. Although this imposing tomb was known and visited in antiquity, it was not excavated until 1888.

the tombs developed in a quite different way. In the older tombs the decorations were limited to the elements considered to be the most significant, the sarcophagus chamber, antechamber and the ditch. It was only with Sethi I that all the elements of the tomb began to be decorated. The scenes on the walls were painted throughout the XVIII dynasty, up to the reign of Horemheb, when the emerging relief technique, followed by the hollow relief technique which was faster, was introduced. The decorative

plan for the tombs included scenes painted on the ceiling. These were divine scenes and the representation of the world beyond the tomb by means of the so-called Books of the Hereafter. Death implied a journey in the hereafter, aimed at the regeneration and rebirth of the deceased, who was taken through the same route as that covered by the sun in its voyage over the Earth. The funereal books, including the Book of the Hereafter, the Book of the Gates and the Book of the Caverns, are instruction

manuals that tell the deceased the route to take and protect him from the dangers he will meet along the way, including serpents and monsters which will try to stop him on his way toward rebirth. The tombs of the valley were robbed continuously beginning in ancient times, and the only one remaining almost intact was that of Tutankhamen, discovered by H. Carter in 1922. The splendid burial treasure found there is today kept in the Cairo Museum. The tombs of the queens and princes of the royal family were dug

127 center The tomb of Nephertari was closed to the public in the 1950s because of deterioration problems with the splendid wall decorations. Restoration work did not begin until 1986 and was preceded by long studies by an international team of scientists. The work, which required major efforts, was completed in 1992. However, in order to preserve paintings, the Egyptian government decided to drastically limit the number of visitors. In the picture, the queen is shown before the god Thoth.

127 bottom Lively murals decorated the antechamber of the tomb of Nephertari. In this view can be seen (from right to left) the god Harsiesi leading the sovereign by the hand to Ra-Harukhti, the solar god sovereign of the horizon, behind whom is Hathor-Imentet, the goddess Hathor linked to the funerary world. On the pillar in the foreground, right, is a painting of the goddess Neith.

out of the rock in a valley called Set Nefaru, meaning the Seat of Beauty, which is to the southwest of the Valley of the Kings. At the start of the 20th century a successful archaeological dig took place in the Valley of the Queens under the supervision of E. Schiaparelli, who discovered the tomb of Nefertari, wife of Ramses II. Even though the tomb had been robbed, it still had all its decorative paintings, extraordinary for the freshness of their colors and the quality of the drawings.

126-127 The paintings in the antechamber of Thutmose IV show an amazing range of colors. The figures here show the ruler before a number of gods.

127 top The tomb of Nephertari, discovered in 1904, is considered the most beautiful in Egypt because of the exceptional quality of the wall paintings. On the eastern wall of the staircase the queen is shown offering two ritual vases to the goddess Hathor.

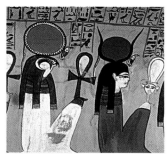

Western Thebes

Near the Valley of the Queens was the village of Deir el-Medina, where the building workers and decorators of the royal tombs lived. Both the residential part and the necropolis of the village remain. We should also mention the burial grounds for the court functionaries and nobles, who were buried near the tombs of the pharaohs they had served. However, the occupation of the entire

area as a cemetery continued up to a much later date, with the grandiose tombs of the functionaries of the XXV- and XXVI-dynasties (712-525 BC), built by Asasif in front of Deir el-Bahari. Eventually, even the great funerary temples were invaded by later burials which took place in a totally different religious context, although the rites were still considered sacred.

128-129 The famous paintings that decorate the burial chamber of the tomb of Sennegem are in perfect condition and can be considered the finest in the Necropolis of the Artificers. On the western wall, seen here, Sennegem and his wife Inypherti worship the gods of the afterlife. In the gable is a double image of Anubis crouching on a shrine.

128 bottom left Heliopolis's cat kills the serpent Apopis under the sacred ished tree. This impressive picture is part of the decorations on the walls of Inherkhau's tomb in the Necropolis of the Artificer.

128 bottom right In this detail, the god Anubis prepares the mummy of Sennegem, respected functionary of the Theban necropolis.

129 top left The tomb of Sennefer, a senior functionary at the time of Amenhotep II, is one of the richest in the Necropolis of the Nobles. In this detail, the deceased is shown with his wife.

129 top right This detail of the vaulted ceiling in the tomb of Pashedu in the Necropolis of the Artificers shows the gods Ra-Harakhti (left) and Hathor (right).

129 bottom left The narrow passage that leads to the burial chamber in the tomb of Pashedu is decorated with two identical images of Anubis, portrayed as a jackal.

129 bottom right The wife of Pashedu, Negemtebehdet, is portrayed in the fresh, lively style typical of the Ramses period. She wears her hair in small curls.

THE NUBIAN TEMPLES, *SAVED FROM THE WATERS*

130 top left The temple of Wadi Sabua was built by Ramses II and consecrated to Amon and Ra-Harakhti, supreme deities of the Egypt of Ramses. The pylon of the temple, made of reddish sandstone, is over 60 feet high.

130 center left The courtyard of the temple of Wadi Sabua is bordered on two sides by porticoes with five pillars each, on which are statues of the pharaoh resembling Osiris.

130 bottom left Two enormous statues, one lying on the ground, guarded the pylon and were at the end of the long access road leading to the temple of Wadi Sabua. Both show Ramses II.

130 right The sphinxes before the temple of Wadi Sabua resembled Ramses II to such a degree that the sanctuary was known as the "House of Ramses-Meryamon in the dominion of Amon".

The region that spreads out to the south of the first cataract of the Nile was under Egyptian control from the time of the Ancient Kingdom (c. 2670-2150 BC). Originally, the Egyptians limited their activities to military and trading expeditions in the area, but from the Middle Kingdom onward (2100-1750 BC) they set up direct military control as far as the second cataract, building strong fortresses. During the New Kingdom (1500-1076 BC) the Egyptian empire extended its boundaries beyond the fourth cataract. The Egyptian presence in Nubia was marked by the building of temples as a natural result of the cultural processes which followed the conquest of the region. The temples were dedicated not only to the gods in the Egyptian pantheon, including deified pharaohs, but also to the Nubian gods. This influence on the region diminished at the end of the Ramses period. At the start of the first millennium the entire region was independent of Egyptian control, to the extent that in the 8th century BC it was the Nubians who conquered Egypt and founded the XXV-dynasty. The clash with the Assyrians marked the end of this dynasty,

which returned to the area of its origins, in Napata, near the fourth cataract. In the centuries that followed a local kingdom developed that combined certain indigenous elements of African origin with others from Egyptian and Greco-Roman traditions, from the Ptolemaic period on. The reign of Meroes took this kingdom to its highest levels along with the Greek domination of Egypt, causing trouble for the

A Aswan Dam
B High dam
C Phyllo
D Kalabsha
E Sebua
F Hamada
G Abu Simbel

130-131 A long avenue flanked by a row of sphinxes and preceded by two colossal statues of the pharaoh led to the temple of Wadi Sebua. This building, like most of the other Nubian monuments, was only saved from the waters of the artificial Lake Nasser by being dismantled into numbered blocks and later reassembled about forty miles from its original site. The new location is called New Sebua.

131 top The temple of Dakke, compact but with excellent dimensions, was built at the end of the 3rd century BC on the orders of the Ethiopian king Arqamon and Ptolemy IV Philopator, the Macedonian pharaoh who reigned at the same time. Later, Ptolemy VIII Evergetes II (146-117 BC) added the portico, but the Romans gave it its final appearance. The sanctuary, dedicated to the god Thoth, was rebuilt near New Sebua.

Roman Empire. In Lower Nubia, the region between the first and second cataract, the valley of the Nile was very narrow, forcing the Egyptian architects to build temples wholly or partially dug from rock. With the intended building of Lake Nasser in the 1960s all these sanctuaries were threatened with destruction. UNESCO developed a major plan which involved technicians and archaeologists from all over the world. It was found possible to dismantle most of the temples in the area, including Abu Simbel, Amada and Kalabsha, and rebuild them on higher ground. Some of the temples were then donated by the Egyptian government to the countries that had taken part in these operations, which explains why the Ellesiya, a shrine dug from the rock by Thutmose III and dedicated to various gods, including the pharaoh Sesostres I is now in the Egyptian Museum in Turin, Italy. The most active Pharaoh in the area was Ramses II, who was responsible for building not only the famous temple Abu Simbel but also Beit el-Wali, Gerf Hussein, Uadi es-Sebua and Derr. The temple of Sebua, partially dug out of the rock, was built on the western bank of the Nile, near an older building by Amenophes III. The temple consists of two pylon entrances leading to courtyards, the

Nubian Temples

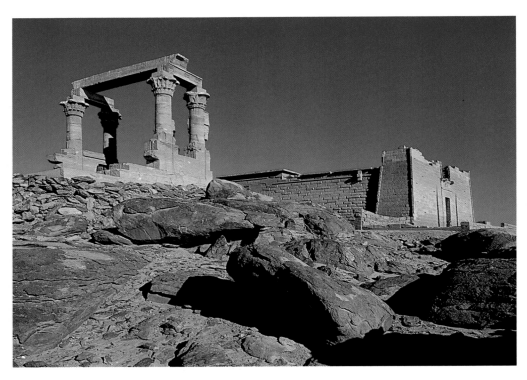

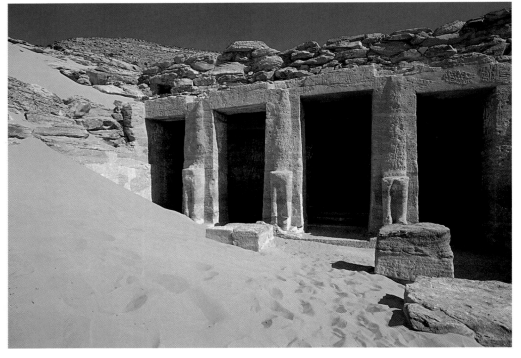

second of which gave access to the part of the temple cut from the rock, including the colonnaded hall, an antechamber which had four shrines off to the sides and the sanctuary. The building was dedicated to Amon and the deified Ramses II.

Derr was the only temple of Ramses II to be built on the eastern bank of the Nile, and was dedicated to the cult of Ra-Harakhti. Completely dug from the rock, this had very much the same structure as Abu Simbel but without the colossal statues that decorated its façade.

Temples of the traditional kind were built in Upper Nubia. At Soleb, to the south of the third cataract, is the great temple of Amenophi III, dedicated to Amon and the deified king. The temple, which is in an east-west position, had two porticoed courtyards, a colonnaded hall with 20 foot high columns shaped to look like palms, and a sanctuary of several rooms.

The building, which is today in ruins, still has part of the decorations and the reliefs which show stages in the jubilee celebrations of the king are of particular interest. The jubilee was a very old tradition, first celebrated when a ruler had been on the throne for thirty years and then repeated more frequently.

In the course of the ceremony, a complex system of rites was celebrated to reconfirm the royal power. At a point slightly further north, in Sedeinga, the king built another temple, dedicated to his wife Teie. Both these sites were explored in the 1960s by archaeological expeditions led by the Italian M. Schiff Giorgini and many of the finds are now at the University of Pisa. Further south is the grandiose temple of Amon at Jebel Barkal, perhaps begun under Thutmose III, although most of it was built under Ramses II. Built against the mountain which was probably the seat of a primitive cult, the temple was an active cultural center around which other temples were built and a flourishing city emerged, home of the kings of the XXV-dynasty and capital in the following period of Meroes.

132 top The small temple Wadi Kardassy, to the left in the photograph, is a small square building of 26 feet to a side, begun in the late Ptolemaic period and completed under Roman rule. This building was dismantled to save it from Lake Nasser and rebuilt near the temple of Kalabsha (far right in the photographs) 24 miles from the original site.

132 bottom Before being moved to New Sebua in 1964 the rock temple of el-Derr was the only sacred Theban building on the right bank of the Nile. Built under Ramses II, it was dedicated to the god Ra-Herkhti and was known as the "House of Ramses in the Dominion of Ra". The pylon and courtyard have been lost. The four pillars of the rear row of the portico on which the Osiric statues of the pharaoh rest have been partly saved.

132-133 Considered the second greatest Nubian monument (after Simbel), the temple of Kalabsha was built in the Ptolemaic period and dedicated to the local god Mandulis, associated with Isis and Osiris. Rebuilt during the Augustan empire, it remained almost entirely undecorated. Between 1961 and 1963 the temple was dismantled and rebuilt 24 miles south in New Kalabasha, at the western end of the Great Dam.

133 top Begun by Thutmose III (1468-1436 BC) and continued by Amenhotep II (1436-1412 BC), the temple of Amada is not large but has elegant proportions and is covered with lovely reliefs. During the salvage operations of the Nubian monuments the small sanctuary was completely closed in a steel and concrete frame weighing 900 tons and moved to its new site, nearly two miles away and over 250 feet higher up, by a specially built three-track cog railway. Originally, the portal of this temple was enclosed by two brick towers, now lost.

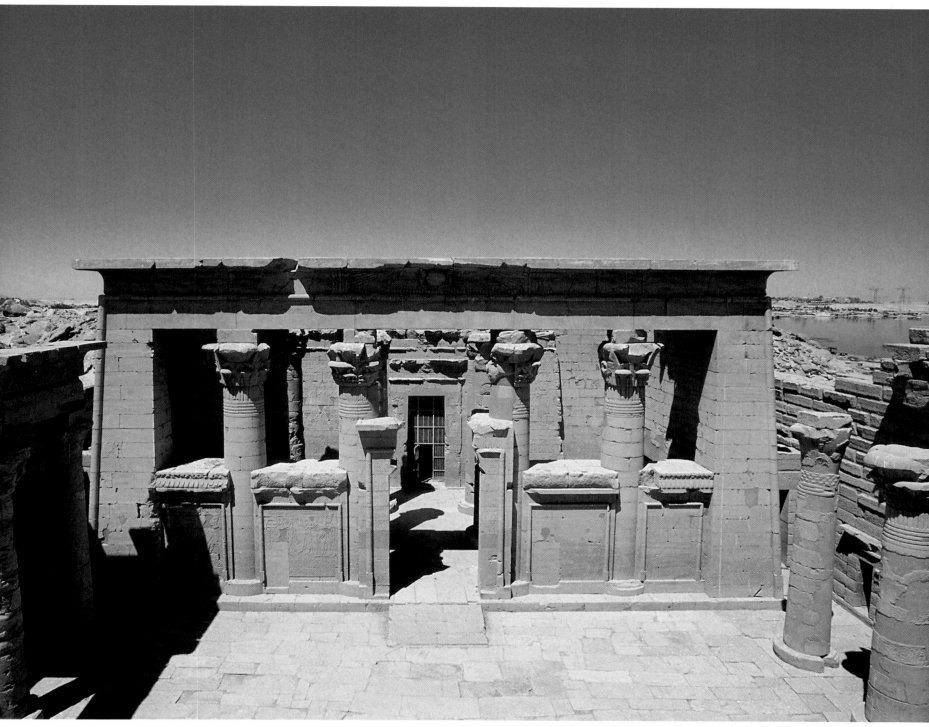

133 bottom left Only the colonnaded hall, supported by 16 columns, remains of the temple of Wadi Maharraka. The building, from the time of the Romans, was rebuilt on the New Sabua site.

133 bottom right The so-called Hall of the Festivals in the temple of el-Derr is a huge colonnaded room supported by six pillars whose bas-reliefs show Ramses II before a number of gods.

A Colossi of Ramses II
B Southern shrine
C Northern shrine
D Great colonnaded hall
E Vestibule
F Sanctuary
G Second colonnaded hall

ABU SIMBEL, HONORING RAMSES II

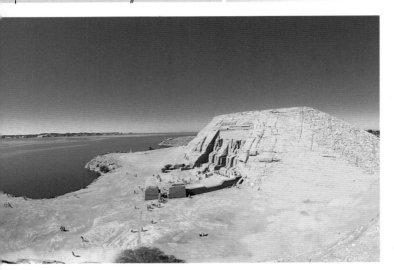

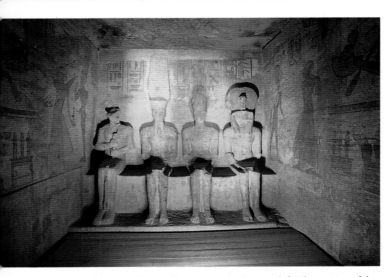

134 top This aerial view shows the new position of the temples of Abu Simbel with respect to the waters of the artificial lake built in the 1960s and honoring the Egyptian president, Gamal Abdal Nasser.

134 center left The portico of the great temple of Ramses II, completely dug from the rock, is 60 feet long and decorated with eight Osiric pillars, about 30 feet high, showing Ramses II in the form of Osiris.

The discovery of the two temples of Abu Simbel was made by the Swiss traveler Johann Ludwig Burkhardt (1784-1817). While he was staying on Malta in 1809, where he had gone to improve his knowledge of Arabic, Burkhardt was converted to Islam, and took the name Ibrahim ibn Abdullah.

He became a Muslim in every sense and traveled throughout Egypt and the Near East, reaching places where no other westerner had been. In 1813 he set out to explore the region south of Qasr Ibrim, in Nubia. On the way back he decided to stop in the village he wrote of in his notes as Ebsambal (this was what Abu Simbel sounded like to him) as the local inhabitants had told him there was an extraordinarily beautiful temple in the

area, not far from the Nile. It was thus that Burkhardt found himself face to face with the splendid rock sanctuary dedicated to Queen Nephertari, decorated with six colossal statues.

Before leaving the area, he decided to explore it further. He headed toward the desert where he discovered a second temple, dedicated to Ramses II, almost entirely buried in the sand. Only the upper part of the southern colossus was visible, and Burkhardt made an ecstatic description of this wonder in his notes. When he returned to Cairo, Burkhardt told what he had seen to Giovanni Battista Belzoni (1778-1823) who visited Abu Simbel the next time he visited Nubia. There, after a great deal of work, he was able to free the entrance to the Greater

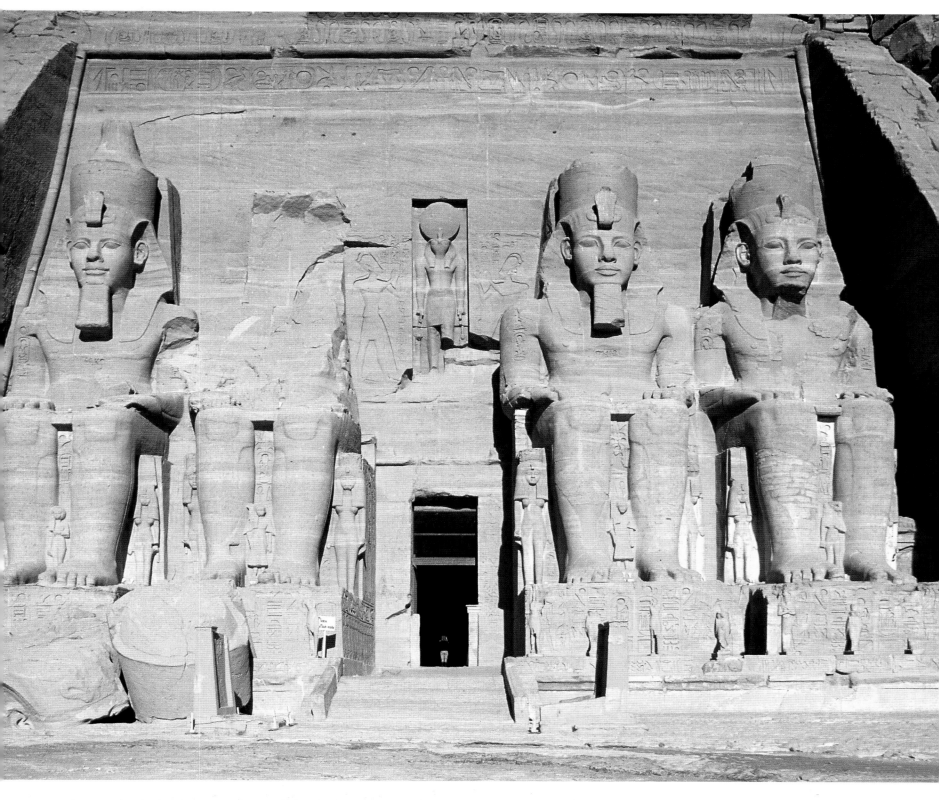

134 center right This famous bas-relief showing Ramses II in his war chariot during the battle of Qadesh is on one of the walls of the portico. The bow and the arms of the pharaoh, shown as he fires at his Hittite enemies, appear to be doubled, as if the artist had second thoughts and covered his first version with a layer of plaster, now lost.

134 bottom The most secret and holy part of the great temple is 214 feet from the entrance door. In this small room, 13 feet wide and just over 23 feet deep are the seated statues of Amon-Ra, Harmakhis, Ptah and Ramses II.

134-135 The façade of the great temple of Abu Simbel, decorated with four immense statues of Ramses II, is of gigantic proportions. It is 125 feet wide and almost 110 feet high, the equivalent of a nine-story building. The second colossus from the left collapsed in the thirty-fourth year of the ruler's reign, possibly because of an earthquake. The third was restored by Sethi II (1214-1208 BC).

135 bottom From this photograph we can appreciate the dimensions of the two artificial hills that house the reconstructed temples of Abu Simbel. The entire complex was dismantled and reassembled between 1964 and 1972 to save it from the waters of the artificial Lake Nasser.

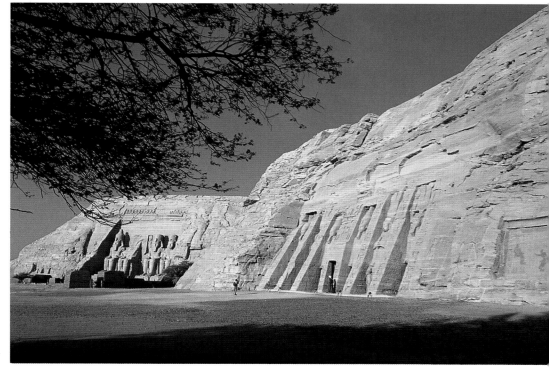

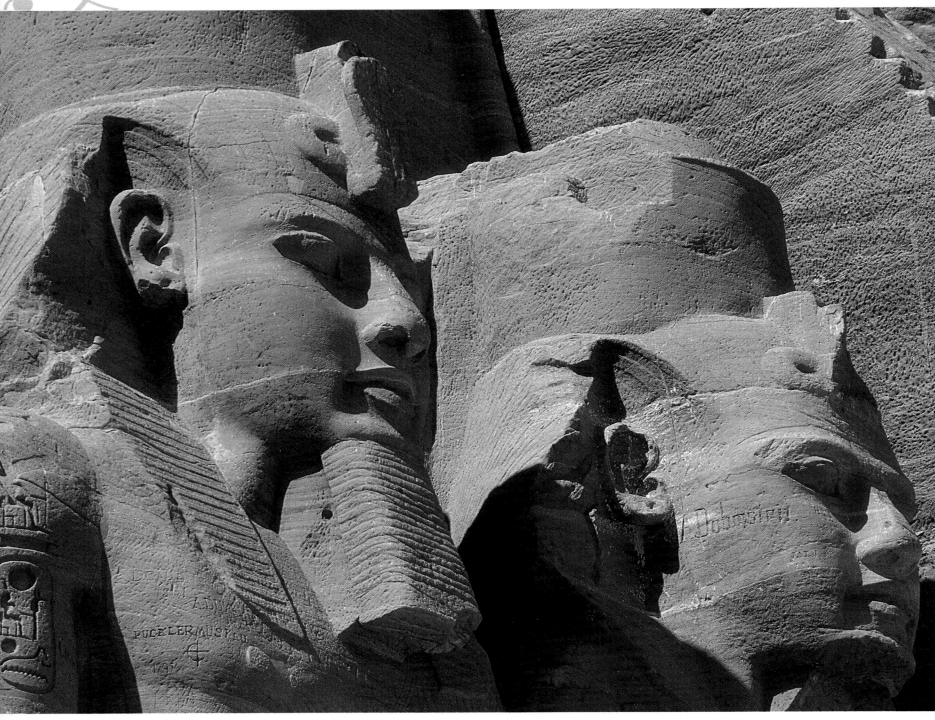

Temple from the sand and penetrate its interior. From that moment on the rock sanctuaries of Abu Simbel became an essential stopping place for every traveler to Egypt.

The local inhabitants were hired to remove the sand that blocked the entrance to the Great Temple. When the tourists and explorers left, the locals returned and covered over the entrance with sand again, so they could be hired by the next group that came to see the sight! Toward the end of the 19th century the Antiquities Service in Egypt decided to put an official end to the this practice and the façade of the Greater Temple was entirely uncovered.

At the start of the 20th century the construction of a dam on the Nile at Aswan made the river waters rise, and it became necessary to protect the site of Abu Simbel from flooding. The situation became even more perilous toward the end of the 1950s, when the decision was taken to build the Great Dam. On March 8, 1960, UNESCO asked for international cooperation to safeguard the rock sanctuaries of Abu Simbel. Among the projects presented, the one chosen was to dismantle the temples block by block and reconstruct them on higher ground. The difficult, huge-scale operation took many years.

The two sanctuaries were first carefully shored up and covered in sand to protect them from damage and then sectioned off into hundreds of blocks. Finally they were rebuilt 500 feet from their original site about 200 feet higher up. The two hills the temples had been dug from were replaced by reinforced concrete domes covered in sand.

During the rebuilding operations every effort possible was made to keep the setting, position and distances between the two monuments as they had been originally.

On September 22, 1968, the official opening ceremony marked the conclusion of this dramatic salvage operation.

The two rock sanctuaries built on behalf of Ramses II (1290-1224 BC) must have been originally located near an Egyptian colonial settlement, of which no trace remains. This would have had the dual function of controlling the southern borders and handling trade with the

Nubian peoples.

The Greater Temple is preceded by a terrace in front of which there is a broad, level area. There are four colossal statues on the façade, arranged in pairs on either side of the main entrance, showing a seated figure of Ramses II.

The upper part of the southern statue closer to the interior is no longer upright, the result of an earthquake which occurred only a few years after the building of the temple. Other damage was caused by this event, so some part of the façade and a number of internal structures were restored.

The enormous statues, nearly 60 feet high, were sculpted out of the rock in the hill behind, and are seated heavily on their thrones. Their majesty is emphasized by

the crown worn by the figures which combines the crowns of Upper and Lower Egypt. Their imposing form contrasts with the mild, calm expressions on the faces, expressions which seem to symbolize the image of a just, generous ruler, prepared to listen to the needs of his subjects.

At the feet of these great statues are various members of the king's family. There are statues of princes, princesses and queens filling all the surrounding space, creating a rich, varied, and almost confusing composition typical of the artistic tastes of the Ramses period.

There are various inscriptions on the surrounding rock, including one that tells the story of the marriage of Ramses II with a Hittite princess.

Above the main entrance to the temple is an

image of Ra-Harakhti, sculpted in strong high-relief. The god is shown walking, from the front, with his arms by his sides. His right hand is resting on a scepter-user, his left on an image of Maat, the goddess of justice.

The presence of these two elements leads to a secondary interpretation of the entire composition that, interpreted as a rebus, makes its meaning to be "Powerful in justice is Ra". The fact that the sculpture can be interpreted as an effigy of Ra or as the name of Ramses II is extremely significant, and forms part of the attempt at self-glorification which is a constant feature of this ruler's reign, and finds its most complete manifestation here at Abu

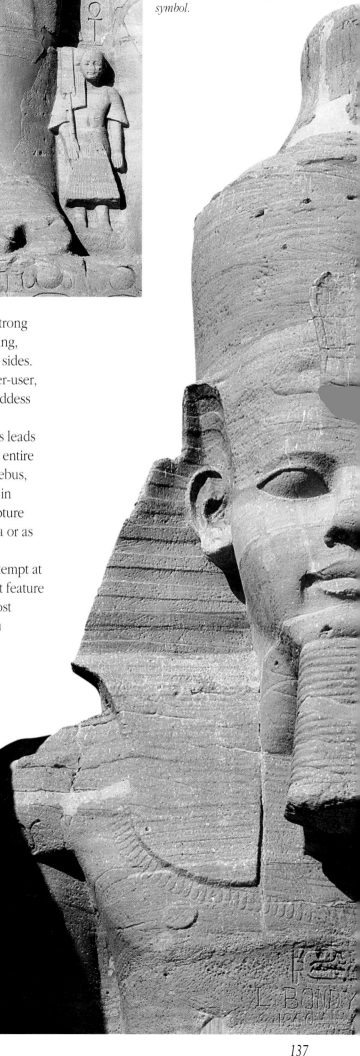

136-137 The statues of Ramses II which are on the façade of the great temple, well over 60 feet high, are believed to faithfully reproduce the face of the sovereign.

137 left A group of sandstone falcons, symbol of the god Horus, adorn the balustrade in front of the great temple.

137 top right Between the legs of each colossus are other similar statues of members of the royal family.

Abu Simbel

Abu Simbel

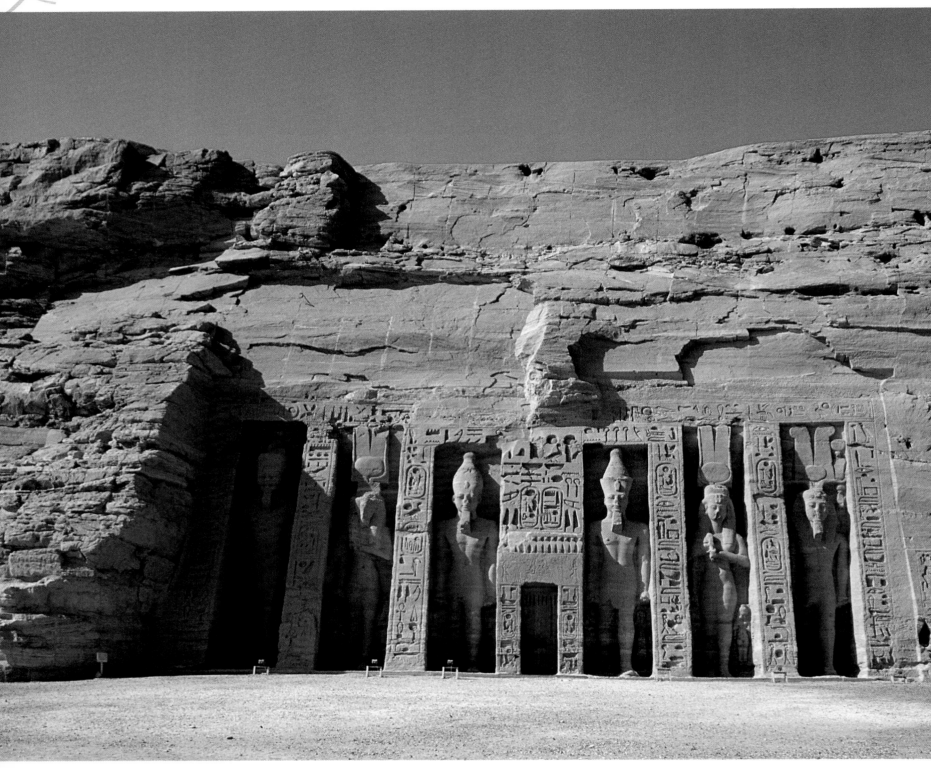

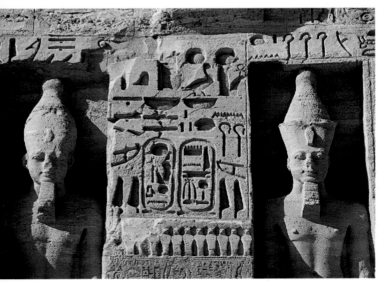

138-139 The small rock temple of Abu Simbel was built on a promontory north of the great temple. It was dedicated to Hathor, considered in Nubia to be the wife of Horus, the falcon god who acted as protector to the royal house. The statues on the façade, over 30 feet high, are placed in a series of deep niches and show Ramses II and his wife Nephertari. The two statues of the queen, resembling the goddess Hathor, are flanked by four statues of Ramses II and, against the usual conventions of this type of sculpture, have the same dimensions as the pharaoh, indicating the great importance of this queen. By equating the queen to Hathor, wife of Horus, the god represented by the pharaoh on earth, her royal nature and the continuity of descent were assured.

138 bottom Above the entrance to the small temple are found scrolls with the name of Ramses II.

139 top In an inscription carved in the small temple Ramses II, who is here seen in two of the statues on the face, states that a pharaoh and his wife have, for the first time, founded a temple together.

139 center Two of the statues in the small temple show Nephertari in the form of Hathor, her head surmounted by the sun and two feathers. The queen is holding a sistrum, a musical instrument beloved by the goddess, in her left hand.

Simbel.

On either side of the image of Ra-Harakhti are two other figures of Ramses II in an attitude of adoration. The entire composition can therefore be interpreted as a scene in which the sovereign pays homage to Ra-Harakhti and, at the same time, honors his own name. The Greater Temple is designed in such a way that all the major divisions of the classical Egyptian sanctuary are incorporated within a structure completely dug out from the rock. For instance, the first hall is decorated like the courtyard of a temple by means of the pillars supporting imposing figures of the ruler, in a standing position with his arms folded over his chest.

The statues on the southern row of pillars are wearing the White Crown, the emblem of dominance over Upper Egypt, while those on the northern row wear the Double Crown, symbol of royal power over the united Egypt. The faces show the same expression of calm detachment that we noticed on the statues on the façade.

The walls of this hall are decorated with inlaid reliefs which show Ramses II's greatest victories in war. The northern wall is completely dedicated to the important moments in the Battle of Qadesh. At the

entrance is shown the Egyptian encampment at the moment of attack by the Hittite army. A little further on, we can see the Egyptian counter-offensive against Qadesh. Around the city in the relief flows the River Orontes, in which the bodies of the Hittite princes and their allies are floating. The colonnaded hall leads to other rooms, only partly decorated, that would have been used to store the furnishings and cult objects of the temple. Among the reliefs in these halls are scenes in which Ramses II makes offerings to various deities, including the king himself.

A second colonnaded hall, following the first, leads the visitor into a more intimate dimension, as the space grows smaller and

the light dimmer. This takes us to the most dignified part of the structure, the sanctuary. At the far wall are the effigies of the gods that make up the so-called "triad of Ramses". These are Amon-Ra of Thebes, Ptah of Memphis and Ra of Heliopolis. Alongside these is a statue of the sovereign. In this most intimate part of the temple the self-celebrating theme that began at the façade of the building comes to an end.

The end of the architectural journey also symbolizes the maximum point of

exaltation of Ramses II. The sovereign is deified by this position alongside the most important gods of the country while he is still alive.

The Lesser Temple, dedicated to the wife of Ramses II, Nephertari, also clearly states the notion of the divine conception of kingship, expressed by the way the monumental art is formed. The sanctuary celebrates Nephertari's relationship to the goddess Hathor of Ibshek. This is a clear way of making the queen a worthy wife for the pharaoh-god. Her temple is a replica in miniature of the Greater Temple.

The façade has six colossal statues, four of Ramses II and two of Nephertari. Both are shown walking, as if they were emerging from the mountain behind them. The queen is wearing the typical Hathoric headgear, a solar disk enclosed in cow's horns, while the crowns worn by the king are of various styles. The interior of the sanctuary has a six-pillared colonnaded hall decorated with the emblem of Hathor, with the face of the goddess shown from the front. This leads to a hall with two smaller rooms leading to the central sanctuary. At the rear wall of the sanctuary is a niche containing a statue of Hathor, shown as a calf protecting the king. The wall decorations show scenes in which the king and queen are shown in adoration of various gods.

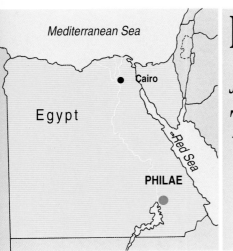

PHILAE,
JEWEL OF THE NILE

140 The Kiosk was built on the island of Philae by the Roman emperor Trajan in 105 AD as the site for the sacred vessel of Isis, in which the statue of the goddess was carried during the procession to the southern Nubian temples. The structure is in the form of a four-sided pavilion made up of 14 columns with floral capitals. They are joined at the bottom with inter-columnar walls mainly without decoration.

The temple complex of Philae is a special one, different from the true Nubian temples. It is situated on an island of the first cataract, which had always been a point of contact between Egypt and Nubia, as it was the most important center of worship dedicated to the goddess Isis. Designed and built almost completely during the period when Greece dominated Egypt, the temple complex of the island became a place of worship venerated not only by the

the time of Justinian in 535 AD that the temple was finally closed and four churches were built on the site in the years that followed.

The first evidence of the cult of Isis on the island of Philae dates back to the era of Psammeticus II (XXVI-dynasty, 6th century BC). The king probably stayed on Philae during his Nubian campaign, and there he built a small building honoring the goddess who was worshipped in his home town of

140-141 This splendid aerial view shows the whole island of Philae including the temple dedicated to the goddess Isis, the colonnade in front of the first pylon, the Kiosk of Trajan and other minor structures. Most of the buildings are from the Ptolemaic-Roman period.

Egyptians and inhabitants of Nubia but also by the cosmopolitan citizens of the capital, Alexandria. The special position of Philae made it particularly important for the southern part of the area and it was a favorite place of worship for the Nubian people, who continued practicing their religion here even after the arrival of the Christianity. In fact, the temple of Philae was the only one throughout the entire Roman Empire that remained open following the edict of Theodosius in 378 AD prohibiting "pagan" practices. It wasn't until

Sais. Later, Amasis (XXVI-dynasty, 6th century BC) built a small temple which was then extended by Nectanebos (XXX-dynasty, 4th century BC). The same king also built a monumental portal which was later incorporated into the first pylon of the temple of Isis and a smaller building that remained unfinished on the southern side of the island. But the great temple to which the island owes its fame was designed by Ptolemy of Philadelphia (3rd century BC). This king and his successors built an original complex in which the elements of

A Vestibule of Nectanebos I
B Temple of Arsenuphi
C Western colonnade
D First pillar
E Mammisi
F Second pillar
G Temple of Herendote
H Gate of Diocletian
I Temple of Augustus
J Coptic church
K Temple of Isis
L Cloister of Trajan

140

141 top In front of the first pylon are two long colonnades, running almost parallel. The western one consists of 32 columns with plant-inspired capitals, while the eastern one is not complete.

141 bottom At the southern end of the island is the Kiosk of Nectanebus, consecrated to the goddess Hathor. The effigy of the goddess of beauty appears again above the capitals of six columns, the only ones of the 14 original columns remaining.

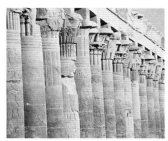

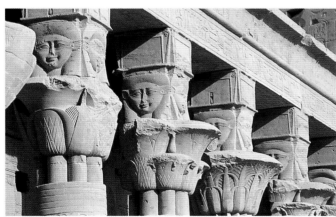

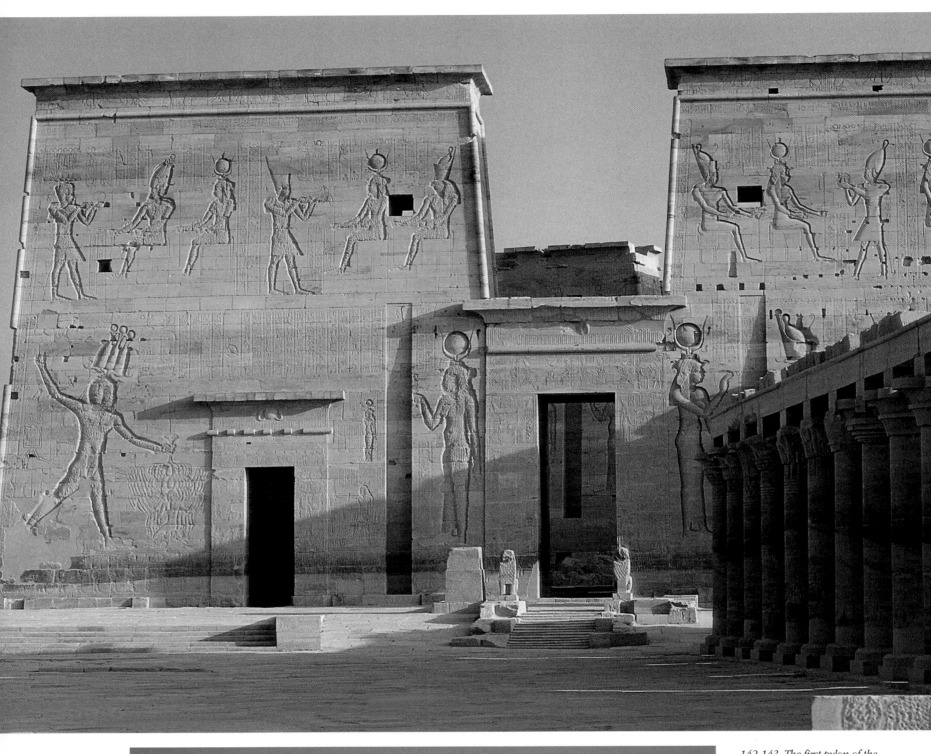

142-143 *The first pylon of the temple of Isis is about 60 feet high and almost 150 feet wide. It was begun by Ptolemy III (285-247 BC) and completed by his successor Ptolemy III, but the decorative work was continued into later periods. On the two towers, Ptolemy XII Neo Dyonisus (81-51 BC) is shown offering the submission of his prisoners to Isis, accompanied by her son Horus and sister Nephtis. The portal is topped by the winged sun and has two pink granite lions in front.*

Egyptian architecture combined with others of Greek style, radically altering the traditional notion of space in the Egyptian temple. Asymmetrical views and Hellenistic influences make this complex absolutely unique in Egypt.

The great temple of Isis has a double monumental entrance in pylon form. The first pylon leads to a spacious courtyard, bounded by other buildings on the eastern and western sides. On the western side is a temple surrounded by columns representing the birthplace, used for

offerings. In front of the first pylon an open space, called a dromos in Greek, was set aside at the end of the Ptolemaic period for the pilgrims who, in ever-increasing numbers, came to the island. The two colonnades at the edges of the area are not parallel which represents a new trend in Egyptian architecture. On the eastern side of the dromos three small temples were built, dedicated to Manduli and Arensnufi, Nubian gods, and to Imhotep, who is linked with the Greek god of medicine, Asclepius. On the

143 top left Inside the temple of Isis, the sanctuary is in semi-darkness, lit only by two small openings in the upper part of the side walls. In this room we can still see the granite pedestal, dating back to the period of Ptolemy III (247-222 BC) and his wife Berenice, on which the sacred vessel of the goddess was placed. On Philae, Isis was associated with Sothis, the name given to the star Syrius, whose appearance marked the start of the rising of the Nile. The cult of Isis was closely linked to the important seasonal floods.

143 top right Isis, here seen in one of the great bas-reliefs of the first pylon, was extremely important in the Egyptian pantheon. Daughter of the sun god Ra and wife and sister of Osiris, she was considered both protector of the dead and mother-goddess of creation. She had an extraordinary knowledge of magic and many miraculous powers.

143 bottom Horus, the falcon-god son of Isis and Osiris, was believed to be the lord of the sky and protector of the pharaoh.

142 bottom Near the first cataract of the Nile, the island of Philae is dominated by the imposing mass of the Ptolemaic temple of Isis, flanked by several other cult structures. All of these structures would have been entirely submerged by the construction of the Aswan Dam. Under the leadership of UNESCO they were saved by an international effort. They were entirely dismantled between 1972 and 1980 and reassembled in a higher position.

special rites celebrating the birth of Horus, the son of Isis. The eastern side of the courtyard is bounded by a portico leading to other rooms, the so-called temple annexes. The second pylon leads to another, smaller courtyard and a porticoed façade. The ceiling is supported by two rows of four columns, the first four of which were probably destroyed when the complex was transformed into a church. From here we cross two antechambers to the tripartite sanctuary where the cult images of the goddess were kept. The walls are decorated with bas-reliefs showing presentations of

eastern side of the island is the colossal building of Trajan built as part of a landing place used for ritual processions on the Nile. Among the other buildings on the island was a temple to the north for the Emperor Augustus and an entrance known as the Gate of Diocletian.

As with other Nubian temples, the construction of the great Aswan Dam made it necessary to move the complex out of the reach of the water.

In 1972 work began on dismantling the temples. This was completed in 1980 with the entire complex moved to the nearby island of Agilkia and rebuilt there.

LEPTIS MAGNA,
THE ROME OF AFRICA

Mediterranean Sea

Tripoli ●

**LEPTIS
MAGNA** Libya

A Theater
B Markets
C Arch of Septimus Severus
D Baths of Hadrian
E Gymnasium

F Nympheon
G Temple of Rome
and Augustus
H Forum
I Curia
J Temple of Dolychene
Jupiter
K Harbor of Severus
L Lighthouse
M Amphitheatre
N Circus

144 bottom left The intense building activity ordered by Septimus Severus, born in the city, transformed Leptis Magna into a metropolis with a luxurious appearance. The picture shows one of the mermaids in the medallions that are part of the decoration of the Severian Forum.

144 bottom right Scrolls of acanthus decorated the pillars that frame the apse of the Severian basilica.

144-145 The great basilica of the Severian Forum reflects the new aesthetic styles that came into the Roman world at the end of the 2nd century AD. The columns are of red granite with white marble capitals and a number of niches give a sense of movement to the massive walls.

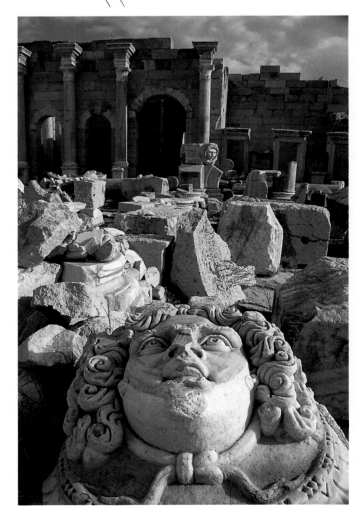

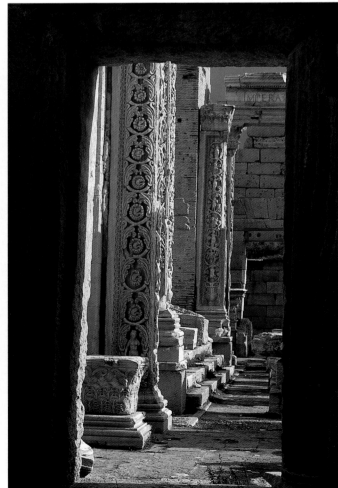

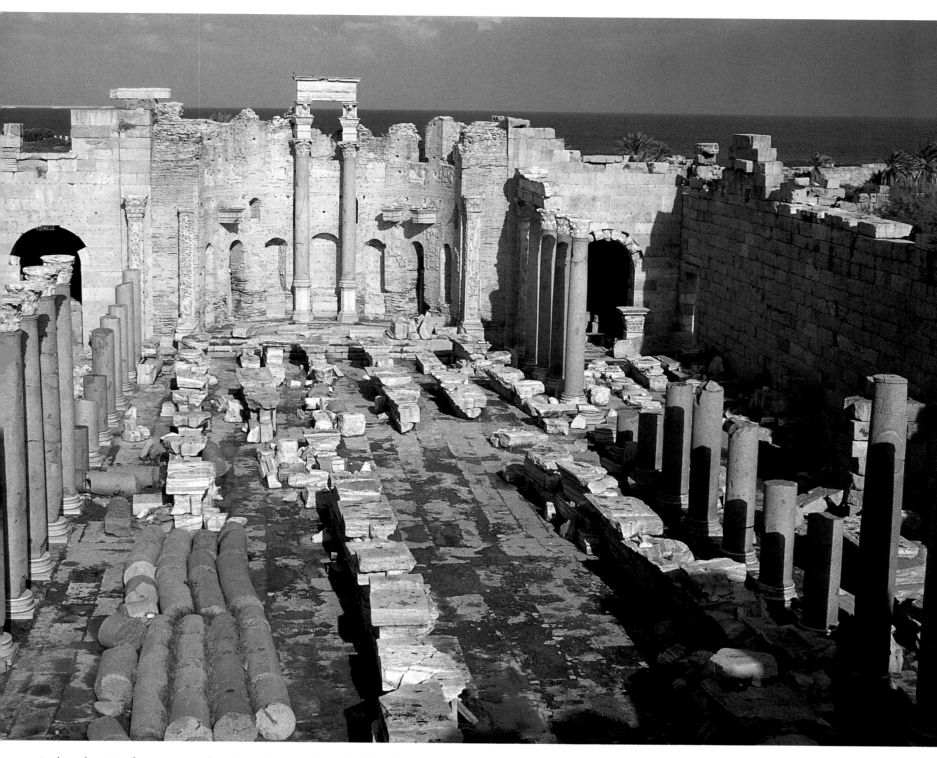

Archaeology is often seen as a heroic and even dangerous field. This is partly the fault of Hollywood, which has created epic characters prepared to stop at nothing to save their extraordinary discoveries from the villains. Many people seem to see archaeologists as Indiana Jones personalities, half scientists and half adventurers, while the archaeological sites are considered to be found only in remote areas, difficult to reach, buried in tropical forests or burning deserts and perhaps under the control of treacherous warriors and hostile tribes. Certainly, there are such places as Piedras Negras and Angkor, which are located in difficult or even dangerous areas, and the history of archaeology lists the names of such people as Hiram Bingham, John Lloyd Stephens

and Frederick Catherwood who were extraordinary people deserving of being called explorers. In most cases, however, archaeology is less romantic than this picture. Today, it is mostly a question of careful study, rigorous methods and long periods of research in the field using advanced technology. While it is true that in the early days of archaeology both research and excavation could turn into real adventure, today technological progress and modern communications have brought us to a point where there are no really inaccessible places left. Even excavations in the tropical rain forests take place in relative comfort with the help of logistical support services that would once have been unimaginable. The use of motor vehicles, helicopters, satellite

communications, echo soundings, self-inflating tents, thermal clothing, portable water purifiers, long-life foods and many other innovations have change the course of archaeology over just a few decades. But this does not mean that it has lost anything of its fascination. It is still a fascinating, intriguing science but it is important to view it realistically from today's point of view. Even Heinrich Schliemann, often mentioned as the great amateur archaeologist, prepared carefully for his expeditions. Actually, it's important to remember that even in the past the great archaeological discoveries were rarely made as a result of stunning human heroic actions. To take one example, the excavations that brought to light one of the most important Roman cities on the African

coast of the Mediterranean, Leptis Magna, came up against very few problems. The city was abandoned relatively late in history and never repopulated. Mostly built from stone, it was covered by desert sands blown by the wind, which to a certain extent served to protect certain architectural details, bas-reliefs and plaster from erosion. The first news of its existence came from a Frenchman who had been captured by Arab pirates and held prisoner in Tripoli from 1668 to 1676. After his release, he returned to France and wrote a report on his adventure, in which he mentioned visiting the ruins of a large city. The remains of Leptis Magna, the city he wrote about, was explored by a small number of scholars and soon became almost a quarry for building materials. Columns, capitals, entablatures, friezes and bas-reliefs were taken to Tripoli and even Paris and London to decorate public and private buildings. Finally, in 1913, after Italy occupied Libya, a serious archaeological exploration of the site began, carried out at first by Salvatore Aurigemma who was followed by Pietro Romanelli and other Italian scholars.

The excavation of the buried city proved relatively easy. The outlines of the streets and buildings could be clearly seen beneath the layer of sand. In fact, the only real problem was that the sand had to be dumped as far away from the excavations as possible to keep the wind from blowing it back. Cataloging the huge number of architectural elements found proved a much longer and more complex job, but it was absolutely necessary for the correct reconstruction of the main monuments in the town. After 1951, when Libya gained her independence, various buildings were restored with the help of British archaeologists. Today the city is known as "The Rome of Africa", due to the sumptuous nature of its layout. Leptis Magna was Phoenician in origin and the main port of the region. It became part of the province of Africa in 46 BC after the battle of Thapsus in which Julius Caesar defeated the forces of Pompey. In the Augustan period the city already had begun to take on the plan it would have in the future. It was built around two slightly diverging main axes, to the west of the Wadi Lebda, a small river subject to severe seasonal flooding. Thanks to the generosity of several local patrons, during the 1st century the city was enriched by a number of monuments, including the old forum, around which the assembly rooms, a basilica, the Temple of Liber Pater and the temples of Rome, Augustus and Hercules (in Ionian style), and a large market were built. The market is particularly interesting, and was formed by a rectangular area bounded by porticoes in the midst of which were two round pavilions inside octagonal porticoes. Nearby was the theater. The lower part of the auditorium was against a natural hill while the lower part was supported by strong constructions filled with stones. Also nearby was the Calcydicus, an elegant building built in the year 11 as a shopping center. In 126 under Trajan Leptis was named a colony and sixteen years later, thanks to his successor Hadrian, it became even more glamorous as he had a large baths complex with a spacious gymnasium built in the southeastern area. However, the city reached its greatest

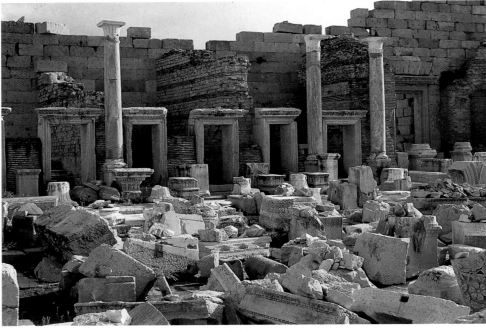

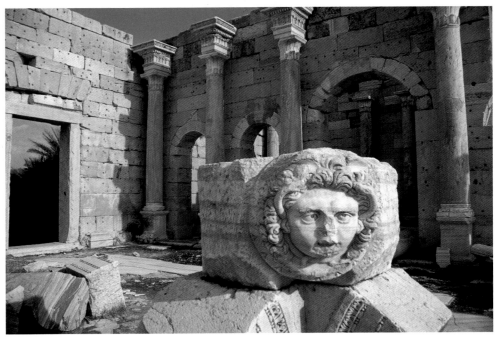

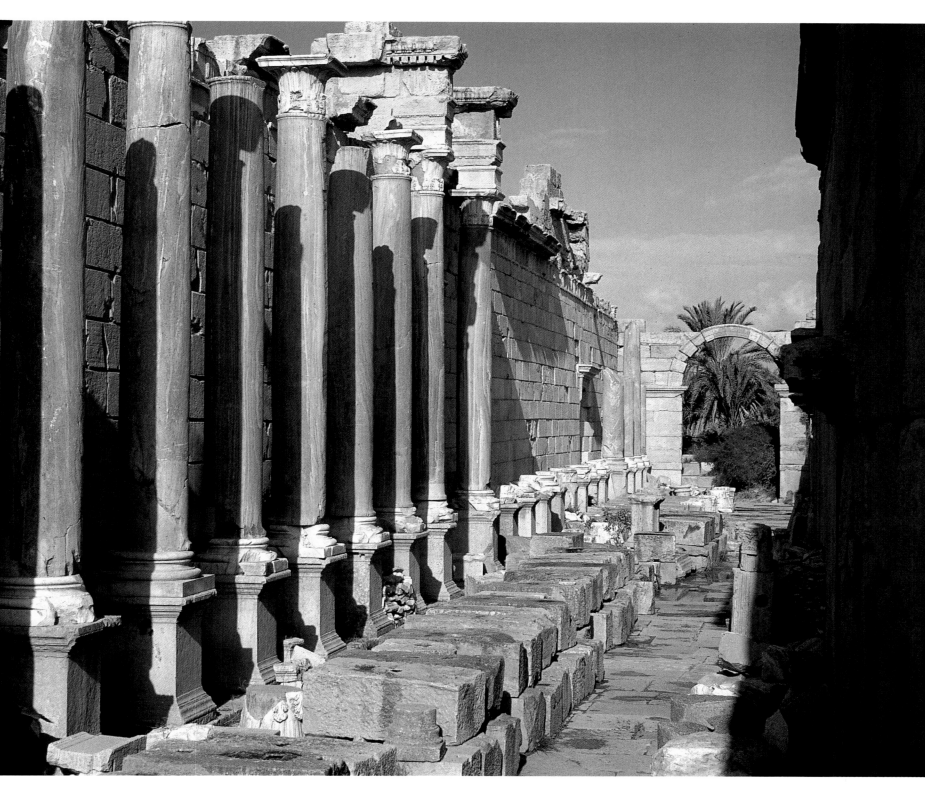

146 top The forum area, cluttered with architectural remains awaiting restoration and their return to their original positions, testifies to the richness of ancient Leptis Magna. Unfortunately, many of the city's treasures were removed as long ago as 1687 when the French consul had columns and marble friezes from Leptis Magna taken to Paris.

146 bottom This mermaid's head was part of the opulent sculpted decoration of the Forum. We can clearly see the way in which Severian sculpture tended to underline the dramatic play of light and shadow.
The Forum was begun by Septimus Severus and completed in 216 AD by Caracalla.

146-147 Severian architectural tastes were both delicate and theatrical tending toward buildings with apses, niches and colonnades. A good example of this is the street outside the Severian basilica and adjacent to the old Forum, which is also interesting for its refined use of different materials to obtain colorful effects.

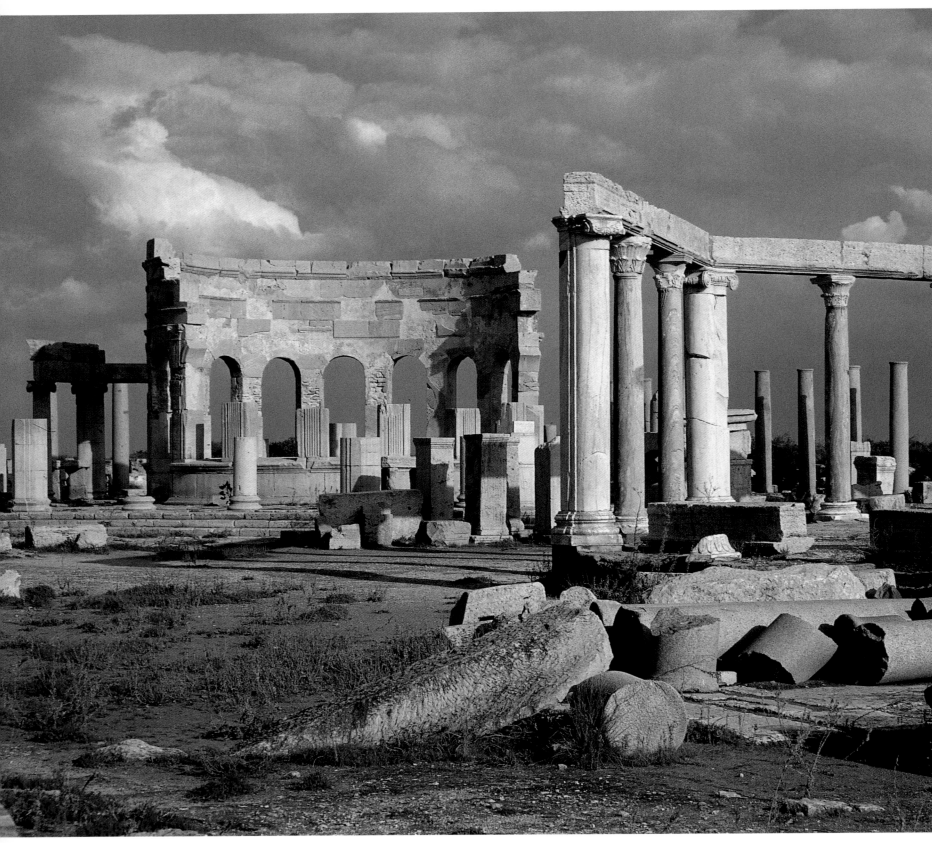

splendor during the reign of the Emperor Septimus Severus, who was born there in 146 and inaugurated intense building. His wide-ranging projects involved the area between the main street and the bed of the Wadi Lebda, which was moved out of the city. The new main street of the city was an imposing colonnaded avenue 60 feet wide, which started near Hadrian's bathhouses with a gigantic Nymphs' shrine and stretched to the harbor basin. To the west of this street was the new forum and the Severian basilica, with its splendid marble work, statues and decorations in relief,

often made up of acanthus scrolls, sculpted animal heads and mythological scenes. Here we can see how theatrical Severius's architectural tastes were, with a strong liking for apses, niches and colonnade prospects affording a continuous play of light and shade emphasized by the use of different materials. The same luxurious, almost baroque, tastes show in the great arch. This arch, which has been patiently reconstructed by the archaeologists, was built at the crossroads of the main east-west and north-south thoroughfares. The pillars show friezes similar to those on the

basilica, while the sculpted decorations include various political and religious scenes whose style is similar to later Byzantine art. The city, superb in its monumental appearance, became one of the richest in the Mediterranean as exports from the interior of ivory, precious stones, slaves, exotic animals and local produce grew. In Leptis Magna, which was also famous for the quality of its olive oil, tuna salting flourished alongside the manufacture of garum, a popular sauce made from the fermented internal organs of salted fish, which was a staple of Roman

cuisine. The city began its decline in the 4th century due to the incursions of tribes from the interior and the rapid sanding up of the harbor, due to a serious flaw in the design of the Severian basin. Later invasions by the vandals wounded the city even further and, after a brief period of recovery under Justinian, it fell into decay. Fifteen centuries were to pass before a small group of archaeologists decided, with infinite patience, to disturb the Libyan sands and allow the birthplace of the twentieth emperor of Rome to tell us the story of its past splendor.

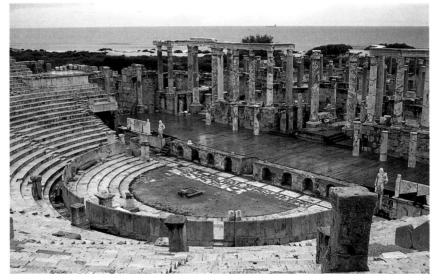

148-149 The market in Leptis Magna was the most flourishing one in the African provinces and was a major destination for caravans from the interior of the continent bringing precious goods, slaves and exotic animals. From the surrounding countryside came vast quantities of olive oil while the coastal area provided salted fish and other goods.

149 top The theater at Leptis Magna was built under Augustus, thanks to the generosity of a wealthy local merchant. The elaborate front was added during the 2nd century AD in the time of Antoninus Pius.

149 center A number of Ionian columns are still standing in the old forum area. These were part of the Temple of Hercules built at the start of the 1st century AD. The square in front, first transformed under Augustus, was the heart of the town up to the renovations of Septimus Severus.

149 bottom The picture shows a glimpse of the large bath complex built in 126 on orders from Hadrian.

ASIA

Introduction

The Middle or Near East extends over about 800 square miles, slightly less than Western Europe. Although the area is relatively small, there is a great deal of variety in its landscapes and types of terrain, rainfall and climate, vegetation and settlement. Mountain chains give way to flood plains and often arid plateaus. Great rivers, like the Tigris and Euphrates, cross areas that would otherwise have been condemned to almost total dryness. The so-called "fertile crescent", an expression used with reference to the Middle East in general, consists of a semi-circle of irrigated, fertile land, settled by both farmers and urban populations and stretching from Palestine to Syria and Mesopotamia, with the Syrian-Arabian desert to the south and the highlands of Anatolia, Armenia and Iran to the north. Here the situation is even more complex, the mixture of different ecological zones is more intricate. The highlands are broken up by valleys and basins that reproduce the features of the

fertile crescent in miniature, the irrigated lands contain lower mountains and desert fringes, and the arid plateaus themselves are scattered with oases. The environmental unevenness of the Middle East is a fundamental fact that is necessary for the understanding of the equally varied social phenomena from an historical point of view.

The geographical fragmentation of the region gives an explanation for the variety of development strategies, the changing nature of the political framework, and the constant cultural interchange in it. In a habitat of this kind, the typical development pattern is a nucleus, a central space, more densely inhabited and civilized surrounded by an irrigated, cultivated plain and scattered with agricultural villages. The outskirts are the surrounding steppe or mountain, less densely and permanently populated by shepherds, vagabonds and brigands, progressively shading into

uninhabited areas which are useful only as deposits of raw materials. Now, within the Near Eastern context, we have to imagine a series of these centers and outskirts emerging from time to time with economic interchanges and cultural and political heritages. It is in a context of this kind that the site of Ur, in southern Mesopotamia, was founded and developed, from a simple village to a powerful city-state, then to the head of a unified empire of Lower Mesopotamia, later to be inherited by the city of Babylon under King Hammurabi. This was founded by western Semitic nomads (Amorreans), a mainly pastoral people, identified as coming from the Syrian-Palestinian and Upper Mesopotamian areas and distinct from the eastern Semitic people who lived in Lower Mesopotamia until the collapse of the Ur empire. The Amorrean nomads slowly entered and infiltrated the territory of Ur, taking advantage of the crisis situation which up to then had kept them on the margins as a force of outsiders. Gradually, the nomadic herdsmen changed into sedentary farmers or people who were at least brought into the economy of the city and subordinated to it as their stock raising and production activities became controlled through a centralized administration. The great Persian Empire founded by Cyrus II and consolidated by Darius I took over the cultural heritage of the Babylonian civilization. The central base of the great Mesopotamia was joined by the centers of the Nile Valley, the Aegean, the valley of the Indus and Central Asia. The ancient, holy city of Babylon was one of the capitals of the empire, together with Susa and Ekbatana. Features of the Babylonian culture as well as Egyptian and Aegean characteristics can be found in the monumental art of Persepolis, the capital of imperial splendor, once again underlining the interchange of ideas and manpower throughout the empire.

The terrible profanity committed by Xerxes in burning down the Acropolis of Athens cost Persepolis dearly, and Alexander the Great burned its splendid palaces, replacing a Persian speaking empire with a Greek speaking one. On the sacred mountain of Anatolia, Nemrut Dagh, the mound of King

Antioch I reminds us of the ancient roots of the ruler with its mixture of Persian and Greek elements. The names of the monumental statues of the gods sound both Greek and Persian, their faces have Greek features but their hairstyles seem to be Persian, while the text of the inscriptions behind the figures is in Greek. Persian culture did not try to impose itself on the local Greek and Anatolian local and immigrant populations. Such is the case of Ephesus, situated at the meeting points of the Lydian, Ionian and Karian worlds, which became part of the empire of Cyrus the Great in 546 BC. The famous sanctuary of Artemis, seat of an ancient local cult devoted to this goddess of earthly fertility, which the Greeks took over and devoted to Artemis, was rebuilt several times in accordance with Greek theories and in 334 received homage from Alexander the Great who offered to continue work on it at his own expense. The ancient tradition of long distance trading, which crossed the Near East by sea (the Persian Gulf), river (the Tigris and Euphrates) and land, was continued in the lst millennium BC by the rich caravan town of Petra which, for various reasons including safety, was built in the heart of the Jordanian desert halfway between the Dead Sea and the Gulf of Aqaba. The city, capital of the kingdom of the Nabateans, nomads from northern Arabia, controlled two major caravan routes during the Persian period, one connecting Arabia and the Persian Gulf with the Mediterranean and the other, running north-south, linking the Red Sea and Syria. As a result of the Roman occupation and the creation of the province of Arabia in 106 AD, the slow decline of the city began, to the advantage of the nearby center of Palmyra in the Syrian desert. An eclectic town, meeting point of the eastern, Greek and Roman cultures, it became an essential stopping place for the caravans that wanted to follow the shortest route between the Indian Ocean and the Mediterranean. First Petra, then Palmyra, were the access gates through which the ancient east communicated with the now dominant west.

Desideria Viola

From the historic and artistic point of view, Asia is one of the most significant and fascinating areas in the world. The remains of the past are countless and it is still possible to make extraordinary discoveries, such as that at Lintong in 1974, when an entire terra-cotta army was brought to light, made up of thousands of life-size warriors, a replica of the army of the 3rd century BC first emperor of China, Qin Shihuang. The Chinese and Indian civilizations can be considered, in a sense, to represent the two poles of Asian history, and even though they are very different from each other, one thing they share is the spiritual experience of Buddhism, a religion which has spread through almost all the Asian countries. Founded in India, Buddhism spread in two main directions, from Sri Lanka to Indochina in the south and, following the Silk Road in the north, to China and Japan. The stupas of Sanchi and the caves of Ajanta in India, the

originally evoked only symbolically, but later appeared in various postures in an increasingly complex pantheon which also included female figures. In the incomparable paintings of the caves of Ajanta, the story of the Enlightened One and the evolution of Buddhism are shown as part of daily life, offering very interesting clues to the past. In China, too, the inside of the mountain became a sanctuary. In Longmen, generations of sculptors carved out nearly a hundred thousand images of Buddha and the bodhisattvas in natural caves, clefts and niches to indicate the devotion of the local community to the Buddhist creed. We can see how complex and esoteric the simple message of salvation preached by the Buddha became in the course of the centuries in mysterious Bayon, which celebrates the ideal of the bodhisattva. Even though this figure has reached enlightenment, he chooses to

remain in the world to share the sufferings of humanity and guide man to understanding and liberation. The Khmer ruler, incarnation of the bodhisattva, is identified in this figure. And yet Buddhism, which had such a strong influence on Asia, was unable to survive in India. There, Hinduism, a complex, global way of being that extends beyond the borders of religion, eventually banished Buddhism largely beyond its borders. Indian culture was strongly Hindu, and a peaceful wave of Hindu conversions set out from the southern kingdoms, of which Mamallapuram is one of the oldest and most fascinating capitals, to reach the countries of Indochina, and found one of its most unique and sublime expressions in the Khmer empire. Angkor, the capital of the god-king, bears witness to the strong Hindu heritage in its temples loaded with symbolism.
It is important to stress that it is difficult to draw clear lines of demarcation between the

Borobudur in Java, the zeidis and temples of Pagan in Myanmar, the Bayon in Angkor, Cambodia, and the caves of Luoyang in China bear witness to its vigor and greatness. Buddhist architecture, beginning with the stupa, a simple funerary mound erected over the remains of the cremated Buddha, developed through a series of changes that enriched the initial monument with balustrades and splendid portals, as in Sanchi, and transformed it into a mystic pilgrims' mountain in Borobudur, up to the point where it became a genuine temple with usable inner spaces in the many and various impressive examples in Pagan. In statues, Siddhartha Gautama, or the Buddha, was

Hindu and Buddhist worlds. The spirit that runs through Asian art shows more points in common than differences between the two, especially in the fundamental conception of the place of worship as a microcosm of the universe and as the center of convergence of the divine forces. The architect-priest, depository of traditional science, starts up the transformation of the profane to the sacred and the devout, who can decode the formal elements of the building into their deep symbolic meanings, can in this way ensure their own reincarnation.

Maria Ausilia Albanese

Asia
Asia

Ephesus

Nemrut Dagh

Palmyra

Masada · Herodion

Petra

Babylon

Ur

Persepolis

CHRONOLOGY

NEAR EAST

Foundation of Jericho
(ca. 9300 BC)

The first settlement stage of nomadic peoples in Mesopotamia
(ca 9300 BC)

The first pottery objects appear in Mesopotamia
(ca. 7000 BC)

Foundation of Ur
(ca. 4500 BC)

The Sumerians settle in Mesopotamia
(ca. 3200 - 2800 BC)

The first form of writing appears in Mesopotamia
(ca. 3400 BC)

Ur reaches the height of its splendor
(ca. 2300 - 2000 BC)

Ur is sacked by King Samsu-iluna of Babylon
(1729 BC)

Babylon dominates Mesopotamia under Hammurabi
(1792 - 1750 BC)

Babylon is sacked by the Hittites
(1595 BC)

The Jewish exodus from Egypt to Palestine
(ca. 1200 BC)

Decline of Babylon
(ca. 1000 BC)

King David conquers Jerusalem
(ca. 1000 BC)

The Assyrian empire reaches its maximum extension under Esarhaddon and Assurbanipal
(680 - 627 BC)

The Assyrian capital, Nineveh, is destroyed
(612 BC)

Ascent of the Persian empire under Cyrus the Great and foundation of the Achemenidean dynasty
(559 - 530 BC)

Babylon is conquered by Cyrus the Great
(539 BC)

Darius I founds Persepolis
(518 BC)

Ur is finally abandoned
(ca. 400 BC)

The empire of Alexander the Great
(333-323 BC)

Alexander the Great burns Persepolis
(330 BC)

Babylon is conquered by Seleuch, founder of the Selencian kingdom
(312 BC)

The Parthians conquer Mesopotamia
(141 BC)

The reign of Herod the Great
(34 BC - 4 AD)

Death of Jesus Christ
(33 AD)

First Judean revolt
(66 - 73)
Destruction of the temple of Jerusalem
(70)

Petra becomes a province of the Roman Empire
(106)

Second Judean revolt
(132 - 135)

ArdashirI founds the Sassanidean dynasty
(224)

Palmyra rebels against Rome under Queen Zenobia
(266 - 272)

Foundation of Mecca
(ca. 400)

Mahomet preaches Islam
(600 - 632)

FAR EAST

In China, the Pan-p'o culture begins to dedicate itself to agriculture and produces the first pottery objects
(ca. 4800 - 3600 BC)

Development of the Indus civilization
(ca. 2750 BC)

Birth of the Shang civilization in China
(ca. 1600 BC)

The development of the caste system in India
(ca. 1300 - 1100 BC)

Jimnu Tenno becomes the first emperor of Japan
(660 BC)

Life of Buddha
(560 - 483 BC)

First regional kingdoms in India
(ca. 550 BC)

Life of Confucius
(551 - 479 BC)

The power of the Ch'in dynasty is strengthened in China
(278 BC)

Ashoka unites nearly all of India in a single kingdom and favors the spread of Buddhism
(272 - 232 BC)

Qin Shihuang is the first emperor of China
(221 - 210 BC)

The Chinese empire begins to expand westwards
(119 BC)

The first Buddhist monasteries spring up in China
(ca. 65 AD)

The rule of the Kstrapas is consolidated in India
(ca. 150)

Unification of China under the Qin dynasty
(221)

The "Steppe Peoples" invade China and cause the break-up of the empire
(317 - 386)

Chandragupta II founds the Gupta Empire in India
(320)

Northern China is united by the Wei dynasty
(386 - 534)

The Khmer conquer Fu-nan and found a Hindu kingdom in Kampuchea
(ca. 500 - 600)

The invasions by the white Huns, in India, lead to the fall of the Gupta Empire
(510)

Wen-ti unites China and founds the Sui dynasty
(589 - 605)

New break-up of the Chinese Empire
(618)

The Borobudur, the largest Buddhist temple, is built in Java
(ca. 760 - 810)

The Javan Sailendra dynasty consolidates itself in Kampuchea
(ca. 700 - 802)

Jayavarman frees Kampuchea from Javan domination
(802 - 850)

CONTENTS

XI'AN
LUOYANG

SANCHI

AJANTA

PAGAN

MAMALLIPURAM

ANGKOR

BOROBUDUR

The Khmer rulers start building at Angkor
(ca. 850)

The dynasty of the Northern Sung begin to unite the Chinese Empire
(960 - 1126)

The Cham invade and destroy Angkor in Kampuchea
(1177)

Foundation of the kingdom of Burma, with Pagan as capital
(ca. 900 - 1000)

The height of power at Pagan
(ca. 1100)

Reign of Jayavarman VII, who rebuilds and improves Angkor, height of the Khmer Empire
(1181 - 1218)

Reign of Genghis Khan and Mongol expansion in Asia
(1206 - 1227)

Kublai Khan unites China and proclaims himself emperor
(1279 - 1291)

The Mongols conquer Pagan and put an end to the first Burmese Empire
(1287)

The journeys of Marco Polo in China
(1271 - 1291)

Sultanate of Delhi
(ca. 1300)

Start of the Ming dynasty in China
(1368)

The Khmer abandon Angkor and transfer the capital to Phnom Penh
(1434)

Black Sea

Ankara

NEMRUT DAGH

Turkey

Mediterranean Sea

NEMRUT DAGH, *THE MOUNTAIN OF THE STONE GODS*

A Mound
B Western
 Terrace
C North
 Terrace
D Eastern
 Terrace

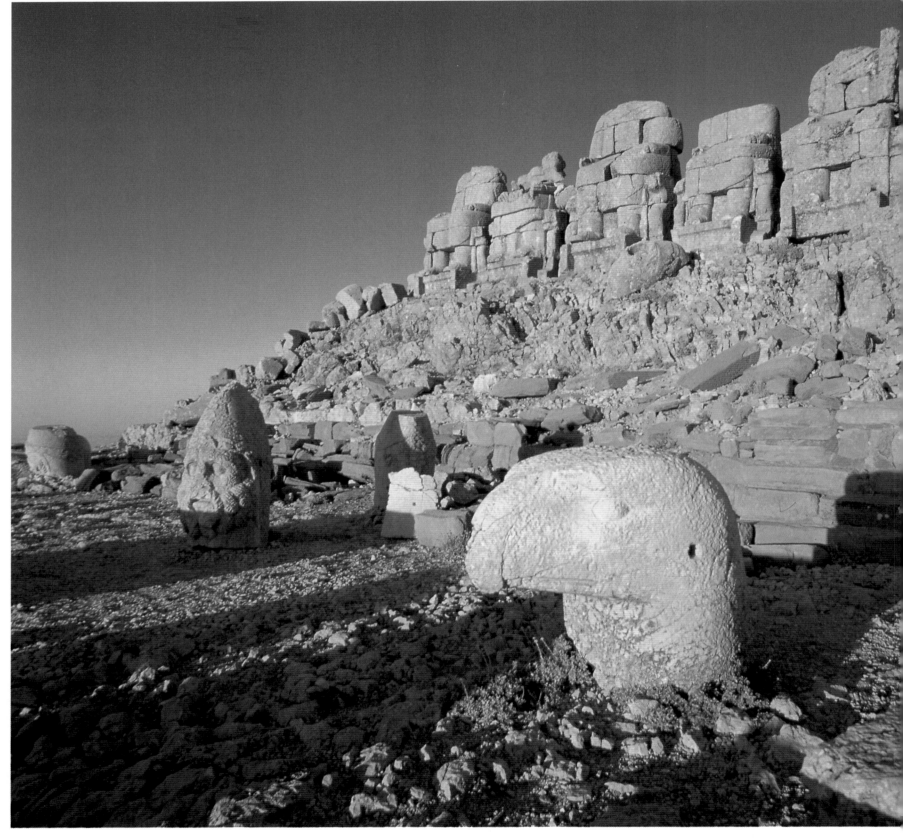

It was 1881 when the German engineer Karl Sester brought the archaeologist Otto Puchstein to Nemrut Dagh. The young scholar, who was to become the secretary of the Archaeological Institute of Berlin and win fame for his re-assembly of the Plough of Pergamon, immediately understood the importance of the discovery. The study of the tomb of Antioch I led, in fact, to knowledge of the little kingdom of Commagenes and its ambitious sovereign.

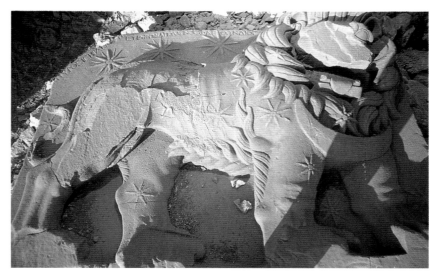

Karl Sester was a German engineer who was sent to Asia Minor by the Turkish government in 1880. His mission: to design a route for communication connecting the region with central Anatolia and Mediterranean ports. To do this, he made long trips on horseback covering the region and, one day, his Kurdish assistants pointed out to him a mound of enormous size in the foothills of the Taurus mountains which was called Nemrut Dagh. It could be seen from a great distance which is one reason that at first Sester discounted stories of enormous statues of gods standing in front of the mound.

He had trouble believing that such a monument would not appear on the maps nor at least be known from other travelers. This was especially logical because he certainly wasn't the first European to visit the area. Many other Europeans had been there, including well-known scholars in earlier years. He felt that they must have noticed the unusual shape of the mound and heard the same stories. He couldn't believe that no one had climbed to the top to check whether or not the summit was natural or man-made. Nevertheless, Sester continued to look at the mound and speculate on it. Finally, he decided to find out for himself what was at the top of the mound. The hike was a long and a tiring one but when he reached the summit he discovered that what he had been told was true.

The summit really was man-made, with gigantic figures seated on thrones on it, just as he had been told.

Around the area were scattered monumental fragments in an almost surrealistic confusion of faces, limbs, heads of animals and blocks covered in Ancient Greek inscriptions. It was clear at once that he was the first person who had been up to the top in many many years, perhaps even centuries.

As soon as possible, Sester presented a detailed analysis of his discovery to the academic world in Berlin but he was met primarily, it appears, with only lukewarm interest and, in some quarters, disbelief. On the other hand, the year was, after all, 1881, only seven years after the sensational discovery of Troy by the amateur archaeologist Schliemann and some of the academicians thought that if Schliemann could make his remarkable discoveries it would be worth at least listening to this unknown engineer, who was by then in

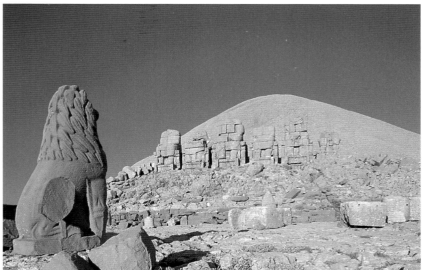

Alexandria, Egypt. The Academy in Berlin got in touch with the archaeologist Otto Puchstein, who happened to be in Alexandria at the same time, and asked him to meet with Sester. Puchstein, who later became secretary of the Archaeological Institute of Berlin and known for his work on the Altar of Pergamon, realized at once the significance of Sester's discovery. His exacting report to the German Academy impressed the board so much that they invested heavily the following year in a research expedition under the leadership of Puchstein and Sester.

155 top This statue of a lion with its body covered in stars was the personal horoscope of Antioch I.

155 center The lion was one of the heraldic animals of the Commagenes kingdom.

155 bottom The heads of an eagle, Antioch I and the mother land of Commagenes, lie on the ground in front of the great statues to which they once belonged.

156-157 The colossal images of gods that stood in front of the two great terraces in front of the burial mound are the symbol of the dreams of Antioch I, dreams which soured in his own lifetime. Each of the great features shown in the stone was a result of an attempt to fuse the characteristics and features of different gods into one figure, although they belonged to different groups and religions which had little in common with each other. His people not only rejected this new religion but also the attempt at Hellenization.

The confirmation of the discovery gained Sester a place in the annals of archaeology and returned from the past the history of a forgotten kingdom and its sovereign. Sester had believed originally that the ruins of Nemrut Dagh were part of an Assyrian monument, but they were actually the grandiose tomb of Antioch I, king of Commagenese. This fertile area, which corresponds to the part of modern Anatolia that lies between the chain of the Taurus mountains and the Euphrates River, was an area of extreme strategic importance. Originally under the rule of the Assyrian Empire, then the Persian, it was conquered by Alexander the Great and then fell under the domination of the Selcuks. Finally, around 162 BC it won its

independence, but from that moment up to 72 AD this tiny kingdom served the difficult role of a buffer state between the warlike Persian kingdom and the powerful Roman empire. Eventually it became a province of Rome. Culturally, the Commagenes were never completely united. Despite the geographical position of the area, the significant Greek influence never prevailed over the middle Eastern nature of the local population which was mainly of Semitic origin.

Antioch came to the throne in 98 BC with the goal of increasing the Greek influence in the country. His first act in this plan was to build a funerary sanctuary honoring his father, Mithridate Kallinikos, in Arsamea, modern Eski Kale. The inscriptions were in the Greek and the bas-reliefs in Greek style. In one of the scenes Mithridates is shown shaking the hand of Hercules. Later, Antioch began building his own enormous tomb on the summit of Mount Nemrut. This 150 foot high mound was, he said, the center of a new religious order with himself as the head. Emphasizing this, he gave it the name *hierothesion*, the Greek for a burial place devoted to a cult. The placing of this mound was not a decision that Antioch could have made lightly. The peak of the mountain was visible throughout much of his reign and its height had symbolic meaning as indicating his closeness to heaven. He seems to have been a man who was well aware that the people of Commagenes knew that they were in a delicate balance between Eastern and Western civilizations and he acted as a point of contact between them. It is apparently for this reason that the sovereign decided to decorate the tomb with images of divinities from the Olympus of the Greeks and Romans, the Persian empyrean and even the Anatolian one. Each figures was a religious fusion that attributed characteristics and features of many different gods to one single divinity.

Inscriptions at Nemrut Dagh proclaim Antioch's friendship with Rome and Greece but stress his descent from Alexander the Great on his mother's side and the Persian king Darius on his father's. He was also convinced that after his death his spirit would rise up to heaven, where it would be seated on a throne next to Zeus-Oromasdes, a fusion of the most important western god and Ahura Mazda, the great god of the Persians. For this reason, he had a statue of himself of enormous proportions built on the terrace in front of the great mound with himself seated beside the main gods in this new pantheon.

This attempt to have himself deified was partly justified, it is believed, by his need to impress his importance on his people with their systematic Hellenization, but it was not realistic.

Greek, especially in its literary form used in Nemruth Dagh according to the inscriptions found throughout Commagenes, was not widely used in the area and the inhabitants had few reasons to learn it or to accept the new religion. Not even the sumptuous ceremonies in honor of the divine king, with food, drink and dancing were enough to win the devotion of a people who saw their

background ignored and viewed the entire operation with suspicion. It is believed that Antioch really wanted to create a new cultural identify for Commagenes, but the tremendous expense required to form a new religion in this way has made some suspect that the whole thing was the mad idea of a megalomaniac. It is known, for instance, that toward the end of his life he took Pompey's side against Julius Caesar, then supported the Parthians who were natural enemies of Rome. Antioch died around 31 BC without seeing his tomb completed, although he was buried there. His son Mithridates did not complete the tomb and abandoned the new religion which, in any case, had probably not been favored by the ruling class except as a matter of expediency.

156 bottom and 157 Antioch I wanted to equal the splendor of other, possibly greater, rulers blending opposing cultural heritages of east and west into one expressive culture. Notice how different the statues are from each other in style, as can be seen by comparing the face of Hercules Artagnes on the west terrace (left) with that of the same god on the east terrace (right).
Although these statues have been mutilated, the gods continue to guard the tomb of Antioch I.

So far, no archaeologist has discovered the burial chamber where the ruler was placed to rest, probably surrounded by an extremely rich burial treasure. Aside from archaeological considerations it is, perhaps, only fitting that this should prove to be the fate of a monarch whose said his sincerest wish was that his body could lie near the "heavenly thrones".

158 top The head of Hercules Artagnes, on the eastern terrace, shows signs of the ravages of time.

158 The two bases on which the enormous statues were placed were decorated with large bas-relief stones, now mainly in fragments, on each of which the god held out a hand to the king. Here, Hercules Artagnes can be identified by the large club he is holding.

159 Antioch I is shown with the high crown of the ancient kingdom of Commagenes.

The monument, reached by two steep avenues, each marked by a column near the peak, today is in the form of a gigantic mound about 600 feet in diameter with broad artificial terraces on the east and west and a smaller terrace on the north. The enormous seated statues of the king and the gods from the king's own personal pantheon were in the main squares, dug from bare rock and connected by a processional avenue 600 feet long. These figures, with inscriptions in both Greek and Persian, were arranged in the same order on both terraces. From left to right are the deified Antioch next to the mother country Commagenes,

symbolized by a woman with a cornucopia in her left hand, a bundle of wheat and fruit in her right and her head adorned with a garland of wheat, apparently as a symbol of the fertility of the area. Zeus-Oromasdes, Appollo-Mithra and Heracles-Arthagnes, recognizable by the enormous club in his fist, are next. At the back of the thrones runs a long votive inscription which has remained almost intact in which the sovereign describes not only the rites to be performed in his honor but also the aims of his hierothésion and its religious concepts to the world. On each side, the rows of gods were flanked by an eagle and a lion, the heraldic creatures of the kingdom. The two bases of the enormous statues were decorated with large bas-reliefs, today mainly in fragments, on which each god stretched out a hand to the king. Finally, the two terraces were partly bounded by the so-called "Ancestors' Galleries", two sets of bas-reliefs showing the effigies of the paternal and maternal ancestors of the king. On the eastern terrace, where the main altar of the sanctuary was situated and the most important religious ceremonies took place, there is a lion nearly six feet high.

The lion's body is covered with nineteen stars, with a half moon at its neck. This strange figure is believed to be the oldest known horoscope, but its exact meaning is unclear. One theory is that it shows the conjunction of Jupiter, Mercury and Mars (or Zeus-Oromasdes, Apollo-Mithra and Heracles-Arthagnes) with the Moon in the constellation of Leo indicating a date. Some scholars say it shows 98 BC and others 62 BC indicating, perhaps, the year of the king's birth, or when he ascended the throne, or when the work began on the sanctuary, or. . . No one really knows. It is clear, however, that the arrangement of the new gods to the east and west symbolized the ideal cultural union between the east and west which Antioch so desired. Unfortunately, while the statues on the eastern side are still in fairly good condition, those on the west are only a scattering of broken blocks, the result of the frequent earthquakes in this region. It is perhaps amazing that the sanctuary still stands up to the elements to this day, but it may be even more amazing that it still defies both archaeologists and treasure hunters. No one has yet discovered the location of the burial chamber, which is believed to be carved out of the bare rock beneath the mound.

EPHESUS, PHILOSOPHERS, MERCHANTS, AND EMPERORS

N
↑

A Harbor
B Harbor bath-house
C Square of Verulanus
D Gymnasium of Vedio
E Stadium
F Gymnasium
 of the Theater
G Theater
H Square
I Library of Celsus
J Odeon
K Baths
L Eastern Gymnasium

"Men do not understand this eternal Word, either before they hear it or after they have heard it once. Although everything is based on this Word, they are as unskilled men, even though they are skilled in words and works such as those I display, distinguishing everything according to its nature and showing what it is. Men, however, are unaware of what they do when awake, and have no memory of what they do when asleep."

With these words, Heraclitus of Ephesus, in what is today Turkey, who was called "the obscure" but was actually considered one of the greatest of pre-Socratic philosophers (6th-5th centuries BC) urged his fellow citizens of Ephesus, one of the finest and richest Greek cities in Asia Minor, to look beyond appearance and to recognize the fundamentals of being, to find the logos, the Word, the Reason for all things.

Centuries later, Paul of Tarsus attempted a similar thing in letters to the Christian community of Ephesus and similar urgings that mankind look to the logos, the word, is found in other places in the Christian Bible. Ephesus was an extremely important city in both periods. Today, it is a popular place for tourists to visit with its superb extensive ruins only a few miles from the Aegean Sea. These ruins can still reveal to us the wealth and luxury, the intense trading and other business, the brilliant cultural life of this ancient Ionian city which flourished from the 6th century BC onward under various governments and political influences, including oligarchies, tyrannies, Persian satraps, democratic colleges, Hellenic dynasties and Roman governors.

It is impossible to mention briefly all the fantastic and amazing monuments that can be found in Ephesus not to mention the many other treasures to be found in the ultramodern museum in the nearby town of Selçuk.

At the gates of Selçuk, far from the ancient center as was the usual Greek practice, was the sanctuary of Artemis Ephesia, goddess of fertility, with numerous breasts on her bare torso. This colossal temple, measuring 500 feet by 150 feet was built around the middle of the 6th century BC and was considered one of the Seven Wonders of the ancient world. Herodotus, the Greek historian, said it was built as a gift by

160 top left This dancing flower girl is one of the surviving reliefs of the classic monument of Caius Memmius in Ephesus.

160 bottom left A great colonnaded avenue on the edge of the marketplace leads to the graceful small square overlooked by the famous library of Celsus.

160 top right The classic statue of Aretes, personification of Virtue according to the Greeks, is modestly dressed in a niche in the Library of Celsus.

160 bottom right The remains of the nymph's shrine and fountain of Trajan are a fine example of the elegant decorations and service structures of the town. They date back to the start of the 2nd century AD.

161 Admirers come from all over the world to see the sumptuous, dynamic front of the Library of Celsus, perhaps the most famous ancient monument in Ephesus and a masterpiece of the style that combined pure classic Greek style with the spectacular Eastern-Hellenic style of the 2nd century AD.

Croesus King of Lydia, a man of enormous wealth. The grandiose monumental nature of the structure and the decorative exuberance of the architects Kersiphrones and Metagenes of Knossos assisted by Theodorus of Samos has been reconstructed only in drawings. Very little remains of the ancient Artemision and its reconstructed version from two centuries later, about 350 BC. The two differently columned plan (21 by 8 columns in one section with a triple row of columns while another section was nine-columned) gave the impression almost of a stone forest similar to that found in the densely columned halls of Egyptian sanctuaries. The temple, built entirely in pale blue marble, is one of the earliest examples of how the use of marble transforms the traditional clay of earlier times. The columns, above all, were overwhelming, measuring 60 feet high, grooved and usually covered up to nine feet from the base with bas-reliefs showing processions of women or warriors. The remains of some of these bases and some other finds are in the British Museum. Only one column survives on site from the reconstructions that took place during the 4th century BC. This rises almost intact from the extension of the foundation and is half-hidden among the wild vegetation.

Ephesus
Ephesus

162 top The grandiose water supply system of Ephesus was set up by order of Caius Sestilius Polliones in the Augustan period. It involved the building of reservoirs, nymphs' shrines and fountains, such as the one shown in the photograph with its splendid Ionian front.

162 center Many statues honoring people and events were among the works of art from Roman times decorating the public areas of Ephesus.

162 bottom left Here, we can still see the remains of the temple of Domitian (end of the 1st century AD), the eight-columned outer colonnade and three-columned inner sanctuary. Here were applied the most advanced principles of Roman engineering.

162 bottom right This view of the ruins of the acropolis of Ephesus shows a cylindrical monument with decorations in the high Imperial style.

162-163 Resting against the hill as is Greek tradition, the theater of Ephesus was built in the 3rd century BC but was extended and modified in the 1st century AD for staging Roman games, including gladiatorial combats and hunts. It held 24,000 spectators. Partially restored, it faces the old harbor, now buried. This view did not exist when the stage rose in front of the semi-circular auditorium.

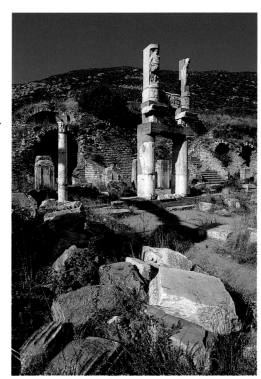

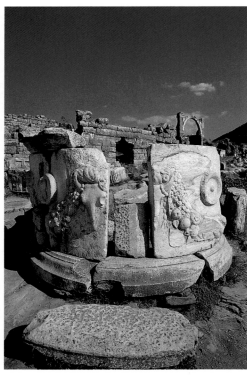

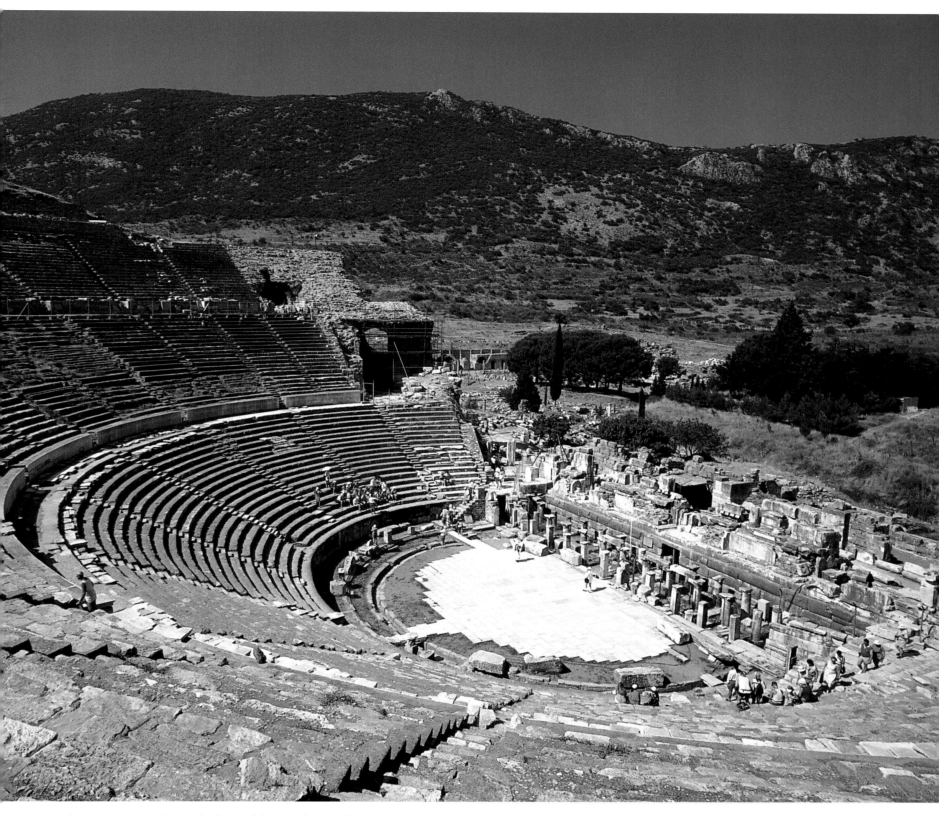

Another exciting building is the beautiful theater, which acted as a spectacular arrival point for those who reached the city from the port of Ephesus along the Arcadian Way. It was built in the 3rd century BC and extended on various occasions during the Roman period. The huge terraced area is on the lower slopes of the ancient Mount Pion (also known as Panacir Dag) and opens up a view toward the sea, although it was apparently originally screened from this by a high building, part of which remains. This theater could hold at least 24,000 spectators. In the city center the road network is scenic and sumptuous, with intersections of colonnaded streets, magnificent fountains and temples in Hellenistic style, typical of the influence of Greece and Rome on architecture, and lined with the homes of the wealthier classes, with mosaics and marble carvings designed to augment the luxury of the paintings and household basics. The most elegant monument in Ephesus, the splendid Library of Celsus, belongs to the Trajan era and was dedicated by Julius Aquila to the memory of his father Julius Celsus Polemeanus, senator under Trajan. It was built in a small square at the edge of the agora in 115 AD. This combined the functions of both a public cultural service and a tomb and sanctuary honoring the deceased, raising him almost to divine rank. The sarcophagus of Celsus was placed in a burial chamber beneath the floor of the single, grandiose, apsed, quadrangular hall. This was enclosed by a double wall with the air space between acting as a way of protecting the precious volumes from damp. The purchase of these volumes was at least partially financed by the heirs of Celsus. The hall contained access stairs to the underground funeral chamber and the two upper balconies, supported by a double, airy peristasis.

The façade introduces a new artistic feature. This was designed as an elaborate theatrical backdrop, with its double arrangement of composite columns placed on staggered levels so that the upper ones protrude less than the lower. In addition, the highly decorated entablatures and the color effects with their dramatic use of light and shade according to the relation of the colonnades to the door and window openings make this façade something very special. Deep gables, alternately curved and triangular, enhance the effect.

Ephesus

Ephesus

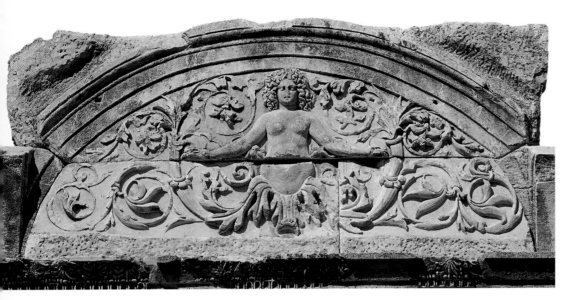

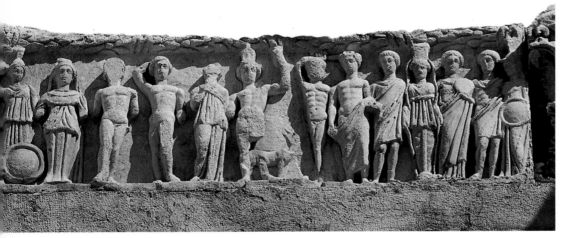

While every element belongs to the classical architectural base, the imaginative plastic movement of the entire façade, which stresses the aesthetic over the structural, makes it stand out.

The glorification of the culture and generous action of those who had the building constructed is clear from the texts of the epigraphs and the allegorical statues of the Virtues. Despite these noble ambitions, it was found necessary to place on the wall a warning to those who visited the shadows offered by the library not to leave ill-smelling mementos behind!

A miniature jewel of the site of Ephesus is the temple of Hadrian (127 AD) which was built in Hellenistic-Roman style with a Corinthian two-columned front between pure Corinthian pillars and an entablature of mixed lines. The horizontal lines of the architrave are broken by a highly decorated Syrian-style arch. A single inner section, which can be reached through a wide rectangular gate with a relief showing a Siren coming out of an acanthus chalice, apparently had a barrel-vaulted ceiling, marble decorations on the walls, and a cult statue, now lost.

In front of the temple, however, we can still see the four bases of the statues of the tetrarchs: Diocletian, Maximianus, Galerius and Constantius Chlorus (the second of these was later replaced by the statue of Theodosius I).

164 top The figures on this bas-relief which decorates the space over the entrance door to the Temple of Hadrian in Ephesus are almost baroque in their styling. This is typical. Note the siren emerging from entwined acanthus branches.

164 bottom The style of this mythological frieze in four slabs is definitely late-Ancient. It was inserted in the restorations of the Temple of Hadrian at the end of the 4th century AD.

164-165 This fine overall view of the Temple of Hadrian stresses the harmony and elegance of its proportions and decoration. In the entablature we see the typically curved element, known as the Syrian arch, found in much of the mid-Imperial architecture of Asia Minor and the Middle East.

165 right Another view of the acropolis of Ephesus shows the Gate of Hercules, marked by two massive pillars decorated with haute-relief figures of the god dating to the 4th century AD.

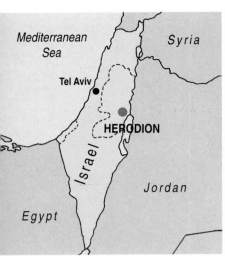

HERODION, STRONGHOLD OF KING HEROD

A Main tower
B Colonnaded courtyard
C Semi-circular towers
D Synagogue
E Cross-shaped hall
F Baths
G Underground passageway

166-167 This aerial view gives us a clear idea of the strict symmetry of the various parts of the building. The tunnel that gave access to the fortified palace emerged near the sumptuous inner garden.
Josephus Flavius said that the access staircase had 200 marble steps.

167 left Herod had the palace built as a refuge, but he also intended it to be his mausoleum. However, no trace of a royal tomb has been found in the ruins. Archaeologists discovered the remains of a synagogue and a mikveh, the ritual Jewish bath, as well as some small ovens used by the Jewish rebels.

167 right The unusual conical shape of the fortress built for Herod dominates the high plains of Judea. The Herodion, considered one of the most extraordinary monuments in the western world, was built on the summit of a semi-artificial hill, with the second residential complex, possibly for guests, built at the foot.

With the emergence of the Hasmoneon state in 142 BC, the Jews began to expand their territory, and during the reign of John Hirkan they took control of a wide part of the Negev region. Later they conquered what later became Transjordan, the land that stretched as far as Banias and the coastal plain south of Ashkelon. Between 67 and 63 BC, however, a bloody civil war raged caused by a conflict over the succession to the throne. At this time the Roman general Pompey, who had recently created the nearby province of Syria, attacked and destroyed the Harmoneon empire with his armies and went on to occupy much of the territory. Only Judea was granted the right to remain an autonomous Jewish state, governed by the Hasmoneon Hirkan II, who had been proclaimed leader of the people and high priest. The Romans, however, also reinforced their presence by appointing Antipatros regent, his son Phasael as governor of Jerusalem and his other son, Herod, tetrarch of Gelilee. These were the most influential members of an Idumenean family that had been converted to Judaism, although they showed more loyalty to Rome than to their own people. In 40 BC the Parthians, a people of Persian stock, invaded Judea and deposed Hirkan. Nevertheless, the new conquerors left the control of the region in the hands of the

Hasmoneons and Matthatias Antigonus was crowned. However, this state of affairs only lasted three years. During the Parthian invasion Antipatros's son, Herod, fled to Rome, where he was proclaimed King of Judea. With the help of Roman troops, he returned home in 37 BC to put the invaders to flight and take control of Idumea, Samaria and Galilee. He then marched on Jerusalem, which fell into his hands after a

five month siege. The Hasmoneon dynasty came to an end with the execution of Matthatias Antigonus. Although Herod was a Jew and may even have adhered to the customs and laws of the religion he was never accepted by the Jewish majority in Judea, who considered him a slave to Rome. Ambitious, a lover of luxury and anxious to please Rome, Herod became famous for the splendid architectural works that sprang up during his reign. He was responsible for the construction of the fortress of Masada, on the Dead Sea, a

luxurious winter palace, in Jericho, a modern harbor and a new barracks for troops loyal to him in Sebastes, near the ancient capital Samaria, and the model city of Caesarea, built in honor of his protector and patron, Caesar Augustus. Jerusalem itself was transformed. Here, Herod built a palace for his own use, with three huge monumental towers, and then in 19 BC he started work on an immense, spectacular temple for the Jews. However, his most outstanding and original creation was the grandiose palace he had built to the south of Jerusalem and named Herodion. Seen from the distance in the arid landscape of the heights to the south of Jerusalem, it looks like a strangely regular conical, flat-topped hill, with the ruins of a great palace, an immense swimming pool, warehouses and bathhouses at the foot.

This superb building was a fortified palace and was designed to become the mausoleum of its founder. However, despite the description of the king's funeral procession by the historian Joseph Flavius, Herod's tomb has never been discovered. The building is at the top of a semi-artificial hill about 200 feet high and is enclosed inside two concentric circular walls with a

diameter of just over 200 feet. The walls were dominated by a circular tower which must have been about 50 feet high, and three smaller towers that protruded from the outer wall. The hill took on its unusual shape from the rubble dug up to lay the foundations and left over from the construction of the palace, tossed onto the slopes, along with other excess material, to make the incline steeper. Access was possible only by way of a vaulted underground passage that opened from the base of the hill. The interior of the circular

palace was divided into two sections. One had a garden, surrounded by columns, a true oasis in the desert, and the other consisted of luxurious apartments with refined baths on the ground floor. The floors were covered in mosaics with geometric motifs, and the walls were coated in stucco with multicolored reliefs. The lowest part of the Herodion was dominated by a huge pool in the center. This was used as an artificial lake and was big enough not only to swim in but also to sail small boats. An ornamental garden with several buildings and a large bath complex surrounded the pool. Inside the semi-artificial hill was discovered an intricate network of secret passages, partly making use of Herod's underwater supply system. The passages were dug out by the followers of Simeon Bar Kokhba during the Second Jewish Revolt, which erupted all over Palestine in 132 AD. Among the finds are many tools and weapons as well as coins minted during the uprising. Later, in the Byzantine period, a monastery was founded on the ruins of the palace. Now, the isolated position of the area makes the structure seem even more unusual, a memorial to Herod's architectural imagination.

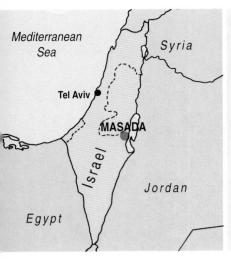

MASADA, THE CHALLENGER OF ROME

168-169 The fortress of Masada stands on an isolated rock overlooking the western shore of the Dead Sea. The main buildings and the fortifications of the level area, almost 1,000 feet long and 400 to 800 feet wide, were built by King Herod in 37 AD. A large area of the plain was cultivated, using the water in the large underground tanks for irrigation.

168 top The grandiose northern palace of Masada was built as the personal residence of King Herod. The apsed hall of the highest level and the circular room beneath were used for important receptions. The lowest level, built around an inner courtyard, was the private quarters of the king and contained a small bath complex.

169 top In a building near the western palace this large space was used as a mikveh, the ritual Jewish bath.

169 bottom The long, narrow rooms of the northern complex were used as an arsenal and warehouses for foodstuffs necessary for the considerable garrison of the king.

Masada, the fortress in the Judean desert built by Herod the Great, is still today one of the greatest living symbols for the Jewish people. On this site, in 73 AD, 960 men, women and children committed suicide rather than surrender to the Tenth Roman Legion. This was the last episode in a rebellion that had reached its height three years earlier with the destruction of Jerusalem by the armies of Titus.

In the Hasmonean period this rocky site, situated in an ideal position near the Dead Sea, with steep escarpments and a huge flat area at the top, was transformed into a military stronghold. In 40 BC it took on a special significance for Herod who had to ensure the safety of his family during his flight from the forces of Antigonus, the Parthian pretender to the throne, during his journey to seek military aid from Rome. His friends and family, along with 800 men charged with protecting them, were

suffering from extreme thirst and only saved by a timely downpour that filled empty water tanks. Later, when he was able to take back his kingdom with the help of the Roman army, Herod transformed Masada into a palace-fortress complex to defend himself from both the threat of a Jewish rebellion and the queen of Egypt, Cleopatra. The entire perimeter of the citadel was surrounded by a turreted defensive wall fortified at strategic points with huge tanks, dug from the bare rock, designed to supply the troops with water. But the most imposing structure at the site is the splendid royal palace at the most northerly point of the complex.

This shows quite advanced architectural concepts and admirable distribution of the rooms. The upper floor consisted of a huge rectangular hall which opened up onto an apse bounded by a Corinthian colonnade, and giving a magnificent viewpoint over the Dead Sea. A covered stairway connected this wing of the palace with the intermediate section, which was formed by a structure with a rounded floor plan, surrounded by columns and topped by a bell-shaped roof.

The lower level was roughly square in plan with an inner courtyard at the center surrounded by a portico supported by pillars with Corinthian half-columns. Alongside was a small but luxurious bath complex. The inner walls and the columns of the palace were covered in lively multicolored stucco, mainly imitating precious marble decoration, some of which can still be seen today. The floors were covered in black and white mosaics with geometric patterns. The large, four-roomed bath complex on the upper floor is

particularly interesting as it is among the best preserved of the sites in Israel dating from Roman times.

The dressing room was decorated with stucco and black and white tiles covered the floor. We can also recognize the lukewarm room and the cool room, with its large seated bath. In the warm room, we can still see the hypocauston, or floor held up by small pillars beneath which the hot air from the boiler circulated. Near the bathhouse was a large complex of rooms used to store food and wine and as a safe deposit area for weapons and valuables. This sector of the fortress, including the palace itself, the bath complex and the warehouses, was separated from the rest of the citadel by a wall and gate.

This luxurious complex was clearly used for banquets and as a showpiece for the wealth and power of Herod, but at the same time it was designed to offer a last line of defense

A	Northern Palace	F	Large Building of uncertain use	J	Residences of the Zealots	O	*Mikveh*
B	Gate of the Water	G	Byzantine Church	K	Western Palace	P	Southern Gate
C	Warehouses	H	Gate of the Serpent's Path	L	Open water tank	Q	Covered tank
D	Baths			M	*Mikveh*	R	Great Pool
E	Synagogue	I	Western Gate	N	Dovecote	S	Southern Bastion

against invaders who succeeded in scaling the walls.

The western palace, on the other hand, had to be more functional. Because of this need for functionality, it consisted of the royal apartments, guest quarters, service rooms, workshops and warehouses, as well as rooms with certain administrative functions including state receptions. Here, too, the floors were covered in mosaics and it is known that some parts of the building were several floors high. Nearby are three other, smaller buildings, one of which contained a mikveh, the Jewish ritual bath.

The most serious problem for Masada, a complex where it might be necessary to accommodate as many as a thousand people at once, was the supply and storage of water. Not only was the fortress in the desert, with only occasional, seasonal rainfall, but it was also on a high plateau at the top of a mountain surrounded by steep escarpments.

For this reason, a drainage system was installed that took the rainwater from the dams of the surrounding valleys to a complex of twelve tanks at the base of the fortress.

These tanks had an enormous capacity and from them water could be taken by men or on mules along a difficult path to the tanks inside the fortress. Despite the fact that Masada was virtually inaccessible, in a remote position surrounded by high, steep walls, it was also fortified with thick walls that enclosed all the buildings on the plateau, with the exception of the northern palace.

The defensive perimeter consisted of an outer and an inner wall, with the space between the two occupied by rooms for various purposes.

The walls of Masada are 5,000 feet long, with 70 turrets, 30 towers, and four gates. When the Zealots conquered the fortress during the six-year-long Jewish uprising against the Romans, they made a number of changes to Herod's complex. To house a large number of families, all the rooms between the two walls were transformed for domestic use and many halls in the palace were subdivided to create extra rooms. The Zealots also built two mikvehs,

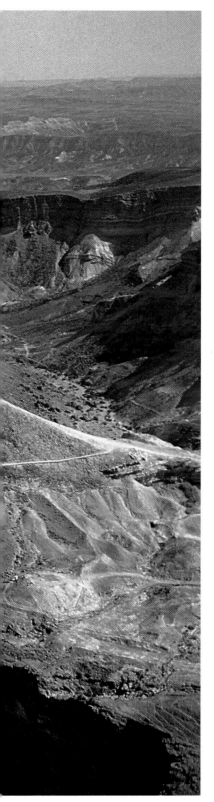

and there is evidence that there was a room that could be used as a beit midrash, a room set aside for religious studies.

The synagogue, on the northwestern side, has been partially reconstructed. Facing toward Jerusalem, the synagogue may have been built by the Zealots on the site of a temple dating back to Herod's time. Masada is a site of exceptional archaeological value not only because of its architectural remains. Among the various finds preserved by the dry desert climate are fragments of clothing, including prayer shawls and leather sandals as well as pottery and baskets. Coins have also been found, minted on the site by the rebels. Fourteen parchment scrolls, found in various parts of the fortress, are of great importance for the study of the Bible. During the excavations, 700 fragments of pottery with inscriptions were found which give us further indications of the lives led by the rebels trapped among the rocky heights of Masada. These fragments bear inscriptions mainly in Hebrew and Aramaic, but also in Greek and Latin. Most of these were found near the warehouses and suggest that a system of rationing was in force during the siege.

In four cases, large pieces of pottery were found whose inscriptions consist mainly of names and number, which may have been

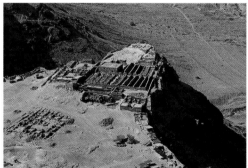

administrative lists.

But the most sensational discovery was eleven fragments, each bearing a single name, found near the doors of the warehouses. One of the names is Ben-Yair, leader of the Masada rebels. Some scholars believe these fragments bears witness to the drawing of lots by the ten leaders of the rebellion during the last day of the siege, after nearly four years of heroic resistance, when it became clear all was lost. The Jewish historian Joseph Flavius, who wrote in Latin, said that each man was given the task of killing the members of his own family and then would be killed himself, with the last man left alive committing suicide.

Around the stronghold can still be seen traces that confirm the account of Flavius about the siege of Masada by the Roman general Flavius Silva.

The men of the Tenth Legion built eight fortified camps around the foot of the mountain, connected by a continuous wall with twelve watch towers. This prevented the rebels from entering or leaving the citadel, while the besiegers could receive food and reinforcements without danger. As the only access point to the fortress was steep and difficult, it could not be used by a large troop of soldiers, and the siege engines had to be taken to the summit of the rock to destroy the walls, Flavius Silva ordered an immense ramp to be built on the western side of the mountain. The catapults were positioned on a nearby promontory to provide covering fire and protect the soldiers building the

earthworks. When this was completed, the huge siege engines could be raised in position, and the walls built by Herod were soon destroyed. The Zealots made a final attempt to defend themselves and quickly built a wall of stones and sand, which was completely ineffective. When this was destroyed by the Roman soldiers Masada fell. Today the citadel on the rock, visited every year by thousands of tourists, is an important symbol of the national culture of Israel. Recruits to the army mark the start of their military service by taking an oath on the summit of the mountain, an oath that includes the words, Masada shall not fall again.

170-171 In this aerial photograph taken from the north can clearly be seen, on the right, the great ramp built by the Roman soldiers commanded by the general Flavius Silva. This is one of the most imposing obsidion structures in the world.

171 left The northern complex contained the great bathhouse, the warehouses and other service areas, as well as Herod's palace.

171 top center The bath complex of Masada shows a clear Roman influence. The caldarium, the hot bath area, still contains the hypocaustic support pillars for the heating system which ran under the floor.

171 bottom center In the photograph we can see that the wall paintings, clearly of Roman inspiration, are still partially preserved on the bottom floor of Herod's palace.

171 top right These two Corinthian columns were part of the inner courtyard of the lowest level of Herod's palace. Note the thick layer of plaster that covered the brickwork.

171 bottom right In this view from the north, the rock of Masada seems to be bordered on every side by steep escarpments. Despite this great natural defense, the fortress was conquered by the Roman legionaries.

Mediterranean Sea
Amman
● PETRA
Egypt
Jordan
Saudi Arabia

PETRA,
THE ROSE RED CITY

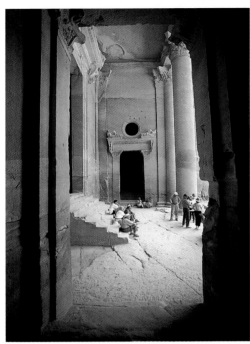

172 top left As we enter Petra from the deep cleft of the Siq, the sudden appearance of the Khasné is a unique, incomparable experience. Such perfection is rarely seen.

172 bottom left The interior of the Khasné consists of a great cubic hall, whose sides measure almost 40 feet. Three smaller rooms open onto this room through enormous doorways.

The ruins of Petra in Jordan are one of the most fascinating monuments of the ancient world. The combination of the exceptional quality of the architectural work of the city, the extraordinary location of it, lying as it does among steep hills and narrow spaces between rocks, add to the rose color of the rock itself to make this one of the most extraordinary sights in the world. Petra is situated in southern Jordan and is mentioned in the Bible occasionally as Sela which is the Hebrew for rock. The Arabs called it Wadi Musa, which means the Valley of Moses. The name given to the city by its original inhabitants is unknown. Petra, of course, is simply the Greek word for rock.

Although it is known that the site was inhabited during the Iron Age its major importance is linked to the Nabatean occupation, during the second half of the 4th century BC.

The Nabateans were originally nomads from the Arabian peninsula who later became settled and, eventually, grew to become a solid monarchy which grew rich through trading. Their stronghold was on one of the rocky spurs of the area and in 312 BC they were able to resist the attempt at conquest by Antigon I, thus confirming their independence and establishing the foundations for a period of tremendous splendor.

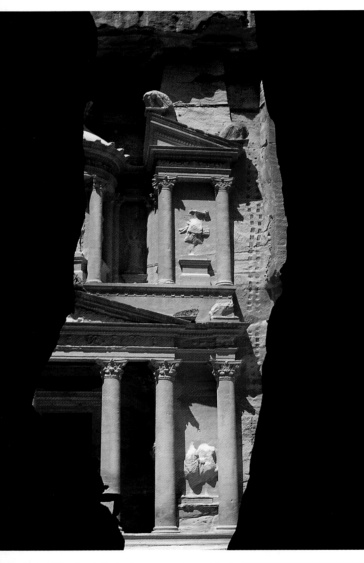

172 top right The Nabatean carvers reached amazing heights in molding the bare rock into a wide range of shapes. These subtle plant motifs are part of the complex decorative designs found here.

172 bottom right After crossing the threshold of the Khasné, the visitor enters into the cool vestibule, a room 46 feet long and almost 18 deep, which leads to the great hall and two smaller rooms opening out on the short sides.

173 The Khasné, a superb funerary temple probably built by King Aretas IV between 85 and 84 BC, is extremely well preserved.

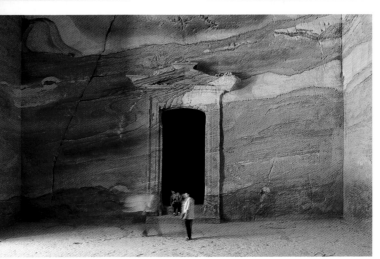

A Florentine
 Tomb
B Corinthian
 Tomb
C Tomb
 of the Urn
D Roman triumphal
 Arch
E Temple
F Theatre
G Kashné
H El-Deir
I Wall remains

The Roman occupation and creation of the province of Arabia under Trajan in 106 AD slowed the development of the city but did not stop it. It was only when other major centers for trading, notably Gerasa and Palmyra became increasingly important and the capital was moved to Basra in the 3rd century AD that Petra lost its importance. For several centuries after that it continued important as a Bishopric and under the reorganization of the empire by Diocletian it became capital of the province of Palestina Taertia. With the Arab conquest of the region it fell into decay, although it was briefly fortified and defended by the Crusaders. After the 13th century it was finally abandoned and forgotten in the West until 1812 when it was rediscovered by Johann Ludwig Burkhardt, a Swiss explorer and authority on the East.

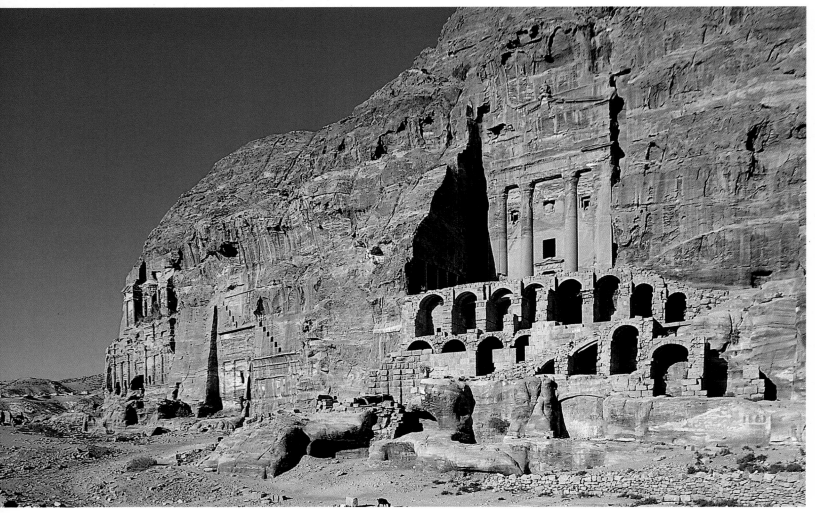

Petra developed as a hill town at a central point of three steep valleys, gradually becoming the place where nearby tribes gathered for meeting and defense. It was named as the capital of the area for safety reasons. Since it was concealed among the mountains with only a few, easily guarded, entry points, it was an ideal place for both refuge and the regrouping of forces. Its links with the Red Sea made it possible to establish trading with Arabia and Mesopotamia while the route across the Negev to Gaza gave not only access to the Mediterranean but also to Syrian ports.

It is because of this continuing connection with the major trading routes and the ever-increasing prosperity of Petra that there was such a strong Greek influence, especially evident in the monuments dug by the Nabatean rulers in the rock walls during the 1st century AD. At the moment of Petra's greatest importance it would have had between thirty and forty thousand inhabitants, most of them involved with trade.

He was unable to thoroughly study the ruins, however, as the local Bedouin tribes stopped him. Twenty-seven years later, David Roberts, a Scot artist, was one of the first Westerners to obtain permission to camp in Petra and to study its buildings. He was one of the first, also, to produce an exhaustive graphic documentation of the site.

A highly gifted man, he was considered one of the best artists of his day and an excellent landscape painter, skills which he used when he made several journeys

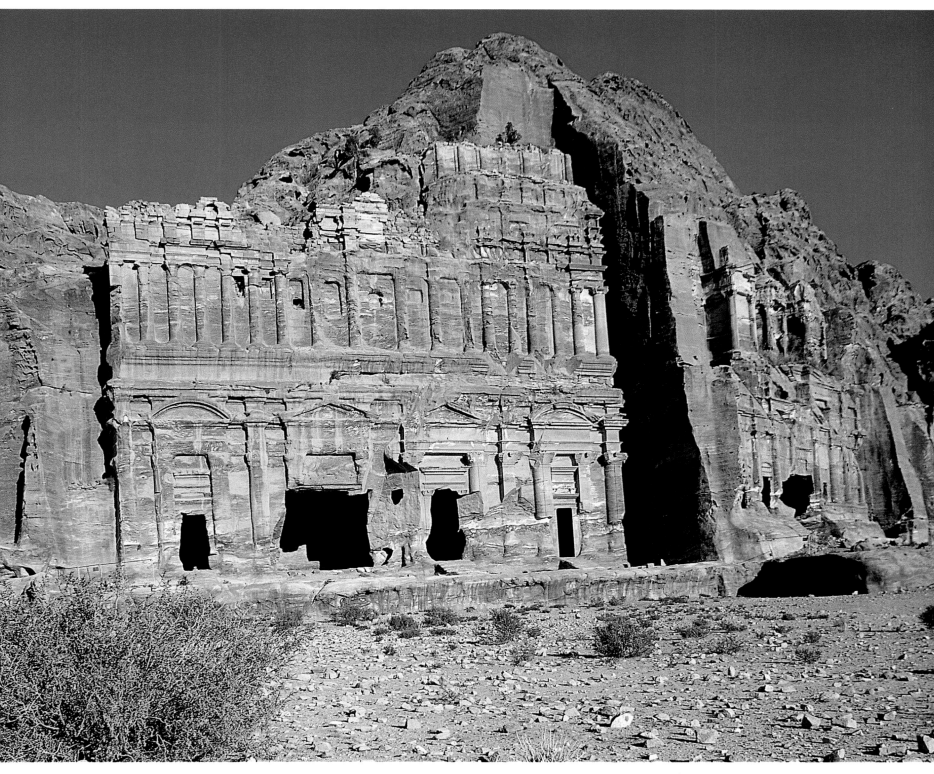

through Europe and followed them by going to Egypt in 1838. Early in the following year he visited the Sinai Peninsula, Palestine, Jerusalem and the coasts of Lebanon and Baalbek. Lithographs made from his drawings of this journey were published in London between 1842 and 1849 and are still valuable. In addition to drawing what he saw, Roberts also wrote down his impressions and practical information about his travels in a diary, describing what seems like an almost incredible adventure

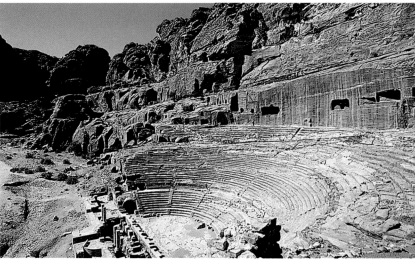

174-175 The Palace Tomb (center) and the Corinthian Tomb (right) are important examples of the construction skills of the Nabateans.

175 bottom The Theater, dating to the 1st century AD, could hold over 6,000 spectators.

175

Petra

176 top The first rock tombs of Petra, mainly dating to the 2nd century BC, usually have high fronts crowned with stepped battlements which show Egyptian and Assyrian influences.

176 bottom A splendid example of its genre, The Tomb of Silk is also known as the Rainbow Tomb because of the many shades of fine sandstone in the façade.

to today's tourist.

Roberts reached Petra on March 6, 1839, and through the influence of his local guides and, of course, the payment of a considerable bribe he was allowed to remain for five days in what was then the territory of a fairly war-like Arab tribe. What he saw was breath-taking. Petra is built on a site which is in the shape of an amphitheater enclosed by rocks measuring about a mile from east to west and half a

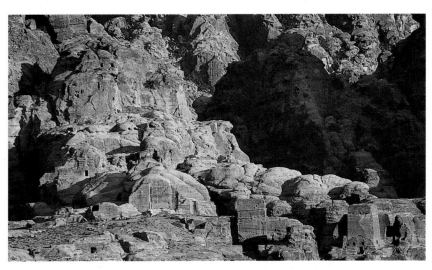

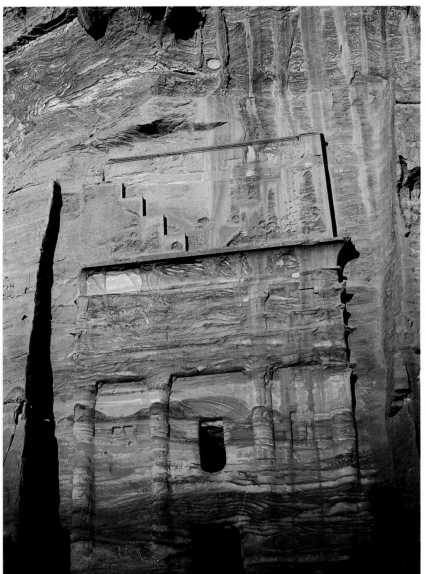

mile from north to south. The bed of a river, often dry, crosses this deep valley and, with its tributaries, forms the boundary of a low, rocky base on which the city was built.

Although the river is often dry it occasionally floods and some of the city has been washed away by these floods. The rock walls that surround the valley, in some places as much as nine hundred feet high, were used by the Nabateans as both tombs and houses. They have been compared to enormous theatrical backdrops of great beauty. On the summits of the peaks which surround this area were several places of worship and small fortresses overlooking the access routes to the city.

What is now the bed of the Wadi Musa was the main street of Petra. It was fully paved and began at the site of a bathing pool which was part of a temple. Further on, there were three market places on terraces. The stalls of the markets were along the sides and there were also such buildings as a large Corinthian temple, bathhouses, the Roman arch and a gymnasium of several floors. The rock wall opposite the theater shows a number of magnificently carved structures. The theater itself is amazing as it seated over six thousand people and was carved completely from the rock.

Rogers was thrilled, and wrote "I continue to be amazed and overwhelmed by this extraordinary city. . . Every ledge, and even the summits of the mountains, were inhabited. The valley is scattered with temples, public buildings, triumphal arches and bridges. The architectural style is different from any other I have seen, and in many places we can see a curious combination of the Egyptian, Roman and Greek styles. The stream still flows through the city.

"Lush shrubs and wild flowers abound. Each cleft in the rocks in full of these and the air is perfumed with their delicious fragrance." As soon as his camp was set up, Roberts decided to visit the Khasné, the most famous monument in Petra.

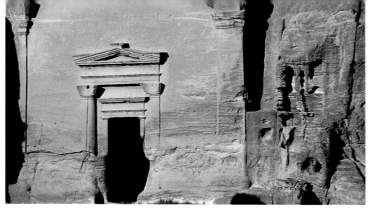

176-177 *This spectacular aerial view of the Road of Façades shows how the rock tombs flank the main street on terraces at various levels, with great effect. They were originally linked to each other with stairs.*

177 top *An inscription states that the Tomb of Aneishu belonged to a minister of Queen Shuquailat II, who lived in the 1st century AD. Extremely dignified, this tomb contains exquisite Nabatean architectural features, such as these two typical capitals.*

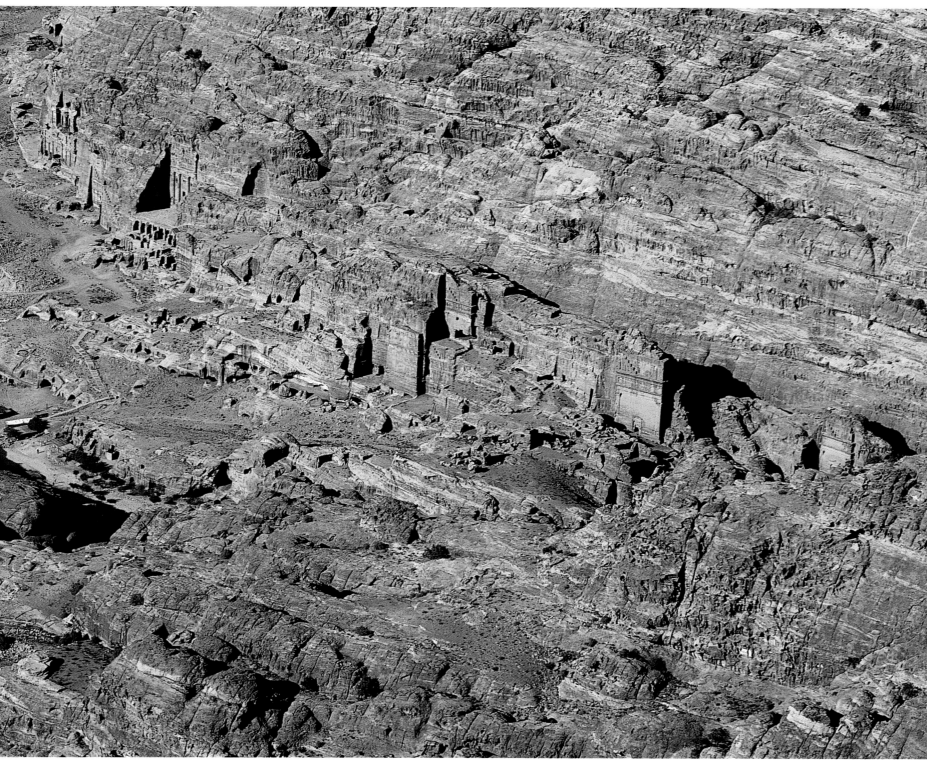

To understand the tremendous impact this monument has on the visitor we have to remember that the only easy entry into the city is from the east, through the narrow bed of the stream which is here bound by a narrow path between two rock walls which at some points are only nine feet or so apart. The passage, which is called the Siq, is about five miles long. In ancient times the water in this stream flowed through two channels dug from the bare rock and then into the town's aqueduct. This gorge itself is permanently shadowed and the rock shows evidence of having been shaped over the centuries by wind and running water. The water in the stream increases rapidly during summer thunderstorms. In some places the path opens up to show spots where caravans might have stopped. Halfway through the

178 top On the inside, these rock tombs are usually large bare rooms, furnished only with niches which held the bodies. Spacious and clean, many of these chambers were lived in by Bedouin peoples in the past.

178-179 The Tomb of the Roman Soldier is given its name because of the bas-reliefs showing Roman legionaries which decorate the niches on the front. It is believed it was prepared for the body of a high ranking individual.

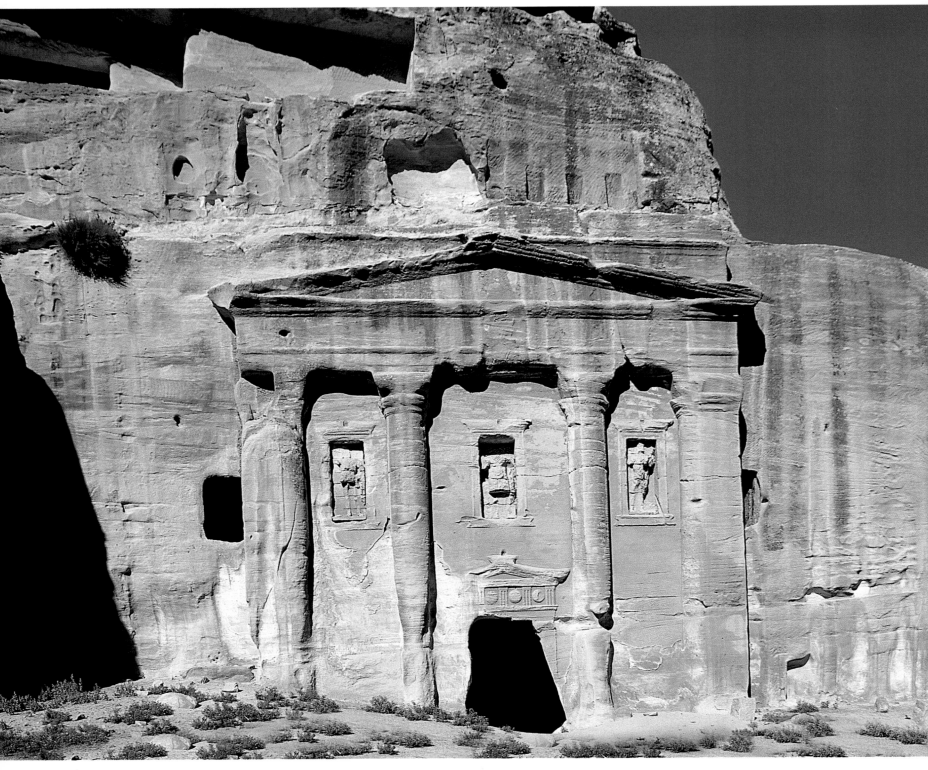

path the Siq suddenly changes direction and the KhasnJ appears, a funeral temple cut from the rock that is unlike any other monument in the world. The dramatic contrast between the gloom of the Siq and the delicate pink façade of the monument is one of the highlights of Petra. The façade itself is symmetrical in form and the proportions are magnificent.

Roberts, thrilled by the sight, wrote ". . . I don't know whether I was most surprised by the appearance of this building or by its extraordinary position. It rises intact from an immense niche in the rock, and the pale color of the rock together with the perfect conservation of the tiniest details give the impression that the work has only recently been completed." The façade, about forty-five yards high and twenty-five yards wide, is divided into two floors.

The lower floor has a gabled portico with six Corinthian columns thirty-six feet high. Between the two pairs of outer columns there are two very large groups of horses in high-relief which over the years have become extremely worn. The frieze on the portico shows a series of griffins facing each other while the gable, which had an eagle with outspread wings at its center, is finished with a scroll. In the corners of the architrave are two lions. The second floor is divided into three sections. At the center, there is a tholos which looks like a miniature rounded temple. It is typical of the local architecture and has a cone shaped roof with an urn on top.

179 top and center The builders of the rock structures of Petra often achieved extraordinarily beautiful results, skillfully incorporating the natural veining of the sandstone to achieve special colorful effects.

179 bottom Near the Tomb of Aneishu are many structures in the rock wall that date to the oldest period in the building of Petra. They all have a very simple, smooth façade topped by a stepped battlement. A door, framed by half-columns, is sometimes inserted in this.

For years there has been controversy among scholars about the real purpose served by the buildings lined up along the valley. From detailed excavations and careful studies it now seems as if many of them were residences, often with a large hall with columns and niches on the sides and a raised area in the center which perhaps served for dining. Some of these houses are decorated with vine-leaf frescoes and floral patterns.

The building styles throughout Petra differ considerably from each other, each indicating a different historical period and cultural influence.

The earliest rock monuments of the Nabatean city had a smooth, very simple façade with only one or two rows of

This has given the building its Arabic name, which means "treasure."

The Bedouins believed that immense riches were hidden inside this and they fired at it with their rifles, trying to break it up to reach these treasures. The tholos is flanked by two half-gables, each supported by four columns. Within the niches are reliefs of female figures, also very eroded. Finally, four gigantic eagles balance the ends.

The inside of the building consists of a large entrance hall which leads by eight steps to the central hall. This, a huge cube of thirty-six feet on each side has small niches on each of three sides. The arrangement of the inner rooms and the lack of an altar as well as the fact that this monument is placed where it is in the narrow trench, which would not have encouraged religious rites, have led recent scholars to believe that the Khasné was a monumental tomb rather than a temple as had been once believed.

battlements, a door at the base with perhaps half columns. This type of tomb, whose earliest examples can be dated to the 3rd century BC, was a typical adaptation by the Nabateans of styles used throughout nearby Syria at that time. During the following two centuries more complex models developed, starting with those which showed a strong Greek influence in the use of the frieze, the architrave and the protruding columns. Meanwhile, a special type of capital,

180 This building, called el Deir which means "the Convent", is considered the most impressive monument in Petra. It stands in an isolated position at the top of a spur of rock at a distance from the center of the rose red city. The face of the temple, deeply set into the rocky mass in order to create a spacious level area in front, is of unusual size. It is almost 162 feet wide and 129 feet high.

known as the Nabatean, had been developed and purely ornamental structural elements were increasing in use. The extremely provincial nature of the local art, developed in a desert region that was far distant from the Mediterranean basin did, however, mean that certain local and in a way obsolete elements in decoration remained, such as rosettes and heraldic animals facing each other. In the second half of the 1st century AD a new type of façade appeared and developed further over the following decades. The basic architectural style was accompanied now by a decorative grandeur that was influenced by Roman developments. The rock façades reached colossal dimensions, with rows of columns overlapping so that they imitated temples and theatrical curtains. The so-called Tomb of the Palace

rough path that soon turned into a steep upward path which rose over one thousand feet before finally arriving at what is probably one of the least visited of all the monuments in the Nabatean city, although it is one of the most imposing and interesting.

This monument is completely dug out of the bare rock. The façade of the temple is one hundred fifty feet wide and one hundred twenty feet high. The decoration is similar to the Khasné but less elaborate.

On the lower floor, which is bounded by pillars, there are eight half-columns framing two niches formed by arches on the sides and a gabled door in the center. The entrance leads into a large, square room, in the bottom wall of which was the altar which is now almost completely

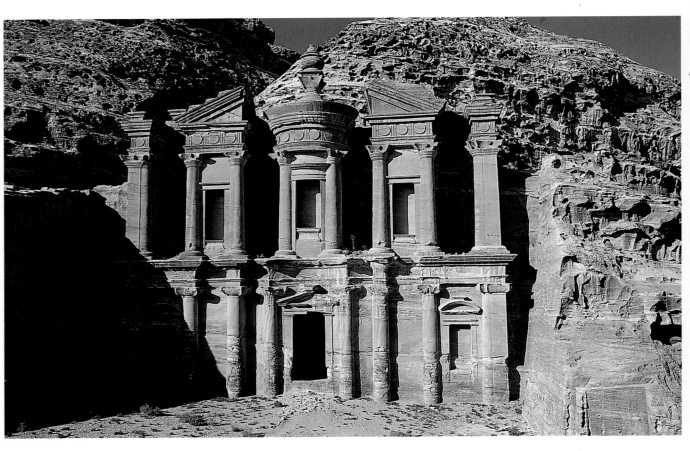

180-181 In this splendid photograph, the upper part of el-Deir emerges almost like a surreal piece of scenery from behind the rocky crests surrounding the rock city. In front of a sight like this it is easy to understand the extraordinary reputation Petra enjoyed in ancient times. The building takes further the conventions of Greek art imported by the Nabateans. Its rhythmic alternation of straight and curved lines is almost a forecast of the baroque.

and the adjacent Corinthian Tomb, similar to the Khasné but with a lower intermediate level between the gable and the tholos, belong to this period of great flourishing.

The remarkable building known as el-deir, Arabic for The Convent, belongs to the Graeco-Roman period. In a sense, it is so rich in its way that it could almost be called baroque. Roberts came to this on the morning of March 8, accompanied by a small group of armed men.

He stepped into a deep gorge along a

destroyed. In the upper level, the façade contains a central tholos and a split gable, as well as two pillars at the corners, while a Doric frieze runs across the entire front. Roberts was thrilled by the view from that balcony of rock, looking down over the valley of El Ghor. "From here," he wrote, "the view is marvelous, the gaze extends over the valley, to Mount Hor which, one tradition says, is crowned at its peak by the tomb of Aaron, and the entire mountain gorge, which weaves in and out amidst dizzying rocky peaks.

The ancient city, in all its extension, stretches out along the valley."
In spite of all this enthusiasm Roberts's stay in Petra had its unfortunate side although the annoyances were certainly minor. Some dishes were stolen and, on the fifth day, the plunderers carried off a number of rifles and cartridges along with other goods.
Given that, there was nothing to do but to leave as the local tribes were considered and, indeed were, quite dangerous.

181 bottom The tholos, of the Convent, almost 30 feet high, emerges from the bare rock in a way that seems to announce the triumph of human genius over the raw materials of nature. With the possible except of Abu Simbel, there are few monuments in the world comparable to el-Deir. The temple, dating to the 1st century AD and originally dedicated to the god Obodas, got its name in Byzantine times when it became a place for Christian worship.

PALMYRA, PRIDE OF QUEEN ZENOBIA

A Field of Diocletian F Theatre
B Great Colonnade G Monumental Arch
C Agorà H Temple of Bel
D Tetrapylon I Monumental
E Sanctuary of Tombs
 Ba'alshamin

182 top and bottom The art of Palmyra is a distinctive combination of the figurative world imported from the Greco-Roman west and local style. Here, in the compound capital from one of the columns of the main road and the refined funerary relief, dating from the final years of the 2nd century, we can see this combination clearly.

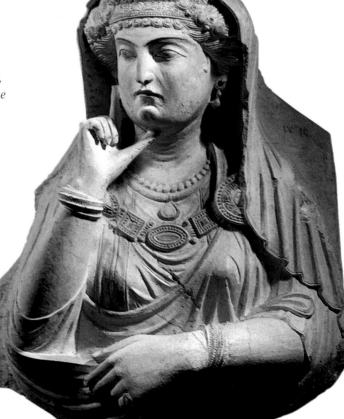

History has tended to favor men over women, and great women are relatively rare in chronicles, but this does not mean that there have been no outstanding women down through the centuries. For example, Queen Hatshepsut not only ruled Egypt with all the rights and privileges of pharaohs, but extended the sanctuary of Karnak, ordered the construction of the funerary temple of Deir el-Bahari and organized major trading expeditions to distant lands which greatly expanded the geographical knowledge of her time. Less well known, perhaps, but not less important was Zenobia, whose history is bound with the city over which she reigned and which she took to the dizziest heights of splendor. Palmyra, now in Syria, is one of the most famous archaeological sites in the Middle East with its spectacular and well-preserved monuments. The ancient city, built on a desert oasis halfway between the Mediterranean and the Euphrates, is far from any other source of fresh water. It was inhabited from Neolithic times, as was proven by a series of careful excavations in 1996 during which a village five thousand years old was found. The area was strategically important because of the abundant supply of water. In Babylonian, it was known as Tadmuru and as the Old Testament refers to the foundation of a city called Tadmor or Thadamora by Solomon it was believed for some time that there was a connection between the two. However, the biblical mention almost certainly refers to a site in Judea known as Tamar. This is one of the many examples which can be found in archaeology in which the study of written sources proves less meaningful than may at first be believed.

The oldest certain historic mention of this settlement is to be found on an Assyrian tablet written in cuneiform characters, dating to the early 2nd millennium BC. Equally certain is the mention of Tadmuru in the annals of Tiglatpileser I, an Assyrian

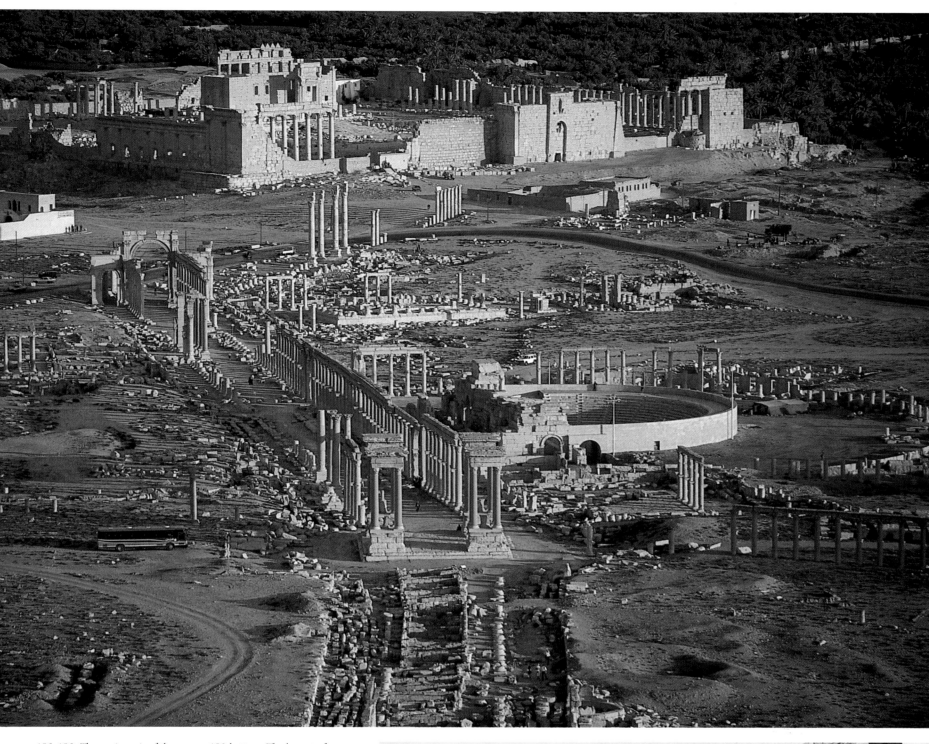

182-183 The main axis of the town center in Palmyra was the famous colonnaded road, which ran from the northwest to the southeast and was built primarily during the 2nd century AD. This long road consists of three straight sectors with an unusual triangular arch with three openings at the junctions (left) and a tetrapylon, which can be seen in the center of the photograph. This was a square monument with two points of passage along the medians, usually placed at the crossing of two roads.
They originally were built in the great eastern caravan towns during the Hellenic period, but later became very common throughout the Roman Empire.

183 bottom The layout of Palmyra underwent intense restructuring from the first Imperial period onward, and reached its current appearance in the Severian period and under Zenobia, when the second stretch of the Great Colonnade, seen here from the west, was built. Along this road were the sanctuary of Nabu, the great theater and the palace of Zenobia which recent excavations have found beneath the later Dicoletian bath complex. Large shelves can be seen on the columns which probably held statues of the city dignitaries, a typical feature of the local architecture.

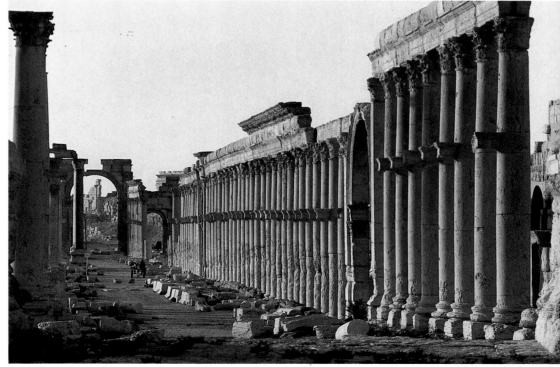

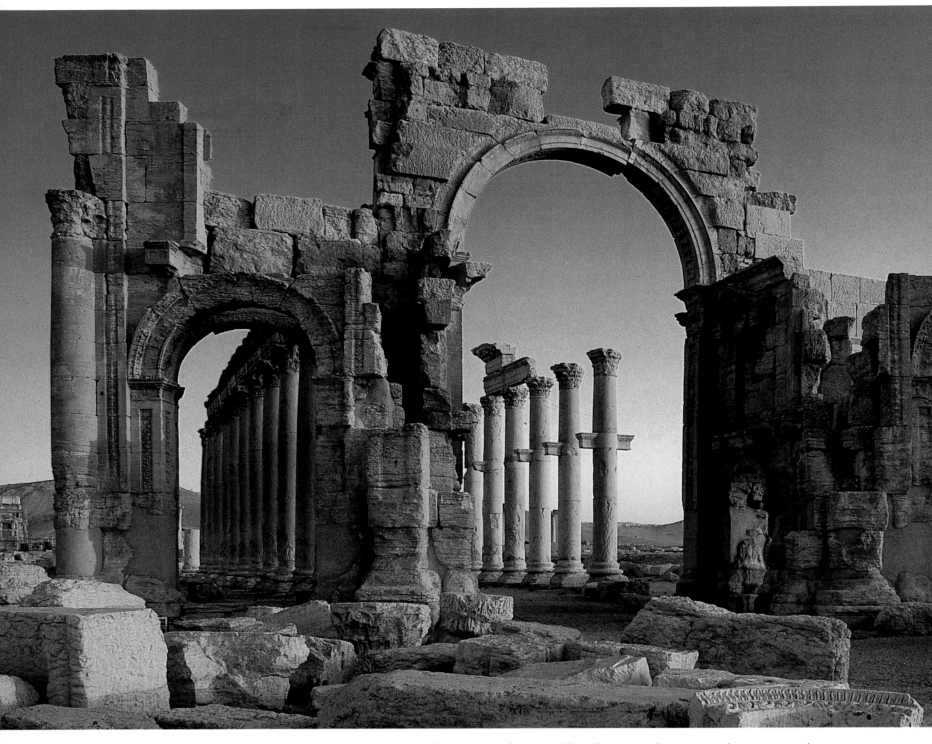

monarch who ruled in the 11th century BC. Unfortunately, if we want to know more we have to wait for the appearance of the classical sources written a thousand years later in Greek or Latin, in which the city finally appears with the name Palmyra, "The Place of Palms". A great deal of time passed, therefore, with no written documents produced, so that the only indications we have on the development of the city are from the archaeological findings. However, we do know that from the 11th century BC onward Palmyra was an important Assyrian caravan center whose wealth grew constantly as a result of its crucial position between the Mediterranean basin and the fertile Euphrates valley along the Silk Route. The city came under Greek influence because of the expansionist policies of

Alexander the Great, but was able to keep a degree of independence and continued to flourish. In short, Palmyra's excellent geographical position made it an ideal halfway house between east and west, but also placed it in the role of a buffer state between the Persian empire and the growing imperialism of Rome. Relations between Palmyra and Rome were always rather uncertain.
In 41 BC, during the civil wars, Anthony allowed the sacking of the wealthy city, although the inhabitants were able to flee to the other side of the Euphrates with some of their riches. Augustus, on the other hand, granted Palmyra autonomy from the province of Syria, which guaranteed its neutrality with regard to the Parthians. Thanks to the taxes which the city levied on

the caravans that transported precious goods from the Arabian peninsula and even further afield to the markets of the Mediterranean, the city returned to a position of great prosperity. But there was a further change in diplomatic relations with Rome around 114 AD, when Trajan occupied Palmyra with his armies to use it as a strategic base during his successful campaign against the Parthian empire. His successor, the refined, learned Hadrian, restored the city's privileges once more. Following his visit in 129, the city gained fiscal autonomy and the name Hadriana. Caravan traffic crossing Syria reached enormous heights due to the constant Roman demand for luxury goods from the east. The so-called "Tariff of Palmyra", a bilingual stelae in Greek and the Palmyran

Palmyra

language dating to 137 and now in the Hermitage Museum in St. Petersburg, gives us an idea of the quantities of goods that were normally carried by the constant caravan traffic. From Arabia came incense and myrrh, from India aromatic essences, dyes, gems, cotton and other fabrics, from China came silk and precious hides. Going in the opposite direction, Asia Minor exported colored wool, silver and gold, and purple dyes, while colored glass and wine arrived from Phoenicia. There is nothing surprising about all this movement. The Romans, highly skilled merchants and great travelers, went as far as Zanzibar and Samarkand, did business in Begram, in Afghanistan, and along the Ganges, reached the banks of the Huang-Ho in China and the southern tip of India. Together with spices

184-185 The archaeological site of Palmyra is the largest and most spectacular group of ruins in present-day Syria. Its glorious monuments reflect the prosperity that the center enjoyed from the 1st to 3rd centuries AD due to the fact that it was an almost obligatory stopping point on the caravan route between the Euphrates basin and the Mediterranean. The great colonnaded road, common to all the great cities during the Imperial age, is a typical expression of the artistic influence of Greece and Rome. Here, however, the style is somewhat unusual. Monotony is avoided with great care and arches break up the succession of columns that mark the junctions with the roads that cross the main road. A distinctive triangular arch (shown here are a few of the most interesting details) marks the change of direction of the route. When we view these monumental remains it is easy to imagine the superb appearance of this city in the desert, its broad streets, its many important monuments with their splendid marble, the forests of columns and the shining roofs of gilded bronze.

186 top The architecture of Palmyra manages to combine western building methods with a feeling of independence. Here, for example, in the great sanctuary of Bel, whose layout is quite different from classical ones, the columns of the portico marking the perimeter of the huge inner courtyard are nevertheless topped by Corinthian capitals.

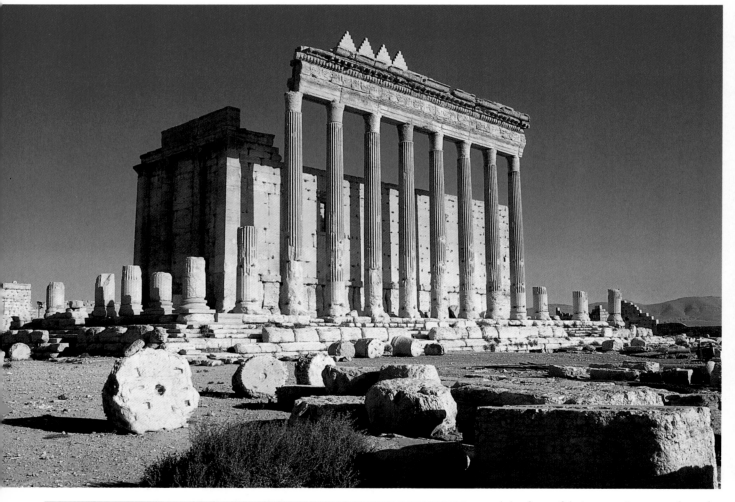

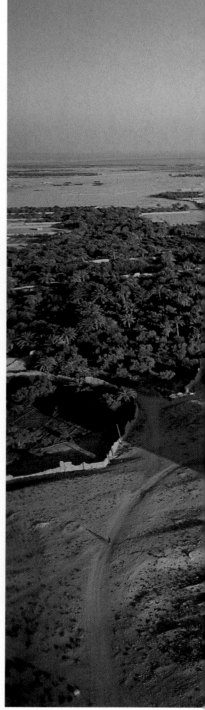

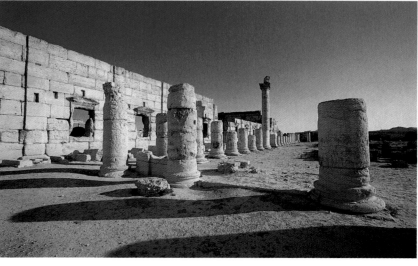

and the finest fabrics, precious metals and works of art, they also brought back an enormous variety of ideas and notions to Rome and the other cities of the empire, in turn influencing distant people and cultures. A statuette of Lakshmi, the Hindu goddess of fertility, was found in Pompeii, for example, while archaeological expeditions in China, India and southern Arabia have unearthed glass and bronze objects and coins showing the faces of Roman emperors.

Palmyra reached the height of its economic power and monumental glory during the

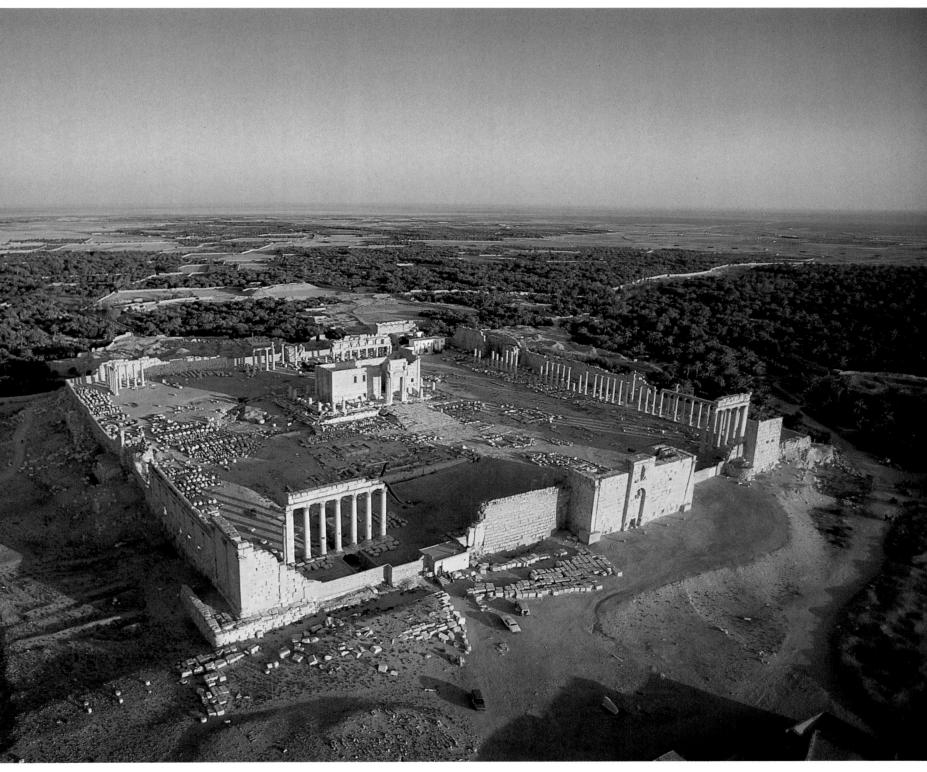

rule of Septimus Severus (193-211) partly because this Roman emperor, who was born in Leptis Magna, had considerable personal interest in Syria. Julia Domna, his wife, was the daughter of the high priest of Emesa, in fact. In 217, under Caracalla, the city was made a colony of the empire but was still able to continue its trading activities which had made it one of the wealthiest cities of its time. A highly sophisticated irrigation system was installed, enabling large expanses of land around the city to be cultivated. Meanwhile, the social organization, which was originally based on tribal systems, had been transformed into a model similar to that of the Greek colonies, with Palmyra becoming a kind of aristocratic republic in which the members of the most important families along with the representatives of the merchant corporations holding the power. In the 3rd century, the new rulers of Persia, the Sassanides, began to pose more and more of a threat, and the increase in hostilities with the Romans caused severe repercussions on the city's economy, while at the same time reinforcing its political and military prestige, its military reputation in particular benefiting from the amazing skill of its archers mounted on dromedary camels. It was for this reason that when the Sassanide sovereign Shahpur I inflicted a terrible defeat on the emperor Valerian in 259, in the battle of Edessa, the army of Palmyra under Prince Odenatus was able to stabilize the situation. As a token of gratitude, the emperor Gallienus granted Palmyra its independence in 261. The city's influence soon extended to Syria, Palestine, Mesopotamia and part of Armenia, while Odenatus acted like an eastern king and at the same time proclaimed his support for

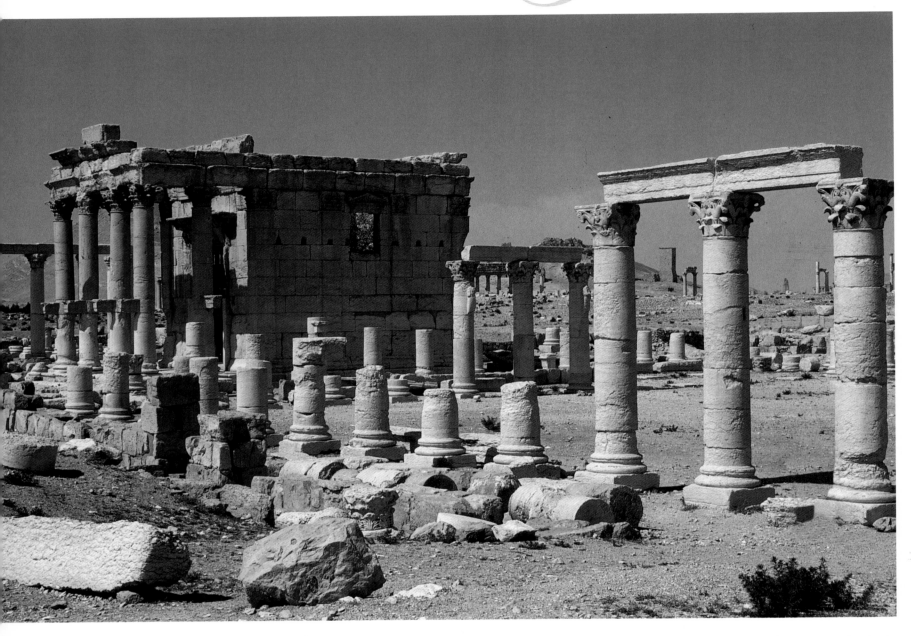

the Romans. On his death in 267 following a palace uprising, his widow Zenobia showed strong hostility to Rome. She became regent in the name of her young son Vaballatus and embarked on a strong policy of expansion. Thanks to the daring courage of General Zabda, she gained possession of Egypt, Anatolia and other neighboring territories, and the imprint of her strong independent character shows in the conquests. She also gave her son the title Imperator Caesar Augustus, thereby placing him in direct opposition to Aurelian, the Roman emperor, who obviously could not tolerate such arrogance. Heavily defeated in

the battle of Emesa, Zenobia's armies had to abandon all their claims and beat a hasty retreat. Victory on the battlefield was not enough for Aurelian, however, and he took further revenge. In 272 Palmyra was put to the fire and sword and the proud queen was taken prisoner. Taken to Rome as a symbol of the emperor's triumph, Zenobia was held prisoner in a villa near the Eternal City where she died. Palmyra fell into a rapid decline as the continuous hostilities had severely reduced the trading traffic. There was a brief period of recovery during the principalities of Diocletian and Justinian, who had the walls rebuilt in 528. But these

were the last sparks of a greatness that had vanished. Conquered by the Arabs in either 634 or 638, Palmyra was finally burnt to the ground by the last Omayyad Caliph halfway through the 8th century during a period of civil unrest. As a result of its privileged position between east and west, and the extremely varied origins of its population, Palmyra in its centuries of maximum splendor had created a number of quite unique artistic and cultural forms, combining Aramaic, Semitic, Greek and, finally, Roman influences. The architecture reflects this mixture, especially in the imposing sanctuary dedicated to Bel and in

189 The temple of Bel, consecrated in 32 BC but finalized in the shape it took on in the 2nd and 3rd centuries AD, stands at the center of a square of 660 feet per side. As can be seen in the photograph, the entrance was placed on one of the building's long sides rather than the more usual short side. Another peculiar feature is that the capitals of the surrounding colonnade, probably Corinthian although there is no trace remaining to indicate this, were each made up of two halves of gilded bronze applied to the columns with metal fasteners.

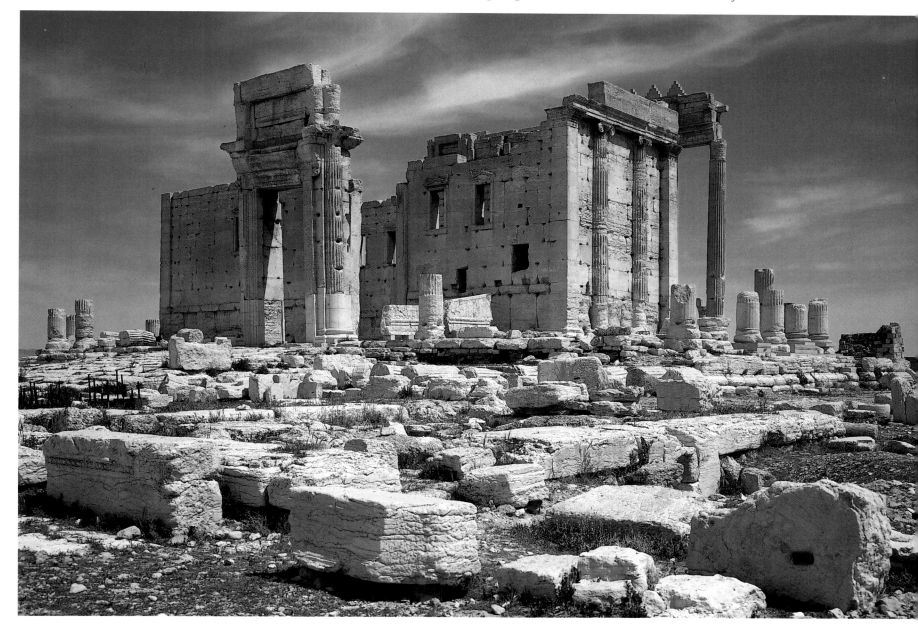

the temple of Ba'alshamin, both of which had inner sanctuaries lit by windows, which is most unusual in a Roman-influenced setting. Palmyra also had a great colonnade avenue, the main street which cut the town in half with various other roads leading off at right angles. The temple of Bel, a supreme deity of Babylonian origin with similarities to Jupiter, was built in the 2nd century AD on a traditional Syrian plan, at the center of a huge porticoed courtyard reached from Corinthian-style colonnaded antechambers. It was clearly influenced by Greco-Roman styles. The temple was very elegant in its decoration and in its structural

188 One of the biggest and best preserved monuments of Palmyra, the temple of Ba'alshamin, was built in 132 AD under Hadrian, to complete an older monumental complex. The sanctuary is formed by a series of courtyards, at the center of which is the temple itself, shown in the photograph. The building has four Corinthian columns in the façade, with no podium. Here, too, the columns at the front have shelves, which may have held statues of gods.

189

190-191 The great theater in the middle section of the Great Colonnade is typically Roman. This splendid building, of which part of the front can still be seen, dates to the first half of the 2nd century AD.

191 top This grandiose Corinthian six-columned temple stands in what is called the Field of Diocletian. It was dedicated to the goddess Allat and built at the end of the 3rd century AD to house the local garrison.

191 bottom The current appearance of the tetrapylon (four-columned) front in Palmyra is the result of careful analysis of the columns themselves. This type of monument, elsewhere crowned with four openings in the form of a square-fronted arch, is typical of the Syrian region.

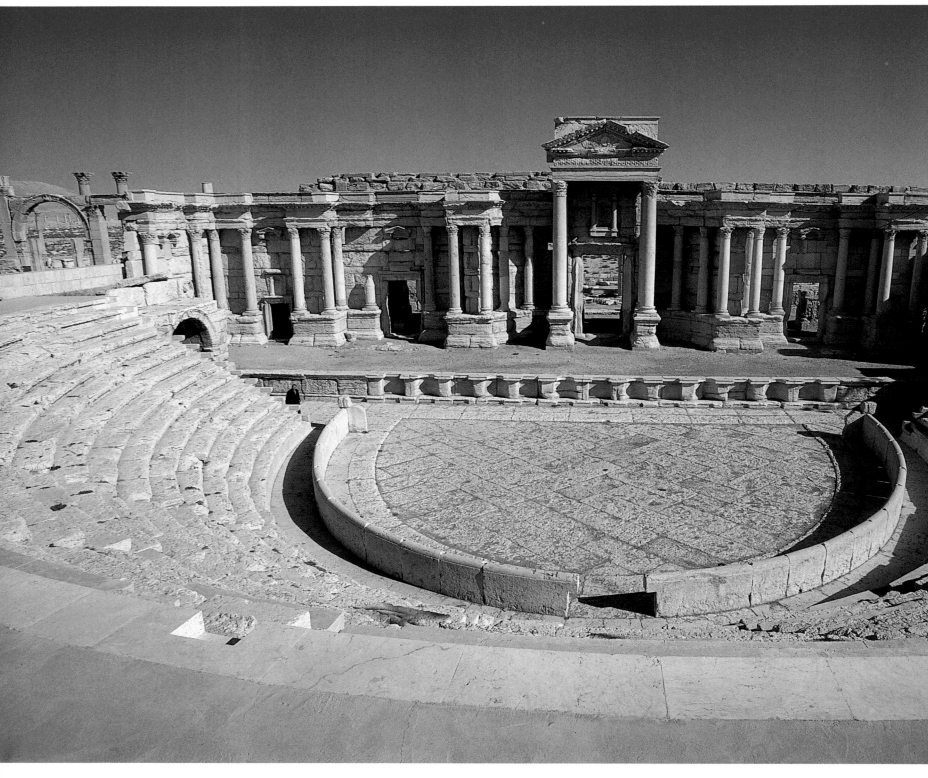

solutions of non-classical origin. These include having the entrance on one of the long sides, giving the cornice triangular patterns and having the roof be formed by a terrace with a turret at each of its four corners. The Temple of Ba'alshamin, built in 132 during the time of Hadrian, consisted of a Corinthian style four-colonnaded building at the center of a complex system of courtyards. Again a wide range of cultural influences can be seen. Although the building is decorated with Ionian and Corinthian capitals, the temple overall

seems closer to eastern models. The same is true of the sanctuary of Nabu, another local god, built between the 1st and 2nd centuries. The most spectacular monumental features of Palmyra, however, are the two great colonnaded avenues. The first of these, known as the Transverse Portico, running from northeast to southwest, dates back to the first imperial period, while the Great Colonnade, running northwest to southeast, dates mainly to the 2nd century AD. Just about a mile long, this street consists of two parallel rows of

Corinthian columns with entablatures. About halfway along, this is broken by a huge pylon of obviously Greek influence with, at the eastern end, a Roman style arch of triumph with an unusual triangular plan. The most interesting detail of these two colonnaded avenues is the presence of ledges halfway up the columns which were probably used as bases for the statues of local dignitaries, another typically local element adapted from the models of classical art. Typically Roman, on the other hand, are the theater, still in relatively good

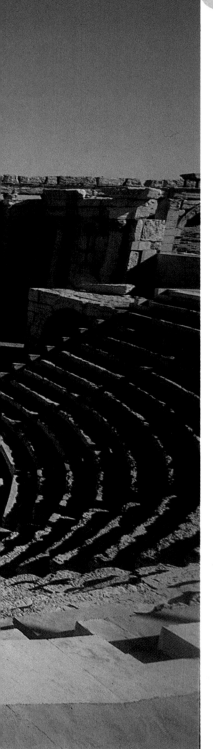

condition, the Diocletian bathhouses, built on the foundations of the palace of Zenobia, and the so-called "Diocletian Field", built near the Transverse Colonnade in the last decade of the 3rd century to house the legion that was to guard the eastern end of the empire. In the same sector, outside the walls, is the western cemetery which shows a great variety of building methods. Tombs shaped like houses, towers often three or four floors high, underground chambers and decorations of frescoes and sculptures make this cemetery outstanding. Most of the sculptures now in the local museum and in the ancient art collections from Palmyra in Damascus and the Louvre were found here. The frontal views of the figures and the somewhat rigid modeling are an example of the unusual combination of local and classical style imported from the Greek and Roman worlds to the west.

BABYLON, MEGALOPOLIS ON THE EUPHRATES

192 top Along the road that led to the gate of Ishtar, the bastion of the main palace of Baylon, were a number of statues, including some extremely ancient ones, which were mainly booty from war.

192-193 Babylon was protected by an outer wall about 10 miles long which enclosed an almost entirely empty area, within which was a double inner wall which formed a quadrangle about five miles long. The photograph shows part of this inner defensive structure, which protected the urban complex.

192 bottom The walls that protected the city of Babylon were 21 feet thick.

193 top This original relief in shaped brick shows the horned dragon, emblem of the god Marduk. This god, the protector of Babylon, was considered the vanquisher of the primordial chaos, creator of the universe and man and responsible for bringing order to nature.

1 Western City
2 Eastern City
3 Northern Citadel

A Temple of Ishara
B Hexagila - Temple of Marduk
C Etemenanki - Ziggurat of Marduk
D Temple of Ishtar Agade
E Southern Palace
F Temple of Ninmah
G Northern Palace

193 center This terra-cotta relief, today in the Louvre in Paris, dates to the beginning of 2000 BC and shows an elegant and natural portrait of a woman weaving.

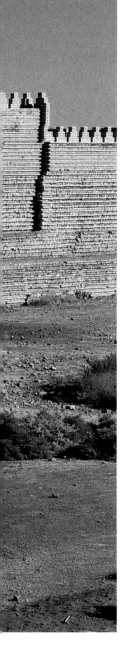

three centuries earlier. The completeness and breadth of the code make it the main source for the reconstruction of Babylonian society.

No statue from the Babylon of Hammurabi has ever been found on the site of the city. The only known ones are those taken to Susa by the Elamites after they defeated the dynasty of the Kassites, whose kings had absorbed Babylonian culture. It is just as difficult to assess the achievements of the first Babylonian dynasty in the field of town planning and architecture, as the Babylon of this period is inaccessible, buried beneath later reconstructions of the city. At the end of the 12th century, the Babylonians, led by Nebuchadnezzar, put the Elamites to flight

Babylon, a name which means "The Gate of God", was the center of the cult of the god Marduk. An administrative capital of some importance when Ur dominated the whole of central and southern Mesopotamia (2112-2004 BC), in the 18th century Babylon became the spiritual and temporal capital of southern Mesopotamia under the Amorite king Hammurabi (1792-1750 BC). Hammurabi, fifth king of the first Babylonian dynasty, was without doubt its most prestigious ruler. He built up an important empire which included the south of Mesopotamia and coincided with the territory which had been under the sovereignty of Ur in the past. A diorite stone slab discovered in Susa at the start of the twentieth century, on which a code was inscribed, was to reveal the genius of this unifying action. A bas-relief shows King Hammurabi receiving the texts of the law from the god Shamash, patron of justice. The slab, which must have been erected in the temple dedicated to Shamash in Sippar or in Babylon itself, was transported to Susa as booty by the king of Elam, Shutruknakhunte, around 1200 BC. The code issued by Hammurabi was not the oldest as the Sumerians had created another

193 bottom The inner walls of Babylon had eight entrance gates, the most famous of which is the Gate of Ishtar. The brick walls of the gate are decorated with reliefs of dragons, symbol of the god Marduk, and bulls, the symbol of the storm god Adad.

193

194 top This picture shows a detail of the kudurru stone of King Melishihu with the ruler shown presenting his daughter to a god. This type of stone, sculpted with symbols of deities, was used in Babylon, especially during the Kassite period, to mark land boundaries.

194-195 The gate of Ishtar, dedicated to the goddess of war, was reconstructed in the Pergamon Museum in Berlin using enameled bricks found on the site. An inscription tells of the works carried out by King Nebuchadnezzar II, an enthusiastic builder. On the gate of Ishtar is inscribed "... I dug the base of this gate, strengthened the foundations from the river with tar and enameled bricks in the color blue, on which wild bulls and dragons were shown... I placed intrepid bulls and furious dragons at the entrance".

and destroyed their capital, Susa, and recovered the statues of the kings of Babylon that had been taken away. In the first millennium, the city fell to the Assyrians, but the rebellions continued and the city was destroyed twice by the Assyrians during the 7th century BC. In 625, the governor Nabopolassar declared the independence of the city and himself king, then formed an alliance with Meda to defeat Assyria and destroy its capital, Nineveh, in 612 BC. Nebuchadnezzar II, his son, overcame the last outposts of the Assyrian resistance and dedicated his reign (604-562) to intense building operations. The remains of the city, still visible today, belong to this period of reconstruction. The exploration of Babylon took place only at the end of the 19th century (1899) by German archaeologists, led by the architect Robert Koldewey who, for eighteen consecutive years until 1917, systematically brought to light the monuments from the eastern part of the city, significantly increasing our knowledge of the architecture and town planning techniques. The city stretched along both banks of the Euphrates, but the most important buildings were on the eastern bank. An outer wall roughly 10 miles long enclosed an almost uninhabited territory that could be used as a shelter for the peasants in time of war.

This outer line of defense was reinforced to the north by a fortress, still over 70 feet high today, which protected the king's

Babylon

palace. A double, four-sided wall five miles long, flanked by a canal which was used as a moat, defended the city itself.

The inner wall had eight gates, each protected by its own god, the most famous of which is the one dedicated to Ishtar, the god of war.

This was a double gate, crossing two walls, flanked by two forward towers and doors that opened inward on the walls themselves, used as guard posts.

The main gate was decorated with the figures of dragons, the emblem of the god Marduk, in smoothed brick, and bulls, associated with the Adad, the god of storms, on enameled bricks. The gate, of which only the foundations were found, was rebuilt to a height of 48 feet, a figure

and capitals topped by palms. The famous hanging gardens described by Diodorus Siculus as one of the seven wonders of the world but not found in any Babylonian text may have been in the northwestern corner of the royal palace with vault-covered parallel corridors. From the palace, the avenue continued to the great temple of Marduk, the most important god in the Babylonian religion. The temple was a fortress with a square floor plan and central tower containing the statue of the god, which was carried during the processions. At the side of the temple, but isolated by a wall, was the famous ziggurat or Tower of Babel. This was an almost 300 foot high square tower, built in bare brick covered in baked

brickwork. This was repeatedly robbed for its materials over the centuries, and all that remains of it today is its enormous square base. At one time, however, it loomed over the city with its seven stories, crowned by a temple where, according to a passage in Herodotus, the holy marriage of the god and goddess took place, imitated by the king and the high priestess as part of the new year celebrations.

derived from the base of the enameled bricks found on the site.

An avenue used for processions, with enameled bricks and figures of lions, emblems of the god Ishtar, passed beneath the gate of Ishtar, followed the double wall that protected the palace and led into the heart of the city, where it connected the Heragila, a word meaning "the high-roofed temple" or temple of Marduk to the new year temple outside the city walls where celebrations marking the beginning of the year and lasting 12 days took place each spring.

The royal palace of Nebuchadnezzar was defended by the River Euphrates and a massive fortification on one side, and was protected by high walls on the others. It had five courtyards which opened onto state rooms on the southern side. The main courtyard opened onto a large throne room with its walls covered in blue and yellow enameled bricks showing scrolled columns

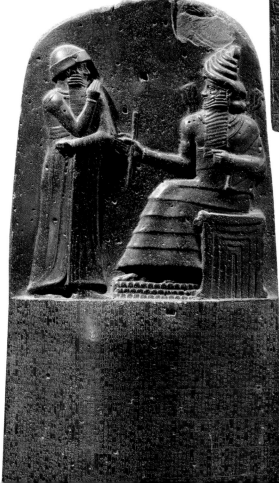

195 top left The walls of the processional avenue that passed through the gate of Ishtar were decorated with enameled bricks showing lions, the emblem of Ishtar, goddess of war.

195 bottom left The Code of Hammurabi, now in the Louvre, shows the king receiving the laws from the god of justice Shamash.

195 right This kudurru stone, made from limestone, belonged to King Marduk Zakir Shumi.

195

UR,
AT THE THRESHOLD OF MESOPOTAMIA

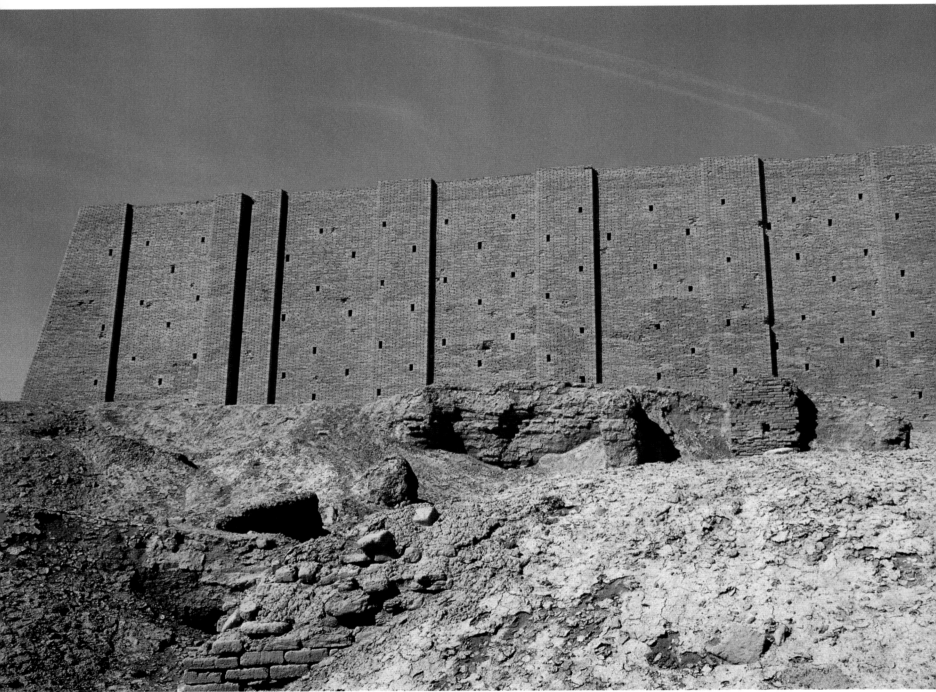

196-197 The Ziggurat of Ur, begun by King Ur-Nammu and completed by his son Shulgi, was part of the temple of the moon god Nanna and probably covered three floors.
Today only the first level of the ziggurat, or temple tower, mostly restored, is visible.

A Ziggurat
B Temple of the
 Moon God
C El-Nunmah
D Sacristy
 of Ningal
E El-Hursag
F Mausoleum
G Royal
 Cemetery
H Temple
 of Nimin-Tabba

top Various objects and furnishings in precious metals have been found in the royal tombs at Ur, showing the extraordinary cultural level and considerable manual skill of these people. In the photograph are shown a golden dagger with a finely decorated handle and a skillfully carved golden sheath.

The site of Ur, modern Tell el-Mukayar, or the "Hill of Tar", is located on a broad, sandy desert plain, about six miles from the Euphrates and over six from the Persian Gulf. The city, mentioned in the Bible as the land of the tribe of Abraham, was founded in remote antiquity, during the so-called Ubaid Period of 4500-4000 BC. It was originally a well-organized village, dedicated almost exclusively to agriculture and stock raising. At the start of the 3rd millennium, or proto-dynastic age, southern Mesopotamia, with its mainly Sumerian culture, had a scattering of city-states, including Ur, with royal dynasties and powerful gods who competed for dominance over the region. In these urban centers, the archaeological documentation shows the progress of quality craftsmanship

administrative documents offer the first details on the organization of crafts, technical procedures and the terminology for materials and objects, and confirm the control of the temple and the royal palace over the trades. Agriculture was supported by major canal building, which made it possible to irrigate the entire territory between the rivers Tigris and Euphrates and provided navigation routes for carrying goods. Around 2300 BC, the Semite King Sargon founded the region of Akkad, to the north, and conquered the land from the Persian Gulf to as far as Eblus. When this empire collapsed two centuries later, it was Ur, under the leadership of the great third dynasty kings (2112-2004 BC), which took it over and dominated this land between the two rivers. In the 2nd and 3rd millennia, Ur

197 This helmet is made of an alloy of gold and silver. It was found in the royal cemetery in the tomb of King Meskalamdug along with an extraordinary treasure of weapons and jewelry. Notice especially the refined embossing and chisel technique on a single sheet of metal which dates to about 2500 BC.

as well as long distance trading which led to the supply of materials including timber from Lebanon, silver from Mount Aman, lapis lazuli from Badakhshan, now Afghanistan. The rich furnishings found in the royal tombs of Ur show a ready availability of precious materials and a mastery of craftsmanship that placed the Lower Mesopotamia of this period over all the other people of its time in the application of technology. At the same time,

was an important center for the cult of the moon god Nanna, and many Babylonian kings carried out restoration work on the temples of the city as a sign of special respect toward that deity. The city was probably abandoned in the 4th century BC due to changes in the course of the rivers. Up to the middle of the 19th century, only the imposing ruins of the ziggurat of Ur emerged from the desert. It was then that the British consul in Basra, J.E. Tailor,

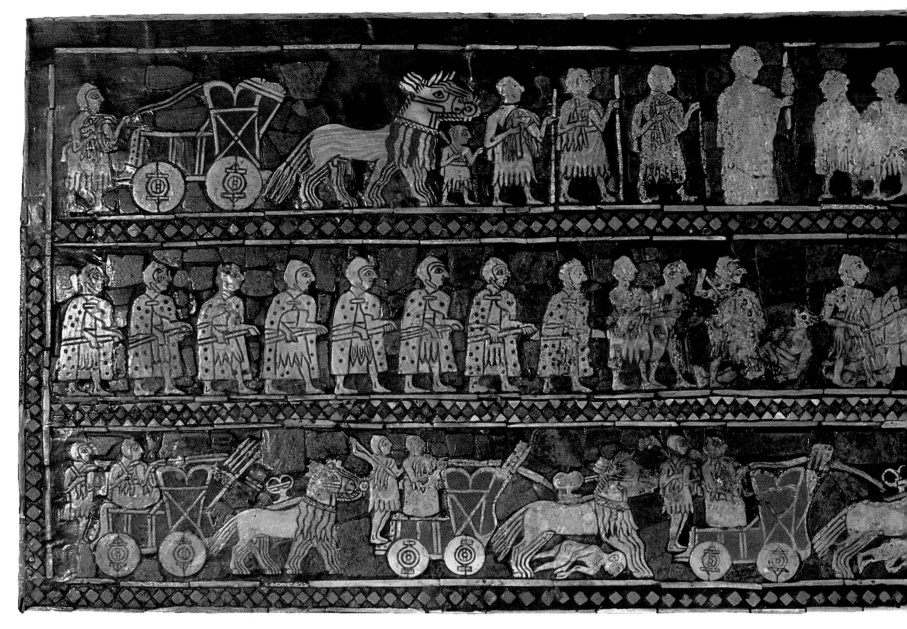

carried out a number of surveys in the area and, as a result of several inscriptions discovered there, the site was identified as the Ur of the Chaldeans, the land of Abraham. In 1922, a joint expedition was organized by the British Museum and the University of Pennsylvania, led by L. Woolley, who was assisted on the site for 12 years by other internationally known archaeologists and epigraphists including M.E.I. Mallowan, C.J. Gadd and L. Legrain. The most sensational discovery was undoubtedly the royal tombs (3rd millennium BC) in 1927, which were excavated from then through 1931. The burial zone, next to the sacred area, contained the tombs of common people in rectangular trenches, over 2000, and 17 graves of high ranking figures, which consist of burial chambers in stone and brick. Many of these tombs were opened and robbed in ancient times but nevertheless what remained was extraordinary.

The best known are those of Arbaji and Queen Puabi, which was named the "Great Trench of Death" as it contained the remains of at least 74 people, and the tomb

of King Meskalamdug. The splendid funeral treasures found include gold vessels, jewelry, hundreds of objects made from lapis lazuli, harps decorated with bulls' heads, golden arms including the helmet of Meskalamdug worked in relief and his dagger with a golden blade and lapis lazuli handle, and even a panel made in shells and red limestone set in a background of lapis lazuli embedded in bitumen. This panel shows a war scene on one side and a banquet on the other. The banquet may be part of the victory celebration. Animals and men bearing offerings are also part of this panel.

The funeral ceremony for these proto-dynastic kings was reconstructed by Woolley on the basis of the findings and the many human and animal sacrificial victims found in the tombs. The dead ruler was accompanied to the hereafter by a large escort of dignitaries and warriors, who were drugged and killed together with the animals that hauled the carriages, a comparable practice to those in Egypt during the same period. To the north of the city, a sacred enclosure contained the ziggurat, or temple tower, and the temple

198-199 and 199 bottom The "Standard of Ur", an oblong wooden chest which may have been the sound box of a musical instrument, shows the main activities of the king and his court on the decorations on the sides, with shells and limestone inlaid on a background of lapis lazuli, attached to the wood with tar.

The panels should be read from the bottom to the top. The upper panel shows scenes of war with the victorious king (above, the large figure) passing through the ranks of his enemies. The other panel, known as the panel of peace, shows the spoils of war and scenes of the victory banquet.

of the moon god Nanna. The buildings, erected by the kings of the 3rd dynasty, were restored by later governors. The ziggurat built by King Ur-Nammu and completed by his son Shulgi on the site of an older temple consisted of three floors and the sacristy of the god, which crowned the building. The bottom floor, over 60 feet high, was entered from three broad staircases which met at the top. To reach the main temple built at the foot of the ziggurat the goddess had to first come down from the heavens to arrive at the temple at the top of the tower dedicated to her. In this way, the ziggurat stressed the connection between the earth and the sky, man and his god. The great courtyard of Nanna, in which offerings for the deity and the clergy were collected, occupied the remaining northeastern part of the sacred area. In the corner formed by the courtyard and the sacred enclosure is the building that was probably the residence of the divine couple Nanna-Ningal. At the opposite side of this enclosure there was a large square building which may have been the royal palace of Ur. Alongside this was a residential quarter, suddenly abandoned

when King Samsu-Iluna of Babylon destroyed Ur in 1729 BC. The houses were generally of two floors, built with walls which, as there was no stone, had baked brick bases and bare brick, hardened by the sun, on the upper part. These houses had a central courtyard onto which the rooms opened. Typically, a chamber for the burial of the dead was located beneath the ground level, and here various offerings were consecrated in a kind of chapel at one end of the courtyard.

198 bottom The lion-headed eagle Anzu, with lapis lazuli wings and a gold head and tail, is part of the treasure of Ur, discovered at Mari and dating to 2600-2400 BC. This mythological animal is the incarnation of the warrior-god Ningirsu.

199 top This gold and lapis lazuli bull's head is the ornament on a harp that belonged to Princess Shub-Ad, found in the royal tombs of Ur. The instrument, which dates to 2800-2700 BC, is an indication of the Sumerians's great love of music.

PERSEPOLIS, CAPITAL OF THE ACHEMENIDIAN KINGS

Persepolis was the ceremonial capital of the Achemenidian Persians, founded by Darius I around 500 BC and later destroyed by Alexander the Great. Its imposing remains are 30 miles from Shiraz in the province of Fars, and over 300 miles from Susa, the administrative capital. Plutarch, the Greek writer, confirms that this fabulous residential complex must have been truly splendid and luxurious. He tells us that Alexander had to organize a caravan of 10,000 mules and 5,000 camels to take the riches he found in Persepolis to Ekbatana. European travelers were attracted to the site from medieval times onward. The first detailed description was by the Roman Pietro della Valle, who brought inscriptions from Persepolis that he had copied back from a journey of 12 years to Mesopotamia from 1614 to 1626. In the 17th century, new documents were added to the older ones, and inscriptions from Persepolis were copied and distributed by the Danish mathematician Carsten Niebuhr. In 1887, the governor of Fars, Mu'tammad al-Daula, conducted some surveys in the Hall of a Hundred Columns which was built by Xerxes I.
In 1931, at the request of the Iranian government, the German archaeologist

Ernst Herzfeld carried out the first of four cycles of excavation on behalf of the Oriental Institute of Chicago. It is to him that we owe the discovery of the porticoes of Xerxes I, the great stairway to the east leading to apadana, and other discoveries. From 1935 to 1939 the excavation continued under the direction of Erich Schmidt then, from 1939 on, the Iranian Archaeological Service continued the work, first with the help of the French expert on Iran, A. Godard, then with the assistance of M.T. Mustafawi. Recently, excavations have slowed as a result of political changes within the country and war in the area itself. The monumental site of Persepolis shows the signs of a complex architecture linked with the history of the Persian empire. The formation of this empire was the work of Cyrus II. The Persians had replaced the Elamites in the region of Anshan (ancient Parthia, now known as Fars), and a family belonging to the Achemenides had been reigning there for several generations, with the title of King of Anshan (Theispes, head of this tribe, ruled around 670 BC), related and subordinate to the royal house of Medea. After proclaiming himself king of the Medes and Persians, Cyrus II took control of Lydia, the

200 left Persepolis was the capital of the Achemenidean empire from the 6th century until 330 BC, when Alexander the Great burnt it down. The royal palaces, the only buildings remaining in the city, had great stone portals with columns and frames. The walls were made of brick which is much more perishable than stone and they have been almost entirely lost.

200 bottom This superb golden rhyton, now in the archaeological museum in Teheran, shows the high degree of refinement achieved by Achemenidean art. The winged lion was one of the heraldic animals of the reigning Persian dynasty.

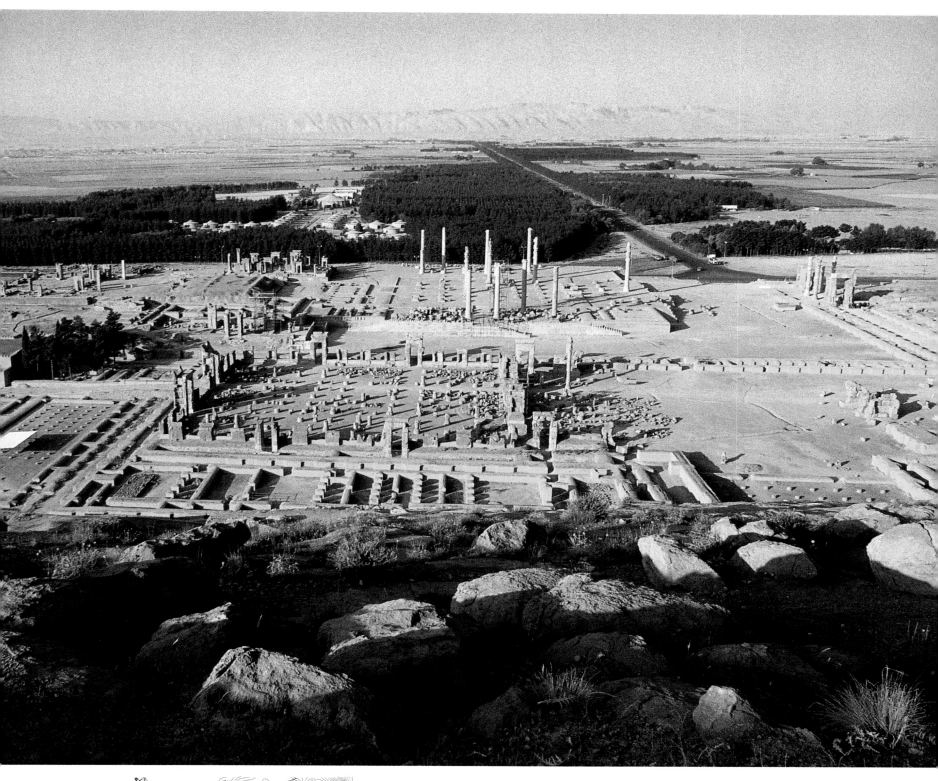

200-201 *The building of Persepolis was based on a strict plan designed by Darius, who arranged for every single part of the construction. His successors, Xerxes and Arthaxerxes I, followed his plans. All the buildings on the great raised terrace, seen here from above, were built and decorated in accordance with their role in the important new year ceremonies.*

201 bottom *Griffins are fantastic creatures that appear frequently in Persepolis. The royal architects made capitals with decorative heads of these animals for the great palaces.*

A Access stairway
B Gate of Xerxes
C Apadana
D Hall of the Hundred Columns
E Palace of Darius
F Palace of Arthaxerxes IIII
G Residential palace of Xerxes
H Tripylon
I Harem
J Treasury
K Part of the fortified walls
L Tomb of Arthaxerxes II

202 top It is usual to consider Persepolis as the main artistic center of the pre-Islamic Near East. However, this belief is largely due to our modern idea of beauty. The ornamental features that decorated the various monumental structures of the royal palaces were primarily designed to make an impact on the onlooker and create a sense of the grandiose, with artistic importance only secondary. Official Archemenidean art shows no trace of the typical Greek or Roman theories of good taste.

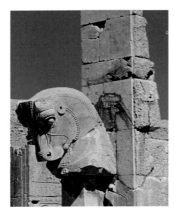

202 center This photograph shows one of the enormous bulls on either side of the Door of the Nations. These enormous statues were designed to defend the palace from the forces of evil. It is interesting to note the way in which Achemenidean art moves away from its usual formal and rigid base to a more realistic view when producing animal figures.

202 bottom and 203-303 Access to the terrace of the royal palaces was from the Gate of Nations, an imposing structure built by Xerxes and consisting of a huge square hall, whose ceiling was held up by four columns with elaborate animal-headed capitals. The three great entrances opening to the west, east and south, were decorated by enormous figures of bulls, some human-headed, taken from traditional Assyrian imagery. The "throat" that crowned the crossbeams of each portal were typical Egyptian. This mix indicates the way in which Persian architecture combined a large number of different influences.

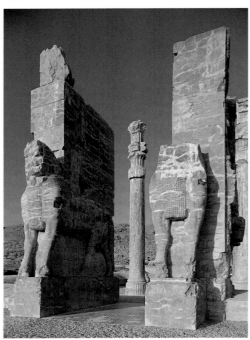

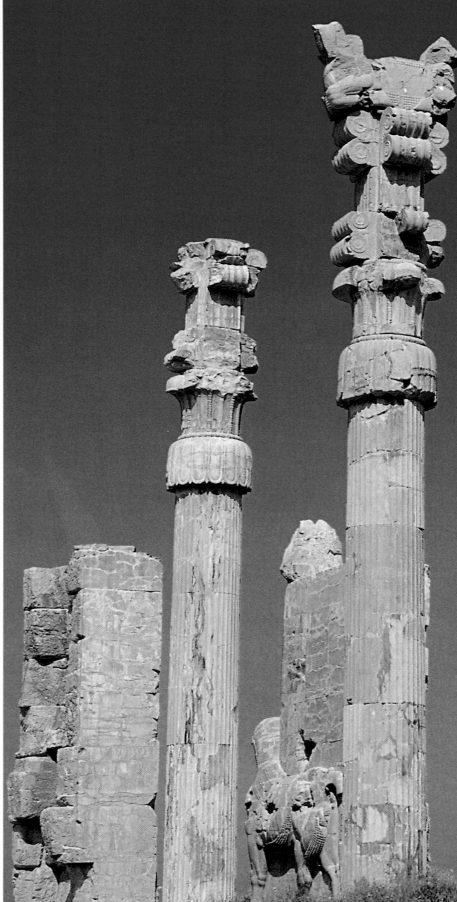

kingdom of Croesus, in 546 BC, and then conquered the Greek cities of Asia Minor. Finally, in 539, he also defeated Babylon, thus taking over all the territories not only of Mesopotamia but also of Syria and Palestine. The conquests of Cyrus were then extended by his successors. In 525, his son Cambises annexed Egypt and Cyprus. After the power struggle that followed his death, Darius I (521-485 BC), who belonged to another branch of the Achemenides, continued and completed the expansion of the empire but devoted his efforts above all

to its structural reinforcement. The Persian empire also continued to make use of the ancient imperial notion of the inward movement of resources and the outward flow of ethical and political services. The palaces of the Achemenides and those of Persepolis are the clearest examples. They are built using materials from every part of the known world and are the work of craftsmen from all the provinces of the empire. Every group contributed its best to the construction of the capital which was seen as the nucleus of the world. In the

opposite direction, safety, respect for the law, agreement with the divine world and civilization moved outward into the world from this central point. Darius I chose Susa, the ancient Elamite metropolis, as the administrative capital of the empire, as it not only possessed consolidated administrative structures but was also located where the highlands of Iran, Armenia and Anatolia and the lowlands of Syria and Mesopotamia met between the Iranian and Semitic worlds. These worlds had always been opposed to each other and now found themselves within

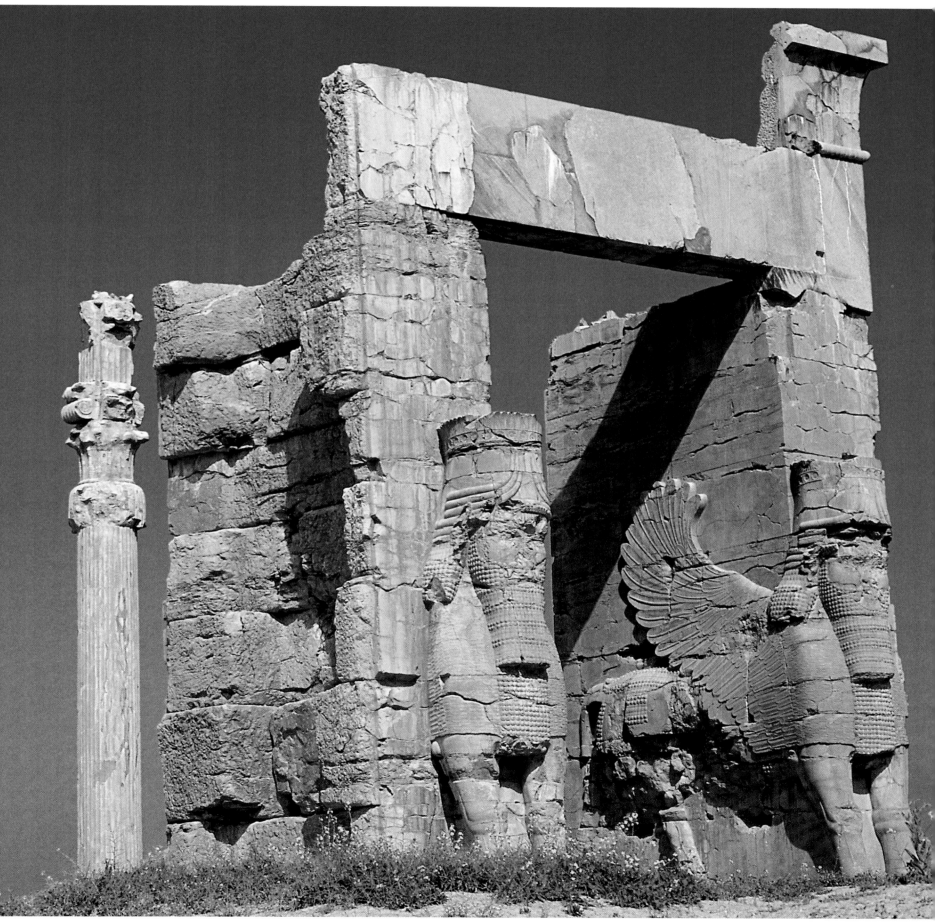

205 top The two monumental staircases that led to the apadana were decorated with bas-reliefs showing delegations from the 25 nations subject to the Persian crown, all offering gifts to the sovereign. From Susa came weapons and lions, the

Armenians were bearing metal vases and horses, the Lydians precious metals and horses, and so on. Each delegation is separated from the others by cypress trees, the Persian "tree of life". All the reliefs were originally multicolored.

205 bottom All the reliefs of Persepolis are designed to exalt the greatness of the empire through a repetition of people and objects. They show foreign delegations, servants, heroes, guards and officers as seen here.

204 top and bottom Gottfried von Herder wrote in 1780 about the long rows of reliefs that cover the staircases of the Apadana that the processions showing bearers of gifts were a "kind of statistical map of the lands that formed part of the Persian empire, a living representation of its provinces and the peoples that lived in them." Furthermore, these images are also of tremendous documentary value as they show in incredible detail the clothing, hairstyles, personal ornaments and weapons, means of transport and everyday objects in common use in the empire.

204-205 The apadana was used for audiences that the "king of kings" granted to the Persian and Medean lords. The enormous hall was reached by two monumental staircases decorated with bas-reliefs showing combat between lions and bulls and, above, a procession of people bearing tributes, some of which we can see here.

a single political entity. On the other hand, as the site for the new capital which would reflect imperial splendor, Darius I chose the fine plain of Marv Dasht, in Anshan, dominated by a rocky spur of Mount Kuh-I Rahmat, but he did not live to see the completion of the work he had started. His son Xerxes continued the work of his father, followed by his grandson Arthaxerxes. Nevertheless, the complex of Persepolis was never finished. In 330 BC a violent fire caused, accidentally or through arson, by the army of Alexander the Great,

destroyed the city once and for all. The Persian empire was then made up of 20 provinces or satraps, whose representatives came to Persepolis for the new year which, in the calendar of Mazda, the religion of Ahura Mazda and the Prophet Zarathustra, corresponds to the spring equinox. They all brought tributes and offerings to the king at this time. Delegations from the vassal states, like travelers in the 19th century, reached Persepolis on horseback, as described by Jeanne Dieulafoy in *La Perse, la Chaldée, la Susiane*, Paris, 1884.

Persepolis

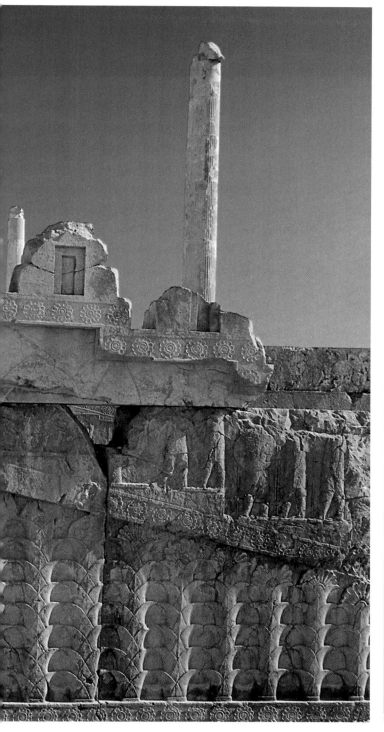

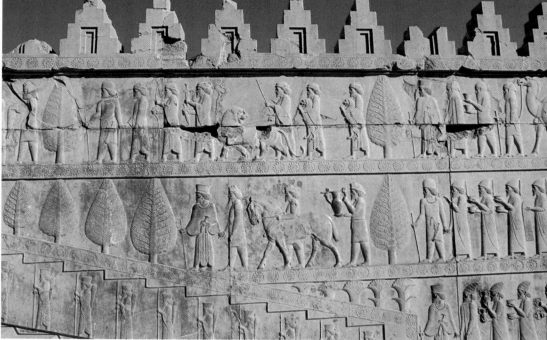

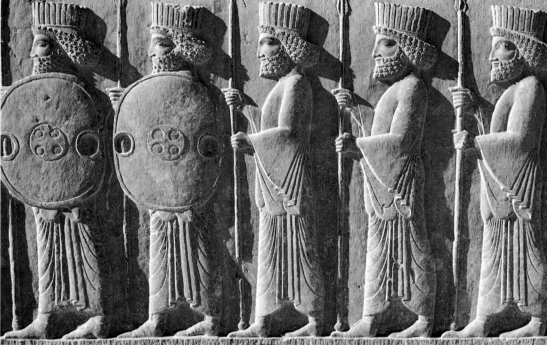

"The steps are so slightly inclined that it is easy to go up and down them on horseback, and they are so broad that ten men can walk along them side by side." The horsemen stopped at the foot of an immense terrace upon which monumental buildings stood. This huge platform measuring 500 yards by 330 yards was built of carefully squared limestone blocks. Its height above the plain varied from 20 to 9 yards. An enormous staircase made of two diverging ramps parallel to the supporting wall led to the upper level, directly in front of the Gate of Nations, built by Xerxes I and guarded to the east and west by two winged genie, with the bodies of a bull, bearded human heads and the crowns of the king, showing a strong Assyrian influence. Over each of these is a cuneiform inscription in which Xerxes says, "Ahura Mazda is a great god. He created the earth, the heavens and man. To man he gave happiness. He made Xerxes the only king over thousands of men. . .this portico. . .from which all nations can be seen, I built, like many other monuments, as built by my father, and this magnificent work and all these splendid buildings we have erected for the grace of Ahura Mazda. . . May Adhura Mazda protect them!" The Persian and Medean nobles who reached this monumental entrance then turned south, before the apadana, the hall set aside for official audiences with the king. The palace was begun by Darius and completed by Xerxes. It had a central hall with a square plan of over 80 yards, and 36 columns, only three of which are still standing. These are almost 70 feet high and are arranged in six

rows to support the ceiling.

From the columns that are left we can see that each was surmounted by a capital in the form of two bull's, lion's or griffin's heads (the griffin was the traditional symbol of balance for the Babylonians and the Elamites). On these columns a structure made of Lebanese cedar rested, brought to Fars from that far distant part of the empire. Three sides of the hall opened onto porticoes made up of rows of six columns. The fourth side opened onto adjoining rooms and a staircase that led to the upper terrace. Access was gained to the apadana from two huge staircases on the east and west sides, both covered entirely in bas-reliefs showing a long row of Persian, Medean and Susean dignitaries, accompanied by infantry, cavalry and archers marching toward a procession of tribute-bearers coming from all parts of the empire to pay homage to the king on the occasion of the new year. Every ethnic group in the procession is preceded by a Medean or Persian dignitary. The ethnic features and the costumes of the various people are so exactly depicted that we can identify the origins of most of the groups. Separated from each other by cypresses, the tree of life, we see Ethiopians, Egyptians, Babylonians, Indians, Libyans, and so on. At the center of the staircase is an image of Ahura Mazda in the form of a winged god above the solar disk, while at the ends of the ramps are motifs of a lion attacking a bull. The bas-reliefs show how Persepolis was entirely dedicated to the power of the Achemenidean king and to the celebration of the new year, under whom these events took place, protected by the god Ahura Mazda. Behind the apadana to the north is the palace begun by Darius and completed by his son Xerxes. We reach the terrace on which it is built by two staircases decorated with scenes showing the guards of the king. These guards were known as the "immortals" because each time one died he was immediately replaced by another. Also shown on these staircases are scenes of vassals bringing offerings. The palace consists of a central colonnaded hall behind a 16 column portico which is flanked by smaller room. The slabs of gray porphyry that covered the walls were so highly polished that the rooms was called "The Hall of Mirrors". The reliefs on the six doors of this hall show the king in a variety of situations. He is seen marching, escorted by servants, or fighting a lion or a mythical animal as a symbol of the king's power over the spirit of evil. Leaving through what is known as the Tripylon, or Triple Gate, we finally reach the immense Hall of the Hundred Columns which covers the entire northeastern part of the terrace. The building was begun by Xerxes I and completed by Arthaxerxes I.

It consisted of a central hall with an over 80 foot square plan which contains a forest of a hundred column in rows of ten. The hall is preceded by a vestibule with two rows of eight columns and was completely destroyed by the fire caused by Alexander's army. Inside, only the bases of the columns remain, while the door frames are for the most part conserved and the bas-reliefs, which repeat the themes seen in the palace of Darius, are still clearly visible. Diodorus Siculus, a contemporary of Augustus, says that a drunken Alexander, instigated by

Thaida, an Athenian courtesan, decided to burn down the palaces of Persepolis as if he was performing a ritual, with a riotous musical cortège parading from one room to the next. In this way, the profanation of Xerxes when he burnt down the Acropolis in Athens was revenged. The nearby civilizations of Mesopotamia, Uratu, Egypt and Greece had a significant influence on the stone and bare brick architecture and the sculpture of Persepolis. The Achemenidean empire took the inspiration for many of its forms, including animals

206 bottom Persepolis was, apparently, divided into two distinct areas for functional purposes. To the north is the ceremonial part while to the south are the private residences in which the nobles lived. The two sectors were joined by a monumental hall, the Tripylon, which could be considered a hinge between the apadana and a small palace situated to the south. The reliefs on the eastern door show Darius on the throne, supported by the subject nations.

206-207 and 207 top The staircase that leads to the palace of Darius, in the southern section of the great terrace, has a relief showing servants bringing food to the royal table. Several scholars believe that this sequence indicates this was the route taken by participants in the new year festival when they left the apadana to go to the banquet offered by the sovereign in his private residence.

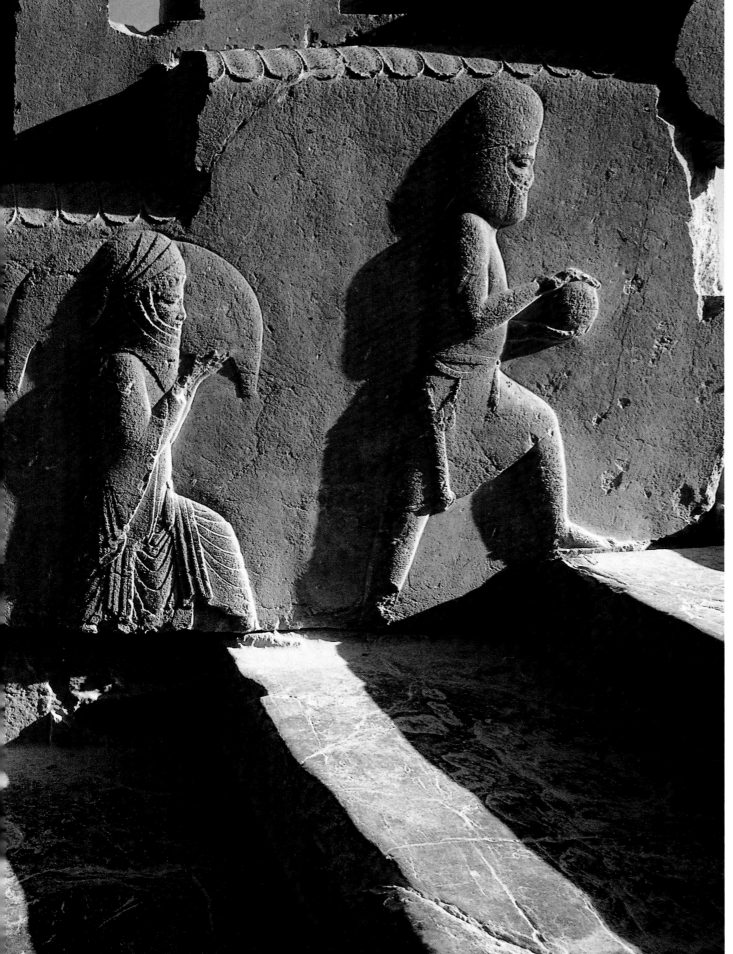

207 bottom The haute-reliefs that decorate the sides of the two doors of the Tripylon, to the north and south, show the "king of kings" followed by a parasol bearer and a fan bearer. Studying these pictures, in which solemn gestures are repeated over and over, we can understand commentators who have said that Achemenidean art was virtually without evolution. It never developed the concept of three dimensions, or moved away from the rigid limits of profile portrayals. However, it is important to remember that court art is always based on the archaic and has a severity considered necessary for representations intended to be passed down to posterity.

207

facing each other, guardian bulls, military parades, stylized cypresses and so on from the art of Sumeria, Assyria and Babylon. The monumental complex on the terrace had to represent the center of the empire, the symbol of the power of the king as mediator and interpreter of the god Ahura Mazda, supreme divinity, who incarnated the principle of good in his fight with other, opposing gods which represented evil. The symbolic and magical nature of the reliefs and motifs shown throughout this complex emphasize the importance of religion. The rosette decorations, the stepped battlements symbolizing the sacred mountain, source of fertility, the columns representing sacred palms and those of the Hall of the Hundred Columns, representing a sacred wood, the struggles between the lion and the bull, believed to have a zodiacal meaning linked to the changing seasons, show the continuing importance of ancient, naturalistic, polytheistic traditions based on adoration of the mountain, the bull and fertility amid a consolidated state religion.

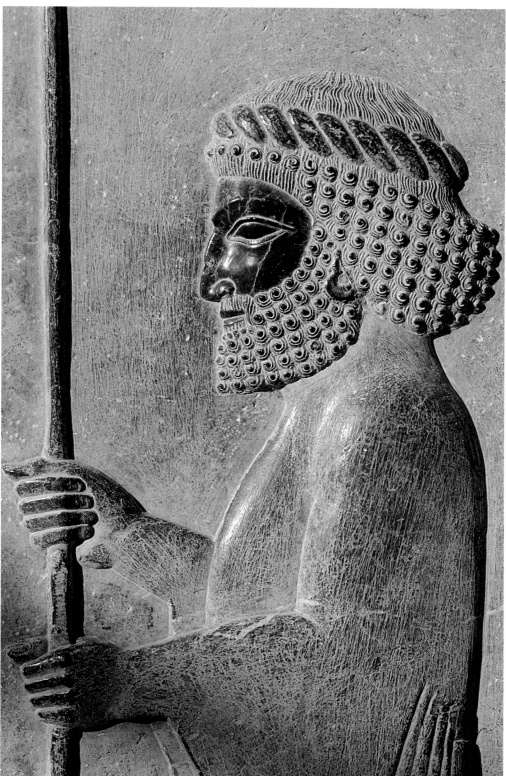

209 top right This head in lapis lazuli paste, found in Persopolis and probably produced there, can be considered a symbol of the ideal of youthful beauty in the Achemenidean court.

209 center right Basically, Achemenidean art is designed as a means of ornamentation. It therefore repeats objects over and over without concerning itself with the risk of monotony.

209 bottom right Although Achemenidean art has been accused of copying the styles of the people they conquered or other nations such as Egypt, Babylon and Greece, therefore making it an art with no roots or evolution, it can surprise. Remarkable plastic solutions, lightness of anatomical details, and a sense of composed dignity are part of this.

208 The portraits in Persepolis show few traces of realism. The figures, whether servants or royal guards as shown here, have the same globular eyes, the same long thin eyebrows, the

same curls of hair and beards, the same solemn expressions. They all are part of the desire to make art serve power, even at the cost of making it pompous.

209 left As in this relief showing a royal guard, the many works of art in the sumptuous decorations of Persepolis were designed and executed exclusively to glorify the "king of kings".

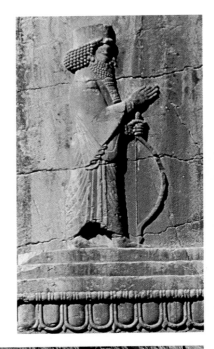

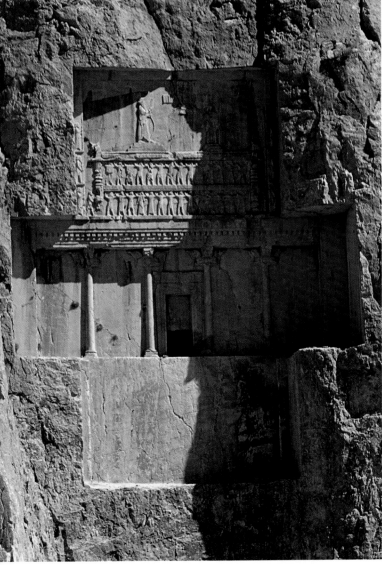

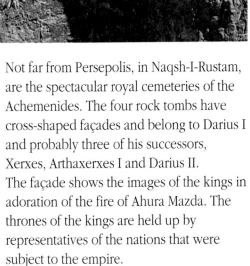

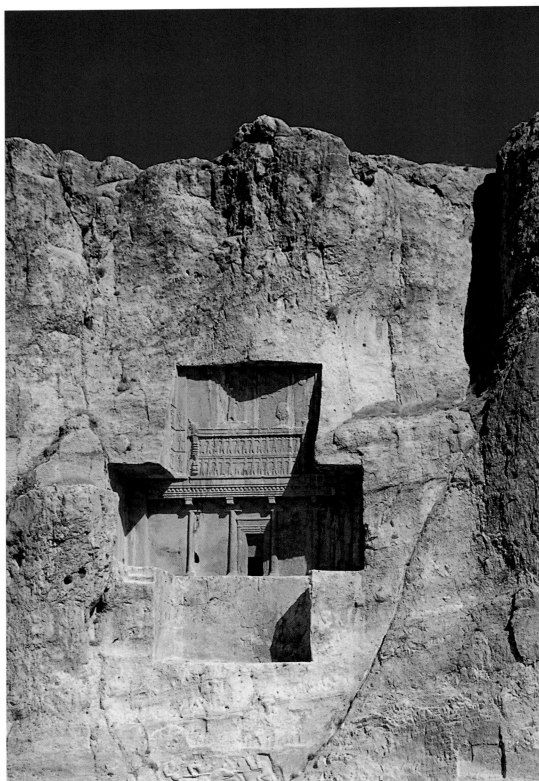

Not far from Persepolis, in Naqsh-I-Rustam, are the spectacular royal cemeteries of the Achemenides. The four rock tombs have cross-shaped façades and belong to Darius I and probably three of his successors, Xerxes, Arthaxerxes I and Darius II. The façade shows the images of the kings in adoration of the fire of Ahura Mazda. The thrones of the kings are held up by representatives of the nations that were subject to the empire.

The Sassanide rulers decided to emphasize their link with the ancient empire by carving some of the most famous reliefs of the time beneath the tombs of the Achemenidean kings. These include the investiture of Ardeshir (224-240 AD), a battle fought by Bahram IV (388-399 AD), or perhaps by Hormuzd II (302-309 AD), and the famous scene of the submission of the Romans, in which two figures, probably the emperor Valerian and Philip of Arabia bow humbly

before the horses of Shahpur I (240-272). Below the tombs and the Sassanide reliefs below is a tower popularly called Kaaba-I Zardust, or the Cube of Arathustra, perhaps an Achemenidean funerary temple dedicated to the royal cult. Other royal tombs dug from the rock appear near the terrace of Persepolis to the east, and have been attributed to Arthaxerxes II and Arthaxerxes III (405-361 and 361-338 BC).

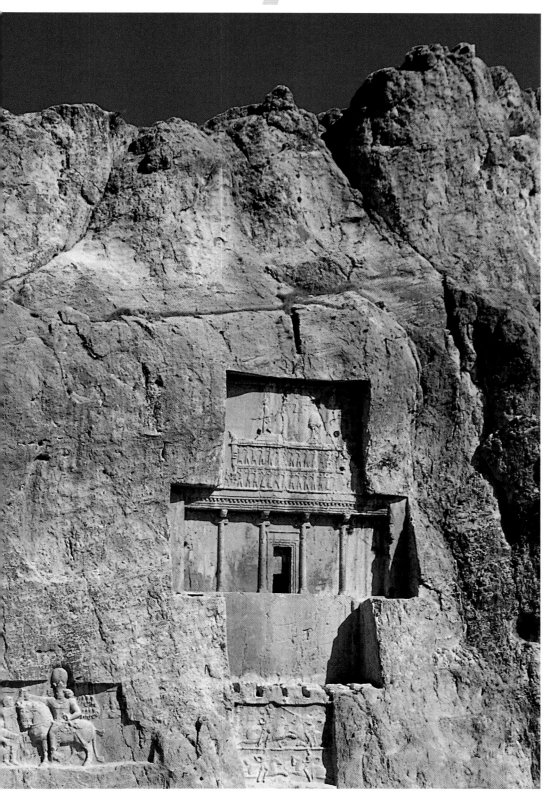

210-211 Beneath the Achemenidean tombs, the rulers of the Sassanide dynasty, founded by Ardashir I in 224 AD, had huge bas-reliefs sculpted to bear witness to their deeds. The selection of the site was highly symbolic, as it emphasized the continuity of Persian Imperial power.

211 top At Naqsh-i-Rustam are the tombs of Darius, Xerxes, Arthaxerxes I and Darius II, but the last three Achemenidean rulers preferred to be buried near the terrace of Persepolis.

211 bottom Beneath the tomb of Xerxes, a Sassanide relief shows Hurmuzd II defeating an enemy.

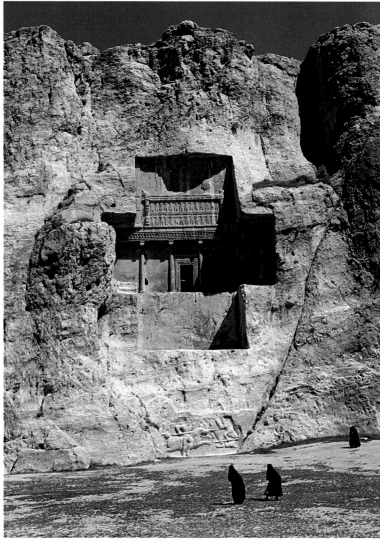

210 About six miles from Persepolis is the rock of Naqsh-i-Rustam, the site chosen by four Achemenidean rulers for their inaccessible rock tombs. Each of these was modeled on the tomb of Darius I and has a cross-shaped façade showing a stylized palace, surmounted by an enormous bas-relief throne,

held up, as always, by the representatives of the nations forming the Persian empire. Above, we see the king (detail above) before Ahura Mazda, the great god of the Persians. At the center of the colonnade is the entrance to the burial chamber, which is dug out of the rock.

211

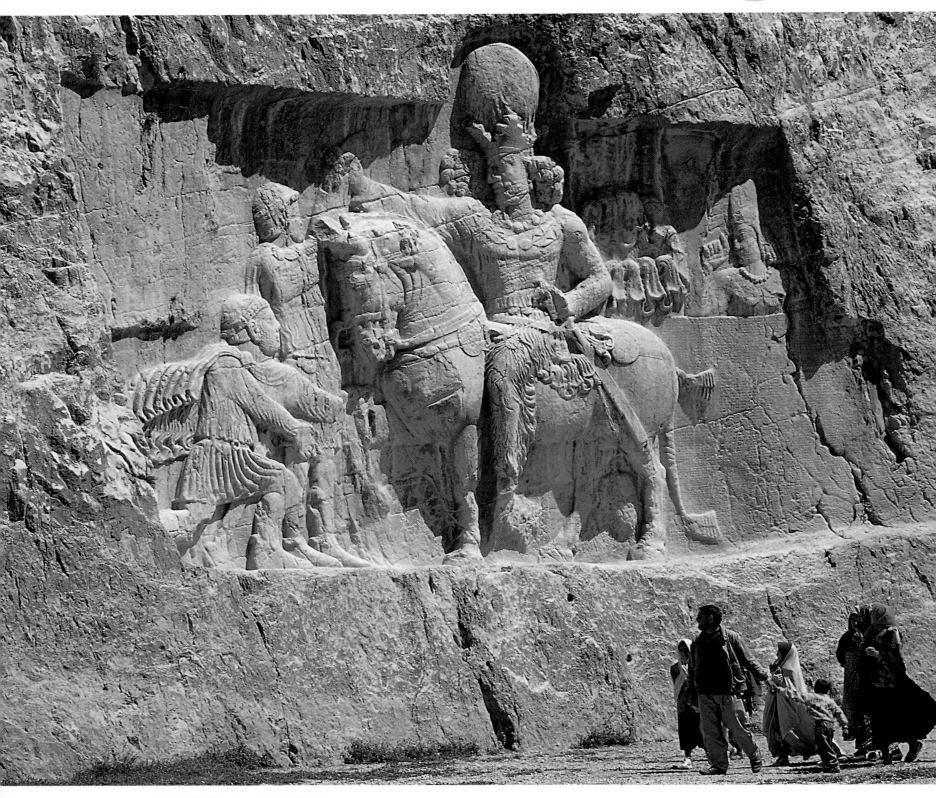

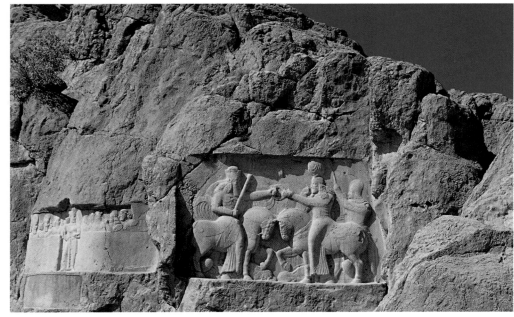

212-213 The best known
Sassanide relief in Naqsh-i-
Rustam, sculpted near the tomb
of Darius I, shows the triumph
of King Shapur I over the Roman
emperors Philip the Arab in 244
and Valerian, defeated in the
battle of Edessa in 260. A long
inscription on the right celebrates
the king's victories.

212 bottom This relief shows the
investiture of Ardashir I, founder
of the Sassanide dynasty. The
king, to the left, receives the royal
crown from the god Ahura
Mazda, on horseback. These
symbols appeared throughout the
3rd century and were often used
by successors to the king on the
rock walls of Naqsh-i-Rustam.

213 left The Achemenidean rock
tombs of Naqsh-i-Rustam have
identical cross-shaped façades
just over 72 feet high. The door is
framed by columns with ram-
headed decorations. Inside, each
tomb contains a number of
chambers cut out of the rock
designed to hold the royal
sarcophagus and the burial
treasure, stolen many years ago.
In the tomb of Darius I the rooms
have sloping roofs.

213 right Sassanide sculpture
was still of high quality under
Bahram II (276-293) when the
range of subjects covered was
enlarged to include more than
investitures and military
victories. There is, for instance, a
monumental bas-relief showing
the king from the front with his
head in profile and his hands on
the hilt of a sword while he
receives homage from the court.
The same ruler is shown in
another relief beneath the tomb of
Darius I, portraying two duels on
horseback.

SANCHI, CENTER OF THE WORLD

214 left The voluptuous figure of a shalabhanjika, a tree nymph also known as yakshi, juts out dramatically from the side and the eastern portal of the main stupa. This dryad symbolizes the fertility of the earth and the vital sap of the trees as well as the Indian ideal of female beauty while suggesting in esoteric and subtle ways the sweep of consciousness that leads to enlightenment. This motif is also repeated in reduced dimensions as the element between the beams.

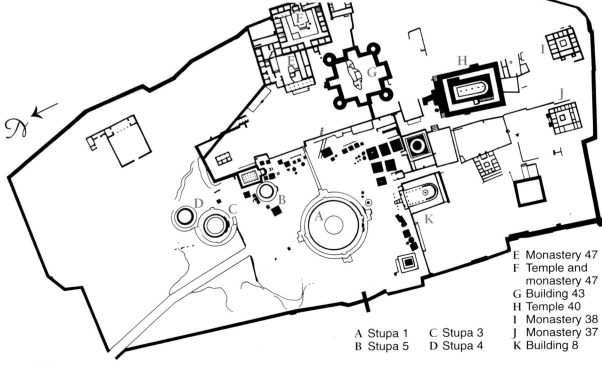

E Monastery 47
F Temple and
 monastery 47
G Building 43
H Temple 40
I Monastery 38
J Monastery 37
K Building 8

A Stupa 1 C Stupa 3
B Stupa 5 D Stupa 4

The most significant feature of Buddhist architecture is the *stupa*, a reliquary or place to hold sacred remains, derived from the ancient burial mound. After the cremation of Buddha, his remains were divided up among the most important warrior tribes that had taken part in the funeral rites and, it is said, that the first ten stupas were built over these sacred remains. In the state of Madhya Pradesh, about 28 miles from the capital Bhopal, is the best conserved stupa complex in all India, Sanchi. Sanchi is at the junction of two rivers, in an idyllic spot perfectly suited to the monastic life, and near the prosperous trading town of Vidisha on a caravan route. Founded during the reign of Ashoka, a great Buddhist emperor of the 3rd century BC, the site remained important up to the 13th century, when the

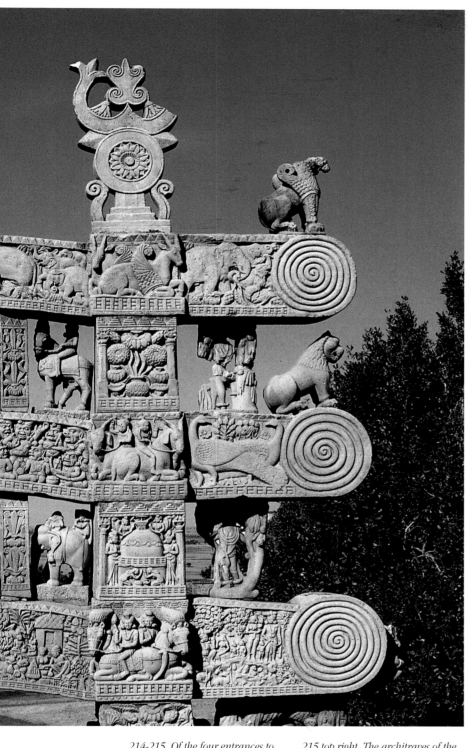

general decline of Buddhism in favor of Hinduism caused it to fall into decay.

The site on the hill was almost forgotten, only to be discovered by mere chance by a General Taylor in 1818. The buildings were still intact, but the area would soon be devastated by amateur archaeologists and treasure hunters. In 1881, Major Cole began proper restoration work which was continued by John Marshall, head of the Department of Archaeology from 1912 to 1919. Over 50 monuments in Sanchi were numbered by Marshall which can be divided into two groups, those at the summit of the hill and those lower down, on the western slope. The main stupa, which currently has a diameter of 122 feet and a height of 56 feet plus an additional 56 feet if we include the series of parasols, incorporates a smaller building in baked brick and mortar, attributed to Ashoka. In the 2nd century BC the building was reconstructed and enlarged with a surrounding wall of blocks in the local sandstone, covered with a thick coating of plaster and given an addition in the form of the terrace at the base with its double access staircase, the balustrades, the corridor and the *harmika* in the form of a reliquary.

215 bottom right The toranas, the splendid portals of Sanchi, are two tiled pillars into which the triple architrave is set. These are supported by elephants in the northern and eastern toranas and by yakshas, pot-bellied good luck genies, in the west and lions in the south, as shown here. The inscription states that they were crafted by ivory carvers of Vidisha as a celebration of the Shakya, the warrior tribe of the Buddha.

214-215 Of the four entrances to the main stupa in Sanchi, the best preserved is the northern one. The first architrave shows a scene from the Jatakas, the collections of the earlier lives of the Buddha, and the Enlightened One appears there in the form of the generous Prince Vessantara. In the second architrave is the temptation of Mara, god of love and death, who clashed with the Buddha, shown symbolically on the left in the form of the tree of enlightenment. In the final architrave there is another episode from the Jakatas, with the Buddha appearing as a six-tusked elephant.

215 top right The architraves of the toranas are separated by four cubic blocks and a double row of riders on horses and elephants, interspersed with small columns with floral symbols. Sanchi stood near the ancient Vidisha, a prosperous caravan town, and it is therefore probable that the rider motif is a celebration of the mercantile world.

215 center right Sanchi is not linked with episodes from the life of the Buddha, but is connected with Mahendra, an historic figure who spread the message of the Enlightened One to Sri Lanka. He was apparently the son of the great emperor Ashoka, patron of Buddhism, and Queen Devi, born into a family of rich Vidisha merchants.

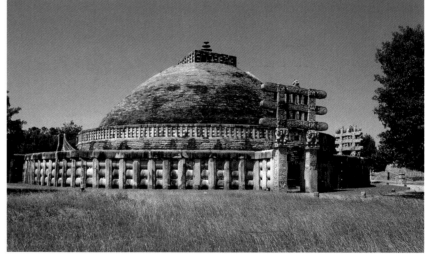

At the base of the structure is a precise set of cosmic symbols. These include the high circular base or *medhi*, representing the earth, with the cupola body or *anda* above it representing the heavens. The square platform with balustrade, or harmika, that tops the structure represents the mythical cosmic mountain at the center of the universe, while the world beyond, hidden, the domain of the ultimate truth, is symbolized by the central pillar, or *chattravali*, the pivot around which the stupa rotates, compacting itself like a three-dimensional spiral. This element is formed by three parasols and celebrates the three jewels or aspects of Buddhism which are Buddha the Enlightened One, the Sangha or the Community, and the Dharma, or the Doctrine. The cosmic mountain, the axis of the universe, the world's umbilicus, stands in the form of the stupa for the totality of Being and, therefore, the Buddha himself.

Around the stupa is a stone enclosure or *vedika*, which marks off space set aside for holy processions, known as the *pradakshina* and a central rite in Buddhism. The processions take place with the object of worship always on the right of the walkers. The vedika extends to the four points of the globe, with projecting bodies ending in splendid portals, the *toranas*, topped by a triple architrave and built in the 1st century AD. The heart of the stupa is the reliquary, which may or may not be housed in a special chamber at the center of the anda, while the toranas are arranged on the arms of a cross that extends outward from the center, emphasizing the concept of cosmic and, above all, doctrinal rays, in the sense that the Buddha's message, since his stone body is the stupa itself, extends out to every corner of the universe. There are no images of Siddhartha, the historic Buddha, on the portals of Sanchi.

Sanchi

Sanchi

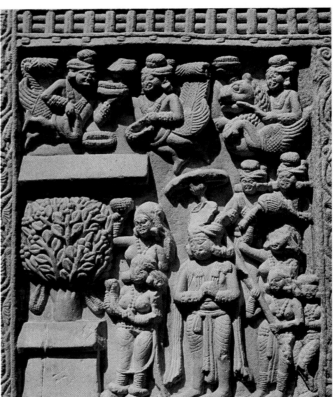

216 *The pillars of the toranas show the main events in the life of the Buddha and the stories of his previous lives.*
A panel on the left shows a scene from a hunt, the favourite pastime of nobles during that period.
In the top right we see the Buddha's conversion of three hermits, the Kashyapa brothers, followed by their disciples.
In the bottom right, a prince, recognised by his parasol (a symbol of royalty), has garlands of flowers placed by his handmaidens on the bodhi tree, or ficus religiosa, under which Siddhartha Gautama achieved enlightenment.

217 *After his enlightenment, Buddha was not sure whether or not to preach the doctrine that had led him to supreme knowledge. He realized it was difficult to communicate such an intangible experience to others. It was the gods themselves who asked him to teach humanity the way to salvation and they persuaded him to do so. The second panel in the southern pillar of the western torana is a reminder of this event, known as adhyeshana. The Buddha is never shown in human form in Sanchi, but always by symbols. Here he is symbolized by the tree of enlightenment surrounded by flying genies, with the procession of the gods below.*

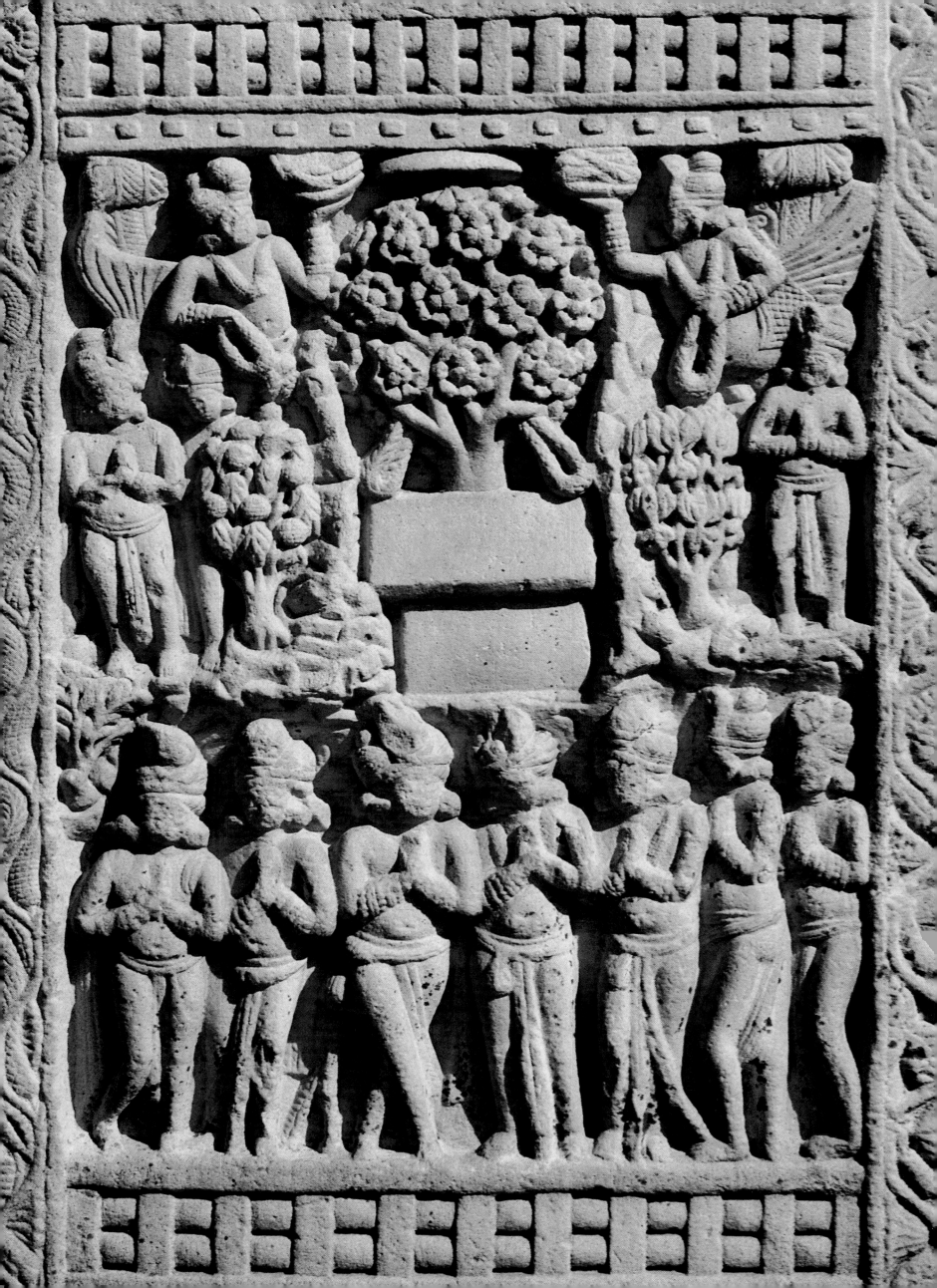

218 top right *Stupa number 2 stands on an artificial terrace over 1,000 feet below the summit of the hill and its older parts can probably be dated to the 2nd century BC. Although there is no torana, the balustrade is beautifully decorated with splendid floral and animal groups. The chamber where the reliquaries were placed, in the west rather than in the more usual central position, contained a sandstone reliquary with the remains of at least three generations of Buddhist teachers, confirming the theory that the stupa had been used as a burial tabernacle.*

218 bottom right Stupa number 3, built in the 2nd century BC and therefore contemporary with the greater one, has a single portal which was probably built by the corporations of carvers, ivory workers and jewelers in the 1st century AD, like the toranas of the great stupa. Although the work may be less elegant, this stupa is of great importance as this was where the remains of two Buddhist saints were found, Shariputra and Mangdalyayana, contained in two sarcophaguses in the chamber of the reliquaries. All around are the remains of other stupas of various sizes, built as votive offerings by the pilgrims.

218 top left The architectural complex of Sanchi contained various other buildings as well as the stupas, such as temples and monasteries. In this photograph, we see part of temple 45 with its monastery annex, dated to the 7th-8th centuries AD but rebuilt in the 9th-10th.

The followers of Hinayana, the oldest form of Buddhism, looked upon him as the supreme enlightened master, and within the bas-reliefs he is seen only through symbols, each connected in some way with specific events in his existence. The creative skill of the artists did find great inspiration in the *Jatakas*, the literary collections of the prior lives of the Buddha, in which he often appeared in the form of an animal. The structure of the toranas consists of two pillars surmounted by four lions, elephants and *yakshas*, plump tree genies which hold up three curved architraves ending in spirals and separated from each other by square blocks and rows of riders on elephants and horses. Jutting outward from the jamb toward the spiral of the first architrave are delightful figures of the yakshis enriching the entire effect. The final architrave is topped by the remains of the wheel of law flanked by two fan-bearers and two *triatnas*, the triple jewel motif of Buddhism. Smaller and simpler, the nearby stupa number 3, built at the same time as the great one, is preceded by a single portal, while stupa number 2, built on an artificial terrace below the top of the hill, has no torana although its balustrade is decorated with splendid medallions.

218 bottom left Temple number 17 is a typical example of the Gupta architecture of the 5th century AD. It is in hall form, with a portico in front supported by four pillars and a flat roof. It is one of the oldest temple prototypes.

219 *The stone balustrade of stupa number 2 is enriched by these outstanding medallions. In this picture Gajalakshmi, a special version of Lakshmi, goddess of fertility and beauty and wife of Vishnu, god of the conservation of life, is bathed by two elephants symbolizing the earth being freshened by the rain.*

MAMALLIPURAM
AND THE MINIATURE
TEMPLES

220 top In this detail we see the god Shiva, who made the River Ganges, the mythical goddess Ganga, come down to Earth.

220-221 Beside the rock of the Descent to the Ganges is the Mandapa of the Five Pandavas, the mythical brothers from the great epic poem the Mahabharata. The manapa, or pavilion or place of worship, is preceded by columns of lions, symbol of the Pallava kings.

The site of Mamallipuram also known as Mahabalipuram, in what is now India was known to the Ancient Greeks and visited by the Romans. Between the 7th and 8th centuries AD this became the main port of the Pallava dynasty. The name of Mamallipuram means City of Malla, a name which refers to one of the titles of Narasimhavarman I, one of the most important Pallava sovereigns who reigned from 630 to 670 AD. The closest town is Madras, capital of the state of Tamil Nadu, about 20 miles away.

221 top Within the mystical geography of India where stones, trees, caves and mountains all stand for the divine, the River Ganges holds the key role. The main artery of the sub-continent, Ganga Ma, or Mother Ganges, the goddess who came down from heavy to bless the Earth, is celebrated in a grandiose bas-relief carved from the rock at Mamallipuram.

221 center The myth says that 60,000 young sons of King Sagara were killed and cursed by an enemy. Their salvation was accomplished by a descendent, Bhagiratha, who persuaded Ganga to come down to Earth and purify their remains.

221 bottom At the right to the Descent to the Granges is this realistic group of three granite monkeys. The male is removing fleas from the female who is feeding the baby.

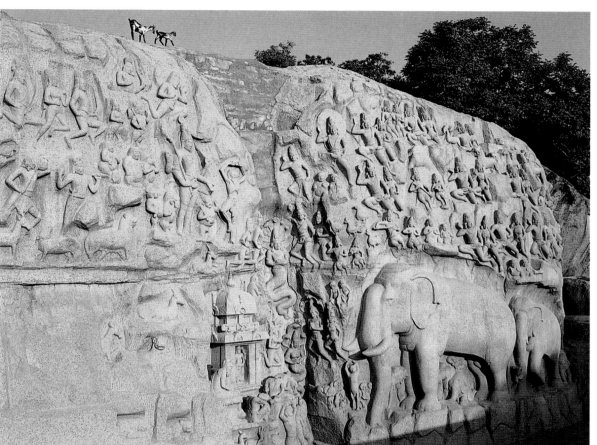

The archaeological complexes are divided into three groups. These are the monumental reliefs of the *Descent of the Ganges*, with a series of pictures sculptured in an enormous spur of diorite, the complex of the five *rathas*, about 500 yards further south, and the so-called "Temple of the Bank."

Facing eastward, the 90 by 25 foot *Descent of the Ganges* panel has been dated to the middle of the 7th century AD and contains a powerful stone fresco believed by many experts to tell of the mythical descent of the Ganges to the earth, although other scholars believe it shows the penitence of Arjuna, one of the five heroes of the great epic poem *Mahabharata*, in order to obtain invincible weapons from the god Shiva. Nevertheless, the theory that the bas-relief is a celebration of India's holiest river is probably the most commonly believed one. The rock is, in fact, split at the center and a tank which was originally at the top of the spur made it possible for a stream of water

to flow along the panel and collect in a small basin in front, in an obvious reference to a river.

The myth, which can be found in many classical texts, tells that the divine river Ganges was only persuaded to descend to earth by the strict penitence of the holy man Bhagiratha who wanted to remove a curse from his ancestors.

Crowded with figures, the Descent of the Ganges shows scenes of idyllic life in the woods with hunters, hermits, local inhabitants and wild animals in various poses. The scene is dominated by the court of the gods with the beautiful nymphs, the magic spirits of the air, the half-animal celestial musicians, and many other mythical figures watching. Baghirata is shown in the yoga position representing the tree, on one leg with his arms raised upward. In the split along which the water flowed are the sinuous *nagas* with their spouses, the *naginas*, part human and part serpent and connected with water, fertility and knowledge. Beside them, a girl is drying her long hair by twisting it gracefully in a movement still seen among Indian women. The wild animals are illustrated with a vivid freshness. A young elephant holds its mother's tail with its trunk, and an antelope crouching on the ground scratches its nose with its leg.

Among the many monuments scattered around the *Descent of the Ganges* are rocky sanctuaries dug out into caves or beneath overhanging rocks which house splendid reliefs. Balconies and columns are often held up by lions, the symbol of the warlike Pallava dynasty. Among the most important is the *Grotto of the Five Pallavas, The Mandapa of Varaha*, which contains an image of the god Vishnu as a varaha, the boar that freed the goddess Earth from the muddy ocean bed, *The Mandapa of Krishna*, another image of Vishnu, *The Mandapa of Mahishasuramardini* dedicated to Durga as the killer of the buffalo-demon Mahisha, and *The Grotto of the Tigers*, with animal heads carved from the rock.

To the south is the famous group of five monolithic temples in the form of wooden ceremonial carriages of a design which is still used today to carry the images of the gods when they are moved from the temples.

Sculpted around the middle of the 7th century from the diorite blocks emerging from the beach, it has been suggested that these temples may be test pieces for a local school of architecture or votive offerings. They are completely unique in the history of Indian art and not completely finished. They have been given the names of the heroes of the *Mahabharata*, the great epic poem that describes the positive forces of the gods against the demons, all incarnated on the earth.

Draupadi is the wife of all five Pandavas, the champions of good, and gives her name to the smallest of the temples, which was probably dedicated to the goddess Durga.

222 bottom center This view shows the main panel of the Mandapa of Krishnu, in which the god raises the mountain Govardhana and uses it as a shelter to protect the local shepherds from the flood released by the god Indra.

222 bottom In this scene of the Mandapa of Mahishasuramardini, Vishnu is shown asleep on the serpent Ananta at the moment between the end of one universe and the birth of another. The Indian vision of time is cyclical and worlds originate and dissolve continuously.

222-223 In the Hindu world there is one Divine Being projected into an infinity of forms that perform specific functions. At the summit of this pantheon is the Trimurti, the Triple Image of Brahma, who begins the universe, Vishnu who preserves it, and Shiva who dissolves it. In the Mandapa of Varaha, Vishnu is shown in one of these persona as a wild boar. In this form the god saved the Earth when it was held prisoner by the Ocean and restored it to man.

223 bottom The Mandapa of Mahishasuramardini is dedicated to the goddess Durga, warlike wife of the god Shiva, celebrated in this case as "She who kills the demon Mahisha" who took the form of a buffalo. The many arms symbolize her great strength.

223

224-225 The five rathas grouped in the southern part of Mamallipuram, although not completely finished, were given the names of heroes of the Mahabharata, the great Hindu epic poem, said to be of Indo-European origins, which depicts the conflict between gods and demons. In the photograph, from left to right, are the Dharmaraja dedicated to Yudhisthira, the Bhima, the Arjuna and the ratha of Draupadi, the common wife of the five brothers, with the bull Nandin, the mount of Shiva.

This temple is a stone reproduction of the hut of an ascetic, taking the form of a simple square room with a straw roof and wooden decorations at the edges. An access stairway leads to the entrance, flanked by two guardians and topped by an architrave with motifs showing mythical sea creatures which are also shown above the niches containing statues of the goddess on the other three walls. The bull Nandi, the mount of the god Shiva, consort of Durga, and the lion carriage of the goddess are sculpted alongside.

The next temple is named after Arjuna, the great horseman, and is probably dedicated to the ancient god Indra, who is shown on his elephant on a base supported by lions and elephants. It has an entrance portico and two lion columns. The other three walls are divided into five panels with various statues, including pairs of lovers. On a ledge decorated with small horseshoe-shaped arches containing laughing faces an upper section, pyramid shaped, is in two levels, bordered by miniature pavilions ending in an octagonal cupola.

The third temple is named for the Herculean-like warrior Bhima. It has a rectangular base and is surrounded by a partly colonnaded verandah held up by lions with a row of pavilions and a vaulted roof, a style borrowed from both Buddhist and secular architecture.

The Dharmaraja temple, linked to Yudhishthira, an extremely just and pious king, bears an inscription dating it to the reign of Narasimhavarman I (630-670 AD) who dedicated it to Shiva.

It is the highest of the group and rests on a particularly interesting base with a square

is *The Temple of the Bank*, erected on behalf of Marasimhavarman II Rajasimha who reigned between 690 and 728 AD. It stands alone on the beach and is dedicated to Shiva. This temple was known to sailors as a lighthouse and was mentioned by the Italian Gasparo Balbi in 1582. It was also written about in the 17th century by Nicolò Mannucci, but the first detailed description was in the book *Asiatic Researches*.

The temple, preceded by a small entrance, is divided into two square structures each topped by a pyramid shaped tower offering protection to the inner cells which later became typical of Dravidic architecture in southern India. The *vimana* has a triangular profile imitating the peaks of the soaring mountain, the mythical Mount Meru, the central axis around which the universe rotates in a well-ordered fashion.

The vimanas of the Temple of the Bank have three and four open floors each. The first and last of these are decorated with heraldic animals and have none of the rows of miniature pavilions that are found on the intermediate floors.

There are three inner sections although one is no longer covered. Shiva, his consort Uma and son Skanda occupy the first of these while in the second Vishnu rests on the primordial ocean.

A narrow passageway runs between the walls of the internal enclosure of the temple which is within a wider enclosure, surrounded by a low wall topped by various decorations including a statue of Durga riding a lion.

224 bottom left The ratha of the twin warriors Nahula and Sahadeva from the 7th century was built in the apsed "elephant's back" style.

224 bottom right Behind the lion, the mount of the goddess Durga, we can see the ratha of Draupadi consecrated to the goddess in effigies in the wall niches and that of Arjuna, the most famous of the five Pandava heroes. We still do not know whether the miniature temples were models or votive offerings.

225 left The Temple of the Bank, built on behalf of Narasimhavarman II, who reigned from 690 to 728, is dedicated to Shiva and divided into two sections with square plans, both topped by vimanas, the pyramid-shaped tower that protects the sanctuary.

225 right The walls of the rathas incorporate many figures from the Hindu pantheon, framed by pillars. Two of these figures appear in the photograph.

plan, preceded by a portico with lion columns.

Built on three floors, it is somewhat similar to the Arjuna model, with the same pyramid shaped structure with ledges separating the various levels and forming the base for rows of miniature pavilions. An octagonal cupola puts the final touch to the building. Statues of deities are found on the walls of the various floors.

The final temple is that of the warrior twins Nahula and Sahadeva. This is relatively small and has a portico held up by lions. The last great masterpiece of Mamallipuram

AJANTA, THE GROTTOES OF THE BUDDHA

The map shows the conventional numbering of the caves of Ajanta, where numbers 9, 10, 19 and 26 are *chaityas*, or places of worship, while the others are *viharas*, or monasteries.

Ajanta is in the central Deccan, in the state of Maharashtra in India, 60 miles from the town of Jalgoan and about 110 from Aurangabad. It consists of a series of 30 caves excavated at various levels in a rocky amphitheater 80 yards high and facing the bed of the Waghora River. It has been a sacred place for thousands of years. It is considered one of the most idyllic settings in the world and was chosen by Buddhist monks as a place of retreat during the monsoon season when other places were uninhabitable. The grottoes extend for over half a mile. Each one was once connected to the river by stone or wooden steps and are now connected by a concrete path. The grottoes, or caves, have been numbered. Numbers 9, 10, 19, 26 and 29 are *chaityas* or places for worship, while the others are *viharas* or *sangharamas*, monasteries where the monks can live. The chaityas can be recognized by their imposing façades. These are always dominated by a gable which includes a horseshoe-shaped opening, called the *kudu*, above the entrance door. This sometimes has an arch with two columns supporting it in front of it.

226

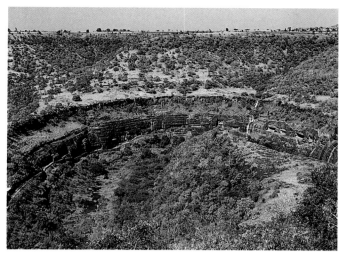

226 left The chaitja of cave number 26, with three naves, the main one topped by a ribbed, vaulted ceiling, has columns close together ending in a figured capital upon which rests a rich entablature. In the apsed section, the stupa acts as a tabernacle. The design comes from the funeral mounds raised over the cremated remains of the Buddha, which later became a symbol of the cosmos with the Enlightened One as the center point that creates order.

226-227 The statue of Ajanta shows the Buddha in various postures related to important moments in his life. In cave number 26, which is used as a chaitya, the Enlightened One is shown at the point of transition. Aware that his earthly cycle is now ending, the Buddha lies down on his side between two trees, his head resting in his hand and pointing to the north. He is ready to accept nirvana, the state when the cycle of reincarnation and pain is over.

227 top left This is an overall view of the 30 grottoes of Ajanta, dug out of the rocky amphitheater created by the stream Waghora. The caves are partly chaityas, places of worship housing the stupa, the symbol of the Buddha and his doctrine, and partly vihara, the residences of the monks. The caves were dug out in two stages, first between the 2nd and 1st centuries BC and secondly, at the height of Ajanta's importance, in the second half of the 5th century AD.

227 top right One of the most significant examples of a chaitya is cave number 19, attributed to the second period of Ajanta. The entrance is preceded by an elegantly sculpted two-column portico, topped by a double cornice. The kudu, or horseshoe shaped opening, lights the interior. As well as the many figures of Buddha on the façade, there are other Buddhist figures, such as the two yakshas, the pot-bellied genies associated with the concept of fertility and wealth.

227 bottom right Cave number 1 shows the artistic maturity reached in the central stage of Ajanta. The verandah is decorated with splendid columns which have finely decorated stems and capitals crowded with figures. The diversity in the decoration of the pillars directs the eyes to the center of the face of the building, inviting the viewer to enter the antechamber. The sides of the verandah extend into two lateral, raised, colonnaded bodies leading to other areas.

228 The female figures are among the most fascinating motifs of Ajanta. They include servants, princesses and celestial nymphs, all with opulent sinuous richly jeweled forms. The half-closed, elongated eyes, full lips, bodies almost bent by the weight of the breasts, all suggest a sensuality which contrasts with the location, cave number 1, a 5th century AD vihara. And yet it is the attraction of the worldly that highlights the greatness of the ascetic choice.

228-229 In the first centuries of Buddhism, the so-called period of the Hinayana or the "small vehicle of salvation", the Buddha is represented only by symbols, never as a man. It is only with the advent of the Mahayana, "the great vehicle", which reinterprets the message of the Enlightened One in metaphysical and devotional terms, that the Buddha begins to be shown with human features. In Ajanta it is the Mahayana that gave the artists their greatest inspiration. In cave number 2 the image of the Thousand Buddhas in the teaching position offers a glorious dimension of the historic body of the Enlightened One and projects it into the infinite figures that every devotee creates of his Lord.

229 bottom Cave number 2, as well as containing splendid cycles of paintings, is one of the most important examples of a vihara. It consists of a great central hall with twelve pillars each with sixteen or thirty-two faces covered with a flat ceiling painted with beautiful circular motifs. This houses the cells of the monks alternating with sacristies. In the main hall, preceded by the vestibule of the Thousand Buddhas, is the image of the Enlightened One preaching as can be seen from his hands, which are placed against his chest with the rounded fingers of one touching the outstretched fingers of the other.

Façades from later periods will have figures of the Buddha in various positions and heights and other figures related to Buddhism. The interior is generally rectangular with three naves separated by purely decorative columns placed very close together.

The central nave is twice as wide as the other two, and has an apse and a reverse keel-shaped ceiling, while the side naves are lower and have either semi-vaulted or flat ceilings. The center of the apse, lit by light coming in from the kudu, is dominated by a stupa, a bell-shaped reliquary. This shape comes from the tumulus which was built on top of the remains from the cremation of the Buddha. This tumulus later became a major symbol in the religion, a place where a ritual procession called the *pradakshina*, in which the monks walked around it clockwise, took place. The *viharas*, or the residential buildings, consist of a large central hall with pillars covered by a flat, paneled ceiling. The monks' cells are placed along three sides of this. They are small openings dug out of the bare rock. In some cases there is a shrine with the stupa in the wall opposite the entrance. In the most recently built viharas there is often also a figure of the Buddha. The entrance to the hall may have a columned verandah opening onto the façade through one or two entrances which are richly decorated with interwoven patterns that imitate wood carvings.

The excavation of the stone that created these grottoes in Ajanta took place during two main periods, the first between the 2nd and 1st centuries BC and the second starting four hundred years later. Excavation initially stopped during the time of the local Vakataka dynasty with the second phase reaching its height in the latter half of the 5th century AD. The dates have been established by the study of the numerous inscriptions, the comparison of the statues and paintings with similar examples which had previously been dated, the study of the subjects depicted and their relationship with the development of Buddhism, and finally by analysis of the paintings and drawings using modern techniques. For over a thousand years the grottoes of Ajanta were forgotten by the world. They were only rediscovered in 1819 by John Smith, a British soldier who found

them while on a tiger hunt.

The first, rather clumsy attempts to restore the grottoes, were carried out in 1875 using yellow paint. Between 1930 and 1955 more sophisticated work was done through the archaeological center at Hyderabad.

Some rooms which are still uncompleted make it possible to understand how the grottoes were created. The work began from the top and the ceiling was the first part to be finished. Working without scaffolding, the workers gradually removed the stone with picks, leaving on the site the blocks that would be used for the columns. These columns are extremely sophisticated with some of them having as many as sixty-four sides. The floor was the last part to be finished.

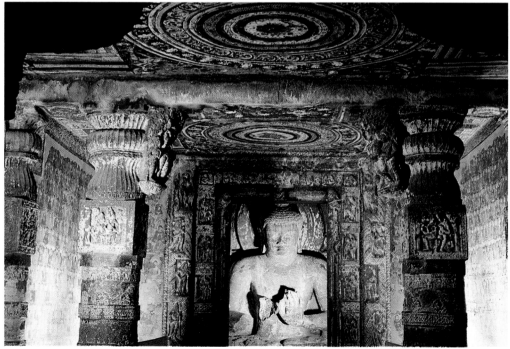

230 top This detail shows the great ability of the painter in depicting the emotions of lovers, including reluctance, passion, jealousy and cooling, shown with a subtle liveliness. The artists of Ajanta never indulged in pathos, agitation or any other emotion that could have disturbed the harmony. Desperation is softened into sadness, the exhaustion of life into melancholy. Although the painter shows these emotions in great detail he is not a realist and his main objective is to evoke a state of mind that leads to a spiritual dimension.

230 center In the ceiling of the entrance hall to cave number 17, contemporary with numbers 1, 2 and 16 in the golden period of Ajanta, the 5th century AD, two heavenly beings unite by joining their forearms and hands. This is actually an optical illusion. Only one arm links the two figures and this can be seen as belonging to either one or the other of the figures. This is a common expedient of painters of decorated motifs, using a single part of the body and making it common to more than one figure, such as four gazelles in a cross formation with a single head in the center.

It seems clear that several groups of craftsmen worked at the same time on finishing these caves, including the stucco work and the painting. The first part to be completed was the façade with the verandah when one was used, followed by the entrance hall, the main hall, the shrines and the cells.

Although the architecture and statues are of considerable importance, the grottoes of Ajanta are most famous for their wall paintings. By looking at grotto number 4, where the frescoes were left uncompleted, it is possible to understand the techniques used. The painting was applied after the wall had been made smooth with an inch or so layer of earth mixed with sand, shredded straw, other vegetable fibers and, in some cases, animal hair. This was left rough, apparently in order to give greater holding to the next layer,

which was made of a similar but finer paste. The third and final layer was a thin one of lime which was leveled out with a wooden spatula. In the next step the initial sketch was traced using hematite powder on the lime while it was still damp and then, after applying a white coating, tracing it again with cinnabar. The background wash for the parts of the drawing was then applied. The colors were always applied separately without one merging into another, apparently in an attempt to give the three-dimensional feeling of sculpture through tonal modeling. The nearer parts are darkened while the smooth and distant features are lightened.
Five basic colors were used, all of either mineral or vegetable origin. They were ochre red, ochre yellow, smoky black, lapis lazuli blue and white. The free contours were

accented in black or red with any final touching up apparently done in dry tempera. The surface was then polished with an agate or elephant's tooth so that the pressure of the polishing made the damp plaster, which was rich in limestone particles, come to the surface. When this thin layer crystallized it gave the paintings a brilliant, enamel-like effect. The most common subjects of the Ajanta frescoes are scenes inspired by the *Jatakas*, or accounts of the previous lives of the Buddha. These scenes are placed in a context showing the everyday life of the times in cities and villages, among both rich and poor. They show an amazing range of clothing, jewelry, objects, setting and characters which provide a rich source of both environmental and anthropological information about the times.

230 bottom Another view of the splendid vihara number 17 which combines the sacred and the profane most impressively. In the frieze immediately above the architrave are shown pairs of lovers in various poses, while the figures of the Buddha above show detachment from earthly pleasures. The knowledge of a precise, subtle body language combining dance, statues and painting enables the artist to create postures suggesting the emotions of the couples while the hand gestures of the Buddhas, standing for specific inner attitudes, show in the two to the sides the position for meditation and in the center the position for teaching.

230-231 A scene from vihara number 17 inspired by the Vessantara-jataka where the Buddha takes the form of an extremely handsome prince, here in an amorous position with his wife, while a servant offers them wine. On the left, continuing the tale, we see the princess again, surrounded by serving girls protecting her with a parasol. Her high rank is emphasized by her pale complexion, which indicates she lives sheltered from the sun. Her body is in the "triple bending" position with the head in line while the shoulders and hips arched in different directions, forming an S and creating a sensually sinuous effect.

PAGAN
BUDDHA'S
KINGDOM

■ Temple
● *Stupa*

A Site of the walled town
B Walls
C Ananda
D Shwegugyi
E Pahtothamya
F Mingalazedi
G Minkaba Kubyaukgyi

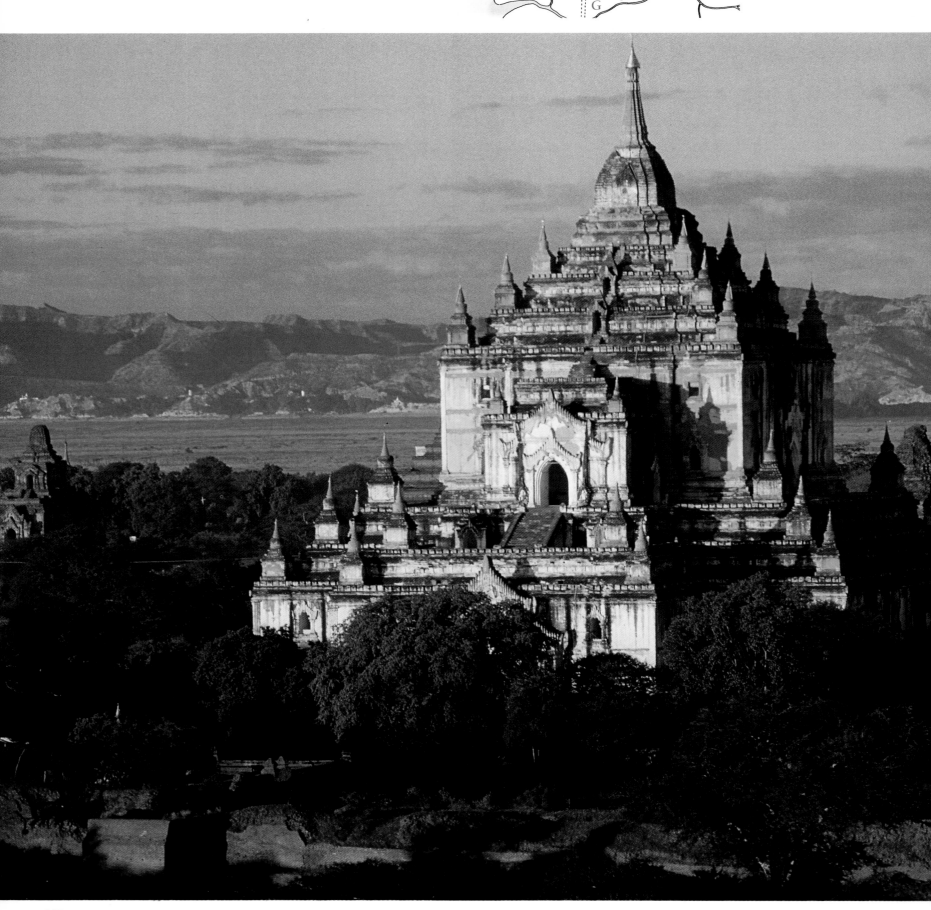

232-233 The Thatbyinnyu or Temple of the Omniscent is perhaps the last great work produced under Sithu I, whose reign from 1113 to 1155 was one of the finest periods for Pagan, its so-called "golden age". The building spreads vertically over five floors, ending in a shikhara, which is a typical arched covering of Indian origin.

233 top Pagan, one of the most important archaeological sites in Asia, stretches over an area of 80 square miles and contains a huge range of Buddhist monuments. The date of the foundation of the city is usually given as 874 AD but its origins are older. Its period of greatest splendor covers just over two centuries, from the reign of Anawrahta (1044-1077) to the final destruction by the Shan princes in 1299.

Known in the past as Arimaddanapura, "The City of the Destroyers of Enemies", or Tambadipa, "The Land of Copper", this place in Burma (now Myanmar) was known as Pagan at least by the end of the 12th century AD.

One of the most important archaeological sites in all of Asia, it covers an area of about 60 square miles. The date of the city's founding is usually given as 874 AD but its origins are undoubtedly earlier. It was at its greatest importance in a period of just over two centuries, from the reign of Anawrahta (1044-77 AD) to the final destruction by the Shan princes in 1299.

Marco Polo was the first western explorer to mention this city, after the troops of Kublai Khan raided it in 1287. In 1795 an English diplomat, Michael Symer, briefly mentioned it, but it was not until 1855 that the Scottish engineer, Henry Yule, recognized its enormous importance. Following surveys by several archaeologists and the sacking by the Shans, the British, who had taken over Burma in 1886, established the first systematic archaeological work and began deciphering inscriptions.

The great pioneer in establishing the importance of Pagan and its architecture

233 center This is the Sulamani, the Crowning Jewel, a typical example of a gu, or cave-temple consisting of an inaccessible center section containing reliquaries or images used as a sacristy, a vestibule and a corridor. It was built under Sithu II who ruled from 1174 to 1211. The pyramid shaped structure, in brick with stone reinforcements, was completed by a shikhara which has been destroyed. A splendid decorated stucco covers the walls of the monument.

233 bottom The corridor of the Sulamani contains several late paintings which take their inspiration from the image of the Buddha and his disciples, central themes of the Theravada or Doctrine of the Ancients that was prevalent in Pagan.

was Gordon Hannington Luce who, although not officially connected with the British department covering archaeology worked with it for several years after 1912 and prevented Pagan from being bombed during World War II.

A terrible earthquake in 1975 seriously affected the area and brought UNESCO to the scene.

The total number of monuments at Pagan has been estimated at around five thousand, but those in good condition are about one thousand or so, some still in use. These are from three periods, the original period, or 850 AD to 1120 AD, the intermediate years, from 1120 AD to 1170 AD, and the later period, from 1170 AD to 1300 AD.

This city was once a green area on the banks of the Irrawaddy, thanks to a highly

influenced by the Theravada monk Shin Arahan and had close links with Sri Linka, the stronghold of Theravada.

The marriage of King Kyanzitha (1084-1113 AD) to Abeyadana, a Bengalese princess and a follower of Mahayana Buddhism brought a whole new group of religious symbols to Pagan.

Brahmins were a significant part of the population and this is a further indication of both the religious tolerance and eclecticism of the city. These individuals, who knew sacred Hindu science and were important in court ceremonies, also favored the belief that the king was an incarnation of Vishnu, the providential aspect of the divine in the Hindu world. Another splendid period in the history of Pagan came during the reign of Sithu II (1173-1210 AD).

sophisticated irrigation system. Now it is one of the driest areas in Myanmar, or Burma.

None of the non-religious architecture remains as the houses and palaces and most of the monasteries and libraries were built in wood.

Chosen for its strategic position on the caravan routes between India and China, the city controlled a number of ports of tremendous commercial importance and was both famous and prosperous. When the Indian influence reached Indo-China, Pagan embraced Buddhism in the form of Theravada, or the so-called doctrine of the ancients.

This is the formula that is believed to be closest to the original message of the Buddha, sometimes called Hinayana which means "small vehicle of salvation."

The great King Anawrahta was highly

234 Local tradition tells that the king, who did not know which of his five sons to choose as his successor, placed the royal parasol, the hti, in the midst of them and this bent toward Nadaungmya, who reigned from that year, 1211, until 1230, under the name of Htilominlo. As a reminder of the event, he built a temple of the same name. The photograph shows the main entrance.

*235 left The Htilominlo is the great temple of Pagan.
The building, terminating in the shikhara, was originally painted white like all the temples of Pagan as this is the color of purity and transfiguration and then decorated with glazed green terra-cotta forms.*

235 top right The Myinkaba Kubyaukgyi or Temple of Many Forms in the village of Myinkaba was built by Prince Rajakumar in 1113 to honor his father Kyanzittha. It contains the oldest paintings in Pagan and the famous Myazedi stone in four languages, Mon, Pali, Burmese and Pyu.

235 center The Indian model of the stupa can be seen in one of its most complex examples here in the Dhammayazika. Completed in 1196 by Sithu II, the building has a pentagonal plan and bears witness to the consolidation of the cult of Mettaya, the fifth Buddha and future savior of humanity, together with Siddhartha, the historic Buddha, and his three mythical predecessors.

235 bottom Built over two floors, the corridor of the Htilominlo has four niches facing the four compass points which house images of the Buddha. The one we see here is in The Gesture of Calling the Earth to Witness. The statue of the Enlightened One follows certain precise symbolic rules. For instance, the protuberance at the top of the head is the sign of the height of wisdom.

236 top The Dhammayangyi, in a Greek cross plan consisting of the central mass and the four access vestibules, takes the form of increasing upward flights of stairs connected by the terminal shikhara, now destroyed and underlined by the sturpa at the corners of the terraces, raised on a square base. The great ability of the builders can be seen in the joins of the bricks which are so perfect that not even a pin can be inserted in them.

At this time there was extensive building of monuments, probably brought on by the need to find suitable housing for sacred objects, the wish to create places of worship and celebrate the glory of the king, and the need to build the merits that give the right to reach Nirvana, the state of liberation from the continuous, painful return to life. There was another motive which is believed to explain this building frenzy.

This is the theory that a new Buddha would come to the Earth in the form of the savior Mettaya and it was important to be born when he was in the world.

Pagan has two basic architectural types: the *stupa* and the grotto-temple.

The Burmese stupa is mainly built from baked bricks which have been

origin symbolizing fertility and abundance in both material and spiritual terms.

The walls frequently have glazed, painted terra-cotta forms holding extracts from the *Jataka*, 550 stories telling about the previous lives of the Buddha. During the sacred procession known as the *pradakshina*, when the monument is always kept to the right of those in the procession, worshippers could reinforce their religious beliefs by reading these writings.

The access stairways to the highest points of the pilgrimage are placed at the four points of the compass.

The heart of the building is the reliquary contained in the sealed central chamber. There is no access to this after the construction of the zeidi.

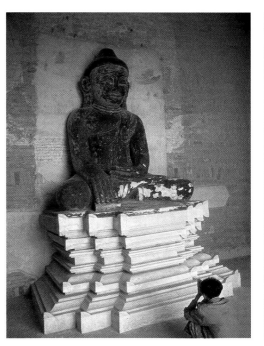

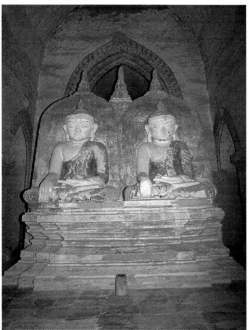

strengthened with sandstone and is known as a *zeidi*.

Derived from the Indian model it is seen as a burial mound built over the remains of the Buddha and therefore symbolizing the doctrine and presence of the Enlightened One, standing at the center of the universe.

It is generally made up of a square platform with a very high, many-sided plinth which holds the bell-shaped stupa itself. The structure is finished by a ringed spire with a sunshade.

There are many variations on this design, especially in the use of curves and the cupola-shaped body of the zeidi itself, and the division of the base into a series of terraces upon which it is possible to walk and which are designed to remind the viewer of the Indian cosmic mountain Meru, the center of the universe. At the corners of these terraces are miniature reproductions of the zeidi which were later replaced by water vases of Hindu

It houses the remains of holy figures, perhaps the Buddha himself or his closest disciples. If there are no such remains, it may contain fragments of sacred texts or statues that were particularly venerated by the Buddha.

The zeidi often contained more than one of these reliquaries as various sovereigns or dignitaries may have placed remains in the same monument over a period of time. At the later period in the development of this site, the interiors of these were maze-like, probably to discourage grave robbers. They were often protected by *dvarapalas*, typical Indian architectural figures placed alongside the doors like guards and other deities from the Hindu world. Buddhism and Hinduism were never in conflict.

When the building was completed it was covered with a thick layer of crude plaster made from sand and limestone and colored white, the color of purity and transfiguration.

238 top In Minnanthu, on the
plain of Pagan, stands the Tayok-
pye temple built by
Narathihapati, the last sovereign,
who ruled from 1256 to 1287, the
year when the area was sacked
by the Mongol armies of Kublai
Khan. The stucco decoration
frames the entrance portals with
dramatic arches.

238 bottom The Tayok-pye is
built on two levels and had a
shikara which was either never
completed or collapsed. The
building is surrounded by huge
walls with monumental
entrances which incorporated
wooden buildings for the temple's
servants.

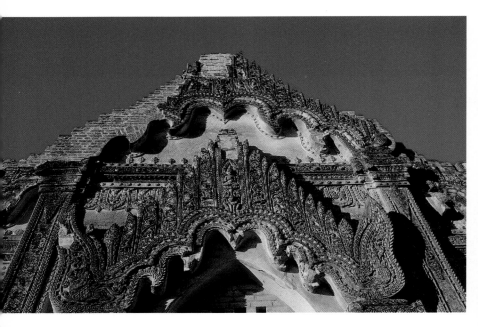

This was then decorated with
multicolored motifs, sometimes garlands
of lotus blossoms or almost frightening
masks symbolizing the all-devouring
nature of time.

The lotus-shaped cushion formed the base
on which the pinnacle was inserted, a
seven-disk stylized reproduction of the
sunshades mentioned earlier. This was
almost certainly made of copper, at first
completed with a series of poles, later
replaced by a crown of pendants and
small bells. The zeidi is distinguished from
the Indian stupa by its vertical sweep. The
original bulbous shapes were gradually
replaced by bell shapes, preferred in
Pagan.

The other architectural shape in Pagan is
the grotto-temple, called a *gu*, which is
both more common than the zeidi and
more suitable for ritual use.

Its structure, an artificial grotto, is ideal
for meditation and worship and its
gradual distribution of light is important
to these purposes.

The contrast between the sun outside and
the first shaded room, with windows
placed to light wall paintings, as well as
the angled slits that move the rays of light
to the face of Buddha in the dark central
part of the grotto, are aimed at creating
this important emotional feeling in the
viewer.

The gu was built facing either east or
north and generally consists of an
inaccessible central block containing
remains or images and four niches
housing the Buddha, each facing a

different point on the compass. The
images in these niches are usually made
of plaster-coated bricks, sometimes
reinforced with wood. The Buddha is
shown with his hands in precise positions
known as *mudras*, each representing a
special moment in his path to
enlightenment. Next to this central block
is a vestibule with a corridor. Over the
building is the typical arched covering of
a northern Indian temple, topped by a
reproduction of a zeidi. The Abeyadana
temple is one of the finest examples of
these.

During the intermediate period under
Sithu I (1113-1155 AD) the design became
less intimate and the symbols less
important, with the accent placed on the
ceremonies dedicated to Buddha, similar

238

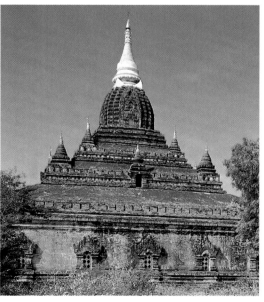

238-239 As well as their fundamental religious function, the stupas also played a magic and protective role in the first period of Pagan and were therefore placed outside the walls at the four compass points. Those that marked the boundaries of the first capital of Anawrahta have been located. Later, as Pagan stretched further out, the defensive nature of these structures faded.

239 left A copy of the Indian Bodhgaya, the Mahabodhi, the temple of The Great Enlightenment, takes the vertical to extremes with its monumental shikhara.

239 right Built in the first period, the Nagayon temple is linked to an episode in the life of King Kyanzittha, who is said to have slept here protected by a naga, a part human, part serpent creature.

to the royal ceremonies in style.
The external architecture, and especially
the roofs of the temples, became of
particular importance.
The vaults, constructed using a special
technique of a radial arrangement of tiny
bricks forming interconnected flat arches,
were closed off at the top with a sandstone
slab. Some of the more massive structures
contain hidden vaulted corridors
apparently used to reduce the weight of the
materials and the loads exerted on the
walls, although these are generally very thick.
A combination of the terraced zeidi and the
temple with atrium led to the emergence of
another architectural type, a perfect
example of which is the *Thathbynnyu*.
Outstanding paintings can be seen in some
of the temples of Pagan. The outlines were

240 top left Six terraces, growing slimmer as they rise, go up from the central block of the Ananda, surmounted by a shikhara which, in turns, ends in a stupa. With its gilded hti (parasol) on the summit, the temple reaches a height of almost 182 feet. The four access doors to the two corridors are preceded by huge entrance arches, or toranas, which are repeated on the first and second terraces.

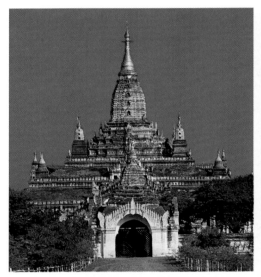

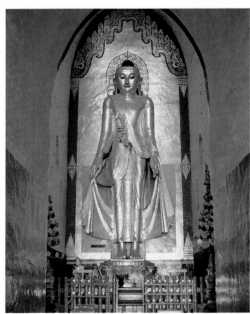

drawn in black or red on a white base and
then spread. Among the most important
zeidis are *Dhamayazika*, built by
Narapitisithu in 1196 and *Shweizigon*,
started under Anawrahta and completed by
Kyanzitta and Mingalazedi, around 1274.
This temple represents the cosmic
symbolism of the five Buddhas, including
Mettaya, and is therefore a pentagon with
five arched antechambers surrounded by

small, exquisite shikharas. There are three
terraces in front of the anda which is built
on a nine-sided base framed by miniature
zeidis. The Shweizigon is highly venerated
as it is believed to contain relics of the
Buddha. The anda rests on an octagonal
plinth on a three layered base with axially
mounted stairs and four pavilions covered
with shikharas to the front. The
Mingalazedi, also divided into three

terraces reached by steps, is on a circular
base, while the zeidi is bell-shaped and
ends in a conical spire. At the corners of the
terraces were originally miniature temples
which were later replaced by miniature
stupas on the top level.
The most famous gu is the *Ananda*, built
under Kyanzitta, a Greek cross construction
surrounded by six terraces topped by a
graceful shikhara and ending in a zeidi and

240 bottom left This figure of Buddha standing with his arms lowered and his cloak open, found in the niche of the sacristy in Ananda, is typical of Burma. The Enlightened One shows classic signs of beauty on his neck and earlobes which were lengthened by the heavy ornaments he wore when a prince. It is believed that the large earlobes show a capacity for compassionate listening.

240 top right The Ananda temple is part of a vast complex that also includes the Ok-kyaung, or residences of the monks. These could range in size from a single hut to a great monastery building containing many rooms. The monastery of Ananda, probably built in 1775, is frescoed with paintings in excellent condition.

gilded *hti*. At the four compass points are the entrance halls and inside there is a central pillar with four colossal Buddhas in the niches, around which there are two corridors with statues and precious decorations. Other important gus, as wall as Ananda, the most venerated, are the *Abeyadana*, which is famous for its paintings, and the *Thathyinnyu* which combines convent and sanctuary styles.

240-241 A view of Pagan from the terraces of the Ananda, the most venerable temple in the area, built under Kyanzittha around 1105 at the request of a group of Indian monks. It was designed to look like the Himalayan cave which was their home. The plan of the gu with its central pillar and outer corridor was extended by a second corridor and four front wings.

241 top Anawrahta, the first great sovereign, who ruled from 1044 to 1077, ordered the building in 1057 of the massive Schuwehsandaw stupa to house a precious reliquary, a hair of the Buddha. The stupa is built on a five-terraced pyramid with staircases at the axes.

241 center Built in 1277 by King Narathihapati, the Mingalazeidi is one of the most elegant buildings in Pagan.

241 bottom The Manuha, a temple built in 1059 on behalf of the Mon king of Thaton of the same name who was defeated and taken as a prisoner to Pagan by King Anawrahta, houses huge statues of the Buddha.

BOROBUDUR MOUNTAIN OF THE MAHAYANA BUDDHA

242 Many of the statues of the Buddha looking into the court were lost or damaged through the years. Originally, there were 104 on the first level, 104 on the second, 88 on the third, 72 on the fourth and 54 on the upper circular terraces.

Boroburdur, the largest Buddhist temple in the world, is found in the heart of the island of Java. Built during the Sailendra dynasty, probably between 760 and 810 AD, it is situated in a plain surrounded by mountains and volcanoes, not far from the shores of the Indian Ocean. The temple is an important document about the kingdoms of Central Java on which there are almost no written documents or other materials to help us reconstruct this historic period.

Seeing these imposing centers of worship we realize that they could only have been built if there were also well-structured government run organizations able to produce surplus wealth which could be used for works on such a scale calling for a serious commitment. We do know that during this period some dynasties were competing with each other for the domination of Central Java, where highly populated settlements organized into often conflicting regimes had emerged centuries earlier, thanks mainly to the development of the agricultural method of growing rice in flooded fields.

The first traces of contacts with Indian culture date to the beginning of our age. Groups of Indian merchants, following after individuals from the higher castes including almost certainly the Brahmins, had reached the courts of the Indonesian kingdoms such as Srivijaya, Sumatra and Central Java by means of the maritime trading routes. It was primarily at the court level that the Indian religions of Buddhism and Hinduism began to spread. Between the end of the 8th century and the start of the 9th, the Buddhist Sailendra dynasty (also called Lords of the Mountains) probably took control from the rival groups and governed a great part of Java. This is the period when Borobudur began to take shape. It was not only a place for religious functions but also a place of celebration for the sovereigns of the period which was during the maximum development of the kingdom. The building of the complex required tremendous effort, especially if we take into account the techniques that were

available at the time. The structure, resting on a small hill, consists of over a million blocks of stone, each weighing over 200 pounds. These were brought to the site from the bed of a nearby river and were then cut, worked and decorated by the craftsmen. Hundreds of people must have been involved in this project, for a period of about 30 years, some time between 760 and 830 AD. The reign of the Sailendras must have been a time of great splendor to permit an effort of this scale. Some experts, in fact, believe that the decline of the country that followed this period was caused by over-extension during this time. A few decades after the completion of the work, in fact, the

A Square Terraces
B Circular Terraces
C Top *Stupa*

entire territory of Central Java fell into the most total obscurity, and the center of Javanese civilization shifted to the eastern part of the island. We still do not know why this area was abandoned, although various theories have been advanced. These include a volcanic eruption, an earthquake, a famine, or a combination of factors including the effort needed for the building of the major Central Java works, with the important Hindu complex of Prambanan, all of which could have been reasons for leaving the area. Boroburdur itself was forgotten, and it wasn't until the beginning of the 18th century that local information about it began to emerge. But the true rediscovery and valorization of the temple was the work of a European, Sir Thomas Stamford Raffles, who was British vice-governor at the start of the 19th century in this part of the world, usually controlled by the Dutch. The Dutch were, however, at the time busy fighting Napoleon and therefore had allowed the control of the

area to fall into the hands of the British. Raffles was young, efficient and knowledgeable, and enthusiastic about the history and civilizations of the countries where he worked. He commissioned a military explorer, Colin MacKenzie, who had spent many years in India and was familiar with Buddhist and Hindu art, to form a research group to investigate the remains of the ancient civilizations that had lived on the island. It was one of the members of this group, a Dutch engineer named H.C. Cornelius, who found the ruins of Borobudur in 1814, led to the site by local inhabitants. It took one and one-half months of work by 200 men to free the temple from the vegetation covering it. The first recovery work ended with the final surveys around 1870 but, ironically, this meant the beginning of the end for the building. The vegetation and ash from volcanic eruptions had not only hidden the structure but also protected it from harmful atmospheric agents.

242-243 Borobudur rests on a square base of 373 feet on each side. It is almost 150 feet high and built over five floors with a three mile route to the top. In this photograph we can clearly see the dual form of the stupa and the mandala.

243 According to legend, the building was designed by the religious architect Gunadharma, whose profile, it has been said, can be seen in the shapes of the Menoreh Hills which rise at the south side of the building itself. A great deal of the magical atmosphere that is so much a part of this area is due to the natural landscape into which the temple blends.

Consequently, when the sun, wind, rain and sudden changes in temperature started again to leave their mark on the building, it quickly began to decay. It was especially affected by very poor drainage during the periods of extremely heavy rain. In spite of this, a long period passed before the Dutch decided to embark on a first restoration and protection operation. This was carried out in 1907 but unfortunately it failed to solve the drainage problem. In the following years the deterioration continued, causing alarm among the administrators of the state of

role as a testimonial to a past of which we know so little. The only building which can be compared with Borobudur, and which may have to some extent inspired the architects, is the temple of Nandangarah, in northeast India. Both buildings can be interpreted as a plastic interpretation of the concept of the earth rotating around a center, as in the case of the Assyrian-Babylonian ziggurat and the layout of the imperial city of the Kings of Iran. If we look at Boroburdur from the air, it takes on the form of an immense *mandala*, a group of

244 The distant past may be far gone, but Borobudur recovers its importance as a major center of religion at least once a year. For Buddhists, a major festival takes place on the night of the full moon in April or May when Buddha's birthday is celebrated with his entrance into Nirvana.

245 top Depending on the side of the building and its position with regard to the terraces, the statues of Buddha take on different positions to express

different meanings. On the north is the abhaya mudra, to eliminate fear, on the east bhumisparsa mudra, the struggle against demons, to the south vara mudra, charity, and to the west dhyani mudra, meditation. Along the four sides of the row above the first balustrade are vitarka mudra, for prayer, and in the circular terraces dharmacakra mudra, the movement of the wheel of the doctrine, as in the statue in the photograph.

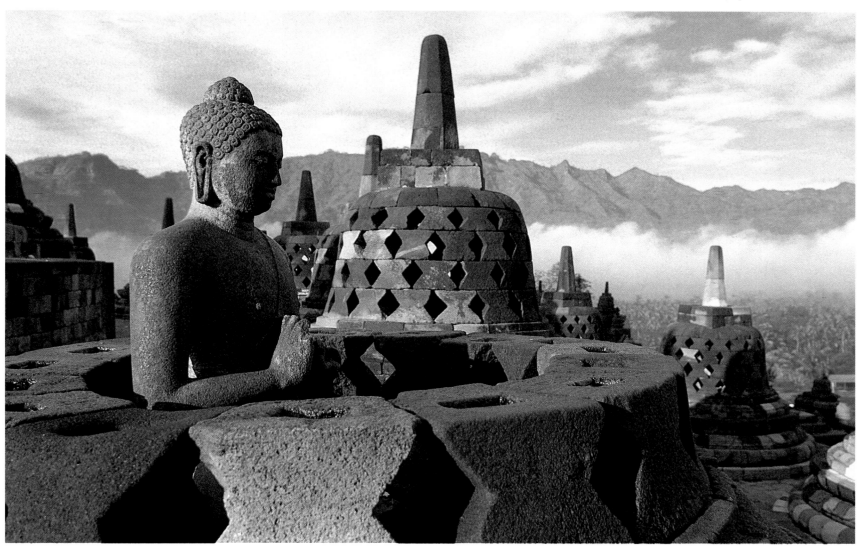

Indonesia, which had been formed during the period. In 1971, it was finally decided to start a serious program of restoration. This was completed in 1983 with the participation of various official bodies, including UNESCO. About one million of the stones of the building were removed, some treated and reshaped, and all were then put back in place in their original order. As a result of this operation it was possible to take a number of steps to stop the infiltration of water, and today the entire construction of Boroburdur has been restored completely, with about one million visitors coming to see it each year. Very few of these visitors are Buddhist pilgrims. Most are visitors who are attracted to the beauty of the building as an exceptional work of art, the fascinating religious aura that pervades the site, and its

geometric shapes marking out a sacred territory, with its most important part in the center and larger and larger areas developing out from that, with precise references to the four points of the compass. The main form of Buddhism in Java was Mahayana, or the Great Carriage, the form of Great Compassion, a religion that was very open toward the individual paths that the faithful could follow even in the course of a single life on their journey to Nirvana where they would be freed of the burden of continuing reincarnation. We know that between the 7th and 14th centuries there was a significant spreading of somewhat esoteric forms of Buddhism, such as Tantrism, which provided quicker paths toward enlightenment and Nirvana through various rites and practices. It is within this context that we have to see

245 bottom The numerous statues of the Buddha in niches look toward the outside of the building. These are on the eastern side, the holiest, and are the mudras, or positions representing the struggle against demons.

Borobudur, which eloquently expresses these conceptions of Buddhism. The temple consists of four square and three circular terraces, surmounted by the small *stupa* on top. In the course of the ritual procession in a clockwise direction, the pilgrim had to walk through the galleries of the first four terraces. These were richly decorated with panels facing inward and on the balustrade. As the first gallery was decorated with four series of panels and the others with two each, the pilgrim had to pass through these a total of ten times, observing and learning from the bas-reliefs, before being granted access to the circular terraces above. According to the cosmic symbolism of Mahayana Buddhism, at the center of the world is the sacred mountain, Mount Meru, around which the planets, skies and seas rotate. The path toward enlightenment metaphorically corresponds to the ascent of the mountain, here symbolized by Borobudur. The base of the temple stands for the material world, form and shape, the sphere of desires and the sufferings of life. The walls of the base, measuring about 380 feet on each side, are

246 top left The image shows a noble on horseback going into the forest with his followers to hunt. This figure can be found in the first gallery in the Avadana. In the bottom image festive musicians celebrate the birth of the Buddha. The Avadanas tell of gestures of bravery in which self-sacrifice is emphasized.

246-247 The young Sudhana sits surrounded by wise teachers. This bas-relief is part of the series in the upper terraces, whose theme is taken from the Gandaviuha, the structure of the world compared to a bubble. It tells the story of the journey of Sudhana, son of a rich, noble merchant, in search of teachers who can give him the wisdom he seeks. At the end of this phase of learning he reaches the palace in the sky where Buddha resides.

247 bottom The sailing vessel shown here is one of the most important sources for our knowledge of the shape and features of ancient Southeast Asian ships. This panel is part of the series of stories in the first gallery inspired by the Avadana episodes of self-sacrifice.

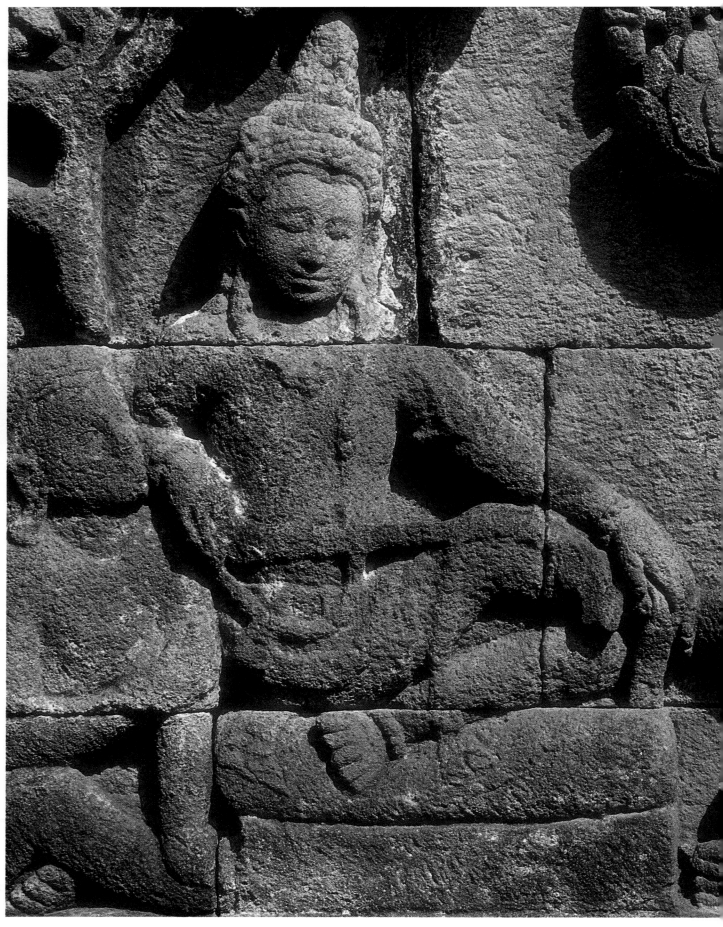

almost entirely undecorated. For reasons that we still do not understand, the 160 decorated panels were covered by a wall and they were only discovered in 1885. Whatever the reason, whether to give the building greater stability or to hide the sections concerning worldly desire and passion from the devotees, a protective wall had been built around the base. After this was completely dismantled to photograph the decorations, it was rebuilt and today only four panels have been left, deliberately, uncovered. These show scenes from a Buddhist text, the *Mahakarmavibbangga*, on heaven and hell, sin and punishment, good deeds and rewards. In the middle of each side of the base there is a narrow stairway leading to the upper terrace. To follow the path correctly, this should be reached from the eastern side, which is considered the holiest. Seen from the outside, the temple shows no bas-reliefs, but there are numerous statues of Buddha. The building takes the form of an immense stupa, a typical Buddhist construction which originally contained the ashes of the historic Buddha, Siddhartha Gautama, and which later became one of the most important symbols of this religion. The stupa is as impenetrable as Borobudur, built on a hill and with no interior parts. To gain access to the teachings contained in the panels, we have to enter the upper galleries. The building is therefore very unusual in shape, inaccessible from the outside on first sight, and closed to those who do not want to enter the gallery and learn from the teachings, but continue on the path toward salvation. The first gallery has a shorter perimeter area, 200 feet per side at the base, with the walls of the upper levels becoming progressively shorter. The four square terraces stand for the Rupadhatu, the physical form of the Buddha. By walking through these the pilgrim has already set out on the path toward Nirvana, and finds himself in the phase of inner growth during which he has to learn the teachings, although he has already begun his process of detachment from the material life depicted on the base.

It is only after crossing all four galleries in the correct way that he can gain access to the final level of Arupadhatu, or non-form. Here we have the three circular terraces, with a series of stupas arranged concentrically, containing statues of Buddha which we can glimpse through small geometric openings. There are no icons. The phase of learning is complete and we can now reach the last great central stupa, which is absolutely impenetrable. The ascent of the sacred mountain, Mount Meru, is completed, we are in a state of non-form, in nothingness. Borobudur is therefore a building with many meanings, and its structure is highly complex. It can be seen in many different ways. It can be appreciated for its beauty and the artistic value of its decorations or as a historic testimony to a glorious past of which all traces have been lost.

However, its deepest meaning has to be interpreted in this threefold image of stupa, Mount Meru and *mandala*, three aspects of the same path which, in the intentions of the builders, would probably have enabled the pilgrims to achieve enlightenment and bring their spirits into contact with Buddha himself.

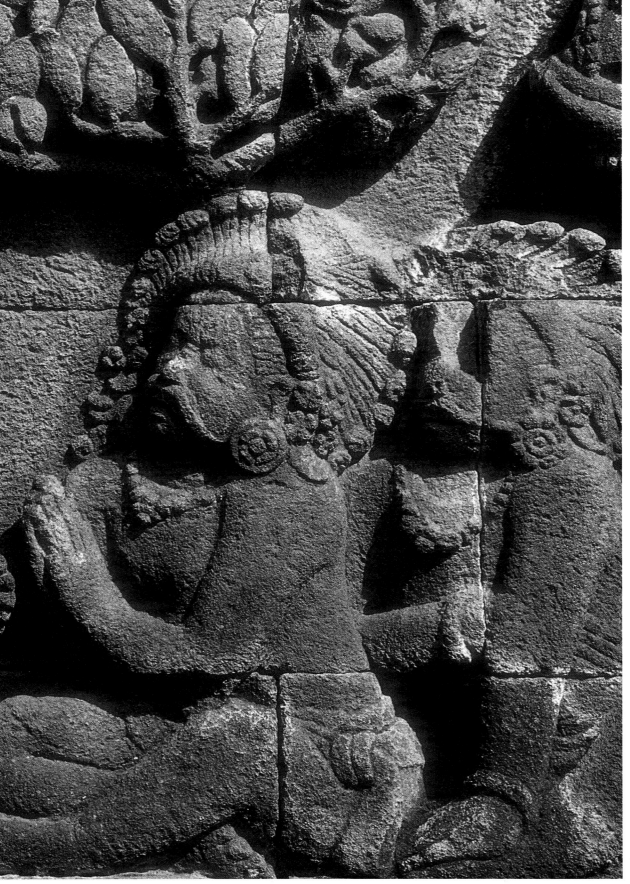

ANGKOR, *PALACES OF THE GODS*

A Angkor Wat
B Phnom Bakheng
C Angkor Thom
D Bayon
E Preah Khan
F Neak Pean

G Eastern basin
H Ta Prohm
I Banteay Kdei
J Sras Srang
K Ta Som
L Eastern Mebon
M Prerup

248 top *The fascination of the Khmer monuments is due not only to their great artistic value but also to their location in the wild, enveloping tangle of the jungle. The problem of restoration is particularly complex here, as the forest suffocates and destroys the temples even though the roots and branches of the trees have helped keep the stones of the buildings together for centuries.*

The first strong but peaceful influence on what was once called Indochina took place in the first centuries of the Christian era. This influence came through the Brahmins, the Indian noble priestly caste, who were followed later by Buddhist missionaries. This is why the great temples at Angkor in what is now Campochia or Khmer or Cambodia are a testimony to a fascinating union of indigenous and imported elements. The local Khmer worship of ancestors and the sacred mountain blended in with the Hindu ideal of the universal cosmic mountain, the axis and ordered pivot around which the world itself revolves.

It was during the 9th century that a grandiose Brahmin rite held on the sacred mountain of Phnom Kulen on behalf of King Jayavarman II sanctioned the culture of devaraja, or the god-king, for the first time. Mythology tells the story of how the god Shiva, one of the most important deities in the Hindu religion, handed the king the lingham, the phallic stone symbolizing the god, and which from that moment became the tabernacle of the royal essence of *devaraja*, protector of the universe, whose place of residence was the temple-mountain.

As part of this tradition, each sovereign during his reign built a personal temple to house the lingam, symbol of both his royal power and divine being. At his death, this became his mausoleum. The most powerful devarajas went one step further. They also had sacred places built for their relatives. In this way the temple became not only an indication of a belief in an after-life but also a bridge between ancestors and descendants.

The Khmer empire had five centuries of splendor until, in 1431, it was destroyed by monarchs of the nearby area roughly similar to modern Thailand. Virtually all memory of the city was lost until a 19th century French naturalist, Henri Mouhot described Angkor for the first time is his book about his journey throughout the world, thus attracting the west toward the history of the Khmer civilization.

While this area was a French protectorate, the Ecole Française d'Extréme Orient, founded in 1900, began work recovering Angkor, cutting the monuments out from the jungle and restoring them. A specific organization, the *Conservation des Monuments d'Angkor*, with a succession of famous directors, was formed for this work in 1908.

In 1929 the Dutch developed a method of archeology called anastilosis, which involves the complete dismantling of a monument followed by its reconstruction, piece by piece, with reinforcements and this is the method used for the Khmer monuments, with outstanding results.

All Khmer architecture is inspired by the cosmic mountain and the square tower-sanctuary with its stepped pyramid is the oldest known Khmer design, in brick, sandstone or clay. The towers, or prasat, which were originally isolated but later grouped together in three or five on a single base were later developed within the complex of the temple-mountain into a five tower form, with one at each corner and the fifth in the middle, all connected by colonnaded galleries.

Hindu mythology of the origin of the world is the basis for these constructions with the

248 bottom *Khmer architecture tends to transfigure the human body into the divine. The devatas, divinities with complex hairstyles and splendid jewelry, smile enigmatically from the walls of Angkor Wat, built by Suryavrman II between 1113 and 1150.*

249 *During the four middle centuries of the Khmer empire, between the 9th and 13th centuries AD, several capitals were built in Angkor, the last of which, Angkor Thom or Great City, displayed the constant motif of the Bodhisattva Lokeshvara, a central figure in Mahayana Buddhism.*

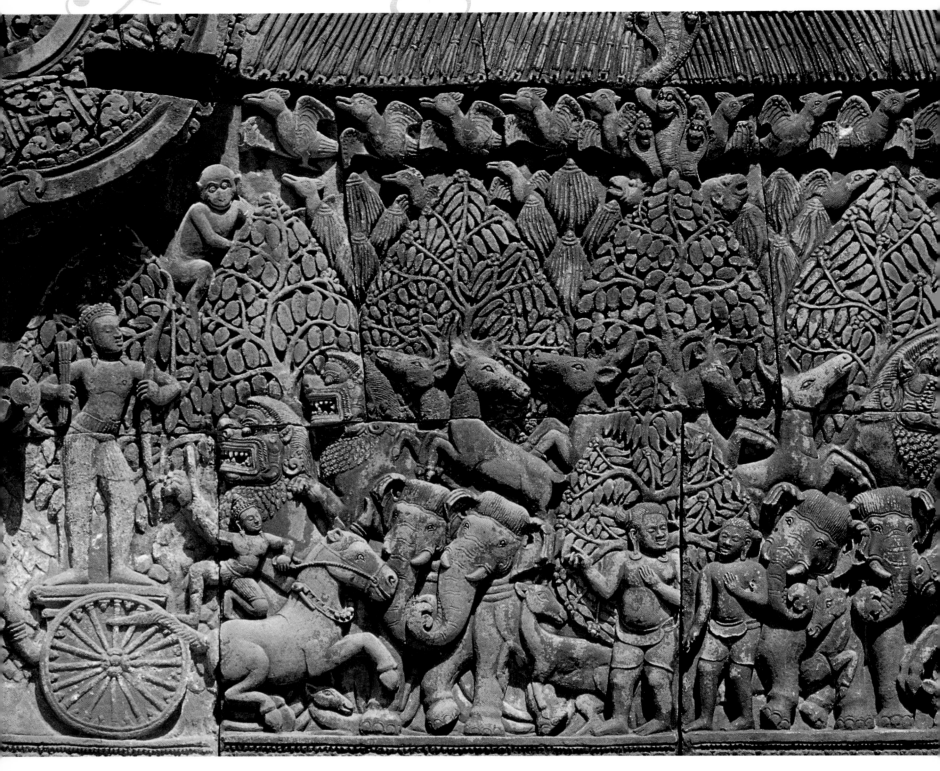

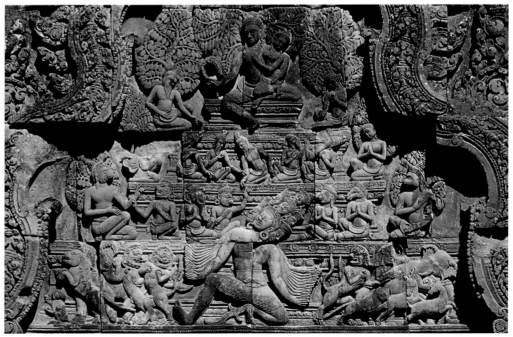

250-251 *Banteay Srei, a small temple complex 12 miles from Angkor, was built in 967 by the Brahman Yajinavaraha, spiritual advisor to Rajendravarman II and Jayavarman V. The reliefs show Khmer plastic art at its best. Here is shown a detail of the eastern front of the north library, centered around the adventures of Krishna, the incarnation of Vishnu, the providential version of the divine.*

250 bottom *The main figure on the eastern front of the south library of Banteay Srei is the thousand-headed demon Ravana, who is trying to uproot Mount Kailasa, the home of the god Shiva. He can be seen above with his wife Parvati who clings to him in terror. All the inhabitants of the sacred mountain, animals, ascetics and attendants, are terrified, but Shiva, unafraid, presses his foot to the ground so the mountain falls and the demon is crushed into the bowels of the earth.*

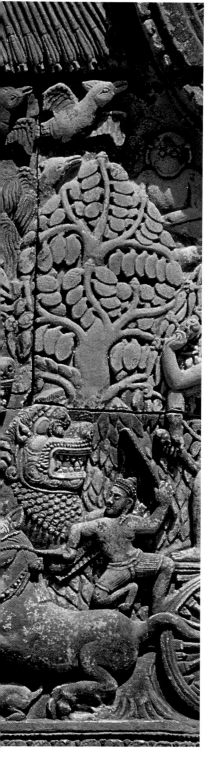

temple-mountain, rising from a base that symbolizes the cosmic ocean or the waters containing life waiting to be born. The importance of the baray which is the Khmer water base is fundamental to the building of religious centers as royal power not only is based on sacred precepts but also on the ability to use the waters for the rice fields. In this way the king became the source of life itself. The main body of the temple represents the mythical Mount Meru with its five peaks which, in the Hindu view, is at the center of the universe and symbolizes the original chaos in the world as we see it. The doors that jut outward in special pavilions from the constructions at the four corners symbolize the extension of royal power into the entire universe.

The bridge with its balustrade formed by *nagas*, serpents with five or seven heads, represents the rainbow uniting earth and sky and the rain the serpents bring.

As every sovereign had to carry out three fundamental duties which were his duty toward his subjects, with the construction of reservoirs and irrigation channels, toward his ancestors, with the building of a temple to commemorate them, and toward himself as devaraja with the building of a mountain-sanctuary, there are many monuments in the Angkor area.

This city extends over 60 square miles near the modern town of Sieam Reap in the northern part of the country.

One of the oldest settlements is near the modern village of Roluos, where the great king Indravarman placed his capital, Hariharalaya, digging out the great Indrataka and building the six-towered temple of

251 center right In addition to the mountain-temple, Khmer architecture also developed low buildings in which the main sacristy is flanked by other rooms and enclosed within a series of walls. Both types of building symbolize the inner pilgrimage in search of the sacred. In the case of the mountain temple the route moves upward, while in low buildings the movement is from the periphery to the center, from the outside inward.

251 bottom right The asuras or demons can be easily recognized in the reliefs. Their faces have distinctive features and round eyes, while the devas, or gods, have refined appearances and elongated, petal-shaped eyes. This relief is found on the steps of the Bakong, the mountain-temple built by Indravarman in 881 as the center of his capital, Hariharalaya, situated in the modern village of Roluos.

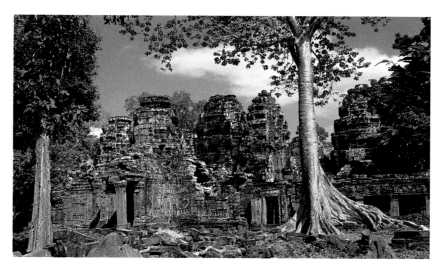

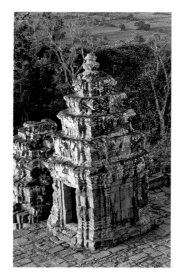

251 bottom left The Phnom Bakheng, from whose summit this photograph was taken, was built by Yashovarman I in 893 as the mountain-temple center of his new capital Yashodharapura.

251 top right The eastern Mebon, a mountain-temple built in 952 AD by Rajendravarman II, is a symbol of the cosmic mountain, the home of the god-king who is the guardian of earthly order.

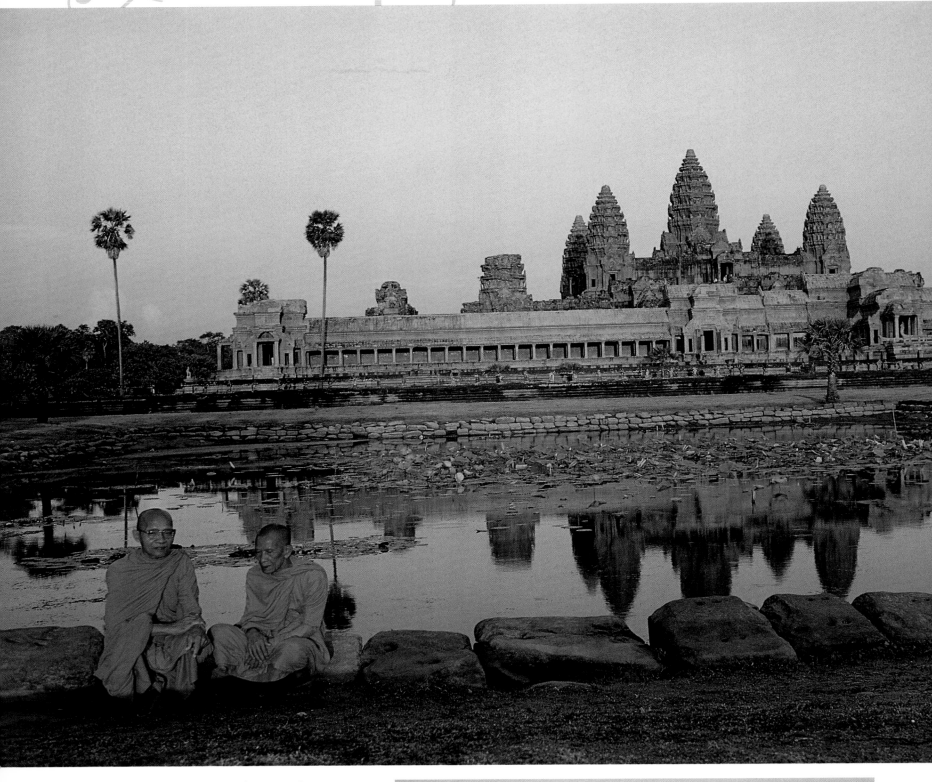

252-253 *The Angkor Wat is seen as the masterpiece of Khmer art and marks the height of its brilliance. The building, surrounded by a huge trench, represents the Hindu myth of the cosmic mountain which emerges from the water of the primordial ocean. The construction of the water basins, one of the main activities of the rulers, performed the dual function of guaranteeing irrigation for the rice fields while symbolizing the role of the god-king as lord of the waters.*

252 bottom *Angkor Wat is enclosed in a double wall which follows the pyramid structure. It consists of three terraces, the last of which houses five towers in a cross formation like the five peaks of the cosmic mountain. It has been considered that the Khmer builders may have deliberately made the access alley nearly twice as long as the façade to provide a scenic relief.*

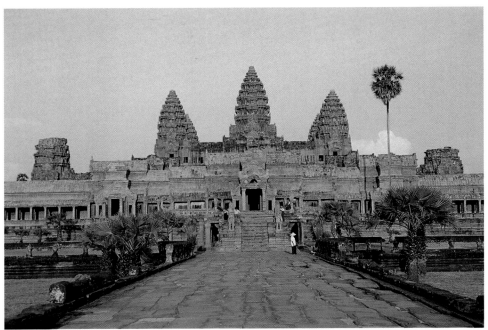

Preah Ko in 879 AD and the mountain-sanctuary of Bakong in 881. Roluos was inhabited from 882 but abandoned by Yashovarman (889-900 AD) who founded his capital Yashodhapura where it was fed by the enormous basin known as the Eastern Baray around the mountain-temple of Bakheng which housed the royal lingam. It is with Yashodhapura that the history of Angkor begins, a city which went on to act as the center of the Khmer empire for five centuries, except for a brief interlude from 921 to 941 AD, during which Jayavarman IV moved the capital to Koh Ker.

But it was not only the kings who built Khmer art. One of its masterpieces, the Banteay Srei, was constructed in 967 by two Brahmins, Yajnavaraha and his brother Vishnukumara about 20 miles northeast of Angkor.

Rectangular, with a series of buildings between the first and second wall and cross-shaped monumental edifices, known as *gopuras*, at the entrances to the third and fourth sections, the walls are accented with blind windows and small circular columns. The access road is flanked by two porticoes and the temple itself is divided into three

253 left Although the Thais sacked Angkor in 1431, thus bringing about the end of its great capital, Angkor Wat was never completely abandoned. Built for the Hindu king Suryavarman II, identified on his death as one of the forms of Vishnu, it became a Buddhist pilgrimage site as can be seen from the many statues of Buddha throughout.

253 top right The walls of the Angkor Wat are adorned with ranks of female deities wearing swirling skirts shown in elegant fabric. Their mysterious smiles are typical of the divine image of this period. Their serene but remote expression suggests the wide gap separating mortals from heavenly beings.

253 center right Nothing has survived of the residential buildings as only the temples were built from lasting materials. Since these were conceived as the home of a divine ruler they were meant to equal the heavenly pavilions of the gods. Eyes open in a vision or closed in meditation, the gods of Angkor Wat show the delights of paradise awaiting the monarch upon his transition.

253 bottom right The cross-shaped plan evokes the symbolism of the expansion from the one to the many and the spread of royal authority. It is the fundamental module used in Angkor Wat for both the towers and the access portals such as the one in the photograph. The side annexes connect it to the galleries and the structures jutting out act as entrance porticoes.

Angkor

small prasats on decorated bases with false doors on three sides beneath a covering of several floors that continue the construction in miniature.

Perhaps the most interesting features in Banteay Steis were the multi-lobed, mainly straight gables on the prasats with their waving profiles in the so-called "libraries" and in wooden imitation in the gopuras, which were frequently built over three floors to provide a telescoping effect, which is one of the typical features of Angkor Wat, the most famous monument.

This temple decoration is considered one of the most successful works in Khmer art because of the freshness and richness of the compositions.

Angkor Wat was built during the reign of Suryavarman II (1113-1150 AD). Restoration

work, hampered by local warfare, has been taking place recently under the leadership of UNESCO.

The monument has had several names. Known at one time as Brah or Vrah Vishnuloka, the posthumous name of Suryavarman, its modern name of Angkor Wat means "royal residence which is also a monastery." There is still some confusion about the exact use of this monument, but the most popular theory is that Suryavarman had it built as his mausoleum.

The building measures about one-half square mile and is surrounded by a moat 600 feet wide with steps leading down to the water. The building faces west, rather than east, which seems to confirm that it was built as a tomb, and has two entrances at ground level where there are several interconnecting

254 left Suryavarman II was devoted to Vishnu, and the bas-reliefs of the outer gallery of Angkor Wat are inspired by the acts of this god and his incarnations of Rama and Krishna. The former, prototype of the just king, is celebrated in the Ramayana, and the latter in the Mahabharata, the two great Hindu epic poems whose battle scenes are shown in the upper

and lower panels. In the photograph in the center is a detail from the judgment of the dead, where several condemned, terrified, and emaciated individuals are beaten by the attendants while an elephant crushes others with its trunk. The function of Yama, god of the afterlife and supreme judge, is performed by Suryavarman II, who became divine after his death.

254 right The scenes, primarily crowded with figures, occasionally open to give emphasis to certain persons, such as this image of a victorious warrior contrasted with that of the enemy he has killed who is lying at his feet.
Etching of the bas-reliefs began with a first sketch, followed by the modeling and application of details, in a procedure very similar to painting.
Unfortunately, virtually nothing of the paints from Angkor have survived.

255 The frequent portrayal of war scenes can be understood by the fact that Suryavarman II was a soldier king and he was responsible for victories against the old enemies of the Khmer, including the Cham from nearby Champa, modern Vietnam. The adventures of Vishnu and his visits to earth, always in order to fight demons, were particularly suitable to express the overlap between kingly and godly deeds.

256 and 256-257 The intense building work under Jayavarman VII, whose face dominates Angkor Thom, coincided with a decline in quality due to the poor availability of sandstone. Considerable use, therefore, was made of wooden beams inside hollowed out stone and this explains the fragility of the monuments. This was the beginning of the end for the great Khmer empire, first Hindu, then later Mahayana, finally dissolving into the simplicity of Hinayana Buddhism, the "small vehicle of salvation", marking a return to the original message of the Buddha.

galleries. At the entrance to the building there is a paved entrance flanked by libraries, two artificial ponds and a cross-shaped platform leading up to the entrance to the temple itself. Angkor Wat is raised onto a three-terraced pyramid, with the first containing a cross-shaped cloister with three parallel galleries leading to three stairways to the upper terrace and a fourth, with three naves at right angles to the others, dividing the space into four ceremonial pools.

The second terrace repeats the same motifs as the first, with a surrounding gallery of *gopura* at the four points of the compass and cross-shaped pavilions at the corners. This also encloses two libraries connected by an elevated platform. Very steep stairways lead up to the third terrace which, in contrast to the other two terraces which are oblong, is completely square. This is

surrounded by a gallery with colonnaded windows, cross-shaped pavilions at the corners and the gopuras above the entrances facing the four compass points, imitating the cross-shaped plan of the cloister.

The monument is completed by outstanding decorations. The eight or sixteen-sided columns are divided into ten or twelve rings, making them seem both light and vibrant. The design of a flat interweaving of leaves creates a tapestry effect in which beautiful celestial nymphs are set.

Among the features of these nymphs are their elaborate hairstyles. In the gables, mythological scenes are repeated in the bas-reliefs of the galleries which run along the walls for about three hundred feet, almost

like manuscripts etched into stone. It seems likely that the technique was copied from painting, but no trace of that type of Khmer art remains. All the figures are from the Vishnu mythology so favored by Suryavarman II and refer to the two great Indian epics Mahabharata and Ramayana and to the myth of the shaking of the ocean which the gods and demons performed to extract ambrosia, the nectar of immortality and supreme knowledge.

Despite, from our viewpoint, certain basic constructional errors (weak foundation, insufficient use of iron tie-rods and joints and limited staggering in laying the stones), Angkor Wat is an architectural masterpiece of harmony and proportion.

257 center The parade of the army in motion against the enemy is an orderly one, with the infantry marching in two lines, the chariots, the imposing procession of the elephants mounted by the leaders, the band of musicians and the dancers. The army was followed by civilians with supplies and the soldiers' families. The expressions, clothing, weapons and details are shown with great care and dynamism.

257 bottom In the first gallery, on the southern face of the east side, the upper section shows fish and a crocodile biting the leg of a soldier who has fallen into the water of the river where the battle against the Cham is taking place, while the lower section with trees shows the bank of the river with life proceeding normally. The simplicity of the civil architecture and the essential objects of the time are the same as those of today.

The last and greatest of the builders was undoubtedly Jayavarman VII (1181-1201) who built without interruption for 30 years and with such speed that a huge brick tower was completed in 30 days. This haste and a lack of good quality sandstone as the best quarries were exhausted affected the quality of the building.

This king was a fervent Buddhist, particularly devoted to the bodhisattva of compassion, Lokeshvara.

The Lokeshvara motif is found in Bayon, a mysterious complex mountain-temple at the center of Angkor Thom, the "great city" which extends over almost three square miles and is surrounded by over 20 foot high

257 top Almost 4,000 feet of bas-reliefs decorate the galleries of Bayon, offering an incredible insight into the life of the period with scenes of day-to-day life beside views of the courts and battles. The images show many different scenes, the most important of which is a celebration of the great victory of Jayavarman VII in 1190 against the Cham, whose state was then annexed to the Khmer in revenge for the sacking of Angkor in 1177.

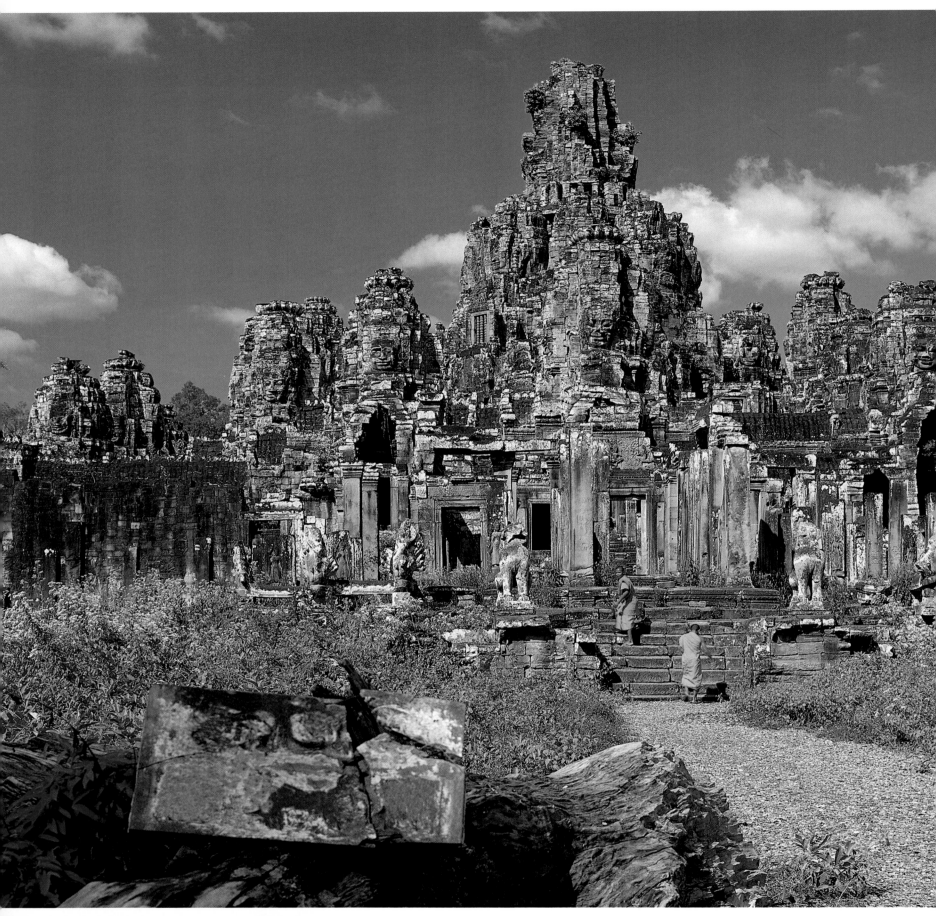

258-259 The Bayon, built at the start of the 13th century, is the most complex and mysterious construction in Khmer architecture and marks its decline.
A wild forest of towers which follows a certain logic despite undergoing many changes in the building, the temple expresses the complex and contradictory personality of Jayavarman VII and identifies him with the Bodhisattva Likeshvara, whose face can be seen on all the towers of the Bayon.

258 bottom Giant statues of the gods are lined up at the entrance to Angkor Thom. The walls of the town symbolize the chain of mountains that surrounded the universe and the moat refers to the cosmic ocean.
The temple of Bayon, in the center of Angkor Thom, stands for the same cosmic mountain that forms the base of the town. Under Jayavarman VII the esoteric meaning of the monuments reached their height.

259 top right *The enormous central tower of the Bayon, dominated by the faces of Lokeshvara, unlike the other mountain-temples, has a circular plan, conforming to Buddhist symbolism. Jayavarman, follower of Mahayana Buddhism, closed the Hindu period, but not that of gigantic monuments that called for great expense in terms of costs and manpower.*

walls with five gates, four at the points of the compass and the fifth north of the eastern gate and dominated at a height of 60 feet by four faces of Lokeshvara, clearly identified with Jayavarman as protector of the universe. In front of the gates are 54 gods with elongated eyes and 54 round-eyed demons, supporting a naga, and there is a clear reference to the shaking of the ocean when the mythical serpent Vasuki was used as a rope around the cosmic mountain, the temple of Bayon, to create the swirling needed for the mixing. The city rotates around the Bayon, whose structures were modified over the years to the point that scholars had difficulty in dating it and determining its use prior to the discovery of the statue of Buddha. In addition to the incredible impression that the great forest of towers creates on the visitor to this site, dozens and dozens of bas-reliefs on the walls of the galleries report the acts of Jayavarman VI, victorious over the Cham of the Champa kingdom, within the context of the everyday lives of the people. These reliefs, noted for their freshness and immediacy, are remarkable for the way in which the artists changed tone and design according to whether they were depicting the powerful, gods and kings, or ordinary people, so much like those of today.

259 bottom Angkor Thom, the Great City of Jayavarman VII, is inspired by a great Hindu myth, that of the Stirring of the Ocean by the gods and demons to extract ambrosia, a symbol of immortality and knowledge, with the cosmic mountain as a whip and the primordial serpent Vasuki as the cord. The gates of the town are preceded by 54 gods and the same number of demons (left) holding up a serpent.

XI'AN,
THE WARRIORS OF QIN SHIHUANG

In 1974 in the district of Lintong not far from the city of Xi'an, in the north of the Shaanxi region, 1400 yards east of the outer walls of the mausoleum of Qin Shihuang, the first emperor of China, a group of peasants made the chance discovery of an enormous trench containing terra-cotta figures of soldiers dating back to the Qin period (221-206 BC). During later excavation work, other trenches came to light.

The entire complex of the Qin Shihuang mausoleum, which was not completed when the emperor died in 210 BC, covers a surface of about 22 square miles.

The center of the burial complex is the burial mound beneath which the emperor's tomb has been identified although not yet opened for excavation.

Around this, over a radius of 10 miles, are the sacrificial trenches. In 1980, a ditch was found to the west of the mound containing two impressive bronze carriages, about half the size of real ones. Not far from there, 18 other trenches were found, containing wild birds and animals and 13 trenches with statues of slaves and servants, apparently symbolizing the hunting ground of the emperor.

Outside the tomb area, toward the east, 93 other trenches emerged. These contain pottery and iron tools and statues of charioteers, as well as a great number of skeletons of horses.

These were the imperial stables. Just over a mile to the east of the mound the four trenches containing the emperor's terra-cotta army were dug up.

These trenches are separated from each other by architectural structures and cover a total area of about 25,000 square yards. Inside there were 130 wooden war carts, more than 600 terra-cotta horses and well over 8,000 statues in the form of warriors of different kinds along with an enormous quantity of real bronze weapons.

All the trenches face east. Number one is on the south, two and three are east and west of one, trench four is between two and three. Excavation work is still taking place on this trench.

Inside trench one are over 6,000 statues of warriors and horses, arranged in rectangular formations of infantry and heavy carts. The front three rows have 210 soldiers, all facing east and not in uniform. They hold bows and crossbows and have quivers over their shoulders. At the ends and in the center of the row are three armored warriors, apparently officers.

Behind these three rows are 38 columns of soldiers, divided into eleven groups, six of which contain a war chariot with two standing soldiers. Each chariot is preceded by three lines of soldiers, each made up of four men with bronze lances.

On both sides of the 38 columns is a row of soldiers facing to the outside of the formation. Many of these are armed with bows and crossbows. At the end of the formation are three rows of soldiers, two looking toward the east and one looking toward the west.

In trench number two, nearly 1,000 statues of warriors were found together with over

260-261 The army of Qin Shihuang stands in rows in the central corridors of trench number 1. The first row shows the stable boys, not wearing armor. Behind them are the officers and men of the light infantry, accompanied by battle chariots drawn by four horses. At the level of the dividing earth walls we can see the marks of the covering beams. The heads of the soldiers, slightly larger than life-size, emerge from the top of the dividing walls to show the magnificent power of the Imperial army.

A Outer wall
B Inner wall
C Trench of the bronze chariots
D Burial mound
E Trench 1
F Trench 2

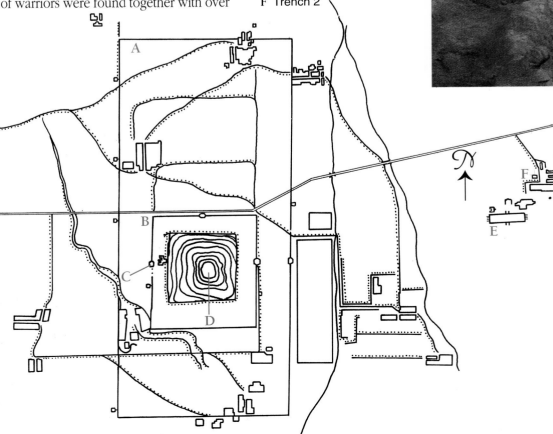

261 bottom An impressive view of the ranks of officers, infantry men and chariots with horses in the corridors of trend number 1. The organized mass of soldiers along the earth barriers shows the solidarity and compact nature of the army of China's first emperor.

400 horses and 89 war chariots in a pattern bringing the cavalry, infantry and chariots together protected by an armed vanguard. Trench number three appears to be the headquarters or the command post for the entire army. It contains a single war chariot and 68 apparently exceptional soldiers armed with bronze javelins.

The figures vary in size. The warriors are slightly taller than life size. The horses are about five feet tall and about six feet long. The soldiers and officers have full military equipment which could have actually been used in battle.

The weapons are made of the best quality materials and include lances, javelins, halberds, axes, hooks, swords and crossbows. The wooden carts and bridles of the horses are also suitable for real use. Some of the soldiers and horses have symbols etched or printed on their heads and bodies with stamps that apparently

indicate the craftsmen who made them. The names of over 85 of these master craftsmen have been found, all of them highly skilled artisans who apparently employed numerous assistants and apprentices.

Scholars believe that each craftsman had about eighteen assistants.

In addition to the names of the sculptors, there are places where the names of other, apparently lower level, functionaries appear as well as inventories of the number of soldiers and horses.

In addition to the great number and imposing appearance of these statues the most striking thing is the extreme realism and precise details these craftsmen gave this army.

The finishing and shapes of the chariots reflect the customs of the time while the horses, including blinders, bridles, bits and saddles are absolutely realistic.

The same precision can be found in the

stature, bearing, clothing and hairstyles of the warriors, but it is most of all the features of the faces which have the greatest impact on the viewer.

These even show the ethnic characteristics of the various parts of the empire from which the emperor's army were recruited. Therefore, some of the statues have elongated profiles, large mouths, fleshy lips, high foreheads, and wide cheekbones, typical of people from the central valley of the River Wei, while others have the round

262 *A young junior officer, whose rank we can identify by the simple helmet and combat uniform covered by square-plated armor, shows both expressive bravery and austerity.*

262-263 *The shape and appearance of the lined up infantry show the real situation of the great army of the state of Qin. The officers can be recognized by their more elaborate hairstyles and the braid on their shoulders. The infantrymen show simpler hairstyles covered with hoods. Every face is different, expressing its own personality in these statues which are masterpieces of ancient Chinese sculpture.*

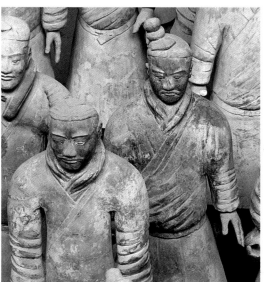

263 bottom *Here are stable boys from the first rows. The seriousness and determination in the faces of these servicemen contrasts with the inferiority of their condition, which we can see in the simplicity of their clothing and hairstyles.*

263

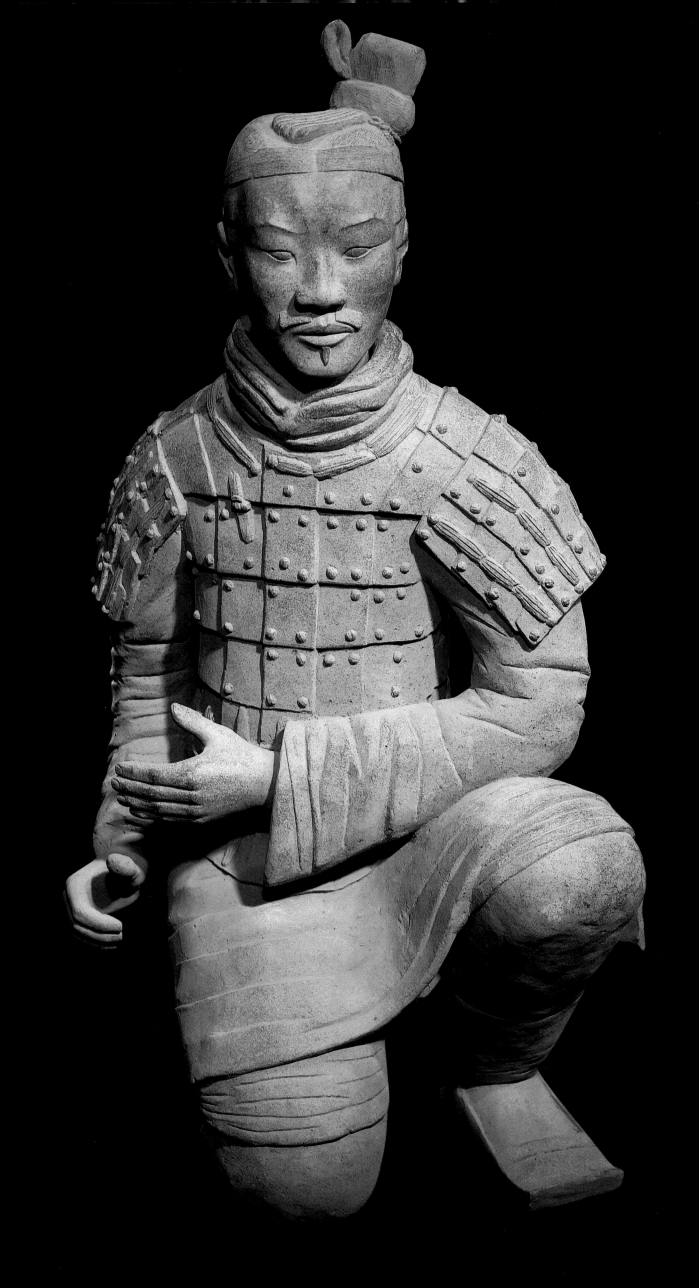

or oval face and prominent chin of the inhabitants of modern Szechuan. Each figure has a truly realistic expression and its own individual features which differ from the other figures.

While the lines and modeling of the bodies of the statues are fairly simple, the heads are highly detailed. The eyebrows are treated with great care. The hair, usually in a topknot beneath a helmet or simple hood, is realistically styled as are the mustaches of many of the soldier. The bodies of the statues have a certain uniformity in styling, apparently due to the fact that they were usually hand-made on the spot, while the heads were designed from an initial sketch, to which the features of the face and expression were added later.

The statues represent different builds, ages, personalities and moods. Each figure seems to have his own character.

Traces of color on some of the statues indicate that after being baked in furnaces at a temperature of around 1,000 degrees Celsius the statues were painted with a variety of colors.

Although most of this color has been lost a few statues still have all their original coloring.

The statues represent not only the high

In this way, King Zheng intended his rule to mark the beginning of a new era and for this reason he placed the character for "shi", which means the first, in front of his title. He was therefore the first Huangdi in a dynasty which he viewed as lasting for 10,000 generations.

This did not, however, turn out to be the case. Instead, he reigned for only twenty years or so and was replaced by the much stronger Han dynasty (206-220 AD) although the reforms he introduced influenced Chinese history for over two thousand years. His fundamental objectives were the political and military unification of the whole of China and the centralization of power.

He believed that the base of the united state rests on the fa, or law.

This meant that the base of the united state was the adoption of a very strict code of laws throughout the country, to guide the government of the ruler. This was an exceptionally modern concept.

Confucians believe that the ideal good ruler is a man with all the virtues.

Taoists believe the ideal ruler is one who did not rule. For the fa school the king would not apply his own will in an arbitrary way, but had the precise task of controlling the correct and fair application of the law.

The code of Qin, founded on the principle of

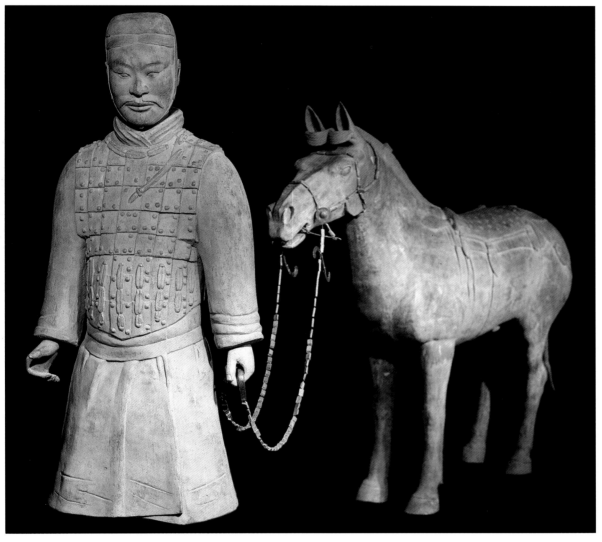

264 and 265 right A crossbow man is kneeling, about to shoot. As his body had to sustain the shock of enemy attacks, he was issued with heavy armor, leggings and square-toed shoes. The position of his hands on his right side show that original he held a real crossbow.

265 left A horseman and his mount. The braided hair covered with a hood, the simplicity of the armor and the single combat tunic shows this warrior was of a low rank. The bit and bridle are copper plate, standard in the state of Qin.

artistic levels and maturity reached by Chinese sculpture during the Qin period, but also establish a style which was to transform the sculpture of the period and develop as typical of Chinese plastic arts in later ages.

The warriors, horses, chariots and weapons in the trenches form a complete army, emphasizing the power and size of the force with which Qin Shihuang was able to bring about the unification of the empire.

In 221 BC King Zheng of the state of Qin took on the new title of Huangdi, which is usually translated as "August Emperor", a term which previously had been used only of sovereigns in the far distant past who, according to tradition, had contributed to the founding of Chinese civilization.

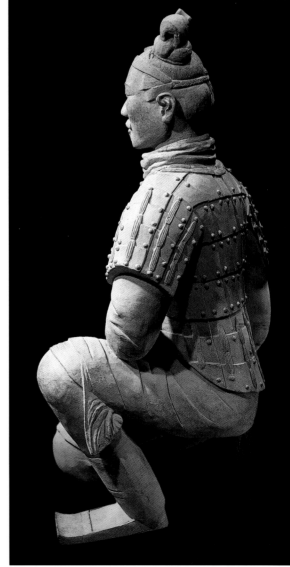

collective responsibility, was imposed throughout the empire to establish principles to which future rulers would adhere with the certainty that the law would protect subjects from the whims of the rulers.

Qin Shihuang's work of unification included the adoption of a set of measures of weight, capacity and length applicable throughout the empire as well as the

in today's cultural unity in China.
In addition, this leader put into effect a unification measure throughout the territory which created a single axle width for carts based on the measurements used in the state of Qin. It was probably these accomplishments that justified this emperor, despite his relatively short reign, being accompanied in death with his own powerful army.

266 bottom left This is an army charioteer as can be told from his helmet. He wears a breastplate above his combat uniform, leggings and square-toed shoes. The position of the right hand suggests that this figure originally held a real weapon, possibly a sword.

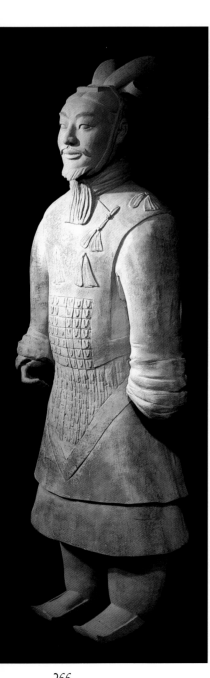

distribution of the circular coins used under his rule which became the only legal tender.

Another measure of unimaginable importance for the future of China was the unification of the writing system.
The letters used during the first period of Zhou (1066-221 BC), in the style called the Great Seal, had changed tremendously over time throughout the country so that scripts were significantly different from each other. Under the central government, the characters were simplified and rationalized to the style used in Qin, called the Little Seal, so that there was a single style of script throughout the empire.

This uniformity of writing despite different dialects in speech is a determining factor

In addition, of course, to illustrating the power of this great ruler, accompanied as so many rulers were into the afterlife with his own servants, the findings of this army illustrate once again the amazingly almost haphazard way in which many of our great archaeological finds are discovered. No one remembered that at one time a great terra-cotta army had been created and buried with a great emperor. It was just, as so often has been the case, chance that ordinary peasants at their ordinary work made a discovery that astonished the world.

266 right A cart horse with shaved mane and handsome tail. In the trench of the cemetery of Qin Shihuang these horses were divided into groups of four, with two yoked to the shafts and the other two in free traction for manoeuvres. The horse has such a realistic expression it seems as if it is about to neigh.

267 The distinct features and elongated face of this figure show all the dignity of an officer, looking proudly to the front. Note the highly elaborate headgear with knotted ribbon under the chin. The armor and the ribbons on the breastplate show signs of high military rank.

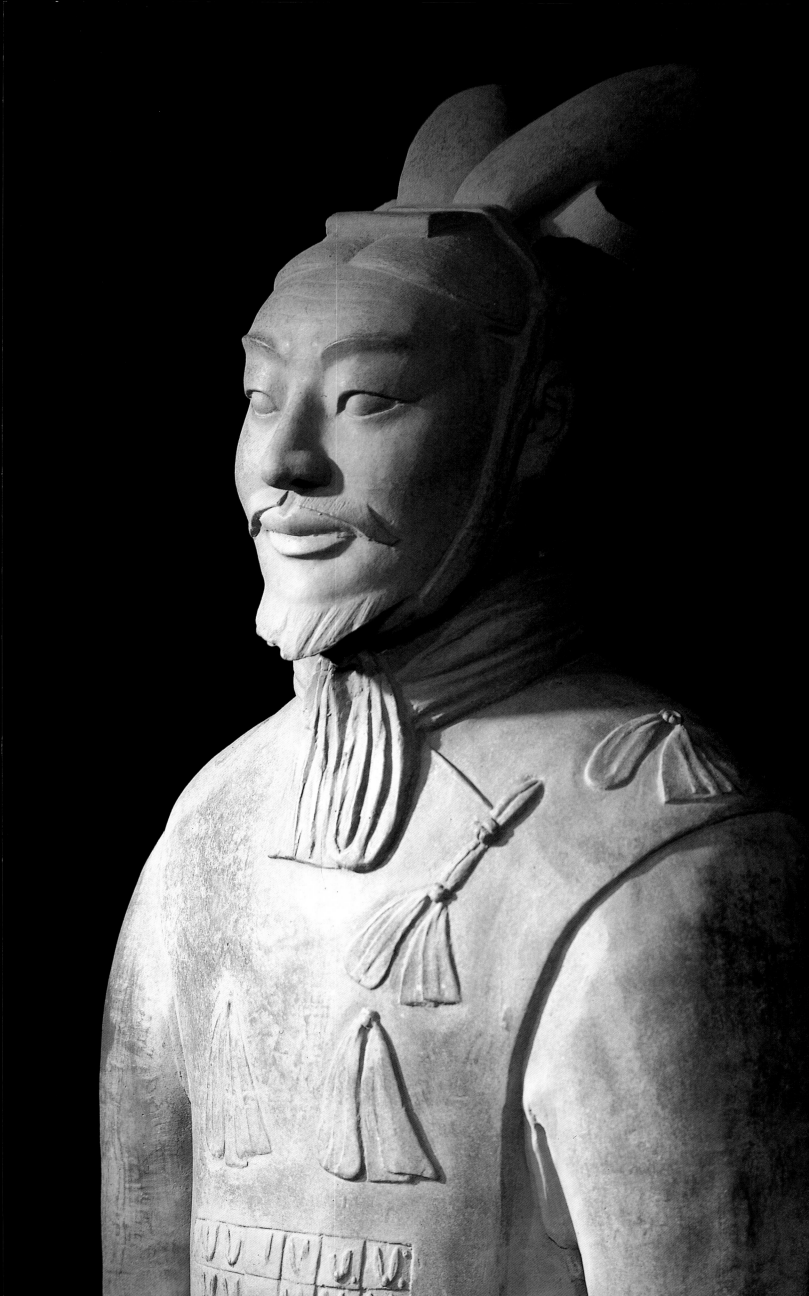

LUOYANG, THE CAVES OF LONGMEN

268-269 A partial front view of the complex of the caves of Longmen. In the foreground is the cave-temple of Fengxian, with an enormous statue of Buddha Amithaba in the center, accompanied by a bodhisattva. On the walls of the great hall and dug from the rock that form the central complex of the temple are two imposing figures of celestial guardians.

The cave is reached by a ramp of stairs which winds through a series of niches dug at the edges of the main temples. On all the rocks of the Longmen complex, next to the main temples, numerous small sanctuaries were built on behalf of single donors.

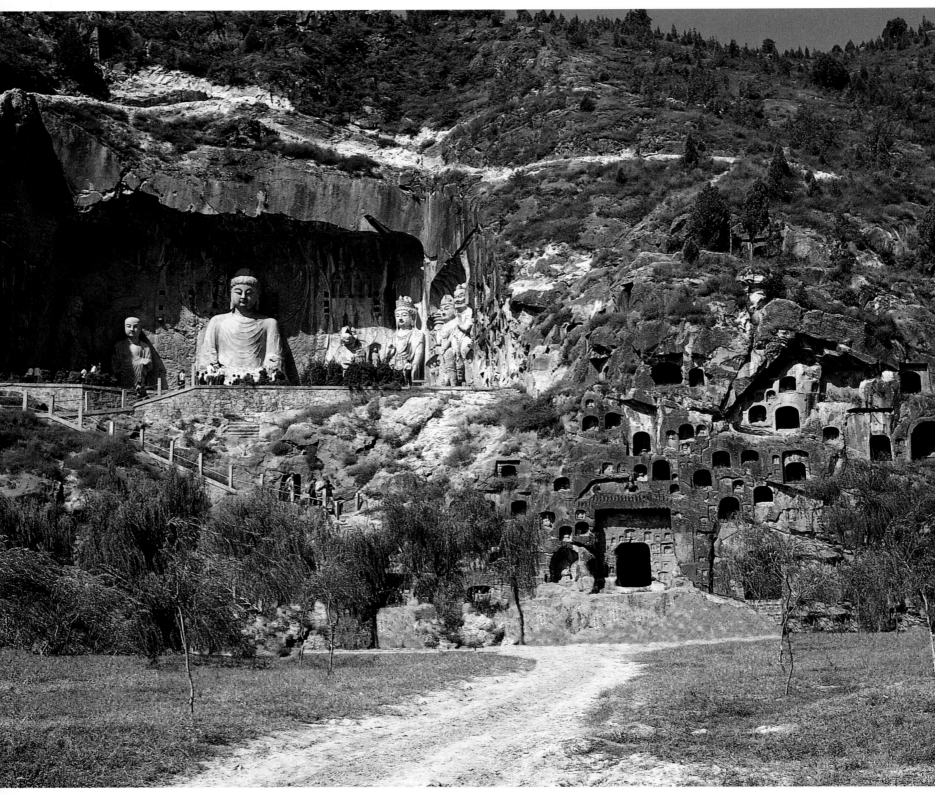

269 top left On the right is standing one of the two great statues of the celestial guardians, 30 feet high. Giants with ferocious expressions are found in many Buddhist temples. Their role was to protect the Buddha from evil spirits. Next to this statue is that of the King of the Celestial Guardians, standing over a dwarf and holding a model of a stupa in his left hand. It was customary to place such guardians at the sides of the entrances to important houses.

About 10 miles south of the city of Luoyang in Henan in China is the cave-temple complex of Longmen. Work on the construction began in 494 AD, during the Northern Wei dynasty (386-534 AD) making use of the original rock clefts, and continued for over 400 years, under various dynasties. The complex extends for over a mile along the rock walls on the banks of the River Yi which is rich in a compact gray limestone particularly suitable for precise, detailed carving.

Over 97,000 statues of Buddha and *bodhisattva* were sculptured out of these walls in various sizes. The largest is over 60 feet high, the smallest is less than an inch. There are also 1,325 large and small caves, 750 niches, and 40 pagodas which together provide the most dramatic and significant evidence of the importance of devotion to Buddha in medieval China.

Buddhism emerged in China during the 3rd century BC. It is unlikely that any images of the Buddha were produced before this date. Research indicates that there was a flourishing Buddhist community in Luoyang by the end of the 2nd century AD and this community later became the center for Buddhism in the country. It was this community that drew up the first monastic rules and the construction of the Longmen complex can therefore be seen as a sign of the importance that the priesthood had acquired.

The construction of the grottoes can be divided into two stages. In the first, which lasted from the start of the Northern Wei to the Sui dynasty (581-618), there are still certain archaic elements in the sculpture. Since three-dimensional sculpture had not yet been developed the figures are all seen against a background so that they are seen in a front view only. The interiors of the grottoes are decorated with images along all the walls on a rich background with almost no space left uncovered. Endless rows of figures are shown with various degrees of realism, with long, angular bodies, thin waists, drooping shoulders, extremely long necks and narrow heads. The faces of the

269 bottom left The central statue of the Buddha in the Fengxian cave. The enormous size of the figure, almost 60 feet high, is softened by the face which is lit up with the hint of a smile, suggesting the sense of well-being typical of believers in the Buddha. The expression is intensified by the arched eyebrows above the eloquent eyes. The figure of the Buddha, seated in the traditional lotus position, blends in with the images of the bodhisattva that accompany it, presumably Avalokitesvara and Makasthamaprapta, making it one of the finest examples of Buddhist sculpture from the Tang period.

269 top right Detail of the wall with celestial guardians in the Fengxian cave, with images of Buddha dug from the rock. The small figures show a certain uniformity in their clothes and hairstyles but are distinguished from each other by their hand gestures.

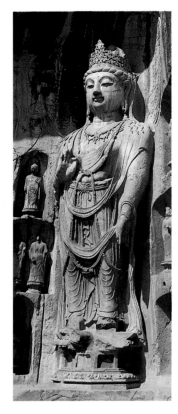

statues have small mouths, eyes which are only narrow slits, high arched protruding eyebrows and earlobes, stretched as was the custom, at the side of pointed chins. The overall impression is of a light, almost fleeting beauty, innocence and an infantile purity that runs through all Chinese Buddhist sculpture of this period.

Typical of this first stage is the great halo, or nimbus, in the form of a leaf that forms the background to the seated or standing images of Buddha and bodhisattva. The most common images are of the historical Buddha, Sakyamuni, but as a result of the spread of the Mahayana Buddhist doctrine, according to which everyone can reach the condition of Buddha with the help of the bodhisattvas, beings who stop on their path toward enlightenment to assist common mortals along the same path, there are also thousands of bodhisattvas shown on the walls of the grottoes along with the various Buddhas in scenes illustrating the sacred writings.

With the spreading of the best-known of the *Sutras*, the story of the Lotus of the True Law, the figure of Bodhisattva Avalokitesvara was introduced to Longmen. In China this takes on the form of the only female figure from popular Chinese religion, Guanyin, the Buddha of Piety, often shown

with a thousand eyes or arms. There are also many images of Buddha Amithaba, whose worship in China dates back to 386 AD. The second building stage began with the Sui dynasty and marks a true step forward in the history of Chinese Buddhist sculpture. It is in this period that isolated stone statues, treated in individual styles and showing a new degree of sensitivity, reflecting a more direct contact with the Indian style, appear. The body of the Buddha clad only in a light

drapery is undecorated except for a delicately carved circular halo with a luxurious leaf motif inside it. The bodhisattvas, also surrounded by a floral wreath influenced by the luxurious Indian styles, are shown wearing heavy jeweled ornaments, crowns, necklaces and pendants, symbolizing the gifts of rich donors. Along the bank of the river the first grotto, called Qian Xi, contains the Buddha Amithaba with two disciples, two bodhisattvas and the guardians. The three following grottoes, known as Binyang, were probably completed in 523 AD and are perhaps the most important examples of the mature rock sculptures of Longmen. The shrine, 25 feet long and 20 wide, is clearly designed with the main statue of Buddha, sculpted from the rock, against the 12 foot

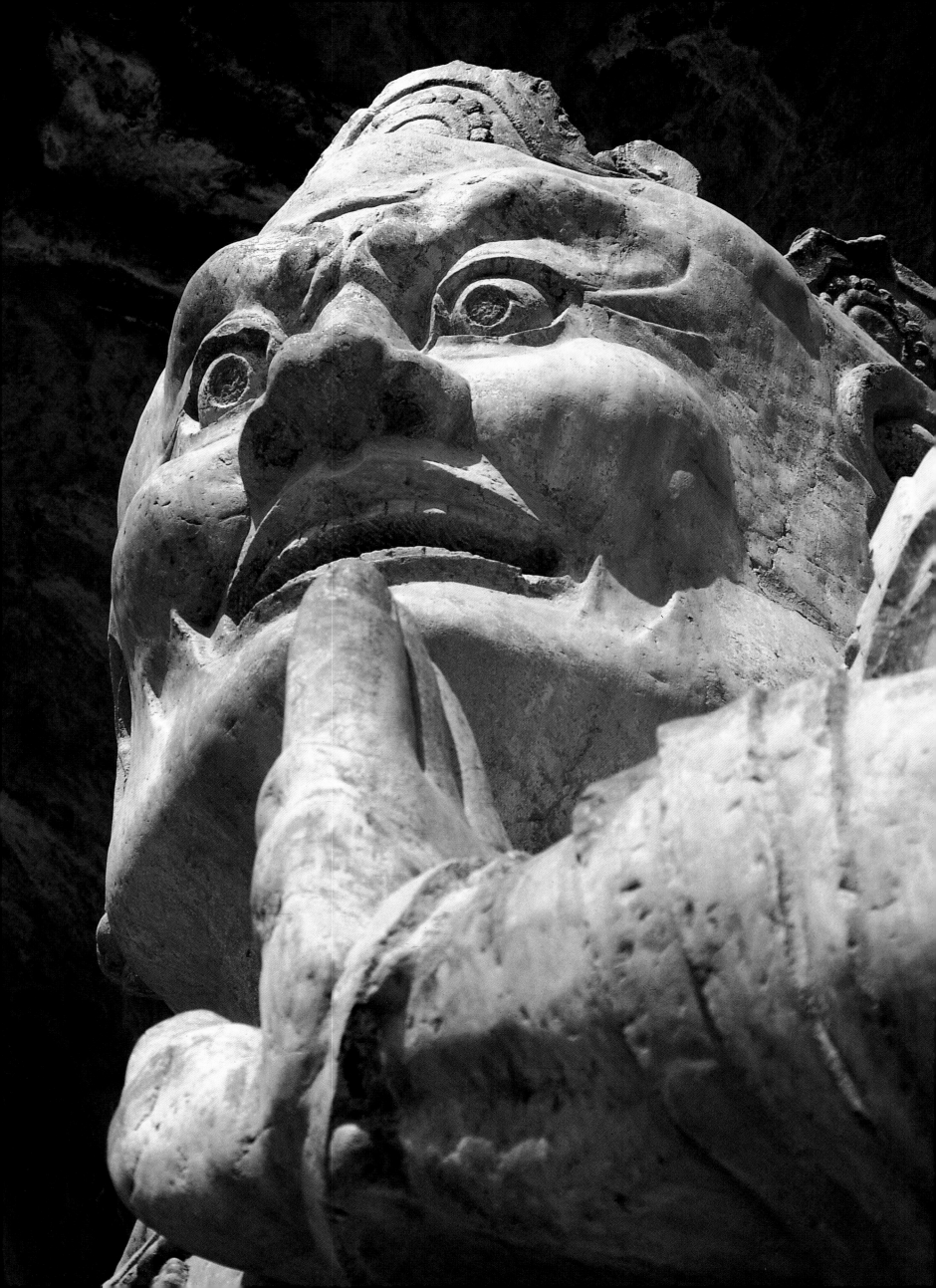

Luoyang

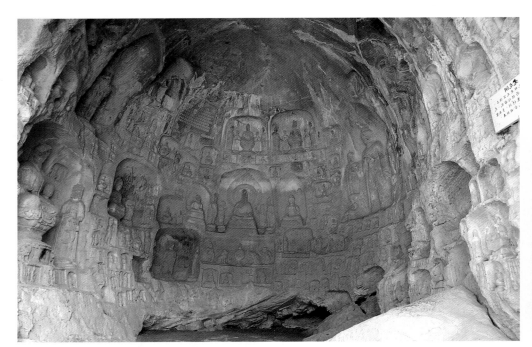

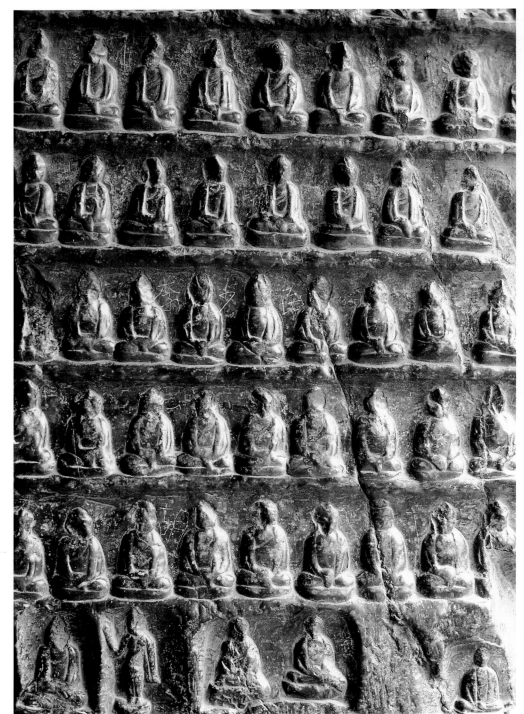

272 top left In the grotto of the Guyang, built in the reign of the emperor Xiaoming (488-528) of the Wei, various niches were dug which contain scenes of the day-to-day life of the Buddha and a number of bodhisattvas with their hands in significant gestures. The age of this grotto can be seen from both the archaic style of the figures which are typical of the first stage of Buddhist rock sculptures in China and the way in which the images overlap.

272 bottom left A detail of the north wall of the Guyang grotto. The repeated statues of Buddha in a variety of positions along the vault of the cave demonstrates intense devotion, expressed in a somewhat archaic way.

272-273 Here in the small niches in the southern wall of the Guyang cave episodes from the daily life of the Buddha are shown. They are enclosed in an architectural structure in Han style, which are enriched with festoons separating them from each other. Images of devotees worshipping the Buddha are also sculpted into the walls.

273 top right In the north wall of the Lianhua cave and in larger caves containing statues of the Buddha in various postures a number of small niches, holding figures of the Buddha alone or with two seated bodhisattvas, have been sculpted. The damaged faces of most of these show the hostility to Buddhism that is part of various periods in Chinese history.

273 bottom right The statue of the Buddha flanked by two bodhisattvas, standing on a lotus-shaped platform, is sculpted in the southern wall of the central grotto in the Binyang group and gives some idea of the artistic maturity of the Longmen sculptures. The central figures of the Buddha expresses the synthesis between the Chinese and Indian styles.

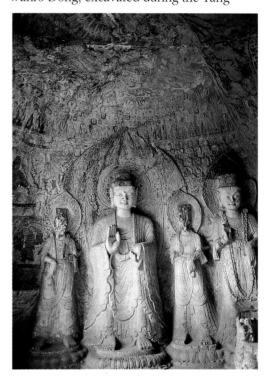

Tzi, the found of Taoism.

Following is the grotto of Fengxian Si, a large chamber dug from the rock which it is believed originally held a wooden temple of which no trace remains.

Inside there is a large Buddha with bodhisattvas off to the sides, still in excellent condition. Two heavenly guards, giants with ferocious expressions, are on the walls. These are found in many Buddhist temples and their role is to keep spirits hostile to Buddha away. Further south is the grotto of Wanfo Dong, excavated during the Tang

wide rear wall. Buddha is seated cross-legged on a step which is nearly 20 feet wide and is accompanied by statues of his disciples who are flanked by two enormous standing bodhisattvas. Against the side walls is a standing Buddha assisted by two bodhisattvas. The space in between, bordered by almond designs and haloes, is filled by rows of worshipping figures. On the opposite wall, at the sides of the door, is an almost life-sized effigy of the emperor to the left and the empress to the right along with a group of courtesans who represent donors to

this combination cave-temple.

The grotto of Lianhua Dong, which means "Lotus Flower", is distinguished by the lotus-shaped roof vault with the whirling movement of the apsaras, or heavenly dancers.

The Guyang cave is the oldest. On the side walls with their many niches we can see scenes from the everyday life of Buddha and the various bodhisattvas with their hands in various significant gestures. The most outstanding statue is that of the Buddha Maitreya which is believed to have been altered in the 17th century to look like Lao

period (618-907 AD) for the Empress Wu Tsetian. The name of this cave, "Ten Thousand Buddhas", comes from the fact that innumerable small statues of Buddha have been carved from the rock. There is also an image of Amithaba on a lotus-shaped pedestal supported by four giants, protectors of Buddhism.

Following the Tang dynasty little was added to this complex. Followers of Buddhism frequently suffered from persecution and the classes which had supported this religion turned away from it.

AMERICA AND OCEANIA.
Introduction

Europeans came to the Americas only recently. Up to 500 years ago our ancestors knew nothing of the continent's existence and certain foods, now familiar, including corn, cocoa, potatoes and tomatoes were completely unknown until the Americas were discovered.

To this day the major questions continue to be asked, including where did the people of the Americas come from? Did they always live there, or did they come from somewhere else? And if their origin was somewhere else, how did they arrive at this land? Unlike explorers and archaeologists of the past, today there are many experts studying these questions, including anthropologists, geneticists and linguists. Today, all we know for certain is that the people of the Americas apparently originally came from Asia, but no one knows for certain why, when or under what circumstances these ancient groups of humans, scientifically defined as "Paleo-Indians", migrated from Asia and how many of them made the move. Recently, various trends have developed in the thinking of the experts. During the last Ice Age, there was a stretch of land free of ice, known as Beringia where today lies the Bering Strait which divides Siberia from Alaska. This joined the two continents, was covered in vegetation, and inhabited by large animals and nomadic hunters from Siberia. Many researchers believe that when the glaciers began to melt, submerging Beringia, around 10,000 BC, the first of three waves of migration took place, involving people searching new lands in which to live and hunt. These people came down along the

natural passageway, a corridor free of the glaciers that had formed as a result of various geological changes, and reached the Great Plains of North America. This theory, which is based on genetic, archaeological and linguistic studies, is not accepted by other scholars who have recently carried out very specific genetic comparisons based on DNA. These scholars believe that the first humans reached America much earlier, around 30,000 BC. What makes the situation both somewhat more intriguing as well as more complicated are recent finds of human remains in South America which carbon dating show to be much older than 10,000 BC, leading to the need to consider that some of the migratory movements took place by sea during periods which we cannot be exact about.

In our journey through this part of the world, we will visit the most significant stops in Pre-Columbian history and follow the traces left by the most important of the cultures that developed on the American continent before the arrival of the Europeans. The most important archaeological sites are described not only in terms of their architecture and the treasure they concealed, but also as to how they were discovered and how they appeared to the first European explorers. Our journey will begin in North America. From the most outstanding cultures in what is now the United States of America, we chose the Anastasis, an ethnic group of very ancient origin, known as the "Pueblos" by the Spanish, a name which is still used today. Between 250 and 1200 AD these people built large villages, cities and fabled palaces along the canyons of the high plain of Mesa Verde, many of them above sheer drops on rocky outcrops. Today, this area is an archaeological attraction of major importance in a very special natural setting of great beauty and is considered an international inheritance.

Moving south, we stop at a number of places in the geographical and cultural area defined by archaeologists as Meso-America. Here,

in the countries known today as Mexico, Guatemala, Belize and Honduras, countless remains have come to light, left behind by people whose names are famous today including the Mayans and the Aztecs and others less well known, whose history remains shrouded in mystery. Monte Albán, the first stop on the route through Central America, is currently believed to be the oldest city in pre-Columbian Mexico. If Monte Albán is the oldest city, Teotihuacan, built on the Mexican plateau a few centuries later by people of an unknown race, was the biggest and also one of the most flourishing with a very modern layout. The Aztecs considered it to be the City of Gods. The visitor cannot help but be impressed by the gigantic pyramids, the long streets and the palaces with their frescoed walls full of religious and cosmographic symbols common to the entire Indo-American world. Thanks to recent discoveries in the deciphering of scripts the Mayan civilization has begun to reveal its mysteries. Among the many Mayan cities that have been freed from the tropical forest vegetation, Tikal and Palenque occupy special places. Tikal is famous for its towering pyramids and the pillars whose inscriptions, now deciphered, have brought to light a great deal of previously unknown history and dynastic events that took place during the Classical Period. Palenque concealed under the base of one of its temples, not revealed until the 1950s, the tomb of the well-known king Pacal, also called "The Sun Shield", together with its precious burial treasure. When the Mayan civilization fell into decay, new towns began to spring up in the Yucatán peninsula, with architectural features that differed from those of the cities that had flourished in previous centuries. Among these, Uxmal is famous for the elegant refinement of the friezes which decorate its palaces and the great importance of the image of the Rain God. The presence of this cult is also an important feature in Chichén Itzá, built sometime after 1000 AD. Here, where Mayan art mixes with the cultural contribution of the Toltec invaders, our

journey through this part of America ends. In Peru, our archaeological journey takes us to a destination that is basic to the history of the civilizations that flourished before the Incas. This is a city known as Chan Chan, the capital of the Chimu people, with its buildings decorated with magnificent stone frescoes. Chan Chan is the most important archaeological complex so far found in the Peruvian area and dates back to the period before the Inca empire. However, in Bolivia, close to the shores of Lake Titicaca, there are the colossal remains of another religious site, whose history is, in a way, linked with that of the civilization that rose up on the Peruvian plateau. This site, Tiahuanaco, which may be the ancient center of a cult linked to the movements of the stars, has monuments which are reminiscent of the megaliths of prehistoric Europe. Tiahuanaco must be included in a study of the pre-Columbian sites of the Andes.

The archaeological panorama of pre-Columbian Peru ends among the imposing

ruins left behind by the representatives of the huge empire known as the Tawantisuyu in their own language and as the Incas to us. Only a few traces of their glorious ancient capital, Cuzco, remain, as it was destroyed by the Conquistadores from Spain who, by killing the ruler Atahualpa in 1533, brought the independence of the Andean people to an end. Today, buildings from the Colonial and post-Colonial periods stand on top of the temples,

palaces and houses of the ancient people. However, other sites with structures on a huge scale and purposes that are still not fully understood, such as Ollantaytambo, Sacsahuaman and Macchu Picchu, whose walls and staircases rise up among the wild mountains, show the power of the Incas and their ability to work in stone. One manuscript that has been found says that one of the rulers of Cuzco, known as Inca Topa, made a number of exploratory voyages by sea in a balsa wood craft which, it is believed, may have taken him as far as the archipelagos of Polynesia. This particular legend of the Incas leads to a number of interesting questions, leading us to consider the many enigmas and theories developed by various scholars. Research using archaeological and anthropological methods seems to indicate that the islands of Polynesia were populated from 4000 BC onward as the result of the last wave of migration by people from Southeast Asia. These people, who had begun their travels some time earlier, sailed in a raft which is known in Tamil as a kattumaram, and is the predecessor of the modern catamaran. On the other hand, some noted scholars, including the Norwegian Thor Heyerdahl, on the basis of botanical and other studies, believe that there were contacts between Polynesia and South America in the even more remote past. According to this theory, pre-Inca people crossed the Pacific Ocean on balsa rafts taking with them plants, religion and other elements of their cultural heritage to these remote islands. The voyage of the raft Kon Tiki, made by Heyerdahl in 1947 from the coast of Chile to the Tuamotu Islands, proved that it was possible to sail for long distances and periods on these fragile balsa wood crafts built by the ancient Peruvians. Viewed in this light, the most fascinating enigma presented by these distant islands is that of Rapa Nui, better known as Easter Island. Easter Island is 2400 miles from the coast of Chile. Its name comes from the fact that it was first

sighted by the Dutch admiral Jacob Roggeveen on Easter Sunday of 1722. The island was later visited by other sailors, including the famous Captain James Cook, and they were all astonished by the gigantic statues, called moai by the inhabitants. Who were these people? Why did they build these huge statues of rock from the volcano Ranu Raraku? One fairly widely accepted theory is that the first inhabitants of Rapa Nui came from the Marquis Islands, over 2400 miles away between 400 and 500 AD, although carbon dating has not so far confirmed this belief. The moai have been interpreted as symbols of the ancestors, worshipped like gods, but there are other theories about this, too. Heyerdahl, on the basis of oral tradition and iconographic motifs, tends toward the theory that Easter Island was colonized by people from the Peruvian coastal regions, perhaps the Incas themselves, who brought the cult of the god Viracocha to the island with them. These are the mysteries that, despite the many sophisticated tools available to us today, continue to perplex archaeologists. It has always been this way and we can be fairly sure it will always be this way. Some enigmas have been explained, others are being solved, new theories replace old ones. After all, it is precisely this element that can be said to make the study of archaeology so fascinating.

Maria Longhena

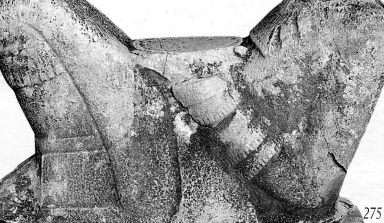

CONTENTS

MESA VERDE

CHICHÉN ITZÁ

UXMAL

TEOTIHUACAN TIKAL

PALENQUE

MONTE ALBÁN

CHRONOLOGY

Presumed start of human colonization in the Americas (ca. 40,000 - 30,000 BC)

Settlement stage of the Meso-America peoples (2000 - 1500 BC)

Birth of the Maya civilization, Meso-America (ca. 2000 BC)

Development of the Olmec ceremonial center of St. Lawrence, Meso-America (ca. 1200 BC)

Birth of the first Andean civilizations, South America (ca. 1200 BC)

Destruction of St. Lawrence and foundation of the center of La Venta, Meso-America (ca. 500 BC)

Birth of the San Augustín civilization, South America (ca. 700 BC)

Flourishing of the civilization of Chavín de Huantar, South America (700 - 100 BC)

Presumed foundation of Monte Albán, Meso-America (600 BC)

Oldest stone inscription in Meso-America (ca. 600 BC)

Start of the decline of the Olmec civilization, Meso-America (ca. 400 BC)

Flourishing of Teotihuacan, Meso-America (200 AD)

Height of power of Teotihuacan, Mesoa-America (ca. 250 - 700 AD)

Height of power of the Mayan civilization, Meso-America (ca. 250 - 800)

The oldest date recorded on a Mayan inscription (Stone 29 of Tikal) (292)

Maximum splendor of the Mochican civilization, South America (ca. 300 - 800)

Birth of the Anastasi civilization, North America (350)

Presumed arrival of the first colonists on Easter Island (ca. 500)

Height of power of the civilization of El Tajin, Meso-America (600 - 900)

Violent destruction of Teotihuacan, Meso-America (725)

Gradual abandonment of Monte Albán and foundation of Mitla by the Mixtecs, Meso-America (ca. 800)

Flourishing of the Mayan Puuc style in the Yucatán, Meso-America (800 - 1000)

Decline of the Mayan cities of the low plains, Meso-America (ca. 800)

Toltec conquest of the Mayan cities of the Yucatán, Meso-America (ca. 900)

Maximum splendor of the civilization of Tiahuanaco, South America (ca. 900 - 1000)

Foundation of Macchu Picchu, South America (ca. 1150)

Birth of the Chimu empire, South America (ca. 1200)

The Mochican civilization is absorbed into the Chimu empire, South America (ca. 1250)

Height of power of the Tairona civilization, South America (ca. 1200)

Birth of the Aztec civilization, Meso-America (ca. 1250)

Chichén Itzá is abandoned, Meso-America (ca. 1200)

Decline of the Anastasi civilization and abandonment of the pueblos, North America (ca. 1300)

Foundation of Tenochtitlán, capital of the Aztec empire, Meso-America (1345)

Birth of the Inca empire, South America (1438)

The Chimu empire submits to the Incas, South America (1465)

Christopher Columbus discovers the Americas (1492)

Arrival of Cortéz in Mexico (1519)

Murder of Moctezuma II; Mexico annexed to the Crown of Castille (1521)

The Quiché Maya suffer their final defeat by the Spaniards in the Battle of Utatlan, Meso-America (1524)

The Incan empire reaches its maximum expansion under Huayna Capac, South America (1527)

Francisco Pizarro arrives in Peru (1532)

The Inca emperor, Atahualpa, is assassinated on the orders of Pizarro (August 29, 1533)

Manco Capac II, last Inca ruler, assassinated by the Spaniards. End of the Inca resistance (1544)

EASTER ISLAND

America and Oceania

America and Oceania

CHAN CHAN

OLLANTAYTAMBO
MACCHU · CUZCO
PICCHU

· TIAHUANACO

MESA VERDE,
THE ROCK PALACES

The National Park, Mesa Verde (Green Table in Spanish), is a small corner of the southwestern plateau of Colorado in the United States. This plateau is known by the name Four Corners and, with its conifer forests, was for many centuries the most important home of the Anastasi Indians. When Mesa Verde was abandoned around 1300 AD, its many remains and deserted cities were not forgotten as so often happens, but rather remembered through oral tradition over the centuries.

At the end of 1888 the brothers Richard and Alfred Wetherill, accompanied by their brother-in-law Charlie Mason, cattle breeders and landowners in the River Valley area to the east of Mesa Verde, were the first to explore the area. At the end of that year they discovered the ruins of buildings and large settlements. Explorations were continued during the years that followed by a young Swedish explorer, Gustav Nordenskiold, who wanted to carry out an archaeological survey where these local explorers had found the mysterious "lost cities". He excavated numerous remains of settlements at the highest point of the areas now known as Wetherill Mesa and Chapin Mesa. Mesa Verde became a national park in 1906 which protected it from exploitation and from then onward systematic archaeological studies have continued. Today it is possible to visit these remains of the Anatasi people which are maintained and constantly restored by the National Park Service of the United States of America. For centuries, the Anastasi Indians lived in the southern plateaus of Utah and Colorado and

the northern plains of Arizona and New Mexico. Traces of their towns and culture have been found throughout Mesa Verde. The history of the settlement of Mesa Verde in ancient times, through the first centuries AD, remains a mystery. At the present time, archaeologists have been able to identify four successive periods of occupation, corresponding to four stages of cultural development. The first, known as "Basket Maker III", dates from 450 to 750 AD, the second, "Pueblo I", from 750 to 900, is followed by "Pueblo II" (900-1100 AD), and finally, "Pueblo III" (1100-1300 AD). This latter was the last period of settlement before the total departure of the Anastasi from the mesas. The first human beings to reach these zones were hunters and herdsmen. After they abandoned their nomadic lifestyle and became sedentary they began to grow corn and pumpkins. They did not make pottery but instead used sophisticated containers made from vegetable fibers. It is from this practice that they were given the name of Basket Markers. Their primitive huts, simple trenches dug out under the ground and supported by wooden stakes, are named jacals. These soon expanded into small villages, originally at the base of the rocky heights, then later on the high plains, near the cultivated areas. Around 500 AD, the Basket Makers discovered the techniques for the manufacture of pottery and the use of the bow and arrow and began raising turkeys. In various sites of the Mesa Verde National Park, especially at Ruins Road and Step House, we can admire the structure of

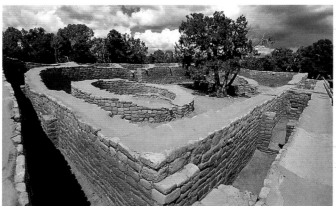

278 bottom left As well as the many-roomed rock houses, towers and kivas, the Anastasi Indians of Mesa Verde also left a series of inscriptions in the rock. These date from between 900 and 1000 AD, and show scenes of dancing and ritual related to hunting and religion.

278 bottom center Along the Ruins Road of Mesa Verde are several villages with trench houses and kivas.
The group of sites gives visitors an idea of the levels and architectural development of the site over a period from 600 BC to 1200 AD.

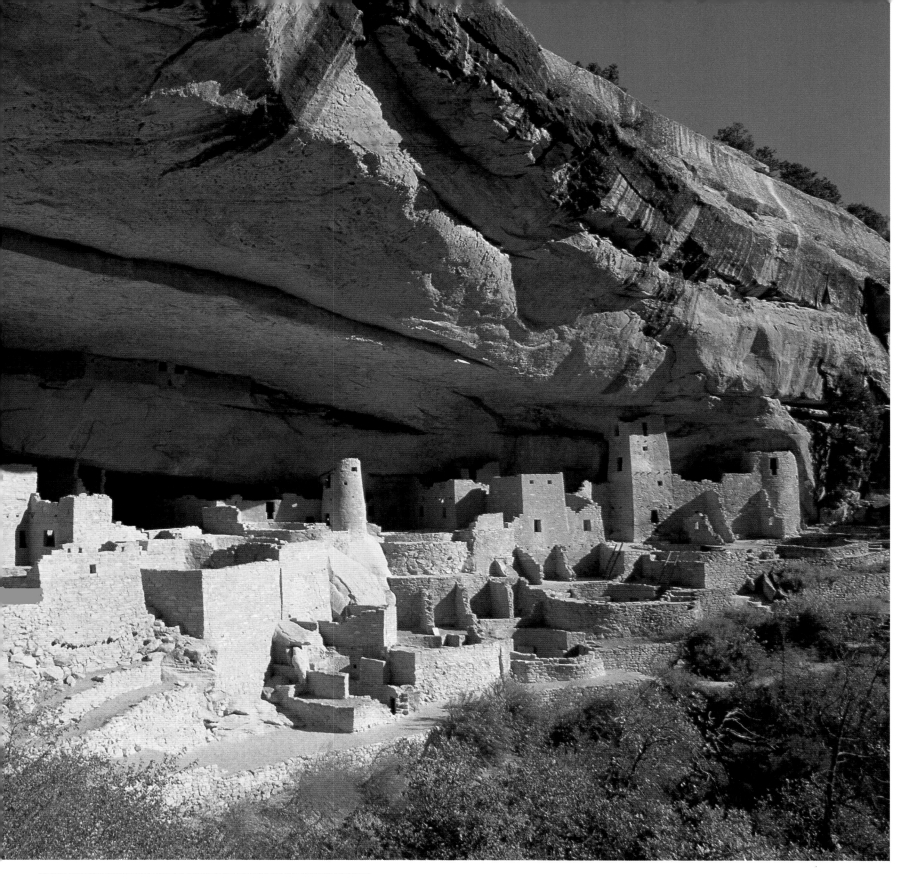

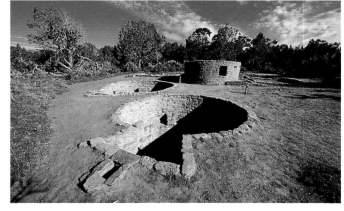

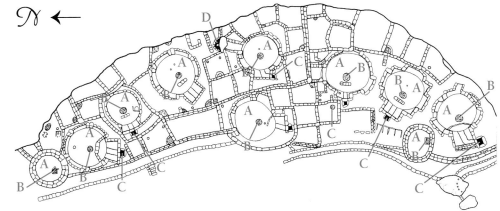

278 bottom right The so-called Sun Temple, a vast distinctive structure surrounded by double walls, was probably either a temple or a funereal monument. High levels of skill can be seen in the way the stone was worked.

278-279 The adventurous cowboys who, at the end of the 19th century, discovered Cliff Palace were amazed by the fairy tale appearance of this town which towers over Cliff Canyon. It contains 220 rooms and 23 kivas.

279 bottom In the northern part of Chapin Mesa is the site of Far View House, built by the Anastasis some time after 1100 AD. The photograph shows one of the five huge kivas which were built, as were 50 rooms, on a terrace supported by a low wall.

A Round rooms, or *Kivas*
B Hearths
C Ventilation openings
D The mouth of a tunnel

Plan of a residential complex in the National Park of Mesa Verde

these houses. One of the best conserved, site number 117, consists of a large room with a central hearth and an antechamber for access and ventilation.

The mud and straw roof was held up by four robust wooden beams and was pierced to allow smoke to escape. From 850 AD onwards, in the Pueblo I phase, the Anastasi changed their living habits. They did not completely abandon the trench houses, but started to build houses above ground on the mesa. These new houses consisted of several rooms with a square floor plan. Originally they were built of dried clay and straw and later with regularly shaped baked bricks. As time passed, the number of rooms in these houses increased and they took on a complex structure, expanding to form villages later called pueblos by the Spanish. The economy and skills of the inhabitants of Mesa Verde, originally based

have been identified in Chapin Mesa, and not far from there was what must have been a type of reservoir in ancient times, today known as Mummy Lake.

According to some experts, however, this was not a lake at all, but a huge kiva used by the whole community for dancing and ceremonial purposes.

Evidence shows that in many cases the kivas were connected to structures similar to towers, whose purpose has still not been discovered. Among these are the Tower of the Cedar and a monumental complex with a double surrounding wall, perhaps a temple or mausoleum, known as the Temple of the Sun. However, the most impressive site in Mesa Verde is without doubt the Cliff Palace, an immense building built around 1200 AD in a sheltered area under the rock, containing 220 rooms and 23 kivas, and clearly housing several

280 This photograph shows a view of Cliff Palace, one of the biggest and most surprising rock villages in Mesa Verde. The houses are built over several floors among the rock walls. Many of the rooms have painted decorations.

281 left This photograph shows the rock village called Spruce Tree House. Its ideal position gave sun and light in the winter and many hours of shade in the summer.

on agriculture, grew thanks to trade. Pottery production reached high quality levels. In the course of the centuries the villages were transformed into towns, and around 1100 AD there was an enormous increase in the population of the Colorado Plateau. In the Mesa Verde National Park, most of the sites are distributed over two high plains separated by deep canyons. These are the Chapin Mesa and the Wetherill Mesa. Chapin Mesa had a large rural community, which led to the construction of twenty or so villages, made up of houses on several floors with a large number of rooms. In spite of this change in dwelling habits, the Indians of the high plains never abandoned the trench huts completely. Instead, they transformed them into *kivas*, huge circular underground structures for ceremonial and religious use. Five kivas

hundred people.

Among the various cliff houses built by the Anastasi inside rock cavities, with their towers on square or circular bases, Cliff Palace is without doubt the most remarkable, and the first sight of it amazed the first explorers who reached the area at the end of the 19th century.

These fabled palaces, the many houses built on the rocky spurs, the towers and the kivas were completely abandoned after 1300 AD. We can only assume that the Anastasi were forced to leave by long years of drought and famine, but there is no clear evidence of this. Today, Mesa Verde with its 4,000 archaeological sites is a world heritage center of incalculable value where, according to the Indians, you can still hear the echoes of the dances and prayers of the ancestors.

281 top right The decoration on this beautiful vase with its rope motif dates to around 1100 AD and shows the heritage of the Anastasi of the Basket-making tradition.

281 bottom right Spruce Tree House is a village from the Pueblo III culture, inhabited between 1200 and 1300 AD. Probably the best preserved village in Mesa Verde, it contains 114 rooms and 8 kivas. In contrast to other sites, many roofs and terraces still remain today and the walls are decorated with painted plaster work.

TEOTIHUACAN, THE CITY OF THE GODS

The European conquerors who took control of the Aztec empire and its capital Teochtitlán in the 16th century learned of the existence of a mysterious ancient city, known by the local inhabitants as Teotihuacan, which means "the city of the gods". At the beginning of the colonial period several Spanish explorers visited the ruins of this city, which had probably been abandoned many centuries earlier. The Aztecs themselves considered Teotihuacan to be a mythical place, linked to the existence of ancestral cults. Friar Bernardino of Shagán relates in his chronicles that, according to the traditional stories of the people of the Mexican plateau the Fifth Era, or the period in which they found themselves living, began in Teotihuacan and many people visited the pyramids there which were dedicated to the Sun and Moon to take part in ceremonies and offer sacrifices. Later, other chroniclers went to the site, attracted by the aura of mystery that surrounded the ruins of the ancient city. The first excavations took place as early as 1617 under the leadership of the Mexican scholar Carlos Siguenza y Gángora. In 1865, Don Antonio Garcia Cubas carried out the first topographical survey of the

Teotihuacan area, and at the end of the 19th century the archaeologist Eduard Seler dedicated himself to the in-depth study of the art and architecture of the city, as well as to the religious iconography to be found on the wall paintings. A series of systematic excavation which was begun in 1917 and is continuing today revealed the enormity and architectural richness of Teotihuacan and its basic features but failed to solve its fundamental mysteries. We still do not know who built this great place, nobody knows in whose honor the great pyramids were built and how they were able to transform the original small ceremonial center into a metropolis that dominated the Mexican plateau for centuries and exerted its cultural influence on the rest of Indo-

283 top This photograph shows a pyramid typical of Totijuacan. The architectural style was based on the use of the talud and tablero, methods used by many Indo-American people. The talud was an inclined surface which alternated with a horizontal framed panel, the tablero, creating a typically elegant effect.

283 center This building served as a place for worship. It is the famous temple of Quetzalcoatl, the oldest in Meso-America. It is dedicated to the Plumed Serpent, later worshipped by the Toltecs after the fall of Teotihuacan, at the end of the Classical Period.

America.

The history of Teotihuacan began in the Pre-Classical period. The oldest archaeological layers, which date back to 150 BC, show evidence of the existence of a primitive trading center and a rural village in an excellent geographical position. The valley, surrounded by mountain chains and extensive plains, is rich in fertile land, lakes, wildlife and waterways. Beneath the main temple of Teotihuacan, the Temple of the Sun, an underground spring was found. In remote times it is believed this gave rise to a cult which linked to water and the caves, which were frequented throughout the centuries that followed. Around 100 BC, a terrible volcanic eruption destroyed the village of Cuicuilco, several hundred miles

283 bottom One of the most interesting artistic forms from Teotihuacan is the burial masks made in hard stone, like the one shown here. The eyes and teeth are made of bone, giving a considerable sense of realism to the object.

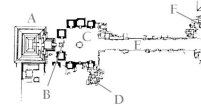

A Pyramid of the Moon
B Altar building
C Square of the Moon
D Palace of Quetzalpapalotl
E Avenue of the Dead
F Palace of the Sun
G Pyramid of the Sun

H Patio of the Four Small Temples
I Priest's Palace
J Viking Group
K Citadel
L Pyramid of Quetzalcoatl
M Gran Conjunto

284 top left Here can be seen a view of the patio inside one of the most distinctive buildings of Teotihuacan, the Palace of Quetzalpapalotl. The name literally means Quetzal Butterfly (a quetzal is a brilliantly colored bird) and refers to a god. Bas-reliefs of this god can be seen on the pillars of the courtyard.

away and it is believed that the survivors took refuge in Teotihuacan. This new ethnic and cultural influence gave considerable energy to the small agricultural center which was gradually transformed into a town. From 100 BC onward various monumental buildings were erected and Teotihuacan took on a role of major importance on the Mexican plateau and in the surrounding areas. Today's visitor to the archaeological site,

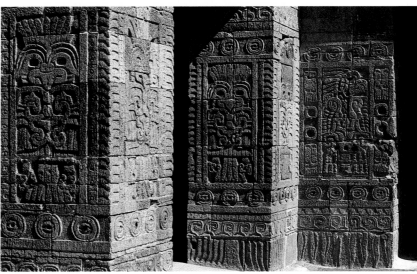

284 bottom left The massive square-based pillars that support the central portico of the Palace of Quetzalpapalotl still have traces of the original painted decoration. The bas-reliefs on the stone slabs covering the columns have geometric motifs associated with the mysterious hybrid bird-butterfly god.

Teotihuacan had been planned to satisfy all the requirements of the ruling classes as well as those of the common people and the way in which the town was laid out so that religious buildings existed side by side with state and civil ones. Two main streets divided the city into four square areas. One of these, the Avenue of the Dead, ran from south to north, ending in a huge square dominated by the famous Pyramid of the Moon, surrounded by stepped platforms. Not far away was the great Pyramid of the Sun, the biggest building in all of this part of the world after the pyramid of Cholula. The Avenue of the Dead intersected with the east-west axis, which was flanked by an architectural complex containing a number of buildings and known as the Citadel. A network of streets and avenues intersecting with each other at right angles divided up the various quarters which were originally made up of buildings of several stories. The inhabitants had constant running water, thanks to an efficient drainage system. The smaller pyramids were a new feature also found among other civilizations in this area, with one panel at a slope followed by another in oblique slab formation, known as *talud* and *tablero*. The citadel includes several interesting buildings, especially the Temple of Quetzalcoatl.

The outer walls of the pyramid are decorated with sculptures showing alternating monstrous creatures. These sculptures are of the Plumed Serpent, known as Quetzalcoatl by the Post-Classical populations of Mexico and Tlaloc, the God of Water and Fertility, with his long trunk-like nose. How important were these images in Teotihuacan? The presence of the Plumed Serpent gives an idea of the existence and age of this cult, later taken

which is only 30 miles from Mexico city, will be struck by the huge size and imposing nature of it. It definitely deserves its title of "City of the Gods". As it appears today the city of Teotihuacan reveals how it appeared in the years between 200 and 650 AD, the centuries of its greatest splendor, during which it reached an area of almost ten square miles and had a population of 125,000. From the impressive stone structures and the terraces of the pyramid-shaped platforms which once supported temple buildings we can see how

284 top right This photograph shows another fine example of a Teotihuacan stone burial mask. Note that the features of the face, especially the mouth, show strong similarities with those on Olmec masks. These masks were placed over the faces of the high-ranking dead, to accompany and protect them on their final journey.

284 bottom right In this detail of one of the decorative panels on the patio of Quetzalpapalotl, we can see the bizarre imagery of the hybrid god, both bird and butterfly, which was worshipped here. Other mythological creatures, linked with maritime and fertility cults, can be found on the wall frescoes.

285 This photograph shows another detail of the Palace of Quetzalpapalotl. What we see is one of the almenas, a type of battlement at the top of the wall which contained the calendar symbol for the year.

Teotihuacan

286 top The immense profile of the Pyramid of the Sun, seen here from the architectural complex of the Citadel, stands near the Avenue of the Dead. This is the second largest pyramid in Meso-America, after the one in Chohula. It was built on the site of an older sanctuary dedicated to the cult of the spring rain.

286 center The cat-like jawed heads of the plumed stone serpents, here, are sculpted along the center staircase that leads to the top of the Temple of Quetzalcoatl. These are associated with images of the Rain God Tialoc.

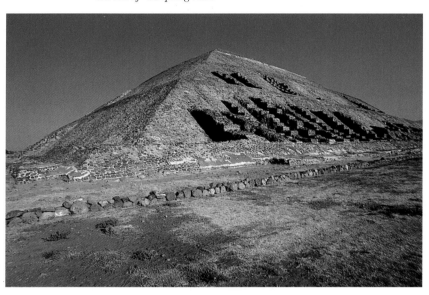

up by the Toltecs and assimilated into their cultural hero Ce Acatl Topilzin. The image of Tlaloc recalls the origins of the first sanctuaries in the city, built near grottoes and underground springs. The importance of these deities is also confirmed by the wall paintings, one of which shows the god at the center of the Tlalocan, a king of aquatic paradise which only certain privileged categories of the dead could enter. Other important buildings are the Palace of the Jaguars, the Temple of Agriculture and the Palace of Quetzalpapalotl. This latter palace, near the Square of the Moon, has a number of levels, each corresponding to extensions which were added over the course of the centuries. The most recent building has a spacious patio surrounded by a colonnaded portico. The square columns are covered in slabs of stone decorated with bas-reliefs, among which there is the image of an enigmatic hybrid god, known as Quetzalpapalotl, which literally means "Bird-Butterfly".

The painted signs accompanying the many wall frescoes of Teotihuacan have not yet been deciphered. Consequently, the artistic images, the layout of the town and the architectural style are the only features that we can use to form hypotheses concerning the type of society and religious ideology of the inhabitants of Teotihuacan during the Classical Period.

The population was probably divided into an agricultural class, dedicated to the cultivation of the fertile land around the city, a class of craftsmen, who left behind a considerable number of objects, produced with great skill, and the merchants and traders, who exported the products of the city to the surrounding regions and beyond. The refinement of the wall paintings and the stuccoes that originally covered all the buildings of the city, the pottery production, and the jade, serpentine and alabaster masks and jewels found among the burial treasure, all clearly illustrate the magnificence and flamboyance of the culture of Teotihuacan. It is presumed that, unlike the Mayan civilization, where absolute power was concentrated in the hands of the monarch,

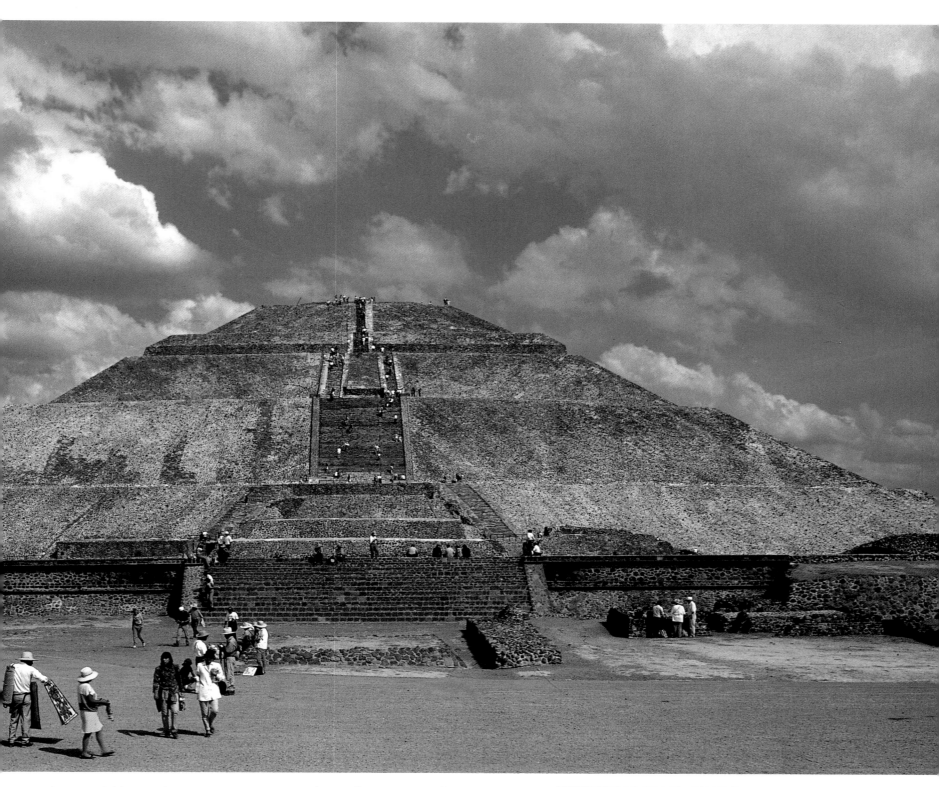

who passed this on to his successor in accordance with rigid hierarchical principles, the prestige and wealth of the city on the plateau was created in a different way. Scholars tend to think that over the centuries a ruling class developed, made up of members of the clergy, the army, bureaucrats and representatives of the strong merchant class.

It is quite probable that these rulers of the city began at a certain point to take on different roles so that each member of the ruling class was a priest, merchant and military officer. Between 650 and 750 AD something disturbed the balance of the city. Fire, destruction and sackings confirmed by archaeological survey point to a civil war or, more probably, an invasion from the north. There is no answer to the many questions that surrounded the end of Teotihuacan. The only thing we know for certain is that the city was completely abandoned at the end of the Classical Period, and several scholars believe that the survivors took the cult of the Plumed Serpent to Tula, the Toltec capital.

MONTE ALBÁN AND THE STONE CALENDARS

289 top left This refined clay object is a burial urn and was found in a tomb at Mount Albán. These urns, typical of Zapotecan art, did not contain the ashes of the deceased, who were buried, but rather terra-cotta statues of a god, painted in bright colors. These statues were thought to protect the deceased on his journey toward the kingdom of the Dead.

289 top right This photograph shows the field used for the ball game in Monte Albán, typical of all Pre-Columbian Meso-American cities. Here was played a ritual game, probably Olmec in origin, which was played by the Mayans and the Aztecs at the time of the Spanish Conquest.

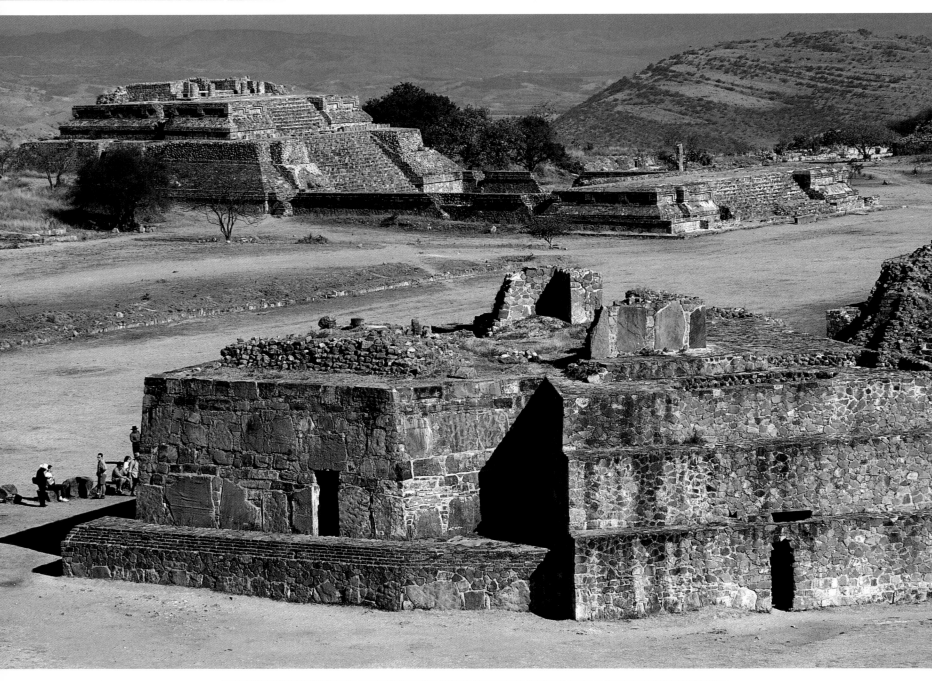

288-289 The photograph shows one of the typical monuments of Monte Albán, Building J, with its distinctive shape. It was probably used as an astronomical observatory. As far as we know today, The Zapotecs were the first people to study the heavenly bodies and the use of the calendar in Meso-America.

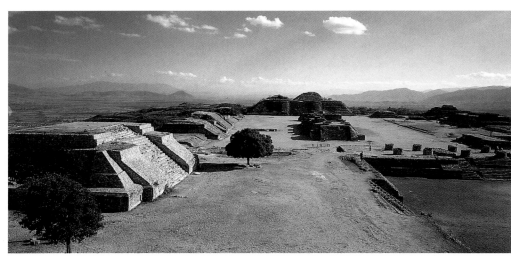

288 bottom The important monumental complex of the North Platform borders the Great Square on the northern side. This complex takes the form of a huge stepped platform on which a number of temple buildings stand.

In the Mexican region of Oaxaca are the interesting remains of Monte Albán, a ceremonial center whose origins date back to around 700 BC and which, over the course of the centuries, developed into a city. Today, it remains a fascinating riddle. One thing of which we can be certain is that as far as we know at present Monte Albán seems to be the oldest urban settlement in Central America. Starting from the late Pre-Classical period and continuing into the Classical, Monte Albán was the capital of the Zapotec people, even though many scholars believe that the oldest archaeological layer shows a strong Olmec influence. We can presume that the peoples that inhabited Oaxaca during the Middle Pre-Classical Period, the Zapotecs, founded a ceremonial center when the area was still strongly under the influence of Olmec culture, as we can see plainly when we view the figures in the bas-reliefs. Graphic symbols have been found in Monte Albán that are believed to be the oldest form of writing in this part of America, dating back to 600 BC. Only a few of these signs including the numbers and those relating to the calendar have been deciphered. These were later adopted and used by the Mayans, the probable heirs to the Zapotecan cultural heritage. The monumental complex of Monte Albán is situated on an artificial terrace in the Valley of Oaxaca, over 6,000 feet above sea level. The oldest remains date back to Monte

A North Platform	I Building I
B Building B	J Platform of
C Ball game Court	the Dancers
D System IV	K Building S or Palace
E Building U	L Building J or Observatory
F Building P	M Building Q
G Building G	N System M
H Building H	O South Platform

Albán Phase I, which can be dated to 700 to 100 BC. During the phase that followed, between 100 BC and 250 AD, other buildings were constructed and the ceremonial center was expended over an area of almost two square miles. The urban structure as it appears today dates back to the Classical Period, when the city and Zapotec culture reached the heights of their importance. A number of pyramid-shaped platforms, used to support the temple buildings which have now vanished, private residences, courtyards, state palaces and the field for the ritual ball game are all placed around the Great

289 bottom The massive structure of Building Y in Monte Albán bears witness to the urban appearance of the site, believed to be he oldest example of a Meso-American town. It was founded around 700 BC. It fell into a decline in the Post Classical Period, with Mitla taking over as the major city of Oaxaca.

290 top This burial urn shows a seated figure with crossed legs and arms folded over the breast in a solemn pose. Note the ornaments on the ears and the elaborate headdress.

290 center This monolith is at the top of the huge platform of Complex IV, and has a bas-relief decoration containing images and graphic symbols.

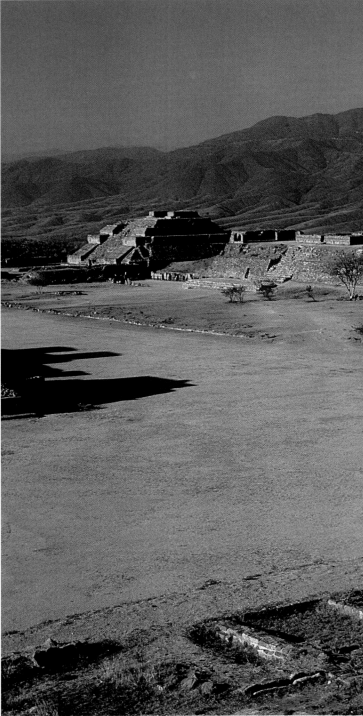

Square, which is a rectangle and oriented north to south. This was undoubtedly the heart of Monte Albán, and is still bounded today by the elegant structures of the Southern Acropolis and the Northern Acropolis. Although the architectural complex of Monte Albán developed in different periods, it is harmonious and well proportioned. The pyramid shaped structures from the Classical Period show the influence of Teotihuacan, as we can see from the use of the architecture modules known as the talud and tablero. Some buildings have particularly unusual structures, and have become emblems of the layout and culture of this sort of "capital" of Oaxaca. Among these we should mention Building J and the Platform of the Dancers. Building J is situated at the southern edge of the Great Square, and has a highly unusual arrowhead form and five-sided plan. Some experts believe that it is an architectural representation of the calendar of the solar year. The peculiarity of its form and its orientation have led many scholars to consider Building J as one of the most ancient of American astronomical observatories. Its construction dates back to the Pre-Classical Period. A series of precise surveys confirms that one of the windows of the building is placed in such a way as to observe the movement of one particular star, Capilla, in the constellation of Auriga. The outer walls of Building J are decorated with figures in bas-relief accompanied by graphic signs. Some interpretations are that the building expresses a kind of exaltation of power, linked with the consolidation of a

ruling class. On the western side of the Great Square is the Platform of the Dancers, one of the oldest structures in the ceremonial center. The southeastern façade of the platform is covered in huge stone slabs decorated with a very long bas-relief containing 140 human figures. All the figures are male, many are deformed, completely naked and portrayed in contorted poses typical of dancers. The decapitated heads, mutilated limbs and closed eyes suggested that the figures show men killed in a sacrificial rite. This theory is backed up by the fact that the mutilated part of the body has been replaced by the sign that stands for blood, the substance which

290 bottom Complex IV is one of the many groups of temple buildings facing the square of Monte Albán. Originally there were religious sanctuaries on the terraced platforms, but these were apparently built of perishable materials and have disappeared.

290-291 Here are two of the most important monuments in ceremonial area which is on the west of the square. In the foreground is Complex IV, with the Platform of the Dancers, one of the oldest buildings in Monte Albán.

291 top right The Platform of the Dancers takes its name from the images on the frieze which covers the southeastern façade. The figures, some of whom are in the photograph, are male and their positions and movements resemble dancing.

291 center right As in the previous photograph, this figure on a slab is part of the series of dancers. The closed eyes, grimaces of pain on the face and the presence of the symbol for blood have led scholars to suspect these figures are sacrificial victims, not dancers.

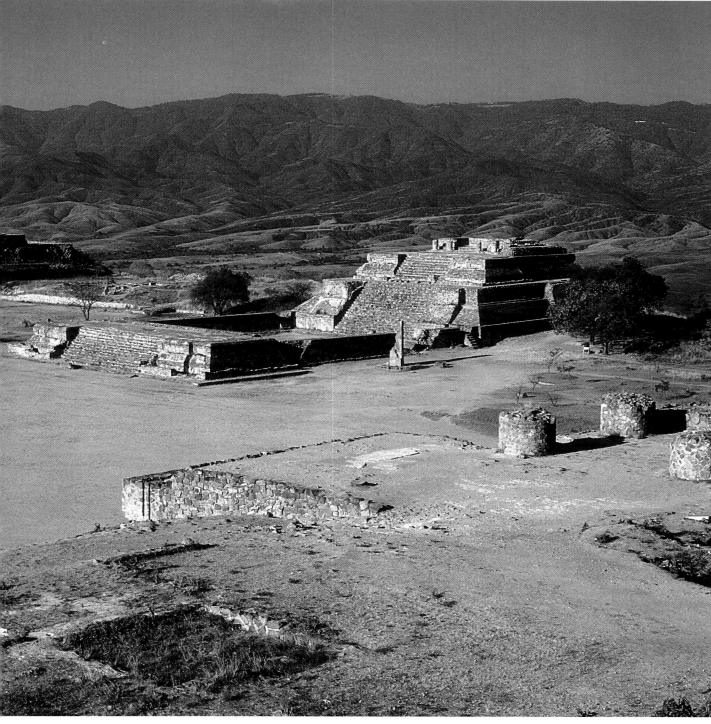

291 bottom right In this image showing the so-called "Complex IV" are clearly visible the wide alfardas, *or slopes bordering the large access stairway on both its sides.*

represented the most precious gift to the gods and nourishment for the earth. The images of the dancers, especially the features of the faces, show strong links with the art of the Olmecs, and are accompanied by an inscription which describes the meaning of the bas-relief and gives names and dates. As well as its civic and religious monuments, Monte Albán also contains burial grounds which emphasize the importance of the cult of the dead even more strongly than in other parts of this world. The tombs, which date to various periods, are dug out of the side of the hill and under the floors of the houses and

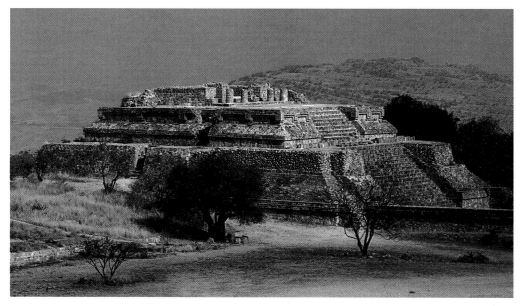

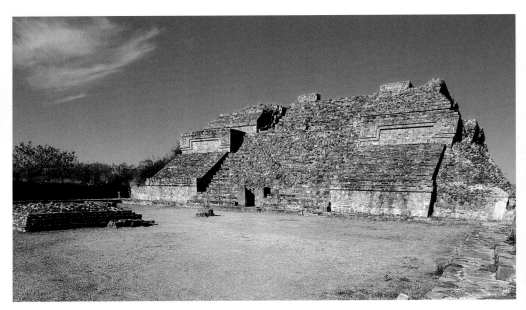

292 top left This stone with bas-relief decorations is found near the great staircase in the north of Mount Albán. As in the other stone, the image shows a figure with attributes specific to the ruling class, a dignitary, priest, or warrior-king.

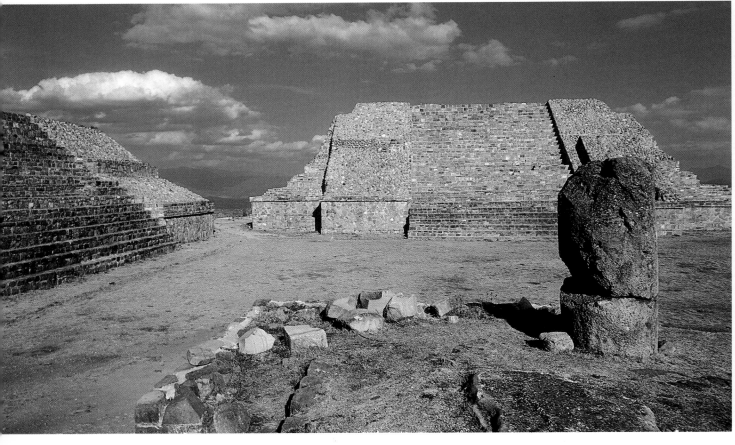

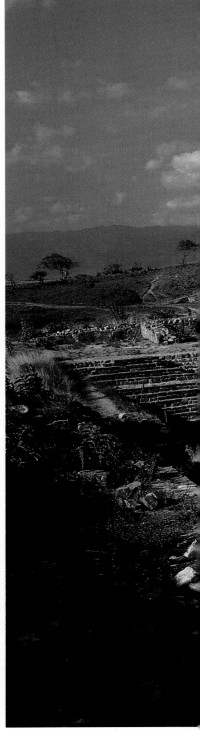

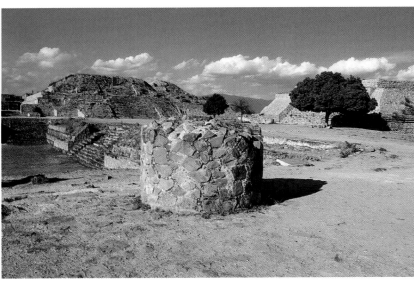

temples. The most spectacular tombs are those dating from the Recent Classical Period. These consist of multi-chambered structures covered with false vaulted ceilings and with several niches for votive offerings. Of particular interest are the multicolored frescoes on the walls, showing mythological scenes and similar to those of Teotihuacan in style. These paintings have enabled us to build up a certain knowledge of the Zapotec religious pantheon, with the identification of images of gods who were also worshipped by other people in the area. Among these are Cocjio, god of rain and fertility as well as the

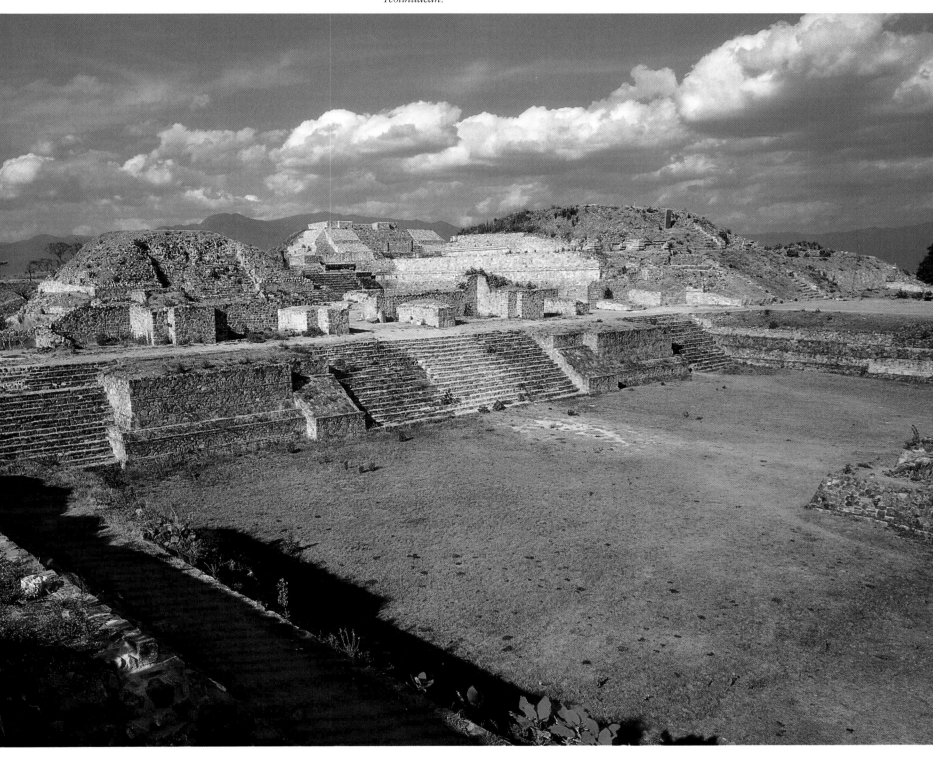

god of corn and the god of the wind, shown as the Plumed Serpent. Around 900 AD the city of Monte Albán began its gradual decline, probably due to the cultural and economic decadence of the Zapotec civilization. The Mixtecs arrived in the Oaxaca region during the Post-Classical Period and the new center of political power was the city of Mitla, in which the civil buildings are more numerous than the religious one. However, the Mixtecs did not abandon Monte Albán. They reused its burial sites, giving the ancient city the role of a huge, rich necropolis. The bodies of Zapotec rulers and dignitaries were replaced by those of the Mixtec ruling classes. The burial treasures of the Post-Classical Period are more sumptuous than those of the Zapotecs, and include gold, silver and turquoise masks and jewels. The working of precious metals, unknown before the Post-Classical Period, was introduced by the Mixtecs as a result of trading contacts with Panama and Costa Rica and possibly even as far away as Ecuador. As things stand now, then, and even though there remain gaps in our knowledge of this culture, scholars have succeeded in understanding some of the most important aspects of the civilization that built the prestigious monuments of Monte Albán between 700 BC and 800 AD. This civilization, the Zapotec as it is known today, underwent the cultural and religious influence of the Olmecs, and in the course of the centuries developed significant astronomical and mathematical knowledge. The Zapotecs are believed to have been the inventors of the most ancient form of script used in the area, the 365-solar calendar and the 260-day ritual calendar, as well as the system of calculation based on the bar and point method.

PALENQUE, *MASTERPIECE OF MAYAN ARCHITECTURE*

A North temples
B Temple of the Count
C The game of pelota
D The Great Temple
E Palace
F Temple of
 the Inscriptions
G Temple of the Cross
H Temple of the Sun
I Temple of
 the Leafy Cross

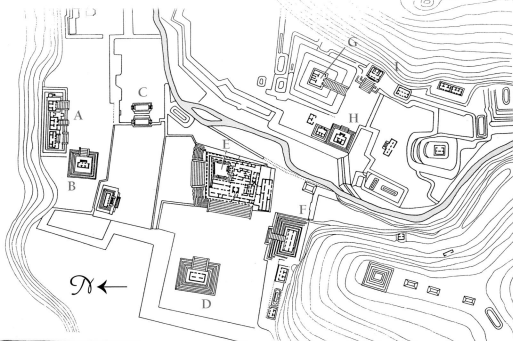

Palenque, one of the best-known although still largely unexplored Mayan archaeological sites, lies in the Mexican region of Chiapas, not far from the valley of the River Usumacinta. The entire, enormous complex covers almost seven square miles of which only the central section, called the Main Group, has been recovered from the tropical forest. By comparison with other Mayan cities of the Classic Period, Palenque was discovered relatively early. It was in 1746 that the Spanish priest Padre Solis was sent by his bishop to a rural settlement in Chiapas known as Santo Domingo de Palenque. When he reached this territory he found some strange looking stone houses, whose existence had not been previously suspected. From that time on, as news of the find spread, a long series of explorations, searches, and visits by travelers, adventurers, politicians and tourists took place.

In 1785 the governor of Chiapas, Don José Estacheria ordered a number of surveys to determine the extent of the discovery, finally sending an Italian architect, Antonio Bernasconi, to map out the site and estimate its size.

Bernasconi found that the ancient city had

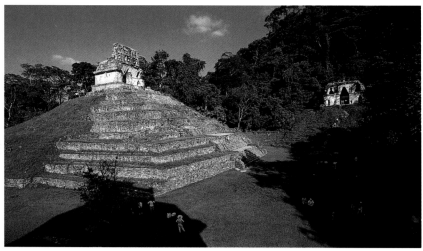

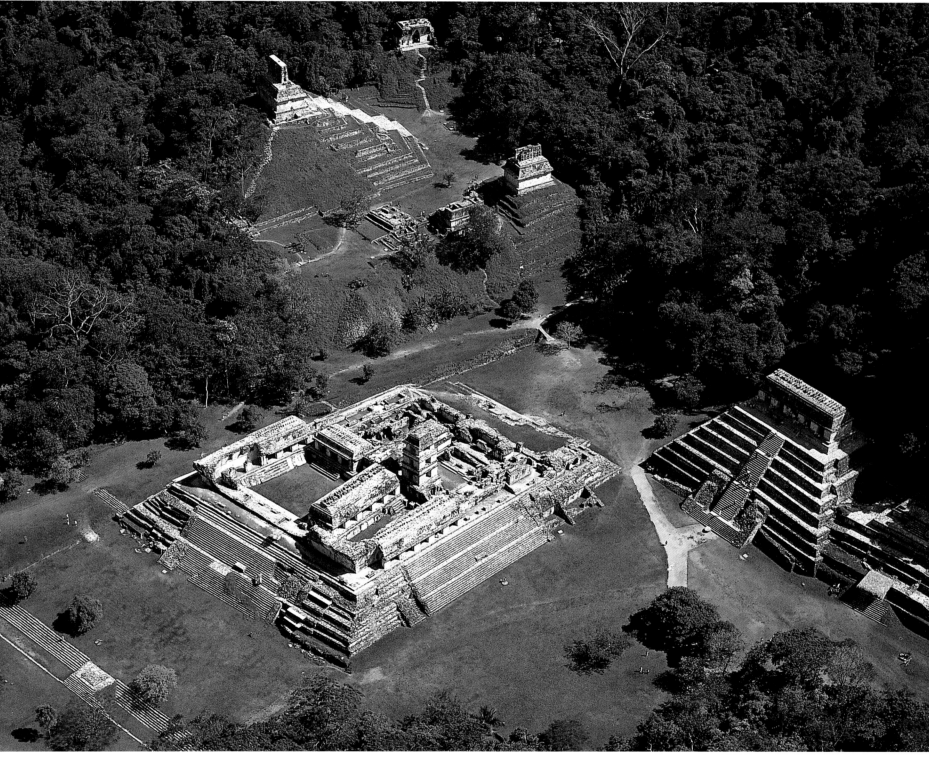

294 King Pacal, who reigned over the city of Palenque from 615 to 683 AD, was buried in an elaborate sarcophagus hidden in a crypt beneath the floor of the Temple of the Inscriptions.
This magnificent mask,

a mosaic of jade with mother-of-pearl and obsidian eyes, was originally placed over the face of the deceased. It was part of the rich burial treasure which was to accompany Pacal during his journey to the kingdom of the After World.

294-295 In this aerial view of the ceremonial center of Palenque is the architectural complex known as The Palace, dominated by the Tower. The Pyramid of the Inscriptions stands to the right and in the background are the three temples of the Group of the Cross.

295 top left This photograph shows three sacred buildings of great important in the ceremonial center of Palenque. On the left is the Temple of the Cross, to the right the Temple of the Sun and, in the background, the Temple of the Leafy Cross.

295 top right This photograph shows the Temple of the Cross, seen from the Tower of the Palace. The sanctuary is surrounded by an elaborate wall and has a bas-relief with a cross, a symbol of the sun.

Palenque

296 top The photograph shows a detail of the architectural complex of Palenque called the Palace although no one actually knows its original function. It takes the form of an inner courtyard, a four-sided patio reached by short staircases.

not been destroyed by fire or earthquake as had been believed by some earlier viewers but rather abandoned by its inhabitants and overgrown by vegetation. A few years later, in 1789, the king of Spain, Carlos III, sent Antonio del Rio, a soldier of fortune, to study these mysterious ruins in the jungle of Chiapas on his behalf. This expedition can be considered, in a sense, the start of archaeological surveys of the pre-Columbian world.

Later, the successor to the Spanish throne, Carlos IV, sent a certain Colonel DuPaix and the Mexican Luciano Castaneda on a mission to explore Palenque. In 1805 and 1806 these travelers visited the ruins and drew the main architectural features, drawings which were later published in Paris as *Antiquités Américaines*. During the 19th century, interest in the remains of Palenque spread throughout the Americas and Europe through the reports of several other respected explorers, including John Stephens and Frederick Catherwood. The main monuments in this ancient Mayan city are covered with inscriptions which have only recently been deciphered, enabling us to solve many of the mysteries that previously surrounded Palenque's history and that of its people. The results of these archaeological surveys show that the site of Palenque was occupied as early as the late Pre-Classic Period, between 150 and 250 AD. However, the city rose to its greatest cultural and architectural heights between 615 and 800 AD, when the most important monuments were built and the historic texts produced which contain the names and acts of the sovereigns who reigned over the city.

Today's visitors travel along a road which starts at the northern part of the urban area and leads to the Main Square, which is believed to be the heart of the ceremonial center. On the eastern side, this huge open space is dominated by what is called the Palace, a huge monumental complex. It is generally believed that the buildings forming this complex had some kind of a civic function, either housing the ruling elite or as an administrative center. This, of course, is by no means proven. The Palace consists of a high platform measuring about 250 feet long and about 200 feet wide topped by a complex of porticoed galleries. These galleries have false vaulted ceilings arranged around three larger interior courtyards. On the square pillars and the surfaces of the roofs we can see traces of the original bas-relief decoration, which was covered by multicolored stucco. The entire complex is dominated by a four-story tower. Some experts have suggested that this may have

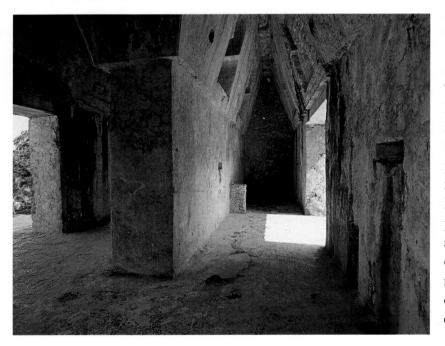

296 bottom The structures that make up the Palace of Palenque consist primarily of porticoed galleries, whose outer walls were decorated with elegant bas-reliefs. This photograph shows one of the galleries with a false-vaulted ceiling. These areas may have been used for religious ceremonies.

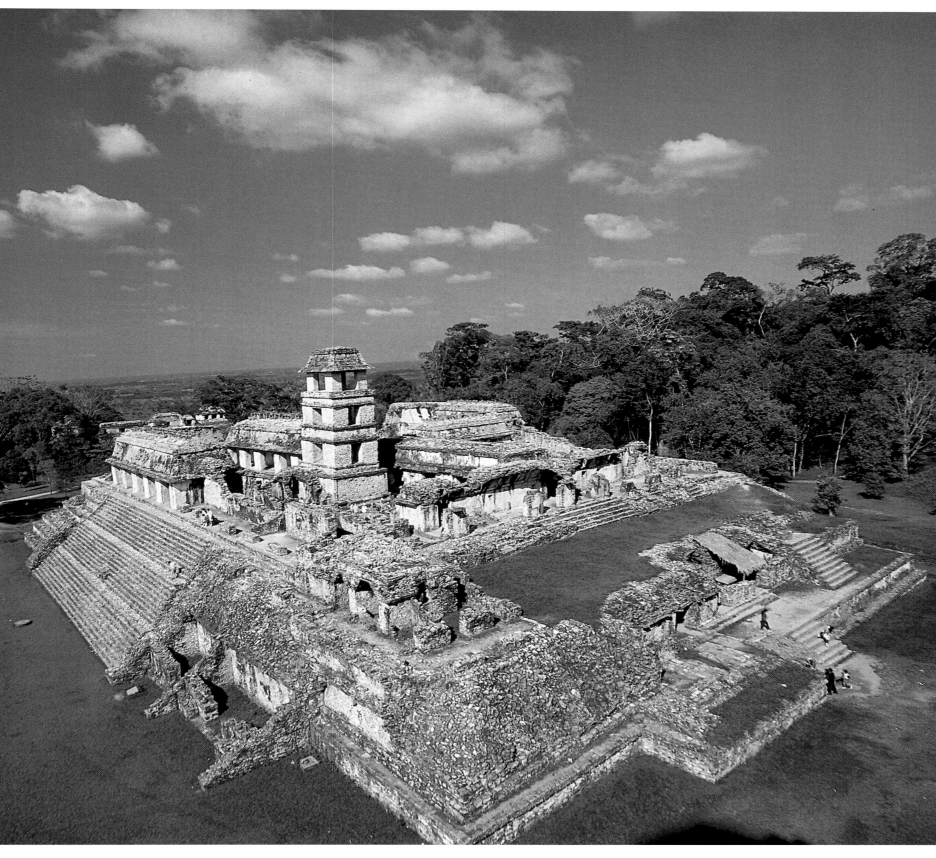

296-297 This unusual photograph shows an overall view of the Palace of Palenque, situated in the heart of the ceremonial center surrounded by the luxurious vegetation of the jungle. The purpose of this architectural complex is still a mystery. It may have been used for religious rituals. The Tower is believed to have been an astronomical observatory.

297 left This plaster tablet was found in the central courtyard of the Palace. It contains a graphic symbol in Mayan script in the form of a human head.

297 right This table, like the previous one, was found in the courtyard of the Palace of Palenque. It contains four signs from the Mayan script of the Classical period, most of which has now been deciphered.

Palenque

*298 top This photograph shows an aerial view of a religious architectural complex at the northern end of the ceremonial center of Palenque, the so-called Northern Group.
It is a stepped platform topped by three sanctuaries.*

298 bottom This picture shows the top of one of the most important buildings in Palenque, the Temple of the Sun, built by the son of Pacal, Chan Balam, in 690 AD. Traces of the plaster bas-reliefs that adorned the roof lining and imposing top still remain.

been a watchtower but the most widely accepted theory at present is that it was an astronomical observatory.

On the southern side of the square, down from a hill still covered in dense tropical vegetation, is the most imposing sacred building of Palenque, the Pyramid of the Inscriptions, which is 120 feet high and formed by nine overlapping bodies. Three stone panels placed inside the upper temple and completely covered in sculpted hieroglyphs, forming one of the longest Mayan inscriptions found so far, gives the Pyramid its name.

A narrow staircase gives access to the temple which is at the top of the building. It is topped by a crest which is a typical architectural feature of the Classical period

in the Usumacinta Valley. In 1952, the Mexican archaeologist Alberto Ruz Lhuillier discovered a long staircase covered by a false vaulted ceiling. Starting at the sanctuary this led down to an underground crypt which was concealed just below the level of the square in front of the pyramid. This secret chamber, which had been completely unsuspected, even by the archaeologist himself and his assistants, contained a large stone sarcophagus with the remains of what had obviously been a high ranking figure.

Years later, following the deciphering of the Mayan texts, it was discovered that the remains were those of King Pacal, who ruled the city of Palenque from 615 to 683 AD, the year he died. The sarcophagus was

*298-299 The sanctuary of the Temple of the Sun stands on a stepped platform. The roof decorations were damaged and corroded over the years by the vegetation which covered most of the monuments after the decline and abandonment of the city of Palenque.
The inside of the temple is divided into two elongated rooms, surmounted by a false vaulted ceiling.*

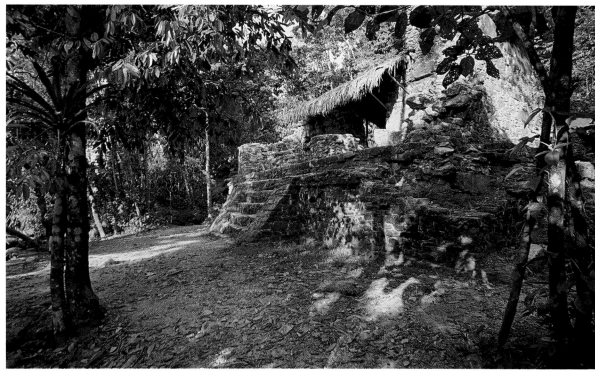

299 bottom One of the religious buildings of Palenque is Temple 18, with its typical terraced structure. Today, only some of the city's monuments have been freed from the spread of the tropical jungle.

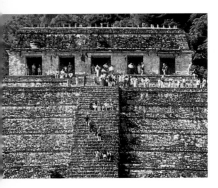

300 left The Temple of the Inscriptions is hidden almost in the thick tropical vegetation. A step staircase leads to the sanctuary at the top, where a porticoed entrance gives access to the vestibule and religious center. At the bottom of the staircase is a stone disk held up by four cylindrical supports which was a sacrificial altar.

300 top right The most important king of the city, King Pacal, Shield of Sun, was buried in a crypt beneath the floor of the Temple of the Inscriptions. The crypt was discovered in 1952 by the Mexican archaeologist Alberto Ruz. The stone sarcophagus that contained the remains of the dead king was covered with a slab weighing five and one-half tons.

300 bottom right In this photograph can be seen the steep narrow staircase inside the Pyramid of the Inscriptions, leading to the crypt in which King Pacal was buried in 682 AD. The ceiling has a typical false vaulted structure.

301 This beautiful stucco head, executed with great skill and found in the burial chamber of Pacal, is almost certainly a portrait of the sovereign as a young man. Inscriptions said that Pacal ruled over the city of Palenque for about 70 years and was an enlightened ruler.

closed by a slab of stone which weighed well over five tons. The stone itself was decorated by an elaborate bas-relief. At the center of the scene is the figure of the dead king, shown as he fell into Xibalbá, kingdom of the deceased, symbolized by the Terrestrial Monster. Behind him is the Tree of Life whose branches take the form of serpents' heads. A two-headed snake with wide open jaws and a fantastic bird with the features of a reptile is perched on the top. Included in the sarcophagus were jewels and ornaments and the fragments of a fabulous jade mask which had apparently been placed over the face of Pacal. It was later patched together. Two stucco heads that were found in the burial chamber give us a portrait of Pacal, the most famous and honored sovereign of Palenque.

This discovery, of course, was important not only for itself but also because it proved that the Mayan pyramids in the Classic Period were not only used as temples but also were funeral monuments for the ruling class.

In addition to the Palace and the Pyramid of the Inscriptions, the ceremonial center of Palenque contains other groups of buildings of importance, such as the Northern Group, the Temple of the Count, and the stadium used for the ritual ball game. A basic role is played by the so-called Group of the Cross. This is formed by three temple buildings which are smaller in size than the Pyramid of the Inscriptions. They have been given the names of the Temple of the Cross, the Temple of the Leafy Cross and the Temple of the Sun. These buildings were built between 672 and 692 for the sovereign Chan Bahlum, "Jaguar Serpent", the son of and successor to Pacal. They are located down from the hill below the Palace. All these are pyramids with their upper sections covered with an attic roof topped by a complex crest which was originally decorated in modeled, multicolored stucco. The modern names of the three monuments come from the iconographic designs on the friezes which run along the walls. These are linked to Mayan cosmological themes which were largely misinterpreted by the first explorers of Palenque. The Temple of the Sun and the

Temple of the Leafy Cross contain a number of interesting inscriptions on the dedicatory rites of Chan Bahlum, who deliberately chose a time when the moon, Saturn, Jupiter and Mars were in conjunction and in an unusual position in relationship to the constellation Scorpio for the consecration of the temples. Although Palenque is a major tourist attraction in Mexico, a great part of it remains to be brought to light. It can be assumed that in the future many more extraordinary discoveries will be made here, raising new questions and answering old ones concerning Mayan civilization.

TIKAL, PYRAMIDS IN THE FOREST

Gulf of Mexico

Mexico

TIKAL

Guatemala

Guatemala

Pacific Ocean

A Temple IV
B Complex N
C Southern Acropolis
D Square of the Seven Temples
E Temple III
F Complex O
G Western Square
H Temple II
I Great Square
J Northern Acropolis
K Temple I
L Temple V
M Eastern Square
N Central Acropolis
O Complex R
P Complex Q
Q Group F
R Group G

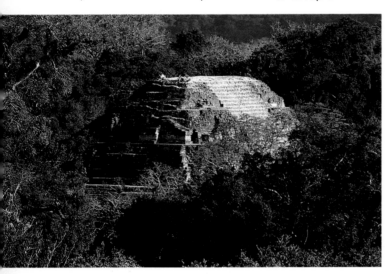

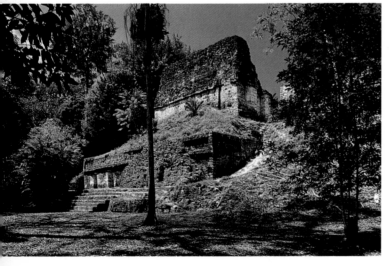

At the end of the 19th century, Alfred Maudslay and Teodor Maler photographed the main monuments of a Mayan city found in the tropical forest of Petán, a region of modern Guatemala. This was Tikal. At the start of the 20th century, work was begun on tracing out the plan of the site and examining its mysterious inscriptions. In the 1950s, the University of Pennsylvania began the first excavations. Even though only part of the city has been brought to light, the remains of Tikal are extremely impressive for their huge size and the dizzying heights of the pyramids, unique in the Mayan area. These surprising constructions, the latest archaeological survey indicates, were erected based on the architectural models of Cerros and Uaxactun, where the oldest Mayan pyramids are located, dating back to the Late Pre-Classical Period.

The recent deciphering of the inscriptions on Tikal's many stone columns has revealed significant aspects of the history and ruling dynasties of this city, which is located in a strategic position among important roads and waterways. The oldest stone column in Takal, number 29 and considered to be the

302 top left The Pyramid of the Lost World has an imposing, massive structure similar to the ancient pyramids of the Pre-Classical Period.

302 bottom left This temple, which is between the Pyramid of the Lost World and the group of Seven Temples, has a large crescent on top, typical of the architecture of Tikal.

302 top right This incense holder with its image of a priest or a god holding a skull was found in a tomb.

302 bottom right Four steep staircases lead to the top of the great Pyramid of the Lost World, which stands at the southern end of the ceremonial center of Tikal.

303 From the endless stretch of tropical forest emerge, in all solemnity, the Pyramid of the Lost World and Temple IV.

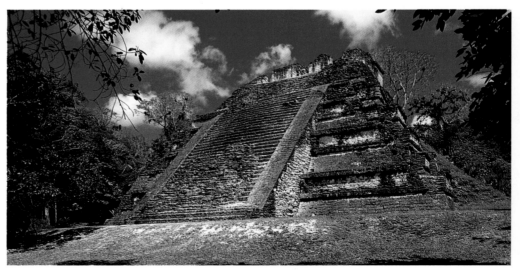

304 top This photograph shows a view of the Great Square, heart of the ceremonial center of Tikal, dominated by the imposing structure of Temple I. The area is scattered with stones, rich in bas-reliefs and inscriptions. Many of the texts on these have been deciphered.

304 center Here is a view of the ceremonial center of Tikal. In the foreground is the architectural complex of the Central Acropolis and, in the background, Temple I and the Square. The archaeological site of Tikal, one of the largest in Meso-America, contains about 3,000 monuments, built at various times.

Tikal

Tikal

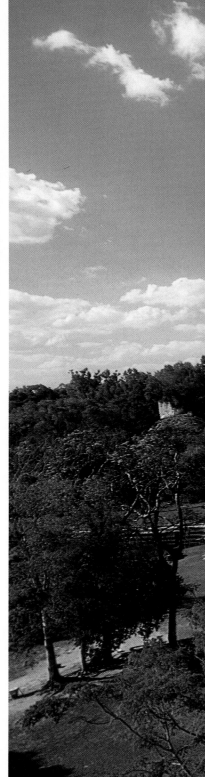

oldest in the entire Mayan area, has been dated to 292 AD, the start of the Classical Period. The most recent, number 11, is dated at 869 AD. We now know that at the end of the 9th century the Mayan cities of the low-lying plains were suddenly and rapidly abandoned and the period between these two dates corresponds to the height of Tikal's political and cultural importance. In recent studies, German archaeologists have shown that Tikal, along with Calakmul, ruled over the other Mayan city-states. The columns scattered throughout the ceremonial center were erected roughly every 20 years, and have passed down to us the names and bas-relief portraits of the rulers who contributed to the political, economic and cultural growth of Tikal. Among these are rulers given the names of Jaguar's Paw, Stormy Sky and Mr. Cocoa. The texts tell us that these rulers conquered many enemies, took control of neighboring territories and formed diplomatic alliances based on the payments of tributes and the arrangement of marriages. Leida's Plate, a tiny jadeite jewel found in the city, contains an inscription referring to a ruler, Bird Zero Moon, whose image is etched on the other side. In Tikal, as in Palenque, the pyramids served as supports for the temple buildings

304 bottom The huge complex of the Central Acropolis, seen here, is made up of a series of terraced platforms used to support the religious buildings. It faces onto the Square, in front of the Northern Acropolis, and is flanked by the large Twin Pyramids.

304-305 Temple I stands near the Central Acropolis and is about 165 feet high. A steep staircase leads to the sanctuary whose center is divided into three rooms with false vaulted ceilings. The summit of the temple is decorated with a dizzying crescent, a typical element in Tikal architecture. Only the kings and priests were allowed to enter the central shrine, where rituals and sacrifices took place.

and the cemetery, a sacred site containing the burial chambers of the ruling elite. Like the tomb of Pacal, the burial sites of Tikal also contained precious burial treasures including painted pottery, masks and jade jewels. These objects are precious evidence of the prestige enjoyed by the ruling classes as well as the extremely high levels of skill displayed by the craftsmen working at the court. The part of the ceremonial center which has been freed from the jungle and brought into the light occupies an area of more than six square miles and contains about 3,000 monuments. It had at least two huge reservoirs which contained the city's water supply. One of the oldest buildings is the one known as "of the Lost World" which is located in the southern part of the city. Its huge structure is similar to others from the Late Pre-Classical Period. Most of the buildings date from 400 to 800 AD, the period of Tikal's greatest splendor. What is most surprising, perhaps, about this town is the height of the pyramids. Temple IV reaches a height of over 200 feet and its summit can be seen emerging from the green canopy of the jungle from quite a distance away. Here more than ever the Mayans attributed the role of "artificial mountain" to the pyramids, which made them a way for man to draw nearer to the gods. In the photographs taken at the start of the 19th century, the pyramids appear to be completely covered in earth, vegetation and rubble. Temple IV is similar in structure to the twin temples I and II which are situated at opposite sides of the Great Central Square. They are step pyramids with a long, steep staircase in the façade, which leads directly to the sanctuary. The sanctuary consists of a simple central section with a false vault which is topped by an impressive crescent. The cultural influence of Teotihuacan is often present in the use of the architectural modules of the talud and tablero. The Square, believed to be the heart of the ceremonial center, is surrounded by numerous architectural structures, including terraced platforms which originally supported the religious buildings, spacious courtyards, groups of palaces used as the residences and ceremonial centers of the ruling classes, and more modest residences for the common people. The most famous terraced platforms are undoubtedly the Central Acropolis and the Northern Acropolis. In the 9th century AD, when Tikal was abandoned, this gigantic platform, 300 feet

305

306 top The scene painted on this multicolored vase from Tikal shows a high ranking figure with an elaborate feathered headdress seated comfortably on a type of sofa. A number of signs which make up a text are near the mouth.

306 bottom This vase too is decorated with a painted scene showing the life at court. A figure kneels obsequiously before a dignitary, perhaps a king, seated on a throne. It is interesting to notice the contrast between the soberness of the clothing and the elaborate, plumed multicolored headdresses. In the top left are a number of graphic signs.

long and 250 wide, supported no less than eight sacred and funerary buildings. Under the paving, the remains of several very old buildings were found, dating back to the 3rd century AD. Along the borders of the central square and scattered here and there throughout the site are the commemorative columns, rich in inscriptions and often associated with stone monuments, cylindrical in shape and with flat surfaces. According to scholars, these were probably sacrificial altars. A road network, known as Sacbeob in the Mayan language, whose original layout remains today, led to the more distant monuments, the reservoirs and the villages that surrounded the city. One of the main avenues, leading from the ceremonial center to temple complex G, has been identified as the ceremonial way.

During the Late Classical Period, Tikal probably had a population in the region of 10,000, making it the largest of the Mayan city-states, and it is not difficult to believe that it reigned supreme over the other urban centers, which were probably smaller and less wealthy. The bas-relief portraits of the rulers, usually in profile, as well as the inscriptions and the rich burial treasures, give us an idea of what these aggressive, powerful people were like. The inscriptions describe sacrifices of enemies defeated in battle and self-mutilation by rulers and priests who, after reaching a trance through taking hallucinogenic substances, stabbed various part of their bodies to let the blood flow out. The purpose of this type of rite was to bring the individual into contact with the gods and to offer the gods gifts of human blood, the

306-307 Temple II, opposite its twin, Temple I, on the square, has a three-level pyramid structure and a high crescent on top, as do the other temples of Tikal.

307 top This photograph shows one of the many stones in the Square of Tikal. The high ranking figure is shown in bas-relief, unlike in Copán, where the stones were sculpted in three dimensions.

vital blood which satisfied and nourished them. From the images, we can see the clothing, jewelry, weapons and head-dresses of kings and warriors. Female figures are extremely rare, appearing only in references to marriage contracts. For as yet unknown reasons, no columns were found that date after 869 AD. This great metropolis that flourished in the luxuriant, fertile region of Petán began a rapid decline and was abandoned, although the reason why remains a mystery. No traces of violent destruction, for instance, have been found. Perhaps there was a sudden decline in trade, impoverishing the city and its surrounding villages. Or, more probably, the absolute power exerted by the monarchy over the people and the inhabitants of the other centers was destroyed by military rebellions or internal civil war. Tikal, like other Mayan centers of the low-lying plains, disappeared from the history of Indo-America, until its pyramids were rediscovered, covered in rubble and overgrown with vegetation.

307 center Pyramid Q is one of the many stepped structures with temple functions in the religious area of Tikal. In the foreground are a group of memorial stones.

307 bottom The Northern Acropolis gives an overall architectural effect that is symmetrical and organic, despite the fact that it has structures built at different times, often on top of older buildings.

307

USA

Mexico

Mexico City

UXMAL

Pacific Ocean

UXMAL, THE CAPITAL OF PUUC STYLE

From 800 AD onward, during the period known as the Recent Classical, the Mayan cities which had reached significant levels of economic and political power in the low-lying plains entered a period of decadence for reasons that remain unknown to us today. Nearly all these centers were gradually abandoned, and all trace of them was lost until the 18th century, when the first explorers found their remains covered by vegetation and rubble.

In the Yucatán the situation was very different. Here, between 800 and 900 AD, a number of small towns that had played a marginal role up to that time received a cultural boost, undoubtedly linked to their considerable economic development. This was probably due to the arrival of peoples belonging to the Maya-Chontal race from

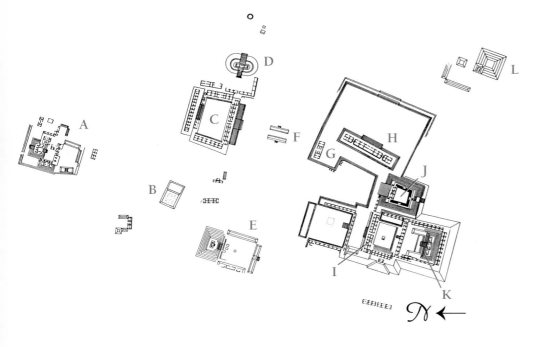

A Northern Group
B Platform of the Stones
C Quadrangle of the Nuns
D Pyramid of the Soothsayer
E Cemetery Group
F Ball game Court
G House of the Turtles
H Governor's Palace
I House of the Doves
J Great Pyramid
K Southern Group
L Pyramid of the Old Woman

308 left and bottom right The House of the Turtle is an extremely sober rectangular building decorated with sculptures in the form of turtles, from which it gets its name, and a frieze on small columns over the entrance door. The original purpose of the building, which dates to the 9th century AD, is unknown.

308 top right This photograph shows a detail from one of the most remarkable monuments in Uxmal, the Pyramid of the Soothsayer. Here is the entrance to the sanctuary to the west, with an elegant decoration in Chenes style.

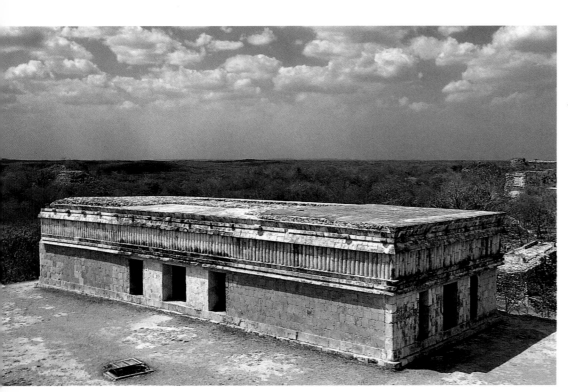

308-309 The imposing profile of the Pyramid of the Soothsayer, seen from the House of the Turtles, shows that the building consists of various structures one on top of the other, dating to different periods. It is topped by two sanctuaries whose style shows the cultural influences of the neighboring areas.

309 top This panoramic view shows three of the most typical buildings in the town of Uxmal. In the background is the Quadrangle of the Nuns, in the foreground the House of the Turtles and to the right the Pyramid of the Soothsayer, also known as the Pyramid of the Wizard, with its unusual elliptical base.

Uxmal

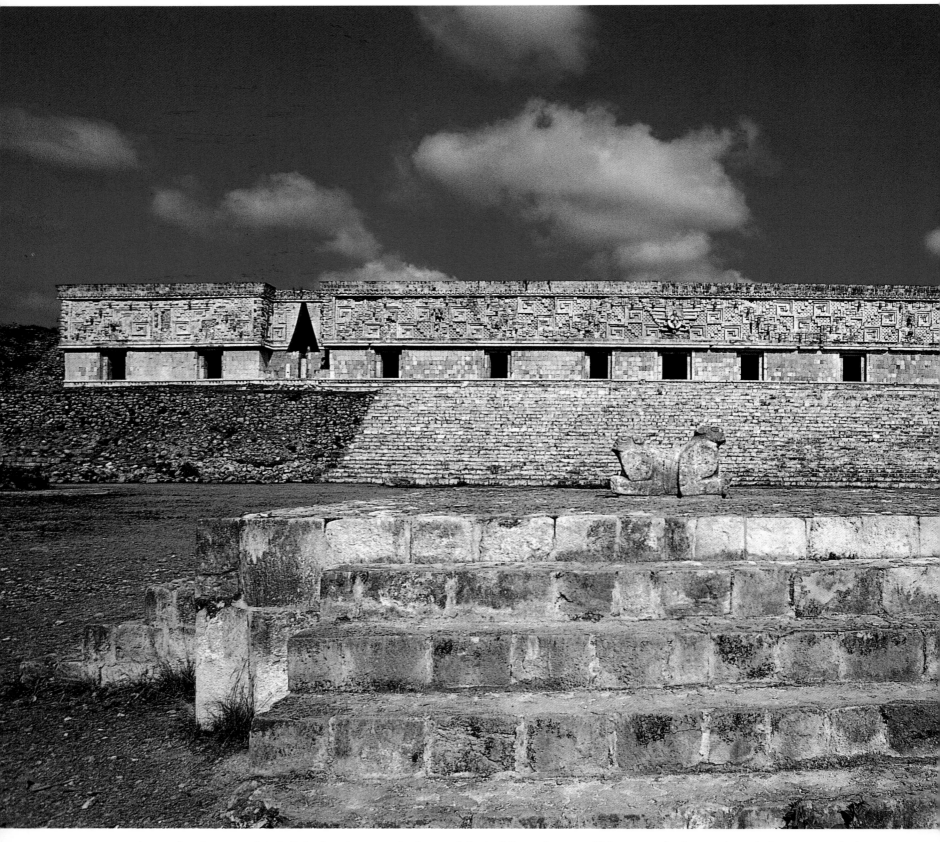

the north, who were closely linked to the culture of the Mexican plateau. This was the period when Uxmal, Sayil, Labná, Kabah, Rio Bec and other towns flourished, and their imposing remains are still to be found, scattered throughout the Yucatán. Although each town had its own characteristics, they all had a single architectural style in common, known as the Puuc Style, from the name of the region in which the most evidence of it has been found. Among the typical elements of this style are the cut stone mosaics that decorate the fronts of the buildings, the use of false vaults, circular stemmed columns and the huge stucco masks linked to the images of Chac and the Terrestrial Monster. Among the remains of the towns from the Recent Classical Period, perhaps the most impressive are those of Uxmal, whose site is so large that it has led archaeologists to consider it as the Puuc capital in Yucatán. One typical feature of Uxmal is the quadrilateral building, an architectural innovation in the world of the Mayans. These buildings are four-sided structures raised up on low platforms around a huge patio. Their elegance is such that they have been called palaces. The most famous quadrilateral building in Uxmal is the Building of the Nuns, so named by the first Spanish explorers, as the closed structure of the court, surrounded by buildings divided into cell-like rooms, reminded them of a convent. The front of the building, covered in cut stone mosaics to form refined geometric, Grecian, lozenge and miniature column motifs, alternating with huge masks of the god Chac with his protruding nose,

311 top *The unmistakable figure of Quetzalcoatl, the Plumed Serpent, decorates one of the panels along the façade of the western building in the Quadrangle of the Nuns. This detail gives an idea of the refinement of the Puuc style, typical of the Mayan cities of the Yucatán.*

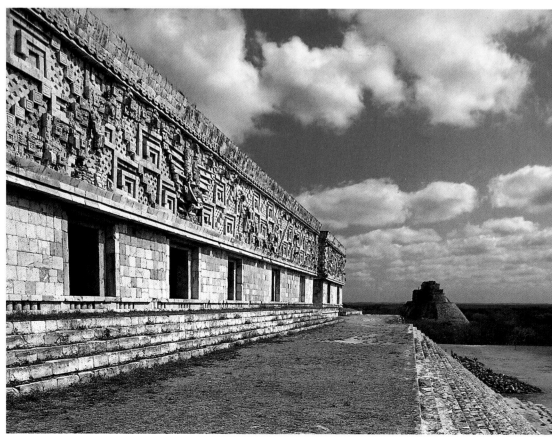

310-311 *The Governor's Palace, seen here together with the Altar of the Jaguars, is a particularly spectacular construction within the architectural context of Uxmal. A large staircase leads to the palace, whose original function is not known.*

311 center *The Altar of the Jaguars is a monolithic monument showing two Siamese cats on a small stepped platform near the Governor's Palace. It was probably a sacrificial altar.*

311 bottom *Here is the staircase that leads to the Governor's Palace. A row of parallel doors runs along the front, decorated in the upper part by an elegant frieze in Puuc style. In the distance is the Pyramid of the Soothsayer.*

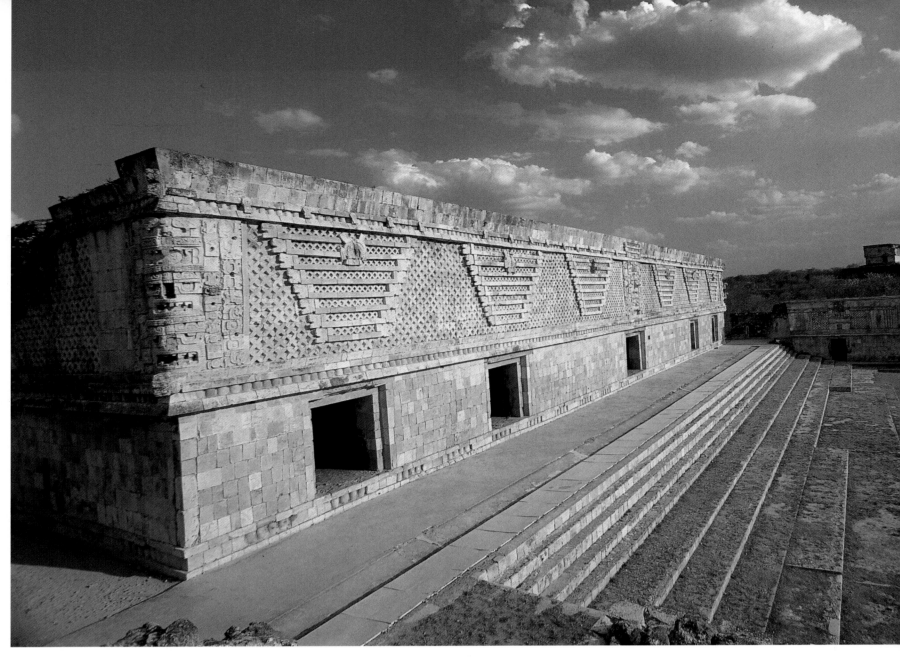

the staircases and porticoed galleries that face on to the courtyard give this building a rare and surprising elegance. The bas-reliefs showing the jaguar and Plumed Serpent echo the religious themes of the Mayan and Mexican peoples. The access gates consist of great arches built using the false vault technique as the use of the true arch was unknown in Mexico until the arrival of the Europeans. The Quadrilateral of the Doves has a similar, though smaller, structure. The name originates from the complex combs at the summit whose perforated structure resembles the style known as the "dovecote".

In the southeastern part of Uxmal is the most prestigious and imposing building in the whole town, the Governor's Palace. This name was given to it by Friar Lopez de Cogolludo, a Spanish cleric who visited the site and described it in his memoirs, published in 1688. When he saw this building for the first time, the friar was convinced that it was the ancient residence of the rulers of Uxmal.

The building rises from a platform formed by three terraces, whose summit is reached by a broad central staircase. It consists of a central four-sided block 150 feet long and

two lateral blocks, each 50 feet long. As in the other structures of Uxmal, the interior is divided into small rooms similar to cells. The mosaics adorning the upper part of the outer façades, the use of the false arch and the colonnaded portico mark off the Governor's Palace as a typical example of the Puuc style from the Final Classical Period.

Even though many scholars believe this palace was the center of royal power among the Mayans and a site of important ceremonies and a royal court in every sense of the term, there is no question that its real function remains very much a mystery. On the basis of recent studies, it has been shown that the Palace was built in accordance with a carefully designed plan and precise directions. From the central gate, individuals observing the stars could see Venus on the horizon as it rose in the morning and moved up to a point above the top of a pyramid.

The city contains other complexes and single buildings of great interest, such as the Great Pyramid and the Northern Acropolis, in the style of a temple, the House of the Turtles and the Group known as the Necropolis, as well as the ever-present

playing field for the ball game. Unfortunately, nothing is known now of the rulers and people of Uxmal and there are no inscriptions that could tell us the history of the reigning dynasties or major events in the history of the city. However, the fascination and the mystery itself that surround this prestigious city can all be summed up in a monument that is unique in the entire world of Pre-Columbian America, the Pyramid of the Soothsayer, also known as the Pyramid of the Wizard. Legends tells us that a wizard won a bet with a king, a bet that he could not build the pyramid in a single night.

312-313 Another distinctive building in Uxmal is the Quadrangle of the Nuns, with its elongated, rectangular structure, here shown from an unusual angle. The name comes from the rooms inside, which are similar to the cells of a convent.

312 bottom This stylized head is a decorative motif on the outer façade of the Quadrangle of the Nuns. It may be the head of a ruler as indicated by the elaborate ornaments. Very little is known about the rulers of Uxmal.

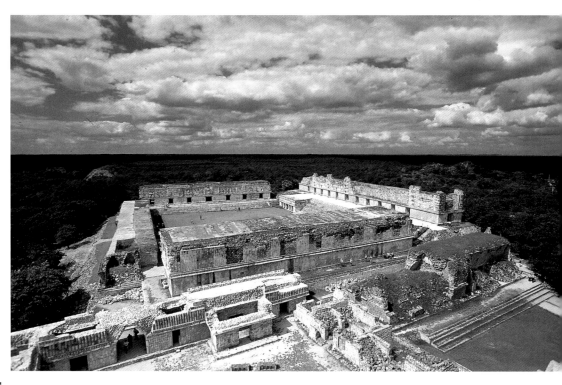

Uxmal

The pyramid is a gigantic, flat-topped stepped structure with an elliptical base. It is the result of a series of reconstructions and superimpositions that took place over several different periods.

Two steep staircases lead to the temples at the top. The one on the western side of the pyramid has a façade decorated in the Chenes style, completely covered in masks which related to the Cosmic Serpent, one of the most ancient cults in the world of the Mayans.

At the base of the staircase that runs along the western side of the pyramid, recent excavations have brought to light the remains of a sanctuary older than the rest of the architectural complex, dating back to 569 AD.

This, some experts believe, is the nucleus of this mysterious temple building, which towers above the vegetation and dominates the remains of the Puuc capital.

313 top The impressive complex named the Quadrangle of the Nuns consists of a group of buildings with an elongated shape built on a low platform and arranged around a spacious patio.

313 center The residential buildings of the Yucatán show masks of the god Chac, with a prominent nose similar to a trunk. The cult of this deity, god of water and rain, was of fundamental importance to the Mayan people of the Post-Classical Period.

313 bottom This photograph shows the walls of the so-called Quadrangle of the Dovecote, a bizarre building in Uxmal. The crescents, with their rectangular slits, perhaps originally holding sculptures, are similar in shape to a dovecote.

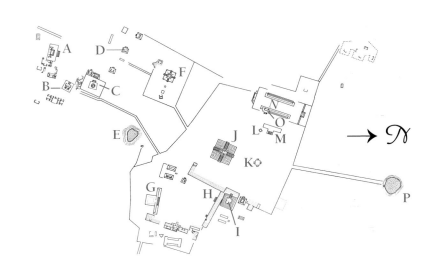

CHICHÉN ITZÁ,
THE CITY OF THE GREAT WELL

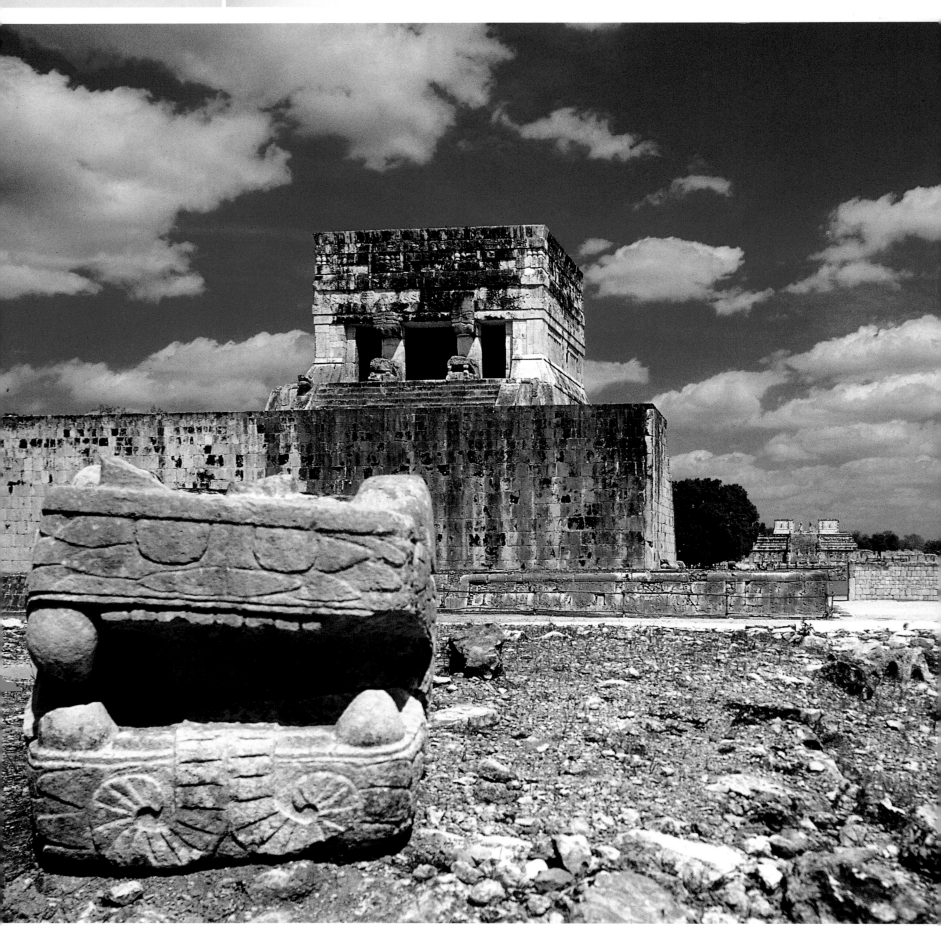

A House of
 the Nuns
B Temple of the
 Painted Reliefs
C Caracol
 (Observatory)
D Casa Colorada
E Cenote
F Tomb of the
 High Priest
G Covered market
H Group of the
 Thousand
 Columns
I Temple of the
 Warriors
J Castillo
K Platform
 of Venus
L Platform of
 the Eagles
M Tzompatli
N Great ball game
 Court
O Temple
 of the
 Jaguars
P Sacred Cenote

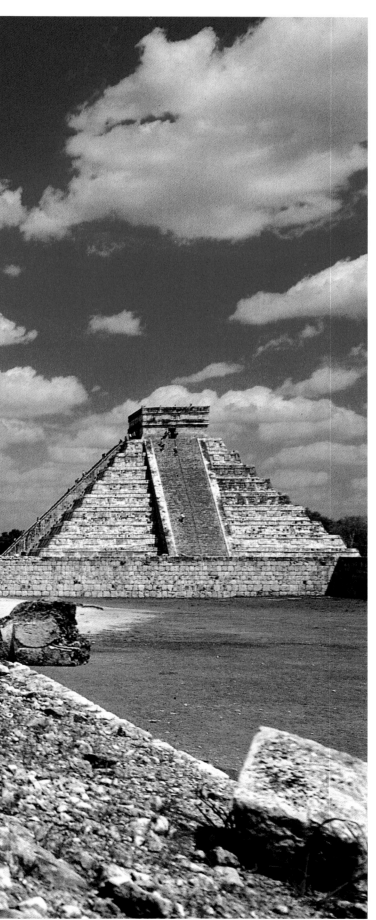

In the 16th century, the Spanish bishop Diego de Landa, who had been given the task of converting to Christianity the Mayan peoples of the Yucatán in what is now Mexico, learned that these people regularly made pilgrimages to their own sacred place. Here, near the ruins of an ancient city was a huge natural cavity which apparently had been worshipped by the local inhabitants for centuries. In his report, De Landa wrote with horror that this was a place of human sacrifice. Here people were thrown alive into the deep dark waters of this cavity, which was called cenote, or deep rock pool, by the Spaniards, a word which was a corruption of the Mayan word dzonot.

The bishop discovered that these human sacrifices were made as part of an extremely ancient cult linking water and fertility. The ruins that were around the well belonged to one of the ancient Mayan cities which had not been entirely abandoned and forgotten. This city is Chichén Itzá which, in the Yucatán language, means Cenote of the Itzá and the Itzá were the people who had inhabited the area for many centuries. In 1814 the explorers John Stephens and Frederick Catherwood visited the area and after drawing the most spectacular buildings began the first archaeological surveys. American scholars continued the surveys and, in 1900, Edward Thompson, one of the best-known archaeologists, continued this work, even going so far as to dive into the sacred pool.

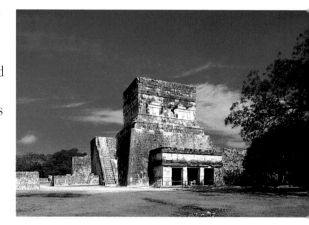

314-315 This photograph shows two famous temples in Chichén Itzá. On the left is the Temple of the Jaguars and on the right the Pyramid of the Castillo. In the foreground is a large serpent's head.

315 top This stone disk is set in a wall of the playing field area. The bas-relief skull expresses the concept of death and sacrifice that were part of the ritual ball game.

315 top center The Temple of the Jaguars in Chichén Itzá contains a porticoed hall with an elegant statue of a jaguar, a sacred animal for the Mayans.

315 bottom center Inside the temple at the summit of the Castillo are two stone monuments typical of the Post-Classical Period, the Chac Mool, in the foreground, which was used as a sacrificial altar, and the Throne of the Jaguars, at the rear of the building.

315 bottom The field for the ball game in Chichén Itzá is the largest in Indo-America. On the eastern side it is overlooked by the structure of the Temple of the Jaguars.

Regular excavations, begun in the 1920s by Sylvanus Morley, revealed numbers of amazingly grandiose buildings which were rescued from the advancing vegetation of the forest.

Today, although Chichén Itzá has still not revealed all its secrets, it is one of the most famous archaeological sites in the Yucatán and the Mayan world.

It's important to take a look at this city's history before viewing its remains. It is situated between the modern cities of Merida and Cancún. At the end of the Classic Period, between 800 and 950 AD, when the Mayan cities of the low plains of Mexico fell into a stage of decay and abandonment, a group of Mayan peoples known as the Itzá or Chontál, who were strongly influenced by the culture of Northern Mexico, established a town of modest size whose importance rested on the cult of the sacred Cenote. According to the data which has come from the various archaeological investigations and what

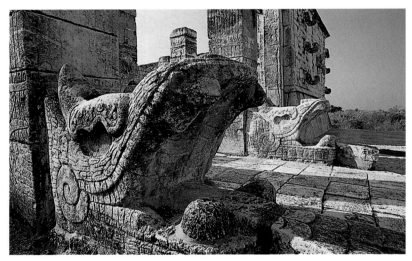

historical information is available, a new group of people, the Toltecs, arrived in Chichén Itzá at the end of the 10th century AD.

These invaders came from Tula, the city that had ruled over the Mexican plateau for several centuries following the fall of Teotihuacan. Several Toltec histories state that around 987 AD, under the leadership of the ruler Ce Acatl Topilzin, who had been removed from his throne by his brother Tezcatlipoca, a group of inhabitants left Tula and, after a long journey through Mexico, reached the Yucatán. Here they settled in Chichén Itzá which became a new capital and where magnificent buildings were built. Both sources and historical tradition linked Ce Acatl Topilzin with Quetxalcoatl, the mythical Plumed Serpent whose worship and iconography permeate the monuments of Chichén Itzá. The Maya of the Yucatán were persuaded to worship this new god which had been brought to them by the Toltec colonists, and this religion took over from the ancient cult of ancestor worship. The new religion was called Kukulkán, a word meaning Quetzal-feathered serpent. (A quetzal is a vividly feathered South American bird.)

The oral history of the flight of Ce Acatl from Tula, sent into exile by his brother with his followers, is borne out by what has been discovered through archaeology. It seems that around 1000 AD Chichén Itzá was transformed into a very large urban center, rich in monuments which clearly illustrate the combining of the Mayan culture of the late Classic Period with that of the Toltecs. A strong militaristic influence in the ruling class can be seen in the local artistic expressions, in contrast to that of the Mayan cities of the low plains

316 bottom Dozens and dozens of columns with designs on four sides once held up the roof of the great colonnaded rooms that formed the so-called Group of the Thousand Columns.

316-317 On the summit of the Temple of the Warriors can be seen the Chac Mool, a sacrificial altar in human shape, introduced to Chichén Itzá by the Toltecs. In the background are two high snake-shaped columns which held up the roof of the sanctuary.

316 top This picture shows a detail of the sacrificial altar on the summit of the Temple of the Warriors. It is the statue of a man used as a support pillar for the stone table on which sacrifices took place. These rituals, which always existed in Meso-America, reached their height during the Post-Classical Period.

316 center Big stone columns ending in large snake heads with gaping jaws held up the roof of the sanctuary on the Temple of the Jaguars. The design of the Plumed Serpent with feline fangs originates in Chichén Itzá and can be traced to the myth of the god Quetzalcoatl.

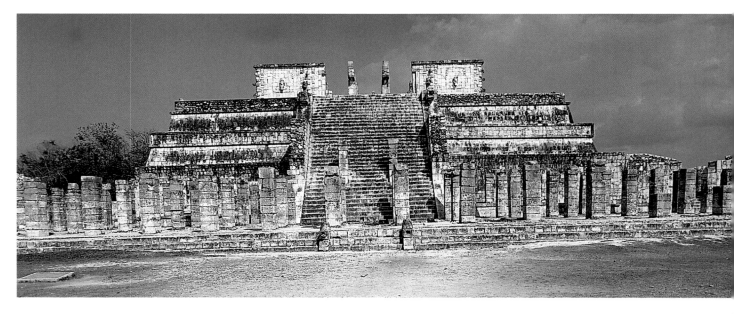

317 top This photograph gives us an idea of the great size of the Temple of the Warriors in Chichén Itzá. The staircase, preceded by the colonnade, is overlooked by the somewhat disturbing Chac Mool.

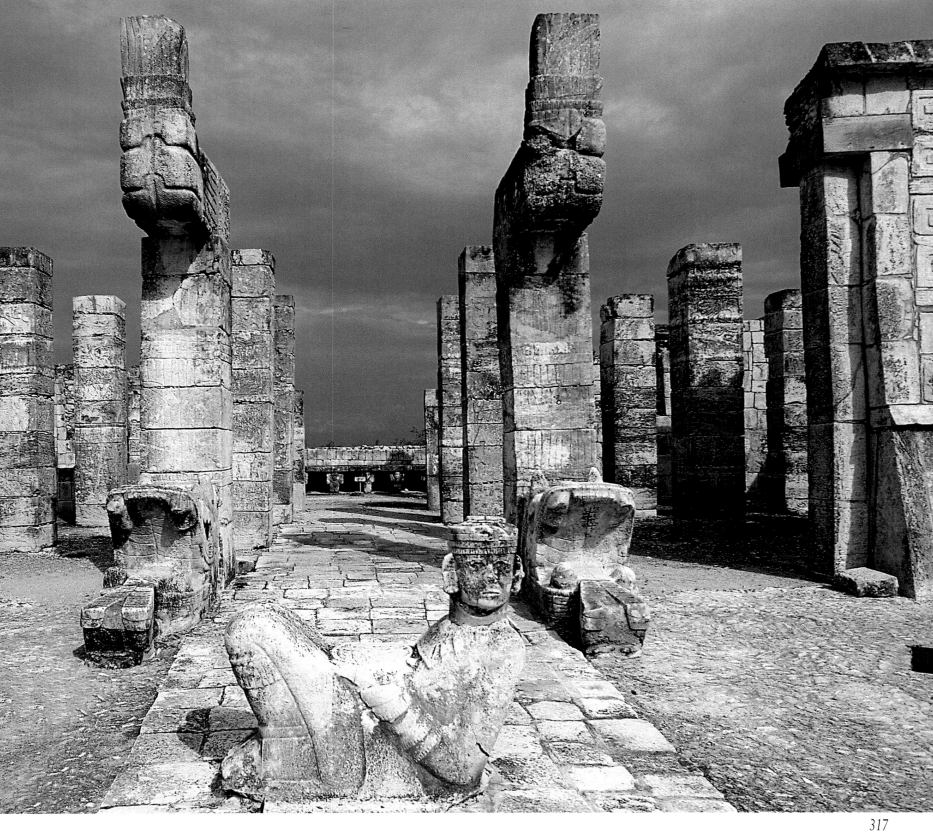

which had flourished in previous centuries. In Chichén Itzá, as in Tula, the presence of a warlike ideology typical of the Indo-American civilization of the Post-Classic Period can be clearly seen imposing itself on older religious cults. The influence of the Puuc style from the Yucatecán centers of the late Classic Period can be found only in a few buildings in the southern part of the area, almost as a final cultural reminder of the Mayan world. The most important of these are the Casa Colorada and the Building of the Nuns. The former is very dramatic with a sober, severe appearance showing the true elegance characteristic of the Puuc style only in the upper part which is enriched by a frieze. This frieze shows masks of the god Chac and is surmounted by an upper crest which is much more stylized than those found during the Classic Period. The Building of the Nuns, on the other hand, is almost baroque in appearance. The main façade is entirely covered in stone fretwork and masks that have to do with the cult of Chac and the Terrestrial Monster. This building, more than any other in Chichén Itzá, is reminiscent of the buildings of Uxmal. Above the central door there is a bas-relief sculpture in a niche, with an unidentified seated figure.

In the northwestern section of the city is what is believed to have been a playing field for ball games. This is the largest field of its kind found in Latin America and covers an

enormous surface area which is extremely impressive. It is about 200 yards long with its eastern side dominated by the Temple of the Jaguars. Its size and appearance indicate the importance of the ancient traditions which are believed to have been linked to this game which had a complex cosmological significance.

At the northwestern end of the city are more grandiose architectural structures rich in the cultural heritage of the Toltecs.

The Tzompantli, which is also called The Platform of the Skulls, may be the most unnerving monument in Chichén Itzá. This type of monument was unknown to the Mayan cities of the Classical Period and stands as a witness to a civilization that found itself obsessed with human sacrifice.

The structure itself is a rectangular stone platform, with its sides covered by a continuous frieze sculpted in bas-relief and showing rows of impaled skulls. This is

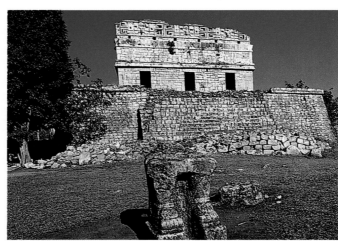

Chichén Itzá

Chichén Itzá

believed to be a replacement for the original tzompantli, a wooden palisade on which the heads of decapitated victims could be placed and displayed. It is believed by some that these heads had belonged to enemies captured in battle or to the members of the losing team at the end of the ball games. Similar monuments exist not only in Tula but also in Tenochtitlan, the capital of the Aztec empire, which inherited its habits and customs from the Toltec people.

The impressive Temple of the Warriors and the neighboring remains of the so-called Group of the Thousand Columns are at the east side of this gruesome building. The Group of the Thousand Columns is a large, stepped pyramid, probably built around the 12th century and designed to be identical to the Tlahuizcalpantecuhtli in Tula, which was dedicated to the morning star we call Venus. A central staircase leads to the summit, where the center of the sanctuary was placed. Its

pillars were decorated with a frieze which supported the now missing roof and tells tales of the past. Two huge columns, shaped like serpents, are on each side of the sanctuary. The monster with gaping jaws and plumed body is another depiction of Kukulkán, the mythological Plumed Serpent. The Chac Mool lies between the two columns which, like the tzompantli, was introduced by the Toltecs. This is a monolithic altar on which sacrificial victims were placed at the time of the conquest. The four sections that form the structure of the pyramid, similar in form to the talud and tablero of Teotichuacan origin, are covered in sculptured designs showing scenes of the successes of the Toltec military groups, the Order of the Eagles and of the Jaguars, alternating with scenes showing cruel sacrifices. In 1841 Stephens discovered a group of wall paintings inside this temple, unfortunately in very poor condition although a naval battle scene could

318 top left This magnificent disk, dated around 1000 AD, is covered by a turquoise, seashell and coral mosaic. There are four serpent-shaped motifs around the center where there may have been a pyrite mirror used during religious rituals honoring the Sun God.

318 top right The macabre stone monument known as the Tzompantli, seen here, takes the form of the wooden rack on which the heads of defeated enemies or sacrificial victims were skewered and exposed to the public.

318 center right This photograph shows a detail of a small religious monument in Chichén Itzá, the Platform of the Jaguars and the Eagles.

318 bottom right These remains are from the Casa Colorada, a sober, elegant building. The frieze on the crescent contains a Grecian lattice motif.

318-319 This structure, an addition to the House of the Nuns, is decidedly Puuc in style as can be seen from the decorative motifs on the façade. Among these can be seen the masks of the god Chac.

be made out. The Temple of the Warriors is flanked by long colonnades placed in various rows. These originally held up the false vaulted ceilings of enormous halls. The stems of the these columns are cylindrical or rectangular blocks, usually with bas-relief decorations.

It should be noted that no similar buildings were found in the Mayan cities of the Classical Period and that these buildings were definitely brought to the Yucatecán

of the pyramid we are given 365, which corresponds to the number of days in the solar calendar. A wide ceremonial street, called the sacbeob in Mayan, leads from the flat area under the bulk of the Castillo to the sacred Cenote, the great natural rock pool into which, it is believed, human sacrifices were thrown to honor and propitiate Chac, god of rain and fertility.

The archaeological route through the remains of Chichén Itzá is one which always

area from the Mexican plateau. The Group of the Thousand Columns surrounds a trapezoid shaped square on two of its sides which contain a structure which is believed to have been a covered market.

Although these monuments are fascinating, the Castillo (Castle) is undoubtedly the most important. This is the main structure and the symbol of Chichén Itzá, given its name by the Spaniards because of its huge size and its dramatic position, isolated as it is in the midst of the spacious plain between the playing field and the Temple of the Warriors.

The pyramid that remains today, formed by nine steps, incorporates an older building dating back to the 10th century. This building, of a similar structure and with a similar square base, is more modest in size. The Castillo is topped by a sanctuary with columns in the typical serpent shape. The entrance to it is by the four staircases at the center of each side in keeping with the style of the ancient Mayan pyramids from the Classic Period.

This particular type of design is very rare in Indo-American architecture. Each ramp is formed by 91 steps. If we add these to the continuous step which runs around the base

amazes visitors. In addition to the temples and elegant palaces with their columns, decorated with the Plumed Serpent motifs and the marks of blood-thirsty cults and the markets and playing fields, there is also a building whose structure reflects the belief that the ancient Mayans, more than any other people, were highly skilled in the study of the stars. This building, called the Caracol by the conquistadors from Spain, is a cylindrical tower. It was originally covered by a false cupola at the summit of two overlapping platforms. Inside it there is a spiral staircase leading to a room with several windows placed so as to permit the study of numerous heavenly bodies and precise astronomical phenomena, including solstices and equinoxes.

Before this amazing indication of human genius, it is sad to think that when the white conquerors from Europe set about eliminating the refined Mayan culture, they used as their excuse that the people were uncivilized savages.

These conquerors demolished the buildings they found and burned the sacred texts in huge bonfires, considering them blasphemous.

321 top left This building with two circular stemmed columns is at the northern end of Chichén Itzá. Although some scholars thought it was a temple, it is now believed to be a pavilion used by members of the elite during the ball games.

321 top right The Platform of Venus also contains the sculpted Plumed Serpent motif. This mythological figure was one of the features of the Morning Star, whose cycle was studied by the Mayans from ancient times.

321 bottom This picture shows one of the most symbolic and impressive structures in Chichén Itzá, the sacred Cenote, an ancient well, in whose waters many victims were sacrificed to honor the god Chac.

CHAN CHAN, ENIGMATIC CITADELS

A Chayuac E Uhle I Bandelier
B Rivero F Laberinto J Huaca
C Tschudi G Velarde K Squier
D Tello H Huaca El Olvido L Gran Chimù

Between 800 and 1000 AD, the cultural unity brought about by the Wari empire in Pre-Columbian Peru crumbled and this collapse led to the formation of a number of short-lived small kingdoms. After about 1450 these were forcefully incorporated into the Inca empire. These new cultures, from what is called the Second Intermediate Period, were regional and inherited the town planning and bronze-working methods of the Wari, unknown in Peru until 700 AD. The names of some of these kingdoms have been handed down to us by the Spanish chroniclers who wrote of the enterprises and conquests of the Inca rulers. The results of archaeological investigations have confirmed what they wrote. They said that in the northern coastal areas there was a flourishing kingdom called Chimu or Chimor, whose representatives had apparently inherited many aspects of the Moches. The Moches had lived along the same valleys several centuries before the Wari empire. The legend about the foundation of the kingdom of Chimu tells that one day a raft would arrive at the Moche coasts from "the other end of the sea", and a man called Tacaynamo would take over power in accordance with the will of a ruler from a far away country. It is not yet clear how much, if any, truth this myth contains. However, there is no doubt that the Chimu left behind them signs of a rich culture, especially in terms of metalwork, pottery, and the art of feather decoration with a society organized and structured in accordance with rigid hierarchical principles. The Chimu of the Moche Valley imposed their power on the peoples of the surrounding valleys and founded what was almost a kingdom-confederation within which each race was able to retain its own

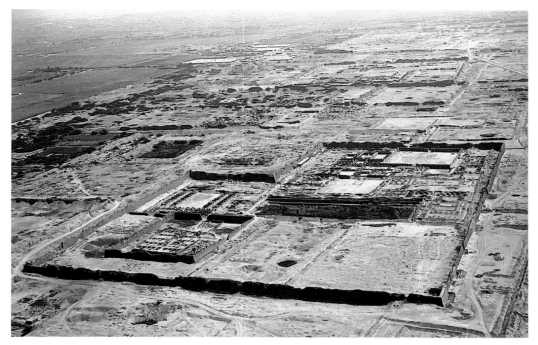

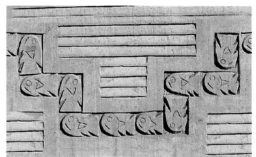

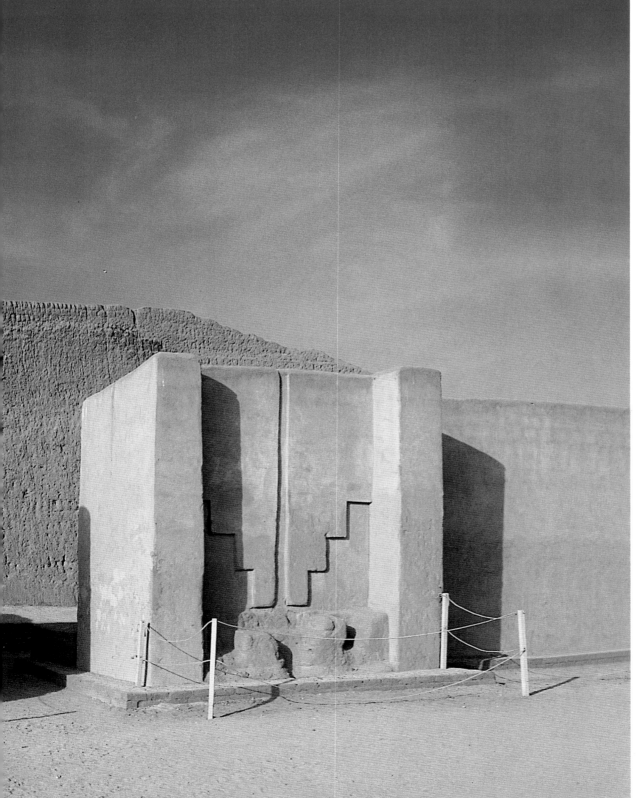

322-323 This photograph shows the imposing entrance on the north side of the square of one of the nine citadels of Chan Chan, known as Tahudi, or First Palace. The staircase motif on the side walls is especially interesting.

323 top left In this aerial view of Chan Chan we can clearly see the four sided plan of the city which stretches over 7 square miles.

323 top right There is an entrance gate to the southern side of the main square of the Tahudi citadel. This one is flanked by adobe walls decorated with elegant molded clay and plaster friezes.

323 center right The citadels of Chan Chan were crossed by straight roads such as the one in the photograph, running along the Tshudi Complex. Each citadel was a separate architectural unit, isolated from the others by walls as high as 20 feet or more.

323 bottom right The stucco friezes on the walls of the citadels are an extremely elegant example of a high level of artistic expression.
In this one, from the citadel of Tshudi, the stair motif is shown along with elegant stylized fish.

cultural identity.

Archaeological information seems to indicate that the rulers of Chimu allowed the various urban centers to enjoy a certain economic independence, although the administrative power was centralized. The main reason for this centralization was probably to handle the distribution of water and consequently the agricultural system which, together with fishing and crafts, was the most important economic resource. Accounts tell us that in spite of both Incan and Spanish conquests the Chimu dynasty remained in existence until 1602.

At the height of its splendor, from 1300 AD onward, the kings of the Chimu appointed the town of Chan Chan the capital. They transformed what had been a modest town, dating back to the late Wari period, into a genuine metropolis. Its ruins, which cover an area of almost eight square miles, would

brick walls decorated with niches and stuccoed friezes, many of which were frescoed, showing fish, birds, half human-half animal figures and geometric motifs, undoubtedly symbols of religious ideology. Although the remains of the area of Chan Chan leaves much to be desired as it was robbed and despoiled many times over the centuries, no visitor can help being impressed by the originality of the architectural style and the elegance of the decorations, similar to arabesques, an element that is quite unique in the Pre-Columbian world. Here, just as in Nazca, Tiahuanaco and other sites, a variety of different and often quite contradictory theories have been developed to explain the remains, especially in the case of the question of the function of the nine citadels, gigantic and isolated from each other. Perhaps a dignitary, known as a curaca in

platforms, one 14 feet high and the other 10 feet high. The structure takes its name from the bas-reliefs on the walls. At the center is a two-headed serpent, perhaps a symbol of water and fertility, associated with other serpent-shaped creatures which have yet to be finally interpreted. The style is similar to the stuccoed friezes that decorate the walls in the citadels of Chan Chan, and the symbols are very similar to those seen on the fabrics, the simple pottery and the gold and silver vessels. The Chimu craftsmen were highly skilled in the working of precious metals, producing items of extraordinary quality. At the end of the 15th century, when Chan Chan was despoiled and abandoned by the Inca army, the sovereigns of Cusco forced the most highly skilled goldsmiths and metallurgists to continue their work at the court, where they continued to work until the Spanish conquest.

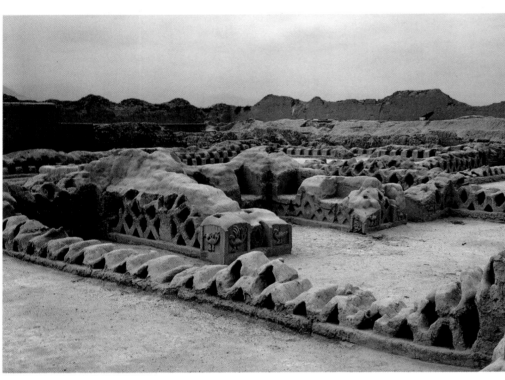

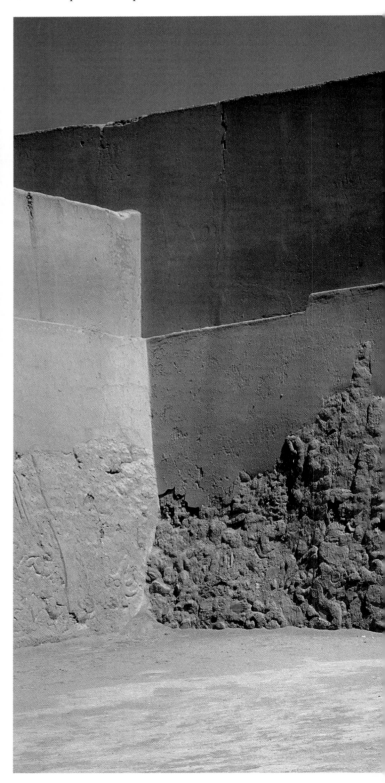

suggest that it was the largest city in Pre-Columbian America. The structure of the town was extremely complex and quite original. Nine walled areas have been identified, considered by some scholars to have been citadels, surrounded by walls up to almost 24 feet high and just a little less than a mile long. Other experts use the term palaces rather than citadels to describe these areas, with the terms understood in the broadest sense as referring to buildings similar to medieval courts. Each of these fortified units contained streets, residential quarters, perfectly irrigated gardens, cemeteries, reservoirs, temples and small cell-like areas for purposes that have yet to be identified.

The most important state or ceremonial buildings can be recognized by their elegant architectures. These buildings have adobe

the local language, was at the head of each of these, as a representative of the king. But there is another theory which suggests that each citadel may have been the headquarters of the members of a specific social class, none of whom were allowed to mix with the others, so that they were forced to live their lives separated from each other by these solid walls. Near the urban complex of Chan Chan, other important structures have been found which are unique to the Chimu civilization. These include artificial platforms known as Huacas, a word which comes from the Spanish for "sacred", due to their original function as places of worship. The most famous of these are the Huaca Esmeralda and the Dragón, which was restored in the 1960s. This is a structure consisting of a surrounding wall within which there are two superimposed

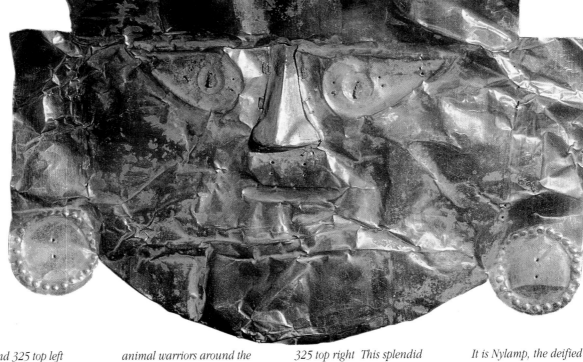

324 Not far from Chan Chan are the impressive ruins of the Huaca del Dragon decorated with complicated scenes of warriors and mythical creatures. This, like other similar structures, was probably used as a temple.

324-325 and 325 top left The thick adobe walls of the Tshudi citadel have diamond-shaped niches and bas-relief decorations showing small, stylized, part human, part animal warriors around the mythological dragon shaped like a two-headed serpent. This recurring motif was possibly connected with the cult of Water and Fertility.

325 top right This splendid golden mask shows the most important god worshipped in the coastal area of northern Peru during the 2nd Intermediate Period. It is Nylamp, the deified hero from the sea, with the eyes of a bird. There are various examples of this type of mask, most from the ceremonial center of Batan Grande.

CUZCO, THE CENTER OF THE WORLD

326 top *This photograph shows a view of the Monastery of Santo Domingo in Cuzco. Still visible are the base of the walls from the Inca period belonging to the Coricancha, the Temple of the Sun, praised by Spanish chroniclers for its fabulous richness.*

Many legends surround the origins of the Incas, the people who created the biggest and last unifying empire in pre-Columbian Peru. According to one of these legends, the founder of the people, Manco Capac, was born in the waters of Lake Titicaca. His father, the Sun God, ordered him to travel and bring civilization to men, and he left the lake with his sister to take up residence in Huanacauri, near Cuzco. The historical reality of the Incas partakes of legend, also. Scholars still do not know the origin of these people although certain linguistic similarities with tribes from the Amazon area have led some scholars to believe this area is their place of origin, but these studies remain unconfirmed. When the Incas settled in the valley of Cuzco, they found a number of powerful, warlike people there who had been there for several centuries. A series of alliances were formed between these people and the newcomers who abandoned their ancient language for the local language, Quechua. Over the course of time, the Incas imposed their power structure on the region and laid the foundations for the future kingdom, whose primitive original settlement went on to become the capital under the name of Cuzco. In the complex interweaving of myths and realities which are part of the legend of the

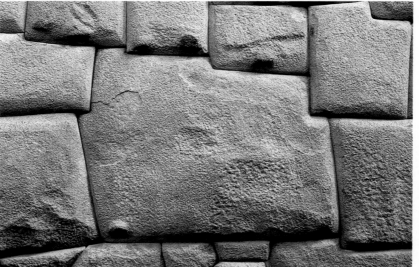

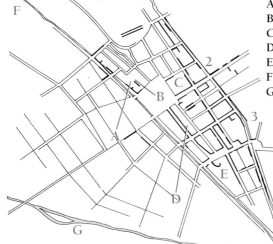

1 Fortress of Sacsahuattan
2 Hanan Cuzco
3 Hurin Cuzco
A Palace of Pachacutec
B Palace of Inti Roca
C Temple of Uiracocha
D Accla Huasi
E Coricancha
F River Huatanay
G River Tullumayo

Inca dynasty, the first date of which we can be certain is 1438, the year when Pachacute ascended the throne and became ruler of Cuzco. From that time onward, through a series of military campaigns, the Incas subjected nearly all the peoples of the area both near and far to their dominance, forming an immense empire. The empire was short-lived, as it collapsed under the blows inflicted on it by the Spanish led by Francisco Pizarro. The word "Inca", which was used by the Spanish to refer to the race as a whole, was actually an honorary title that the people used for their emperor. Its exact meaning is unknown. Under the rule of Pachacute, Cuzco was transformed from a small rural village into a city with stone buildings, paved

326 bottom *The so-called Twelve-Cornered Stone inserted in one of the ancient walls of Cuzco is a typical example of the Incan skill in producing megalithic architectural complexes.*

326-327 *The Coricancha, or Temple of the Sun, was in the low part of the city, known as Hurin Cuzco. The most famous of all Incan buildings, it was probably dismantled by Pizarro for its gold-plated covering and the golden statues in the gardens. The photograph shows the foundations of the temple, on which the Monastery of Santo Domingo was built.*

327 bottom left This trapezoid gate, typical of Incan architecture, belongs to the surviving structures of the Coricancha.

327 bottom right In some streets of Cuzco today we can still see traces of the Incan walls on which Colonial and Post-Colonial buildings stood.
The photograph shows the Monastery of Santa Catalina, built on the foundations of the Accla-Huasi, the House of Women.

Cuzco

streets and a water supply and it became the capital of the empire. Pachacute and his successors designed the layout of the city using as their models some of the ancient Andean cities, such as Huari, Tiahuanaco and Chan Chan, the capitals of peoples they had conquered. The town plan of Cuzco, which is placed between the Huatanay and Tullumayo rivers, followed the shape of a puma, one of the sacred animals of the Andean people. The Spanish chroniclers have handed down ecstatic descriptions of this city as a marvelous place where luxurious palaces and gardens leave no space for poverty. The town was divided into two parts, with the area of Hanan Cuzco above and Hurin Cuzco below. It consisted

of a group of kanchas, quarters with closed structures, formed by buildings grouped around a squared shaped like a patio. The inhabitants of Cuzco amounted to roughly 300,000. The central nucleus, the oldest part of the town, contained the Incan palaces grouped around the two main squares together with the temples and the buildings reserved for the members of the elite. This, the heart of Cuzco, was the starting point for the four great roads that divided up the empire. The Spanish chroniclers wrote that each ruler, when he came to the throne, had a large, elegant, new palace built with rooms for his family, his concubines and the priests as well as state rooms in which the ceremonies took place. Only a few fragments

of the walls remain of the Palace of Pahacutec, described as the most luxurious of all. Various public buildings were situated near the palace, including the Accla Huasi, Quechua for "The House of the Chosen Women", the Temple of Viracocha, the Palace of Inti Roca and the "House of Knowledge", where the members of the upper classes were educated. Hundreds of girls were brought, every year, to the Accla Huasi from every corner of the empire, to become slaves of the Incas and the Sun God. They were kept here and remained at the disposal of the emperor. Parts of the ancient walls of the building were reused during the colonial period. On the site of the Accla Huasi is the Convent of Santa Catalina,

328-329 *The famous Fortress of Sacsayuaman, not far from the city of Cuzco, was probably a large religious complex dedicated to the cult of the sun. Notice the enormous walls built of huge stone blocks, worked and fitted together with amazing skill.*

built in the 17th century. In Cuzco, many of the remains of the Inca civilization were used in building the new city during the centuries following the conquest. The remains and, above all, the foundations of the massive stone buildings erected by Pachacute and his successors still stand today, enabling us to admire the construction technique. Nearly all the palaces and residences had a rectangular or polygonal structure, and were built using large blocks of stone, cut and fitted into each other perfectly, with no need for cement. The chronicles have given us a description of the most sumptuous palace in the center of Cuzco, the Coricancha, or "Golden Garden", a splendid temple dedicated to the cult of the Sun, Moon and Stars, with its walls covered in gold leaf and an inner garden containing statues of animals and human figures in gold and precious stones. Cuzco did not have the appearance of a fortified town, unlike many earlier Peruvian towns. No walls were ever built to separate the town from the surrounding countryside. However, a few miles from the city, there is a megalithic structure that was up until recently believed to be a fortress, despite various other theories that had been put forward to explain the function of the site. The fortress of Sacsayuaman, whose impressive bulk dominates the city, was probably built by the Incas on the remains of a much older stone structure of unknown origin. At the top of three platforms, one on top of the other, which reach a height of 60 feet, there is a triple row of toothed walls formed by huge blocks of granite. One of these blocks, about 25 feet high, weighs at least 360 tons. This complex, which is entered through a series of gates arranged in a zigzag pattern and surmounted by monolithic beams, looks at first sight to be an impregnable defensive position, but three other mysterious buildings, with circular and rectangular plans, have also been linked with the walls. The reports handed down to us speak of a temple dedicated to Inti, the Sun God, on the site of Sacsayuaman, which may not have been a simple fortress at all, but rather a place of worship, a temple complex protected by triple defensive walls. Some scholars have put forward another theory, based on a much more complex role for the site. They suggest it may have been an astronomical observatory, accessible only to the emperor and a highly select group of

329 top This detail shows one of the three megalithic doors which joined the platforms which formed the vast architectural complex of Sacsayuaman.

329 center The Fortress of Sacsayuaman, together with Pisac, Ollantaytambo and other similar complexes, is typical of Incan architecture.

329 bottom This charming female idol, not even two and one-half inches high, comes from Sacayuaman and indicates the religious aspect of the site. The Incas learned the art of working in silver from the expert Chimu craftsmen.

priests. It has been confirmed that the stone blocks used for this huge structure were brought from the quarry of Huacay Pata, only a few hundred yards from the site. An extensive level space separates the fortress from another extremely interesting monument, a staircase cut out of a spur of volcanic rock known as "The Throne of the Inca". According to the Spanish records, the Incas considered this to be a sacred site. They used the word "Ushnu", meaning sacred site, for this and other places like it, natural rocks of a very special shape or size, scattered more or less everywhere, which were dug out to create niches or cut into staircases to be used as thrones or sacrificial altars.

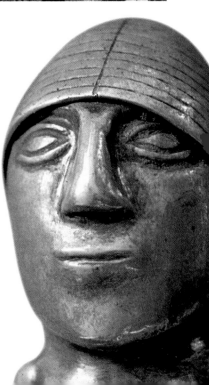

OLLANTAYTAMBO, STRONGHOLD OF THE INCAS

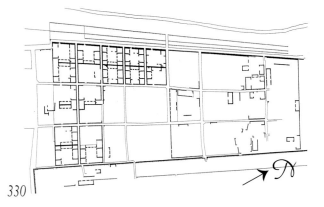

Plan of the grill-pattern road layout of the town. The remains of the houses are in black.

330-331 As in Sacsayuaman and Pisac, at Ollantaytambo, too, one of the famous Fortified Sites of the empire of Tahuantisuyu with vast walls and temple structures, built at a height of almost 10,000 feet, forms a spectacular architectural complex that dominates the valley below.

330 top This photograph shows a wall of the Main Temple, formed of enormous blocks perfectly cut and fitted together. In the center is an unfinished double-pillared portal.

Sacsayuaman is not the only massive fortress in the Cuzco area. There are other similar sites, always with their own air of mystery. One of the most famous of these is Ollantaytambo, on a slope at the entrance to the Sacred Valley, a couple of dozen miles from the Inca capital. The Spaniards wrote that Ollantaytambo, together with Pisac, was one of the strategic places from which it was possible to control the main road to Cuzco. Here, too, the imposing nature of the structures and their enigmatic appearance amazes the beholder. The lowest part of the site contained an urban settlement organized in the same Inca style that we can see in Cuzco and elsewhere, with a series of neighboring kanchas occupying a huge four-sided area on the low flood plain of the river. Above this, at the top of a rocky spur, are the remains of massive walls, whose construction was probably interrupted by the arrival of the Europeans. These walls consist of six monoliths in red porphyry, over 12 feet high, connected by very thin vertical plates in the same material. The façades of these monoliths show strange protuberances whose meaning is still unknown. On the central one is a bas-relief showing the staircase motif, similar to the one found on the stones in the site of Tiahuanaco. Here, too, it is impossible to say for certain whether or not the building is a fortress. As in Sacsayuaman, it has been suggested that the site was occupied by a temple dedicated to the sun and protected by surrounding walls. These remains, like many others from the Inca civilization, show that these were a people with a rich material culture, a wealth of knowledge and a set of religious beliefs, all of which was brusquely interrupted. Understanding and true knowledge of this people, despite the efforts of experts in many fields, may continue to elude modern man. In his writings, Garcilazo de la Vega, one of the most important witnesses to life in the court of the last of the Incas, describes some of the magical and esoteric aspects that filled this place, whose name means "The Place of

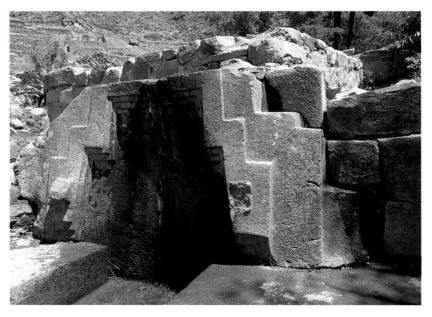

332-333 *One of the dominant features of Ollantaytambo is the terracing and staircases that climb the steep slopes. The photograph shows the remains of houses, originally covered with sloping roofs.*

332 bottom *In Quechua, Ollantaytambo means "The Place to Rest". As in Sacsayuaman, this monumental complex was a fortified religious center rather than a military outpost.*

Ollantaytambo

333 left The great trapezoidal door shown here, a typical feature of Incan architecture, is the entrance to the Main Temple. Many of the buildings at the summit of the archaeological site are unfinished, as they were abandoned when the Spaniards arrived in 1536.

333 right Another photograph of the Main Temple, this time showing the huge walls made of perfectly cut and joined stone blocks. These are another indication of the high levels the Incas reached in architectural techniques as seen also in other sites similar to Ollantaytambo such as Pisac and Sacsayuaman.

the Rest". It would appear, for example, that the inner organs of the dead rulers were buried at Ollantaytambo once these had been extracted from the embalmed body. And according to tradition a golden statue was built in memory of each sovereign after his death. At the time of the Conquest, there was an important war. In 1536, the king Manco Inca succeeded in not only fleeing from the army of Francisco Pizarro at Ollantaytambo but also in defeating it during his attempt to reconquer the empire and his power, after withdrawing from the city of Cuzco. Access to the fortress is by a steep stone staircase built into the incline. To the right, we can admire sixteen terraces, while on the other side there is a series of huge walls which enclose most unusual structures, some of which have been described by scholars as

Terrace-Observatories.
In the highest sectors of the Alacenas is the so-called Chincana, an enclosure built with large stone blocks, which probably reached a number of underground galleries. Today, archaeologists who have worked on this remarkable group of structures and who have studied the building techniques used to construct them tend to believe that the quarry from which the stone was taken was on the opposite bank of the River Vilcanota, about five miles from the village of Cachiquata. This theory assumes that the people of the time had both the knowledge and the high technological level necessary for the movement of large blocks up and down rocky inclines and across the river. There is one theory that the course of the river was perhaps diverted to make the work easier.

MACCHU PICCHU, THE LOST CITY

Among the many outstanding remains that tell us of the power of the last Indian civilization of the Andes, the Incas, the most amazing are those of Macchu Picchu, which is situated in an area that is almost inaccessible and virtually impossible to enter.

While the town of Cuzco, of which only a few fragments of walls and foundations survived the Spanish conquest, is known to have been the capital of the empire, mystery still surrounds Macchu Picchu and we know neither when its massive constructions were built nor what functions they served. The site was forgotten for four centuries, and only rediscovered in 1911 by the American architect Hiram Bingham. The ruins of Macchu Picchu are about 70 miles northwest of Cuzco at a height of over 9,000 feet, between two Andean peaks, known as the Young Peak (Huayna Picchu) and the Old Peak (Macchu Picchu). When we visit this site, we can recognize the imperial style of the other Incan centers, although here the surroundings are very different as it is set among the luscious vegetation irrigated by the River Urubamba that thunders through the valley below. For many years scholars have searched for explanations as to why the Inca rulers would build such a majestic complex in this hot, humid area at the edge of the Amazon rain forest.

Perhaps it was to protect the inhabitants of Cuzco from the pressure of the warlike peoples who lived in these regions, in which case it would have been built as a fortress, a strategic center with a truly eccentric structure.

Another theory is that Macchu Picchu was a kind of giant convent used to house the Virgins of the Sun, young foreign women whose purpose was to satisfy the desires of the Inca ruler.

Others believe the complex was built to

A Main Square
B Sector of the Three Doors
C Sector of the Stonemasons
D Sector of the Prisons
E Sector of the People
F Stairway of the Fountains
G Terraces
H Sector of the Torreón
I Temple of the Three Windows
J Intihuatana

hide King Manco, who was placed on the throne by the Spaniards as a puppet ruler after the betrayal and death of Atahualpa. In 1536 Manco rose up against the conquistadors and was forced to flee. Many legends handed down to modern times speak of the Last City of the Incas which may refer to Macchu Picchu or another fortress, hidden forever in the tropical forest.

Recent studies have led to some interesting new hypotheses about the function of the site, such as as a place of worship linked to

334 left This unusual altar, unique to the Inca world, bears witness to the skill of this people in the art of stone cutting.

334 right Walls, houses and staircases leading from one terrace to another are among the outstanding features of Macchu Picchu, an Inca site whose purpose is still not known.

324-335 The famous site of Macchu Picchu stretches over a mountain ridge linking "Old Peak" (Macchu Picchu) to "Young Peak" (Huayna Picchu). Its splendid location and extraordinary architecture, blending in perfectly with the landscape, make it the most fascinating archaeological site in Peru.

335 bottom The many terraced levels over which the outer sector of Macchu Picchu extends were probably used for agriculture. Some experts, however, believe the structure has other meanings which are not yet known.

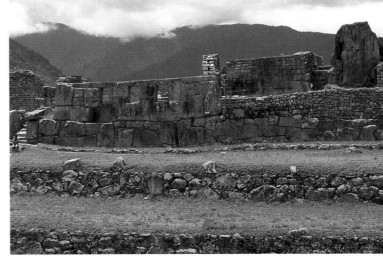

Macchu Picchu

336 top This photograph shows a view of the huge non-urban structure of Macchu Picchu, considered to be the agricultural sector, with a number of terraces stretching along the slope.

336 bottom The religious sector of the town of Macchu Picchu contains buildings for worship including the Temple of the Three Windows, the Main Temple and the Intihuatana Monument (in the picture).

the observation of the stars. For the moment both clues and theories are limited, but research continues.

The architecture of Macchu Picchu shows the extraordinary way in which the human settlement adapted to the natural features of the site.

There are no more than 200 buildings, arranged on spacious parallel terraces and organized around a vast central square, which is also divided into various levels and oriented east-west, dividing the city into two sectors, each on a natural summit. The quarters, known as kancha in Quechua, are narrow in shape, elongated and divided in such a way as to take maximum advantage of the space offered by the terraces.

These, outside the inhabited areas, were used for agriculture and we can presume that there were also rural huts and settlements there, now vanished as they would have been built from perishable materials.

Sophisticated irrigation channels kept the crops watered and various stone staircases on the sides of the walls led to different levels of the structures. The two sectors of Macchu Picchu presumably had residential and ceremonial-religious functions respectively.

In the ceremonial western section, one structure that stands out is El Torreón, a massive semi-circular tower with windows, similar to the lookout towers that can be seen all through Europe.

Another famous example of a building of this kind from the Inca period was the Coricancha of Cuzco, which contained the Temple of the Sun and the Golden Garden, upon whose walls the modern Santo Domingo is built. The rock that supports the Torreón has been dug out and has the appearance of a burial chamber. For this reason, the place was called the Royal Mausoleum, even though there is nothing to prove that a person of high rank is buried there.

Another ceremonial building was probably the Temple of the Three Windows, so-called because of the three great trapezoid niches built into it.

An even bigger sacred complex is the Intihuatana, a word meaning "The place where the sun is kept prisoner". At the top of this group of buildings, at the center of a kind of patio, is a granite monolith, considered by some to be simply an usnu, the sacrificial altar to be seen in all the Inca centers, while others believe it to be a sundial, a theory that supports the belief that Macchu Picchu was the site of an important astronomical observatory connected with the cult of the Sun God, but once again it is impossible to say anything with mathematical certainty.

If we cross the great square, leaving the ceremonial part of the city behind, we reach the northeastern section, believed to have been the residential quarter.

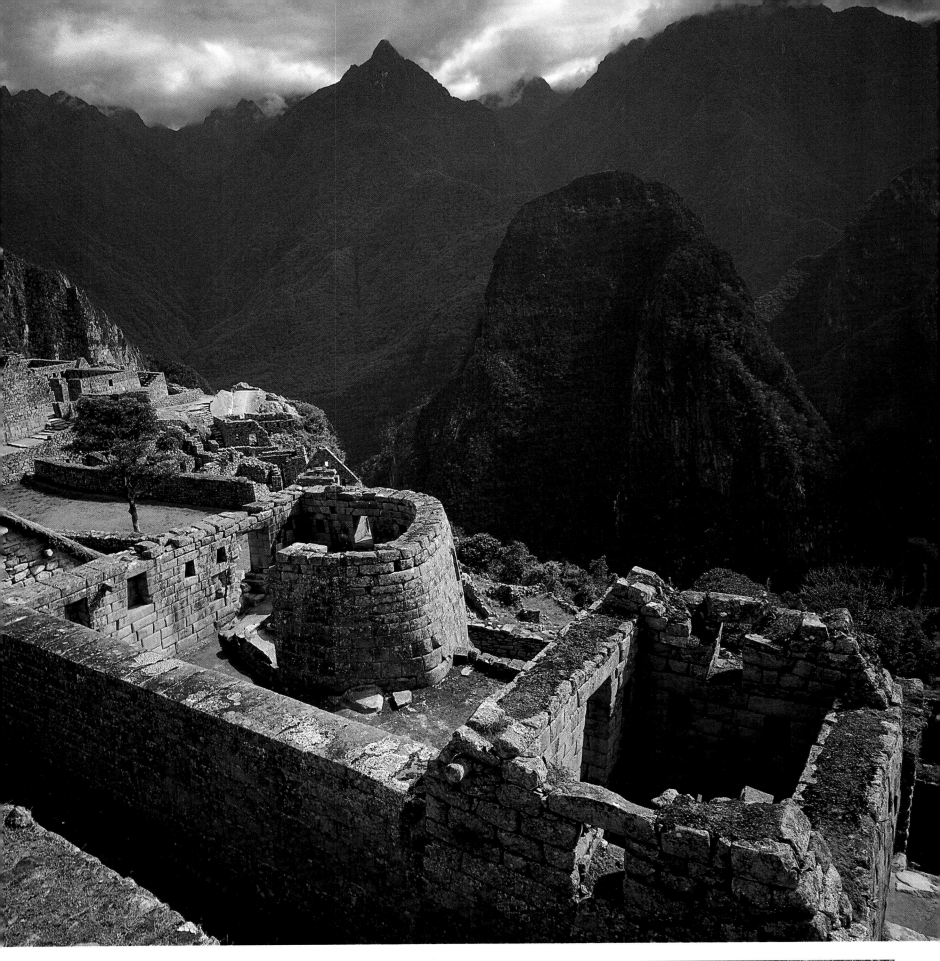

Each quarter has been given a different name, according to the functions it is believed it performed from the architectural elements found there. So we have the quarters of the Three Doors, the Stonemasons and the Prisons. Wandering up and down the narrow streets is an impressive experience. Most of the houses were of one story only, had sloping roofs and were fitted with four-sided doors and windows that narrowed toward the top, probably to create a kind of balance with the weight of the architecture.

The structure of these modest buildings

336-337 The imposing, circular building, known in Spanish as the Torreón, reminds us of the lookout towers seen on European castles. Here, however, some experts believe it may be an astronomical observatory or a temple dedicated to the cult of the Sun.

337 bottom The so-called Sector of the Stonemasons is a group of small, modest houses with windows, believed to be the town's crafts center.

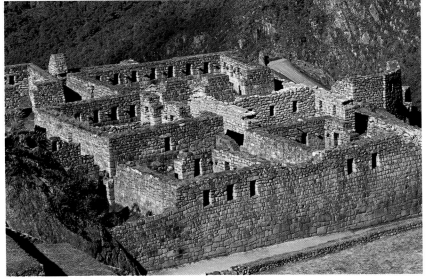

consists of blocks of crude granite joined together with a clay-based cement. However, here too, as in Cuzco, Pisac, Ollantaytambo and other centers built by the Incas, the surprising feature for experts and tourists alike is the enormity of the surrounding walls, made out of gigantic blocks of granite, using the technique typically applied to the most important ceremonial buildings. The Incas, like the other Andean peoples, had neither the wheel nor iron tools, and this makes their ability to work with and transport masses of granite weighing several tons even more amazing. Research has shown that the blocks were simply cut out from the quarries and that the finishing work took place on the building sites, to which the blocks were apparently taken by rolling

338 top left In the eastern quarter of Macchu Picchu, near an unusual building at the top of a spur of rock, is what some experts believe is a small fountain cut out of the rock. Other experts believe, however, that it is an altar on which a stylized condor head is sculpted.

338 center left No one knows for certain what the original role of the various sections of Macchu Picchu was. Archaeologists have suggested various theories, in accordance with the architectural features or the archaeological elements found in the specific areas.
This photograph shows a view of the Temple of the Condor in the Prison Quarter.

338 bottom left Archaeologists have given different names to the different quarters into which the urban area of Macchu Picchu is divided. This photograph shows a view of the Central Sector with the Sacred Sector, which stretches to the summit of a spur of rock from which it dominates the center of the town, shown in the background.

338 top right In the heart of the town, near the Sector of the Torreón and the Royal Cemetery, is the long Stairway of the Fountains, shown here. This and the Central Stairway link various residential areas.

339 Among the several sections in which the urban area of Macchu Picchu is divided is the Sacred Sector. A long staircase leads from the Temple of the Three Windows and the Main Temple to another sacred structure on the summit of a rocky spur, the monolith called Inithuatana.

them on tree trunks. In spite of the popularly held belief that the blocks were fitted together using a dry stone technique, they were nearly always joined together using a kind of mortar which is no longer visible today.

Archaeologists have discussed widely the question of whether the Incas were the inventors of these building techniques or if they followed pre-existing models. Although many believe they invented them, it seems probable that they actually got their inspiration from the much earlier constructions of Tiahuanaco. The agricultural system of terraced cultivation, particularly impressive and applied to perfection in Macchu Picchu with the aid of ingenious systems of irrigation canals, was certainly nothing new, but a continuation of a tradition in the Andes that goes back to the First Intermediate Period. It has been confirmed, in fact, that on the northern coast of Peru the Moche people had created aqueducts and systems of canals several centuries before the 1st millennium which enabled them to grow excellent crops on artificial terraces. The Incas, skilled and ingenious, took these and other ancient ideas and modernized them, adapting them to their own special architectural and town planning requirements, giving birth to one of the most unusual and mysterious civilizations found on the American continent.

TIAHUANACO, GODS OF THE SCEPTERS

A Palace
B Gate of the Sun
C Kalasasaya
D Inner wall

E Eastern Temple
F Kantatayita
G Akapana

On the shores of Lake Titiaca on the Bolivian plateau are the monumental remains of an ancient civilization, undoubtedly linked with the Andean cultures of Pre-Columbian Peru, but rich in stylistic expressions of its own. The archaeologists named it the civilization of Tiahuanaco, and it was the first pre-Inca civilization of the Andes that the Europeans discovered. The Conquistadores of the 16th century learned from local legends that the royal blood of the Incas had its origins in the sacred places around Lake Titicaca, and a number of them went to visit the mysterious ruins of settlements long before abandoned. The 16th century Spanish chronicler Pedro Cieza de León described the remains of Tiahuanaco as "A sight worthy of admiration" and believed they belonged to Antigualla, "the oldest city in all Peru." Some scholars, including Arthur Posnanski, fascinated by the many unresolved problems surrounding the site of Tiahuanaco, reached the conclusion after years of research that its origins were very ancient, that it perhaps even dated back as far as 10,000 years ago. More orthodox archaeologists, however, were unwilling to accept this hypothesis and identified a number of chronological stages in the history of the site, from 100 BC to 1000 AD, based above all on the information obtained from the developments in pottery production. Along the basins of the rivers flowing into Lake Titicaca evidence was found for the existence of an older civilization than that of Tiahuanaco, known as Pukará, including its architecture, pottery and monumental sculpture, even though there are still many unresolved mysteries surrounding the type of settlement it was and the origins of its symbols and motifs. The archaeological site of Tiahuanaco

340 left The mysterious geometric shapes carved in these stone monuments at Tiahuanaco include the stair design which is found throughout Peruvian culture.

340 right Among the ruins scattered throughout Tiahuanaco, north of the Calasaya, is the architectural complex known as Pumapuncu. Here a series of cut sandstone

blocks form a platform on whose eastern side a series of "seats" are cut from the rock. Some experts believe this monument is the remains of an ancient pyramid.

occupies an area of roughly 600 square yards, and is located at over 11,000 feet above sea level. The various architectural structures, some of which are extraordinarily large, were built at different times. Some would appear to be unfinished, as if something had suddenly brought this civilization to an end. The monumental appearance of the buildings has led many archaeologists to consider Tiahuanaco as a vast, flamboyant trading

ceremonial center, where gods were worshipped and cults linked to the observation of the stars were practiced. It is believed that for many centuries it was a place of pilgrimage for the Andean peoples, but no one has yet succeeded in attributing an undoubted, definite role to the site. For the construction of the monuments, great blocks and slabs of basalt and sandstone were used, squared off and smoothed with great technical

340-341 The Gate of the Sun was originally in a different section of the Calasaya. It has been estimated that the entire structure weighs about 12 tons. The great crossbeam is decorated with a frieze made up of four rows of winged figures with the god of the Arc in the center, a being that has been identified with the mythical Wirs Cocha.

341 bottom This photograph shows the remains of one of the most distinctive monuments in Tiahuanaco, the Calasasaya. The monolithic walls surrounding it are reminiscent of the megalithic stone monuments in the Old World.

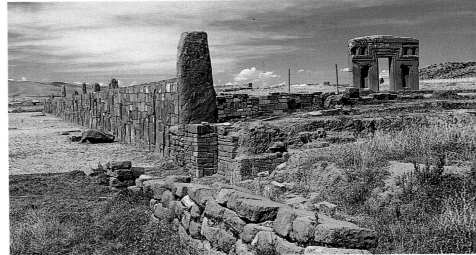

skill. These blocks were then fitted to each other using T-shaped copper or bronze joints. The quarries were several hundred miles from the site. One of the most important structures is known as Akapana. This is a flat-topped pyramid formed by superimposed platforms, square in plan and about 50 feet high, oriented from east to west. The name of the monument, perhaps one of the oldest in the ceremonial center, means "Artificial Rise" and is believed to have been a kind of temple. To the north of the Akapana is a most unusual complex, once believed to have a connection with the megalithic stone circles of Europe such as Stonehenge.

The name of the site, Kalasasaya, means Straight Stone, and clearly comes from the peculiar nature of the structure. A series of monolithic plates, not unlike menhirs,

with virtual certainty is that this is the same being as that of the Stelae Raimondi of Chavin de Huantar, dating back to around 1000 BC. There is therefore a definite connection between the cult of the Gate of the Sun in Tiahuanaco and the ancient cult of the cat and serpent-shaped figures worshipped by the civilization of Chavin, which many experts now believe to be the parent of the later cultures of pre-Columbian Peru. The God of the Arch remains a fascinating mystery still to be resolved. Equally enigmatic and unusual are the other two human-like sculptures of the Kalasaya, the Fraile, which is Spanish for "friar" and the Ponce, named after its discoverer.

Rather than sculptures in the true sense of the word, these are massive pillars on which the figures and other details are etched or sculpted in bas-relief.

342 center This photograph highlights the monoliths standing at the center of the sacred area of the Semi-Underground Temple. In the background is the access staircase to the Calasasaya and, at the center of the portal, the Ponce monolith.

342 bottom This photograph shows another example of a sculpture of a human head, this one with a square, stylized face, inserted in the wall of the Semi-Underground Temple. The style of this head is very similar to that found in the monoliths, such as the Faile and the Ponce.

342 top This delightful silver statuette comes from Tiahuanaco and was certainly part of the votive remains found at the site of a temple. Silver carving was a major and ancient skill in the Andean cultures.

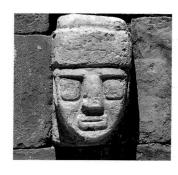

form a circle enclosing a low, square platform, at the center of which is a partly-buried square, a kind of patio facing the east. Inside the Kalasaya are a number of stone monuments whose current location, after restoration work, is different from their original position.

The most spectacular of these is the Gate of the Sun, which is now the symbol of Tiahuanaco. As well as the massive structure of the whole, weighing ten tons, it owes its fame to the friezes that decorate its architrave. These show a series of supernatural-looking winged creatures converging on a center figure of a man with his head crowned with feathers who is holding a serpent shaped stick in both hands. Countless theories have been put forward to explain this divinity, commonly known as the God of the Arch or the God of the Sticks. The only thing we can say

There are two other temple buildings, to the east and west of Kalasasaya, the semi-underground temple and the great complex known as Pumapunku, the remains of a sandstone pyramid structure. Not far from this are the remains of the Palacio and the so-called Gate of the Moon.

A large quantity of pottery items was found in the area of the ceremonial center. By means of comparisons between the decorations on these and those of the monoliths and the fabrics, the specialists are continuing in their difficult task of putting together the fragments of the puzzle that will lead to a final understanding of the many obscure aspects of this civilization, which built great monuments near the banks of Lake Titicaca, in the cold of the Andean Plateau.

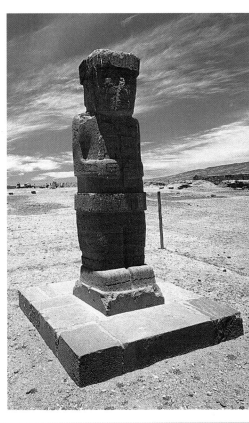

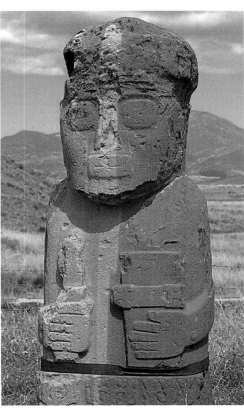

342-343 The Semi-Underground Temple is a small building to the east of the walls of Calasasaya. In this photograph small head-shaped sculptures, inserted in the walls, can be seen.

343 top left This large human-shaped monolith, almost 10 feet high, is known as the Ponce. Like the other sculptures of Tiahuanaco, it has highly stylized features and a square face. Some scholars believe these monuments represent priests.

343 top right One of the most important monolithic sculptures of Tiahuanaco is the Fraile, shown here. Like the others of its kind, the features are rigid and stylized, the arms are folded over the breast and the hands are holding a number of objects. The sculpture is called the Fraile from the Spanish word for Friar, but there is no sure knowledge of what it represents.

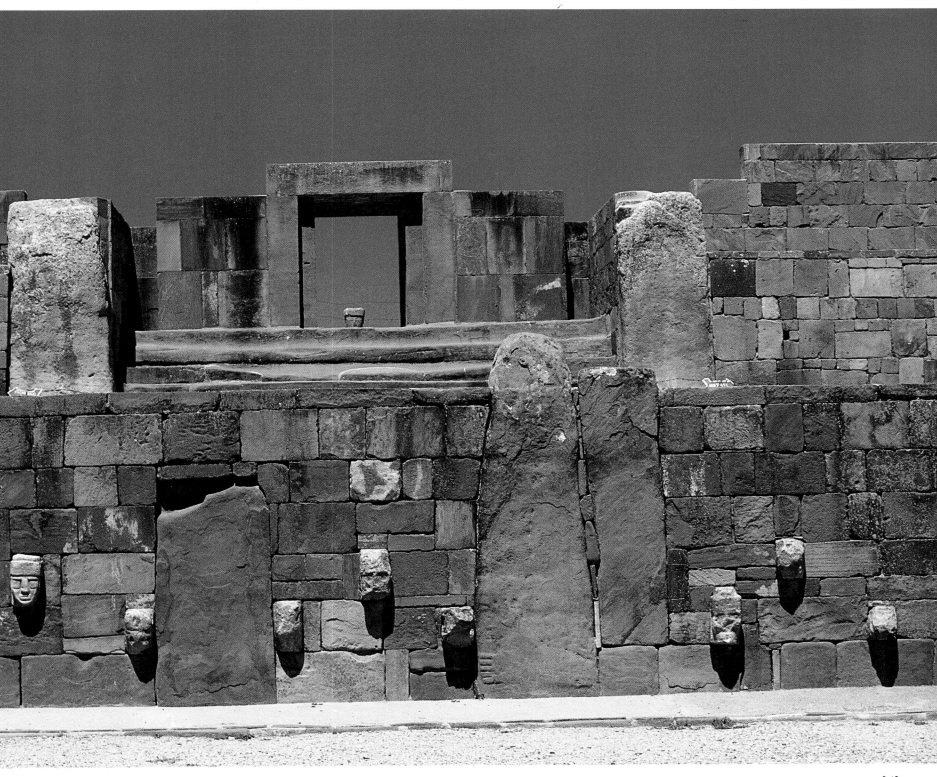

EASTER ISLAND,
LAND OF THE MOAI

A Rano Raraku
B Trench of the
Long Ears

344 The moai, mainly sculpted in the rock of the volcano Rano Raraku, were erected on the ahus, one beside the other. Their number apparently varied according to the importance and wealth of the family that commissioned the monument. It is believed that the ahus were sanctuaries honoring the deified ancestors of the noble families and political and religious centers. The moai were erected along the coast, turning their backs to the sea, perhaps to watch over the plains used for meeting places and celebrations.

345 Recent research seems to indicate that some moai were erected according to an astronomical pattern. The inconsistent nature of this apparently deliberate arrangement has complicated even more attempts to understand Easter Island. One of the few certainties is that the construction and transport of these stone giants must have cost enormous energy in a civilization without metals. There must have been a sophisticated social system to keep teams of workers together for entire seasons.

The fact that Easter Island was an unusual place was clear at once to the first westerners who, by pure chance, discovered this isolated strip of land in the middle of the Pacific Ocean, almost 2500 miles from the coast of South America and 1200 from the nearest atolls of Polynesia. The Dutch admiral Jacob Roggeveen landed there on Sunday, April 5, 1722, during his search for what was called Davis Land which had been seen by a passing English corsair 40 years earlier. The island Roggeveen found needed a name and April 5 was Easter Sunday, so he gave it the name Easter Island.

The captain noted in his log that the natives seemed less surprised by the strange meeting than his crew, and that they showed great interest in the three ships as if they had never seen such things before. The Dutch, on the other hand, were surprised by the monolithic statues scattered around the island, before which the natives prostrated themselves every sunrise. Unfortunately, Roggeveen did not have time to look into the matter in greater detail as the relationship with the islanders quickly deteriorated and shots were fired. On April 10th the ships sailed away. Forty years later, the islanders had another encounter with Europeans when in 1770 two Spanish ships commanded by Don Felipe Gonzales y Haedo, who stayed for six days, arrived. He drew a map of the island and took possession of it in the name of the King of Spain. Again, the visitors were amazed by the great statues. Gonzales reported that they were about 30 feet high and many had a circular red stone on their heads. On March 11, 1774, the famous English navigator, Captain James Cook, came to the island as he wanted to see for himself how true the accounts of this totally isolated island were. Like his predecessors, Cook said it was a windswept, totally treeless land, clearly of volcanic origin and inhabited by modest people with nothing savage at all about them. The natives

seemed to belong to the Polynesian race, lived in large huts made of rushes and wattles in a society based on agriculture and fishing. The Englishman also described the statues with interest, saying that there were hundreds of them all over the island but also noticing that many of them were overturned. As such large statues, solidly implanted in the ground, were unlikely to be moved by the wind or even by earthquakes, they must have been knocked over intentionally. But why? Even more difficult to explain was how the islanders had been able to erect such colossal structures in the first place, as there was not a single tree anywhere on the island, which meant they could not do it by using trees to roll them. In 1786 the Frenchman Jean-François De La Perouse, landed on the island and drew pictures of some of the stone giants. He too noted that the islanders were unable to explain the origins of the statues nor did he discover why all the statues faced away from the sea. In 1804, a Captain Lisjanski, commandant of a Russian ship, reached the island and he wrote that many of the statues that had still been standing when Cook visited were now lying on the ground. Twelve years later, the captain of another Russian ship, the Kotzebue, said that he found only two statues still standing on their bases. When the first Christian missionaries came to the island all the monoliths had been knocked over. Clearly, a fierce war among the island tribes had been raging since time immemorial and after every battle the victors humiliated the defeated party by knocking over the most sacred monuments. But worse was to come. In 1805 the captain of a U.S. vessel had captured some of the islanders to make slaves of them. This naturally angered the islanders who massacred many missionaries as soon as they set food on the island. Then, between 1859 and 1863 over a thousand men and women were captured by the Peruvians and taken to the island of Chincha where they

were forced to dig up the guano from the local mines. The vast majority of these slaves died of deprivations suffered during their work and when the hundred or so survivors were returned to Easter Island following pressure from several foreign governments they brought with them a terrible heritage. Only 15 men survived the return voyage and they brought with them smallpox and tuberculosis to their native island. These terrible diseases ravaged the population, so that only 111 inhabitants remained alive in 1877. Naturally, the missionaries did their best to change the lives of the few survivors by canceling out their traditions, customs and history while other westerners introduced alcohol and venereal diseases. Since experts estimate the maximum population of the island at

15,000 to 20,000, and there were at least 4,000 people on the island when the first Europeans arrived, the tragic figures speak for themselves. Unfortunately, the destruction and the cultural crises that followed the attempt by the westerners to "civilize" the islanders meant that the confused history of the place was totally unknown to the few survivors, who only rarely told credible legends and beliefs. It should not therefore be surprising that no one has ever been able to trace the various stages of the island's history with any certainty and the origins of its inhabitants remain obscure. All we can do, then, is set out the few known facts and a few of the more believable hypotheses. Easter Island is a triangle of volcanic rock with a surface area of about 70 square miles. The natives,

who were so isolated that they knew of no existence of any other land, called it Rapa Nui, meaning "The Center of the World". There are some who believe that the first settlers came from the Marquis Islands, 2400 miles away, about 500 AD, and that once they had settled they developed a completely independent culture based on their Polynesian roots. This theory is backed up by a local legend that tells of a ruler who abandoned an island named Hiva in the remote past on two long vessels and reached the new land after a long and tiring voyage, naming his new home Hotu Matua. Here, his people, beginning in the 10th century BC, started to build large statues, known as moai, aligned on monumental platforms called ahu. These statues were dedicated to the gods and to deified

346-347 Various moai have been carefully restored in recent years, such as these at Tahai (left) and Anakena (center). They stand in what are believed to be their original positions, their heads once again adorned with the pukao in red volcanic rock, their eyes once, it is believed, made from coral now replaced with white plaster. The fact that the moai were knocked over bears out the theory that they were effigies of the leading members of the most important families, in which case their destruction would make sense if anarchy swept the island. Unfortunately, the true history of Easter Island is still unknown.

ancestors. Unfortunately, after an initial period of splendor a long period of tribal war followed, lasting from the 17th century until the start of the 19th, and this led to both the destruction of the moai and the society itself. This idea offers as proof the fact that the name Hiva is very widespread on the Marquis Islands, and there are also linguistic affinities between the language of Rapa Nui and the ancient Polynesian languages. Finally, an examination of the DNA on some human bones found on the island has shown a close similarity with the DNA of the Polynesians. That would be the end of the story and would discredit the theory of colonists from Peru put forward in the 1940s by Thor Heyerdahl, the Norwegian explorer who succeeded in reaching the Polynesian islands from the

coast of South America on board the Kontiki, a fragile balsam wood raft. But there's a second legend that complicates things further. This legend tells that the ruler Hotu Matua came from the Marquis Islands with his people in the 12th century, and found the island already inhabited by a fairer-skinned people. The two ethnic groups lived together in peace and merged into a single race. All went well until a third group suddenly appeared, this time from the east. They were so robust they were called the Hanau Eepe which means "Strong Race". Since they also had ears with highly developed earlobes they were also nicknamed "The Big Ears" with the more established residents calling themselves "The Small Ears". There are several elements that favor this theory, too, such as the

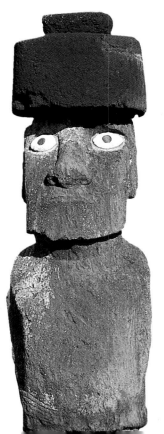

347

presence on the island of certain species of plants that are only found in South America. The camote is a kind of sweet potato and the totora, which grows in great numbers on the banks of Lake Titicaca between Peru and Bolivia, is a reed that the Indians have used since time immemorial to manufacture extremely sturdy boats. The inhabitants of Easter Island used the totora that grew around the volcanic lakes of the island to build fishing vessels. In addition, the Inca nobles deformed the lobes of their ears as a sign of their position, to the point where

Pizarro's Conquistadores nicknamed them orejones which means "big ears" in Spanish. A Peruvian legend tells of an Inca prince who abandoned his land with a number of faithful subjects in a period of dynastic struggles and traveled east, never returning. For centuries, then, the "Strong Race" lived side-by-side with the original inhabitants, the "Weak Race".

This was when work began on sculpting the moai. Previously, the only forms of sculpture were small human figures carved in the wood of a now extinct plant, known

as the tomiro, and small images made out of volcanic stone. Archaeological excavations have supplied various examples of both these primitive art forms. Furthermore, some ahus, such as those of Vinapu, show features quite similar to the Inca walls of Cuzco and Macchu Picchu. At a certain point, perhaps at the end of the 17th century, disputes sprang up between the two races, and these soon erupted into a very violent war, fought to the very bitter end which meant the total annihilation of the Hanau Eepe. This would explain why

348-349 Looking at these moai abandoned at various stages of their completion gives us an idea of how they were made. After selecting a length of rock the sculptors, using only stone tools, outlined the head and then the body, then dug a trench to create the sides and finally smoothed the entire figure before breaking it off from the rock. The monolith was then moved by wooden rollers or a bed of rounded stones to the foot of the quarry where it was placed in a hole. Once the statue was standing, the sculptor finished the back.

there is no similarity between the DNA of the current inhabitants of the island, descendants of the Anau Momoko, and that of the Indian populations of the Americas. After the massacre, clearly still not satisfied despite the vast amounts of blood that had been shed, the "Small Ears" began to fight among themselves, perhaps from about 1730 onward. This would explain why Roggeveen saw all the moai while they were still standing, while Captain Cook noted that some of these had been knocked over. It seems that the civil war only came to an end when the Peruvian slave dealers intervened and, afterward, when the curse of the epidemics swept over Rapa Nui.

There is, however, a third story which partly contradicts that one. According to some accounts heard by 19th century French missionaries, the first inhabitants of Rapa Nui were the "Long Ears", who arrived from the east under the leadership of Hotu Matua. They were the people who raised the first moai on the ahu as well as the stone houses with the false vaulted entrances which are so similar to those found in South America and can still be seen in some parts of the island. This story says that it was only later that other people arrived from the west, sailors from the islands of Polynesia. These, called "Short Ears", were welcomed. They brought with them their long houses made of rushes and shaped like overturned sailing vessels. Their foundations

have been found in many places. These people lived in peace and helped the original inhabitants to raise the moai. Two hundred years later, the situation degenerated and there was a tremendous clash between the two groups. The "Short Ears" massacred the "Long Ears", leaving only one alive. The others were tossed into a crevasse that crosses the eastern point of the island from one end to the other and their bodies were burnt. An archaeological excavation found a large number of half-burnt human bones in the trench known as the "Ditch of the Long Ears". This story also gives an explanation for the genetic heritage of the current inhabitants of the island and are the most credible versions of the history of Rapa Nui. In general, the archaeologists divide the various phases of human settlement on the island into the First Period, or the Population (500-1000), the Second Period, or Expansion (1000-1500) and the Third Period, or Decadence (1500-1722). The period of maximum flourishing must have been between the 12th and 15th centuries. We know that the economy was built around fishing and farming, and that the tribal society was divided into fishermen and peasants, who were responsible for the sustenance of the craftsmen and the ruling classes. The houses were mostly elliptical in shape, similar to overturned sailing vessels, and nearby were the oven, hen house and vegetable garden, protected against the

wind. Life was lived mostly out in the open, the women worked alongside the men and the young and elderly were well cared for. The discovery of a number of fossil pollens, statuettes and tablets inscribed with characters that have yet to be deciphered, known as rongo rongo, has shown that there were once forests on Rapa Nui. Probably all the trees were cut down for use as building materials, wood for burning and, above all, to build the tools necessary to move the moai from the quarries. Over 600 of these statues have been counted on the island, the

oldest one dating back to the 12th century. They take the form of busts with elongated heads, many with rudimentary arms and hands or bas-relief decorations on their backs. The eyes, today empty holes, were filled with white coral and obsidian. The style evolved as time passed, becoming more stylized and the statues got bigger and bigger. It would also appear that they all had a cylinder of red volcanic stone on their heads. Most of the moai are made from the rock of the volcano Rano Raraku, have a height of from 10 to 33 feet and weigh as much as 82 tons. About 80 have been found unfinished on the slopes of the volcano, and at least 200 were abandoned at the foot of the mountain even though they had been completed, probably due to the outbreak of the tribal wars. Perhaps the collapse of the society was, in the end, due to the breaking up of its fragile balance, a breaking up caused, perhaps, by over-population, the exhaustion of resources and the cutting down of the trees. If this is so, the tragedy of Rapa Nui is a warning for contemporary society, unwilling to face the results of failing to respect nature.

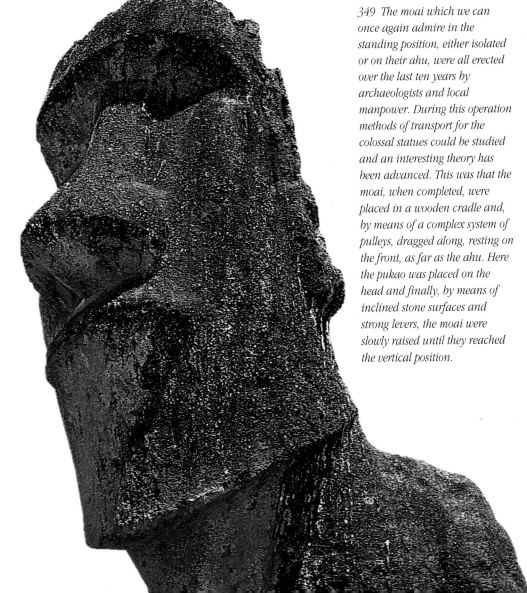

349 The moai which we can once again admire in the standing position, either isolated or on their ahu, were all erected over the last ten years by archaeologists and local manpower. During this operation methods of transport for the colossal statues could be studied and an interesting theory has been advanced. This was that the moai, when completed, were placed in a wooden cradle and, by means of a complex system of pulleys, dragged along, resting on the front, as far as the ahu. Here the pukao was placed on the head and finally, by means of inclined stone surfaces and strong levers, the moai were slowly raised until they reached the vertical position.

GLOSSARY

ABACUS: square or rectangular tablet-shaped element between the capital and the architrave.

ACROPOLIS: highest part of the city, often defended by walls and containing temples.

AMALAKA: architectural element that takes its name from the fruit of the same name. It terminates the oval structure above the cell in the temples of Northern India.

ANDA: central body of the *stupa*, semi-circular in shape.

APSARA: celestial nymph.

ASURA: powers of the darkness, demons.

BARAY: artificial basin for the collection of rainwater in the Khmer towns.

BODHISATTVA: venerable Buddhist figures who, in spite of being enlightened and therefore deserving to go to Nirvana, remain in the world to succour suffering humanity.

CHAC MOOL: stone sacrificial altar showing a semi-reclining man resting on his elbows, with his head to one side. Introduced to Meso-America by the Toltecs. The most famous chac mools are in Tula, Chichén Itzá and Tenochtitlan.

CHAITYA: places of worship, especially Buddhist, consisting of a naved, apsed structure.

CHATTRAVALI: the final pillar of the *stupa* that holds up one or more parasols.

COMB: ornamental structure at the top of the Mayan temples from the Early Classical Period onwards. During the Post-Classical Period, the combs were covered with modelled, painted plaster decorations showing masks of the gods, serpents, jaguars and high ranking figures.

DEVA: powers of light, gods.

DEVARAJA: the Khmer ruler, considered as being a god.

DEVATA: diviniy.

DHARMA: in the Hindu world, the cosmic order that regulates the phenomena of the universe and the moral law that inspires men. In the Buddhist world the doctrine preached by the Buddha.

DYPHTHERON: temple surrounded by a double row of columns.

DROMOS: corridor leading to the entrance of a monumental tomb, or a kind of avenue that leads to the entrance to a temple.

DVARAPALA: armed figures that guard the entrance doors of Hindu temples.

ENNEASTYLE: exceptional type of classical temple with nine columns at the short sides.

ENTABLATURE: in classical archaeological orders, it is the structure lying on the columns, composed by the architrave, the frieze and the cornice.

HEXASTYLE: classical temple with six columns at the short sides.

FALSE VAULT OR SHELVED VAULT: architectural element used by the Maya, who knew nothing of the use of the arch of the true vault. The shelved vault is obtained by building two walls that jut out progressively upwards until they meet.

GABLE: triangular architectural element placed in the façade as the crown of a temple or other classical monumental buildings.

GANDHARVA: genie of the air and celestial attendant of the gods.

GYMNASIUM: in Ancient Greece, school for the moral and intellectual education of young boys.

GLYPH: graphic symbol (from the Greek glifein, "to write") in Zapotec and Mayan writing. It appears closed in a kind of cartouche and may serve as an ideogram, phonetic or mixed.

GOPURAM: monumental structures above the entrances to the temple surrounds in South India.

GU: "grotto", term used to define the temples at Pagan.

HARMIKA: enclosed structure at the top of the *stupa*, from which the pillar with parasols emerges.

HTI: a kind of hanging parasol with small bells above the *zeidi*.

HYPOSTYLE HALL: a room whose ceiling is held up by columns or pillars, very common in Egyptian religious or funerary buildings.

KALASHA: the water vase at the end of the Hindu temples which evokes the origins of the universe from the primordial waters and symbolizes fertility and abundance.

KINNARA: partly animal celestial musicians.

KIRTIMUKHA: the "face of glory", a grotesque mask symbolising all-transforming, all-devouring time.

KUDU: small horseshoe-shaped arch.

LINGA: phallic stone symbolising the god Shiva.

MAKARA: mythical sea creature.

MANDAPA: colonnaded hall or pavilion.

MASTABA: Arabic word for the four-sided bench with slightly tapering sides, built in bare brick covered in plaster and found in front of the houses in Egyptian villages. The term is used to refer to the Egyptian tombs, which are similar in shape.

MEDHI: the base of the *stupa*.

MUDRA: hand gestures expressing the most important moments in the spiritual experience.

NAGA: half human half serpent creatures connected with water, fertility and knowledge

NAGINI: the female companions of the nagas

NIRVANA: the state of liberation from the continuous, painful return to worldly existence.

NYMPHEON: building with niches and central fountain, often with apse.

OPISTODOME: the rear part of a temple, opposite the pronaos, used as a storage area for the treasure.

PERIPHTHERON: building or temple surrounded by a row of columns.

PERISTASIS: the colonnade that surrounds the cell of the periphtheral temple or, more rarely, a building of varying type.

PERISTYLE: in sanctuaries and Greek houses - and later in Roman ones - courtyard surrounded by a colonnaded portico.

PRADAKSHINA: a rite of procession with the object to be venerated always to the right of the walkers.

PRASAT: the sanctuary towers in Khmer architecture.

PRONAOS: in Greek and Roman temples, the space between the cell and the colonnade of the façade.

PYLON: monumental entrance to the Egyptian temples, formed by massive towers of trapezoid shape, alongside the portal.

RATHA: wooden carriage that contains the images of the gods when these are taken in procession outside the temple.

RYTHON: drinking vessel in the form of a curved horn, often terminating in the head of an animal.

SALABHANJIKA: nymph of the trees.

SANGHA: monastic community.

SANGHARAMA: residence of monks, see "vihara".

SHIKHARA: oval tower above the cell in the temples of North India. The term also defines certain domed structures in the architecture of the south of the country.

STUPA: bell-shaped reliquary deriving from the burial mounds built on the remains of the cremation of Buddha, later becoming cosmic symbol.

STYLOBATE: base of the columns in classical temples.

TABENA: the reliquary in the central sealed chamber of the *zeidi*.

TALUD-TABLERO: architectural element originating in Teotihuacan, and found in many other areas of Meso-America. It consists of a vertical panel, or *tablero*, above an oblique part, or *talud*. The dimensions of the two parts vary, creating a wide range of architectural compositions.

DOWNSTREAM TEMPLE: building connected to the funerary temple annexed to the pyramid with a descending covered ramp, in which the mummification and purification rites of the body of the ruler take place. In front of the entrance, there was usually a boarding stage connected to the Nile by an artificial channel.

THOLOS: temple, building or part of a building, with circular plan, bounded by a row of columns and usually terminating in a dome or conical roof.

TYMPANUM: in classical temples, the triangular part of the façade bounded by the two projections and the architrave, usually adorned with groups of sculptures.

TORANA: access portal to the surrounding enclosure of the *stupa*.

TRIRATNA: the "triple jewel", or the Buddha, his doctrine and the community of monks.

TZOMPANTLI: stone monument reproducing a wooden rack to which the skulls of the sacrificial victims or decapitated enemies were attached, brought to Mesoamerica by the Toltecs in the Post-Classical Period.

VARAHA: the "wild boar", one of the *avataras*, or earthly forms, of the god Vishnu who took this form to set the goddess Earth free from the muddy depth of the ocean.

VEDIKA: the enclosure surrounding sacred buildings.

VIHARA: monastery.

VIMANA: terraced pyramid structure used to cover the cell and other important buildings in the temples of South India.

YAKSHA: pot-bellied genie of the trees.

YAKSHI OR YAKSHINI: dryads, nymphs of the trees and woods.

ZEIDI: Burmese term used for the *stupa*.

BIBLIOGRAPHY

Abu Simbel
-L. A. Christophe, *Abou-Simbel et l'épopée de sa découverte*, Brussels 1965.
-Chr. Desroches-Noblecourt and Ch. Kuentz, *Le petit temple d'Abou Simbel: "Nofretari pour qui se lève la dieu- soleil"*, Cairo 1968.
-Various authors, *The Salvage of the Abu Simbel Temples. Concluding Report*, Stockholm 1971.
-H. el-Achirie and J. Jacquet, *Grand temple d'Abou Simbel* vol. I: Architecture, Cairo 1984.

Ajanta
-S.P.M. Mackenzie and M. Taeda, *Ajanta. I monasteri rupestri dell'India*, Milan 1982.
-Philip Rawson, *La pittura indiana*, Milan 1964.
-Debala Mitra, *Ajanta, Archaelogical Survey of India*, New Delhi 1983.
-Jayanta Chakrabarti, *Techniques in Indian mural painting*, Calcutta 1980.

Angkor
-D. Mazzeo and C. Silvi Antonini, *Khmer Civilisations*, in *"Le grandi civiltà"*, Milan 1972.
-B. Dagens, *Angkor, la foresta di pietra*, Trieste 1995.
-J. Boisselier, Le Cambodge, in *"Manuel d'archéologie d'Extrême Orient, Asie du sud-est, Tome I"*, Paris 1966.
-G. Coedès, *Angkor, an introduction*, London 1963.

Athens
-C. Tiberi, *Mnesicle, l'architetto dei Propilei*, Rome 1964.
-A. Giuliano, *Urbanistica delle città greche*, Milan 1966.
-H.A. Thompson and R.E. Wycherley, *The Agora of Athens*, Princeton 1972.
-E. La Rocca, *L'esperimento della perfezione. Arte e società nell'Atene di Pericle*, Milan 1988.

Babylon
-H. Frankfort, *Arte e Architettura dell'antico Oriente*, Turin 1970.
-J. C. Margueron, *Mesopotamia*, in *Enciclopedia Archeologica*, Geneva 1976.
-M. Liverani, *Antico Oriente, Storia Società Economia*, Rome-Bari 1988.
-N. Roaf, *Cultural Atlas of Mesopotamia and the Ancient Near East*, Oxford 1990.

Borobudur
- Lucilla Saccà, *Borobudur Mandala de Pierre*, Milan 1983.
- John Miksic, *Borobudur - Golden Tales of the Buddhas*, Singapore 1990.
- Jacques Dumarçay, *The Temples of Java*, Singapore 1986.
- Pietro Scarduelli, *Lo specchio del cosmo*, Turin 1992.

Carnac
-Pierre-Roland Giot, *I menhir allineati di Carnac*, Rennes 1992.

Chan Chan
-A. Lapiner, *Pre-Columbian Art of South America*, New York 1976.
-D. Bonavia, *Perù. Hombre y Historia*, Lima 1991.
-Various authors, *Inca-Perù*, Rito, Magia, Mistero, Rome 1992.

Chichén Itzá
-M.E. Miller, *The Art of Mesoamerica*, New York 1986.
-M.E. Miller and K. Taube, *The Gods and Symbols of Ancient Mexico and the Maya*, London-New York 1992.
-S. Morley and G. Brainerd, *I Maya*, Rome 1984.

Cuzco, Sacsahuaman and Ollantaytambo
-H. Favre, *Les Incas*, Paris 1972.
-D. Lavallée and L.G. Lumbreras, *Les Andes. De la Prehistorie aux Incas*, Paris 1985.
-Various authors, Inca. *Perù, 3000 Ans d'Histoire*, Ghent 1990.
-F. Kauffman Doig, *Perù*, Venice 1995.

Easter Island
-G. della Ragione, *L'Isola di Pasqua*, in *Atlante di archeologia*, Turin 1996.
-A.G. Drusini, *Rapa Nui. L'ultima terra*, Milan 1991.
-T. Heyerdahl, *Archaeology of Easter Island*, Santa Fe 1961.
-M.C. Laroche, *Ile de Pâque*, Paris 1981.

Ephesus
-W. Alzinger, *Alt Efesos topographie und architectur*, Berlin-Vienna 1967.
-W. Alzinger, *Die ruinen von Efesos*, Berlin-Vienna 1972.
-E. Akurgal, *Ancient Civilisations and Ruins of Turkey*, Istanbul 1983.
-H. Lauter, *Die Architektur des Hellenismus*, Darmstadt 1986.

Hadrian's Villa

-S. Aurigemma, *Villa Adriana*, Rome 1962.
-F. Coarelli, *Lazio*, Bari 1982.
-H. Kähler, *Villa Adriana*, in *Enciclopedia dell'Arte Antica*, Rome 1961.
-F. Rakob, *Villa Adriana*, in *Enciclopedia dell'Arte Antica*, Rome 1994.
-H. Stierlin, *Roman Empire. From the Etruscans to the Decline of Roman Empire*, Cologne 1996.

Herodion
-V. Corbo, *Herodium: gli edifici della reggia-fortezza*, Jerusalem 1989.
-Y. Netzer, *Herodium: an Archaeological Guide*, Jerusalem 1997.

Karnak and Luxor
-P. Barguet, *Le Temple d'Amon-Rê à Karnak. Essai d'Exegese*, Cairo 1962.
-H. Brunner, *Die Südlichen Räume des Tempels von Luxor*, Mainz 1977.
-A Roccati, *Karnak e Luxor*, Novara 1981.

Knossos
-A. Evans, *The Palace of Minos at Knossos*, London 1921-1935.
-S. Hood, *The Mynoans*, London 1971.
-S. Hood and D. Smith, *Archaeological Survey of Knossos*, London 1981.

Lascaux
-A. Leroi-Gourhan and J. Allain, *Lascaux inconnu*, Paris 1979.
-L.R. Nougier, *La Preistoria*, Turin 1982.
-L.R. Nougier, *Lascaux*, in *Atlante di Archeologia*, Turin 1996.

Leptis Magna
-P. Romanelli, *Storia delle province romane dell'Africa*, Rome 1959.
-P. Romanelli, *Leptis Magna*, in *Enciclopedia dell'Arte Antica*, Rome 1961.
-J.B. Ward Perkins, *Leptis Magna* in *The Princeton Encyclopedia of Classical Sites*, Princeton 1976.

Luoyang
-L. Sickman and A. Soper, *L'arte e l'architettura cinesi*, Einaudi, Turin 1969.
-W. Willets, *L'arte cinese*, Sansoni, Florence 1963.
-Various authors, *Longmen Shiku*, Wenwu, Beijing 1980.
-Various authors, *Luoyang Longmen Shuangku*, in Kaogu Xuebao no.1, Beijing 1988.

Macchu Picchu
-C. Bernand, *Gli Incas. Figli del Sole*, Milan 1994.
-L.G. Lumbreras, *Arqueología de la América Andina*, Lima 1981.
-Various authors, *I Regni Preincaici il Mondo Inca*, Milan 1992.

Mamallipuram
-Stella Kramrisch, *The Hindu Temple*, Delhi 1980.
-Christopher Tadgell, *The History of Architecture in India*, Hong Kong 1990.
-A Volwahsen, *Architettura indiana*, Milan 1968.

Masada

-Y. Netzer. *The Buildings, Stratigraphy and Architecture (Masada III)*, Jerusalem 1991.
-Y. Yadin, *Masada*, London 1966.

Mesa Verde
-J.J. Brody, *Beauty from the Earth*, Philadelphia 1990.
-M.D. Coe, D. Snow and E. Benson (eds.), *Atlante dell'Antica America*, Novara 1987.

Monte Albán
-I. Bernal and M. Simoni Abbat, *Il Messico dalle Origini agli Aztechi*, Milan 1992.
-A. Caso, *El tresoro de Monte Albán*, Mexico City 1969.
-R. Pina Chan, *Olmechi. La Cultura Madre*, Milan 1989.

Mycenae
-S.E. Iakovidis, *Late Helladic Citadels on Mainland Greece*, Leyden 1983.
-G.E. Mylonas, *Ancient Mycenae*, London 1957.
-W. Taylour, *The Mycenaeans*, London 1964.

Nemrut Dagh
-S. Sahin, *Watchful Stones*, in *Atlas Travel Magazine*, Ankara 1996.
-F.K. Dörner, *Nemrut Dagh*, in *Enciclopedia dell'Arte Antica*, Rome 1961.

Nubian Temples
-J. Baines and J. Málek, *Atlante dell'Antico Egitto*, Novara 1985
-S. Curto, *Nubia*, Turin 1966.
-Various Authors, *Topographical Bibliography of Ancient Egyptian Hieroglyphic Texts, Reliefs and Paintings*, Vol.VII: *Nubia, the Desert and Outside Egypt*, Oxford 1952.

Paestum
-E. Greco and D. Theodorescu, *Poseidonia - Paestum I*, Rome 1980.
-E. Greco and D. Theodorescu, *Poseidonia - Paestum II*, Rome 1983.
-D. Mertens, *Der alte Heratempel in Paestum und die archaische baukunst in Unteritalien*, Mainz 1993.

Pagan
-Mario Bussagli, *Architettura orientale*, Venice 1981.
-Thein Sein, *The Pagodas and Monuments of Pagan*, Rangoon 1995.
-Paul Strachan, *Pagan, Art and Architecture of Old Bhurma*, Singapore 1989.

Palenque
-C. Baudez and S. Picasso, *Les Cités perdues des Mayas*, Paris 1987.
-L. Shele and D. Friedel, *A Forest of Kings: the Untold Story of the Ancient Maya*, New York 1990.
-Various authors, *Mondo Maya*, Milan 1996.

Palmira
-M. Harari, *Palmira*, in *Atlante di Archeologia*, Turin 1996.
-K. Michalowski, *Palmira*, in *Enciclopedia*

dell'Arte Antica, Rome 1961.

Persepolis
-M. Liverani, *Antico Oriente, Storia Società Economia*, Rome-Bari 1988.
-M. Roaf, *Cultural Atlas of Mesopotamia and the Ancient Near East*, Oxford 1990.

Petra
-M. Avi-Yonah, *Petra*, in *Enciclopedia dell'Arte Antica*, Rome 1961.
-F. Bourbon, *Yesterday and Today, The Holy Land, Lithographs and Diaries by David Roberts, R.A.*, Bnei-Brak 1994.
-H. Keiser, *Petra dei Nabatei*, Turin 1972.
-M. Rostovtzeff, *Città Carovaniere*, Bari 1971.

Pompeii
-A De Franciscis, *The Buried Cities: Pompeii and Herculaneum*, New York 1978.
-E. La Rocca, A. de Vos and M. de Vos, *Pompei*, Milan 1994.
-A. Maiuri, *Pompei ed Ercolano fra case e abitanti*, Milan 1959.
-P. Zanker, *Pompei. Società, immagini urbane e forme dell'abitare*, Turin 1993.

Philae
-G. Haeny, *A Short Architectural History of Philae*, BIFAO 85, 1985.
-E. Vassilika, *Ptolemaic Philae*, OLA 34, Leuven 1989.
-A. Roccati - A. Giammarusti, *File, storia e vita di un santuario egizio*, Novara 1980.

Rome
-J. P. Adam, *La construction romaine. Materiaux et techniques*, Paris 1984.
-M. Brizzi, *Roma, i monumenti antichi*, Rome 1973.
-F. Coarelli, *Roma*, Milan 1971.
-A.M. Liberati and F.Bourbon, *Roma Antica, Storia di una civiltà che conquistò il mondo*, Vercelli 1996.
-U. E. Paoli, *Vita romana, usi, costumi, istituzioni, tradizioni*, Florence 1962.
-Various authors, *Vita quotidiana nell'Italia Antica*, Verona 1993.

Sanchi
-Michel Delahoutre, *Arte indiana*, Milan 1996.
-Debala Mitra, *Sanchi*, New Delhi 1978.
-Calambur Sivaramamurti, *India, Ceylon, Nepal, Tibet*, Turin 1988.
-Maurizio Taddei, *India antica*, Milan 1982.

Saqqara and Giza
-M.Z. Goneim, *Horus Sekhemkhet*, Cairo 1957.
-S. Hassan, *Excavations at Giza*, 10 Vols., Oxford 1932-1960
-J.P. Lauer, *The Royal Cemetery of Memphis*, London 1979.
-E. Leospo, *Saqqara e Giza*, Novara 1982.
-C.M. Zivie, *Giza au deuxième Millénaire*, Cairo 1976.

Stonhenge
-R.J.C. Atkinson, *Stonehenge and Avebury*, Exeter 1974.
-J Dyer, *Southern England: an Archaeological Guide*, London 1973.
-W. Schreiber, *Stonehenge*, in *Atlante di Archeologia*, Turin 1996.

Tarquinia
-M. Torelli, *Elogia Tarquinensia*, Florence 1975.
-Various authors *Gli Etruschi di Tarquinia, catalogo della mostra*, Modena 1986.
-Various authors, *Studia Tarquinensia*, Rome 1988.

Teotihuacan
-I. Bernal and M. Simoni Abbat, *Il Messico dalle Origini agli Aztechi*, Milan 1992.
-E. Matos Moctezuma, *Teotihuacan, La Metropoli degli Dèi*, Milan 1990.

Tiahuanaco
-P. Cieza de Leon, *La Cronica del Perù* (1553), Lima 1973.
-F. Kauffman Doig, *Perù*, Venice 1995.
-A. Posnanski, *Tihauanaco y la Civilización Prehistórica en el Altiplano Andino*, La Paz 1911.

Tikal
-M. Grulich, *L'Art Precolombien. La Mesoamerique*, Paris 1992.
-H. Stierlin, *The Maya Palaces and Pyramids in the Rainforest*, Cologne 1997.

Ur
-H. Frankfort, *Arte e Architettura dell'antico Oriente*, Turin 1970.
-M. Liverani, *L'origine della città*, Rome 1986.
-M. Liverani, *Antico Oriente, Storia Società Economia*, Rome-Bari 1988.

Uxmal
-C. Baudez and P. Becquelin, *I Maya*, Milan 1985.
-P. Gendrop and D. Heyden, *Architettura Mesoamericana*, Milan 1980.
-Various authors, *Mondo Maya*, Milan 1996.

Western Thebes
-E. Edwards, *Tutankhamon, la tomba e i tesori*, Milan 1980.
-B. Porter and R. Moss, *Topographical Bibliography*, Vol. I, *Theban Necropolis*, Oxford 1960.
-B. Porter and R. Moss, *Topographical Bibliography*, Vol. II, *Theban Temples*, Oxford 1972.
-N. Reeves and R. Wilkinson, *The Complete Valley of the Kings*, London 1996.

Xi'An
-X. Nai, *Sanshi Nian Lai De Zhongguo Kaoguxue*, in *Kaogu*, Beijing 1979.
-W. Willets, *Origini dell'Arte Cinese*, Florence 1965.
-Various authors, *Settemila anni di Cina*, Milan 1983.

ILLUSTRATION CREDITS

Luciano Pedicini/Archivio Dell'arte: pages 51 top left, 53 top right.

Tarquinia
Archivio Scala: pages 56 bottom, 56-57, 57 top, 58-59, 59 top, 59 bottom.
Giovanni Dagli Orti: page 59 center.
Marco Mairani: page 57 bottom.
Luciano Pedicini/Archivio Dell'Arte: page 56 top.

Pompeii
Giulio Veggi/Archivio White Star: pages 60 top, 60 center, 62, 63, 64 center, 64 bottom, 65 bottom, 68 top.
Archivio Scala: pages 66, 67, 69 bottom right, 70 bottom, 70-71, 71 top.
Giovanni Dagli Orti: pages 61, 64-65, 65 right.
Luciano Pedicini/Archivio Dell'Arte: pages 68 bottom, 68-69, 69 bottom left, 70 top.
Guido Rossi/The Image Bank: "Concessione S.M.A N.01-337 del 03-09-1996" pages 60 bottom, 64 top.

Rome
Marcello Bertinetti/Archivio White Star: "Concessione S.M.A. N.325 del 01-09-1995" pages 72-73, 76 bottom, 76-77, 78-79, 80 top, 80 center, 80-81, 81 bottom, 82-83, 84-85, 85 top, 85 bottom right .
"Concessione S.M.A. N.316 del 18-08-1995" pages 82 center, 84 bottom.
Giulio Veggi/Archivio White Star: pages 72, 73 right, 74, 75, 76 top, 77 bottom left, 77 bottom right, 80 bottom left, 82 top, 82 bottom, 83 bottom, 84 top, 84 center, 85 bottom left.
Archivio Scala: pages 78 top, 78 bottom, 79 top, 79 bottom.
Araldo De Luca: pages 73 bottom, 80 bottom right.

Hadrian's Villa-Tivoli
Marcello Bertinetti/Archivio White Star: "Concessione S.M.A. N.316 del 18-08-1995" pages 86 top, 86-87, 88-89, 91.
Giulio Veggi/Archivio White Star: pages 86 center, 86 bottom, 89 bottom, 90 top.
Giovanni Dagli Orti: page 89 top.
Araldo De Luca: page 90 bottom.
Archivio Scala: page 87 bottom.

AFRICA
Antonio Attini/Archivio White Star: page 92-93.
Giulio Veggi/Archivio White Star: page 93 bottom.
Alberto Novelli/The Image Bank: page 92 bottom left, 92 bottom right.
Alberto Siliotti/Archivio Geodia: page 92 top.

Saqqara
Antonio Attini/Archivio White Star: page 101 top.
Marcello Bertinetti/Archivio White Star: pages 96-97, 97, 100 top right, 100-101, 103 top right, 103 center right.
Araldo De Luca/Archivio White Star: pages 100 top left, 102, 103 top left, 103 bottom.
Giulio Veggi/Archivio White Star: pages 98 top, 98 top right, 101 center, 101 bottom.
Giulio Andreini: page 98 top right.
AKG Photo: page 104 top.
Giovanni Dagli Orti: page 96 top.
Claudio Concina/Realy Easy Star: page 98 bottom right.
Werner Forman Archive: pages 99, 104 top, 104-105, 105 bottom.

Karnak
Antonio Attini/Archivio White Star: pages 106 right, 111 bottom left, 111 bottom right.
Marcello Bertinetti/Archivio White Star: pages 106 left, 108 top, 108 bottom left, 108 bottom right, 108-109, 110 top left, 110 top right, 110-111, 111 top, 112-113, 113.
Giulio Veggi/Archivio White Star: pages 107 bottom, 109 top, 110 bottom, 112.
Anne Conway: pages 106-107.

Luxor
Antonio Attini/Archivio White Star: page 117 top.
Marcello Bertinetti/Archivio White Star: pages 114-115, 115 bottom.
Giulio Veggi/Archivio White Star: pages 114, 116, 116-117, 117 bottom.

Valley of the Kings
Antonio Attini/Archivio White Star: pages 118 top, 120 center top, 120 center bottom, 123 center.
Marcello Bertinetti/Archivio White Star: pages 118 bottom left, 118-119, 119 top, 120 top, 120-121, 122-123, 122, 123 top, 123 bottom.
Giulio Veggi/Archivio White Star: pages 118 center, 121 bottom, 124 top left.
Hervé Champollion: page 126 bottom.
Christophe Boisivieux: pages 126 top left, 126 top right.
Giovanni Dagli Orti: page 127 top.
Archivio White Star: pages 127 center, 127 bottom.
Damm/Bildagentur Huber/Sime: 128-129, 128 bottom right, 129 top left.
Araldo De Luca/Archivio White Star: pages 118 bottom right, 124 top right, 124 bottom left, 124 bottom right, 125.
Bertrand Gardel/Ag. Hemispheres: page 120 bottom.
Andrea Iemolo: pages 126 center, 126-127, 129 top right, 129 bottom left.
Charles Lenars: pages 128 bottom left, 129 bottom right.

Nubian Temples
Antonio Attini/Archivio White Star: pages 130, 131, 133 top, 133 bottom left.
Giulio Veggi/Archivio White Star: pages 132-133.
Hervé Champollion: page 133 bottom right.
Enrico Martino: page 132 bottom.
Sandro Vannini/Ag.Franca Speranza: page 132 top.

Abu Simbel
Antonio Attini/Archivio White Star: pages 134 top, 134 bottom, 134-135.
Giulio Veggi/Archivio White Star: pages 134 center right, 135 bottom, 136-137, 137, 138, 139.
Enrico Martino: page 134 center left.

Philae
Antonio Attini/Archivio White Star: pages 140, 142 bottom.
Giulio Veggi/Archivio White Star: pages 141, 142-143, 143.
Guido Rossi/The Image Bank: pages 140-141.

Leptis Magna
Cesare Galli: pages 144, 144-145, 146, 147, 148-149, 149 top, 149 center.
Giancarlo Zuin: page 149 bottom.

ASIA
Marco Casiraghi: pages 150-151.
Photobank: page 150 top right.
Alison Wright: page 150 left.

Nemrut Dagh
Massimo Brochi/Archivio White Star: pages 154-155, 155, 156, 157, 158, 159.

Ephesus
Antonio Attini/Archivio White Star: pages 160, 161, 162, 163, 164, 165.

Herodion
Marcello Bertinetti/Archivio White Star: pages 166-167.
Itamar Grinberg: page 167 right.
Charles Lenars: page 167 left.

Masada
Antonio Attini/Archivio White Star: pages 169 top, 169 center, 171 center top, 171 top right.
Marcello Bertinetti/Archivio White Star: pages 168 top, 168-169, 170-171, 171 left.
Itamar Grinberg: page 171 center bottom.

Petra
Antonio Attini/Archivio White Star: page 173.
Massimo Borchi/Archivio White Star: pages 172, 174, 175, 176, 177, 178, 179, 180, 181.

Palmyra
Felipe Alcoceba: pages 182 top, 186 bottom, 191 top.
Giovanni Dagli Orti: page 182 bottom, 189 top, 189 bottom left.
Suzanne Held: page 185 bottom.
Franck Lechenet/Ag. Hemispères: pages 182-183, 186-187, 190-191.
Robert Tixador/Ag. Top: pages 183 bottom, 184-185,

186 top, 186 center, 191 bottom.
Angelo Tondini/Focus Team: pages 185 top, 188, 189 bottom right.

Babylon
Bildarchiv Kulturbesitz: page 194-195
Giovanni Dagli Orti: pages 193 center, 195 top left, 195 right.
Charles Lenars: page 193 bottom right.
R.M.N.: pages 194 top, 195 bottom left.
Henri Stierlin: page 193 top.
Robert Tixador/Ag. Top: pages 192 top, 192-193, 193 bottom.

Ur
Giovanni Dagli Orti: pages 198 bottom, 199 top.
Henri Stierlin: pages 196 top, 197.
The Ancient Art & Architecture Collection: pages 198-199, 199 bottom.
Robert Tixador/Ag. Top: pages 196-197.

Persepolis
Christophe Boisivieux: pages 210 bottom, 211 bottom, 212-213, 213 top.
E. Boubat/Ag. Top: page 207 top.
Marco Casiraghi: pages 202 bottom, 204 bottom, 204-205, 206-207, 210-211.
Giovanni Dagli Orti: page 209 top right.
Duclos-Gaillarde/Ag. Gamma: pages 202 center, 208, 209 center.
Suzanne Held: pages 200 left, 200-201, 201 bottom, 202 top, 205 bottom, 206 left, 207 bottom, 209 left, 209 bottom, 212 bottom, 213 bottom.
Henri Stierlin: pages 200 bottom, 204 top, 205 top, 210 top.
Minnella/Overseas: pages 202-203.

Sanchi
Marcello Bertinetti/Archivio White Star: pages 214-215, 217.
Suzanne Held: pages 214 left, 215 bottom.
Enrico Martino: page 215 top.
Photobank: pages 215 center, 216, 218, 219.

Mamallipuram
Photobank: pages 220, 221, 222 top, 222 center top, 222 bottom, 222-223, 223 bottom, 224-225, 224 bottom left, 225.
Robert Tixador/Ag. Top: page 222 center bottom.
Cesare Galli: page 224 bottom right.

Ajanta
Charles Lenars: page 228.
Photobank: pages 226, 226-227, 227 top left, 227 top right, 228-229, 229 bottom, 230, 231.
The Ancient Art & Architecture Collection: pages 227 center right, 227 bottom right.

Pagan
Christophe Boisivieux: pages 232-233, 233 top, 233 bottom, 234, 235 bottom, 236, 236-237, 237 left, 238, 238-239, 240 top right, 240-241, 241 top.
Photobank: pages 233 center, 235 left, 235 center, 239, 240 top left, 240 bottom left, 241 center, 241 bottom.
Alison Wright: page 237 right.

Borobudur
Marcello Bertinetti/Archivio White Star: pages 243, 244, 245, 246, 247.
Charles Lenars: page 242.
Photobank: pages 242-243.

Angkor
Patrick Aventurier/Ag. Gamma: page 250 bottom.
Christophe Boisivieux: pages 248 top, 251 bottom right, 252-253, 252 bottom, 253 center left, 254 center top left, 257, 258 bottom, 259 top, 259 bottom right.
Marco Casiraghi: page 249, 254 top left, 254 center bottom left, 256-257, 259 bottom left.
B. Harsford/Fotograff: page 253 center right, 254 bottom right.
A. Lanzellotto/The Image Bank: pages 250-251.
Photobank: pages 248 bottom, 253 top, 254 bottom left, 258-259.
Ben Simmons/The Stock House: page 255.
Alison Wright: pages 251 top, 251 center, 251 bottom left, 253 bottom, 256.

Xi'an
Brissaud/Ag. Gamma: page 261 bottom.
Giovanni Dagli Orti: pages 26, 263, 264, 265, 266, 267.
Nigel Hicks/Woodfall Wild Images: page 263 bottom.
H.LLoyd/SIE: pages 260-261.
Angelo Tondini/Focus Team: page 262.

Luoyang
Suzanne Held: page 272 bottom, 273 top.
Christian Viojard/Ag. Gamma: pages 270, 271, 272-273, 273 bottom.
Werner Forman Archive: page 272 top.

AMERICAS AND OCEANIA
Angelo Tondini/Focus Team: page 274 left.
Massimo Borchi/Archivio White Star: pages 274-275 on the background, 274-275 center, 275 right.

Mesa Verde
Christophe Boisivieux: pages 278 bottom center, 281 left, 281 bottom right.
Jerry Jacka: page 281 top right.
Guido Rossi/The Image Bank: page 278 bottom right, 279 bottom, 280.
Simon Wilkinson/The Image Bank: pages 278-279.

Teotihuacan
Antonio Attini/Archivio White Star: pages 282, 283, 284, 285, 286, 287.

Monte Alban
Antonio Attini/Archivio White Star: pages 288, 289, 290, 291, 292, 293.

Palenque
Antonio Attini/Archivio White Star: page 301.
Massimo Borchi/Archivio White Star: pages 294, 295, 296, 297, 298, 299, 300.
Giovanni Dagli Orti: page 294.

Tikal
Massimo Borchi/Archivio White Star: pages 302, 303, 304, 305, 306, 307.

Uxmal
Massimo Borchi/Archivio White Star: pages 308, 309, 310, 311 top left, 311 top right, 311 center, 311 bottom, 312-313, 312 bottom, 313 top, 313 bottom.

Chichén Itzá
Massimo Borchi/Archivio White Star: pages 314, 315 316, 317, 318 center, 318 bottom, 318-319, 320, 321.
Giovanni Dagli Orti: page 318 top left.

Chan Chan
Massimo Borchi/Archivio White Star: pages 322-323, 323 top right, 323 center right, 323 bottom right.
Giovanni Dagli Orti: pages 324, 324-325, 325 top left.
Charles Lenars: pages 323 top left, 325 top right.

Cuzco
Antonio Attini/Archivio White Star: pages 326, 327, 328-329, 329 top, 329 center.
Giovanni Dagli Orti: page 329 bottom.

Ollantaitambo
Antonio Attini/Archivio White Star: pages 330, 331 top, 332, 333.

Macchu Picchu
Marcello Bertinetti/Archivio White Star: pages 337 bottom, 338 top left.
Antonio Attini/Archivio White Star: pages 334, 335, 336, 336-337, 338 center left, 338 bottom left, 338 top left, 339.

Tiahuanaco
Antonio Attini/Archivio White Star: pages 340, 340-341, 342, 342-343, 343 top left.
Massimo Borchi/Atlantide: page 341 bottom, 343 top right.
Giovanni Dagli Orti: page 342 top.

Easter Island
Bruno Barbier/Ag. Hemisperes: page 347 center.
Massimo Borchi/Atlantide: pages 346-347.
Guido Cozzi/Atlantide: pages 348 top, 349 top, 349 bottom.
The Image Bank: pages 344 top, 345.
Angelo Tondini/Focus Team: page 347 top.
Giancarlo Zuin: page 344 bottom.
A. Ponzio/Overseas: page347 bottom.

All black-and-white maps are by Livio Bourbon